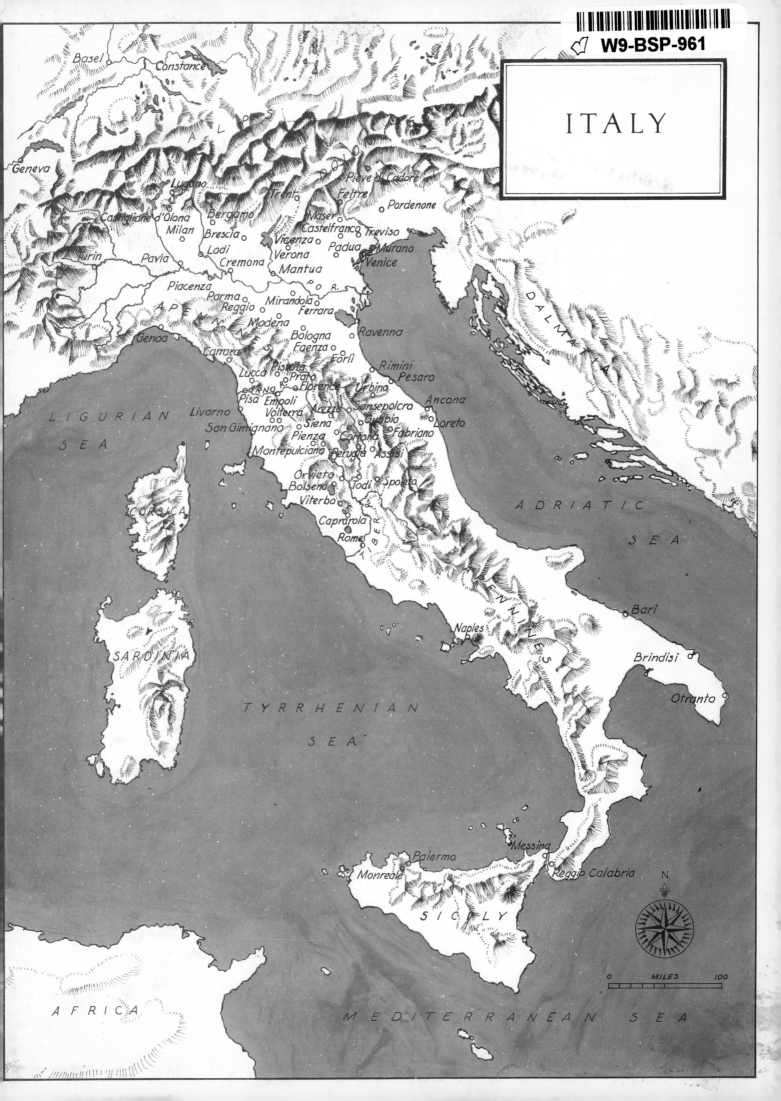

ITALY

Basel
Constance
Geneva
ALPS
Lugano
Pieve di Cadore
Trent
Feltre
Pordenone
Bergamo
Maser
Castiglione d'Olona
Castelfranco
Treviso
Milan
Brescia
Vicenza
Padua
Murano
Lodi
Verona
Venice
Turin
Pavia
Cremona
Mantua
Piacenza
PO R.
Parma
Mirandola
Reggio
Ferrara
Modena
APENNINES
Bologna
Ravenna
Genoa
Faenza
Carrara
Forlì
Rimini
Pistoia
Pesaro
Lucca
Prato
ARNO
Florence
Urbino
Ancona
Pisa
Empoli
Aretto
Sansepolcro
Livorno
Volterra
Loreto
San Gimignano
Siena
Gubbio
Cortona
Fabriano
Pienza
Perugia
Assisi
Montepulciano
Orvieto
Bolsena
Todi
Spoleto
Viterbo
Caprarola
TIBER
Rome
APENNINES

LIGURIAN
SEA

CORSICA

SARDINIA

TYRRHENIAN
SEA

DALMATIA

ADRIATIC
SEA

Naples
Bari
Brindisi
Otranto

Messina
Palermo
Monreale
Reggio Calabria
SICILY

N

AFRICA

MEDITERRANEAN SEA

0 MILES 100

HISTORY OF RENAISSANCE ART

LIBRARY OF ART HISTORY H. W. JANSON GENERAL EDITOR

PRENTICE-HALL, INC., ENGLEWOOD CLIFFS, NEW JERSEY

and HARRY N. ABRAMS, INC., NEW YORK

History of

RENAISSANCE ART

ART PAINTING · SCULPTURE · ARCHITECTURE

throughout EUROPE

CREIGHTON GILBERT

Professor of Art and Chairman of the Department of Art,
Queens College of the City University of New York

ACKNOWLEDGMENT

The essential precondition for writing a book of this sort,
a period of time without other obligations or distractions,
was provided to me by Brandeis University in the form of a
sabbatical year, and by Harvard University in the form of a
Kress Fellowship for use at its Center for Renaissance Studies
at Villa I Tatti, Florence. It is satisfying to be able to
record here my thanks to these institutions,
and equally to Silvia Menchi.

Library of Congress Cataloging in Publication Data

 Gilbert, Creighton.
 History of Renaissance art: painting • sculpture •
 architecture throughout Europe.
 (The Library of art history)
 Bibliography: p.
 1. Art, Renaissance—History. I. Title.
 N6370.G45 1973 709'.02'4 72-10180
 ISBN 0-13-392100-X

Editor's Preface

The present book is one of a series. *The Library of Art History* comprises a history of Western art in five volumes, devoted respectively to the Ancient World, the Middle Ages, the Renaissance, the Baroque and Rococo, and the Modern World. The set, it is hoped, will help to bridge a gap of long standing: that between one-volume histories of art and the large body of specialized literature written for professionals. One-volume histories of art, if they are to be books rather than collections of essays, must be—and usually are—the work of a single author. In view of the vast chronological and geographic span of the subject, no one, however conscientious and hard-working, can hope to write on every phase of it with equal assurance. The specialist, by contrast, as a rule deals only with his particular field of competence and addresses himself to other specialists. *The Library of Art History* fits in between these two extremes; written by leading scholars, it is designed for students, educated laymen, and scholars in other fields who do not need to be introduced to the history of art but are looking for an authoritative guide to the present state of knowledge in the major areas of the discipline.

In recent years, such readers have become a large and significant group. Their numbers reflect the extraordinary growth of the history of art in our system of higher education, a growth that began in the 1930s, was arrested by the Second World War and its aftermath, and has been gathering ever greater momentum since the 1950s. Among humanistic disciplines, the history of art is still something of a newcomer, especially in the English-speaking world. Its early development, from Vasari (whose famous *Lives* were first published in 1550) to Winckelmann and Wölfflin, took place on the Continent, and it became a formal subject of study at Continental universities long before it did in England and America. That this imbalance has now been righted—indeed, more than righted—is due in part to the "cultural migration" of scholars and research institutes from Germany, Austria, and Italy thirty years ago. The chief reason, however, is the special appeal of the history of art for modern minds. No other field invites us to roam so widely through historic time and space, none conveys as strong a sense of continuity between past and present, or of kinship within the family of man. Moreover, compared to literature or music, painting and sculpture strike us as far more responsive vessels of individuality; every stroke, every touch records the uniqueness of the maker, no matter how strict the conventions he may have to observe. Style in the visual arts thus becomes an instrument of differentiation that has unmatched subtlety and precision. There is, finally, the problem of meaning in the visual arts, which challenges our sense of the ambiguous. A visual work of art cannot tell its own story unaided. It yields up its message only to persistent inquiry that draws upon all the resources of cultural history, from religion to economics. And this is no less true of the remote past than of the twentieth century—if we are to understand the origins of nonobjective art, for instance, we must be aware of Kandinsky's and Mondrian's profound interest in theosophy. The work of the art historian thus becomes a synthesis illuminating every aspect of human experience. Its wide appeal is hardly surprising in an age characterized by the ever greater specialization and fragmentation of knowledge. *The Library of Art History* was conceived in response to this growing demand.

H. W. Janson

MEMORIAE

KATHARINAE GILBERT

ARTIS HISTORIAM

SCRIBENDI

MAGISTRAE

Author's Preface

Nearly everything in a book such as this is predetermined by the topic. There is an assemblage of objects, most of them inevitable choices, and the rest one hopes chosen well. There is the recording of elementary information about them, which one hopes is accurate. There is the exploitation of the sequence of objects to offer a reading of how the history went. And—the reason for doing all this—there is the constant attempt to answer the reader's challenge: "Why is this supposed to be good?" or, to say the same thing in a slightly more sophisticated way, to offer comprehension of the interesting circumstance that the history of art is a point where, more explicitly than anywhere else, physical things and our feelings of their value interlock.

This book also contains a few aspects that are not predetermined and are novel. They may induce complaints, and are mentioned here so that it shall at least not be supposed that they were done without consideration. The most obvious is the abolition of chapters. Since the book will be used (perhaps in most cases) by students in courses, this is based on my opinion that in textbooks chapters are inappropriate, and are an empty structure taken over from other kinds of books. On the one hand, they are characteristically avoided when a teacher asks students to read certain parts of several chapters, as he normally does; on the other hand, they actually do harm when the writer invents concepts because he has to pull the various things in a chapter together. The arrangement in this book is meant to fit the real circumstances of classes. Each of the three main parts has a theme corresponding to a usual course, and is subdivided into about the same number of smaller parts as a course has meetings. Each of these smaller parts has approximately the degree of complexity and amount of material that seem normal for a class session. It is hoped that they may be used as the basis for such meetings, preferably by being read beforehand by each student (since they are indeed very short), and being used as a point of departure for further enquiry, either a lecture on additional related works and areas, or questions and arguments about what the students now know. In this way much more can be learned than

in the usual course with its review textbook. The small parts also permit people to skip what they do not want. For those not using the book in a course, the small parts may be convenient in the manner of an analytical table of contents.

The record of the size of each work illustrated, in feet or inches, is another departure from precedent. Some books provide none, and those that do seem customarily to tell the sizes of movable paintings and sculpture and the plans of buildings, but not of frescoes, architectural sculpture, or building heights. There seems no rational basis for such discrimination, and a good reason to give all sizes. Readers, even if they have seen many of the works, as only a minority have, will not hold their sizes accurately in visual memory; no one really does. The result in classes is that sizes tend to gravitate toward a median, given by the size of a slide projection. The records of sizes can help to draw the reader back from that sensuous experience to the original. It is objected that most people do not readily grasp in the mind's eye a visual equivalent for figures like $62'' \times 48''$, and this is true. But on the other hand in classes students constantly ask their teachers "how big is that?" (and get vague answers). If the figures are at hand, the questioner can be drawn out to get a grasp of such equivalency, which is very satisfying. The tradition of not giving sizes in books means that some have been quite hard to obtain. Some printed here (notably for frescoes) are new unpublished figures, perhaps the one original part of the book, for which I am indebted to many courteous correspondents. Other sizes were tracked down in such remote resources as eighteenth-century engravings, apparently the only occurrence of such concern in the intervening centuries. A half dozen illustrations appear here unmeasured on purpose, such as details of frescoes and project drawings of buildings never built or since torn down, which seem to be inherently without measurements. One or two evaded all my efforts. The missing information will be most welcome from readers, as will the correction of wrong measurements, certain to be present in this pioneer effort. (Some apparent errors, however, may be due to such variations as

inclusion or exclusion of bases. On the other hand, the necessity in many cases for making several intermediate calculations in arithmetic between the existing resources and the final figures here printed may well have a side effect of producing some actual mistakes startlingly larger than one has allowed for in anticipation.)

To present the author's own new historical hypotheses, not previously published in the literature, is certainly not expected in a book of this kind, and indeed is in general a mistake. This objection does not apply to novel critical analysis, which is welcome. But novel history can be presented only very briefly, without the supporting arguments, which often means that the author has indeed not tested the arguments and they may be wrong. They also cannot usually be recognized as new proposals by the reader. I have nearly always avoided novelty, except for one category of new hypothesis which I believe is, unlike the others, especially suitable to a book of this kind, likely to be stimulated by the writing of it more than in other circumstances, and likely to be of help to the reader. This is the problem of the backgrounds of the art of those artists who do not obviously belong to an ongoing tradition. It happens quite often, with artists as different, say, as Vitale da Bologna, Sassetta, Niccolò dell' Arca, or Grünewald, that they have no obvious precursors in their own localities, or anywhere else, and yet we are not ready to call them great innovators. Their backgrounds are then either left in silence, or, more unhappily, they are shunted into a short chapter-end in which "other artists flourishing at this time" are listed because they are not members of a standard school. In this book I have proposed new theories of the stylistic origins of these and a number of other artists, which I have labeled as such in most cases, except when it seemed to involve a disproportionate distraction. Besides origins, I have also made novel groupings of contemporary artists—such as Francesco Laurana with Antonello da Messina, or Moroni with Leoni—novel at least in the standard literature, though no doubt the relationships have been mentioned in one study or another. I think this will also help to take these artists out of an "other" category of catchalls and evoke their intimate situations. As those examples suggest, I have also been concerned to let the various media show their mutual stimuli more freely than is the case in most general books. And in the same way, I have been concerned to include various beautiful accomplishments—such as Pisanello's medals, English architecture, and Spanish sculpture —which are often neglected in general books on the Renaissance, because of the superficial fact that the study of them, affected by the accident of medium or geography, has been conducted by a separate tradition of scholarship.

The final departure from the obligatory that I wish to justify is the fact that I have given many minor artists more attention than they may seem to deserve. I have preferred to omit many other minor artists often given notice, who seem to me to have benefited unduly from some accidents in the history of scholarship—say Cosimo Rosselli or the Master of the Holy Blood, and many like them—and to be without either talent or historical interest. But I have made a point to try to evoke the specialness of even rather small personalities, say Amico Aspertini or Johannes Junge, even to the point (and here objection may begin) that they steal space from some greater artists. Thus I may, after discussing a dozen works by Raphael, omit the thirteenth in order to mention one by Aspertini, even though everyone would regard the thirteenth Raphael as more beautiful and interesting than the best Aspertini. My justification is that the book is to assist the reader to become his own guide, since something must be omitted. After the twelve Raphaels, he will be able (if the book is doing its job in the first place) to make his own approach to the thirteenth, but would still be in no position to make an approach to an Aspertini, and hence I choose to give a word to the latter despite its inferiority. The arrangement is somewhat analogous to a map in which the names of larger cities are printed in larger type, but not in true proportion. "London" is shown larger than "Stratford" but not a hundred times as large, because that would defeat the use of the map in reading. I hope that in other ways what follows will serve, in good Renaissance Florentine fashion, as a helpful broker, making the connection between the reader's eyes and the work of art.

C. G.

Contents

Editor's Preface
Author's Preface

PART TWO THE HIGH RENAISSANCE IN ITALY

PART THREE THE RENAISSANCE OUTSIDE ITALY

The Early Renaissance in Italy

SUPPLEMENTARY NOTES, PAGES 141-143

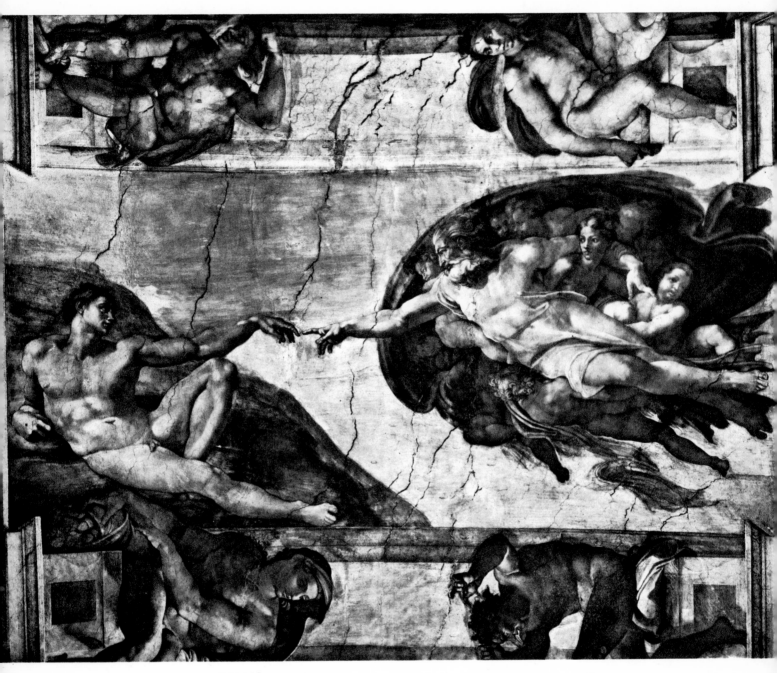

1. MICHELANGELO. *The Creation of Adam*. 1508–12. Fresco, 9′2″ × 18′8″. Ceiling, Sistine Chapel, Vatican, Rome

1. Introduction

In all societies works of art are produced in rapid succession, nearly always echoing older ones. Skills are taught, attitudes evolve, agreements form and persist on the ways of making things and communicating statements. Quantitatively most of the results are simple copies of approved older objects. At the opposite pole, the rare mutation or rebellion may interest us most, but even that is obviously affected by its environment and, less obviously, by existing works. This is why it is so absurdly hard to begin a history of art anywhere after cave painting; the temptation to keep looking back one more step is based on the reasonable suspicion that light will be cast on a problem.

When we speak of the art of the Renaissance, the very fact that we name a period implies an opinion that a large mutation occurred. How should it be defined? The only true definition of Renaissance art is all the works made in the period. The vast number of lesser instances omitted from this book would modify the whole effect but only to a small extent. The book is the definition. But a desire remains to have the definition given an explicit formulation, even if merely as a guide through the series of works. The easiest and most accurate approach to this is negative, by noticing the contrast between art in the Renaissance and art earlier and later. And such a contrast can be seen most clearly and indisputably if we choose works from the middle of the Renaissance rather than seek traces of new qualities at the time of its birth, or of sterile ones at the time of its death.

It is acceptable that Leonardo's *Mona Lisa* (see fig. 197) and Michelangelo's *Creation of Adam* (fig. 1) are not like typical works of the preceding Middle Ages, the sculptures of Chartres or the mosaics of Monreale (colorplate 1). All four wish to state something believed by referring to things in the world that have been seen before. But in the Middle Ages the concept believed plays a stronger role, so that the qualities of the things in the world

can be freely altered to help in expounding it. For example, human beings can be shown near each other in very different sizes, which is different from our experience but effectively states the claim that one is more important than the other. The Renaissance does not permit such violations of outside reality; at most, it uses a convention agreed on as being true to it. Either the artists must report just what they see, as in portraits (it is typical that the Middle Ages practically excluded portraits), or, when they present an invisible subject, such as God creating man, they are required to find a means that assimilates the theme to standards of visual truth. The event is then shown just as actors, even in the Middle Ages, might perform it in a pageant.

Although the principle is fidelity to the visible world, the examples given were human, and that is again basic to the Renaissance. The emphasis on people is in obvious contrast with the succeeding mutation to modern art (from the time of Impressionism, say), in which both fidelity to the visible world and the human being lose value. Sometimes the concern of the Renaissance with human beings is overstated, when it is labeled individualism. Individual people, in portraits, are typical Renaissance images, but always secondary in the period to others. The chief sort of image is of a small group of people, shown affecting each other psychologically at an instant of time, like a tableau of a climactic moment in a play. This kind of painting received the label "story" at the very beginning of the Renaissance, and was defined as the most important that a painter could do. Later, types of themes were codified and ranked, and "stories" were given first place.

A corollary is that, parallel to the dominant status of Gothic architecture in controlling other visual arts, and again parallel to the modern tendency for all the arts to "aspire to the condition of music" (as Walter Pater said in an essay on the Renaissance written at the time of Impressionism),

we may think of the arts of the Renaissance affected by the conditions natural to the drama. We might also notice that, very much unlike the Middle Ages and the nineteenth century, literature in the High Renaissance and the Baroque in Europe makes the drama its greatest vehicle. But before that happens the dramatic imagery of human situations is central to the greatest painting and sculpture, just as the device of perspective sets up a stagelike environment for human events in painting first and in the drama later.

A second corollary might be that in the Renaissance the lead in the visual arts changes from architecture, where it had certainly been before, to painting, where, if in any single place, we would have to locate it in the later age. It seems characteristic that many Renaissance painters and sculptors receive architectural commissions, and not the reverse. But it may be better to think not of a shift from one medium to another but of a decline in the value given to all-embracing systems and organizations. There is no Renaissance equivalent for the *Summa Theologica*[1] (or the *Encyclopaedia Britannica*), but there is a breakup of the Holy Roman Empire, of the universal Catholic Church, and of the international monopoly of the Latin language into more modest, limited-application tools. Conversely new Renaissance concerns—national states matching language areas, exploration of the non-European world, banking and accounting—typically failed to produce matching theoretical formulations of the kind so common soon after in the seventeenth century, the great age for philosophical and scientific systems in our culture. The greatest intellectuals of the Renaissance are excited about problems of observation and experience—in nature (Leonardo da Vinci), politics (Machiavelli), social behavior (Castiglione), ethics (Erasmus), contemporary history (Guicciardini)—which they organize either not at all or into small schemes for immediate purposes. Coming back to images, we might surmise that even the rejection of the medieval classification of people by sizes, along with the rejection of the feudal system, is part of such a tendency. Today when we praise someone as a "Renaissance man," we have in mind his versatile command of skills or knowledge, and imply that it is not unified.

The career of the Renaissance artist shows a changed relation to his public. Today there is widespread understanding of the status of medieval art-ists, skilled craftsmen who might command respect for their mastery of the specialty, with an established and secure social position but neither ranking high nor expected to express their personalities; the most successful might be compared to dentists or instrumental musicians today. We are also familiar with the nineteenth-century artist, a bohemian outside social networks yet often a celebrity. The position of the Renaissance artist, less well known and sometimes by default assimilated to one of the others, is distinct, and, halfway between, combines the more advantageous aspects of both. He is a celebrity within society, and is comparable to the trial lawyer or architect today, a professional sought out by usually rich clients to serve their ends by articulating his own personality. He is often the more famous the more he has idiosyncrasies, but his imagination genuinely is used to help the client. Today we would not expect the lawyer to "express himself" in a case, nor, usually, the architect, and the Renaissance artist likewise was entirely committed to his society; an outsider's standpoint would not have occurred to him. A Renaissance work such as the Sistine Ceiling is a mirror of its time (like Chartres), but one presented by a powerful personality (like Picasso); or we may turn this around and say it is the statement of a shared ideology (unlike Picasso's) made by a celebrity (unlike Chartres). We may be suspicious of an artist who is committed to his social structure and works more for his patron's interest than for himself, but we are inconsistent in this; we do not raise such a question with the lawyer, and indeed would resent him if he did anything else. To accept this motivation in Renaissance art is easier if we avoid an unhistorical universalizing of our own habits for other ages, in the way that anthropology has taught us not to apply our attitudes to other civilizations of the present.

Western history is usually divided for convenience into ancient, medieval, and modern, but Western art history into ancient, medieval, Renaissance-Baroque, and modern. This apparently trivial difference allows us to deduce that Renaissance art coincides with early modern history. Thus Renaissance art, which today is superseded, begins along with the beginning of social patterns that are still quite ordinary and taken for granted, such as the dominance of the city, capitalist economics, and the nation-state. This correlation between a past art and a surviving culture is confirmed by the well-

known dissociation between modern art and our society. The surviving social arrangements can be helpfully correlated with qualities in Renaissance art such as visual realism, human emphasis, and the key role of small social groups.

Such general connections are in part stimulating but in part quite arbitrary, and their difficulty is illustrated by the awkward position of the Baroque. Some of the preceding comments have implied that the important mutations occurred at the end of the Middle Ages and then at the beginning of modern art. In such a case, Baroque would be reduced to a subdivision of the Renaissance, and this approach has sometimes been used by art historians, though decreasingly by recent ones. It is true that some of the Renaissance innovations that seemed to define it best live on, scarcely modified, in the Baroque age. The modifications occur on a narrow level, in devices of style, like those made famous since 1890 by the art historian Heinrich Wölfflin's principles of Renaissance and Baroque painting, such qualities as relatively smooth or sketchy brushwork, resolved or continuing action, surface or depth emphasis. And on a broader level, at the same time, major social changes take place, the climax of absolutism symbolized by Louis XIV and Versailles and the climax of philosophic and scientific theory already mentioned. If we relate these great changes in people's lives and ideas with the relatively slight changes in the character of the visual arts, we might infer that the Baroque age was giving the arts less of a role in articulating its sense of life than the Renaissance had done. Such a hypothesis would certainly be challenged, but it suggests the nature of the problem.

The Renaissance begins at quite different times in various places, and in the same place it may begin sooner in one art than in another. It was virtually over in Italy when it became established in England. Where it was born, in Italy, it was built up through strange explosions and obscure modulations even while artists accepted older postulates. Where it arrives mature, as an import, it may collide discordantly with local ways or reach compromise accommodations that would puzzle its creators. It may be that a mutation in culture is likely to happen in a place where the old culture had never been at its strongest. Where the Middle Ages were greatest, in Byzantium and in France, the Renaissance either never came or came late and remained thin; French and Byzantine artists naturally continued to feel that the different ways were no improvement. On the other hand, it has to be admitted that the Middle Ages were provincial in Italy, however meaningful then and now to a local public, and however many talented individuals were at work. To look at the Romanesque in Lombardy and then in Burgundy is to accept this. And in the odd ways in which medieval Italian art has special powers, we may sometimes with hindsight see that irregularities were involved that were helpful in nurturing the Renaissance. An easy instance of this is the fact that, among all the schools of Romanesque sculpture, only in Italy are the chief monuments usually signed by their artists and rarely anonymous. This takes us to the Italian towns, and their adornment.

2. The Liberation of the Painting

A painting is nearly always a portable rectangular object; the point seems to us too obvious to mention. But such objects played a very small role in medieval painting. A few can be found, small icons of Byzantine pattern that seem to have been treated as rare cult objects. But if we think of medieval painting (colorplate 1), the examples we cite often turn out to be in other "pictorial" media, like mosaic or enamel, and almost always are on surfaces larger than themselves: pages of books, small valuable objects such as the utensils of rituals, and walls of buildings. The same is true of sculpture, which is either architectural or, in small scale, on ivory book covers, caskets, and the like. It is the Renaissance that detaches painting and sculpture, and works with paintings and sculptures. Of course it is attractive to think of medieval painting and sculpture, integral parts of larger wholes, as symbolic of the feudal hierarchy or of other medieval wholes. The detached painting becomes free, like the ex-serf who may now become a capitalist.

Separate paintings become a significant vehicle of painting at a specific place and time: in some towns of Tuscany, in central Italy, in the thirteenth century. Some of these same towns later become the places where, for the first time, artists can be discovered who are personalities, with biographies and styles. And still later Florence, one of these towns, creates the self-conscious theory of the Renaissance. Since the works of these first artist personalities are separate paintings, and the first Florentine works of art are too, we seem to have here a true—if partial—beginning, a context where it is plausible to start. These early paintings are not actually Renaissance works, but an odd mutation within the Middle Ages—minor for all medieval purposes, but important for the future Renaissance. Within this context, the first to use paintings as its vehicle, the first paintings are not rectangular, as paintings later became (apparently because this shape is neutral, the shape most nearly avoiding any significance). Their outlines at first are complex, which seems to fit in with the fact that these paintings are only one step away from being painted on larger objects. The paintings

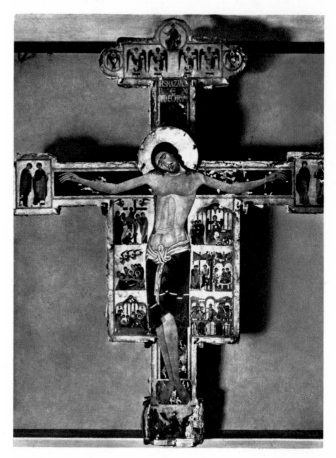

2. *Cross* No. 20. Panel, 9′9″ × 7′8″.
Museo di S. Martino, Pisa

are still executed on a carpentered structure with its own character, but now carpentry and painting coincide in size: the most frequent objects are crucifixes. These of course existed before, often as small bronze sculptures. Now over-lifesize painted crucifixes appear in Tuscan churches; a hundred or so survive from the thirteenth century, and one or two from the twelfth (suggesting that, like many new things in history, this was an emphasis upon what had long been a possible choice).

The paintings are in a style provincially derived from Byzantium, the great power to the East. As copies, they enhance the Byzantine tendency to work in formulas for everything, eyes, hair, rib cage, or toes. The purpose is not to render a body, but,

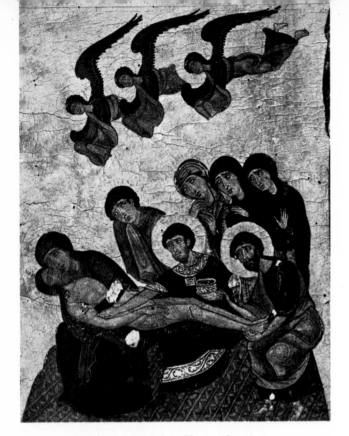

3. . *Lamentation*, from *Cross* No. 20 (fig. 2)

commonly the interest of heretical groups. The order he founded felt continuous stress between his ascetic image and its growing institutionalization, and that may be evoked in this altarpiece, with its medieval hierarchy of parts expressing the relative importance of areas within the totality, while yet the central figure speaks through its stylized forms of tense asceticism. The smaller parts are scenes of the drama of his life, as those on crucifixes are of Christ's life. Painted altarpieces were soon to become more common than crucifixes, encouraged by a change in the rules of the Mass. Priests earlier had faced congregations from behind the altar, but now everyone faced the altar. This stimulated the placing of an object of reverence on the altar, and in the next century church law required that each altar carry an identification of the saint to whom it was consecrated. An image was the readiest way of meeting this need.

Both the Saint Francis altarpiece and the Pisa *Cross* communicate by varying the sizes of the parts to classify degrees of importance—a device that to us seems odd, though we have it in other visual contexts such as newspaper headlines, where we, as the

like other religious icons, to induce worship. A set of symbols is learned by an apprentice who is successful when he repeats his master (like an apprentice electrician today), and it communicates without resembling—like words, the most commonplace of symbols.

A series of crosses painted in Pisa in the early thirteenth century includes one of the most beautiful (fig. 2). The anonymous painter's unusual finesse seems to fit his having painted not directly on the wood, as usual, but on parchment, the standard surface for illustrations in books. This prepares us for the expressive strength in the sweeps and curved silhouettes of the small mourning figures (fig. 3), but not perhaps for the similar power in the large Christ, with zigzag patterns in large body elements as well as small folds. The bent head and closed eyes, in contrast to the upright head and open eyes of most painted crucifixes of the period, suggest that the connection between rhythmic pattern and human pathos is purposeful.

In nearby Lucca, Bonaventura Berlinghieri, whose father had also been a painter, executed in 1235 the remarkable altarpiece of Saint Francis and scenes from his life (fig. 4). The saint (1182–1226) had accomplished an exceptional infusion into the established Church of an evangelical poverty, more

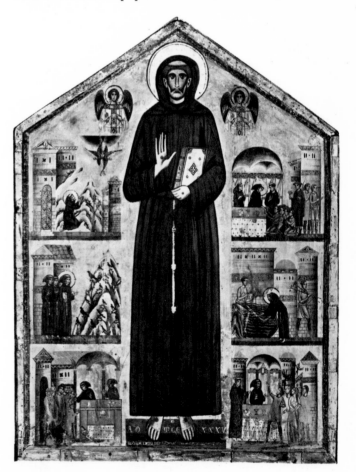

4. BONAVENTURA BERLINGHIERI. Altarpiece of St. Francis. 1235. Panel, 60″ × 46″. S. Francesco, Pescia

19

Middle Ages did, use design to transmit social information. Therefore in realistic images of the Renaissance the range of information is much reduced, while within the narrower span the accuracy rises.

A tell-tale modification appears in an artist of Pisa in the next generation, Giunta Pisano (docs. 1229–1255), whose crucifixes do away with the small narrative compartments. The panel shape remains the same, and the area now free is given to the sideways writhing motion of Christ's body (fig. 5). The negative suppression of systematic divisions of the painting coincides with the positive enhancement of expressiveness in the physical body. The eyes are closed and the focus is on the expressive line pattern in the face, with the exaggerated lids. The only other people are Mary and John, persons suitably present at the Crucifixion and both painted on a scale closer to Christ's, though they remain by con-

vention (and by the necessities of carpentry) at the ends of the crossbars. Thus Giunta insists in several ways that we must be shown only what we could see at one time, abolishing elements whose interrelationship is through meaning.

All this seems suitable in a man who might be called the first known artist in history, in that we can see several of his works and that we know something of his biography as well, specifically that he traveled away from Pisa to work elsewhere—to Assisi, which was a place of pilgrimage after Saint Francis' death, and to Bologna over the mountains in north Italy. (Earlier we have no more than a name signed to a work, perhaps with a date, and sometimes a second work with the same signature.) Physical existence seems to be asserted in both his life and his paintings, but the crucifixes are still variations within the Byzantine formulas of style.

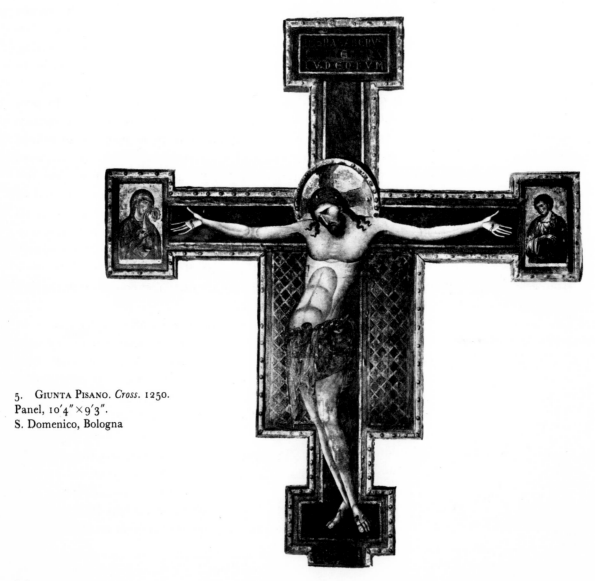

5. GIUNTA PISANO. *Cross.* 1250.
Panel, 10′4″ × 9′3″.
S. Domenico, Bologna

3. Nicola Pisano

A generation later Pisa welcomed an artist who could develop these potentials much further, because he commanded remarkably varied vehicles of style. The sculptor Nicola Pisano (docs. 1258–1278) came from southeastern Italy, but it is only after his arrival in Pisa that we know him. The first of his complex projects is the marble pulpit for the Baptistery (1259; fig. 6). Both in Tuscany and south Italy pulpits had traditionally been among the objects on which sculpture was applied. In Nicola's work the energy of the figures and the decreased weight of the frames make his scenes no longer subordinate elements rigidly enclosed, but of equal importance with the entire object. He was stimulated by the figure carving of other traditions, conspicuously the ancient Roman tomb reliefs visible in Pisa in some quantity. He absorbed the ancient sculptors' technique and their control of organic mobile forms of the body, which until then had, at most, been literally copied in some earlier medieval sculpture (especially in south Italy). He also adopted the relations of the figures in space typical of these tombs, resulting in a dense packing of active torsos against a shallow wall.

7. NICOLA PISANO. Pulpit. 1265–68. Marble, height 15′. Cathedral, Siena

But his curiosity also led him to understand the greatest art of his own time, High Gothic in France. His work especially resembles the recent sculpture on Reims Cathedral, approachable because it too had borrowed Roman ways of carving folds and other devices. Yet his relationship to Reims seems to be not that of a copyist, but a parallel inventive jump from the Roman base. His people move in active shifts of direction and surface angles, as in Reims, but, held inside small reliefs, with much closer interaction, creating incidents of drama. The stocky figures, dense in volume, are intense in expression. All this is more marked in his second pulpit, for the Cathedral of nearby Siena (1265–68; fig. 7). The figures are smaller and weave among each other like snakes, evoking the pressures of the Biblical epic of the life of Christ. In their swarming life we are no longer conscious of the slab sides of the pulpit.

Nicola is most literally affected by France in his last work, the large city fountain for Perugia (finished 1278).[2] In general his style might best be labeled "Italian High Gothic," a parallel to the other contemporary variations on France found in Germany. His standing in the international art of his age has been obscured by the traditional concepts that classicism is un-Gothic, that Italy has only a "Late Gothic," and that Nicola is mainly interesting as a trailblazer of the Renaissance. He created a standard for sculpture in central Italy, and the major sculptors of the next generation were trained in his shop.

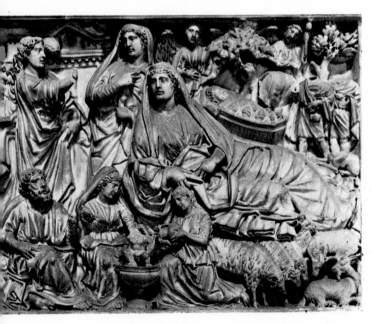

6. NICOLA PISANO. *Nativity*, panel of pulpit. 1259. Marble, 33″ × 44″. Baptistery, Pisa

4. Giovanni Pisano and Arnolfo

Nicola Pisano's son Giovanni (docs. 1265–1314) produced the greatest Italian Gothic sculpture, and so may perhaps be called the greatest known Gothic sculptor. He had the advantage of training in his father's busy workshop, where his personal style is thought to have emerged, when he was about seventeen, in the Siena pulpit. Today it seems strange to think of a major artist inheriting his art from his father, though we know that such upbringing may still be a real advantage to professionals such as architects (e.g., Eero Saarinen[3]), whose relationship to their social environment is similar to the Renaissance artist's.

Only at about thirty-five, when his father had died, did Giovanni leave the workshop. From then on he headed a still larger shop, producing two rich series of lifesize statues for the outside of Siena Cathedral (1287–95; fig. 8) and the Pisa Baptistery (from 1297).[4] Since these are badly damaged by weather, we have the problem (as with many other Renaissance artists) that we know some kinds of his work much better than other kinds. Giovanni's small figures and pulpits are better known, but the ruined huge statues at Siena magnificently illustrate his expression of tension on a scale of monumental grandeur, a fundamental inheritance for Donatello and Michelangelo. In all sizes they are elastic, pulled from end to end with a stress that their faces show, but also blockily cut, with a weightiness that makes us take their feelings seriously. They are Gothic in every way, with none of Nicola's classicism; the Gothic qualities in the Siena pulpit have therefore been interpreted as the young Giovanni's contribution, but it seems more likely that the father pioneered the exploration of French methods.

Giovanni was given Sienese citizenship, and was the overseer of all the work on the Cathedral. The sculptor-architect combination is common—it was all a matter of cutting stones—but though Giovanni enriches the cathedral front with statues like none other in Italy, his method is not very architectonic. The surface is frosted with carved ornament, and the statues are hooked on like hats on a rack, in an unexpected rhythm. The dynamic punctuation is not structurally ordered. It is more so in the pulpit for Sant'Andrea in Pistoia (finished 1301; figs. 9, 10), using Nicola's old Siena scheme, but the excitement here is all in the carved scenes. Small forceful figures act on each other, all shaped like lengths of thick rope, swerving and intertwining. Typical carriers of drama are stretched arms, like the nurse's to the water basin and Herod's in command. Heads press forward to learn answers, like the Virgin's as she sits in bed. A second pulpit, in Pisa Cathedral (1302–10; fig. 11), carries these qualities to a shrill extreme, partly in assistants' copying of the master's external traits, but also in his own work. Bodies are elongated and sway like question marks, twisted figures make their points by scooped-out shadows, tendons are thinned down to single lines. Yet in the large supporting figures below the reliefs, Giovanni abruptly offers upright people squarer in outline, as he does again in his *Madonna* (fig. 12) made for the Arena Chapel frescoed by a young artist, Giotto (see p. 29). The firmer and milder carving may show a magnetism toward the younger artist's achievement, or a return to his father's methods, or an intended distinction between dramas in relief and full round columnar statues. But the variation may also be related to the complaints of abuse and misunderstanding that Giovanni carved onto the Pisa pulpit itself, suggesting that he shared the nervous stress of his works.

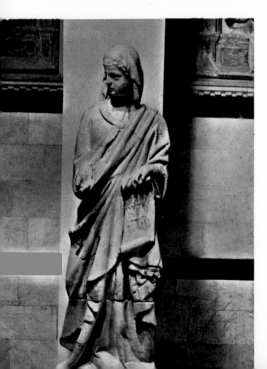

8. GIOVANNI PISANO. *Sibyl*, from façade of Siena Cathedral. c.1290. Marble, height 6′3″. Museo dell'Opera del Duomo, Siena

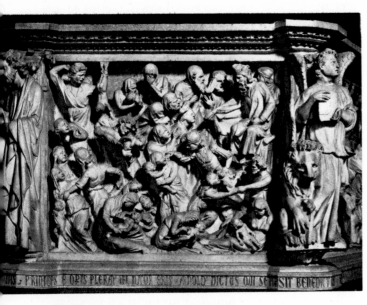

9. GIOVANNI PISANO. *Massacre of the Innocents*,
panel of pulpit. 1301. Marble, 33″ × 40″.
S. Andrea, Pistoia

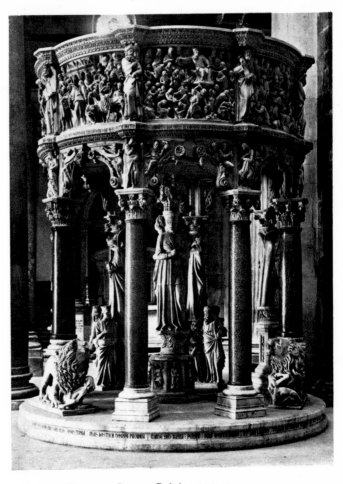

11. GIOVANNI PISANO. Pulpit. 1302–11.
Marble, height 14′2″; width of each panel 43″.
Cathedral, Pisa

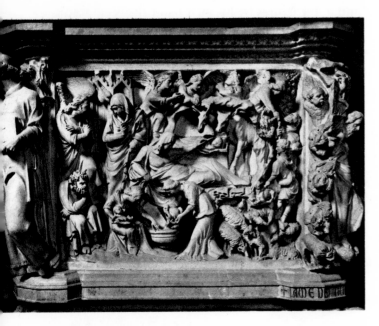

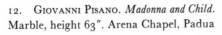

10. GIOVANNI PISANO. *Nativity*,
panel of pulpit. 1301. Marble, 33″ × 40″.
S. Andrea, Pistoia.

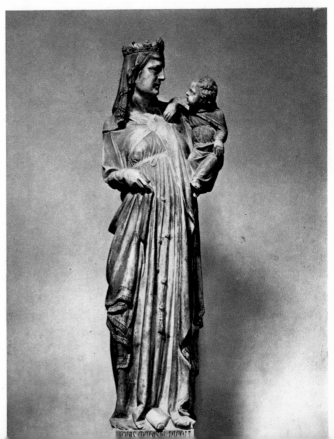

12. GIOVANNI PISANO. *Madonna and Child*.
Marble, height 63″. Arena Chapel, Padua

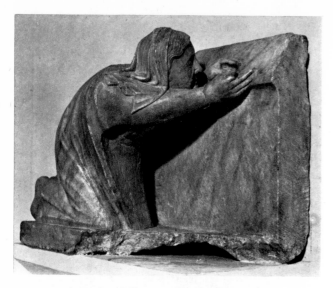

13. ARNOLFO DI CAMBIO. *Thirsting Woman.*
Marble, 14″ × 21″ × 11″.
Galleria Nazionale dell'Umbria, Perugia

Arnolfo di Cambio (docs. 1265–1300), Nicola's other brilliant assistant, left the shop soon after the Siena pulpit was done. Although a citizen of Florence, he lived most of his life in Rome, working more often as an architect than Giovanni did. We first see his sculpture clearly in two small, extraordinary figures about 1280 (fig. 13). Some fragments from a fountain in Perugia (apparently a small one near Nicola's big one) include people on their knees crouching and pushing to drink, low-class images

serving, like the marginal anecdotes in Gothic manuscripts, as small vivid labels for the structure. They are unforgettable images of thirst, stretching their necks like turtles out of their cubic bodies. They express yearning as intensely as Giovanni does, but not wirily. Arnolfo's figures are architectonic, or stonemason's people, and this alternative had great meaning to younger artists. Another haunting marginal group of Arnolfo's is in his complexly built tomb of Cardinal de Braye (d. 1282; fig. 14), where two angels pull curtains aside and let the ends sweep around their bodies like lassos. Action initiated by human intelligence is interlocked with the material it acts upon, while the two are clearly distinguished by texture.

In 1300 (for certain, and perhaps earlier) the elderly Arnolfo was honored by Florence by being made the overseer for its recently begun new Cathedral. What definitely survives of his work there (apart from much debate as to how far the later building of the Cathedral retains his plans) is again the sculpture, much of it done under his supervision and a few figures by his own hand (fig. 15). Angels and holy figures with the same hulking volume again lean forward in eager dramatic contact, a formulation that became fundamental to Florentine artists despite the obsolescent ties to architecture that remain in all Arnolfo's carving.

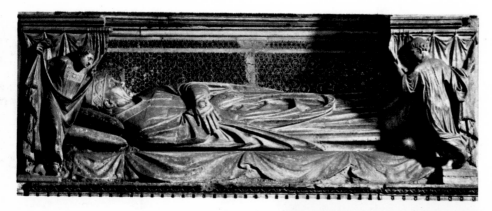

14. ARNOLFO DI CAMBIO.
Effigy and Angels,
from tomb of Cardinal de Braye.
Marble, 32″ × 95″.
S. Domenico, Orvieto

15. ARNOLFO DI CAMBIO.
Death of the Virgin,
from façade of Florence Cathedral.
1300–1302. Marble, length 67″ (destroyed).
Formerly Kaiser Friedrich Museum,
Berlin

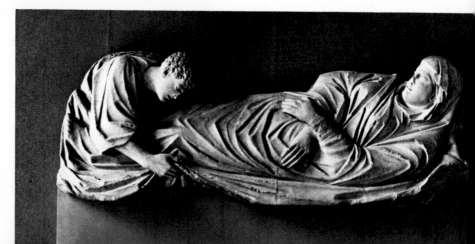

5. Cimabue, Cavallini, and Other Painters

The first personality in Florentine painting is found at work in 1260. Coppo di Marcovaldo (docs. 1260–1274), like Giunta Pisano before him, is still completely Byzantine in his stylistic allegiance, not at all classical or Gothic like the sculptors. He is even more affected than Giunta had been by mosaic, that most Byzantine of media, and replaces highlights on cloth folds by gold lines (fig. 16). This stylized show of rich materials reminds us of craftsmanship and of the high rank of the Virgin who wears them—thus medieval on two levels. It also reinforces Coppo's personal handwriting, which tends to thick color in bright units, wide dark contours, and underlined shadows, all assertions of bulk. Such heavy richness appears in anonymous painters in Florence at the same time, the masters of the Bardi Saint Francis altarpiece[5] and of the Magdalene altarpiece.[6] Coppo was taken prisoner by the Sienese in a battle in 1261, and then painted an altarpiece in Siena, one of the two almost identical ones by him that survive.[7] The leading local master there, Guido da Siena, is known from a huge altarpiece of the Madonna (1271)[8] and other works in the now very

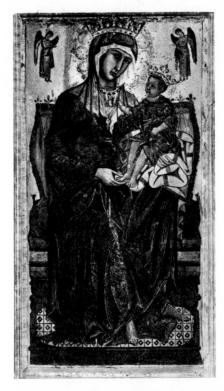

16. COPPO DI MARCOVALDO. *Madonna.* 1261. Panel, 87 × 49″. S. Maria dei Servi, Siena

17. CIMABUE. *Crucifixion.* Fresco, about 16′9″ × 23′. Upper Church, S. Francesco, Assisi

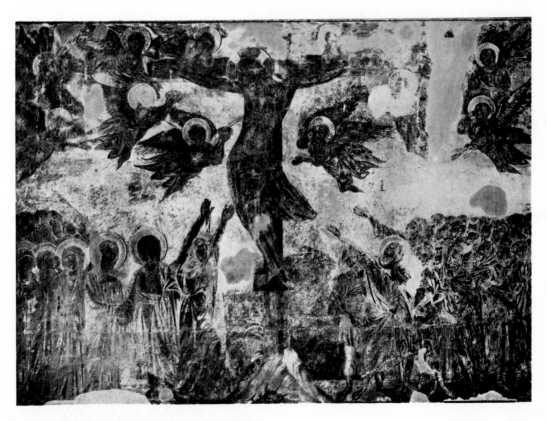

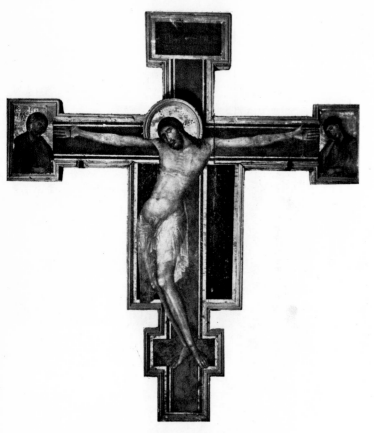

18. CIMABUE. *Cross*. Panel, 14′8″ × 12′10″. Museo dell'Opera di S. Croce, Florence (before flood damage of 1966)

standard forms of the Tuscan Byzantine painters, given a bright and massive celebration.

The greatest personality of Florentine Byzantine painting is Cimabue (docs. 1272–1303). A crucifix that is probably his earliest surviving work[9] is painted rather in the style of Coppo but is less conservative, omitting the small scenes and developing from Giunta's expressive movement. Although the lines in the face are self-assured formulas, the rhythmic accents of their tight pressure refer to the human tragedy of death with a power parallel to Giovanni Pisano's. While Giovanni, though, developed realism and expressiveness together, which seems natural or even inevitable to us, Cimabue retains the old unrealistic Byzantine vocabulary and yet gives us a fine-tuned statement of agony. Like Bach, he exemplifies the phenomenon of the great artist who is not involved with the avant garde but successfully works what seemed a used-up mine. This is possible where the provincial environment of his place and time makes his public expect a traditional language.

Cimabue's passionate power within this archaic vehicle is most vividly shown in his *Crucifixion* fresco in Assisi (fig. 17), more in the shocked, contorted mourners than in the undulating Christ; the drawn forms overstate the violent feelings with an autonomous rhythmic order. This fresco has lost all its color, leaving only the underpaint resembling (as is always said) a photographic negative. It is part of a huge cycle (1280s) in the upper part of the two-story double church of Saint Francis at Assisi, a major pilgrimage center (see fig. 73). Fresco painting in the Middle Ages had generally been a cheap substitute for mosaics, but was now about to acquire its own virtues.

Cimabue's style is better preserved in his twelve-foot-high altarpiece of the Madonna and Child enthroned with angels and prophets (colorplate 2). It is appropriately majestic, but its amendment of Coppo is more remarkable. Its pattern of sharp lines, including gold ones, creates tiny units everywhere, on the big throne and the cloth folds, producing a very refined surface, like filigree or cobwebs, even in the incised gold background. Perhaps this marks the growing urbanity of an artist in Florence within the old-fashioned methods of drawing. It is transitional to Cimabue's latest painting (fig. 18), a *Crucifix* in which line almost vanishes, a translucent cloth becomes a gossamer veil, and the body is modeled with gentle modulations of shadow. Features and pose still reflect Byzantine layout systems, but they have been erased from the surface painting, and we have a modeled real body.

Cimabue was certainly stimulated in this direction by being aware of painting in Rome, a city where he had been in his youth. There Pietro Cavallini (docs. 1273–1308) was working in two media, mosaic and fresco, but reversed the medieval view about their relative importance: he was basically a fresco painter, who sometimes made mosaics that look like frescoes. In the surviving fragments of his *Last Judgment* fresco (fig. 19), the bodies are organisms whose fleshy forms keep turning, supported by a blend of light and shade with no lines. This depends on the quality of the brush stroke, distinct from mosaic cubes. But Cavallini's mosaics reveal a further range of his interest in physical reality, that of the spatial environment, with parts of buildings constructed like sentry boxes to contain the action. In all this Cavallini leaned on visible examples of ancient Roman painting—actually Early

Christian painting of the fourth and fifth centuries A.D. What we do not see in Cavallini is anything beyond the physical truth of form and space; one is tempted to think of him and Cimabue as the two halves of a whole, natural forms without human meaning and vice versa. But Cavallini's many lost works may have shown more, to judge from a remarkable anonymous artist who painted the story of Isaac, again in the upper church of Saint Francis at Assisi (fig. 20). He follows this "Roman" way of painting figures, with a somewhat more brittle handwriting but the same organic turning effect, and similar buildings even a little more complex in structure. Inside them the figures respond to each other with grave, slowly moving gestures that seem to mark off the space in rhythmic stresses and to evoke a poignant psychological moment. A team of painters with generally similar methods, but with texture still a little tinnier and with jerkier gestures, painted a little later in the same church a huge series of frescoes of Saint Francis' life (fig. 21). This cycle has benefited from its attractive subject and conspicuous location to receive more admiration than its quality would warrant. Indeed, two centuries later the idea emerged that it was by Giotto, who had actually supervised much work in the lower story of the double church. This view is still often stated, but now usually with two (conflicting) qualifications, that it was a work of his youth and that he assigned large parts of it to imitative assistants.

Cavallini's effect on younger talents is clearest in the Master of Saint Cecilia. His first work is a part of this large cycle; he then left for independent work in Florence, and is the only important artist there after 1300 who is also anonymous. In the Master's last, most beautiful work, the Saint Margaret altarpiece (fig. 22), he underlines Cavallini's feeling for the soft, dignified figure, and for lively drama in front of little rooms, by a rich, glowing pigment that makes his energetic little people in their thin drapery move fluidly in a shifting air.

About 1260–80, then, a new art established itself in the merchant towns of Tuscany and nearby. Its vehicle is the visible and tangible truth of the world around us, and its theme is the human situation. It rejects the old vehicle of diagrammatic layout and the old themes of hierarchical and supernatural ideas which had held the emphasis in France, Byzantium, and other centers. The correlation between style and society in both cases is not

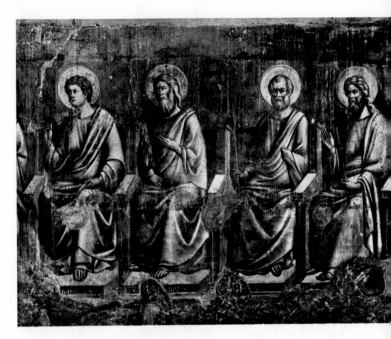

19. PIETRO CAVALLINI. *Apostles*, portion of *Last Judgment*. Fresco, height of preserved frieze about 10'. S. Cecilia, Rome

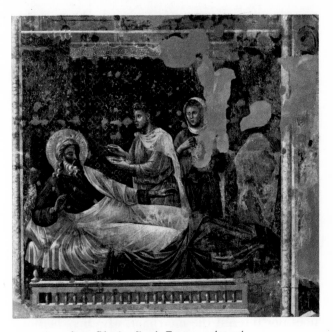

20. *Isaac Blessing Jacob*. Fresco, 10' × 10'. Upper Church, S. Francesco, Assisi

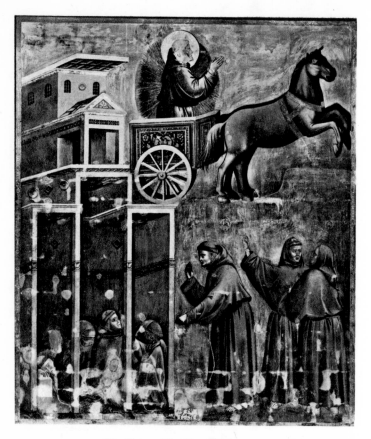

21. *The Vision of the Fiery Chariot,*
from cycle of the Life of St. Francis.
Fresco, 9′ × 7′1″.
Upper Church, S. Francesco, Assisi

this period a valuable study for students of social problems.

Merchant towns appeared in Flanders, Lombardy, and Tuscany; why, then, did the new art appear in Tuscany only? Perhaps it required, to be realized, the suggestion of ancient Roman art, which in fact was important to the first sculptor and the first painter in the new fashion, Nicola Pisano and Pietro Cavallini, in Pisa and in Rome. These materials were not available elsewhere. If we ask further why the new art soon found different centers, in Florence and Siena, we should notice a striking concidence: these cities were also the banking centers; Florence in 1252 issued a gold coin which created the gold standard basic to international trade for the next seven centuries; Siena reaped advantages from her silver mines. The Sienese at first, and the Florentines for much longer, did the banking work of the papacy, the largest international economic activity of the period. It is common to speak of "three generations to culture," from the business pioneer to his grandson the rich dilettante, and there might be an analogy from the manufacturer to the banker, calling the latter a more sophisticated patron. However that may be, certainly Siena (around 1300) and Florence (in the early fourteenth century and then in the fifteenth) led the world simultaneously in just two activities, banking and the visual arts.

hard to find. Merchants must be concerned about the physical truths of materials and weight when they buy and sell goods, and about the human qualities of salesman and customer, whether clever or honest or the opposite. With knowledge of this kind they and their town will prosper; otherwise they will suffer. The medieval lord, vassal, or churchman was not anxious about such questions, for an error would not change his life. His life depended on his grandfather's slot in society, and he was anxious about the order of such slots; but that order does not interest the merchant, who may be born poor and die rich, or vice versa. The status society has yielded to the contract society, feudal to capitalist economics, and soon medieval art will yield to the Renaissance. (Of course there were some merchants before, and some realism in Gothic art, but both now move from a marginal to a central role.) The mutual help of materialism and humanism in this time contrasts with our frequent concept of their mutual antagonism, and might make

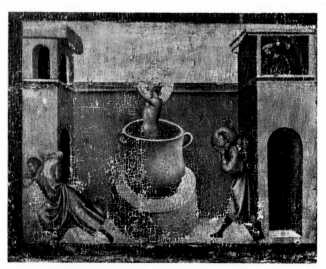

22. MASTER OF ST. CECILIA. *Martyrdom of St. Margaret,* scene on St. Margaret Altarpiece.
Panel, 12″ × 16″. S. Margherita a Montici
(near Florence)

6. Giotto

The Florentines, besides their other areas of leadership, dominated the early writing of art history. That is one reason why Giotto (docs. 1300–d. 1337) has been viewed as the first artist, or, more modestly, as the first painter, to leave Byzantine formulas for reality. But the larger reason is that he was the greatest artist who had yet done so. (The idea that Giotto began it all has also supported the view that he painted the Assisi frescoes of Saint Francis, where the new style makes one of its earliest appearances.) Giotto's close contemporary, the Florentine poet Dante, alludes to him in the *Divine Comedy*, saying that he had displaced Cimabue in public reputation. This is the first record of the concept of fashion in art, and the remark itself assisted the fame of Giotto further. Giotto's reputation led him to do work in many other cities, and we can see it best preserved far from home, in Padua, near Venice. There he painted for Enrico Scrovegni, son of a rich banker, a semiprivate chapel (consecrated 1305) known as the Arena Chapel. Its frescoes are a narrative of the lives of Christ, His mother Mary, and her parents Joachim and Anna. The latter, a novel choice, suggests the bourgeois sense of a family group with the grandparents, as against a feudal interest in a family tree of noble lineage.

Detailed observation of a few scenes may suggest Giotto's remarkable qualities. The pious Joachim, who has been excluded from the temple because, a childless man, he is thought to be cursed by God, arrives in the second scene at a pasture where he is greeted by shepherds, his employees (fig. 23). He walks in from the left (many of the scenes exploit the left-right movement of our eyes), and the shepherds are surprised. The moment has no theological importance, but vivid human sentiment. Joachim's body seems massive because his plain cloak is pulled about him, with a few taut folds but no subdivisions. Giotto works on the sense of weight more simply and effectively than almost any other artist: indeed, if, after looking at such a figure, one turns one's eyes to a real person, Giotto's will seem weightier because the usual distractions of details are wiped out. The shepherds, whose

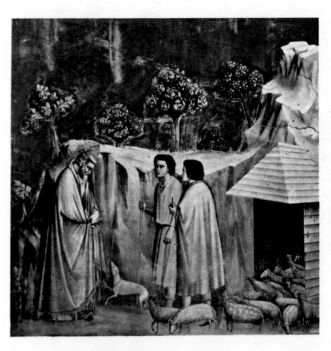

23. GIOTTO. *Joachim and the Shepherds.*
Fresco, 6′6″ × 6′. Arena Chapel, Padua

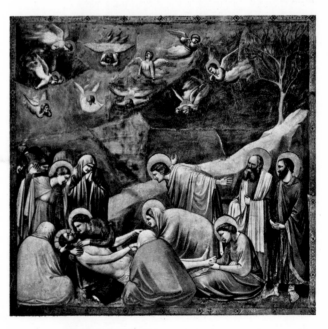

24. GIOTTO. *Lamentation.*
Fresco, 6′6″ × 6′.
Arena Chapel, Padua

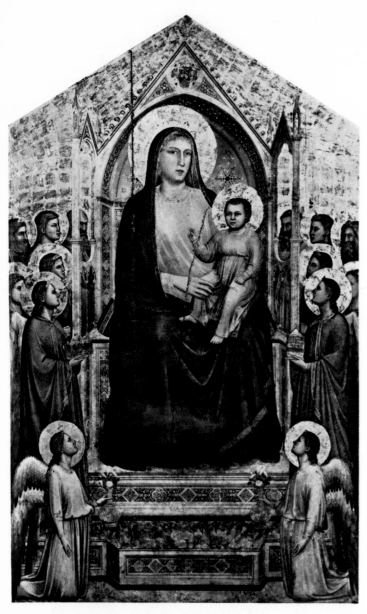

25. GIOTTO. *Madonna and Child Enthroned with Angels*. Panel, 10′8″ × 6′8″. Uffizi Gallery, Florence

forms are more cut up, seem to weigh less. Thus weight is a device to signify importance, replacing the use of size in the Middle Ages. Indeed, our word "weighty" means "important." Joachim's weight is built up through his body and seems to be released in his bent head, where his feelings are shown, so that his sadness appeals to us as significant and the material facts of weight and human feeling have a particularly tight interrelationship. Weight is not shown for its own sake (it is slight in the shepherds), but to convey emotion. Joachim does not necessarily have the higher rank, but he is the protagonist in the scene.

This is a scene in a drama, a tableau as of one moment on a stage. This is why often in Giotto there is not one chief figure, but the center of the work is in the interrelationship among two figures or groups. The Joachim scene shows something of this, and a classic example is the *Kiss of Judas* (colorplate 3). The two colliding faces and the emphasized gesture of the enfolding arm, reaching along stretched folds from the massive cloak, make a solemn instant very graphic. Materialism, which in the figures is so strong a means to a nonmaterial end, is less marked in the landscape backgrounds. The *Joachim* and the *Lamentation* (fig. 24) show a double standard in this respect. It disturbs us, since our eyes expect equal realism or abstraction throughout a visual field, yet we do not maintain this convention in the theater, where we see real actors against a stylized backdrop. Joachim's rocky wall is such a backdrop, and the three larger trees on it clearly relate to the three large foreground forms (Joachim, shepherds, hut). In the *Lamentation*, the diagonal outline of the hill points to, or from, the central group of Mary and Christ. As their two faces are the focus, the figures as they are farther from them are less weighted, more subdivided, and less important and solemn. The two extraordinary boulder-like figures seen from the back tell us of their despair by the degree of sag in their simple contours.

Of Giotto's panel paintings the most important is a large altarpiece of the Madonna (fig. 25), of the same type as Cimabue's (see colorplate 2). This Child, though, is not a symbolic giver of blessings, but must stretch his arm out like Giovanni Pisano's Herod (see fig. 9). Giotto absorbed Cimabue's sensitivity to heroic passion, and Giovanni Pisano's similar control of tense emotions, along

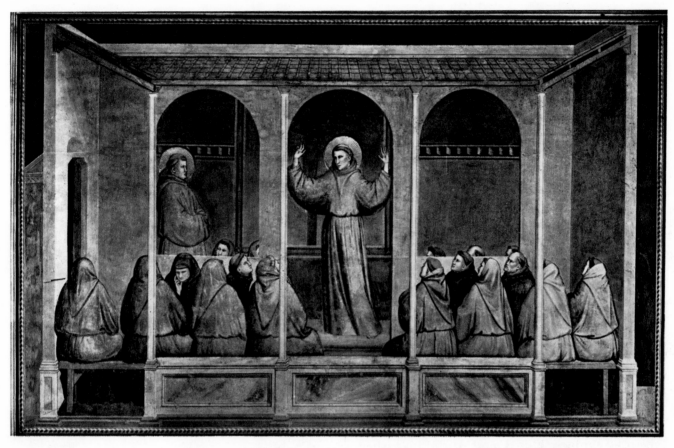

26. GIOTTO. *The Miraculous Appearance of St. Francis to the Monks at Arles.* Fresco, 11′2″ × 14′9″. Bardi Chapel, S. Croce, Florence

with Cavallini's very different expertness in painting modeled forms. But his truest predecessor is Arnolfo di Cambio, whose thirsting woman (fig. 13) comes closest to Giotto's sense for the essential human circumstance made meaningful by weighty form. To be sure, Arnolfo has a stonecutter's clumsiness in interrelating figures if we compare him with Giotto's orchestrations of groups and scenes. But their common concern foretells the permanent essence of Florentine art. (And Arnolfo legally was a Florentine, born in a village under Florentine rule, though he worked mainly in Rome.)

Giotto's people are classics because they state their specific point with the most basic simplicity, telling us at once what it is and that it is worth notice. All other artists, whatever other advantages they may have, seem elaborate beside him; the simplest figure by Caravaggio or a cubist Picasso is much more elaborate. Yet this applies mainly to the Arena Chapel. Like all great artists, Giotto was unsatisfied with what he had done, and his later work adds complexity, especially in the environment. In two frescoed chapels (for great banking families) in Florence, in the Franciscan church of Santa Croce,[10] Giotto pushes his people through the doors and windows and screens of firmly bolted spaces (fig. 26). They lose the intense finality of a universe where people are the only forces, to gain a more relaxed interplay with the force of the world upon them. The directions in which people look, move, or turn become the vehicles in which they express their drama, restricted by the modest capacity permitted by the enclosed space and the softening air. This art of many potential variations, rather than his early strong and few statements, is Giotto's bequest to his successors.

7. Giotto's Pupils

In Giotto's old age, in 1334, the overseers of Florence Cathedral put him in charge of building activity, simply because he was the most famous artist of the city. His enormous prestige is also apparent in his effect on younger painters, who all imitated him, but who each developed a small specialty within Giotto's general procedures.

Of these Bernardo Daddi (docs. 1328–1348) is most accessible to us, since relatively many of his works survive and have been long studied. His Madonna images range from large church altarpieces to small panels for citizens' prayers. His type of Mary is well cushioned and pleasant, with a smile and a head bent toward the Child (fig. 27). The forms are built up with the softened weight we would expect, but the suave grace involves an emphasis on curving line that departs from Giotto and reflects another tradition, as we shall see. In small scale his figures have a sharp bright presence as they turn before tapestried thrones. This is most true of his earlier work; later it stiffens into a dry routine.

The Florentine public, who (starting with Dante) made critical judgments of their painters, rated Daddi less highly than three other disciples of Giotto. The works of one of these, Stefano, are all lost. No doubt some of the finer anonymous paint-

28. TADDEO GADDI. *The Annunciation to the Shepherds*. 1332–38. Fresco, 7′5″ × 4′8″. Baroncelli Chapel, S. Croce, Florence

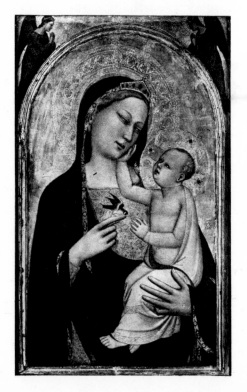

27. BERNARDO DADDI. *Madonna and Child with a Goldfinch*. Panel, 32 1/4″ × 21 1/4″. Berenson Collection, Villa I Tatti, Florence (reproduced by permission of the President and Fellows of Harvard College)

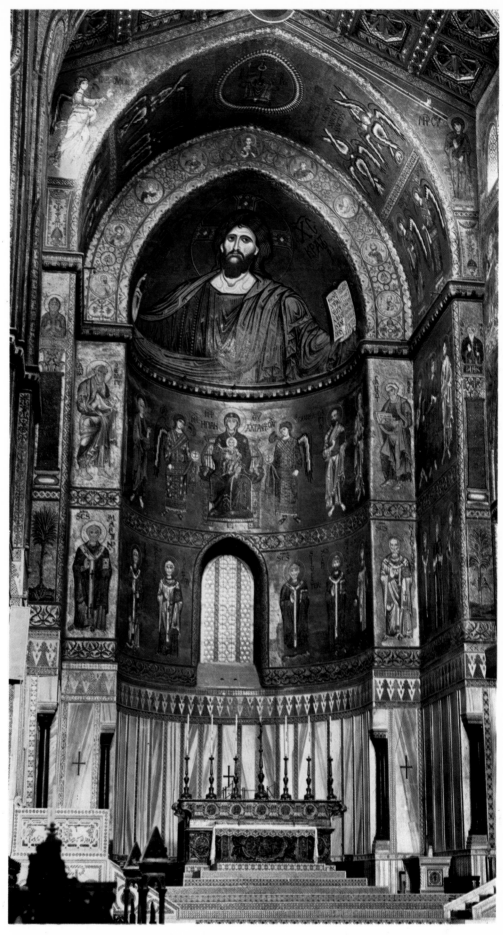

COLORPLATE I. *Christ Pantocrator, the Virgin, Angels, and Apostles.* 1180–90.
Mosaic, height of the three figurative mosaics, on the vertical, 56′;
width following around the curved apse wall, 47′6″. Cathedral, Monreale

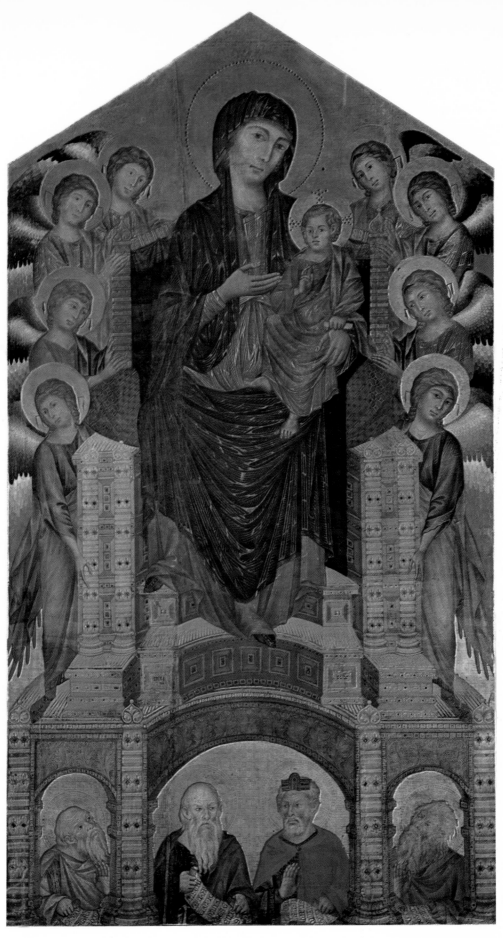

COLORPLATE 2. CIMABUE.
Madonna and Child Enthroned with Angels and Prophets. c.1285–1300.
Panel, 11′7″ × 7′4″. Uffizi Gallery, Florence

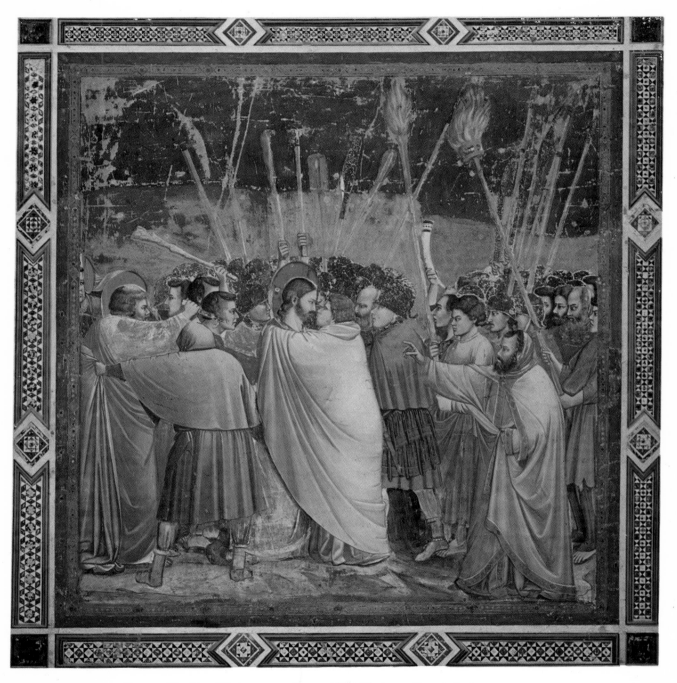

COLORPLATE 3. GIOTTO. *The Kiss of Judas*. c.1305. Fresco, 6′6″ × 6′. Arena Chapel, Padua

COLORPLATE 4. MASO. *St. Sylvester Restoring to Life the Victims of a Dragon*. 1335–45.
Fresco, 8′3″ × 14′3″. Bardi di Vernio Chapel, S. Croce, Florence

ings in existence from this stylistic context are his, and several theories on this point have been offered. The second, Taddeo Gaddi (docs. 1334–d. 1366), assisted Giotto faithfully for years, but in the 1330s he was also active on his own account in a number of complex narrative sets of frescoes and panels. These and his Madonnas tend to have a wooden, blocky effect, with stiffly hinged angular features and limbs, suggesting his devotion to Giotto's principles with limited fluency. He lifts some of his large compositions from his master's, only adding ornamental details to enliven them. But he is more fascinating in another novelty, night scenes with sudden supernatural light effects (fig. 28). Egg-yolk-colored glowing ground bursts out of darkness and models the figures half black, half yellow. Stimulated by Giotto's exploration of environment and air in his later years, this is Taddeo's original controlled vision.

The pupil who has left us the most brilliant works was Maso (docs. 1341–1346), though they are few. His masterpiece is a scene in a fresco cycle painted in another family chapel in the Franciscan church, Santa Croce (colorplate 4). It is a legend of Saint Sylvester, the pope who converted the Roman emperor Constantine, and it represents Rome as a city of ruins, as it looked in Maso's time. A series of walls appears like flat screens in broad high-keyed color fields, the farther ones visible behind the conveniently damaged nearer ones. This goes beyond Giotto's exploration of environment, since one can conceive of these buildings as being there without people, while in Giotto's scenes buildings always derive their form from the people they contain, like a mold. Maso's people remain thick and cubic, but their creamy planes of faces and strict lines seem to enclose a smoldering gleam, as if pressures were being held in, and this justifies their imposing breadth. Maso thinks only of the same problems as Giotto, but arrives at some additional answers.

8. Duccio

In the early fourteenth century the two greatest centers of painting in the Western world were Florence and Siena, neighbors and rivals in the same region, Tuscany. Siena seems more medieval: it is on a hilltop, and owed its early growth to being a safe refuge in times of wars fought before there was artillery, like many other hill towns. Florence, like all great modern cities, is on water. Siena had long adhered to the Ghibelline party, supporting the feudal structure of the Holy Roman Empire, while Florence had always been Guelph, in theory supporting the pope, but in practice the local autonomy of town commerce. Siena's great Cathedral sculpture by Giovanni Pisano alludes to Gothic France, while Florence's, by Arnolfo di Cambio, foretells future tastes in imagery (see figs. 8, 15). Siena was now losing out in the rivalry and adopting Guelphism, and had been deprived of its papal banking business even before its greatest financial firm failed in 1309. Yet it was still energetic enough to produce remarkable painting and, as rivals often do, to conduct intimate exchanges of resources with Florence, including commissions for artists.

Thus Duccio (docs. 1278–1311), the great figure who determined the special character of Sienese painting, is first seen in an altarpiece painted for Florence (1285; fig. 29). This grand Madonna is of the same type as Cimabue's (see colorplate 2), and both take Byzantine shapes to be the norm. But Duccio, who was younger, departs from them more positively. The throne in Cimabue's is something of a diagram, signifying Mary's rank, and then at the bottom reworking itself into a frame for the prophets; Duccio's is a fairly plausible object of carpentry, with its simple-minded receding diagonals. Duccio's angels cling to the throne with both hands; their bodies are not exclusively crystallized rhythms of homage. The abstract gold folds are now restricted to the Christ Child, and the Madonna's golden hem is a line that runs down in a twining flow with calculated irregularity, evoking three-dimensional projection and recession too. The

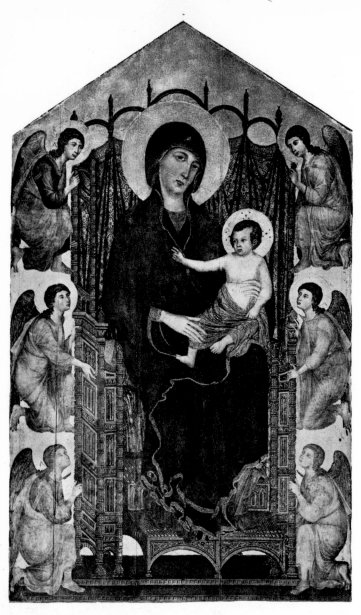

29. DUCCIO. *Madonna and Child Enthroned with Angels*. 1285. Panel, 14'9" × 9'6". Uffizi Gallery, Florence

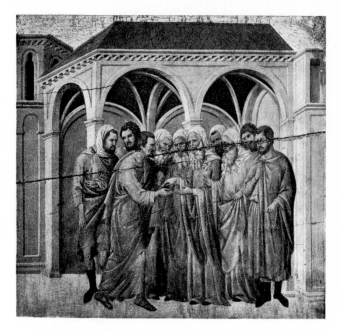

30. DUCCIO. *Judas Receiving the Thirty Pieces of Silver*, from the *Maestà*. 1308–11. Panel, 18" × 20". Museo dell'Opera del Duomo, Siena

31. DUCCIO. *The Calling of Peter and Andrew*, from the *Maestà*. 1308–11. Panel, 17" × 18". National Gallery of Art, Washington, D.C. Samuel H. Kress Collection

elegant rhythms of line, important in these borders and in the angels, are Duccio's most famous specialty and show the stimulus of Giovanni Pisano, but here they become more beautifully ornamental and less classically volumetric, so that they suggest the "Late Gothic" of northern Europe. This is most obvious in the *Madonna with the Three Franciscans*,[11] tiny like an enamel reliquary. There the gold hem winds down to the passionate prostrated monks, in front of a flat patterned wall that resembles French manuscript illumination.

Duccio's *Maestà* (1308–11)—the Madonna surrounded by a court of saints—was the widest panel painting until then, made to be placed on

the high altar of Siena Cathedral.[12] Linear refinement of folded loops and twisting figures, on a monumental scale, restates religious function in the terms of aristocratic pageantry. The work is even more overwhelming because its back surface and both sides of the baseboard underneath (the predella) were covered by an immense series of panels, more than forty, of the lives of Mary and Christ (figs. 30, 31). These explore the powers of space as a vehicle of drama with a succession of inventions that outdistance Giotto. Duccio's spatial pursuits here, as in his Florence *Madonna*, are more surprising than the linear rhythms that are in tension with them. When Judas receives the thirty pieces of silver (fig. 30), the point where the hands meet to hand over the money is marked by their cupping lines, but also by stone arches that shoot up like a fountain, and cover a porch which establishes an extra range of depth, quite unoccupied by the action. When Christ and the disciples come to the gate of Emmaus, the path which their next steps will take is marked for us like a tunnel. Most fantastically, in the *Denial of Peter*,[13] the maid who casually asks Peter the dreaded question rests her hand on the rail of a stair up which she will walk the next minute. These scoopings into depth are unprecedented, and always work to accentuate the drama, even though they are probably not as close to the heart of Duccio's method as the purely linear drama. We see its choreography when, in the *Three Marys at the Tomb*,[14] the hands lift in three variations on the theme of shock, or in the swiveling bodies of the *Calling of Peter and Andrew* (fig. 31), as they swing ninety degrees from their fishnets to Christ, a composition just slightly revised from an old Byzantine formula.

9. Sculptors of the Early Fourteenth Century

In the generations after the formidable pioneers, Nicola and Giovanni Pisano and Arnolfo, there is a drastic decline in the role of sculptors. And shortly after 1300 the finest ones seem to be bemused by the influence of Duccio or of Giotto.

The bronze statues and marble reliefs on the front of the Cathedral of Orvieto, a small town southeast of Siena, are connected with two mysterious names. A Sienese sculptor named Ramo di Paganello (docs. from 1281) was working there from 1298 to about 1310; no certain works of his are preserved anywhere, but he was described as an equal rival of Giovanni Pisano in Siena, and he may have traveled in France. Then in 1310–30 the Sienese architect Lorenzo Maitani (docs. 1302–d. 1330) was in charge of work on the Cathedral. The sculpture on the flat panels of the façade (fig. 32) is extremely sophisticated, suggesting at first a dancing calligraphy, yet, closer up, full of soft textures of flesh and even of leaves. It is a late decorative version of the classical Gothic of Notre-Dame in Paris and even Reims, making the rough strength of Giovanni and Arnolfo

32. "Lorenzo Maitani." *Damned Souls*, portion of *Last Judgment* façade relief. Marble, about 36″ × 54″. Cathedral, Orvieto

33. TINO DI CAMAINO.
Tomb of Emperor Henry VII. 1315.
Marble, height of central figure 71″,
others about 60″. Campo Santo, Pisa

34. TINO DI CAMAINO.
Bishop Orso of Florence, from his tomb. 1321
Marble, height 52″. Cathedral, Florence

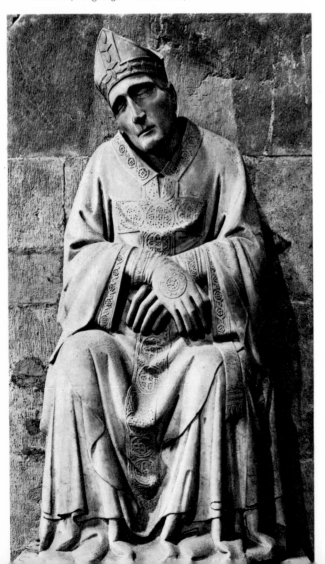

look ungainly. All this suggests Ramo di Paganello, but the carving was evidently done during Maitani's time, and perhaps he or a collaborating sculptor worked in a style that Ramo had established; the work is now usually labeled "Maitani." It is most remarkable in the drawn reliefs of the *Last Judgment,* where the cutting line stretches the bodies tight, like a Giovanni Pisano transferred to a decorative surface.

Tino di Camaino (docs. 1312–1337) has a clearer personality. A Sienese apprentice of Giovanni Pisano's, he succeeded to some of his master's Pisan honors, and so produced the elaborate tomb of Emperor Henry VII (1315; fig. 33), Pisa's guest, the last Ghibelline hope and much admired by Dante. The arrangement of the main part, enthroned emperor between standing counselors, is analogous to a Maestà (or vice versa), but surprisingly the carving is less like Giovanni's than like Arnolfo's. The emperor is a trunk, enlivened by wrapped folds, and the counselors are the tough cubes, articulated with diagonal incisions to mark their gestures, which become Tino's hallmark, of an insistent antigracefulness. Back in Siena (1317–18) he carved for a cardinal the first of a long series of many-storied tombs,[15] elaborations of Arnolfo's type, which he produced with astonishing speed in a few months each. Moving on, he reached his peak of achievement during a brief stay in Florence. The tomb figure of the powerful Bishop Orso (1321; fig. 34) is shown in an original motif, as if sitting asleep, concentrated in bulk like a bear, his big head flopped over. Another fragment, a cubic but heavily active allegory of Charity with two children, is equally powerful. Tino was obviously finding in Giotto an exciting reinforcement for his previous love of massive plainness. In 1324, now the most reputed living sculptor, he settled in Naples, where he worked as an architect, but chiefly on a series of tower-like tombs for the prolific royal family, up to his own death.

Andrea da Pontedera (docs. 1330–d. 1348/49). called in Florence Andrea Pisano, is first known when he arrives there to execute the great bronze doors for the eleventh-century Baptistery.[16] He modeled and chased them, relying technically on the prototype of the medieval bronze doors of Pisa Cathedral, but a specialized craftsman did the casting. The panels of stories of John the Baptist copy older compositions with a cool expertness of mod-

eled form that is completely Giottesque in its serious sense of the body but diluted with graceful Gothic line. Andrea then succeeded Giotto as head of the Cathedral works, and for its Bell Tower carved a set of panels symbolizing the arts, industries, and other allegories, graphically individuated (fig. 35). Typically, it is debatable whether he used designs left by Giotto for the purpose; it is also typical that such reliefs should be the most important sculpture at the time.

35. ANDREA PISANO.
The Art of Seamanship. Marble, height 40″.
Bell Tower, Cathedral, Florence

10. Simone Martini

Duccio was older than Giotto, and did not exhaust his own new methods. Hence the next generation of painters in Siena had more leeway than in Florence, and was far more varied in strong personalities. Simone Martini (docs. 1315–d.1344) first appears with his *Maestà* (1315; fig. 36), as large as Duccio's but less surprising since it is frescoed on a wall. It criticizes Duccio's very recent work by wiping out its Byzantine turns of phrase. Mary is separated off from her courtiers by delicate Late Gothic tracery. Duccio's lovely thin meanders of line and his spatial probing appear in the crowds of saints, but most strikingly in the marquee above, with its long-and-short rhythms. Sienese painting now seems possible to define by line and depth in terms of wiry structures winding through space. This *Maestà* is not in a church but in the assembly room of the city hall, and its inscription says that Mary loves Heaven no more than she does a man of good counsel. The context seems typical of the strongly political quality of Sienese painting at this time and of Simone in particular; it also symbolizes a tendency for themes to be as religious as

ever but less connected with the Church. (When historians first noticed the Renaissance withdrawal from a churchly culture, they overdrew the idea of a "pagan Renaissance," and some recently have reacted too far back again.)

Simone worked much of the time far from Siena, and for King Robert of Naples (Tino di Camaino's patron) he produced a political masterpiece (fig. 37). Robert was a younger son whose claim to the throne depended on the renunciation of an older brother, Louis, who had joined the Church; when he died, Robert successfully urged the pope to declare Louis a saint. Simone painted him in an altarpiece, enthroned, receiving a heavenly crown and handing an earthly one to the kneeling Robert. The two crowns are incised into the gold background, and their sharp preciousness recurs in the main figure. The churchman's embroidered cloak, falling in heavy rhythms and covered with shields, reveals his monk's robe underneath and the rope belt dropping in long curves. Humble withdrawal and rich rank are considered congruent.

A cardinal who was a friend of King Robert left

a legacy for a chapel at the Franciscan shrine in Assisi, and Simone frescoed this with the legend of Saint Martin. The most famous incident in this saint's legend, when he cut off half his cloak for a beggar, is celebrated in the central motif of the grand swath of cloth, swinging in folds from shoulder to steadying hand. Much is made of Saint Martin being a knight of chivalry, and we see the scene of his being knighted and getting his spurs (fig. 38); elsewhere his funeral is held in a church full of tracery windows and deep shadow. The chapel utilizes the artist's whole range, and he designed its windows and pavement, too.

Simone's linear expressiveness is never mere ornament, and his simplest masterpiece shows it serving a more dramatic psychological statement. The *Annunciation* (1333; colorplate 5), painted for Siena Cathedral, has no space, but only the relationship of the two people: the angel pressing forward, with his cloak in a quick flounce of ending flight, and the more extraordinary Mary, who is startled and presses backward to hide, her reality ensured by gold scalloped lines in the hem of her dress. Simone belongs to the second generation of strong artist personalities concerned with the material and the human; the new style can now be taken for granted and manipulated, and the town culture can safely offer an alliance to feudal kings. This is particularly true when a personal style is naturally aristocratic like Simone's, but he is nonetheless an individual painting reality.

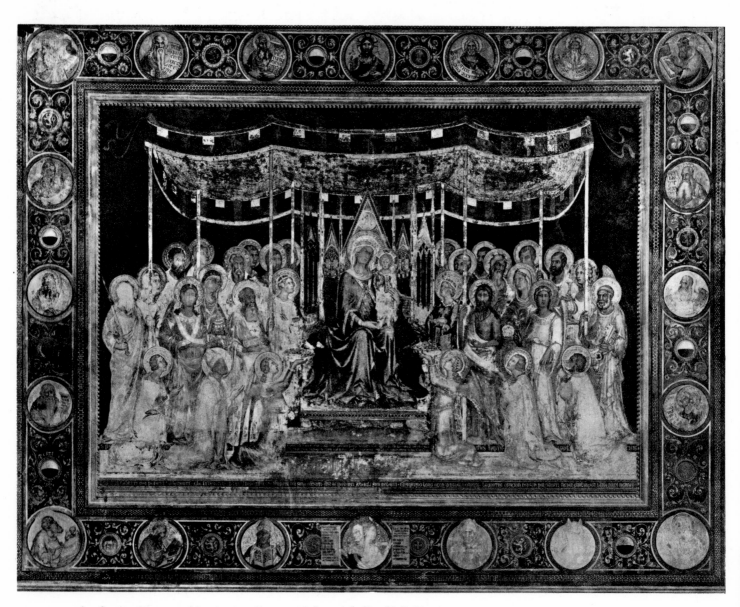

36. SIMONE MARTINI. *Maestà*. 1315. Fresco, 27′5″ × 32′2″. City Hall, Siena

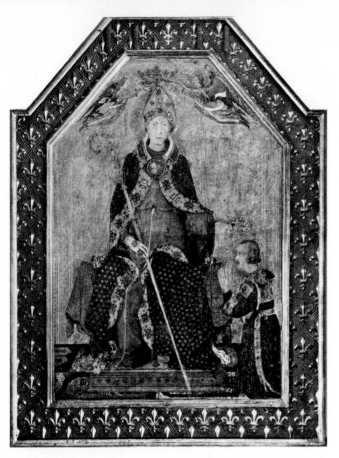

37. SIMONE MARTINI. *St. Louis of Toulouse Crowning King Robert of Naples.* 1317. Panel, 78″ × 54″. Museo Nazionale di Capodimonte, Naples

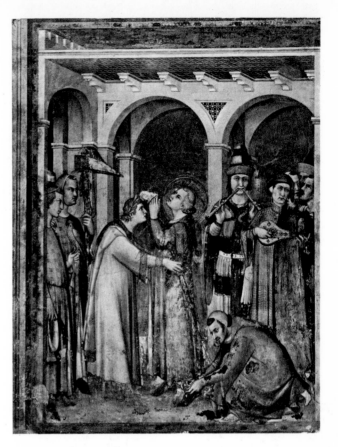

38. SIMONE MARTINI. *The Knighting of St. Martin.* Fresco, 8′8″ × 6′6″. Lower Church, S. Francesco, Assisi

11. The Lorenzetti Brothers

Less thinly elegant than Simone's, the work of the two Lorenzetti has its political place in the context of the Sienese republic itself. Both were also interested in Giotto, and one of them, Ambrogio, spent a good deal of time working in Florence, yet they are modern in being distinct individual personalities. The older, Pietro (docs. 1306–1342), first appears (1320) in a large altarpiece whose Madonna turns gently to the Child with a grace accented by a linear curve.[17] Both figures are heavy and soft, but are related to each other not in Giotto's way so much as in Giovanni Pisano's, who had taught the Sienese how to coat Gothic line with sculptural weight. In that vein Pietro's masterpiece is his *Deposition* (fig. 39), one of a set of frescoes, again, in the church of Saint Francis at Assisi. The cross itself is ornament-

ally marked with the grain of its wood, and from it the body falls in a waving collapse, pulling out the shoulder bones, so that sharp drawing serves the exposition of pain. But below, the figures standing to take the limp body are Giottesque sacklike masses, only modified by a pattern of thin folds around the edges. Equally physical and unaristocratic, yet more Sienese, is Pietro's late masterpiece (1342; fig. 40), the altarpiece of the *Birth of the Virgin*. It is in three panels, a triptych, like a cross section of a Gothic church; the form is commonly used for painting a Madonna between Saints. Pietro treats the carpentry system and its frames as the architecture of his painted space, building rooms back from the picture plane and from the four wooden uprights. One large room asymmetrically fills the center and right-

43

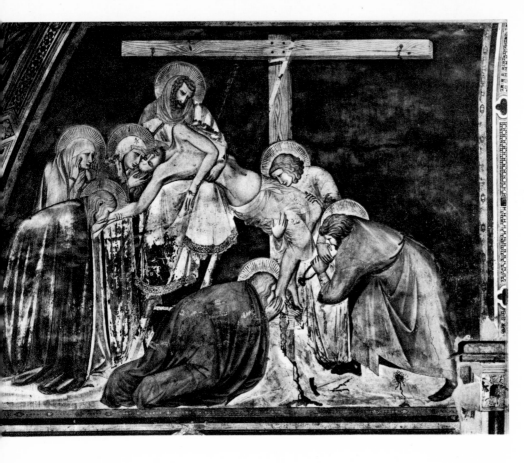

39. PIETRO LORENZETTI.
Deposition from the Cross.
Fresco, 12′4″×6′9″.
Lower Church, S. Francesco, Assisi

40. PIETRO LORENZETTI.
Birth of the Virgin. 1342.
Panel, 73″×71″.
Museo dell'Opera del Duomo,
Siena

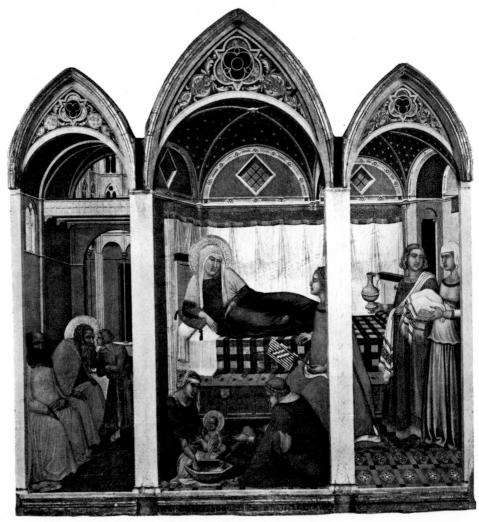

41. AMBROGIO LORENZETTI. *Presentation in the Temple.* 1342. Panel, 8'5" × 5'6".
Uffizi Gallery, Florence

His brother Ambrogio (docs. 1319–1347) is even more insistent on physicality. In his many Madonnas, the Child is fat and active, squirming and bouncing. In his late *Annunciation* (1344)[18] for the city hall, the figures are assertively plump as if by a Sienese Rubens, and distract our attention from the fact that depth is measured more systematically here than in any other painting of the time. Jewell-like lozenge patterns reinforce architectural depth in his *Presentation in the Temple* (1342; fig. 41). But his fame depends on a set of frescoes around the room in the city hall where the executive committee of nine counselors met (1337–39). Nothing similar to this *Allegory of Good and Bad Government* survives anywhere. On the end wall opposite the windows, the allegorical images of Justice, Concord, and others make a medieval schema, though the almost Roman solidity in some figures seems modern. We are more drawn to the side wall which offers specific instances of the *Effects of Good Government* (colorplate 6, fig. 42; the other side wall, *Bad Government,* is poorly preserved). The city is before us in a bird's-eye view, its people walking, doing business, and dancing, and beyond the walls the farms, with roads and travelers, are a green panorama matching the checkerboard of the town roofs. The allegory of Safety in the sky blesses all. With unique articulateness (among surviving works) Siena was honoring the concrete results of urban morality, the ideal goal of capitalist energy. To this concern the artist brought his sense of weight and rhythmic motion, live forms suspended in broad airy space. These concerns and techniques are common to the period, but Ambrogio perhaps concentrates most intensely on their interplay and the resulting conviction of a shared world.

hand panels, a bedroom where the mother sits up and receives visitors; in the left panel the father waits in the hall outside. This is Pietro's most monumental assertion of the everyday bourgeois and material quality of holy events, a tone that later, through indirect channels, will stimulate the Flemish Renaissance.

42. AMBROGIO LORENZETTI.
Good Government in the Country.
1338–40. Fresco, total wall length 46'.
City Hall, Siena

12. Orcagna and His Contemporaries

About 1350 the most highly regarded young paint- ers in Florence were the Cione brothers, Andrea (docs. 1344?–d. 1368), known by the nickname Orcagna, and Nardo (docs. 1344?–1365). Both their most impressive works are in the Strozzi family chapel in the church of the Dominican order, Santa Maria Novella. Orcagna's altarpiece (1354–57; color- plate 7) is original, omitting the internal frames between the three parts so that Christ enthroned, fixedly frontal, can give the keys to his successor, Saint Peter, with one hand and the book to the fa- mous Dominican theologian Saint Thomas Aquinas with the other. Thus the picture makes its points about the relations of God, the Church, and theolo- gy through ceremonial public gestures; the strict frontality of one figure and the profile of another further organize the statement into a kind of dia- gram. The themes are reinforced in the scenes of the predella underneath, where Saint Thomas cele- brates Mass, alluding to his importance in formulat- ing the doctrine of the sacrament, and where Christ during a storm rescues the disciples' boat (fig. 43), a traditional symbol of the Church. But in these little scenes the presentation is far from diagrammatic. In a vaster space than any up to now, the figures of the boat scene exert themselves, craning their necks and pulling ropes. Both upper and lower figures are

44. NARDO DI CIONE. *Christ Carrying the Cross.* Fresco, 13′4″ × 8′2″. Badia, Florence

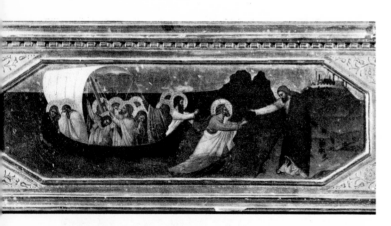

43. ORCAGNA. *Christ Rescuing the Disciples,* from predella of *Christ Enthroned among Saints* (see colorplate 7). 1354–57. Panel, 7″ × 25″. S. Maria Novella, Florence

modeled with a rocklike density that connotes com- manding strength.

In the same chapel, Nardo's *Last Judgment* frescoes are again diagrammatic, notably the huge *Paradise,* where saints appear row on row without any space. His figure modeling, unlike Orcagna's, is softly yielding in texture and gracefully curving. It reappears in dramatic, nondiagrammatic guise in his other most important work, the damaged fresco of *Christ Carrying the Cross* in another Florentine church, the Badia (fig. 44). Mary tries to approach Christ and he swings around to see her, but a sol- dier in between prevents their meeting, holding his sword horizontally in the empty central space; keen tension uses movement and space as its vehicle. Thus both Cione brothers make vivid statements about physical humanity, developing the Florentine concern with such dramas.

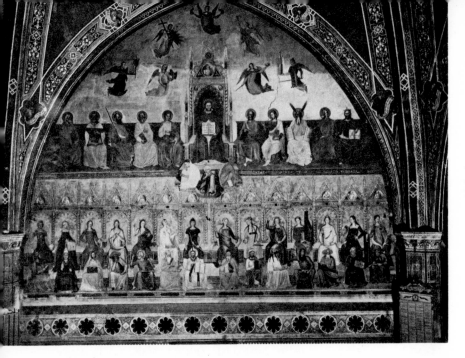

45. ANDREA DA FIRENZE. *Triumph of St. Thomas Aquinas*. Begun 1366. Fresco, width of wall 38'. Spanish Chapel, S. Maria Novella, Florence

Since their "diagrammatic" works are their most conspicuous ones, it has been sometimes inferred that this was the typical new style of their generation, a view that seems to gain confirmation from the *Triumph of the Church* by Andrea da Firenze (docs. 1343–1377; fig. 45), a fresco cycle in the Dominican convent next to Santa Maria Novella. It is minor painting in quality but a major document of its epoch, and again dominated by flat schematically arranged figures clarifying concepts. But the special qualities of all these paintings may reflect the interests of their patrons, Dominicans in every case. Since Saint Thomas' *Summa Theologica* this order had had a great role in the expounding of philosophical concepts in scholasticism, in contrast to the Franciscans, whose greatest literary product was the *Little Flowers of Saint Francis*,[19] a very human narrative. The Dominicans indeed did increase their patronage at this time, and to that extent there is a change of mood. Yet even in works for them, Orcagna's predella and the crucified thieves of Andrea da Firenze's *Crucifixion*, writhing in spatial depth, seem to slide away from the formal thematic concern. And it is even less visible in Orcagna's great Last Judgment fresco for the Franciscans of Santa Croce, where the *Triumph of Death* is filled with churning fighters, crippled beggars, and biting monsters (fig. 46), all having the same energetic solidity as the predella of his Strozzi altarpiece. This modeling style may have developed through Orcagna's relief sculpture, the finest of its time, which we see on his marble canopy enclosing a Madonna by Daddi, at Or San Michele. Its articulation of marble hardness suggests that he found inspiration in Tino di Camaino, the most sculptural of recent carvers and one who had far-ranging influence. Orcagna also designed the canopy and worked to a problematic extent as an architect.

Human narrative and elaboration of architectonic depth also dominate the art of Giovanni da Milano (docs. 1346–1369), a visitor from north Italy who painted in Florence the most beautiful cycle of this period for a Franciscan church (colorplate 8). Its tall figures gaze gently and as if tired out of thin, shadowed faces, swaying and leaning forward with graceful reserve. Such aristocratic manners naturally suggest a background in the feudal courts of Milan and north Italy generally. But what is extant there is of lesser interest than its own source, and Giovanni's probably as well, the "courtly" art of Simone Martini.

46. ORCAGNA. *Beggars*, fragment of *Triumph of Death*. Fresco, entire height at left edge 32'. S. Croce, Florence

13. Barna and Traini

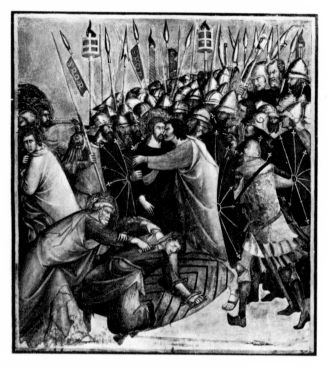

47. **BARNA DA SIENA.** *The Kiss of Judas.* Fresco, 8′3″ × 7′5″. Chiesa Collegiata, San Gimignano

Two artists of the 1340s are famous for one huge fresco cycle each, almost their only works. Barna da Siena's big cycle of the life of Christ, in the main church of the little hill town of San Gimignano, was finished by other artists. The word "Barna" may best be regarded as a convenient label for these frescoes, since nothing is known about him. They show that he learned most from Simone Martini, especially the enriching value of sharp undulating line and its lacy patterns. This pattern of drawing, seen everywhere in robes and curly hair, clashes oddly with what seems to have been a naturally hard and violent temperament. His exaggeratedly tall people swing out their stiff arms like poles, with elementary strength, not bending them. When faces are distorted by pain to the point of unrealistic caricature, a rough effect, as of an inarticulate provincial, assists it. The most striking figures are in themes like the *Crucifixion*, where foreshortened faces between crude and comic are painted with undulating contours, or *Judas Receiving His Bribe*, ugly with sprawling legs, or Peter cutting off the servant's ear

48. **FRANCESCO TRAINI.** *The Triumph of Death.* Fresco, 18′6″ × 49′. Campo Santo, Pisa

with a grand swing in the *Kiss of Judas* (fig. 47). Siena was not for generations to produce new masters with their own styles, so the choice was between the usual manner of repeating the old formulas straight, or Barna's of exaggerating them excitedly.

The Lorenzetti were the inspiration of Francesco Traini (docs. 1321–1347? or 1363). Pisa, where he is the one notable artist in his time, had close links to Siena. Traini's Saint Dominic altarpiece (1344–45)[20] is remarkable for tiny scenes with complicated spaces, full of expressive mobile crowds. This has led to the now usual deduction that he painted the most remarkable parts of the huge fresco of the *Triumph of Death* in the Pisa Cathedral cemetery, the Campo Santo (fig. 48). The fresco includes the standard scenes of Christ's death, but it has had special impact on later observers, including Shelley and Liszt, through its rare additional images, such as the three cavaliers confronted by three corpses, the groups of lovers, merrymakers, and musicians, like people in Boccaccio's *Decameron*,[21] and the incidents of hermits' lives in the desert of the Thebaid, based on a book by a contemporary Pisan monk.[22] They may attract us more than works of greater pictorial quality. But even if we ignore the narratives, this must be regarded as the only work of the time that can be set beside its prototype, Ambrogio Lorenzetti's *Good Government* (see colorplate 6, fig. 42), in the spread of an encyclopedic theme through wide panoramic space, making its up-to-date sense of physical events reinforce its ethical aim. Some of the incidents in their roughly forceful gestures and forms have, besides, unforgettable graphic characterization.

14. The Fourteenth Century outside Tuscany

Modern painting in the fourteenth century is predominantly Florentine and Sienese. The activities of late thirteenth-century Rome, with Cavallini, Arnolfo, and others, stop when the papacy moves away to Avignon in 1305. Yet extraordinary talents appear in Bologna and Padua, which have been given their due only in recent years.

The Master of Saint Cecilia, himself a wanderer and the chief developer of Cavallini's approach, inspired a prolific but routine school in Rimini, on the Adriatic coast. From this source, and especially from the Master's late Saint Margaret altarpiece and its wildly gesturing soft figures (see fig. 22), a brilliant young painter emerges in Bologna. In Vitale dei Cavalli (docs. 1334–1359), known elsewhere as Vitale da Bologna, the centrifugal energetic busy-ness of crowds and monks is again steeped in a softening shadow, but endowed with a dashing exaggeration of acrobatics that can be comic or agonizing (fig. 49). His Madonnas smile straight at us like archaic Greek kouroi, suggesting a similar desire to enliven. The effect of spontaneity in Vitale's art makes Giotto and Simone Martini by contrast seem embedded in a system.

49. VITALE DA BOLOGNA.
Legend of St. Anthony Abbot.
Panel, 31″ × 15″.
Pinacoteca Nazionale, Bologna

49

50. TOMMASO DA MODENA. *The Mission of the Ambassadors*, from St. Ursula cycle. Fresco, 7′ × 7′4″. Museo Civico, Treviso

But Tuscan resources attract Vitale's successors. The most talented painter after him is Tommaso da Modena (1325/6–1379), who went north to paint frescoes in the Venice area, in the town of Treviso.[23] For the meeting room of the Dominican convent there he painted an endless row of portraits of Dominican saints, all writing at desks, whose constantly varied gestures avoid monotony with comic vigor and lively freshness. His other surviving large work, frescoes of the life of Saint Ursula (fig. 50), is equally bright in color, casual in gesture, and persuasive in physical reality, but leans much on Ambrogio Lorenzetti for its types of graceful, heavy women and for its linear patterns. And the most talented native painter of the area, Guariento (docs. 1338–1368), turns to the same mine. In externals he copies Giotto's nearby work, but when on his own he makes Gothic patterns of wonderfully refined line, meandering over three-dimensional human forms and often adding lyrical pressure to dramas (fig. 51). In so doing he is not above lifting whole figures from Pietro Lorenzetti. Some of his finest works are small-scale panels, and until recently he has suffered from being best known for big "machines," particularly a long series of white-robed angels[24] which led to his being labeled a traditional Byzantinist.

In Padua Altichiero (docs. 1369–1384), from nearby Verona, painted two fresco cycles about 1380 in collaboration with Avanzo (docs. 1379–1389?), an unclear figure who was perhaps a secondary assistant (fig. 52). Altichiero was probably the finest painter in Italy in this generation, near the end of the century. He commands vast crowds in not too orderly processions, coming still closer to Tuscan ideas, in this case to Giotto's organic dense figure modeling. In grays and other pale colors, he emphasizes fine networks of line with rich Late Gothic architecture, creating a profuse but controlled world. His contemporary in Padua, a Florentine immigrant, Giusto de' Menabuoi (docs. 1363–1387), stems instead from the "mechanical" phase of Guariento. Giusto's art consistently adopts repetition, with infinite rows of identical holy figures like Indian temple sculptures, isolated and immobilized, or endless narrative scenes, or even, when he paints buildings, endless rows of columns and steps. His major work, filling the inside of the dome of the Padua Baptistery, seems indeed to want to revert to the mosaic schemes usual in such locations in the Middle Ages.

The one isolated work of north Italian sculpture of active power in this period is a tomb monument that has a striking parallel to Vitale. It emerges from a quantity of routine Lombard carving that is either still Romanesque, or begins to imitate Tino di Camaino in a standard formula that even spread to tombs as far away as Catalonia. This exception is the tomb of Can Grande della Scala (d. 1329; fig. 53), the ruler of Verona, who was a

51. GUARIENTO. *The Three Children in the Fiery Furnace*, from Old Testament cycle. Fresco, height of frieze 38″. Accademia Patavina, Padua

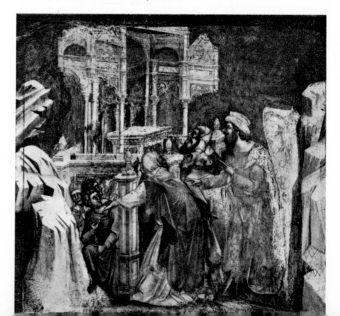

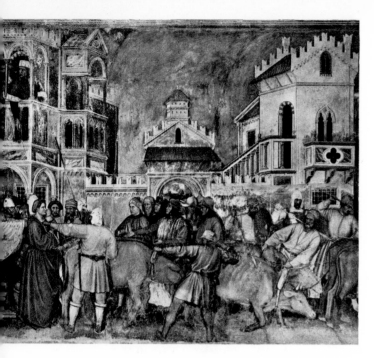

52. ALTICHIERO and AVANZO. *Miracle of St. Lucy.*
c.1380. Fresco, 12′6″ × 9′10″.
Oratory of St. George, Padua

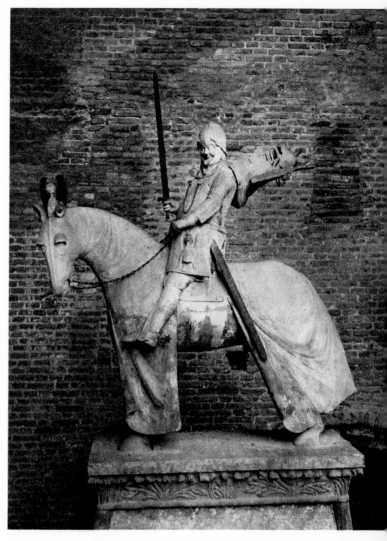

53. *Can Grande della Scala,* tomb statue.
Stone, height 6′5″, base 2′ × 6′7″.
Castelvecchio, Verona

fierce soldier, the head of the Ghibelline league, and the patron of Dante in exile. The monument is silhouetted steeply over the door of a church; the knight sits on his blanketed horse and pulls it back, grinning while the horse leans ahead and the horse cloths fly like sails. The local sculptor, used to architectural contexts, was no doubt stimulated by the superb location to produce this unforgettable image in which we instantly recognize a moment of civilization just before feudal rule was diluted into chivalry.

15. The Competition for the Doors of the Florence Baptistery

Among other new things, fourteenth-century Florence gave birth to the expression of artistic tastes by the public. After Dante's time many other Florentines, including Boccaccio and Petrarch, may be found saying "I like (or "people like") this artist best." Naturally the same artists are often selected—Giotto always, Stefano and Orcagna often—but in comment at the end of the century, for the first time, contemporary artists are omitted from the choices. And indeed, after about 1370 Florentine painting

and sculpture slipped into a mechanical repetition of the forms of Taddeo Gaddi and Orcagna. With the death (1396) of Agnolo Gaddi, Taddeo's son and the least muscle-bound painter at the time, a nadir was reached. The renewal around 1400 rejected this whole tradition in favor of other stimuli: ancient Roman sculpture, foreign Gothic art, and Giotto.

The shift focuses on one point of excitement. In 1401 the Florentine Wool Finishers Guild, the sponsor of expenditures at the Baptistery, opened a

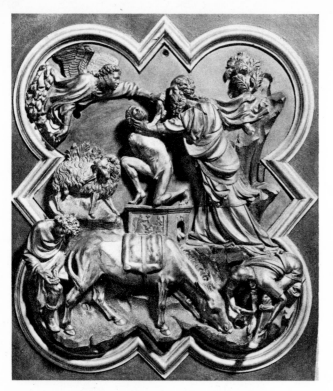

54. FILIPPO BRUNELLESCHI.
Sacrifice of Isaac. 1401–2.
Bronze, 21″ × 17″. Museo Nazionale,
Bargello, Florence

55. LORENZO GHIBERTI.
Sacrifice of Isaac. 1401–2.
Bronze, 21″ × 17″. Museo Nazionale,
Bargello, Florence

competition for a set of bronze doors to match the admired ones by Andrea Pisano. The two finalists were both young Florentine goldsmiths, probably twenty-three and twenty-four, and the choice between them became a fascinating public debate; the sample panels submitted were luckily saved. Both, presumably following instructions, represent Abraham sacrificing Isaac, with the same set of actors. Filippo Brunelleschi (1377–1446) built up one dense group to climactic action, Abraham grasping his son's neck while the angel seizes his other hand. For this tableau the servants waiting with the donkey below form a pedestal (fig. 54). It is a direct reversion to the early Giotto of *Joachim and the Shepherds* (see fig. 23), with its drama between human masses, weight built up to be released in expressive faces, and lighter secondary figures. The power of Giotto's simplicity is plainly understood. Lorenzo Ghiberti (docs. 1401–d.1455) kept the angel apart from the main pair, the servants even more so, and even Abraham and Isaac measure off the distance between them (fig. 55). They relate as parallel curves, Isaac fitting inside the curve of Abraham's swing. Horizontal folds in Abraham's robe echo the

same parenthesis-curve, while Isaac is a beautifully realized quotation of ancient Roman sculpture. The relief is more sophisticated spatially, and far more suggestive of fine workmanship, as of a polished jewel. The committee chose Ghiberti, perhaps for this reason. To us Brunelleschi, human, physical, and dramatic, may seem more Florentine, Renaissance, and modern, while Ghiberti is Gothic, decorative, and craftsmanly; yet Ghiberti's work may have seemed more original just because it was less in the Florentine tradition. Certainly the resulting doors were a great success with younger artists and the public, and they became probably the most familiar work of art in the city (fig. 56). The twenty-eight panels took twenty years (1403–24), partly to design and model, but more to cast, and mostly to chisel details by hand. They maintain the style of the *Sacrifice of Isaac,* as we see for example in the *Annunciation* (fig. 57). Two figures curve reciprocally, more abstract in line system than Sienese rhythms which would twine around the body, and yet creating a no less solid sculptural form. Other panels again explore classical allusions or spatial capacities.

COLORPLATE 5. SIMONE MARTINI. *Annunciation.* 1333. Panel, 10′ × 8′9″. Uffizi Gallery, Florence

COLORPLATE 6. AMBROGIO LORENZETTI. *Good Government in the City*. 1338–40. Fresco, total wall length 46′. City Hall, Siena

COLORPLATE 7. ORCAGNA. *Christ Enthroned among Saints.* 1354–57. Panel, 8′6″ × 9′8″. Strozzi Chapel, S. Maria Novella, Florence

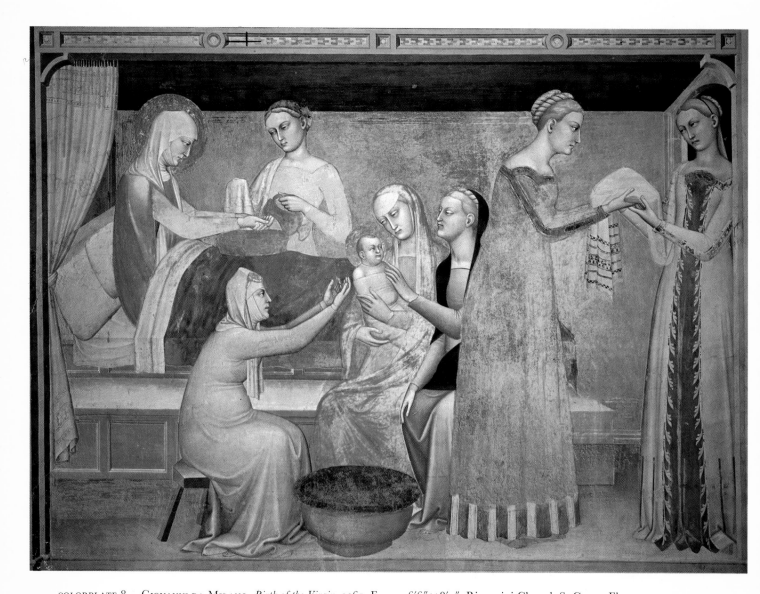

COLORPLATE 8. GIOVANNI DA MILANO. *Birth of the Virgin.* 1365. Fresco, 6'6" × 8'9". Rinuccini Chapel, S. Croce, Florence

57. LORENZO GHIBERTI. *Annunciation*, panel of
North Doors. Gilded bronze, 21″ × 17″.
Baptistery, Florence

56. LORENZO GHIBERTI. North Doors. 1403–24.
Gilded bronze, 18′6″ × 12′.
Baptistery, Florence (above doors:
GIANFRANCESCO RUSTICI, *John the Baptist
Preaching*, 1506–11, bronze)

16. Late Gothic Painters in Florence

A fresh style that is closely parallel to Ghiberti's appeared in painting, which discarded the lumpy heaviness of figure that had come to mark the Orcagna tradition. Transitional reform is perhaps seen in the shadowy figure of Starnina (docs. 1387–1409), whose probable work is marked by its sparkling and witty jumpiness of small forms in space (fig. 58), perhaps taking Orcagna's friend Traini as a model (see fig. 48). But the real revolution comes with Lorenzo Monaco (docs. 1391–1422), of the same age as Ghiberti. His great *Coronation of the Virgin* (1413; fig. 59), in un-Florentine pale blues and pinks, makes its figures arch in Ghibertian parentheses and reinforces the patterns with cutting

curves in repetition, constructing thin folds. It is again a Late Gothic decoration, and again pleasurable in the polish of its technique as in the cylindrical three-dimensionality of the figures. Lorenzo was a monk and started by illustrating manuscripts, the only painting then usually done by monks. When he broke into larger forms he brought along his training in enamel surfaces and elegant precision. As with Ghiberti's goldsmith training, a minor tradition became available to replace a major one that had run down.

Lorenzo's art develops until in his last works he abandons sculptural suggestions and gives his figures a butterfly life of intense gem colors and

intricately lacy line. His themes are elegant, too, emphasizing those churchly subjects that have a feudal or courtly potential, such as the Adoration of the Magi (colorplate 9) or the Coronation of the Virgin. In the former, a ceremony of vassalage, the chief actors take up only half the surface, and a pageant of the kings' retinue and horses fills the rest.

Such a mode prepares for the visit to Florence in 1421–23 of Gentile da Fabriano (docs. 1408–d. 1427). He brought with him a genuinely feudal and courtly art, the International Gothic from north Italy. This style, previously most developed in objects of luxury for the French royal family, he presented to the richest bourgeois merchant of Florence, who ordered an *Adoration of the Magi* from him (colorplate 10). Here, too, half the surface belongs to pages and horses, along with pet monkeys, leopards, greyhounds, peacock feathers, and flowers. But elegance does not come through abstract curves of line. There is a sort of realism: a greyhound is in reality an elegant object that evokes aristocratic daintiness both in its social suggestion and in its shape; it does not have to be stylized. The same is true of the rosebush and the leopard's pelt, and of the two maids behind Mary who daintily inspect her cosmetic jar, turning their heads with models'

58. STARNINA. *Thebaid.* Panel, 30″ × 82″.
Uffizi Gallery, Florence

59. LORENZO MONACO.
Coronation of the Virgin. 1413.
Panel, 16′3″ × 14′7″.
Uffizi Gallery, Florence

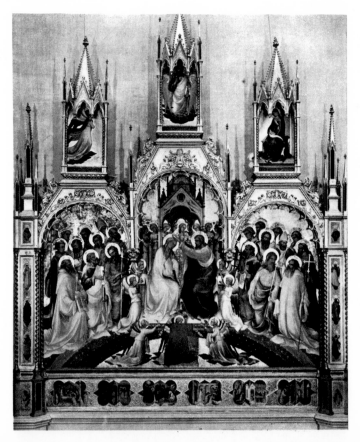

60. GENTILE DA FABRIANO.
Presentation in the Temple, predella of
Adoration of the Magi
(see colorplate 10). 1423.
Panel, 10 1/4″ × 24″.
The Louvre, Paris

grace and making Mary a high lady. By choosing enough such images, one can make a real world convey the same mood as Lorenzo's artificial one. Hence it is that Gentile's faces are not stylized masks, but are soft flesh, and hence he also can include (as the French artists do) the crippled beggar in the square, when he paints the *Presentation in the Temple* in the little predella below (fig. 60). Although Gentile was a wanderer, with a fertile career earlier in Venice and Brescia and later in Siena and Rome, little of his work elsewhere is preserved.

His impact on Florence appears in the most talented painter of slightly younger age, Masolino (docs. 1423–d.1440). Up to 1423 he was imitating Lorenzo Monaco, with handsomely stylized hairpin curves of spreading robes on the floor. With slight transition his figures turn soft and yielding. When he frescoes Adam and Eve eating the apple (colorplate 11), they have a well-mannered conversation, like Mary's maids. But Masolino was subject to even greater pressures, first from a younger revolutionary artist, Masaccio, and, finally, from the enticing new device of perspective, which he worked at with naïve elaboration (fig. 61).

61. MASOLINO.
The Martyrdom of John the Baptist.
1435. Fresco, 15′8″ × 12′5″.
Baptistery, Castiglione d'Olona

17. Jacopo della Quercia

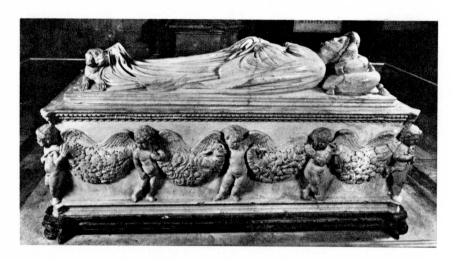

62. JACOPO DELLA QUERCIA.
Tomb of Ilaria del Carretto.
Marble, height 2′2″, base 8′ × 2′10″.
Cathedral, Lucca

The same renewal touched Siena. There, too, good heavy-handed craftsmen had filled churches with standard altarpieces for fifty years. Perhaps the most attractive of them was Paolo di Giovanni Fei (docs. 1372–1410), a creator of glowing people like gentle fireflies, who have something in common with Lorenzo Monaco's. But the shift involved a return to stone sculpture, an almost forgotten factor of Siena's great days, by Jacopo della Quercia (docs. 1401–d.1438), who at about twenty-five also competed for the Florence Baptistery commission. He passed much of his life away from Siena, and appears first with mature work when he carves a tomb for the young wife of the tyrant of Lucca (fig. 62). The coffin of Ilaria del Carretto (d. 1405), in the French style, shows the lady lying on it, her beautiful face no smoother than the beautifully flowing folds of her robe, taut and sure. The construction of linear ornament is repeated on the sides of the coffin, where classical Roman infants hold garlands. Here and in the case of Ghiberti's Isaac figure (see fig. 55) observers have felt troubled by the mixture of Gothic and classical influences, but in both works the artists' attitude toward the classical is to admire and quote literally an isolated refined object of Roman workmanship, consistent with their feeling for handsome polished forms.

Jacopo was helped to become more than a fine Late Gothic gem cutter by being Sienese. It is obvious from his first complex work, a fountain for the main city square of Siena (begun 1412; fig. 63), that he had been attentive to the great Sienese painters of the early fourteenth century. As in Ambrogio Lorenzetti and, less obviously, all the others, his line does not make patterns but models form, moving over a surface in relation to its heights and depths like a road through mountains. In stone sculpture this makes sharp folds twist with great complexity, always related to the body's own involutions. The fountain includes seminude female figures clutching their children in their arms (fig. 64), one child feeding at the breast, that particularly evoke the warmth of the live creature through linear accenting of the intricate turning actions.

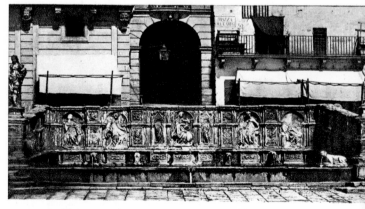

63. JACOPO DELLA QUERCIA. Fonte Gaia
(before dismantling). 1414–19.
Marble, 19′ × 84′6″.
Piazza del Campo, Siena

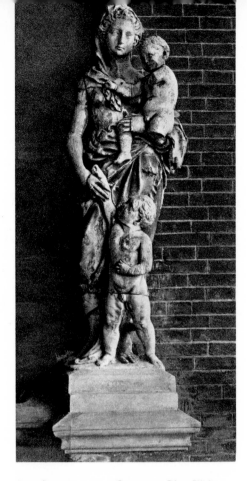

64. Jacopo della Quercia. *Rhea Silvia*,
from Fonte Gaia. 1414–19. Marble, height 67″.
City Hall, Siena

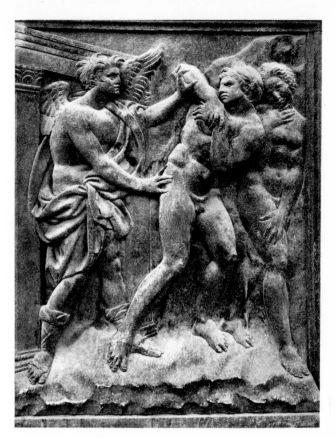

65. Jacopo della Quercia.
The Expulsion from Paradise, panel on façade.
Begun 1425. Marble, 33″ × 27″.
S. Petronio, Bologna

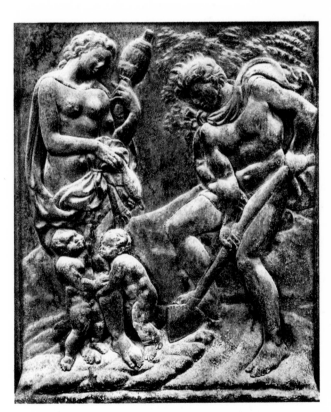

66. Jacopo della Quercia. *Adam and Eve Working*,
panel on façade. Begun 1425. Marble, 33″ × 27″.
S. Petronio, Bologna

Jacopo's masterpieces, the panels around the door of San Petronio in Bologna (from 1425; figs. 65, 66), make the clearest use of beautiful line to mark strong human forces. This new cathedral that the Bolognese were building gave the sculptor great opportunities. Jacopo was a slow worker and only finished a number of panels, small in size but having such power that they strongly affected the young Michelangelo generations later. The focus on drama, so often the most favorable vehicle for early Renaissance statements, becomes available to a carver when he works in relief, and here is reinforced by Jacopo's tendency as a sculptor to minimize the factors of environment. The famous *Expulsion from Paradise, Creation of Eve,* and *Adam and Eve Working* exploit the imitation of Roman modeling, the isolation of the figures on a nearly blank surface, and the interplay between the curved outline and the swelling and dipping forms to obtain the most concentrated meaning for the events. The *Expulsion,* the climax of the familiar tragedy, was being thought about at the same time with different means by younger artists in Florence.

18. Nanni di Banco and the Young Donatello

The commission for the Baptistery doors by the Wool Finishers Guild is the first of many in Florence for large outdoor sculptural schemes between 1401 and 1434, when such orders ceased. In 1401–2 Florence was fighting a losing war and in danger of invasion by the powerful duke of Milan, but instead of reducing patronage, this seemed to stimulate civic pride. The city regarded itself as a free republic fighting off a military tyrant. The sculpture, ordered for public places by merchant committees, seems to express a similar civic self-consciousness. Most of it was executed by three superb artists, who gave it most of their attention, making few and small works for indoor locations.

Nanni di Banco (docs. 1405–d.1421) first produced a very original if awkward *Isaiah* (1408) for the Cathedral. Like Ghiberti's and Jacopo della Quercia's first works, it mixes an undigested classical quotation with a pleasure in linear sweep, but Nanni, working in the round, carves a harder and denser form into which the folds do not dig tunnels. He is soon mature in the graphic *Saint Luke* (1408–14; fig. 67), one of four over-lifesize Evangelists done for the Cathedral by several artists, to a control of broad characterizing gestures and cleaner classical forms. His next works imitate classical Roman work most literally, but this is obviously a means to the end of massive dignity. Their active poses and light-and-shade arrangements remove any danger of dead copying. All of them are part of another series, commissioned by all the guilds for the shrine church of Or San Michele; each guild was represented by its patron saint. Ghiberti also produced three of these,[25] ranging from a Gothic *John the Baptist* (1412–15), with big scallops of folds, to a classical *Saint Matthew* (1419–22), standing seriously in a thin-textured toga (fig. 68). Like Nanni's *Saint Eligius,* in the same series, it recalls ancient commemorative statues of the Demosthenes type. Nanni's last big work is an *Assumption* relief over a door of the Cathedral (1414–21; fig. 69); its intertwining ropes of drapery follow the twisting actions of the people and have led to the view that Nanni reverted at the end to Gothic. It is more likely that,

like his contemporaries, he had both vocabularies at his command for special purposes, though he is the most classical of them all. His early death has made him less famous than his two rivals in these projects, Ghiberti and Donatello.

Nanni's *Saint Luke* is accompanied by the seated *Saint John the Evangelist* (1408–15; fig. 70) by Donatello (1386 1466), a still younger sculptor's first masterpiece. Completely un-Gothic and monumental in its dignified mass, using the beard to make the head and body blend into a single unit, it is rich with realistic textures in face and hands. The classical pose of *Saint Mark* for the Or San Michele series (begun 1411)[26] provides the saint with autonomy as a freestanding figure, a new achievement in monumental Renaissance sculpture, and the sober power of its detail of surface adds to the conviction of reality without lessening the weight. These first major works of Donatello evoke the basic Florentine mood of Giotto, human, heavy, and dramatic, and suggest that the Gothic and classical borrowings of Ghiberti and others had been useful temporary expedients when a reform was needed. Donatello thus confirms the direction of his friend Brunelleschi's competition relief (see fig. 54), and, since he is pointing the main future direction of the Renaissance, in this sense Brunelleschi won the competition. Donatello celebrates the establishment of this approach in his famous *Saint George,* also for Or San Michele (fig. 71). Rigid in armor, the youth turns his head and stands with feet apart, evoking taut alertness as of a sentinel. Surface lines pull toward focal points, such as the wrinkled eyebrows and the knot of the cloak. They illustrate one of Donatello's favorite and telling schemes, the contrast between surface and core: the former is active and complicated, the latter a simple mass that emerges with the head and is implied everywhere else inside the wrappings.

A variant interplay between the human and the geometric is emphatic in Donatello's first complex relief, the bronze plaque of the *Dance of Salome* for the font of the Siena Baptistery (1423–27; fig. 72). Our eye goes through a series of rooms in a spatial game; the dramatic focus is the head of

67. Nanni di Banco.
St. Luke. 1408–14.
Marble, height 6′9″.
Museo dell'Opera del Duomo, Florence

69. Nanni di Banco.
Assumption of the Virgin,
center portion of tympanum,
Porta della Mandorla. 1414–21.
Marble, height of vertical axis 13′3″.
Cathedral, Florence

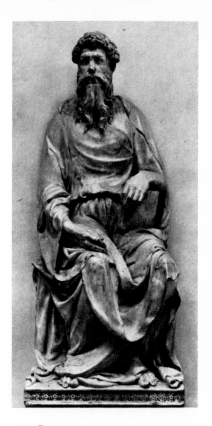

70. Donatello.
St. John the Evangelist. 1408–15.
Marble, height 6′11″.
Museo dell'Opera del Duomo, Florence

68. Lorenzo Ghiberti.
St. Matthew. 1419–22.
Bronze, height 8′10″.
Or San Michele, Florence

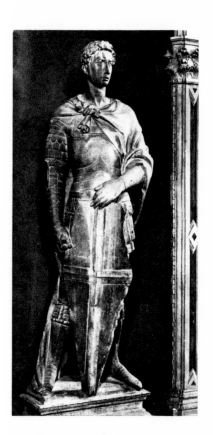

71. Donatello. *St. George.*
Marble, height 6′11″.
Removed from Or San Michele to Museo
Nazionale, Bargello, Florence

the murdered saint, offered by the executioner to his master. From this head, lines of centrifugal force stretch away along the arms and bodies of people trying to move off from the shock. Thus a muscular motion through space, measured by geometry, also measures the force of feelings. Human drama is choreographed in a strict beat. Its technical vehicle is perspective.

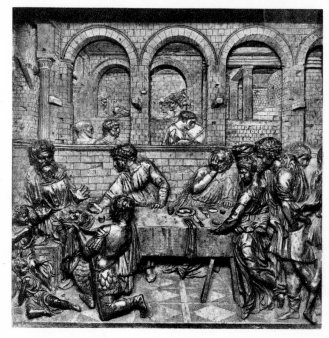

72. DONATELLO. *Dance of Salome*, panel on baptismal font. 1423–27. Gilded bronze, 24″ square. Baptistery, Siena

19. The Later Brunelleschi and Architectural Tradition: the Later Ghiberti

Brunelleschi seems to have invented perspective, in its precise form, almost incidentally, while making drawings in Rome of ancient buildings. It turned out to be useful for painters, allowing them to project their three-dimensional scenes onto two-dimensional surfaces by drawing measurable objects (such as buildings) smaller in proportion as they are to appear farther off. It seemed the height of realism, and a basic tool; to us it seems part of a tendency to treat the world as design, and an early phase of the modern scientific method of quantifying nature. Brunelleschi also invented machines, especially improved hoists useful in his work of building at a height, as well as in staging miracle plays with angels flying (a kind of pageant common at the time, which we more often connect with the Baroque). His inventiveness may be related to his background—not in a craft shop, where skills may tend to be accepted, but as the educated son of a lawyer, almost an amateur. Soon after his traumatic loss of the competition

for the Baptistery doors, he went to work in the Cathedral construction and made himself into an architect, in the process inventing Renaissance style in architecture.

Earlier architecture in Italy is entirely medieval. Taking French Gothic as a standard, it is traditional to see it as a technically inferior variant, and there are indeed many Italian churches that reflect French Gothic more or less competently. But in a few the lessening of Gothic structural virtuosity and demonstrativeness may match a positive growth in a different direction. The great Franciscan churches seem to show this best. The famous oddities of the original shrine church at Assisi (begun 1228; fig. 73) are all perhaps explicable by an assimilation to the qualities of secular or domestic architecture. The church is in two stories, not with any distinction in rank, but to provide for heavy use. Both lack aisles, which is strange in large churches of the time, but they replace the hierarchic

COLORPLATE 9. LORENZO MONACO. *Adoration of the Magi*. Panel, 4′8″ × 5′9″. Uffizi Gallery, Florence

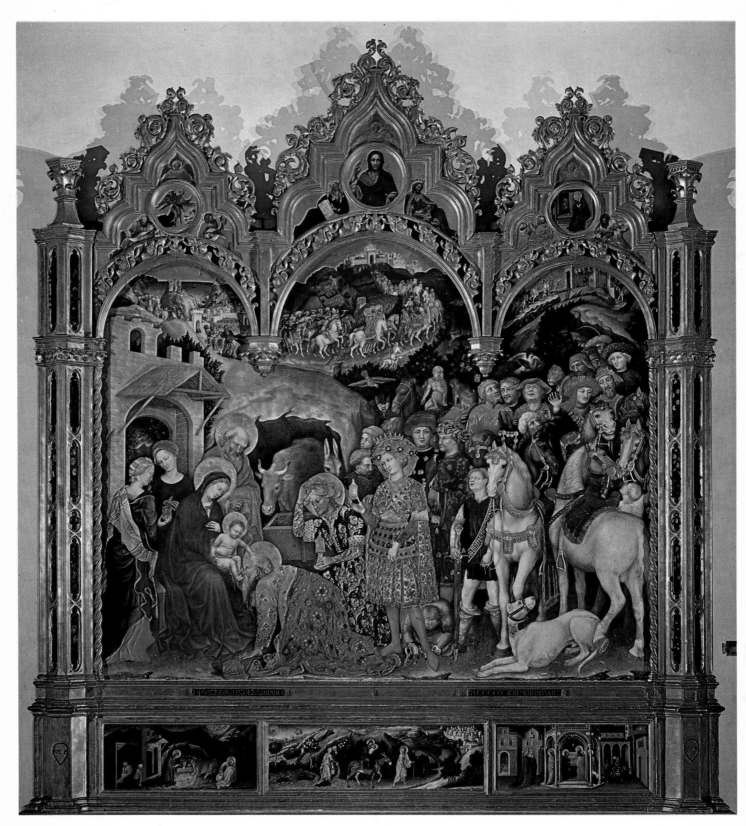

COLORPLATE 10. GENTILE DA FABRIANO. *Adoration of the Magi.* 1423. Panel, 9′10″×9′3″. Uffizi Gallery, Florence

COLORPLATE 11. Masolino.
The Temptation of Adam and Eve.
c.1427. Fresco; 81″×35″
Brancacci Chapel,
Church of the Carmine, Florence

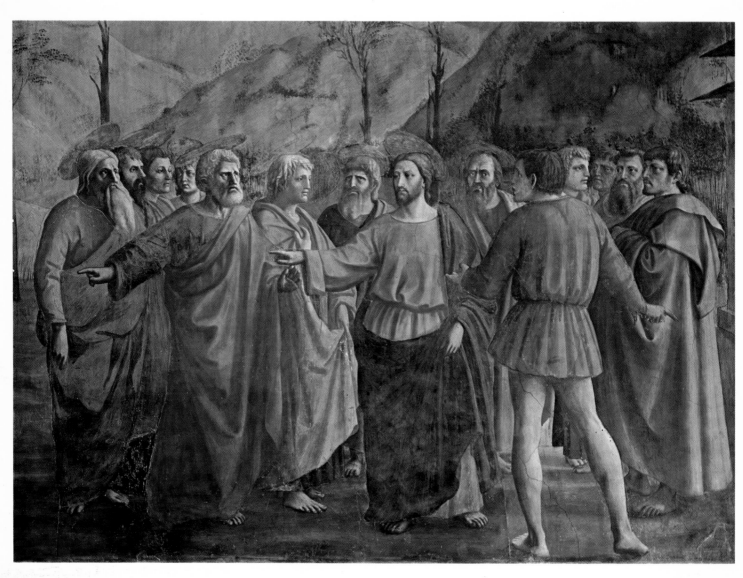

COLORPLATE 12. MASACCIO. *The Tribute Money*. c.1427.
Fresco, 8′4″ × 19′7″. Brancacci Chapel, Church of the Carmine, Florence

73. Section of Upper and Lower Churches,
Basilica of S. Francesco, Assisi.
Begun 1228. Lower Church, height 34'9";
Upper Church, height 61',
width of transept 92'

sense of main and secondary spaces with the sense of a room, as in a dwelling or city hall. The Lower Church soon acquired chapels, which are not secondary parts of the nave space but, again, separated rooms, as in a house, with steps and passages. The nearest analogy to this approach is the Sainte-Chapelle in Paris (1246–48), also with two stories of equal floor area. The Sainte-Chapelle directly betrays a dependence on secular arrangements in the fact that it was built as an annex to a palace, but unlike Assisi it belongs wholeheartedly to the Middle Ages in its typically feudal social distinction between the stories (the lower for servants, the upper for the king), and of course in its pure Gothic look.

A different explanation for the innovation at Assisi, that it develops out of the ordinary tradition of churches with crypts under them, is less attractive, since crypts are regularly meant to contain tombs and are smaller in area, and Assisi possesses just such a crypt as a third and lowest level. Nothing else in Italy in this century is as ambitious as Assisi,

74. Interior, S. Croce, Florence. Begun 1296. Height 101', width 125', length 295'

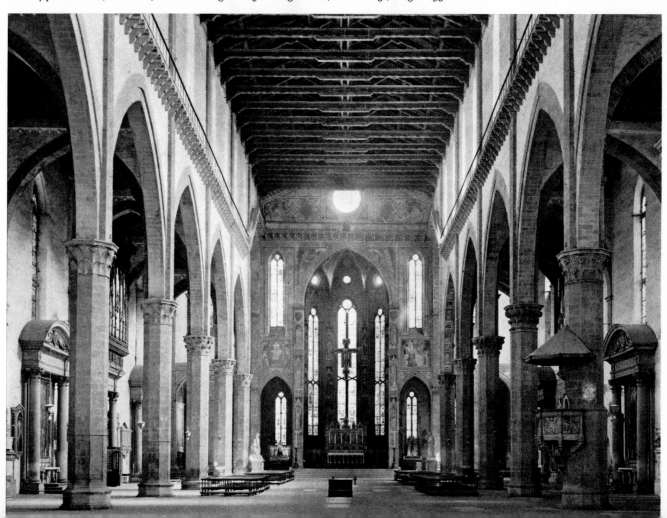

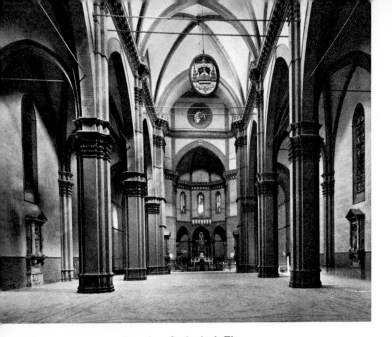

75. Interior, Cathedral, Florence.
Begun 1296 (vaulting begun 1357).
Height 145', width 135'

76. BENCI DI CIONE and SIMONE TALENTI.
Loggia dei Lanzi, Piazza della Signoria,
Florence. 1376–80. 69'10" × 134'6" × 46'

but the Franciscan church in Florence, Santa Croce (begun 1296; fig. 74), has an interior effect dominated by its ceiling of wooden beams. It is unlikely that this signifies humility (the church is richly furnished), or technical incompetence (the Dominicans of Florence had just begun vaulting their large church, Santa Maria Novella); its technical meaning is suggested in the extreme width of the nave it roofs (between narrow aisles) and the related sparse spacing of the nave columns, connected by huge stretching arches. The all-over result is a sense of broad spaciousness. The "barnlike" breadth and the likeness to secular spaces may be paralleled at this date in northern Europe, notably in Gloucester Cathedral.

The late fourteenth century in Florence, so secondary in sculpture and painting, is unexpectedly triumphant in architecture. The Cathedral vault (begun 1357; fig. 75) is as high as that of Amiens, which is famous for its height among the classic Gothic cathedrals; but Florence does not seem so because it is so much wider, again like Santa Croce, with the sense of expansiveness accentuated by the fewness of the supports. Still more brilliant is the Loggia dei Lanzi (1376–80; fig. 76), a ceremonial pavilion off the main city square, one of those creations that has won such popular acceptance that we tend not to think of it in terms of period at all. Here the lift of the columns and their round arches articulate the qualities of a swelling enclosed space already achieved in structure. And at the same time

the Cathedral dome was conceived, as the biggest cup in the world.

While Brunelleschi inherited this attitude to structure and space, he evidently felt a need for qualities of stylish emphasis that such plain constructions did not offer. These he found in the local Romanesque buildings, such as the Baptistery and San Miniato, with their splendid colored marble walls designed in neat square patterns. Thus Brunelleschi brings self-aware and expressive articulation to tendencies that had gradually developed through the simple growth of functions, much like Sullivan's contributions to the pre-existing skyscraper in the nineteeth century.[27] In doing so, he is most original in replacing the earlier builders' freehand treatment of arithmetical ratios with exact measurements, similar to his innovation of precise perspective.

To the Cathedral dome, when he took charge of building it in 1419, he added height, making it noticeably pointed instead of almost hemispherical. And on it he set the white ribs which call attention to and measure its eight sides and the tension of their shape, springy like barrel staves (fig. 77). Such a dome is the best possible focus for a city, as since proved by the imitations from Rome to Washington. Very tall and also round, it has a centripetal force for the people who see it that no tower could match, as was instantly recognized when Alberti in 1436 told Brunelleschi that it could hold all the Tuscan people in its shadow. Again following a partial sug-

gestion from the local Romanesque in Pisa, it is the first dome completely geared to being seen from outside; medieval ones, coated inside with mosaics, were meant to awe the worshiper underneath with an idea of Heaven.

Brunelleschi's porch for the new Foundling Hospital (1419–26; fig. 78) makes each arched unit of its front wall the side of a square covered by a little dome. The same shape is seen also in his first original work to be finished, the Old Sacristy (1420–29; figs. 79, 80) added by the Medici family to their parish church of San Lorenzo. These square spaces, to a person inside them, have a height humanly proportionate to the square dimensions around him. In tnese buildings we are inside a complete comprehensible world; we relate to it rationally, by mathematics. This is a Renaissance experience. It is insisted on by color accents, for lines of columns and arches are darker than the curtain wall areas, and even the floor plan is drawn similarly under us.

In Brunelleschi's earlier works the experience is of lines, planes, and spaces, but not of solid structure, since the series of rational parts is assembled without allowing for the thickness of walls or columns, and the total is therefore irregular. It is the

77. FILIPPO BRUNELLESCHI.
Dome of Cathedral, Florence. 1419–36.
Height from ground 351′

78. FILIPPO BRUNELLESCHI. Hospital of the Innocents, Piazza SS. Annunziata, Florence. 1419–26. Height of porch to first cornice (including steps) 31′; width (including 9 arches and flanking pilasters) 180′

79. FILIPPO BRUNELLESCHI. Old Sacristy,
S. Lorenzo, Florence. 1420–29. 35′ square

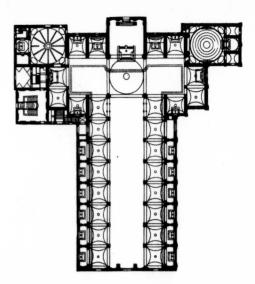

80. FILIPPO BRUNELLESCHI. Plan, S. Lorenzo,
Florence. Width of nave 31′, length
(including choir) 262′.

82. FILIPPO BRUNELLESCHI. Interior,
Pazzi Chapel, S. Croce, Florence. c.1430–46.
Height to cornice 31′

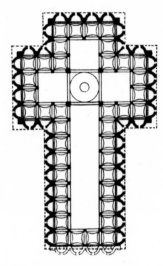

81. FILIPPO BRUNELLESCHI. Projected plan,
S. Spirito, Florence. Begun 1436.
Interior dimensions as built 316′ × 182′

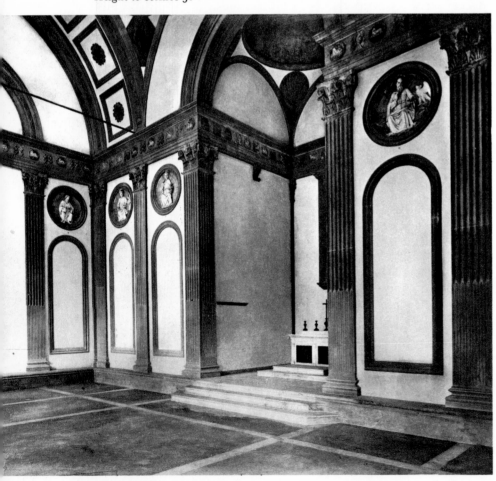

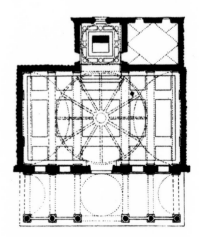

83. FILIPPO BRUNELLESCHI. Plan,
Pazzi Chapel, S. Croce, Florence.
Main area 35′8″ × 59′9″

architecture of a geometric diagram drawn on paper, not of a mason. But later this complexity is also absorbed and indeed celebrated, typically by scooping niches into the thickness of walls and marking their proportion to the other spatial units. The plan of Santo Spirito (begun 1436; fig. 81) is a wide nave, aisles each half that width, and chapel niches each half *that* width, which would have left the exterior as a scalloped wall. The aisles and niches would also have continued around the ends of the church, giving its standard cross shape the effect of a centralized space, one in which the person inside relates to the circumference surrounding him. But this logical formula was too extreme for those who finished building it after Brunelleschi's death. Earlier, the Pazzi Chapel was built as a rectangular room with a three-part ceiling; a dome on a square base is flanked by broad supporting arches (figs. 82, 83). Lines drawn on the floor and wall reflect these three units above, so that the room becomes a square with side rectangles and the measured cube of space seems itself the support of the roof. We are thus satisfied with the rational comprehensibility of our environment and with a sense that the structure is safe, and the result is the harmony of alive calmness often noticed as the visitor's response.

Brunelleschi's old rival Ghiberti, after the success of his Baptistery doors, was given a second identical commission in 1425 and produced what we now call the "Doors of Paradise" (fig. 84). These took another quarter century, so that the two doors filled his life. He discarded the Gothic frames of the scenes, and used only ten large neutral rectangles for his scenes of the Old Testament. The first rectangles contain many incidents each, but then one group becomes the most prominent, and finally only one scene is represented. Ghiberti now uses his great skill in modeling to make spaces, exploiting perspective and very small gradations of relief to design marvelous airy halls where his graceful Gothic people freely dance (fig. 85). His conversion to the Renaissance is late, borrowed, and superimposed on traditional habits, but may have had all the more success, and is a personal and authoritative variant.

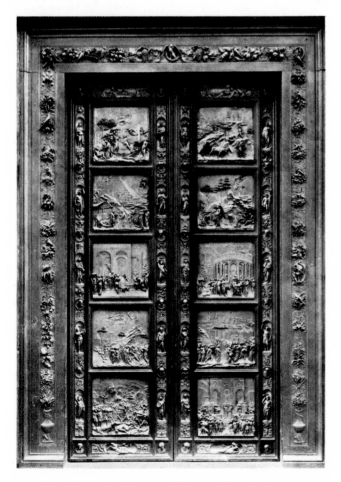

84. LORENZO GHIBERTI. "Doors of Paradise"
(East Doors). 1425–47.
Gilded bronze, 18′6″ × 12′.
Baptistery, Florence

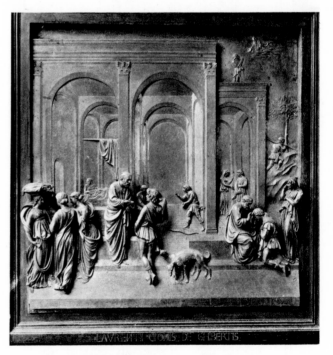

85. LORENZO GHIBERTI. *Story of Jacob*,
panel of "Doors of Paradise."
Gilded bronze, 31″ square. Baptistery,
Florence

20. Masaccio

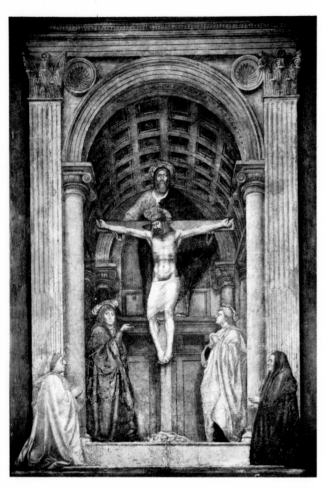

86. MASACCIO. *Trinity*.
Fresco, 21′10″ × 10′5″.
S. Maria Novella, Florence

In 1424, probably, Lorenzo Monaco died, Gentile da Fabriano departed from Florence, and Masolino became the leading painter there. He was also much in demand elsewhere, at the court of Hungary and later in Rome, and so in 1427 he shared one of his Florentine jobs with a bright young man, Masaccio (1401–1428). Masaccio had already been encouraged by the two friends Brunelleschi and Donatello, who rightly saw in him someone talented enough to translate their new methods into painting.

Masaccio's first major work, the *Trinity* fresco in the Dominican church of Santa Maria Novella

(fig. 86), is so dominated by the perspective architecture probably designed for him by Brunelleschi that the figures seem small. The theme combines the image of the three persons of the Trinity with the narrative of the Crucifixion, the figure of Christ functioning twice, in each group, and in that way illustrating the idea of the double nature of Christ as God and man. The artist uses his "realistic" perspective knowledge to subdivide the space in ways that assist this scholastic symbolizing, in parallel to Jan van Eyck's use of *his* favorite realistic motif, the ordinary object, to present symbols (see p. 290). The painting is as diagrammatic as the earlier ones in the same Dominican church by Orcagna, Nardo, and Andrea da Firenze (see p. 46), and is also like them in that Masaccio's other works have no such iconic strictness. Indeed, because people rightly observe that the new style has perspective as its most obvious hallmark and has Masaccio as its greatest painter, this painting of perspective by Masaccio has often been taken to typify the period, without notice that there are no others like it.

The frescoes by Masaccio in the Brancacci Chapel in the Carmelite church (figs. 87, 88; color-plates 11, 12), shared with Masolino, are filled with Donatellian people. They are serious and heavy, with sweeping robes, but also throbbingly warm. The pasty color application, with shifting light areas and almost no line, insists on a physical glow, as if these were all athletes pausing. They tend also to be rough lower-class types, with no other glamour than their bodily presence. They are then set in a limited space, the contained comprehensible world of Brunelleschi. It is bounded by mountains or buildings and never recedes to infinity. Thus we see powerful Donatellian people in a precise Brunelleschian location, which is like a Donatello relief, or like ourselves inside a Brunelleschi building. The perspective, once laid out, is always covered up and its technique not emphasized, so that the space echoes the vigorous human tone. In the famous *Expulsion from Paradise* Adam strides and Eve yells, measured against the gate through which they have been extruded. Our passions and our measuring capacities work on a single surface. The

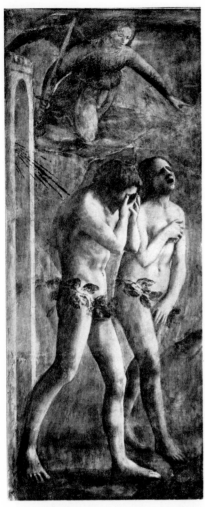

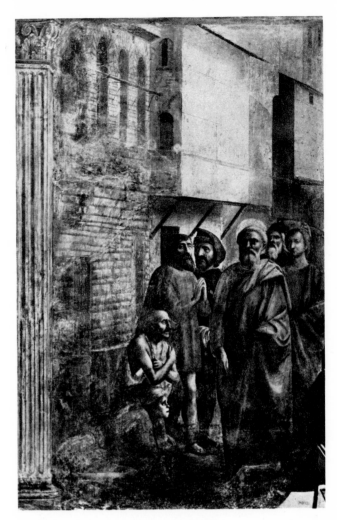

87. MASACCIO. *The Expulsion from Paradise.*
Fresco, 81″ × 35″. Brancacci Chapel,
Church of the Carmine, Florence

88. MASACCIO. *Miracle of the Shadow.*
Fresco, 7′6″ × 5′3″. Brancacci Chapel,
Church of the Carmine, Florence

Miracle of the Shadow carries the same conjunction further. Saints walk forward along a street parallel to its houses, and we read them in terms of the time sequence of walking, from back to front; three crippled beggars are being cured, and we read them instead from front to back as lameness changes into wholeness. Where the forward-moving and backward-moving series pass each other on their parallel tracks, the miracle happens, at the moment of "now." The healing is caused by Saint Peter's shadow falling on the beggars, and this theme of the value of light and shade must have delighted the painter. Thus the men's acts, the perspective, and the theme coincide absolutely. The famous *Tribute Money* (colorplate 12), where Christ orders Peter to get money for the tax collector, is a quieter cluster, a semicircle of figures before mountains, with proportionate spaces. It certainly is affected by a current event, the new system in Florence of assessing taxes (on the clergy, too). In all this Masaccio also pays homage to Giotto, using his intensity of weight and drama. But he is less simple; he elaborates not only spatial mathematics but human anatomy and light. He makes the Florentine Renaissance more vivid and more organized, and when he died at twenty-seven, he had changed painting forever.

21. Fra Angelico, Uccello

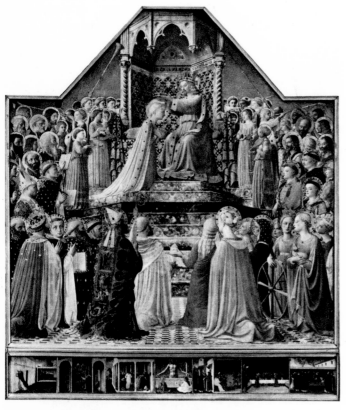

89. FRA ANGELICO. *Coronation of the Virgin.*
Panel, 7′ × 6′11″. The Louvre, Paris

ation. Solid figures sit or stand before an abstract starry sky, as they sometimes do in relief sculpture, and similarly in his *Coronation of the Virgin* (fig. 89) the exact perspective floor runs back and then bends up to Heaven. But there is no such ambiguity in the little stories of the predella below, which have an empirical street space like Masaccio's. Measured and walled depth is first completely controlled in the great *Descent from the Cross* altarpiece (colorplate 13), where cross and ladders are a yardstick of figure action. The density of the smoothly modeled people seems guaranteed by the cohesion of the enamel-like pigment, and their location on the

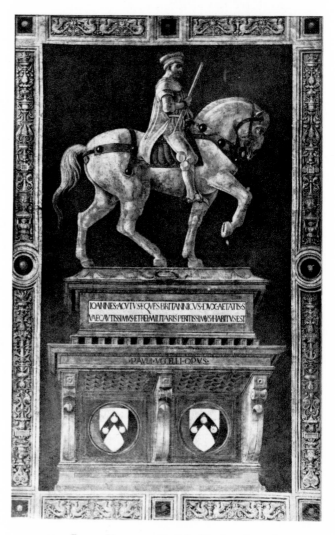

90. PAOLO UCCELLO. *Sir John Hawkwood.* 1436.
Fresco, transferred to canvas, 27′ × 17′.
Cathedral, Florence

The number of great painters in Florence in Masaccio's age group is equaled only by the Paris group of 1870. Among them Fra Angelico (docs. 1417–d.1455) is a victim of doting legend. He has long been regarded as an inspired monk, painting sugary devotional images. Such works exist, and were thought to have been painted in his early unrecorded years. But recent study has moved his birthdate later by about twelve years, so that this early unrecorded period does not exist (the works are by his imitators). He was trained as a painter before he joined the Dominican order. After that he no doubt illustrated manuscripts, learning his bright enamel coloring, but in 1429 he emerged with an altarpiece in Masolino's style;[28] in 1433 the grand altarpiece for the Linen Drapers Guild (for which a very high price was paid)[29] established him as a leader of his gener-

chessboard by its luminousness. He shares their columnar polish with Ghiberti, the other great convert to the Renaissance. Later, recognized as the greatest living painter in Italy, he developed a fuller apparatus of architectural settings with classical symmetry, but he was most influential in this earlier phase.

Paolo Uccello (1397–1475) was full of technical curiosity: about mosaic, which he practiced in his youth, and about animals, which gave him his nickname, the Italian for bird. His most famous curiosity was about perspective, which he kept trying out in difficult special cases in his drawings. In his early frescoed tomb monument of the soldier of fortune Sir John Hawkwood (1436; fig. 90) the meditation on the meaty stride of the horse is more conspicuous than the perspective understructure of the tomb. But, in contrast with Masaccio, it is clear that these things pleased him for their own sake. The fresco of Noah's Flood (colorplate 14) is part of a set of stories

of Genesis, and shows two events in one space (like many works of this time whenever the stories outnumbered the surfaces, as in Ghiberti's "Doors of Paradise"; it was not a matter of special notice). The two here are the flood itself and the exit from the ark. The figures, whom we now see in damaged state, swim and clutch with Donatellian vibrancy, so that there is an acute mix of human and carpentered extremism.

Uccello's battle scene for the Medici family mansion was in three huge sections. These unluckily are now split among three museums (fig. 91),[30] so that we do not see the driving clash of the two cavalry charges from the ends, but only the details of capricious-seeming bright toy horses, armor and spears in a rigid perspective net, and the hill walling in this world. Uccello shares Masaccio's imagery of human crisis in geometric clarity, but has the personal handwriting of one who loves seeing how it is put together.

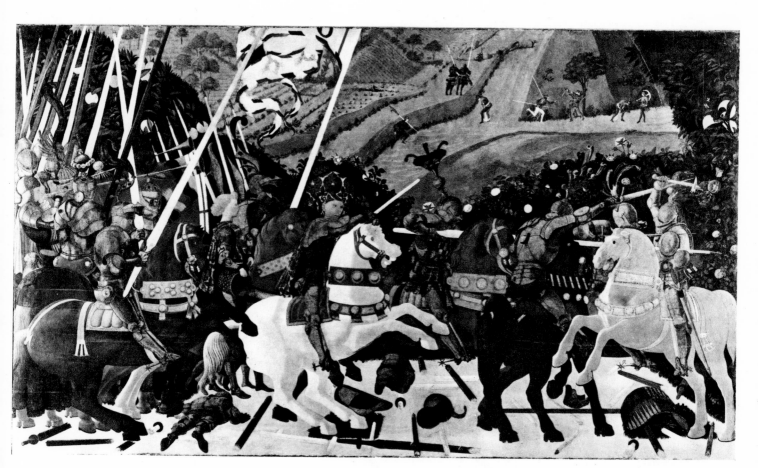

91. PAOLO UCCELLO. *The Battle of San Romano*, center of three panels. 6′ × 10′6″. National Gallery, London

22. Domenico Veneziano, Fra Filippo Lippi

As an immigrant from Venice who saw as an adult the new Florentine art when it had reached its full form, Domenico Veneziano (docs. 1438–d. 1461) not unnaturally evolved a median blend of it. He may have brought from Venice the ideas of Gentile da Fabriano which show up in his *Adoration of the Magi*,[31] with falcons, an enormous peacock, and peacock robes for the courtiers. But even here the hedged fields are rearranged to set up a contained Florentine world. His masterpiece, the Saint Lucy altarpiece (colorplate 15), is a modern rectangular panel like Fra Angelico's later altarpieces, and also like him in the broad lit surfaces that hold the people in place. It surpasses him in unified equilibrium. The translucent cool tones suggest that the people are not only steeped in air but in the particular weather of a sunny spring day. This refinement was to be fascinating to younger painters.

Fra Filippo Lippi (1406–1469) belongs with the Masaccio generation like the last three painters, but is probably the youngest, and also finds the new style already in being. An orphan boy who became a Carmelite monk at fifteen, he watched Masaccio paint in his convent church and reflects him from the start. As soon as he became a full-fledged painter, he left the convent, and later left the order to marry. His concern with the three-dimensional body makes him invent plump articulate people, often in grayish tones, whole paintings being almost neutral in color. He alone comes close to justifying the tag that the Florentine school likes form but not color. His slow painting was also superbly sure in drawing, sharpening the contours to catch gestures and movements. His space accepts the patterns offered to it, at first Fra Angelico's recession that shifts into a flat backdrop, later on symmetrical halls, and always fourteenth-century formulas of rocky landscape. Although he also records obvious symbolic references to an unusual extent, his figure groups communicate a healthy life without intensity of feeling or of paint. His Madonna and Child groups (fig. 92) were, perhaps as a result, much admired in the nineteenth century for their pleasant realism, while today he is less appreciated than his contemporaries. But a close look at a moving figure in one of his agreeably congested crowd scenes will reveal the invention of nonconventional stances which exploit line and modeling for a finely tuned sense of human life in process.

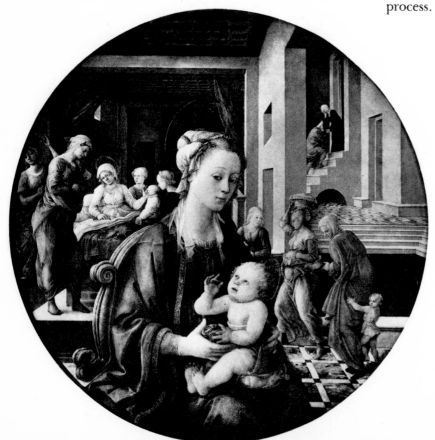

92. FRA FILIPPO LIPPI. *Madonna and Child* (with Birth of the Virgin). 1452.
Panel, diameter 53″. Pitti Palace, Florence

23. The Later Donatello; Luca della Robbia

We have just looked at five remarkable painters born around 1400 (from 1397 to 1406), who succeeded to a generation born around 1380 that was dominated by sculptors (Ghiberti, Brunelleschi, Nanni di Banco, Donatello). The 1400 group produced just one sculptor, Luca della Robbia (1400–1482), whose behavior will only serve to confirm the dominance of painting in his time. The leading sculptor continued to be Donatello. In our modern context of artist-personalities, most successful artists in mid-career do not alter their methods greatly, but the great ones keep changing even into old age; Donatello is the earliest example. After the *Saint George* and other Or San Michele sculptures he produced one more set of big outdoor figures, the prophets for the Bell Tower of Florence Cathedral. They take the contrast between surface and core further (see p. 62). The one famous as *Lo Zuccone* ("Old Pumpkin Head"; fig. 93), because it is such a graphically characterized individual, contrasts the naked skull with the thick soft robe, flung over the shoulder like a too-bulky blanket. The carved surface of *Jeremiah*[32] seems to reproduce a clay sketch that the artist has pulled at with rapid pressures, producing willful rivers of twisted stone. Donatello was also exploring a new kind of relief, so slight in depth that it is more incised than carved, yet creating airy distances; these would seem to imply the stimulus of painting, though the earliest (partial) example, in 1416,[33] precedes any comparable paintings. A set of round stucco reliefs ordered by the Medici for the spandrels of their Old Sacristy (see fig. 79), located overhead at an angle, plays games with illusionary spaces and worm's-eye views as vibrant as his stone masses. These works are typical of the 1430s as small private commissions for reliefs or single moderate-sized statues, the public ones for sets of over-lifesize statues having stopped.

For the Medici he probably also made the bronze *David* (fig. 94), a lifesize boy. Its face is startlingly smooth and symmetrical, perhaps following a trip to Rome where Donatello saw classical remains. With the *David* Donatello seems to break continuity and revert to his earliest work, and

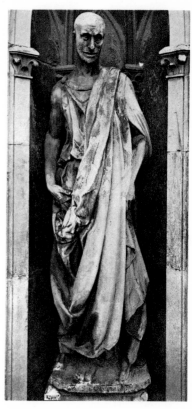

93. DONATELLO. *Prophet ("Lo Zuccone"),* from Bell Tower. Marble, height 6′5″. Museo dell'Opera del Duomo, Florence

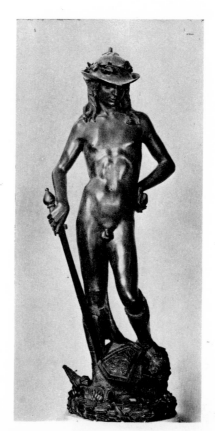

94. DONATELLO. *David.* Bronze, height 62″. Museo Nazionale, Bargello, Florence

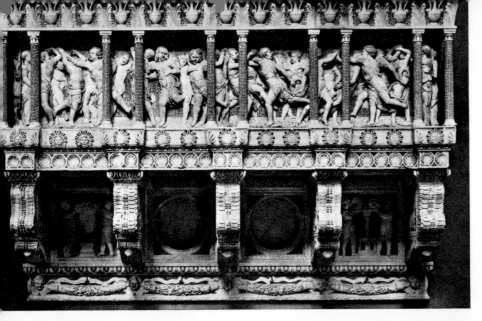

95. DONATELLO. Music Gallery. 1433–39.
Marble, frieze 3′2″ × 18′8″.
Museo dell'Opera del Duomo, Florence

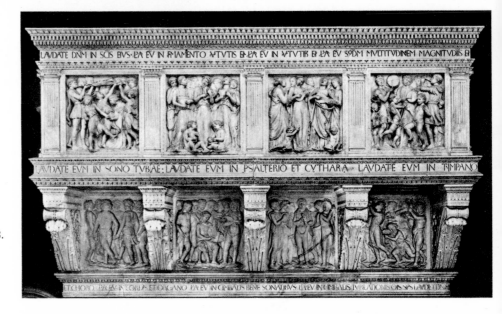

96. LUCA DELLA ROBBIA. Organ Gallery. 1431–38.
Marble, length 17′.
Museo dell'Opera del Duomo, Florence

indeed the second half of his career, after this point, is analogous to his evolution in the first half, from quiet massive forms to more and more active and nervous complexity of surface. Stress affects the *David* only in that the heavy round forms at top and bottom clamp the pneumatic body between them, making the whole a neat ornament. In another of these smaller-scale works, the frieze of dancing children in relief, made for a music gallery in the Cathedral (1433–39; fig. 95), probably to hold an organ, not singers, measures the tossing mass of bodies against the strict meter of columns in front of them.

A matching organ gallery (1431–38; fig. 96) was the first major work of Luca della Robbia (1400–1482), the sculptor who after Masaccio's death seems to have been the young artist most favored by Brunelleschi. Its smooth rounded forms and bland classic equilibrium share and perhaps inaugurate a mood of this moment, seen also in Donatello's *David* and Fra Angelico's *Descent from the Cross* (see colorplate 13). The figures stand in ten groups, each a semicircle making a niche space of gleaming, smoothly turned human columns. It is an expert presentation of the ideal order constructed from human materials, in the simplest of traditional rhythms, clear and self-contained. Yet after this major start Luca was also affected by the end of big sculpture commissions in Florence, and soon turned to his famous invention, "Robbia ware"—glazed pottery in high relief panels on a big scale (color-

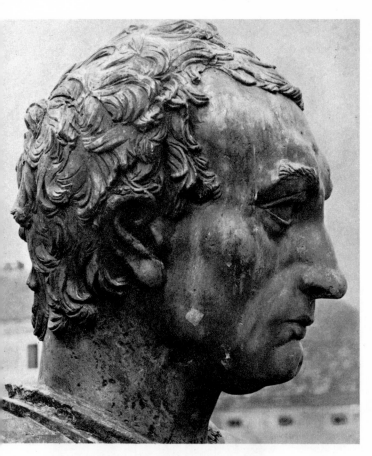

97. DONATELLO. Head of *Gattamelata*, from his equestrian monument. 1447–53. Bronze, height of entire work 17′10″.
Piazza del Santo, Padua

plate 16). It is cheap and indestructible, so that today examples can be found even in modest museums, gleaming with undimmed blue and white. It calls for undetailed forms and provides the clean luminousness that Luca already liked. Dependent less on depth than on color and surface, the medium is more like painting than any other sculpture in history, and later was called painting by Leonardo da Vinci. Thus Luca's career confirms the domination of painting in his generation.

Donatello left Florence for ten years and went to Padua, where a big commission awaited him: the equestrian statue of the general Gattamelata (1447–53; fig. 97). On the massive horse, equally sharp incision marks the rider's rich armor and expressive, humanly worn face. A large altar also in Padua (1447–50) is most notable for four big bronze reliefs of miracles of Saint Anthony, where the incised perspective buildings are worked as thickly as rough-woven cloth (fig. 98). Back in Florence at seventy, Donatello pursued an art now entirely personal, unrelated to trends of the time. The bronze *Judith Killing Holofernes* (fig. 99) presents two figures, stiff as in a starched rough blanket, on

98. DONATELLO. *The Miracle of the Angry Son,* panel on the High Altar. 1447. Bronze, 22 1/2″ × 49″.
S. Antonio, Padua

81

an odd triangular base from which one leg loosely
dangles; a sketchiness and asymmetry used by no
previous artist are its vehicles. The wooden *Magda-
lene*[34] with gilded hair has a similar stiff surface and
torn face, but alludes to the tradition of images for
worship. Most incredible are the pulpits for San
Lorenzo,[35] reliefs whose loose drawing, spatial slic-
ing, and confusion of bodies create a world where
tensions are not allowed to be resolved, the most
private works of Renaissance art.

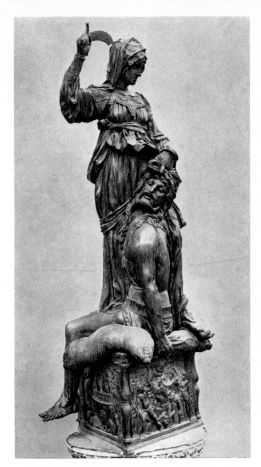

99. DONATELLO. *Judith Killing Holofernes.*
Bronze, height 7′9″. Piazza della Signoria,
Florence

24. Alberti

The Masaccio generation of painters also includes
one great architect, Leon Battista Alberti (1404–
1472), who, however, had a most surprising career
and did not design a building until he was about
forty-five. The Alberti were the richest merchant
family of Florence in the late fourteenth century,
patrons of the largest chapel in Santa Croce, but
had the not unusual experience of being exiled after
a political defeat (as Dante had been). Leon Battista
was born far away, took a law degree, and entered
the papal civil service, also developing interests in
philosophy and Roman literature. In 1434, after
the exile had been repealed, he went to Florence
with the pope, and became a friend of Brunelleschi
and Donatello. In a book on painting,[36] dedicated
to Brunelleschi, he expressed his sense that a new
kind of art had been invented, the first writing about
Renaissance art and one of the few books on an art

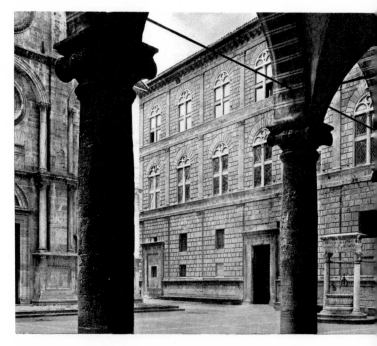

100. BERNARDO ROSSELLINO. Civic Center,
Pienza. Designed 1458.
Width of church façade 66′6″

82

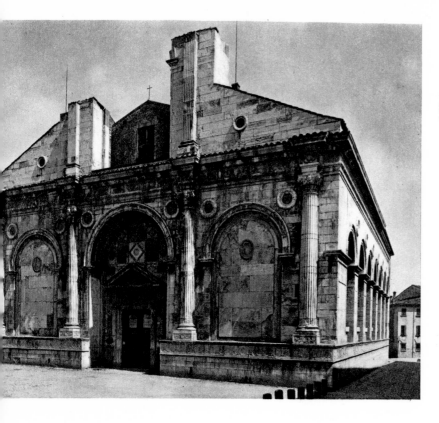

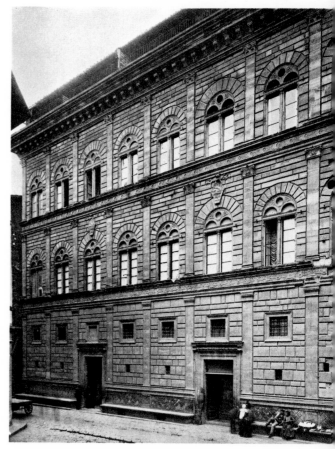

movement in any age by a leading participant. Its first section is a handbook on perspective, today often treated as the most important. Even there it shows a typical shift from medieval books, which emphasize techniques of paint mixing, to a more intellectual approach. But the new art is really "explained" more intimately in the second and third sections, which involve the relation between geometric design and the expression of human drama. A later book by Alberti on architecture [37] uses an ancient Roman one by Vitruvius [38] as its starting point but moves to a concept of an ideal city plan, with monumental isolated buildings on wide squares, beautiful in their balanced proportions. This mood is reflected in papal plans for rehabilitating Rome, and in the surviving small city of Pienza ordered by Pope Pius II (from 1458; fig. 100) from Bernardo Rossellino. Besides an Albertian cathedral and palace, it is remarkable for its self-conscious provision for distant vistas.

About 1446 Alberti began to design buildings for admiring princes, leaving the construction to others, whom he often instructed by correspondence. He was thus protected from blame for faulty execution, and established the modern split between

designer and technician. For the lord of Rimini he designed the exterior of the family burial church, San Francesco, better known by the dynastic name of the Tempio Malatestiano (executed 1450; fig. 101). Wrapping a modern screen around a Gothic interior, Alberti placed on the front the first Renais-

83

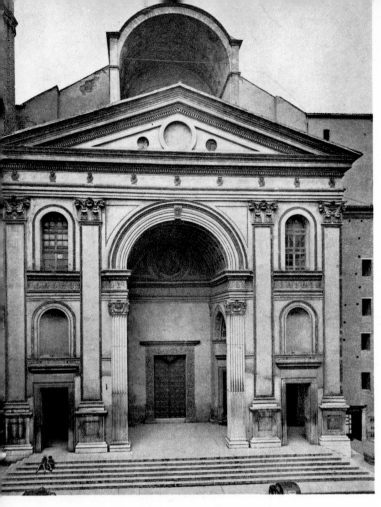

103. LEON BATTISTA ALBERTI. Façade,
S. Andrea, Mantua. Designed 1470.
Height to top of pediment 75′

104. LEON BATTISTA ALBERTI. Plan,
S. Andrea, Mantua.
Width of nave 61′, length 380′

sance church façade, adopting the Roman triumphal arch design of a central arch and two smaller ones, separated by columns. On the side walls a row of arches rests on heavy piers, which Alberti considered the only logical support for them. Both in front and on the sides the thickness of the wall is strongly articulated, a constant in Alberti's work.

Soon he designed Palazzo Rucellai in Florence (fig. 102), one of the earliest Renaissance town houses. Here the distinction between the curtain wall and the post-and-lintel construction of pilasters and cornices is shown only by difference in texture, but it is the essential motif of the design. The curtain wall is conceived of as on a farther plane, but on the narrow street the whole is actually executed as if in a drawing in two dimensions. Since the "curtain" areas between pilasters are largely made up of framed windows, the sense of a skeleton construction is strong. Alberti's last work, Sant'Andrea in Mantua (figs. 103, 104, 105), also ordered by the local marquis, is his richest and most influential state-ment. Indeed, its command of large dramatic units, emphatically pulled toward the center, made it a favorite object of quotation in the Baroque period. The front porch is treated as if it were a very thick wall, cut into by a colossal three-story arch contrasting with smaller openings at the sides, all again articulated with a post-and-lintel skeleton. The scale contrast is repeated inside, where the big arch reappears repeatedly on the side walls of the nave as entrances to the chapels. There are no aisles. The interior space is thus centralized again, driven down the nave tunnel along the rhythmic arcade to the domed choir. Because the big outer and inner arches are identical in height, the roof heights cannot match, a problem not resolved in the design or execution. Thus the incomplete blend of idea and realization is traceable. Yet Alberti, the only Renaissance architect before Palladio who works primarily with exteriors (see pp. 235–36), shows in his constant emphasis on wall thickness his awareness of the task of articulating the construction.

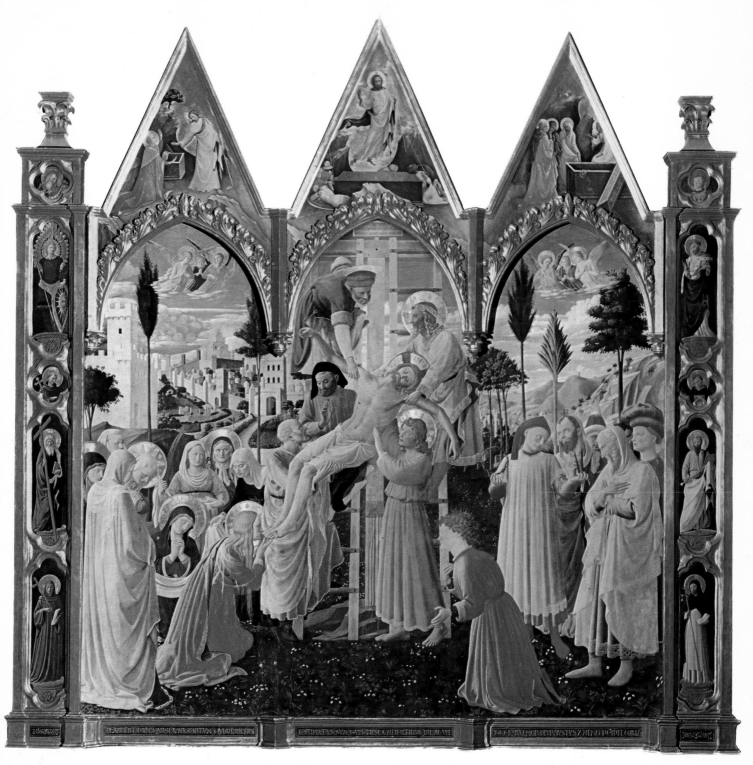

COLORPLATE 13. FRA ANGELICO. *The Descent from the Cross*. c.1432–40. Panel, 9′ × 9′4″. Museo di San Marco, Florence

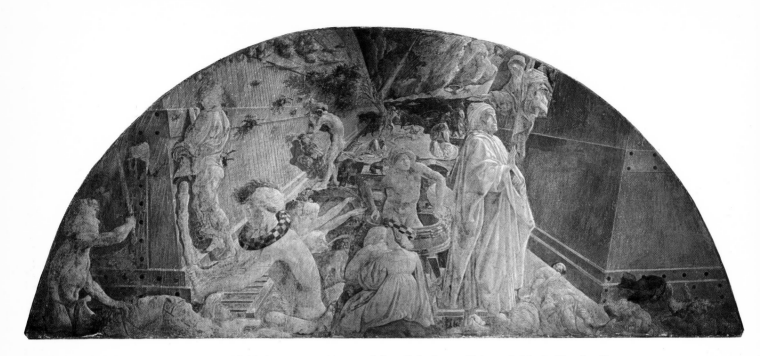

COLORPLATE 14. PAOLO UCCELLO. *The Deluge.* c. 1450. Fresco, 7′1″ × 16′9″. Green Cloister, S. Maria Novella, Florence

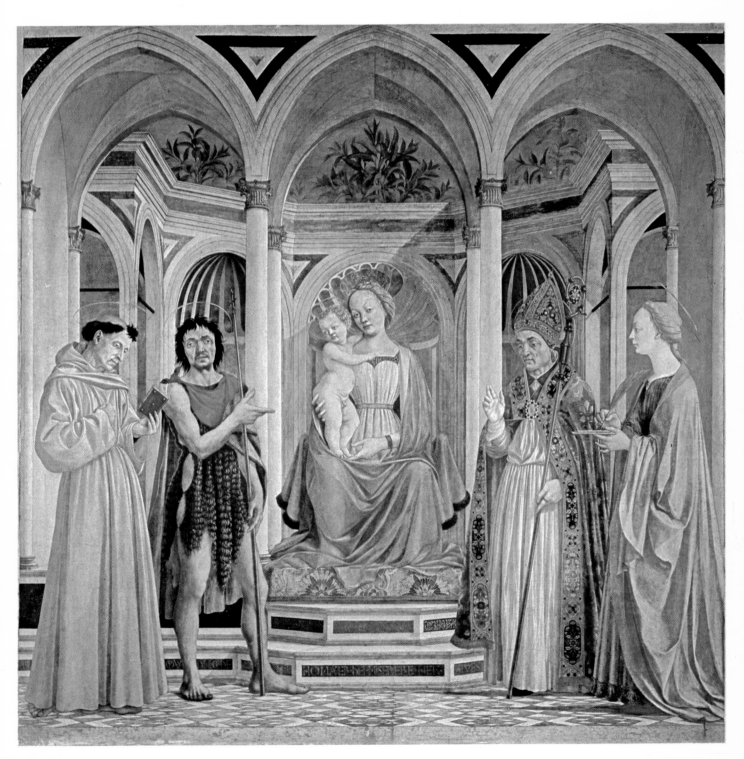

COLORPLATE 15. DOMENICO VENEZIANO. St. Lucy Altarpiece. c.1445. Panel, 6′10″ × 7′. Uffizi Gallery, Florence

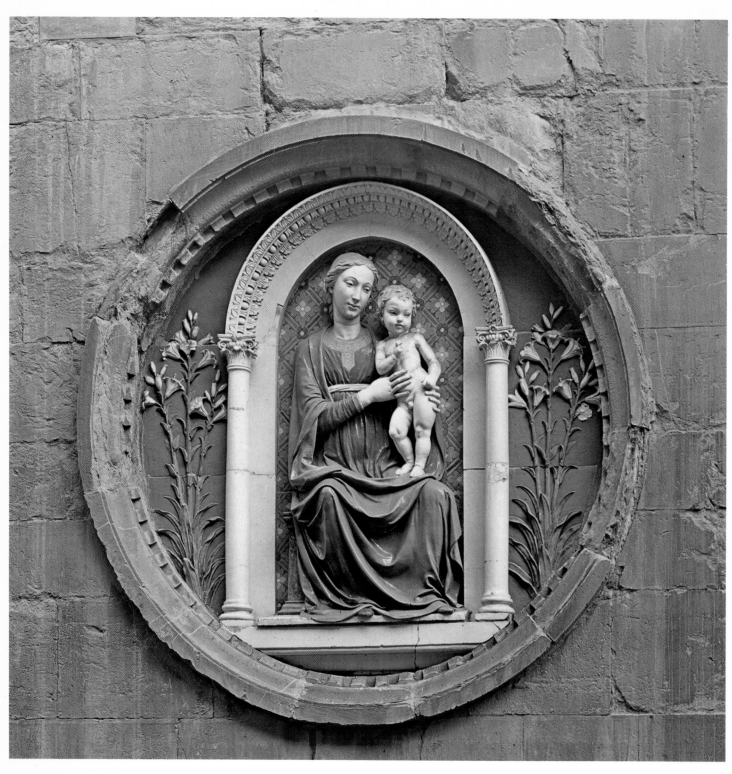

COLORPLATE 16. Luca della Robbia. *The Madonna, Patron of the Doctors' Guild.*
c.1440–50. Glazed terracotta, diameter 71″. Or San Michele, Florence

105. LEON BATTISTA ALBERTI. Interior, S. Andrea, Mantua. Height of nave 92′

25. Castagno, Pollaiuolo

Between 1397 and 1406, as we have seen, five remarkable Florentine painters were born, as well as one pictorial sculptor and one late-blooming architect. By chance, no other important painters were born until 1421, making a contrast of generations easy (just as with the sculptors born around 1380). The painters of the decade 1397–1406 presented man's activity and his environment in equipoise. Through perspective, the cosmos is seen walling the people about, but not dominating them. There is a parallel to the Stoic philosophy expressed by Alberti, that man cannot change fate and bad fortune but can use his mind to understand and discount them, so that they cannot defeat his essential nature either.

This formula of geometric balance between form and space yields, in the next generation, to an emphasis on the figure. Castagno (1421–1457) and his close successors make man dominant over space. Their learned skill in perspective is employed to lessen the role of the environment. Figures stand before either a flat wall, or a blank paint surface or the open sky, and they often elbow out toward us from niches not big enough for them or stand on a hill that drops down behind to a tiny distant panorama, all relationships avoided by the preceding generation.

The set of nine famous men and women frescoed in a country villa (fig. 106), a modern variation on the "nine worthies" of medieval halls,[39] illustrates this vividly. The figures here are three Florentine soldier-statesmen of the recent past, three Florentine writers (Dante, Boccaccio, and Petrarch), and three famous women. They differ in tone—the

soldiers do most of the elbowing forward—but are chiefly single sculptural presences, as hard as the marble slabs behind them and influenced by Donatello's niche statues. Castagno's later painted tomb of a general in the Cathedral (1456)[40] typically modifies Uccello's earlier fresco (see fig. 90) by eliminating the perspective construction and introducing two muscular pages. His greatest work, the *Last Supper* for a convent refectory (colorplate 17), wraps the statuesque figures in a perspective room, and so, unlike the others, appears to retain the approach of the previous generation of painters. But in fact it embodies an unresolved contradiction between two systems of space, one for the figures and one for the architecture. The figural space sets just one man at each end of the table, with room perhaps for a second, and ten behind the table, and thus is very wide and shallow; the room measurements have a much greater depth, exactly half the width, as proved by the cloth hangings and the molding that runs under the ceiling. The space we accept is the one asserted by the figures, so that this fresco, like Castagno's other works, does illustrate domination by figures over a minor environment. And the men are sculptures, tough like Masaccio figures, exuding impact through their density of color and stoniness.

The next brilliant painter to emerge, Antonio del Pollaiuolo (1431–1498), is an actual sculptor, so it is not strange that he has a quite similar approach to painted figures. They are not stony but suggest metal, his own favored medium in sculpture. Athletic heroes are recurrent: David, the Florentine symbol of resistance;[41] the martyred Saint Sebastian;[42] and especially Hercules, painted for the Medici town house (1460). Hercules (figs. 107, 108) fights and wins in shining anatomical precision of line, high above exact landscapes that rush back in low perspective. This new space, which does not enclose the figure but leaves it all the more statuesquely isolated above the world, seems typically Renaissance, but emerges for this purpose only about 1460, utilizing Flemish procedures. Pollaiuolo's anatomical skill was much admired, and he probably engraved his *Battle of Ten Naked Men* (fig. 109) as an aid to artists, showing ten variations on the body in action, again before a shallow, flat backdrop. It is his only engraving, and the earliest in Italy by any distinguished painter or sculptor. Pollaiuolo worked in a great variety of media, including designs for embroidery (from 1466) and a silver panel to be inserted in a fourteenth-century altar.[43] Only in these "minor art" contexts does he design perspective spaces in the geometric manner of his predecessors, and may thus suggest that it seemed old-fashioned to him.

106. ANDREA DEL CASTAGNO. *Nine Famous Men and Women* (portion), frieze from Villa Carducci, Legnaia.
Fresco, each section 8' × 5'3". Cenacolo di S. Apollonia, Florence

107. ANTONIO DEL POLLAIUOLO.
Hercules and the Hydra. Panel, 7″ × 5″.
Uffizi Gallery, Florence

108. ANTONIO DEL POLLAIUOLO.
Hercules and Antaeus. Panel, 6″ × 4″.
Uffizi Gallery, Florence

109. ANTONIO DEL POLLAIUOLO. *Battle of Ten Naked Men*. Engraving, 15″ × 23″. The Metropolitan Museum of Art, New York. Purchase 1917, Joseph Pulitzer Bequest

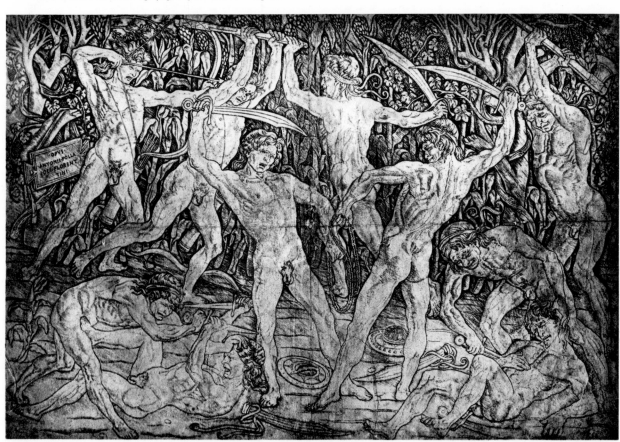

26. Trends in Florentine Painting at Mid-century

Old-fashioned painters survived alongside the modern movement, with its "realism" of perspective. The late fourteenth-century tradition persists in such painters as Bicci di Lorenzo (docs. 1416–d.1452), and Lorenzo Monaco's Gothic persists more richly, as in outdoor frescoes in the Cathedral square (1445–46).[44] But the modern art was favored by critical comment and the most important patrons. This is thoroughly illustrated by the reaction of the remarkable archbishop Antonino, who was the only saint of Renaissance Florence, the first theorist of mercantile capitalism, and a close adviser to the Medici. He attacked the International Gothic style of Gentile da Fabriano as a frivolous distraction from the holy events depicted, and asked for naturalism and simplicity in painting, a set of qualities best matched in his environment by Masaccio. This is connected with Antonino's idea of what was later called "natural religion," the ancestor of Deism; he was opposed to the concept of religion as irrational and super-sensuous, shared by medieval scholastics and modern agnostics alike. His view that the empirical world supports faith can also be linked to the fact that the pioneers of the Renaissance in Florence produce mainly religious works, while secular work of the time tends to be old-fashioned and Gothic, contrary to a familiar formula about the close relations of humanism and the Renaissance. The modern masters of Florence produce secular works in more than minute amounts only after about 1450.

At mid-century the most impressive old-

110. BENOZZO GOZZOLI. *Procession of the Magi.* 1459. Fresco, width about 25′. East wall of chapel, Palazzo Medici, Florence

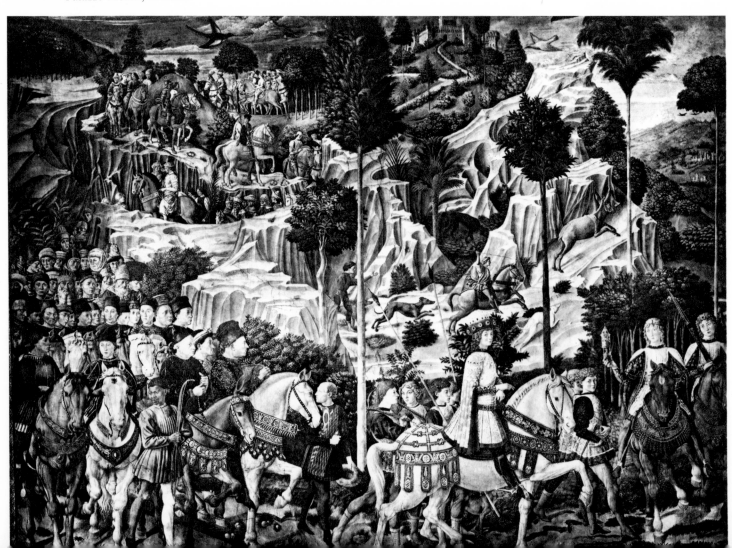

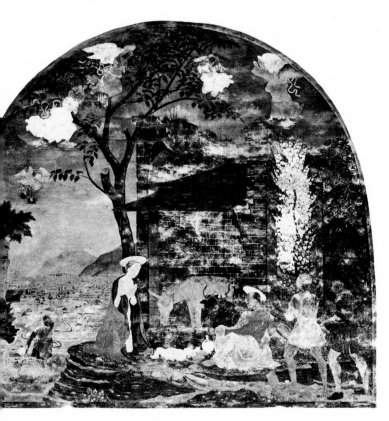

111. ALESSO BALDOVINETTI.
Adoration of the Shepherds. 1460–62.
Fresco, dimensions within border 13′4″ × 14′.
SS. Annunziata, Florence

fashioned painting is the *Procession of the Magi* (1459; fig. 110) frescoed by Benozzo Gozzoli (1420–1497) on the walls of the private chapel of the Medici mansion. This favorite theme of International Gothic is treated once again as a delightful cavalcade with golden ornament. At its two ends many portraits are tucked in, suggesting more interest in the modern Flemish preference for real particulars than in the metrical order of Masaccio and Castagno. But at the same date Fra Filippo Lippi, too, was

inserting portraits at the edges of big frescoed scenes, and the two artists are also alike in keeping old-fashioned landscape conventions, with scooped cliffs. Thus Benozzo, who had worked for years as an assistant to Ghiberti and Fra Angelico, operates at the more old-fashioned end of the available range of styles, in a work for Florence's greatest secular patron. He is also happy to copy a king's horse literally from Gentile, and today the work's Gentile-like luxury and anecdote have won it a tourist popularity, but it was evidently not a success with patrons since Benozzo never got another order in the city. He spent the rest of his long life in Pisa and even smaller provincial towns, where he carefully signed himself "Benozzo of Florence."

In Masaccio's revolutionary generation every painter was either a modern innovator or old-fashioned, but in Castagno's there are halfway imitators of the two modern generations. Pesellino (1422–1457) derives from Filippo Lippi, and also reflects Domenico Veneziano, in small, beautifully drawn scenes of clear, luminous action. The early work of Alesso Baldovinetti (1425–1499) reflects very beautifully the translucent volumes of Domenico Veneziano's figures, but puts them in the new spaces of Pollaiuolo, building up forms against the sky above superb sweeps of low landscape (fig. 111). Later he explores the shallow space patterns too, but at the end of his life fades into becoming a repairer of mosaics. Pesellino retains the older spatial equipoise, but since he has always been understood as an artist of second rank, he is not an exception to the trend of his generation by which equipoise gives way to the dominant figure. It is true that his work has helped to keep alive a general impression that perspective space interested Florentine painters throughout the fifteenth century, rather than a particular generation.

27. Trends in Florentine Sculpture at Mid-century

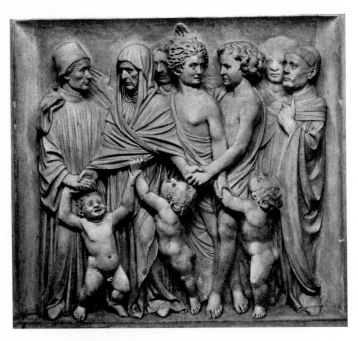

112. MICHELOZZO MICHELOZZI.
Bartolommeo Aragazzi Bidding Farewell to His Family,
from tomb of Bartolommeo Aragazzi. 1438.
Marble, 30″ × 29″ (without restored side frames).
Cathedral, Montepulciano

If, instead of scanning one sculptor's whole career and then another's, as is usual, we looked at them all in the decade of the 1440s, we would notice a drop in sculpture in Florence. Donatello, after thirty years at work, went away for a decade, yet that did not bring commissions to others. Luca della Robbia left work unfinished and turned to his ceramic production. Michelozzo (soon to be noticed) turned almost entirely from sculpture to architecture, and the most promising youth, Agostino di Duccio, emigrated. Even a faithful hack, Bernardo Ciuffagni, constantly busy earlier, suddenly vanishes from all records. Thus almost no sculpture was done in Florence; in the 1450s, there was a revival, but without any of the large-scale projects typical of 1401–34. This seems to be related to the greatest political change in a century, the shift of power in 1434 from the guild committees to Cosimo de' Medici. At once no desire was felt for outdoor monuments, expressive of community consciousness, of

the type of Ghiberti's two Baptistery doors and the sets of statues for Or San Michele, the Bell Tower, and the Cathedral. Some of the older projects were finished off, others stopped. Then about 1450 we see new sculptural types which emphasize private ownership, indoor location, sophisticated collecting, and celebration of the individual: the portrait bust, the small bronze, and a greater role for tombs. Style has a parallel change.

Michelozzo (1396–1472) worked for years as assistant or junior partner to various of his contemporaries, especially Donatello. He made his mark with the tomb of the papal secretary Aragazzi, in Montepulciano (finished 1438; fig. 112). It is more literally classical than other work of that date, even Luca della Robbia's, in the airless juxtaposition of cylindrical people. It also makes its subject archaeological, apparently reflecting the patron's scholarly interests. It may be noted that, consistent with the preponderance of nonsecular work at the time, humanists and modern artists had rather slight contact. A successful humanist might order a tomb, and both groups shared a curiosity about Roman sculpture, but neither group was much involved with the other's chief concerns. It seems typical that when humanists praise an artist in their writings (showing that they could), it is not a modern Florentine, but Pisanello.

Agostino di Duccio (1418–1481), in reliefs for churches in Rimini and Perugia, created a strange flat style, with drapery swirling around hard bodies in curved parallel lines. It is not a Gothic line, and its first appearance in a learned archaeological context (fig. 113), decorating the church in Rimini for which Alberti designed the exterior (see fig. 101), suggests that it was meant as a variant type of Roman imitation, reflecting the ornament we know on neo-Attic vases and Arretine pottery.

When young sculptors again emerge in Florence, they seem interested in isolated vehement figures, like those in Castagno's paintings, but often diluted by a pleasure in rich, polished ornamentation. Pollaiuolo's bronzes, the most brilliant work of the time, will be considered separately (see p. 113).

113. AGOSTINO DI DUCCIO. *Saturn.*
Marble, 54 1/2″ × 36 1/2″.
Chapel of the Planets, S. Francesco, Rimini

115. DESIDERIO DA SETTIGNANO. *Angel*, from
the Tabernacle of the Sacrament. 1461.
Marble, height 36″. S. Lorenzo, Florence

114. BERNARDO ROSSELLINO. *Effigy*, on tomb of
Leonardo Bruni (d. 1444). Marble, width 10′4″.
S. Croce, Florence

Bernardo Rossellino (1409–1464), also active as an
architect under the wing of Alberti, is inspired in
sculpture by Michelozzo. His greatest pleasure
seems to be in refined moldings and frames, of the
kind now generally regarded as "typical Renais-
sance." His shapes for doors and especially for tab-
ernacles to hold the sacrament were very influential.
His chief work was the tomb of Leonardo Bruni
(d. 1444; fig. 114), conceived as a wall tabernacle
with delicate ornamental figures but focusing on
the sensitive portrait. If it was produced soon after
the death of Bruni, the chancellor of the Florentine
republic, it would be the most ambitious work of
the decade, but it may well have been delayed, like
most tombs.

Desiderio da Settignano's (docs. 1453–d. 1464)
chief works are still another tabernacle for the sac-

95

Bernardo's youngest brother, Antonio Rossellino (1427–1479), swings between suave Madonna reliefs, many times repeated in low relief by imitators, and tough portrait busts of old men that allude to ancient Roman types. His Castagno-like *Saint Sebastian* (fig. 116), a hard body in expressive spiral motion, seems surprising after the delicate Madonnas, but makes it less surprising that his most monumental tomb, for a Portuguese cardinal-prince who died in Florence,[46] lacks his brother's decorative boxed unity and splits visually into its various forceful statues. A similar doubleness is striking in Mino da Fiesole (1429–1484), who is most famous for smiling cherubs and for tombs of almost two-dimensional delicacy but who also produced the first examples of the portrait bust, such as the *Piero de' Medici* (1453; fig. 117), with rocky jaws and brutal realism. The unity of tone among all these carvers tells us that the Florentine Renaissance was now an established institution.

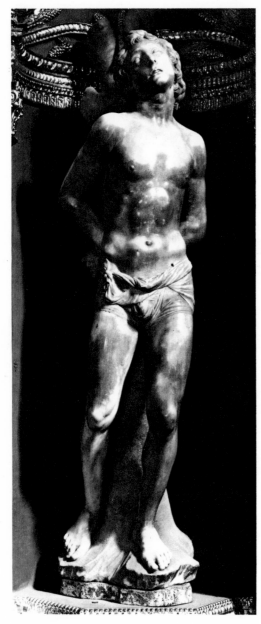

116. Antonio Rossellino. *St. Sebastian*, from altar dossal. Marble, height c. 56″.
Galleria della Collegiata, Empoli

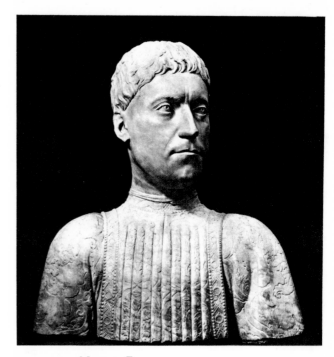

117. Mino da Fiesole.
Piero de' Medici. 1453.
Marble, height 18″.
Museo Nazionale, Bargello, Florence

rament (fig. 115), and the tomb of Carlo Marsuppini,[45] the next chancellor of the republic, both accepting the formulas of Bernardo. In his time he was labeled "lovely and sweet," but his grace is not so much in decoration as in the treatment of the figure, immensely refined and civilized. Under the thin smiles and alabaster glow of his heads of women and children there are tougher skulls than photographs suggest, and his angels lift their heads with fresh excitement.

28. Michelozzo and Florentine Architecture

The small sculptures and the secular paintings of
1450 adorn a new kind of building, the palazzo.
The word need not mean palace, but town house,
mansion, or, in other contexts, just building. A
Renaissance visual type for dwellings is first seen in
the 1440s, a quarter-century later than churches
and public buildings. The three pioneer examples
are Alberti's Palazzo Rucellai (see fig. 102), the
Palazzo Pitti (1458), which seems less inventive—
though its later enlargement and royal use (see p.
233) perhaps encouraged a tradition that Brunel-
leschi had designed it—and Palazzo Medici by
Michelozzo (probably begun 1444; fig. 118). Mi-
chelozzo was Cosimo de' Medici's favorite builder,
constructing his country retreats and the churches
he endowed. A project by Brunelleschi for the town
house was rejected by Cosimo as too pretentious,
according to a report, yet it may be reflected in the
finished version, Michelozzo's one masterpiece, a
complete structure in contrast to the annexes and
remodeling that generally occupied him. Its sud-
den appearance, mature in the first example of the
building type, may also suggest that it is simply the
natural way to transform the older Florentine house,
which was tall and narrow, often with shops on the
street floor. Palazzo Medici eliminates the shops
and is wider, and thus can create a squarish balance
of width and height. We are invited to read the
qualities of each story through changes in texture—
the rough stone blocks at the bottom, as of a fortress,
the cut squares in the middle, the completely smooth
top—a lightening that suggests lessened weight and
receding perspective. The whole is then framed at
the far end of the eye's upward journey by the grand
cornice, defining the building as a unit and prevent-
ing it from floating against the sky. Although the
removal of the shops assists the analogies between
the three stories, the corner of the ground floor was
used for a public porch, later filled in. It all seemed
a classic formulation, using essential Renaissance
axioms easily.

Yet Michelozzo's later major work at Santissima
Annunziata (1444–55; fig. 119) shows none of this
empirical quality. He remodeled the interior, and

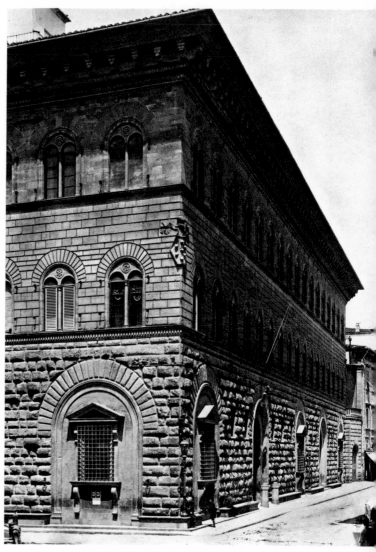

118. MICHELOZZO MICHELOZZI. Exterior,
Palazzo Medici, Florence. Begun 1444.
Height 80′6″

added a square colonnaded court in front, a circular
domed choir at the other end (executed later with
changes), and some other annexes. These spatially
self-conscious innovations, based on concepts about
ancient Roman building, were attacked as impracti-
cal for the church services because the opening from
the main nave into the round choir was too narrow.
It seems ironic that the necessary practical adjust-
ments were provided by Alberti, the architect whom

97

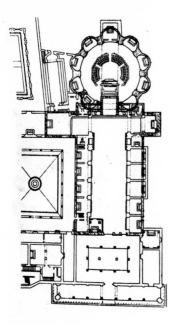

we think of as a theorist in contrast to the builder Michelozzo. In fact the two architects shared the same classicism and excitement about centrally planned spaces, which may thus be regarded as dominant in the mood of the time. After Michelozzo left Florence in 1455 under attacks on his skill, the trends of the following years there are less clear, and only about 1475 does another strong personal style emerge.

119. Michelozzo Michelozzi. Plan, SS. Annunziata, Florence. Remodeling begun 1444. Total length 314', width of nave 26'

29. Sienese Painting in the Early Fifteenth Century

Siena was by now a backwater with a glorious past. Its own painters seemed pleased to repeat tradition, though interested in suggestions from Florence. The most talented, Sassetta (docs. from 1423–d. 1450), was rediscovered in the late nineteenth century and much liked as an "available primitive" of the Fra Angelico type, medieval enough to suggest high-minded purity but modern enough to be comfortably realistic (fig. 120). His suavely incised line and his pleasure in elaborate deep spaces identify him readily as Sienese, but the absence of any immediate ancestry has disturbed critical treatments of him. When some of the more poster-like paintings related to him were recognized as the work of imitators, he was tied closely to modern Florence, especially Fra Angelico. But his simply modeled doll-like smiling people, moving on errands of goodness through wide bright spaces, are better associated with a slightly earlier moment in Florence, with Ghiberti (who visited Siena in Sassetta's youth). From him Sassetta learned to place smoothly tubular bodies, with precise folds, in well-constructed

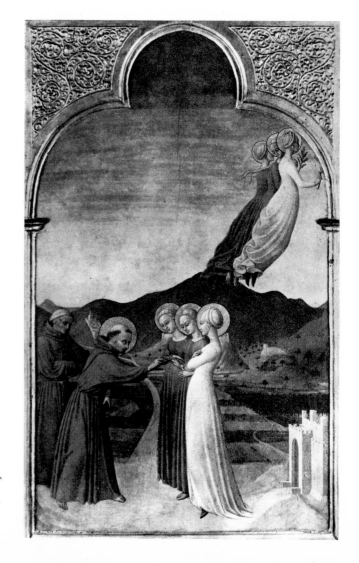

120. Sassetta. *St. Francis Meeting Poverty, Chastity, and Obedience,* from an altarpiece. Panel, 34" × 21". Musée Condé, Chantilly

98

little buildings. It was a natural attachment, since Ghiberti admired the great Sienese of the past. Sassetta only loses a little of Ghiberti's bodily flexibility, and adds a sensitive color harmony implying fresh air.

More truly Gothic and primitive, Giovanni di Paolo (docs. 1423–1482) adapts Sassetta's patterns with a repetitive stylization as of folk-art schemas (fig. 121). Very tall thin people, with incised contours and incised renderings of the veins in their hands, walk through perspective fields where the parallel hedges are incised. The peasant reduction of a sophisticated source is clear, and its iconic abstraction has a special appeal to part of twentieth-century taste.

Two other painters looked at newer Florentine devices than did Sassetta, though with less sureness of instinct. Domenico di Bartolo's (docs. 1428–1444) realism of facial details and anecdotes of costumed crowds seem a response to Gentile da Fabriano's visit to Siena, and show the younger generation's capacity to modernize Gentile with organized space and cool harmonies of color much as Domenico Veneziano does. The boldest, even desperate, effort to jump into the Renaissance is made by Vecchietta (docs. 1428–d. 1480), who insisted on richly modeled figures steeped in changing light to the point of strained caricature. Unlike any of the rest, he did much work away from Siena, and eventually solved the problem by turning to sculpture. Indeed Michelozzo, who was at work nearby when Vecchietta was in his teens, seems to have been the stimulus for his painting style, to judge from the stiff but exaggeratedly active figure types. Vecchietta's abortive revolution in painting and his very handsome Donatellian bronzes of later years usher into the city an art that is satisfactorily Renaissance but no longer Sienese in the traditional sense in which the term is the name of a style.

121. GIOVANNI DI PAOLO. *St. John in the Wilderness.* Panel, 27″ × 14″.
Art Institute, Chicago.
Mr. and Mrs. Martin A. Ryerson Collection

30. Piero della Francesca

122. PIERO DELLA FRANCESCA. *Resurrection.*
Fresco, 8′2″ × 6′7″. Pinacoteca, Sansepolcro

tomb, and little or no interest in perspective. Piero was already a prominent local citizen, and soon was receiving job offers from lords and churches of that area and even beyond. His most famous work, the fresco cycle of the *Legend of the Wood of the Cross,* was begun in this same energetic vein for the main chapel of the Franciscan church in Arezzo (fig. 123; colorplate 18). The theme was old-fashioned, typical of these provincial commissions, based on the medieval stories that had grown up around the relics of wood from the cross in the churches of Europe. The account starts with Adam's death, and shows us striding and mourning people, anatomically sophisticated and passionately dramatic, strung out on the shallow stage. They also have the smooth translucency and exact placing in the air that had been so important to Domenico Veneziano.

But at this point Piero's work seems to have been interrupted by a visit to Rome (1458–59) and exposure to Alberti's ideas about city planning, with their sense for clear geometric space measurements. This may have triggered in Piero something that has no literal precedent, and is a new aspect

123. PIERO DELLA FRANCESCA. *Death of Adam,* group at right. Fresco, entire work 12′9″ × 24′5″. S. Francesco, Arezzo

Working in Florence as an assistant to Domenico Veneziano, the young painter Piero della Francesca (docs. 1439–d. 1492) evidently participated in the invention of the new style of the muscular figure along with Castagno, the most talented Florentine of his own age. Such at least is one of the ways of reconstructing his beginnings, after which, we know, he returned to his small native town of Sansepolcro, in the hills between Arezzo and Perugia. On this view his first major work is the *Resurrection* for the local city hall (fig. 122), which indeed Castagno seems to have echoed in a work of about 1447.[47] Piero's fresco is a masterpiece of this style, with the bony and drooping flesh of the large-eyed figure rigidly looming over the flat marble slabs of the

of Renaissance painting. In the rest of the frescoes of the Arezzo series, starting with the famous *Queen of Sheba* scene, and then in the *Baptism* altarpiece and the small *Flagellation* (figs. 124, 125), the translucent figures turn into remote, expressionless counters in a pure geometric world. They stand with the fixity of columns, alive only in the intensity of their form and light. Perspective became so important that Piero wrote a book about it, the first after Alberti's.[48] This art has appealed to the same modern taste that developed in connection with Cézanne and Seurat.

In later years Piero relaxes to the point of being interested in particular things, portraits, and textures, especially shining ones like jewels and water; the double portrait of the count and countess of Urbino[49] shows all these concerns. His research attitude toward light also led him to a nocturnal fresco in the Arezzo series, the *Dream of Constantine,* which is a drama of optical abstraction. Piero's elegant control of the adjustments of proportion between areas, in scale and color, is very much of the Renaissance, but his temporary abandonment of human expressiveness is not, and is what makes him most effective today. His intense cultivation of pure forms may be connected with his retiring from his Florentine training to his remote little town. Other artists of great talent with a similar experience (for example, El Greco, Georges de la Tour, and Cézanne) have tended to rely less and less on a link to nature and more and more on reworking their own stylistic patterns, and all of these emerged from obscurity to fame during the early twentieth century.

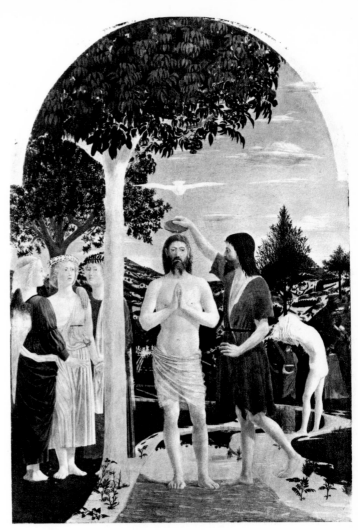

124. PIERO DELLA FRANCESCA. *Baptism.* Panel, 66″ × 45″. National Gallery, London

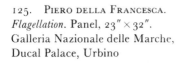

125. PIERO DELLA FRANCESCA. *Flagellation.* Panel, 23″ × 32″. Galleria Nazionale delle Marche, Ducal Palace, Urbino

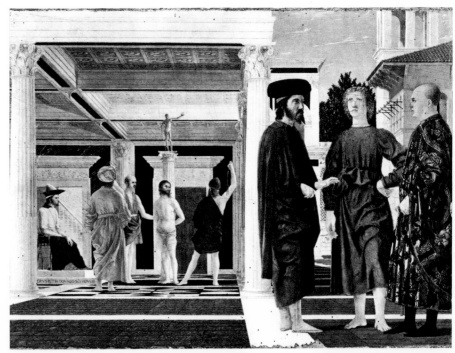

31. Pisanello and Jacopo Bellini

The version of International Gothic that Gentile da Fabriano took from Venice to Florence in 1423 was assimilated as part of a recent Gothic revival in Florence, but in Venice it was a subtle amendment of the established Gothic past; very little done there earlier could be related to the Renaissance. The other north Italian towns with their feudal courts (Milan, Verona, Ferrara) also favored a Gothic vocabulary, generally in the vein of Simone Martini; their masterpiece was the tomb of Can Grande della Scala (see fig. 53). As in Florence, Gothic seems to have taken two visual forms. One is an art of ornamental rhythmic line like Lorenzo Monaco's, and Stefano da Zevio (docs. 1425–1438) in Verona is the most polished painter in this style. The other, like Gentile da Fabriano's, makes patterns not from line but from beautiful real objects; both are equally decorative and luxurious. A notable new vehicle in this context is artists' notebooks of drawings, made common at this date because parchment was giving way to cheaper paper. The earliest of interest, still on parchment, is by Giovannino de' Grassi (docs. 1389–d. 1398), a Milanese who has only left this book,[50] one sculpture, and some manuscript illuminations. Like others, his sketchbook emphasizes costumes and animals, including exotic ones—monkeys, greyhounds, and leopards. No such note-

books survive from Florence at this time; they were evidently kept when treated as mines for repeating ornamental motifs, not as memoranda of artists' observations.

From this emerges one great master, Pisanello (docs. 1422–d. 1455). His earliest work, a fresco of the *Annunciation* in Verona (1423–24),[51] is in the "Lorenzo Monaco" vein, but soon the influence of Gentile da Fabriano transforms him. His masterpiece in painting is the fresco of *Saint George Rescuing the Princess* (fig. 126). Tales of chivalry are typical pleasures of this culture, to be seen here and in Malory's *Morte d'Arthur*,[52] dreams of feudalism as it had never been imagined to be during the actual feudal age. The princess in her ermine and the knight in his chased armor are less notable than the horses in their trappings, which provide another example of the real decorative object, but one whose sweaty gravity seems the more imposing. And Pisanello's drawings (many now assembled in a notebook[53]) are also keener than Giovannino de' Grassi's in being quick sketches, not standard motifs to be traced. Their success has hidden their quality, as many duller imitations were soon mixed in with his originals. What is probably a typical early drawing (though sometimes thought to be by another artist) is the *Allegory of Lust*,[54] a nude girl in an

126. ANTONIO PISANELLO.
St. George Rescuing the Princess.
Fresco, 19'6" × 10'8".
Museo Civico, Verona

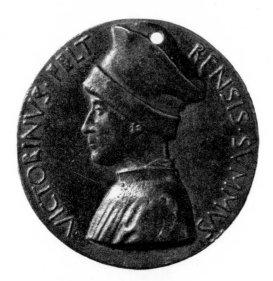

127. ANTONIO PISANELLO.
Medal of Vittorino da Feltre
Bronze, diameter 2 5/8″.
National Gallery of Art, Washington, D.C.
Samuel H. Kress Collection

128. ANTONIO PISANELLO.
Medal of King Alfonso of Naples, reverse.
Bronze, diameter 4 1/4″.
National Gallery of Art, Washington, D.C.

elaborate peacock-like hairdo, sprawling on bony hips; the reform of the courtly formula by the unconventional direct vision is typical of Pisanello. He works within existing formulas but sharpens them; he is one of the great nonrevolutionary artists, but a reforming one.

His most surprising novelty is the reinvention of the bronze medal, of which he remains to this day the one complete master. His medals are not die-cut and stamped (like coins) but cast, so that they are small sculptures (figs. 127, 128). They are repeatable portraits, at first luxurious favors that lords could hand out, like autographed photographs today, yet soon including the poor man but respected teacher Vittorino da Feltre, and other scholars. The backs show pictorial mottoes, chosen by the subjects but freely worked out by Pisanello. One for the king of Naples, with a nude leaping on a boar and a greyhound beside it, shows how in the new medium courtly motifs could still be made to come alive. As these medals mark the individualism of the sitters, they also mark the artist's; the usual signature, *Opus Pisani Pictoris,* must take a larger proportion of the surface than signatures on any other works of art.

Venice in the fourteenth century had been politically part of the Balkans more than of Italy and had produced Byzantine painters while receiving visiting Gothic ones from north Italy. Late in the century its own painters were Gothic, too, but

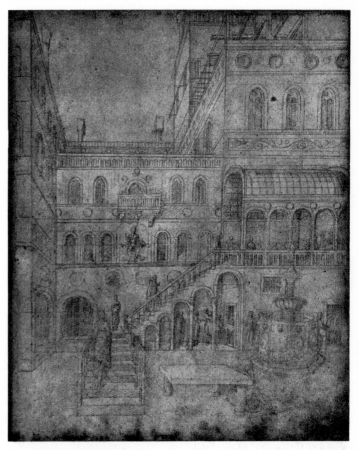

129. JACOPO BELLINI.
The Beheading of John the Baptist,
right half. Pencil, 16″ × 13″.
British Museum, London

103

around 1420, as the city turned its interests to the control of the nearby mainland, Venetian painting finally entered the Renaissance. When Gentile da Fabriano went from there to Florence, he took along his Venetian assistant Jacopo Bellini (docs. 1424–d. 1470). There is a notable analogy in the works of Jacopo Bellini, Masolino (the Florentine whose work changed under Gentile's impact), and the Sienese Domenico di Bartolo: all depend on Gentile for their soft shadowed modeling, but throw away the accompanying courtly apparatus and replace it with excitement about perspective. In all of them perspective tends to be more luxuriant than systematic, producing colonnades to infinity and nests of spiderweb arches. Jacopo's version leans on the

structures Altichiero had painted in Padua (see fig. 52). His paintings are largely lost, and we know him, again, mainly from notebooks of drawings,[55] which stretch the perspective experiments to the point of reshaping subject matter (fig. 129). He will draw the figures of an event small and at one side, magnifying the scale of the building and making the flow of space the heart of the effect, a genuine visual innovation which sets a great Venetian tradition going. When it appears in landscape, it hints at independent flowing of air and light. This may have been explicit in his paintings, if we may infer from the latest of several surviving small Madonnas,[56] which replaces contours with gently subdued tonalism.

32. Mantegna

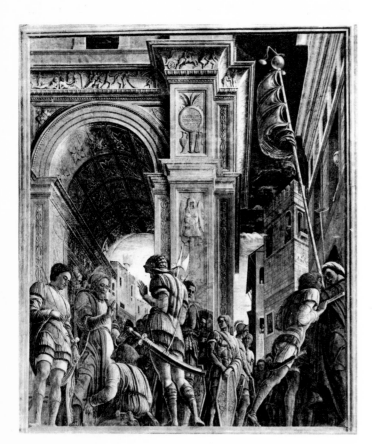

130. ANDREA MANTEGNA. *St. James Led to Execution.* Fresco (destroyed), 11′11″ × 10′10″, including borders. Ovetari Chapel, Church of the Eremitani, Padua

Jacopo Bellini founded Venetian Renaissance painting in the literal sense, through his family. His daughter married Andrea Mantegna (1431–1506), the phenomenon who at eighteen was beginning to produce his first masterpiece, the Ovetari Chapel frescoes, nearby in his native Padua (begun 1448). He had naturally been much attracted to Donatello's Padua reliefs (see fig. 98), whose emphasis on incised drawing and space construction was easily translatable into painting. He renders not only the sharp contours of the keyed-up people, but an equally fine network of gauzy threads in their blueprinted environment, neatly factual and detailed. His future father-in-law stimulated Mantegna's hobby of the archaeological recording of ruins (as did his local teacher), but more important, he affected Mantegna's sense of space. In the later parts of the Ovetari Chapel, Mantegna adjusts the perspective to the viewer's position on the floor below and makes people project forward from the picture plane, erasing the line between the picture space and our space (fig. 130). This is contrary to the usual Florentine postulate that perspective sets up a balanced, self-contained cosmos in the picture, a packaged totality. Its sources are some slighter but suggestive experiments by Donatello and Jacopo Bellini with a contin-

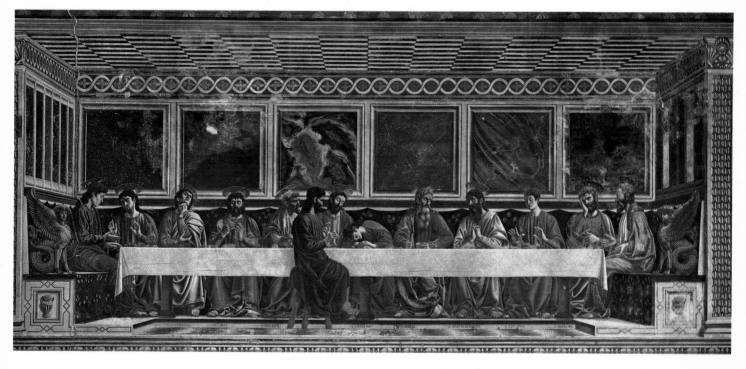

COLORPLATE 17. ANDREA DEL CASTAGNO. *Last Supper*. c.1450. Fresco, 13′9″ × 31′6″. Cenacolo di S. Apollonia, Florence

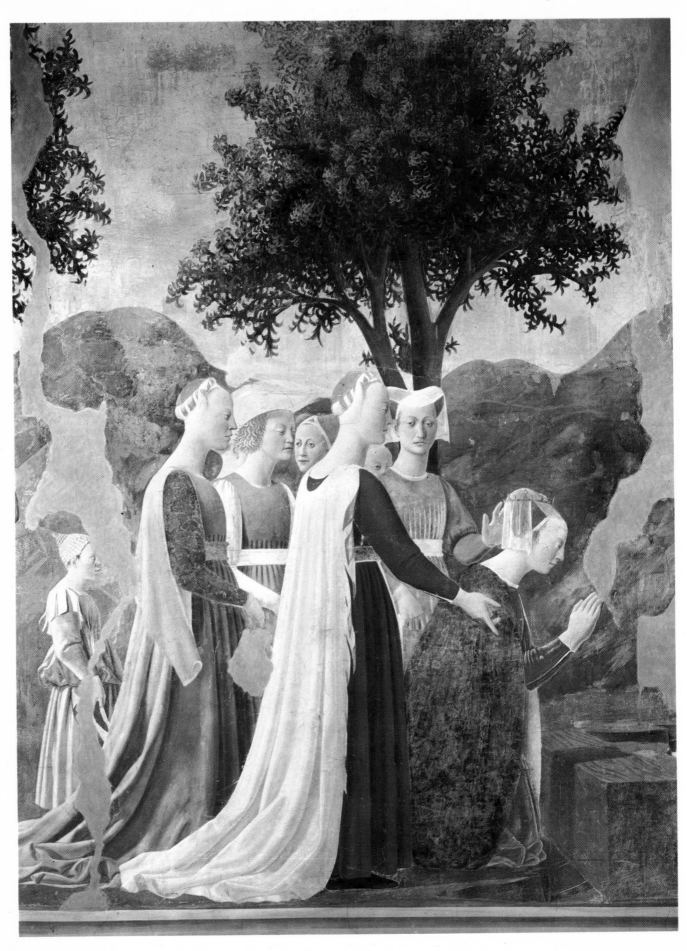

COLORPLATE 18. PIERO DELLA FRANCESCA. *Story of the Queen of Sheba* (detail of group at left). c.1460.
Fresco, 10′11″ × 24′5″ (entire scene). S. Francesco, Arezzo

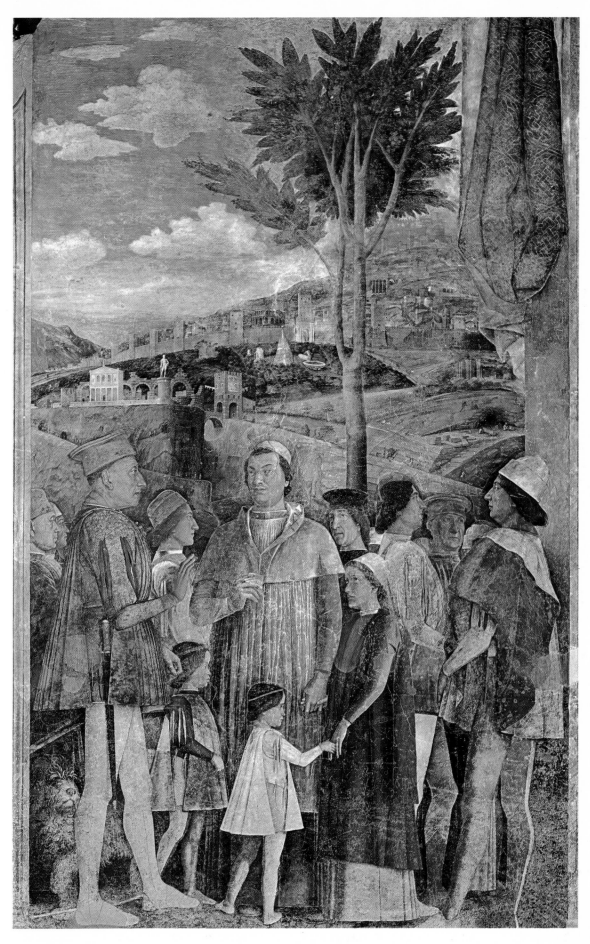

COLORPLATE 19. MANTEGNA. *Return to Rome of Cardinal Gonzaga.* 1474. Fresco, width 7′7″.
Camera degli Sposi, Ducal Palace, Mantua

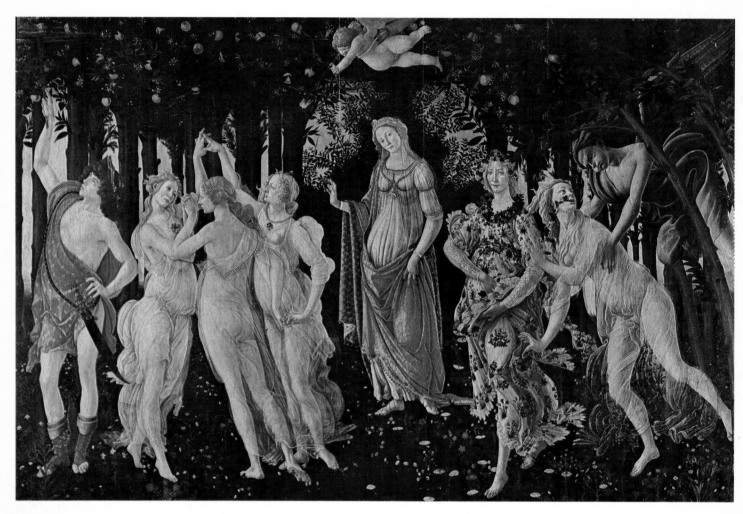

COLORPLATE 20. SANDRO BOTTICELLI. *Spring*. c.1478. Panel, 6′8″ × 10′4″. Uffiizi Gallery, Florence

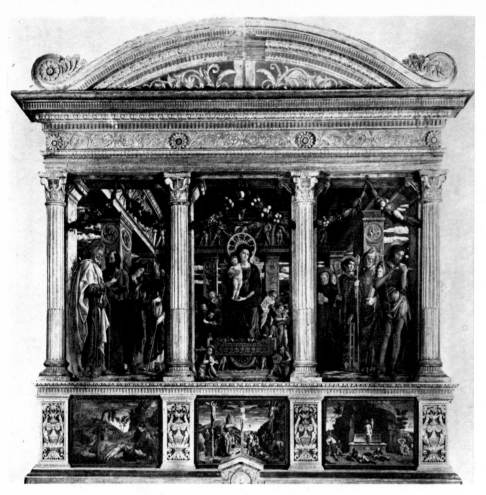

131. ANDREA MANTEGNA.
Enthroned Madonna with Saints,
San Zeno Triptych. 1457–59.
Each panel 86″ × 45″.
S. Zeno, Verona (originals of
predella panels in Musée des
Beaux-Arts, Tours, and The Louvre,
Paris)

uum of space in which people are minor incidents. When Mantegna opens up the sky behind the stage too, the effect is that of a line of vision from our eye becoming intense in the segment of drama and then reverting to lower intensity as it continues to infinity. The single continuity of space inside and outside the painting is basic to Venetian Renaissance art as it evolves in Giorgione and Titian.

Mantegna, who is nothing if not a constant experimenter, develops this idiom in his great San Zeno triptych of the Madonna and Saints (fig. 131). The figures are inside a roofless porch. Its front columns are the carved frame of the altarpiece (as, long ago, in Pietro Lorenzetti; see fig. 40), which thus push in front of the picture plane and are also reciprocal with the far piers that take us into the open blue. In another experiment, in one of the predella scenes originally beneath, the ground drops down toward us at the front, marked by foreground figures far enough below the rest so that we only see them from the waist up. They look into the scene, becoming an equivalent for ourselves; such predella panels are naturally a critical point for contact with the observer. The most famous of these experiments is the foreshortened *Dead Christ* (fig. 132), where the rationally yet violently distorted

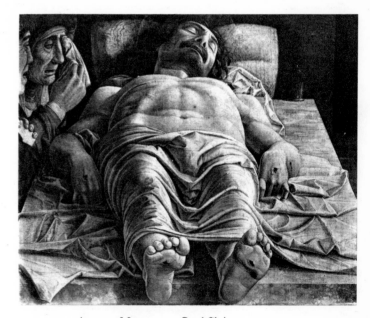

132. ANDREA MANTEGNA. *Dead Christ*.
Canvas, 27″ × 32″. Brera, Milan

image is used to assert the shock of tragedy, and the projectile effect of the feet involves us.

The marquis of Mantua, who needed to adorn his court not merely with art but with a celebrated artist (reflecting the emerging role of the artist as personality and entrepreneur), induced Mantegna to be his painter with a large salary which Mantegna used to build a mansion to his own learned design. His masterpiece for the marquis' palace is a fresco cycle all around one room, showing the marquis and his family in ceremonial activities (finished 1474; fig. 133, colorplate 19). Since the room was no doubt used for the same sorts of ceremonies, the uniform flow of reality from viewer into picture is evoked in a further and startling way. Again people with massively realistic faces step in front of the picture plane established by the framing pilasters. But the most famous spatial trick is the ceiling: Mantegna opened up a view of the sky, with people (some mythological cupids, some the marquis' Negro servants) looking down at us as we look up (fig. 134). It is another logical but spectacular extension of

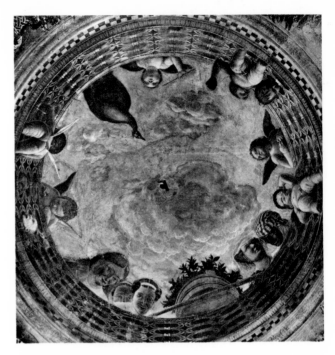

134. Andrea Mantegna. Ceiling,
Camera degli Sposi. 1474. Fresco, diameter 60″.
Ducal Palace, Mantua

133. Andrea Mantegna. *The Duke of Mantua and His Court.* 1474. Fresco, entire wall 19′8″ × 26′5″.
Camera degli Sposi, Ducal Palace, Mantua

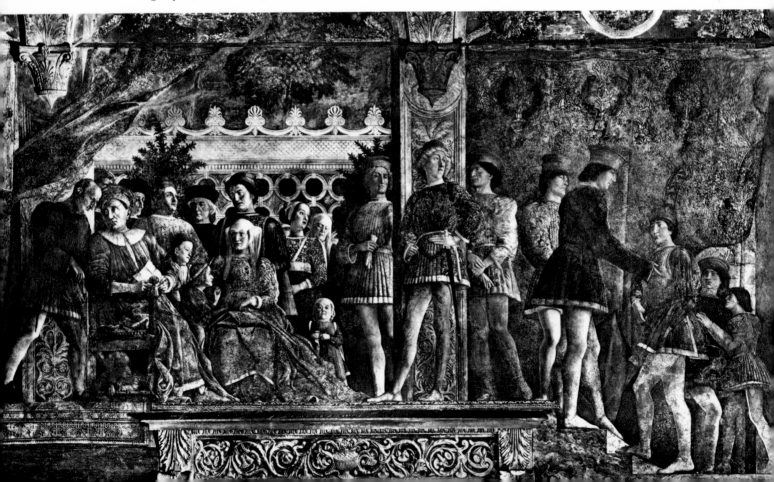

the space through the stage segment, letting the eye continue on a straight line to infinity. Here and in his later work Mantegna damped his linear constructions with broader modeling (e.g., in the *Parnassus,* 1497,[57] for the study of the young marchioness Isabella), with gentler landscape and easier motion. He circulated some of his compositions as well as his mastery of incisive drawing in engravings, which were the finest by any artist in Italy. They kept his fame alive when most fifteenth-century art had become ignored (e.g., in a utilization by Rembrandt).

33. Ferrara

The dukes of Ferrara were great importers of artists: in the 1440s they had Alberti, Pisanello, Jacopo Bellini, and Piero della Francesca, in 1450 Rogier van der Weyden. But then by luck a local school emerged, producing a series of three brilliant painters who again begin by responding to Donatello's work in Padua nearby; the connection was eased no doubt by Niccolò Baroncelli, a bronze sculptor and pupil of Donatello's who lived in Ferrara from 1443 until his death in 1453. Cosimo Tura (docs. 1430–d. 1495) is chiefly a painter of single figures, sometimes a court allegory but often a saint. Their reality comes from his brilliant imitation of burnished metal, bent in fanciful intricacy, not only in robes but in gesturing arms and turning heads (fig. 135). Donatello literally strained and tortured the metal in his late *Judith* (see fig. 99), implying psychological stress in the figure; the fact that it is metal which is contorted makes the tension a permanent condition, and thus an irretrievable fate. Tura, like other provincial imitators of subtle urban creations (e.g., Giovanni di Paolo, with whom Tura shares a fashion today), rigidifies such pulling forces into decorative pattern and line and, characteristically, does not vary them during a forty-year career. The ultimate effect, far more sophisticated indeed than Giovanni di Paolo's, is of a shining filigree of twining glittering forms.

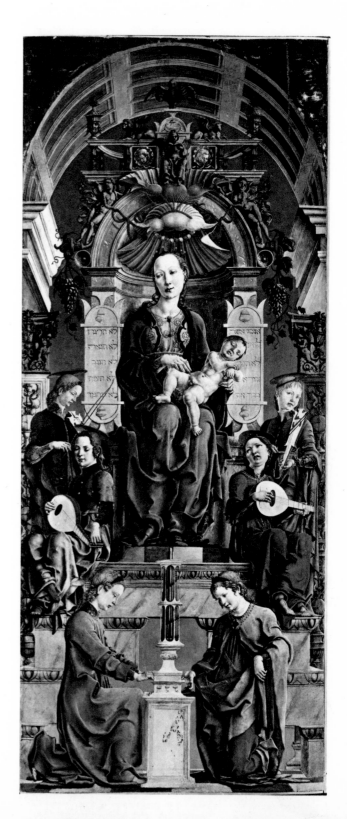

135. COSIMO TURA.
The Virgin and Child Enthroned,
center panel of altarpiece. 94″ × 40″.
National Gallery, London

136. FRANCESCO DEL COSSA.
Astrological Figures for the Month of March. 1470. Fresco, 3'3" × 11'.
Palazzo Schifanoia, Ferrara

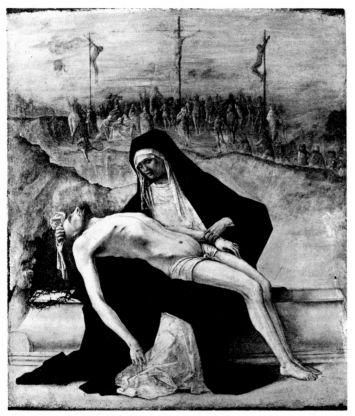

137. ERCOLE DE' ROBERTI. *Pietà.*
Panel, 13" × 12".
Walker Art Gallery, Liverpool

Francesco del Cossa (docs. 1470–d. 1478) produced his masterpiece as part of a crew frescoing a pleasure villa for the duke (1470; fig. 136). He did not have Mantegna's status; indeed his application to be paid more than the rest of the crew, because of his professional reputation, was rejected, in a context that suggests that here the medieval role of the artist as a feudally dependent craftsman remained almost intact. And the anonymous executants present us with a group style. Cossa's modern modeling clashes with the theme of the frescoes—a set of the signs of the zodiac, scenes of the influences of the planets on men, and typical activities of the months (the duke watches a falcon catch its prey, the duke gives his court fool a coin)—local variants on a medieval image. Cossa's figures, reflecting Donatello less than Mantegna, vibrate with only slightly tinny textures, smooth faces, and clear fields of space. Yet he retains from Tura what seems a Ferrarese idiom of taut yet ornamental poses, so that the isolated standing figures symbolizing the astrological system are his most brilliant images. In Cossa's panel paintings the protagonist is the single columnar figure, sometimes seen from below and sometimes gaining heroic dignity from the austere restraint of the artist's tight drawing and round mass.

Ercole de' Roberti (docs. 1479–d. 1496) began as the one talented assistant to Cossa in the same fresco project, and later helped him in other work. His figures, again, stand incised against the sky, very tall and with less weight than Cossa's. But in his narrative pictures the opening up of Tura's

twisted tensions to a more human modernity results in a forceful discharge, people running and shouting, falling and beating each other, in stiff collisions expressing passionate grief or excess of violence. All is contained within the tight incised Ferrarese line, modified by Ercole to stylized lozenge patterns that move teeteringly. This is most impressively visible today in a small *Pietà* (fig. 137), a more direct source for Michelangelo's early *Pietà* (see fig. 201) than the north European sculptures sometimes cited. Ercole, who died prematurely one year after the elderly Tura, marks the end of this tradition. It has an echo in sculpture in the local groups of clay figures by Guido Mazzoni.[58]

34. Pollaiuolo, Verrocchio

Other young Florentine talents soon followed Castagno (and the young Piero della Francesca) in losing interest in perspective organization, substituting a sculptural muscular style. Typically, some of them are now also sculptors. Pollaiuolo's paintings of athletes (see figs. 107, 108) dominating their surroundings may be only duplications of his bronzes, his favorite medium. The tiny bronze of Hercules holding Antaeus away from the ground by pure muscle (fig. 138) has a three-cornered base like Donatello's *Judith*. In this case it tells us that the sculpture has no front view, and that we must try all three approaches to follow the interlocked forces. It is a small object for a table, which one picks up to examine. Even more than the portrait busts of the same generation, it marks the new dominance of small-scale indoor private sculpture. These small bronzes, perhaps evolving from lamps or inkwells, are now becoming the first pure aesthetic objects. Pollaiuolo, who made only one engraving (see fig. 109), is also only known to have made one of these. Altogether he is a nonmonumental artist, though he abandoned Florence for the monumental commission of the tomb of Pope Sixtus IV (from 1484) in Rome,[59] followed at once by another tomb, for Pope Innocent VIII (finished 1498; fig. 139). They are more elaborate than any previous papal tombs, reflecting the growing role of the popes as territorial lords, and the seated figure of Innocent, smiling and giving us a blessing, alive through the modulation of curves and lights, is the first true ancestor of Bernini's papal tombs. Yet the brilliant complexities in it still keep an effect of all-over ornament.

Andrea del Verrocchio (1435–1488) worked

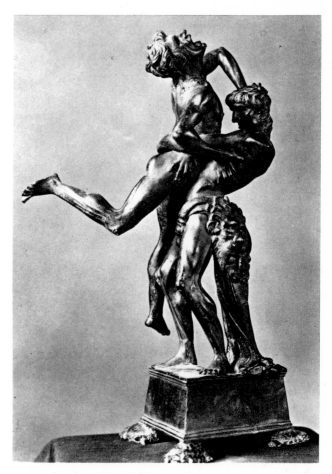

138. ANTONIO DEL POLLAIUOLO.
Hercules and Antaeus. Bronze, height 18".
Museo Nazionale, Bargello, Florence

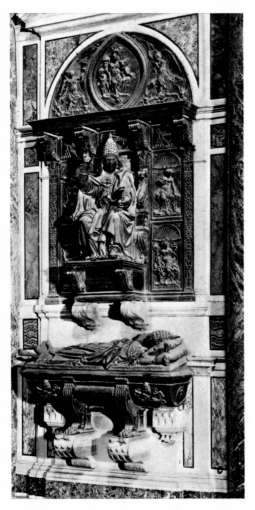

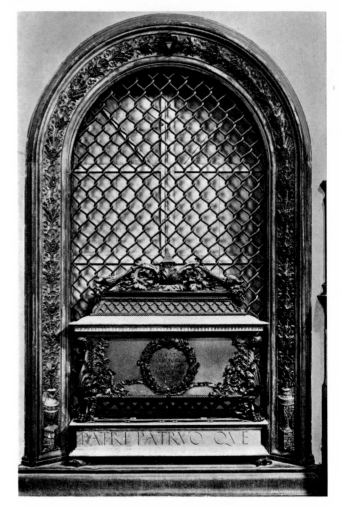

139. ANTONIO DEL POLLAIUOLO. Tomb of Innocent VIII. 1498. Bronze, height of rectangle and lunette about 13′. St. Peter's, Vatican, Rome

140. ANDREA DEL VERROCCHIO. Tomb of the Medici. 1472. Marble and bronze, height of opening 15′. Old Sacristy, S. Lorenzo, Florence

in a great variety of media. But in all of them, like the stone sculptors, the effect is made by combining ornamental frames and tough Castagno-like heads. Verrocchio's early work is all bronze ornament, but its grandeur of scale and original design already lift it from a decorative level. His tomb for two of the Medici (1472; fig. 140) is a handsome porphyry sarcophagus encased in bronze foliage, beneath a tall lattice of bronze rope. The ropes pull thickly, the closest to active realism possible in ornament. So we are not surprised that his bronze *David*[60] is a Castagno type, stringy-tendoned and almost smiling, an apprentice in the street with none of the classicism of Donatello's *David*. It is also splendid technically, with the most precise embroidery stitched on the shirt. Verrocchio received the largest commission of the generation (fig. 141), for a two-

figure group to replace one saint in the old Or San Michele set when a different organization became a patron (1465–83). In the niche Christ stands and is approached by Saint Thomas, who reaches out to touch His wound doubtingly. Thomas is partly out of the niche, like a Castagno soldier (see fig. 106); Christ is more remote psychologically, and hieratically central, and the spatial difficulty of the group in the niche is elegantly handled.

Verrocchio's paintings were few, but he had a large shop. The most significant is the *Baptism of Christ* (fig. 142), again a composition of two related figures. They stand high above the horizon as in other paintings of this generation, and the irregularities of the stringy bodies are silhouetted. The metallic precision of flesh surfaces in Verrocchio's painted figures was a formula imitated by many

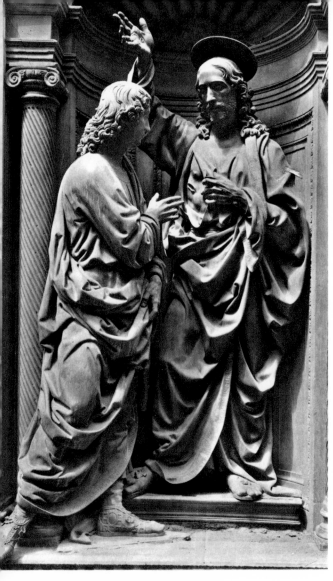

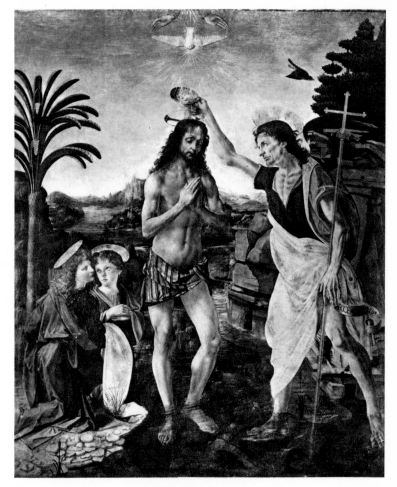

141. ANDREA DEL VERROCCHIO.
Christ and Doubting Thomas. 1467.
Bronze, height 7'5". Or San Michele,
Florence

142. ANDREA DEL VERROCCHIO
and LEONARDO DA VINCI.
Baptism of Christ. Panel, 69" × 59".
Uffizi Gallery, Florence

provincial painters (such as Matteo di Giovanni in Siena, Fiorenzo di Lorenzo in Perugia).

Verrocchio, too, left Florence for a big commission, an equestrian statue in Venice (1481; fig. 143), but he died before it was finished. This monument to a general, Bartolomeo Colleoni, is the only rival to Donatello's *Gattamelata* in Padua (see fig. 97), less profound but at once more decorative and more energetic. The converse of the earlier active bronze ropes, here the popping eyes are as close to ornament as active realism may come. The strength of the work is the surprising synthesis of these diverse qualities.

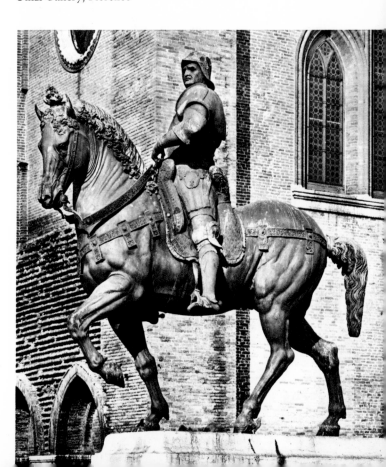

143. ANDREA DEL VERROCCHIO.
Equestrian monument of Bartolommeo Colleoni.
Begun 1481. Bronze, height 13'.
Campo SS. Giovanni e Paolo, Venice

35. Antonello da Messina; Francesco Laurana

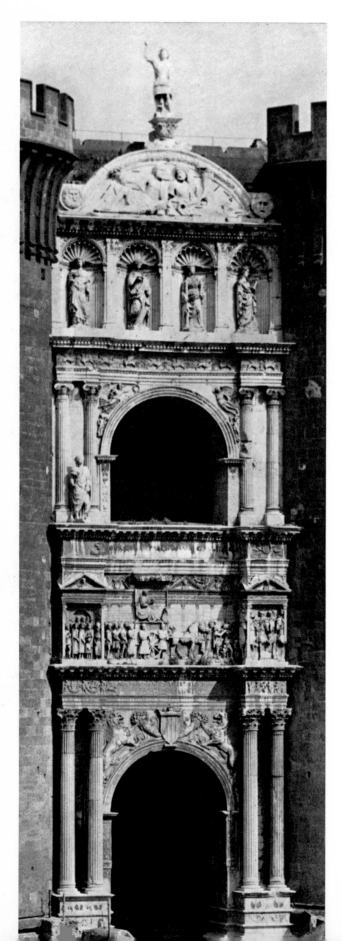

144. Triumphal Arch, Castel Nuovo, Naples.
Begun 1453. Height 125', width 29'6"

Naples plays almost no role in Renaissance art. After the early fourteenth century, when the visits of Giotto, Simone Martini, Tino di Camaino, and others left their marks, a century of civil war between dynasties left sterile ground. The brief conquest about 1440 by the connoisseur-king René of Anjou brought modern methods of painting from Flanders to the leading local painter, Colantonio (see p. 298). King René was overthrown by the more stable Alfonso of Aragon, who marked his ascendency with a spectacular triumphal arch of many stories (fig. 144). It is a gateway, a feudal work in which the many artists' personalities are less marked than the king's (as in the astrological frescoes at Ferrara; see p. 112). Sculptors are recorded who came from many places, but they functioned like members of a medieval cathedral workshop. Aside from the influence of a recent work in Naples by Michelozzo,[61] the style is very literally Roman, with a relaxed, broadly modeled figure type and neutral space. After the king's death the sculptors scattered again, but some later effects of their work can be found.

Antonello da Messina (docs. 1457–d. 1479) started painting in his native Sicily in the provincial reflection of the late medieval Spanish style which was normal there. He no doubt traveled to Naples and learned about recent Flemish painting, but his great moment was the discovery at thirty-five or so of Piero della Francesca's most luminous and formal work, probably in Rome. He creates his own variant on it in paintings, nearly all small heads: Christ, Mary, and secular portraits. They are of a very smooth geometry indeed, with light often gleaming on an egglike skull, but not as remote in feeling as some of Piero's. The close-ups of faces with a drooping lip or swiveled eye, sometimes supported by a lifted hand or the emphasized measurement of space between head and hand, provide concentrated images of states of feeling. The liking for portraits and the small scale are themselves Flemish

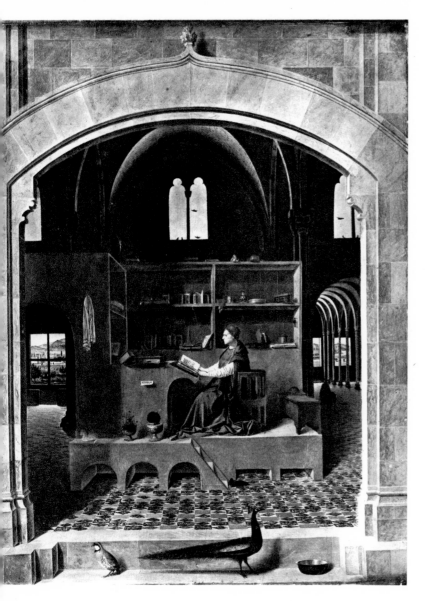

145. ANTONELLO DA MESSINA.
St. Jerome in His Study. Panel, 18″ × 14″.
National Gallery, London

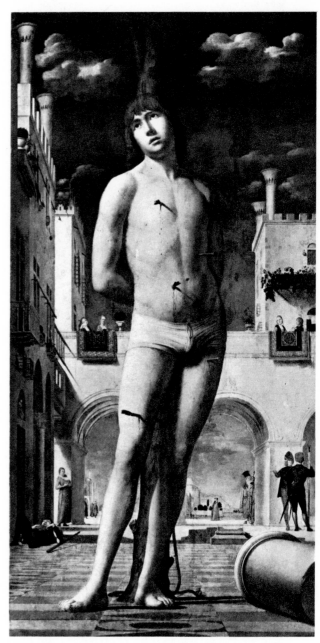

146. ANTONELLO DA MESSINA. *St. Sebastian*.
Panel, transferred to canvas, 67″ × 34″.
Gemäldegalerie, Dresden

tastes, and one elaborate work, *Saint Jerome in His Study* (fig. 145), fills a hard light-box with small objects everywhere that show how a more literal Flemish sense of the world was potential in Antonello all the time. One larger panel of *Saint Sebastian* (fig. 146) is again a single concentrated smooth form, here not the egg of a head but the cylinder of a body. We have lost Antonello's largest set of works, painted, in a continuation of his wanderings, in Venice. There this backwoods genius had an unexpected success, for the altarpiece became a model to young Venetian painters who were seeking to make three-dimensional forms out of luminous color alone.

117

147. FRANCESCO LAURANA. *Battista Sforza,
Countess of Urbino.* Marble, height 20″.
Museo Nazionale, Bargello, Florence

The Dalmatian Francesco Laurana (docs. 1458–d.1502), one of the carvers of King Alfonso's triumphal arch, fled to France to the rival King René and there emerged as a maker of medals, the best of the generation after Pisanello. With wide blank edges, they build up portraits of Louis XI of France and others that are strongly characterful with simplified form; perhaps this is the reaction of an easily influenced artist to a move from the context of Roman carving to one of Flemish portraits. But it hardly prepares us for Laurana's sudden maturing, also at thirty-five, when he returned south to Sicily. His Madonnas there, and his portraits soon after, in Naples again, for princesses in the circle of King Alfonso's son Ferrante, are limited in range and expressiveness but perfect and unforgettable (fig. 147). As mannered portraits, they have superficially seemed to typify Renaissance culture. The half-closed eyes, slight smiles, and barely suggested hair draw all attention to the egglike forms like Antonello's, and they are certainly based on him, carrying Piero della Francesca one more step toward simple abstraction. It is often speculated that Laurana was affected by Piero directly, partly because both happen to have made portraits of the same princess;[62] but he probably never saw a work by Piero, and certainly evolved this procedure in Sicily shortly after Antonello had.

36. Botticelli and Ghirlandaio

Shortly after 1480 Pollaiuolo and Verrocchio, the most prominent artists of Florence, and Leonardo, the brightest young talent, all left the city for better long-term employment elsewhere with, respectively, the pope, the Venetian senate, and the duke of Milan. It was an unprecedented vote, so to speak, against the city which had become proud of its artists but was slowing down economically and also finding rivals in its invention, Renaissance style. At this date a neutral observer, a minor painter in Urbino, surveyed all the notable painters and sculptors working in Italy and judged Mantegna the greatest. Florence manifested a retrospective attitude, with such tell-tale evidence as the first biography of any artist (Brunelleschi),[63] the first historical plaque ever installed in a building (to Giotto in the Cathedral),[64] an effort to bring Fra Filippo Lippi's body back for reburial, and systematic quoting of older compositions in modern works. The "second team" of artists remaining at home also handled perspective in a new way, neither to express a balance of figures and environment as the 1400 generation had, nor, negatively, to exalt the figure as in the more recent generation, but as a routine cliché. They often revive the balanced space of the earlier artists but now with completely symmetrical stage

spaces, that were almost never used by the originators of perspective.

Botticelli (1445–1510) in his youthful work echoes the general group style of the generation before him, especially Pollaiuolo. *Saint Sebastian* (1474)[65] tied to a tree and seen against the sky, and *Judith* (fig. 148), whose walk is sharply silhouetted into a dance, use the space in Pollaiuolo's *Hercules* panels (see figs. 107, 108) and his incisive drawing of muscles under tension, but Botticelli intentionally slips a cog, loosening alert tautness into the tension of fatigue. The same vehicles appear in his grander compositions, the famous *Spring* (colorplate 20), with dancers before a shallow hedge, to be compared spatially to Pollaiuolo's engraving (see fig. 109), and the *Birth of Venus* (fig. 149), where sharply drawn people, thin and stylized with gold lines, remote from feeling, respond to a sky blank to the point of abstraction. The patrons were the Medici, aesthetically sophisticated owners of villas, in which they also had small bronzes and collections

148. SANDRO BOTTICELLI. *Judith.*
Panel, 12″ × 10″. Uffizi Gallery, Florence

149. SANDRO BOTTICELLI. *The Birth of Venus.* Canvas, 5′9″ × 9′2″. Uffizi Gallery, Florence

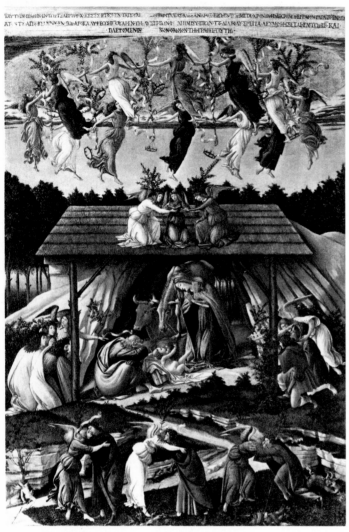

150. SANDRO BOTTICELLI. *Nativity*. 1500.
Canvas, 43″ × 29″. National Gallery, London

the Magi employ exact if uninterested perspective.

His continuing attachment to the Medici after their fall makes it unlikely that he was a devotee of Savonarola's antiluxurious evangelism[66] as has been supposed. Savonarola's theme of God destroying the wicked city appears in just one of Botticelli's works,[67] which thus may be a client's order. A more remarkable late work is the *Nativity* (1500; fig. 150), with a strange prophetic inscription, an archaistic composition derived from the Fra Angelico tradition, and angels whose linear bending patterns do indeed distort their bodies with expressive effect. But in his last years his unshaded modeling had become obsolete; he could get no work, and died forgotten. His unfinished drawings for Dante's *Divine Comedy*[68] may be of these years.

Ghirlandaio (1449–1494), a successful painter of fresco cycles all his life, was perhaps the first to rework the spatial formula of his predecessors' predecessors, the painters of the 1400 generation, setting up narratives neatly and symmetrically in rooms or on similar stages. But within them the details are new, especially the small anecdotal objects of daily life that mark the pleased discovery of Flemish methods. This particularism has a larger effect in portraiture. Earlier, clients of frescoes could have their portraits in a corner, among the onlookers of a miracle, or could even pose as models for the main figures. But Ghirlandaio paints them in modern dress in front of the tableau of the traditional subjects, offering two levels of reality as of audience and pageant. In his cycle of Saint Francis (completed 1485) the most masterly scene, the *Approval of the Franciscan Rule* (fig. 151), wraps portraits of the patron and his friends around three sides of the formal composition, which is closely derived from a fourteenth-century work. The background is a photographic view of Florence. There is a reversal of the Florentine assumption that the ordering of reality is superior to the details. Ghirlandaio is at his finest in separate portraits, notably the *Old Man and a Little Boy* (fig. 152). The old man's diseased nose is not more emphasized than the sense of love filling the space between the two heads. In a portrait, Ghirlandaio can even invent a composition.

Benedetto da Maiano (1442–1497) is the Ghirlandaio of sculpture. His vivid bust of Pietro Mellini (1474; fig. 153) modifies portrait sculpture by covering the head with wrinkles and the shoulders with embroidery, shifting the emphasis from mass

of older and ancient art and cultivated the fashion of neo-Platonism. This teaches, in its literary diffused version, that physical love and beauty introduce us to spiritual versions of themselves which wipe out the original physical factors. Botticelli's classical goddesses of love, grace, and wisdom belong to this world, and so, more intrinsically, does his style, whose formalist extremism tends to deny bodily life. But this is only true in comparative terms, and a close look at his most linear arabesques, as in the thin interlaced hands of the Graces, shows accurate drawing and firm, massive modeling. To avoid tying Botticelli to a decadent syndrome, we may recall that a contemporary called him "virile" in comparison to other painters. His portraits are like Antonio Rossellino's, while his Adorations of

151. DOMENICO GHIRLANDAIO.
The Approval of the Franciscan Rule.
1483–85. Fresco, width 12′2″.
Sassetti Chapel, S. Trinità, Florence

152. DOMENICO GHIRLANDAIO.
Portrait of an Old Man and a Little Boy.
Panel, 24″ × 18″.
The Louvre, Paris

121

to surface realism. His narrative panels of the story of Saint Francis,[69] ordered by the same client, take their space systems from Ghiberti. Since there are no records of his working as an architect, the traditional linkage of his name with just one spectacularly good building, Palazzo Strozzi, is open to doubt (see fig. 165). He may well have contributed designs for such sculptural elements in it as the splendid bronze lamp holders around the outside. Yet these, the most dashing such objects ever made, certainly owe much to their execution by Niccolò Grosso, il Caparra, who because of them was remembered with respect in later generations as the best of Renaissance blacksmiths.

153. BENEDETTO DA MAIANO.
Pietro Mellini. 1474.
Marble, height 21″.
Museo Nazionale, Bargello, Florence

37. Perugino and Pinturicchio

A painter growing up at this time in one of the many small towns south of Florence had a choice between the figural imagery of the leading Florentines, like Pollaiuolo, or Piero della Francesca's local revolt from it. Perugino (docs. 1472–d.1523), so called because he was connected with Perugia, began with frescoes in the Pollaiuolo-Verrocchio vein, but then created a beautiful variant on Piero. Painting for Pope Sixtus in the new Sistine Chapel (1480–82), he avoids all drama in the mild, softly turning figures of his *Christ Giving the Keys to Saint Peter* (colorplate 21), all in a row in the front. Behind them is a vast city square, articulated at the far end by two symmetrical Roman arches through which we can see the farthest, whitest sky. Here the symmetrical space is a powerful aid in exalting dispassionate architectonic calm, rich with filtered atmosphere. In the Chapel Perugino led a crew of bright young painters, Ghirlandaio, Botticelli, Signorelli, and others,[70] and they evidently borrowed his symmetrical formula, but to less intense effect.

Perugino maintained two successful studios, in Perugia and in Florence, and his work in Florence about 1490 marks his peak. Painting Saint Bernard's vision of the Virgin (fig. 154) he sets each quiet figure in front of a square pillar, and there is a deep tunnel of air in the middle; the only sense of an event is in the lifted hand of the saint, an architectural irregularity. The big frescoed *Crucifixion* (1493–96)[71] sets gentle, sweetish figures before an infinite empty whiteness, chilly at the base and gradually rising to a mild blue, and then ties them to the painted frames on the same plane. But he had no further variations to offer, and in old age he shuttled among the villages around Perugia to produce the same altarpieces again and again, as did his many followers.

Just one of these is distinctive, Pinturicchio (docs. 1480–d.1513); he is a vulgarized Perugino,

a cousin of Ghirlandaio in his tastes. His best-known work is the fresco cycle of the life of Pope Pius II in Siena (begun 1503),[72] unusual for its modern theme, commissioned by the family. The relaxed figures stand ceremonially, in gaudy clothes, in symmetrical spaces. There is much ornament and gold leaf. Earlier, in his works at the Vatican in the new Borgia apartments of Pope Alexander VI (begun 1492),[73] the gold surfaces seemed to be attempting to take attention away from the scattered looseness of the narrative tone. Pinturicchio's most notable fresco series had been his first, in the Roman church of Aracoeli,[74] most closely indebted to Perugino and perhaps to Signorelli.

154. PERUGINO. *The Vision of St. Bernard.* Panel, 5′8″ × 5′7″. Alte Pinakothek, Munich

38. Signorelli; Melozzo da Forlì

155. LUCA SIGNORELLI. *The School of Pan.* Canvas, 6′4″ × 8′5″ (destroyed). Formerly Kaiser Friedrich Museum, Berlin

Luce Signorelli (docs. 1474–d.1523), growing up in Cortona, another small town south of Florence, was faced, like Perugino and many other painters in the area, with the rival patterns of the city of Florence and of his teacher Piero della Francesca. Reversing Perugino's evolution, Signorelli, the greatest figure of the area in his time, began with a youthful reflection of Piero, and then when he learned about Verrocchio produced a unique synthesis that is provincial but powerful. It appears in his earliest important painting, the *Scourging of Christ,* [75] where a firm perspective space is in harmonious proportion with a new kind of man, as defined in musculature as any painted by a Florentine, and as dramatic, and even like Verrocchio's in the tinny shine of flesh. Yet it also uses this texture to stylize the form into an intentionally stiff-jointed pattern that has its own architectonic abstraction. Signorelli's people remain constructed metaphors of sweaty humanity, an abstraction in which he pro-

123

156. LUCA SIGNORELLI. *The Punishment of the Damned.* 1499–1504. Fresco, 19′7″ × 23′. Cathedral, Orvieto

duced endless altarpieces among the small towns of the area. His rare inanimate objects show the same geometric handling; a favorite is an open book with stiffly fanning pages. He attracted the patronage of the Medici, for whom he painted a unique homage to pagan gods, the *School of Pan* (fig. 155). The slightly stilted athletes make a formal group having isolated dignity like a Madonna and Saints, and their tension between life and geometry, each threatening to flatten the other, became the surprising inspiration in the twentieth century for the German painter Max Beckmann. Signorelli also painted portraits rich in distant grandeur and in tough personality. But his masterpiece is the fresco cycle in the Cathedral of Orvieto, a minor hill town (1499–1504; fig. 156). The end of the world and the Last Judgment are the themes; the latter, with

parts of the subject distributed on the vaulted ceiling and wall surfaces so neatly that the unity of time and meaning is not noticed, is actually the same subject that Michelangelo painted later on one wall (see fig. 306). At its date it no doubt gained extra power from the dread of a calamity in the magic year 1500, which also stimulated Dürer's Apocalypse series of 1497–98 (see fig. 427). The *Resurrection of the Dead* and the *Punishment of the Damned* are the most powerful segments. Heaps of congested nudes, twisting in torture, are marked by ropy tension like the muscles in an anatomy book, and by geometric tricks of foreshortening like examples in a perspective book, creating a painful but impersonal anguish. The all-over regular rhythms of line contain the squirming bodies as in a net, heightening the pressure on them. Here and in *Pan*

Signorelli found themes involving the nude at an emotional distance which carried him beyond his other achievements. Like Perugino, he spent the last twenty years of his life in obscure village-church work.

The unusual and underestimated art of Melozzo da Forlì (1438–1494) is affected by his origin in a town, otherwise without importance for us, in the remote southeast corner of the great north Italian plain, at a time when its artists were dominated by Mantegna. His early life is unknown, and has been linked to Piero della Francesca on the loose grounds that both were interested in perspective and that Forlì is near Urbino, to us best known as a center of Piero's activities. But a better reading can be obtained if we take note that even in Urbino the most admired painter in Italy was Mantegna, according to a local artist who was a friend of Melozzo's. With these clues, a look at Melozzo's impressive fresco for the papal library in Rome, *Sixtus IV with the Librarian Platina,* is suggestive (1477; fig. 157). Compared with Mantegna's court frescoes at

Mantua completed in 1474 (see fig. 133), it has a very different architecture, but both structures reflect the rooms in which they are painted. More interesting is Melozzo's seizure of Mantegna's concept that the fresco is continuous with the viewer's activity in the room, in subject as well as in its perspective. He supports this with firm portraiture having the serious-minded realism and plain weight of Roman busts. In a dome in Loreto[76] he again follows Mantegna in cutting through to the blue sky, with foreshortened attendants clustering about. He is most pioneering in his fresco for the apse of the Santi Apostoli, Rome, an *Ascension of Christ* (fig. 158), where a wind from the side flaps the robe of Christ laterally while he rises up, a motion of mass that anticipates Roman Baroque painting more literally than do the works of Michelangelo commonly cited. Melozzo's special interest is that he is the first Renaissance painter of distinction to make Rome his permanent headquarters, setting the stage for Raphael and others in this as he does in some of his ideas.

158. MELOZZO DA FORLÌ. *Ascension of Christ,* for apse of SS. Apostoli. Fresco (detached), 9′9″ × 7′10″. Quirinal Palace, Rome

157. MELOZZO DA FORLÌ. *Sixtus IV with the Librarian Platina.* 1477. Fresco, transferred to canvas, 12′ × 10′4″. Pinacoteca Vaticana, Rome

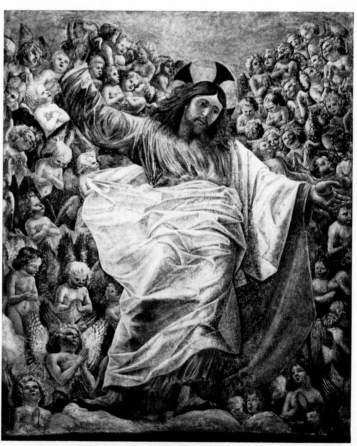

39. Architecture in Central Italy, 1465–1500

Some notable individual buildings of this period echo Alberti in varying degrees. Duke Frederick of Urbino, patron of Piero della Francesca and other painters, had his palace built by a talented architect of whom no other work survives, Luciano Laurana (docs. 1465–d.1479). Its exterior focus is a design of twin towers flanking a vertical set of four arched porches (fig. 159), an agreeable civilian revision of the gateway on the castle of the king of Naples (see fig. 144), who was an admired mentor of the duke. This looks across the valley, as in Albertian Pienza. Within, the main feature is the two-story courtyard (fig. 160), with its two white friezes that bear a long inscription, like Alberti's at the top of Santa Maria Novella. The two friezes and the intersecting verticals (pilasters above columns) make a net of white lines over the brick walls, recalling the system of Palazzo Rucellai (see fig. 102). But the

duplicate pilasters in the four corners are new, framing each of the four walls as an independent plane. Since the four walls as they touch set up the courtyard space, the system is of planes and space, an early Brunelleschian way of thinking made explicit through the new, tighter Albertian vocabulary.

The Sienese Francesco di Giorgio (1439–1502) also worked at the palace. In his generation Siena ceased to be a carrier of its own style tradition and became simply one of the hill towns among which artists journeyed; typically, Francesco worked in his friend Signorelli's home town, Cortona, and vice versa. He had begun as a skilled painter in the Verrocchio manner then current in the area, with nervous but firmly sculptural tinny figures. Later he was a similarly skilled bronze sculptor in the vein of the mature Donatello. But he was outstanding as an architect, spending much of his time as a military engineer designing artillery (a short technical step from bronze sculpture) and forts (a short step from palaces). His drawings for forts show complex shapes based on how artillery can be fired;

159. LUCIANO LAURANA. Loggia on exterior,
Ducal Palace, Urbino.
Total height of porches 50′, width 13′

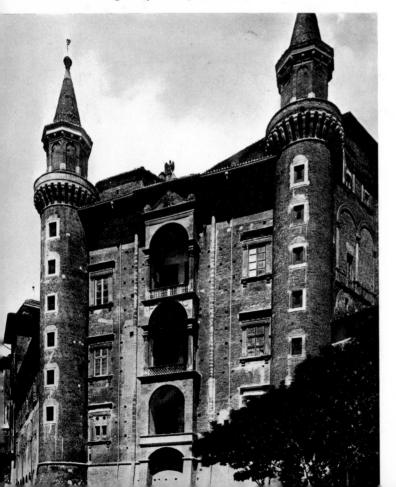

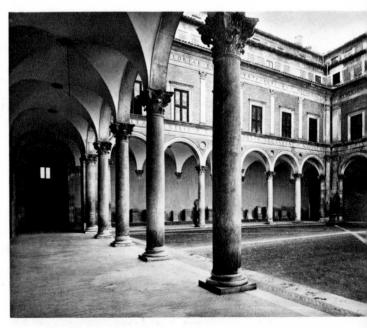

160. LUCIANO LAURANA.
Courtyard, Ducal Palace, Urbino.
Begun 1465. 110′ square, height 39′

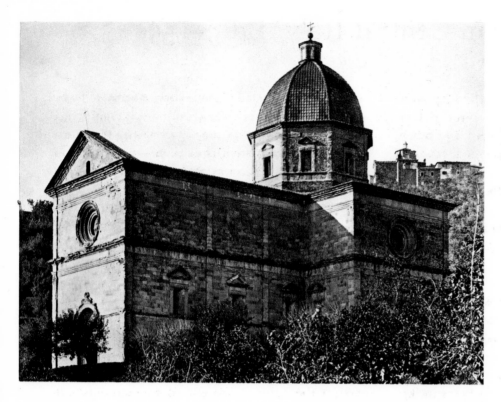

161. FRANCESCO DI GIORGIO. Exterior,
S. Maria del Calcinaio, Cortona. 1484.
Length 144′, width
at transept 118′

162. GIULIANO DA SANGALLO. Façade,
Villa at Poggio a Caiano (near Florence).
Dimensions of the two main floors 47′ × 142′

their dynamic asymmetrical logic anticipates Michelangelo and fort designers of later ages. His writings on architecture expound the idea, assumed in Renaissance architecture already, that building plans should develop their proportions from the human body.[77]

One major building by him survives, Santa Maria del Calcinaio in Cortona (model 1484; fig. 161). Externally, the four crossarms extending from the dome are articulated with pilasters at the outer ends, so that the effect is of struts over which the walls are drawn tight; the interior structure has a similarly taut effect, setting up a series of big hollow cubes. The exterior was influential in Rome in the following years, notably in the façade of the anonymous Cancelleria palace.

Giuliano da Sangallo (1445–1516), the most prominent Florentine architect of this time, began as a woodworker and sculptor. He made a mark with a country house for Lorenzo de' Medici, the

127

villa at Poggio a Caiano (fig. 162). The first Medici villas had been fortified farms, but this is a pleasure retreat. It is isolated by being built on a wide basement platform, as Alberti recommended for important buildings. (The curved steps are a later replacement of the original straight ones.) The temple front has also an Albertian classical dignity, but seems a nearly flat ornament, useful in marking the center opening considered suitable to dignify villas in contrast to ordinary dwellings. A central-plan church, Santa Maria delle Carceri in Prato (begun 1484; figs. 163, 164), very near Florence, similarly emphasizes the surface more, and the construction less, than Francesco's church at Cortona. Outside, above the platform, the wall is articulated with green marble strips, a Florentine tradition, on the same plane as the white between them. Inside, the richer pilasters and the short crossarms make a more unified space between these brackets than Cortona. As the villa is the perfect illustration of Medicean aesthetic culture, so the church is the first instance actually built of the preference in Renaissance architectural thought for central-plan spaces proportional to man, rarely realized because they were inconvenient for celebrating Mass. The Albertian pilastered walls, diminished to the planar

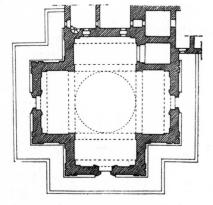

163.　Giuliano da Sangallo. Exterior, S. Maria delle Carceri, Prato. Begun 1484. Each arm 72′ × 52′6″

164.　Giuliano da Sangallo. Plan, S. Maria delle Carceri, Prato. 88′ × 88′

165.　Benedetto da Maiano and Il Cronaca. Façade, Palazzo Strozzi, Florence. 1489. 105′ × 134′

effect of the early Brunelleschi, parallel Laurana's results and suggest an eclectic formula of the period. The perfect illustration of the Florentine town house, Palazzo Strozzi, was built following a model that Giuliano made (1489; fig. 165), but the designer was probably Simone Pollaiuolo, il Cronaca, a serviceable builder. Its polished proportions are no more admirable than its superb masonry details. As the finest execution of what was now a set formula, it suggests the nature of the palazzo more readily than the more individualistic originating ones of forty years before.

40. Painters in North Italy, 1450–1500

In the duchy of Milan the changeover from courtly Gothic to Renaissance occurred with one remarkable master, Vincenzo Foppa (docs. 1456–d. 1515/16). His first known paintings, such as the *Crucifixion* (1456)[78] and *Saint Jerome* (fig. 166), blend the figures into a gray and slightly fuzzy air. Three-dimensional classical modeling is there, perspective is skillfully performed, but there is no Florentine mass-void balance; the figures wilt and blur into their world with modest informality. This presentation evolves from Jacopo Bellini's airy explorations. Because Foppa so abruptly cuts off Milanese Gothic, he has been called a pure inventor of Lombard realism, or his inspiration has been sought far off in France; but this nearer link is the closest to his visual effects. Following a set of frescoes in Milan with active elaborations of perspective,[79] his later works are chiefly Madonnas and routine altarpieces.

Painting in Venice (as well as very minor work in Verona and other towns) stems mainly from Mantegna's early masterpieces in Padua (see p. 104). Carlo Crivelli (docs. 1457–1493) adopts Mantegna's literal mannerisms of handwriting, cutting line, and strict spatial units, so that brilliant unshadowed people are cut to fit an area. Sharp drawings of gripping fingers or of screaming mouths can, as in Mantegna and Mantegna's other admirer Tura, evoke spectacular grief, but here the chief effect is decoration, not feeling. In this context that means a falling back into Gothic, and indeed Crivelli had to leave Venice and make a career in small moun-

166. VINCENZO FOPPA. *St. Jerome*. Panel, 19" × 13". Accademia Carrara. Bergamo

167. VITTORE CARPACCIO. *The Leavetaking of St. Ursula and the Prince.* 1495. Canvas, 9'2" × 20'. Accademia, Venice

tain towns far from his birthplace, like Benozzo Gozzoli. This suggests a new modernity of taste in the city. It is established by Gentile Bellini (docs. 1465–d.1507), Jacopo's son, who became the official state painter, producing historical scenes for the Doges' Palace,[80] and in 1479 was sent off to Constantinople when the sultan asked the Venetian senate for an artist. Gentile's work has suffered like his father's from loss and, also, damage. After imitations of his brother-in-law Mantegna, we have some small portraits of doges and one late remarkable set of narratives for a religious society, the School of San Giovanni Evangelista (1496–1501; colorplate 22). They tell the society's own boastful history centering on its relic of the true cross. Masses of people take part in parades, with minute linear detail, before equally detailed buildings. These are portraits of the squares and canals of Venice, seen with a mapmaker's accuracy, and begin the Venetian love affair with the sights of the city that continues to the eighteenth century. Splendor accrues from associations and from the evocation of spatial expansion laterally rather than perpendicularly. These are inventive variants on Mantegna's images continuing the observer's experience.

Vittore Carpaccio (docs. 1472–1525), who worked in a similar vein on commissions from the humbler religious societies, is more admired today. He begins with his most famous series (1490–98), ten huge scenes of the life of Saint Ursula, a story of a princess' courtship and pilgrimage that gives ample occasion for panoramas of cities with jostling crowds, complicated buildings, and brightly colored anecdote (fig. 167). But the incidents are disciplined by geometry; suitable to the human materials of his vision, it is not an angular geometry but curved, with patterns of cylinders recurring everywhere, from the slick tights worn by the pages to rows of trumpets. This shape is a token of the interplay in his art between rhythm and reportage. It is refined in a later series for the local Slavic society (1502–7). In the most famous scene, *Saint Augustine in His Study* (colorplate 23), the saint becomes convinced in his mind that his friend Saint Jerome has died far away and been received in Heaven, and this feeling is made visible by the subtle light flooding an empty room, from which all the chairs and papers have been pushed aside. This luminous gentleness pulls the reality of oddments into unity in Carpaccio's maturest work, without suppressing their qualities. From Jacopo Bellini luminosity had developed into the typical Venetian attitude.

41. Sculptors and Architects in North Italy, 1465–1500

Families of stonemasons, often working as both builders and carvers, have come down from the Alps to the north Italian cities from the Middle Ages onward. In the early Renaissance they willingly, as good craftsmen, learned the newest style and used it with honesty and skill, but it was not their idea or expressive of their viewpoint. Pietro Lombardo (docs. 1463–d.1515) brought Renaissance patterns in stone to Venice. His first known work is the Roselli tomb in Padua (1464–67),[81] a systematic reuse of the newest Florentine type, Desiderio da Settignano's, with lively classical figures and refined ornament. Its principal change is in pressing the relief carving down so that it has an effect of being ironed flat, leaving sharp creases. Perhaps this is how a stonecutter would see Donatello's expressive modeling. Pietro's later reliefs use this incisive planar carving for characterization of faces, as in the bust of Dante on his tomb (1482).[82] His most spectacular work is the building of the church of Santa Maria dei Miracoli in Venice (finished 1489; fig. 168), a jewel box encrusted with marble inside and out, expressing its sound four-square masonry as a matter of pride like Palazzo Strozzi in Florence. His tomb statues, tending toward blank cylinders with classical heads, inspire or perhaps parallel those of another Lombard, Antonio Rizzo (docs. 1465–1499). They were rivals in producing tombs of doges, with many-storied and -statued triumphal arches. Rizzo's masterpieces, the *Adam* and *Eve* in his still Gothic annex of the Doges' Palace (fig. 169), have the globular tautness of wineskins, given stony dignity by their volume and precision.

Another such craftsman, Mauro Coducci (docs. 1469–d.1504), offered modern architecture to Venice with a series of churches based on Alberti's in Rimini; they articulate the façade with columns under a semicircular top. His masterpiece, San Zaccaria (from 1483; fig. 170), is so Venetian in exploiting light and shade among the projecting and receding members inside the emphatic frame, and so convincing in construction, that it loses the sense of being an imitation. His interiors use very thin supports, square spaces, and white and gray stone,

168. PIETRO LOMBARDO. Façade, S. Maria dei Miracoli, Venice. Completed 1489. 52′ × 38′

creating cool light, harmonious proportions, and a mild centripetal effect. He also evidently designed the Palazzo Vendramin-Calergi, which retains the traditional local scheme of a wide central window area and narrow walls beside it, only shifting to a Renaissance vocabulary of column, arch, and cornice, with balanced proportions. It thus reinforces the scenic rhythm of palaces along the Grand Canal.

The dukes of Milan poured resources into their burial church near Pavia, the Certosa (Char-

131

169. ANTONIO RIZZO. *Eve*. Marble, height 6′9″.
Doges' Palace, Venice

and gracefully Gothic, but was then transformed by the impact of the Mantegazza brothers, Cristoforo and Antonio (docs. 1464–d.1482, 1495, respectively), the rivals with whom he shared the façade carving. Their carving is distinctive and mannered, cutting people out of zigzags and lozenges in a further stylization of Pietro Lombardo's creased and ironed reliefs. From this they make sharp expressionist images of running motion and stress, applied all over so that it becomes a pattern. Ultimately derived from Donatello's late reliefs, they are analogous, as provincial responses, to Cosimo Tura's frenzied ornament.

170. MAURO CODUCCI. Façade, S. Zaccaria, Venice. Begun 1483. 120′ × 74′

terhouse, i.e., Carthusian monastery). Giovanni Antonio Amadeo (1447–1522), with many assistants, carved much of its sculpture and built the lower half of its façade (from 1474). The latter turns out to be like one by Coducci, a heavily framed marble rectangle, rich with windows and active ornaments. Alberti's Renaissance wall has now become a decorative fashion, with fantasies of classical ornamentation. Amadeo's early carving is placidly

COLORPLATE 21. PERUGINO. *Christ Giving the Keys to St. Peter*. 1481. Fresco, 11′ × 18′. Sistine Chapel, Vatican, Rome

COLORPLATE 22. GENTILE BELLINI. *Procession in Piazza San Marco*. 1496. Canvas, 12′ × 24′5″. Accademia, Venice

COLORPLATE 23. VITTORE CARPACCIO.
St. Augustine in His Study. c.1502. Canvas, 56″ × 81″.
Scuola degli Schiavoni, Venice

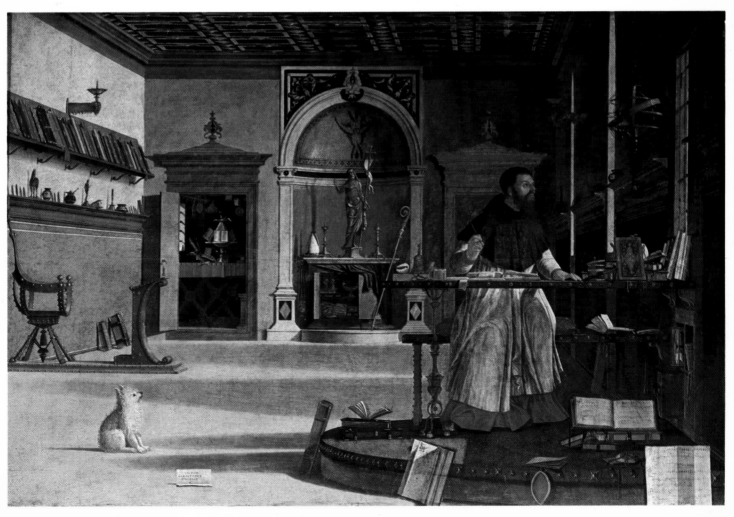

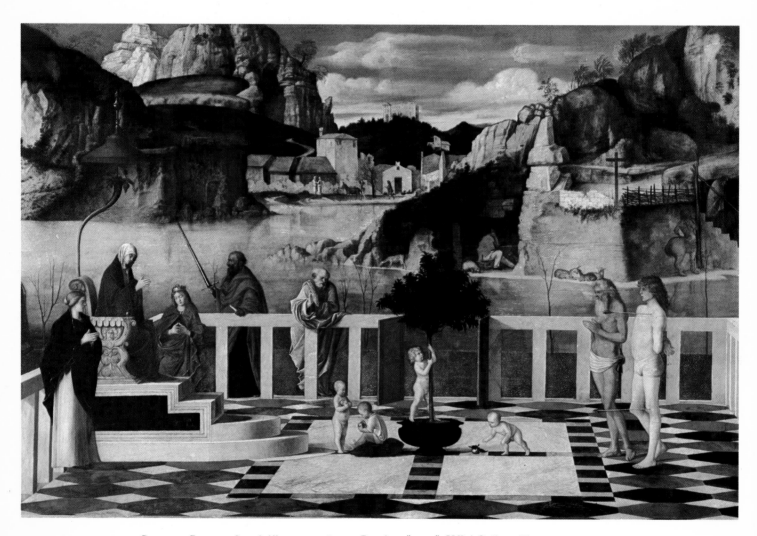

COLORPLATE 24. GIOVANNI BELLINI. *Sacred Allegory*. c.1485–95. Panel, 29″×47″. Uffizi Gallery, Florence

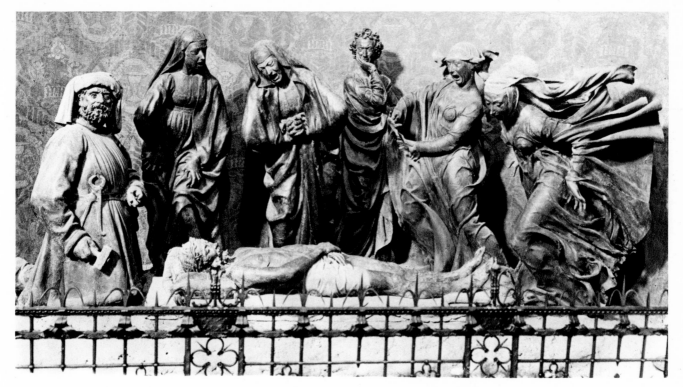

171. NICCOLÒ DELL' ARCA. *The Lamentation over Christ*. Terracotta, partly painted; height of tallest figure 65″. S. Maria della Vita, Bologna

Donatello also stirred the remarkable Niccolò dell' Arca (docs. 1464–d.1494) in Bologna to model a lifesize set of clay figures to be grouped as a cluster representing the lamentation over Christ's body (fig. 171). The idea for such groups came from France. Niccolò's figures have a shock effect of naturalism, suggesting plaster casts of people, but are given seriousness by broadening of forms. They are related to the folk art of crèches and wax museums. Niccolò's stone sculpture for the tomb of Saint Dominic (begun 1469)[83] is relatively restrained, though here and there it flares out with an imaginative adjunct of disproportionate ornament.

42. Giovanni Bellini to 1500

Jacopo Bellini's younger son Giovanni (docs. 1459–d.1516) was the great painter of the family, first imitating and later superseding his brother-in-law Mantegna. In his youth his labor was merged in the family enterprise, and only some small devotional panels have been isolated as probably his. He first appears clearly, between thirty and thirty-five, with a group of masterpieces very much like Mantegna. The *Agony in the Garden* (fig. 172), a small panel, imitates literally a Mantegna composition and even some of its details, such as the foreshortened sleeping man in the foreground, the fence winding off into our space, and the cliff with striated rock. But the drawing is different: the cliff is not rendered with a close net of lines; surfaces are larger and simpler, as if the mold was set and could be removed, letting light wash over the edges. In the great *Pietà*[84] the irregular balance of the two central heads is a vehicle of human poignancy, with light glazing the simplified surfaces and coming to rest

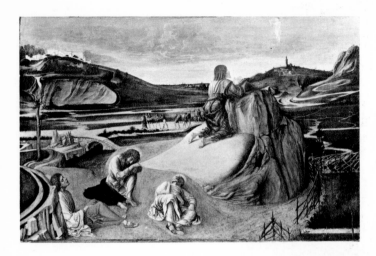

172. GIOVANNI BELLINI. *Agony in the Garden.*
Panel, 32″ × 50″. National Gallery, London

173. GIOVANNI BELLINI.
Madonna and Child with Two Saints.
Panel, 21 1/4″ × 29 7/8″.
Accademia, Venice

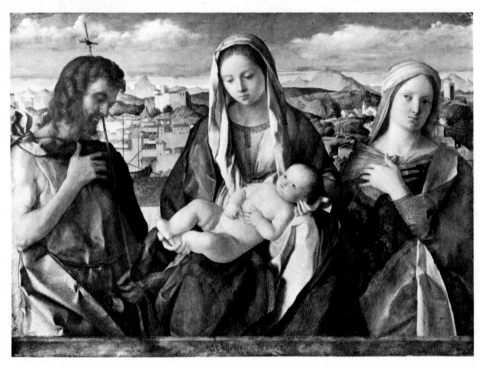

in the streaky twilight background. The first great altarpiece, for Santi Giovanni e Paolo (1464),[85] gives us the same sharply placed, cool-toned people. Space is stretched far, as by all the Bellini painters, but in a new way, without Jacopo's improbable intricacy and scale contrast, Mantegna's forward pressure; or Gentile's lateral probes. Giovanni's, as one would expect, is easier and more optical; the viewer's eye, focusing on the main figures, incidentally finds whatever is beyond them in the same sightline. Giovanni therefore provides a "second theme" far beyond the people, a sunset or town or populated landscape on which we come to rest at the horizon. Thus begin Bellini's famous landscape vignettes, always atmospherically fresh, and separate in space and psychology from the quite conventional devotional figures in front (fig. 173). Bellini's art is one of straightforward painterly sensibility, both in its innovations and its acceptance of routines, in contrast to Mantegna's conceptual systemizing; the two of them might be compared with Matisse and Picasso. In compositions Bellini is quite willing to follow formulas, but he is absolutely independent in the appearances of things, color, air, and space.

In 1475 he was drawn away from Mantegna by the attraction of Antonello da Messina. This led to the Pesaro altarpiece,[86] a traditional composi-

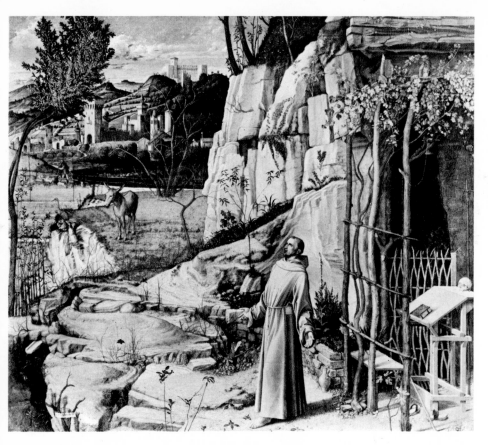

174. GIOVANNI BELLINI.
St. Francis in Ecstasy.
Panel, 49″ × 56″.
(Copyright) The Frick Collection,
New York

175. GIAMBATTISTA CIMA.
John the Baptist and Saints.
Panel, 10′ × 6′9″.
S. Maria dell'Orto, Venice

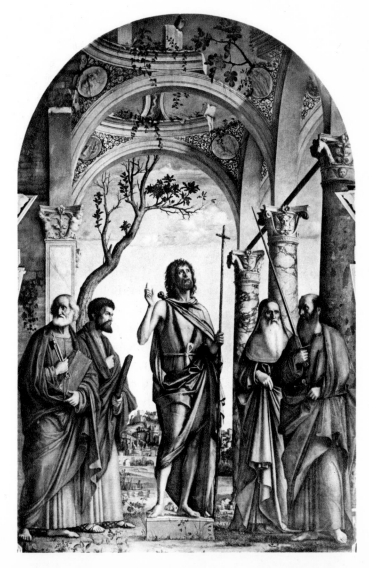

tion with its figures smoothly set in place but still less linear; they are glowing and cylindrically taut, as is also the vigorously fresh panorama of a complete hill town behind. The *Resurrection*[87] poses oddly jointed people, perhaps reused from another subject, in live textures, before a wild sunrise. Light is even more powerful in *Saint Francis in Ecstasy* (fig. 174), where the figure on one side looks at the air on the other—as in Jacopo Bellini—and in the *Transfiguration of Christ.*[88] In both, a heavenly light may be part of the subject, making people freeze in place, yet itself pleasingly warm. Light's influence on form is still more pervasive in works of standard design like the San Giobbe altarpiece,[89] the Frari altarpiece of 1488,[90] or the *Madonna of the Trees,*[91] where the calm formal people are suffused by its slight dimness, abolishing definite edges. Both these tendencies appear in the strange *Sacred Allegory* (colorplate 24), a masterpiece where the lack of interrelationship between the small, formal figures has left the subject matter puzzling. Since Giovanni does not show concern with his themes, those not standard are not comprehensible. Here the people contemplate the central space, or meditate, while behind a river a complicated mountain in honey-colored light is filled with incidents. Sen-

sibility to light has brought forth a poetry of nature, and it will lead to still further discoveries in the old age of the artist, who, like Donatello, develops a late aesthetic more related to younger artists than to his own generation (see fig. 226).

Antonello da Messina had a basic effect on other talented painters in Venice. Alvise Vivarini (docs. 1458–1503), also the scion of a family of painters (his uncles had reflected Gentile da Fabriano and Mantegna), now began painting tall crystalline people looming over bright deserts; Bartolommeo Montagna (docs. 1467–d.1523) began a long series of Madonnas having beautifully adjusted triangular designs; and Giambattista Cima (docs. 1473–1517), painting brilliant forms in light with equal exactitude, enlivened them with scattered foliage and pebbles picked out like coins in the sun (fig. 175). In this context of sensibility there was a rich growth of beautiful pictures by talented painters with minimal individuality.

Supplementary Notes to Part One

1. St. Thomas Aquinas, *Summa Theologica*, written 1266–73.

2. Nicola Pisano, Fontana Maggiore, Perugia.

3. Eero Saarinen (1910–1961), son of Eliel Saarinen (1873–1950), a distinguished environmental architect. The son worked in his father's architectural office until the latter's death, and became an architect of great structural ingenuity and monumentality.

4. Giovanni Pisano, figures for exterior of Baptistery, Pisa; now removed to interior of building.

5. St. Francis altarpiece, Bardi Chapel, S. Croce, Florence.

6. Magdalene altarpiece, Accademia, Florence.

7. The other is the *Madonna and Child* at S. Maria dei Servi, Orvieto.

8. Guido da Siena, *Madonna and Child*, City Hall, Siena.

9. Cimabue, *Crucifix*, San Domenico, Arezzo.

10. Giotto, fresco cycles in S. Croce, Florence: life of St. Francis, Bardi Chapel; lives of St. John the Baptist and St. John the Evangelist, Peruzzi Chapel.

11. Duccio, *Madonna with the Three Franciscans*, Pinacoteca, Siena.

12. Duccio, *Maestà*, Museo dell'Opera del Duomo, Siena (panels in pinnacles and predella, and some from back of altarpiece, now dispersed in numerous collections).

13. Duccio, *Denial of Peter*, from the *Maestà*, Museo dell'Opera del Duomo, Siena.

14. Duccio, *The Three Marys at the Tomb*, from the *Maestà*, Museo dell'Opera del Duomo, Siena.

15. Tino di Camaino, tomb of Cardinal Riccardo Petroni, Cathedral, Siena.

16. Andrea Pisano, doors (now on south side) of the Baptistery, Florence; twenty-four panels of the life of John the Baptist and the Virtues.

17. Pietro Lorenzetti, altarpiece of the *Madonna and Child with Saints, Annunciation*, and *Assumption*, Church of the Pieve, Arezzo.

18. Ambrogio Lorenzetti, *Annunciation*, Pinacoteca, Siena.

19. *The Little Flowers of St. Francis*, account formulated in the fourteenth century from older versions; published 1476.

20. Francesco Traini, altarpiece of St. Dominic, Museo Civico, Pisa.

21. Giovanni Boccaccio, *Decameron*, written 1348–53.

22. Fra Domenico Cavalca, *Vite dei Santi Padri* (*Lives of the Holy Fathers*), written before 1342.

23. Tommaso da Modena, *Portraits of Dominican Saints*, meeting room of the Dominican convent, Treviso.

24. Guariento, twenty-nine panels now in Museo Civico, Padua.

25. Lorenzo Ghiberti: in addition to the two statues mentioned at Or San Michele, *St. Stephen* for the Linen Drapers Guild.

26. Donatello: in addition to the two statues mentioned at Or San Michele, *St. Louis of Toulouse* for the council of the Guelph party (now in Museo Nazionale, Bargello, Florence).

27. Louis H. Sullivan (1856–1924), a pioneer of the Chicago School of architecture.

28. Fra Angelico, St. Peter Martyr altarpiece, Museo di S. Marco, Florence.

29. Fra Angelico, altarpiece for the Linen Drapers Guild, Museo di S. Marco, Florence.

30. Paolo Uccello, *Battle of San Romano* (dismantled): now in the National Gallery, London; Uffizi Gallery, Florence; and The Louvre, Paris.

31. Domenico Veneziano, *Adoration of the Magi*, Staatliche Museen, Berlin-Dahlem.

32. Donatello, *Jeremiah*, Museo dell'Opera del Duomo, Florence.

33. Donatello, *St. George and the Dragon*, marble relief below *St. George*, Or San Michele, Florence.

34. Donatello, *Mary Magdalene*, Baptistery, Florence.

35. Donatello: two bronze pulpits carved with reliefs of the Passion of Christ, Pentecost, and the martyrdom of St. Lawrence; on either side of nave, S. Lorenzo, Florence.

36. Leon Battista Alberti, *Della pittura*: written in Latin, 1435; published in Italian, 1436.

37. Alberti, *De re aedificatoris*, completed 1452, published 1485.

38. Vitruvius, *De architectura (On Architecture)*, written first century B.C.: published in Latin, 1486; in Italian, 1521.

39. The Nine Worthies, a popular theme in the fourteenth century; consists of three Old Testament heroes, three pagan heroes, three medieval Christian heroes.

40. Andrea del Castagno, *Niccolò da Tolentino*, Cathedral, Florence.

41. Antonio del Pollaiuolo, *David Victorious*, Staatliche Museen, Berlin-Dahlem.

42. Antonio del Pollaiuolo, *Martyrdom of St. Sebastian*, National Gallery, London.

43. Antonio del Pollaiuolo, *Birth of John the Baptist*, silver relief panel for altar frontal, Baptistery, Florence; now in Museo dell'Opera del Duomo, Florence.

44. Frescoes of the life of St. Peter Martyr, on exterior of Loggia del Bigallo, Florence

45. Desiderio da Settignano, tomb of Chancellor Carlo Marsuppini, S. Croce, Florence.

46. Antonio Rossellino, tomb of the Cardinal of Portugal, S. Miniato, Florence.

47. Andrea del Castagno, *Resurrection*, Cenacolo di S. Apollonia, Florence.

48. Piero della Francesca, *De prospectiva pingendi (On Perspective in Painting)*.

49. Piero della Francesca, two portraits: *Federigo da Montefeltro, Count of Urbino*, and *Battista Sforza, Countess of Urbino*, Uffizi Gallery, Florence. On the back of the count's panel, *The Triumph of the Count, accompanied by the Cardinal Virtues*; on the back of the countess' panel, *The Triumph of the Countess, accompanied by the Theological Virtues*.

50. Giovannino de' Grassi, sketchbook, Biblioteca Civica, Bergamo.

51. Pisanello, *Annunciation*, Brenzoni tomb, Church of S. Fermo, Verona.

52. Sir Thomas Malory, *Morte d'Arthur*, finished 1469–70.

53. Pisanello, the Vallardi Codex, so called after the owner who sold it to the Louvre, Paris, in 1856. Other drawings in numerous museums.

54. Pisanello, *Allegory of Lust*, drawing, Albertina, Vienna.

55. Jacopo Bellini, notebooks: on vellum, The Louvre, Paris; on paper, British Museum, London.

56. Jacopo Bellini, *Madonna and Child*, Accademia, Venice

57. Mantegna, *Parnassus*, The Louvre, Paris.

58. Guido Mazzoni, sculptural groups in terracotta of religious subjects, in Busseto, Modena, Cremona, Ferrara, and Venice; his masterpiece is the *Lamentation*, S. Anna dei Lombardi, Naples.

59. Antonio del Pollaiuolo, tomb of Pope Sixtus IV, Vatican Grottoes, Rome.

60. Andrea del Verrocchio, *David*, Museo Nazionale, Bargello, Florence.

61. Michelozzo, Cardinal Rainaldo Brancacci monument, S. Angelo a Nilo, Naples.

62. Battista Sforza, countess of Urbino; see above, note 49.

63. Antonio di Tucci Manetti, probable author of the biography of Brunelleschi.

64. Bust of Giotto, by Benedetto da Maiano; epitaph by Politian (1490).

65. Botticelli, *St. Sebastian*, Staatliche Museen, Berlin-Dahlem.

66. Girolamo Savonarola (1452–1495), a Dominican monk who came to Florence from Ferrara and called for reform of the Church through his writing and preaching. He dominated Florentine political life from 1494 on, but his accusations of church corruption led to his condemnation to death by burning.

67. Botticelli, *Mystic Crucifixion*, Fogg Art Museum, Harvard University, Cambridge, Mass.

68. Botticelli, drawings for Dante's *Divine Comedy*, preserved in Kupferstichkabinett, Berlin-Dahlem, and the Vatican Library, Rome.

69. Benedetto da Maiano, pulpit with narrative panels depicting the life of St. Francis, S. Croce, Florence.

70. Sistine Chapel wall frescoes: left wall, scenes from the life of Moses; right wall, scenes from the life of Christ. Other painters in the crew were Cosimo Roselli, Pinturicchio, Piero di Cosimo.

71. Perugino, *Crucifixion*, S. Maria Maddalena dei Pazzi, Florence.

72. Pinturicchio, frescoes of the life of Pope Pius II (Aeneas Silvius Piccolomini), Piccolomini Library, Cathedral, Siena.

73. Pinturicchio, fresco series in the six Borgia Apartments, Vatican, Rome.

74. Pinturicchio, frescoes of the life of S. Bernardino, S. Maria d'Aracoeli, Rome.

75. Luca Signorelli, *Scourging of Christ*, Brera, Milan.

76. Melozzo da Forlì, dome of Sacristy of St. Mark, Basilica of the Santa Casa, Loreto.

77. Francesco di Giorgio, Turin Codex: *Trattato di architettura civile e militare (Treatise on Civil and Military Architecture)*, written

after 1482, containing drawings and measurements of ancient buildings.

78. Vincenzo Foppa, *Crucifixion*, Accademia Carrara, Bergamo.

79. Vincenzo Foppa, frescoes of the life of St. Peter Martyr, Cappella Portinari, S. Eustorgio, Milan.

80. Destroyed, with works by many other artists, in the fire of 1577.

81. Pietro Lombardo, tomb of Antonio Roselli, S. Antonio, Padua.

82. Pietro Lombardo, tomb of Dante, Cathedral, Ravenna.

83. Niccolò dell' Arca, tomb (*arca*) of St. Dominic, S. Domenico, Bologna.

84. Giovanni Bellini, *Pietà*, Brera, Milan.

85. Giovanni Bellini, *St. Vincent between Sts. Christopher and Sebastian*, with *Annunciation* and *Pietà* above, SS. Giovanni e Paolo, Venice.

86. Giovanni Bellini, Pesaro altarpiece, Pinacoteca, Pesaro.

87. Giovanni Bellini, *Resurrection*, Staatliche Museen, Berlin-Dahlem.

88. Giovanni Bellini, *Transfiguration of Christ*, Museo Nazionale di Capodimonte, Naples.

89. Giovanni Bellini, S. Giobbe altarpiece, Accademia, Venice.

90. Giovanni Bellini, Frari altarpiece, Sacristy, S. Maria dei Frari, Venice.

91. Giovanni Bellini, *Madonna of the Trees*, Accademia, Venice.

PART TWO # The

High Renaissance

in Italy

SUPPLEMENTARY NOTES, PAGES 262-263

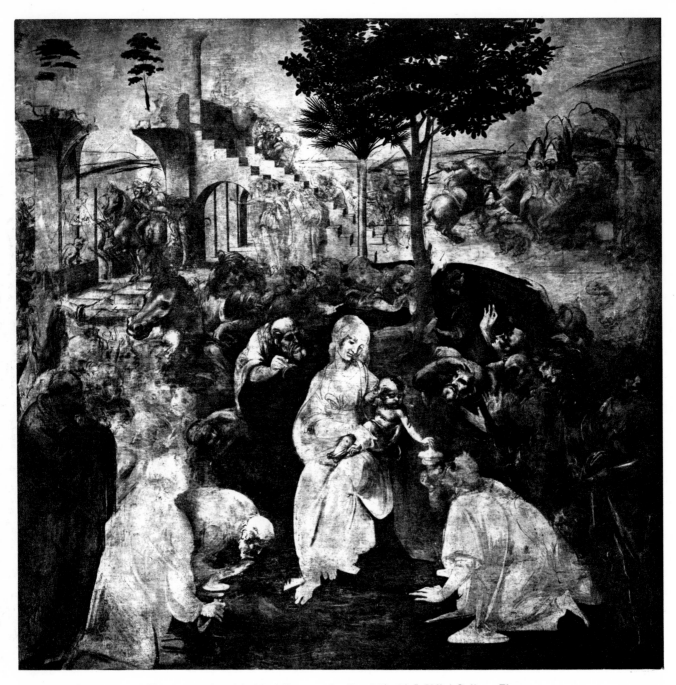

176. LEONARDO DA VINCI. *Adoration of the Magi*. Begun 1481. Panel 8′ × 8′1″. Uffizi Gallery, Florence

1. Leonardo to 1500

Leonardo da Vinci (1452–1519), one of Verrocchio's many pupils, stayed in his shop for some years as a foreman painter, and there produced the first High Renaissance painting. Verrocchio painted his *Baptism of Christ* (see fig. 142) in his familiar style, with wiry, real figures and a low perspective. As usual in this story, two angels hold the clothes, but they are painted in different ways. One has a face with a neat contour line, round eyes, and shiny hair, and sits up straight; the other turns its neck like a swan, and has fluffy hair into which one sees, and eyes into which one also sees, just as one does into the jewels, like pools. This figure is by Leonardo, and so too is a part of the landscape that is a continuum of dim light rather than a stack of rocks. He may also have retouched Christ's skin, yielding flesh unlike the linear strict metal of John's. Leonardo is presenting a further level of visual realism, available only when an earlier level has been mastered: things do not heve boundary lines, but yield to other things as they begin to turn a new side. Life is a continuum of organic motion, like the angel's turning neck and many things that Leonardo later drew with special interest: water, grassy plants, hair, the action of running, dust—all not so much things as processes. It was recognized at once that Leonardo had created a modern kind of art, and younger artists found Verrocchio and all his generation stiff and unsubtle. This is already the High Renaissance, which was quickly to produce so many particularly famous artists: Michelangelo, Raphael, Titian. A reason for this is that painting was felt to be actually improving technically as it became more realistic (so older artists were cast aside), but this group reached the final stage of realism (and so remained in honor); later generations could not continue further in the same direction, but only rearrange the same elements.

Before the *Baptism,* Leonardo had probably painted the more traditional *Annunciation,*[1] and the portrait of *Ginevra de' Benci,*[2] with shadowy water and skin but lacquered hair. His first big commission was for the *Adoration of the Magi* (1481; fig. 176), which remained unfinished (when he left to work for the duke of Milan) with the figures

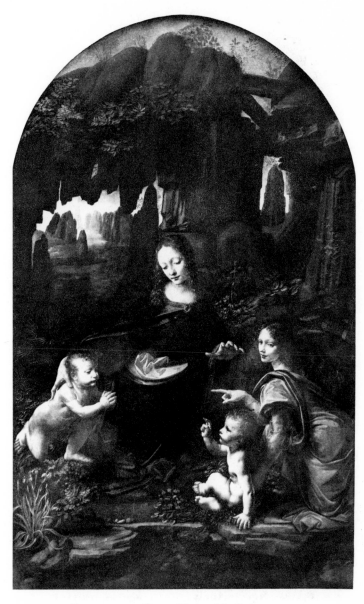

177. LEONARDO DA VINCI. *Virgin of the Rocks.*
Panel, transferred to canvas, 78″ × 48″.
The Louvre, Paris

blocked out in a light brown tone on a deep brown background, so that they seem at first to be leaning out of caves. When one has looked long enough to read the picture better, one sees the extraordinary dynamics of the people's lives, reflecting a moment of drama with tremulous variety. The background with leaping horses is equally in the process of a

147

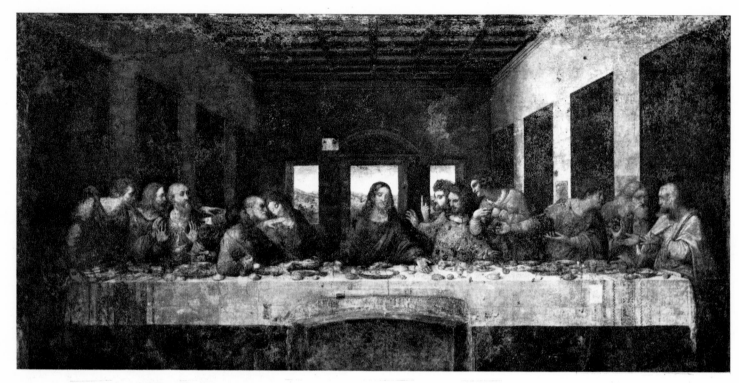

178. LEONARDO DA VINCI. *Last Supper*. 1495–97. Mural, 13′9″ × 29′10″. Refectory, S. Maria delle Grazie, Milan

moment. But at the same time Leonardo rethought the traditional composition of this story, which showed two groups meeting each other in profile, the Holy Family and the Three Magi, a natural treatment. Leonardo gives it a central emphasis and thus a stronger focus on the Holy Family. He is like a scientist in that he observes phenomena intently but also likes to deduce regular schemes from them, laws or patterns; both the phenomena and the order are more complex than before. The same composition recurs in the *Virgin of the Rocks* painted in Milan, a central group in a cave (fig. 177). The cave is an old motif which suits Leonardo, who remarked that it is helpful to paint people in the shade.

In the *Last Supper* for a monks' refectory in Milan (1495–97; fig. 178), he reorganized the old design of this theme, which had been a row of thirteen people like a group photograph. He sub-divided them into a pattern of three, three, one, three, and three, while also heightening the sense of the spontaneous instant. The painting soon lost its color because Leonardo did not paint it in the usual fresco technique but used oils, an experiment through which he hoped to gain more shadow. Experiments, not always successful, were stimulated by his universal curiosity about how things work and live, and he couldn't take any tradition for granted. He hoped to cast in bronze a statue of a man on a leaping horse, using a design seen on Roman coins, but had to settle for a more modest effort, with a quietly walking horse that carries the weight of the bronze on all four feet.[3] His revolving stage worked, but his project for a canal failed. At this time he was also keeping anatomical notebooks and exploring the basis of architectural proportions.

2. Filippino Lippi and Piero di Cosimo

Young Florentine painters of the 1480s felt Leonardo's impact at once, even in his absence, somewhat shifting the center of gravity from the methods of the dominant figures, Botticelli and Ghirlandaio, who had formed their own methods in the 1470s. Filippino Lippi (docs. 1467–d.1504) is obscure as an apprentice to his father Filippo and later as an assistant to Botticelli, but then emerges with an approach built on Ghirlandaio's. He too takes perspective space to be routine, often making it symmetrical, and pays homage to the old masters, most strikingly when he modifies his personal style in adding scenes (a typical enterprise of the time) to Masaccio's unfinished Brancacci Chapel fresco cycle (see p. 74). Homage to the past and to exotic Flanders join in his early masterpiece, Saint Bernard's vision of the Virgin (fig. 179), a composition closely derived from Rogier van der Weyden's *Saint*

180. FILIPPINO LIPPI.
Triumph of St. Thomas Aquinas. 1488–93.
Fresco, width of wall 7'10".
Caraffa Chapel, S. Maria sopra Minerva, Rome

179. FILIPPINO LIPPI.
The Vision of St. Bernard. Panel, 6'10" × 6'5".
Badia, Florence

Luke Painting the Virgin (see fig. 374), so conveniently similar in theme. Yet Filippino's is highly personal. Rocks zigzag outward like roughly piled books, little monks gesticulate like actors, little devils peer from crannies, pages curl; and the saint's pose and his fingers in vibration—all use sensibility of line to induce unsettled nervousness. Despite Filippino's reliance on line, Leonardo's ideas appear in the strong shadow and, more basically, in the insistence on living processes. A major fresco in Rome, the *Triumph of Saint Thomas Aquinas* (begun 1488; fig. 180), gives us a Ghirlandaio city view beyond a symmetrical room, but in front the shrill debating among the scholars is made visual in the thrown and torn books, forming a still life of intellectual tension. In his most important fresco cycle in Florence (finished 1502)[4] the scene of *Saint Philip Destroying a Dragon* sets up a symmetrical wall strung with lamps like a nervous Christmas tree, and similar fussy decoration bestrews the *Resurrection of Drusiana,* in a design quoting

Giotto. For a patron who admired Savonarola he painted a hollow-cheeked Christ in a *Crucifixion* on a gold background,[5] a medievalism that seems suitable since Savonarola's preaching of doom and Filippino's forms both combine anxiety and archaism.

Piero di Cosimo (1462–1521) worked chiefly for rich private houses where a non-Savonarolan paganism was cultivated. He painted some beautiful if unoriginal altarpieces, with deeply glowing color surfaces and occasional anecdotal tokens of admiration for Flanders, but his fascinating work is secular. Its unique themes have their kinship, and that remote, with second-rate engravings that had been made to illustrate books of history and mythology; he makes them as sophisticated as Botticelli and humorous as never before. A series showing primitive men hunting seems to reflect the amused curiosity of a patron about a learned theory of the origins of human civilization, quite un-Christian. The *Discovery of Honey* (colorplate 25) is part of another set similar in mood, a comedy of the weaknesses of the Greek gods. Piero enters into this spirit by painting figures that are properly modeled but always a bit eccentric in their gestures and faces. Somewhat more Botticellian in evocation, and Leonardesque in lighting, is the *Death of Procris*,[6] a tragic love story from classical poetry, where people of a species slightly different from the human appear as statuesque victims, in a rich landscape. A head of Cleopatra is a fancy portrait,[7] a real but odd profile before a live sky. His only actual portraits were done for a friend, the architect Giuliano da Sangallo.[8] All his work over forty years is undated (consistent with his minor-league practice), adding to the puzzles. He has irrelevantly been admired recently as a pre-Surrealist because of the surprising connections among real things in his work, but his painting manner was conservative in his time and uninteresting to young artists, so he was forgotten.

3. Painting in Milan after Leonardo

Foppa, the finest painter in Milan among the generations just preceding, must have seemed, with his gray atmospheric art, to have prepared the ground for local painters to receive Leonardo (see fig. 166). Many young ones were so carried away that they could only copy him. A few soon made their mark by treating these copies explicitly as decorative objects; later others gained strength by retreating partway into tradition. There is a laboratory of tension here between a settled conservative tradition and a modern import.

Of the first group, Boltraffio (1464–1516) painted smiling Madonnas turning their heads in the darkness, but his enamel-like firmness of texture and brightness of hue seem to contradict Leonardo's meaning. Andrea Solario (docs. 1495–d.1524) also produced Madonnas, of which one has become an anthology piece, the *Virgin with the Green Cushion*.[9] Leaning over the Child's body, she is all curving smiling intimacy, with pretty decorator's colors, within the Leonardesque context. Solario's thoughtfulness about what space can do emerges also in portraits, notably his late *Chancellor Morone* (fig. 181), impressively staring, with his hands projected in front of him on a table and concentrating his personality.

Of the later group Sodoma (1477–1549) first emerges from provincial Vercelli, fifty miles west of Milan; like Leonardo, he traveled south in 1500. He saw the current work of Perugino and Pinturicchio in Rome before settling down to become the leading artist in Siena. There he continues to out-Leonardo the Leonardo style of about 1504, twining and gauzy. A once-famous *Saint Sebastian* (1525)[10] lifts his slashed body in almost smoky ethereality, gazing at Heaven; to late Victorians he seemed inspired, to more recent observers, sugary. The swooning of *Saint Catherine of Siena* (begun 1526),[11] a limp gray S-curve, seems to foretell Bernini's *Saint Theresa* and the Counter Reformation, which in some respects tap a permanent aspect of human concern. Current taste finds Sodoma most acceptable

when, back in Rome, he paints a fresco of the *Marriage of Alexander and Roxana* for the house of the Sienese banker Agostino Chigi (fig. 182). The bride, featherily melting, realizes a type seen in Leonardo's drawings, and the bridegroom is a neoclassic Apollo in profile, surrounded by columns.

Bernardino Luini (docs. 1512–d.1532) may have learned from Sodoma. He emerges in a Leonardesque vein when already mature, and his smiling Madonnas refer back to the earth tones and firm modeling of the fresco medium. He is most interesting in secular villa decorations, with narratives from the Old Testament, mythology, and, surprisingly, daily life, where people stand about as if unable to move, inflexible poles for all their graded textures. Luini's style is dehydrated Leonardo, using the comfortable local tradition of Foppa, and had in its archaism the special virtue for Victorians of the cushioned primitive, pure but easy, like Fra Angelico and others.

Still more archaic is Gaudenzio Ferrari (docs. 1508–d.1546), who spent most of his life in Vercelli. His art is less of the provinces than of folklore; he

181. ANDREA SOLARIO.
Portrait of Chancellor Morone.
Panel, 29″ × 24″.
Collection Duke Gallarati Scotti, Milan

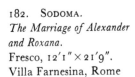

182. SODOMA.
The Marriage of Alexander and Roxana.
Fresco, 12′1″ × 21′9″.
Villa Farnesina, Rome

worked in country sanctuaries where painted wooden statues of the Christian story stood before backdrops of frescoed crowds. The Passion-play tone accompanies profuse storytelling, borrowing compositions at times from Dürer woodcuts. The exuberant patterns of drapery, in stylized swirls, setting up an abstract fanning motion in the figure, have no Italian parallel, but have ties to mountain artists farther north, like Nicolas Manuel Deutsch, or the Master H. L. and other carvers of wooden altarpiece complexes at this date (see pp. 332–33). Gaudenzio's sense of the fluid figure is the only evidence of Leonardo's passage, in a style one generation away from Gothic.

151

4. Bramante

Another great artist in Milan besides Leonardo was establishing the High Renaissance by his work during the same twenty years. Donato Bramante (1444–1514) was born near Urbino, and trained as a painter probably under Piero della Francesca, but his few surviving paintings are more influenced by another visitor there, Francesco di Giorgio. He is first seen in Milan as the designer of a strange engraving, apparently an illustration of perspective to assist painters, parallel to Pollaiuolo's for anatomy (fig. 183; see fig. 109). As if it had marked a transition, he then settles into being an architect. His remodeling of Santa Maria presso San Satiro (from 1482; figs. 184, 185, 186) attracted Leonardo's attention; Bramante was repeating Francesco's move

183. DONATO BRAMANTE. *Architectural Fantasy.*
Engraved by Previdari after a drawing by
Bramante. 1481. 29″ × 20″. British Museum,
London

to architecture, and Leonardo was also interested in Francesco's expert bronze casting and proportion theory, so that stimulating interplay can be guessed. San Satiro has a circular chapel with niches cutting into it, rhythmic concave accents in the convex mass, and this is topped by an octagonal lantern with windows cut deep in each side. Decisive managing of a central plan by pure three-dimensional units, alternate masses and voids, is basic to Bramante. The main interior area is dominated by a heavy barrel vault over nave and transepts, climaxed in the hemispherical dome over the crossing. The fourth crossarm is a fake, a perspective optical illusion of a choir, recalling Bramante's start as a painter; a nearby street left no room for that crossarm to develop symmetrically with the others. Its visual purpose is to reinforce the sense of space stretching outward from where we stand, as in the inside of a balloon. The same suggestion is made on a larger scale in the choir of Santa Maria delle Grazie (1492–97; figs. 187, 188), where a harmonious space on the scale of grandeur is bounded at the far end and above by semicircular masonry. Our view extends deeply and then is closed in a cup, a pressure and return balanced by the equipoise of the measurements and by the massiveness of the plain walls. We are still at the center of the rational cosmos, but it is no longer of human scale; the new growth implies that we, no longer equal with our environment, may become either overawed by it or manipulators of it, just as Leonardo's science was attentive to awesome natural forces and also sought their control.

Going to Rome with some thought of retiring and studying antiquities, Bramante found a new career among the many new projects there. The modest cloister for Santa Maria della Pace (1504) alternates stocky piers and voids as equal forces, thus again making three-dimensional units from the original modules. Attached to the piers are not classical half columns but pilasters, sliding down the sides of the piers and maintaining the unity of vocabulary in a second melodic line. The small shrine built in 1502 beside San Pietro in Montorio

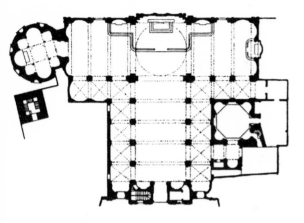

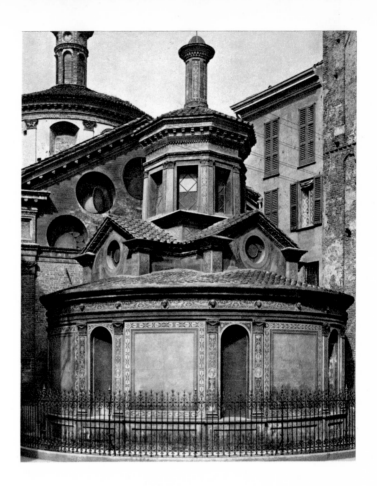

184, 185. DONATO BRAMANTE.
Plan of S. Maria presso
S. Satiro, Milan,
and exterior of circular chapel.
Begun 1482.
Nave 200′ long; transept 226′ wide;
height of chapel 48′6″

to mark the spot of Saint Peter's crucifixion (figs.
189, 190), too dignified to be called a jewel box,
instantly became, as "the Tempietto," a classic work
defining the High Renaissance, like Leonardo's
Last Supper. It is a ratio between two cylinders, an
inner, tall, solid one and an outer, short, transparent
one; the solid one is articulated with concavities,
the transparent one with columns; the whole was
intended to be inserted in a circular courtyard, a
dynamic celebration of the circle as an evocation of
perfection.

Thus Bramante was ready to undertake the
new Saint Peter's, where the imperious Pope Julius
II proposed to tear down the greatest landmark of
the city and replace it with the world's largest church,
within which (then or soon after) he planned to
give a dominant location to his own tomb. Bramante
planned the church (1505–6) as an equal-armed
cross, with a central dome over four huge piers (figs.
191, 192). The arms are huge niches ending in semi-
circles; each has its own transverse arms and so do
those arms; thus he fills a square which consists of
spaces thrown off from the center and then from
smaller and smaller centers. The piers also are
gouged by niches balancing opposite niches, so that
the central piers have an intricate profile, logical
and lively like one of Francesco di Giorgio's forts.
All this is on an immense scale, and Bramante only
had begun to build the central crossing when he
died at seventy.

186. DONATO BRAMANTE. Interior,
S. Maria presso S. Satiro, Milan. Begun 1482.
Height under arch 34′9″, depth of choir 4′

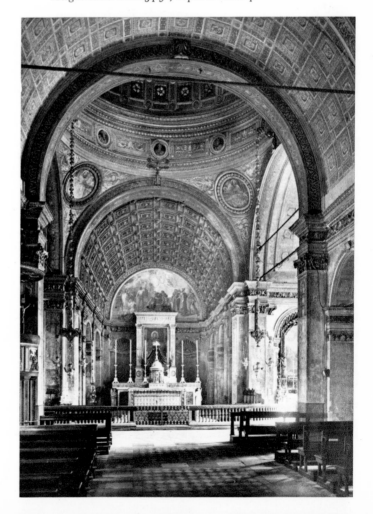

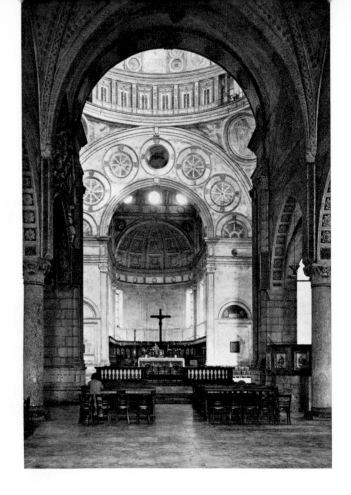

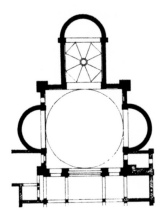

187. DONATO BRAMANTE. View toward choir,
S. Maria delle Grazie, Milan. Begun 1492.
Height of crossing 110′

188. DONATO BRAMANTE. Plan of choir,
S. Maria delle Grazie, Milan. Begun 1492.
Choir area 120′ × 102′

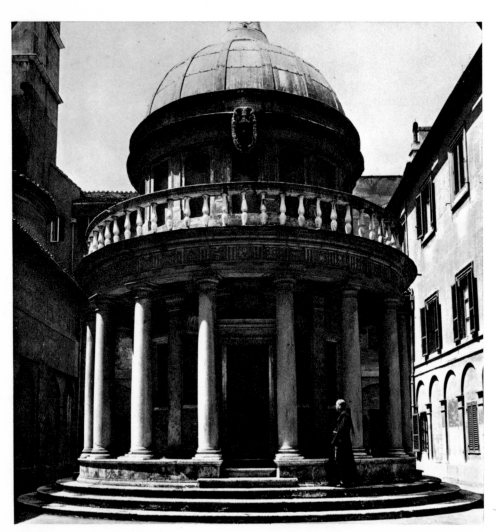

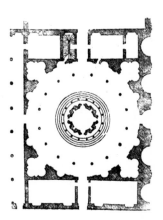

189. DONATO BRAMANTE. Tempietto,
S. Pietro in Montorio, Rome. 1502.
Height 47′

190. DONATO BRAMANTE. Plan,
Tempietto, S. Pietro in Montorio,
Rome (woodcut from Serlio, *Il terzo
libro d'architettura*, 1551).
Diameter including steps 37′

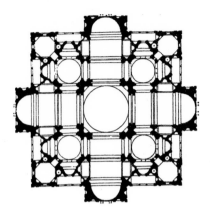

191, 192. DONATO BRAMANTE.
Plan and perspective study of St. Peter's,
Vatican, Rome. 1506. 544′ square
(anonymous drawing, ink and pencil,
Gabinetto dei Disegni, Uffizi, Florence)

193. ANTONIO DA SANGALLO THE ELDER.
Interior, Madonna di S. Biagio,
Montepulciano.
Height 136′; 104′ square

194. BRAMANTINO. *Crucifixion.*
Canvas, 12′2 1/2″ × 8′10 1/2″.
Brera, Milan

Bramante's arrival in central Italy is reflected in the rise of central-plan churches of sonnet-like orderliness, much more modern than Giuliano da Sangallo's and somewhat more so than Francesco di Giorgio's. Santa Maria della Consolazione at Todi (begun 1506, perhaps on a Bramante design), has an interior much like Francesco di Giorgio's at Cortona not far away, with four equal semicircular arms, but its dome is much more ornate. Giuliano da Sangallo's younger brother Antonio (1455–1534), mostly a builder of forts, produced his masterpiece in San Biagio at Montepulciano (1518; fig. 193). The walls are still thicker and more orchestrated, with niches cut in, columns bounding these, and a frieze of metopes running above. This heavier vocabulary is part of the monumentalization that concerned Bramante.

In Milan Bramante had left one remarkable disciple in painting, called by the nickname Bramantino (docs. 1503–d.1536). His figures in perspective space are plotted at scattered points like chessmen, vertically stiff before diagramed walls (fig. 194). This now archaic fixity is accented further by viewpoints from below making them bizarrely schematic as they evolve from jointed shapes, like Erocole de' Roberti's, to a Raphaelesque classicism. This is an antimodern Mannerism like Gaudenzio Ferrari's, but complete and expressive within its own constructed world.

5. Leonardo's Last Years

Leonardo's return home to Florence in 1500 was exciting to young artists, who watched attentively his work on the cartoon—the full-scale drawing—of his *Virgin with Saint Anne* (fig. 195). He had already prepared one version in Milan, and still later painted it in a third form. The theme is essentially medieval, designed to expound the genealogical relationship of grandmother, mother, and child, a diagram of meaning and not a report of the visible. But Leonardo liked it as a token of processes of growth, like the theme of Leda and the Swan[12] that he was also working on. In both subjects the figures

twine among each other or among plants, a sinuousness accompanied by a further reduction of the edges between forms and air. The newly formed republican government of Florence commissioned a Cavalry Battle (1503–6; fig. 196) to be painted in its assembly room in the city hall, a work intended (like a similar commission to the younger Michelangelo; see fig. 203) to show off both a military victory and the specialty of the leading Florentine artist. Horses leap against each other, fighting men are interlocked, the dust rises, anatomical detail is absorbed into speedy motion. This painting was

195. LEONARDO DA VINCI.
The Virgin with St. Anne.
Charcoal on paper, 55″ × 40″.
National Gallery, London

never finished, but Leonardo did paint the portrait of a citizen's wife which we call *Mona Lisa* (fig. 197). The famous smile is another image of a process, a face in motion, but as in the *Last Supper* new observations are combined with new patterns in this finished painting. The folding of the hands, which seems quite ordinary, is a device to provide a convincing base for a half figure, and indeed, it turns the forms into a pyramid, rising and narrowing with the inevitability of a theorem. Another product of these years is his supervision of Gianfrancesco Rustici's (1474–1554) large bronze group above one of the Baptistery doors, *John the Baptist Preaching* (1506; see fig. 56), the closest we can come to a sculpture by Leonardo. Traditional in its simple poses, it is vibrantly animated in its surfaces and gestures in a way otherwise seen at this time only in small-scale works.

Leonardo's wandering last years are mainly represented by drawings (figs. 198, 199). At this time he made most of his anatomical studies, which are rightly called not so much anatomy as physiology, since, unlike those in modern medical textbooks, they convey the function and action as well as the forms. It was now too that he speculated about the flight of birds, and the oceans that had covered mountains in past epochs, and made the drawings of floods that extend beyond physical experiments to an imagery of doom, either a personal feeling or a dramatic creation.

196. LEONARDO DA VINCI.
The Battle of Anghiari
(copy by Peter Paul Rubens).
Designed 1503–6.
Pen, ink, and chalk, 18″ × 25″.
The Louvre, Paris

157

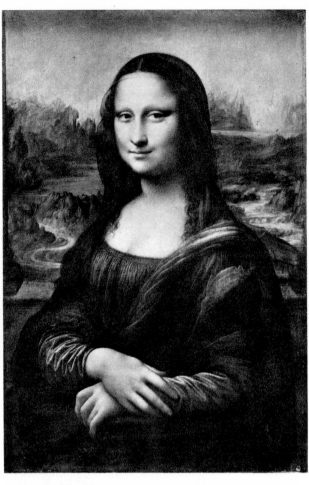

197. LEONARDO DA VINCI. *Mona Lisa*.
Panel, 38″×21″.
The Louvre, Paris

199. LEONARDO DA VINCI. *Deluge*.
Chalk, 6 1/2″×8 1/4″.

6. Young Michelangelo

Michelangelo's (1475–1564) family had some social pretensions, so until he was thirteen he stayed in school rather than being apprenticed. Then he entered the shop of the favorite painter of Florentine society, Ghirlandaio, but did not like it much, if his later memory is trustworthy. Perhaps reaction drew him to sculpture, though not to the style then practiced, which was similar to Ghirlandaio's. His natural refuge was in a greater past, in this case Donatello and ancient Roman sculpture, both to be seen in the Medici collection. The two were combined in the work of Bertoldo (docs. 1461–1491), once an assistant to Donatello and now the keeper of the Medici antiquities, probably as a restorer. The boy was allowed with others to study the objects and was even, he said later, a regular guest at the Medici table. This seems possible in the light of his first sculpture, at about age sixteen, a battle of men and centaurs in high relief.[13] It was stimulated by a court poet's reading of a Latin poem on this theme, and imitates Roman sarcophagi in marble as Bertoldo does in bronze. But it is uncourtly art, with simplified and very dense forms, suggesting the collision of intertwining volumes.

A break in Michelangelo's life resulted from Lorenzo de' Medici's death in 1492 and the fall of the family from power, when Savonarola became the city leader. A puritan evangelist, Savonarola opposed all but devotional art, and the evidence that Michelangelo supported him is shaky. After working in Bologna and returning home briefly, Michelangelo took a *Cupid*[14] to Rome and there carved his first large work, *Bacchus* (fig. 200); both were anti-Savonarolan in theme. The *Bacchus* is technically bold, perhaps suggested by Rossellino's *Saint Sebastian* (see fig. 116). The god, again dense in volume, teeters and turns drunkenly, with an action suitable to the statue's original placement in the middle of an outdoor space. It was followed at once by his big *Pietà* (fig. 201), a theme not then standard in Italian sculpture though familiar in painting (it is unfortunate that fame has given this example the popular title of *"The" Pietà*). Among earlier ones, the painting by Ercole de' Roberti in

200. MICHELANGELO. *Bacchus*.
Marble, height 6'8".
Museo Nazionale, Bargello, Florence

Bologna (see fig. 137) was probably familiar to
Michelangelo. The image of Mary with the dead
Christ on her knees had first emerged as an abbrevia-
tion of the scene of Christ mourned. The power of
this over-lifesize polished marble comes from its
volume, since it is restrained in expression and
gesture; the Christ's face derives from Verrocchio
(see fig. 141). The group absorbs its contrasts of
vertical and horizontal, clothed and naked, living
and dead, into one moundlike mass. At twenty-four
Michelangelo was clearly the most talented sculptor
around, but he had not modified tradition.

He found Savonarola gone when he returned
to Florence in 1501, and a republic now anxious to
re-create the age before the Medici takeover of 1434,
including the big public works of art. The city and
other public bodies expropriated some Medici-
owned statues and commissioned new works like
Rustici's bronze group and Michelangelo's *David*
(1501–4). This colossal figure (fig. 202), set up before
the city hall, is in the same bland, quiet, balanced
weighty style as the *Pietà*. But by the time it was
finished Michelangelo had changed his ideas. Side

203. MICHELANGELO.
Battle of Cascina (copy).
Designed 1504.
Grisaille on panel, 30″ × 52″.
Earl of Leicester, Holkham Hall
(courtesy Courtauld Institute of Art,
London)

by side with Leonardo he began (1504) his own big scene for the city hall assembly room, likewise patriotic and geared to his specialty (fig. 203). This *Battle of Cascina* showed soldiers, who had been swimming, answering an alarm, athletic nudes in complex positions. It is a solider revision of Pollaiuolo's engraving (see fig. 109), with figures in three neat rows. Naturally influenced by Leonardo, as all young artists in Florence were, Michelangelo concentrates on force in process, and yet this is no less dense in weight than the earlier works. From now on a seeming contradiction, great solidity fused with fervor of action, creates the special power of Michelangelo's works.

7. Young Raphael

Raphael (1483–1520) is perhaps the least liked today of artists generally admitted to be great. He seems to approve and praise the world too readily and create too easily. He was indeed a "quick study" of every style he saw, and could without strain rework any into his own unmistakable synthesis. But he constantly abandoned the elegant results to try new ones, often more problematic.

His father, a painter in Urbino, died when Raphael was eleven, and he worked under Perugino before becoming an independent master at seventeen, a little younger than average but not prodigious. The altarpieces he painted for Perugia and still smaller places are in the undramatic local tradition of Perugino and Piero della Francesca, with suave figures in cool space. Yet from the start his people are warmer and more mobile than Perugino's, their contour lines not just traced but swelling with gentle breath; this was partly because he was a talented and critical pupil and partly because

he had also seen Signorelli, the strongest painter of the area. At first he is most accomplished in small panels like the *Three Graces* (fig. 204), where shifting curved line bonds the soft skin to the deep soft air. In 1504 he moved to bigger competition in Florence, where he painted small Madonnas and portraits while continuing to get altarpiece commissions from Perugia. The portraits of Angelo Doni (fig. 205) and his wife[15] reflect Leonardo's *Mona Lisa,* with pyramids growing from a base of bent arms, but exclude the potential of motion and of psychology in favor of pure pictorial effects, with emphatic structural areas of color. This is when most of the traditionally famous "Raphael Madonnas" were painted (fig. 206). They relate the two figures dramatically through changing patterns of curves, such as the forearms of mother and child enclosing each other reciprocally. Here the two available traditions, the geometric-spatial one of the small central Italian towns and the mobile-

161

204. RAPHAEL. *The Three Graces*.
Panel, 7″ × 7″.
Musée Condé, Chantilly

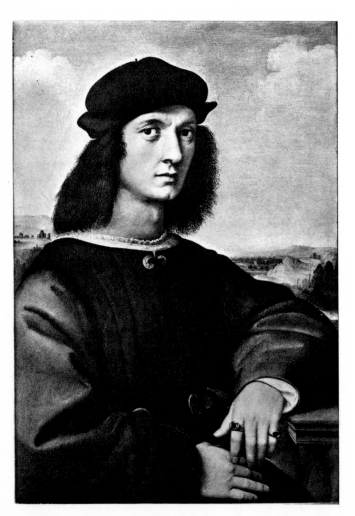

206. RAPHAEL. *La Belle Jardinière*.
Panel, 48″ × 31 1/4″.
The Louvre, Paris

205. RAPHAEL. *Angelo Doni*
Panel, 24″ × 17″.
Pitti Palace, Florence

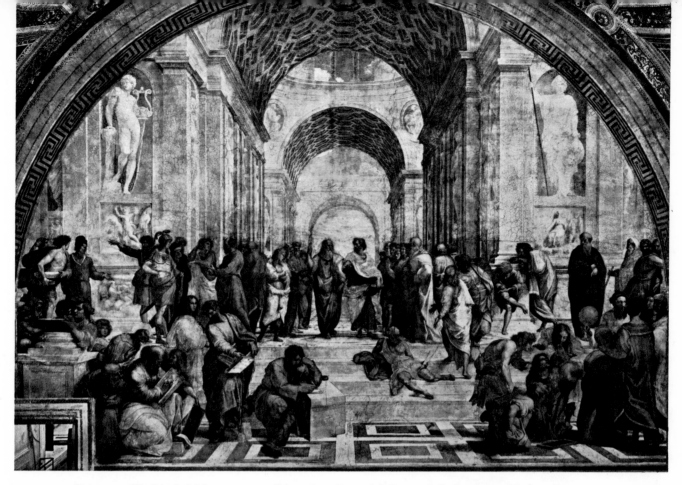

207. RAPHAEL. *The School of Athens.* 1509–11. Fresco, base line 25′3″. Stanza della Segnatura, Vatican, Rome

figural one of recent Florentine painters, are completely blended, so that Raphael almost restores their common source in Masaccio; hence when he makes a big fresco it will resemble the *Tribute Money*.

In 1508 he went to Rome and suddenly was challenged by a large commission from Pope Julius II for a roomful of frescoes. In the resulting Stanza della Segnatura (1509–11) he responds with his usual apparent ease. Since the room is vaulted, each wall is a big half-circle, and the rather unvisual themes assigned were Theology, Poetry, and Philosophy, along with smaller images (colorplate 26, fig. 207). Raphael presents the ideas through groups of theologians, poets, and philosophers in conversation. Like Leonardo designing the *Last Supper,* he evades lining them up as for a group photograph and invents softly changing rhythmic patterns of action which add up to a general symmetry. Listeners turn their heads keenly, smile and point; chains of curves set up animation and repose; a muse's continuous quarter turn is measured by the folds in her robe and finished off in her head and feet.

Homer very graphically thrusts out a hand in the classic gesture of a blind man, and is also dictating to a scribe who twists his head up to hear. It is a vividly recognizable anecdote which also stays within a formal choreographic system of curves. The Poetry wall has a window; there Raphael set the poets on Mount Parnassus, which rises around the window as if it were not awkward, and indeed we never notice how peculiar the shape of the painted surface is. For Philosophy Raphael designed a grand space reflecting Bramante's intentions for Saint Peter's. Huge vaults and piers, alternating with spaces, reverberate into the distance; to this the imposing Masaccio-like figures respond in a dignified parade. With this work, the *School of Athens,* Raphael established his permanent authority as the master of the High Renaissance figure, softly tonal and sculpturally firm, majestic and restrained, spontaneously alive and produced by formulas of grace. Having done so, he at once abandoned it to explore wholeheartedly what he had already taken into account, the more difficult imagery of his strongest rivals, Michelangelo and the Venetian painters.

163

8. Andrea Sansovino; Fra Bartolommeo

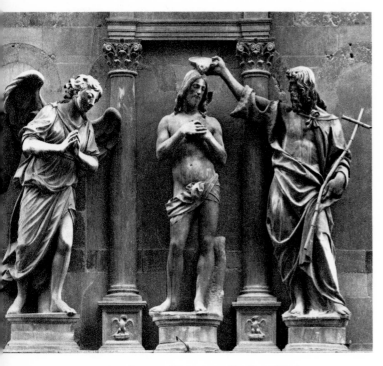

208. ANDREA SANSOVINO. *Baptism of Christ*
(above "Doors of Paradise"). Begun 1502.
Bronze, height 9′3″. Baptistery, Florence

of big outdoor sculpture like Rustici's group over another door on the same building (see fig. 56). The easy full-fleshed movements, gracefully inter-related and alive, are readily labeled "Raphael-esque," yet the work is earlier than Raphael. Rather both artists were moving toward the High Renaissance orchestration of the figure, less linear and more monumental, imposing in a way that is some-times academic. Sansovino was learning from Roman art and Leonardo, and also from individual bold works of his predecessors, like Antonio Rossellino's *Saint Sebastian* (see fig. 116). Rossellino also is behind Sansovino's most startling experiments with the spatial depth of marble reliefs, undercutting figures and objects in a technically involved and clever way whose excitement depends on its virtuosity. Like some of his contemporaries carving in

209. FRA BARTOLOMMEO.
Marriage of St. Catherine. 1511.
Panel, 8′5″ × 7′7″.
The Louvre, Paris

By the time of Michelangelo's generation, second-rank artists in Florence were also involved in the High Renaissance. Andrea Sansovino (docs. 1491–d.1529) always belonged solidly in the local carving tradition, but seemed to enjoy the experimental end of its range. He was perhaps an apprentice to the little-known but lively Francesco Ferrucci (1437–1493), an associate of Verrocchio. His first marble altar in Florence[16] and his later tombs of two cardinals in Rome (1506–9)[17] use the same thin running ornament as Mino da Fiesole, but some of the figures are surprising in their open-mouthed athletic pressure. His first monumental work, a *Madonna* for Genoa Cathedral (1504), lets grandeur grow in a controlled breadth of curvilinear power which, as in the young Michelangelo, is an appeal to ancient Roman art. This reaches its peak in his masterpiece, the two over-lifesize figures of the *Baptism* (begun 1502; fig. 208), a group for the Florence Baptistery that is part of the new campaign

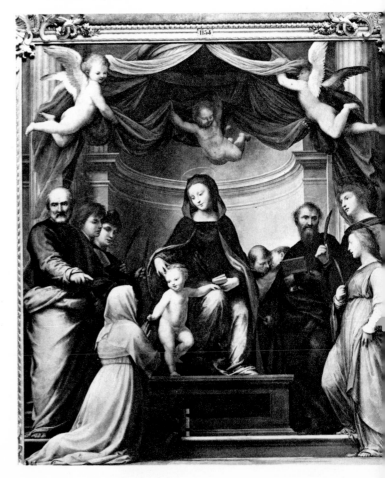

north Italy, he is essentially an expert craftsman whose vehicle, following Leonardo, happens to be the High Renaissance.

Far Bartolommeo (1472–1517) also gives the impression that Leonardo and Raphael had affected him, before it was possible. In an early *Last Judgment* (1499–1501),[18] a warming up of a neat Perugino-like arrangement does indeed fit in with the 1490s, including an application to a more traditional layout of Leonardo's shadowy figure modeling in the early *Adoration*. When he joined the Dominican order in 1500, he stopped painting for three years, but then emerged as such a master of the traditional formal altarpiece that he succeeded without question to the leadership of Florentine painting in 1508, when Leonardo and Raphael had gone away and again a "second team" remained. The figures in his large paintings are still related to their world in the Perugino way, fixed in silhouette against an abstract sky, but we are not visually reminded of Perugino because these figures, swathed in toga-like robes, have such dignified breadth and easy stances. The shadowing of the surface means that the tie between figure and air is not a cutting contour but an absorbent unity (fig. 209). The semicircular plans, the emotional detachment of saints each related only to the viewer, the fixity of position, seem oddly like a throwback to "diagrammatic" Dominican imagery of the fourteenth century (see fig. 45). The construction of the figures, with a brush stroke like Leonardo's or Raphael's but without those artists' related dramatic evocation of human meaning, gives us a High Renaissance academic style. After a visit to Rome in 1514, when he saw the newest works by Raphael and others, Fra Bartolommeo takes this tendency further, painting huger but still more vacant people. Academicism also seems hinted at by the disconnection between his finished paintings, with their increasing limitation to pure profile and full face, and his loose, sparkling drawings of figure groups, not to mention the direct original naturalism of his landscape drawings. These drawings had to be dehydrated for use in the paintings, just as happened later in the classic home of the academic, seventeenth-century Bologna.

9. Andrea del Sarto

Andrea (1486–1530) is the first artist of talent in Florence who finds the High Renaissance already an institution. His predecessors, including Raphael, had worked to construct a set of forms for representing the human figure that would convey their discoveries of its reality. Andrea, like artists who admired Raphael in later centuries, simply used that set of forms, so that he evolves not in a steady linear increase of control of reality but in a meander among available forms according to his taste. This changed situation is connected with the tag calling him "the faultless painter," which means that it is the best one can say of him: he is highly accomplished but not original. It is also connected with the brilliance of his drawings, mostly of the figure or (unlike Leonardo) sketches for paintings. But their freshness and loose contours are retained in the paintings, which thus never become chill, and so contradict the idea of academicism, unlike Fra Bartolommeo's.

Since Andrea was so obviously an admirable craftsman, it seems fitting that his early works are old-fashioned. Small, vivacious, but rather puppet-like figures are frescoed in a big space, usually symmetrical; it seems a step as far back as Ghirlandaio, beyond Filippino and Piero di Cosimo who used such frameworks for more complex purposes. But his early masterpiece, the *Birth of the Virgin* (1514),[19] recalls Ghirlandaio only in using the theme to record contemporary bourgeois life; the suave smiling faces, the easy rhythmic turns, the fuzzy contours, are all homages to Leonardo's glow of life. Andrea typically adds a factor linked to the craft of fresco, the warmth of earth colors. Mineral

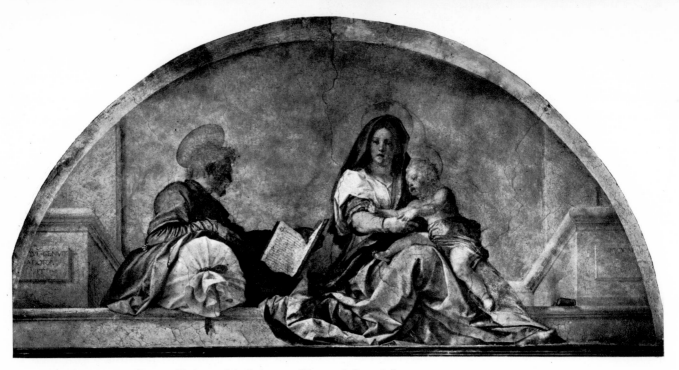

210. ANDREA DEL SARTO. *Madonna of the Sack.* 1525. Fresco, 5′9″ × 11′2″. Courtyard, SS. Annunziata, Florence

reds, yellows, and greens are to remain typical, and their slight suffusion in shadow marks his independent, double relation to modern and old.

The famous *Madonna of the Harpies* (1517; so nicknamed from a minor detail of ornament, to distinguish it from other Madonnas)[20] depends more closely on Leonardo in its suppressed gray tones, and on Fra Bartolommeo in its rigid formality as a holy piece for the altar. But perhaps such rigidity was what Andrea needed as a counterpoise to modern softness, and in his mature work he likes to arrange strict balances between soft parts. A classic instance is the *Madonna of the Sack* (1525; fig. 210), where the Virgin, sitting on the ground, balances the big white sack that Joseph leans on; the two shapes are adjusted in distance and color and thus equalized, both with vague cushiony edges. To be able to compose refined balances of fuzzy materials was a necessary art in the new Florentine situation, but not an easy one. In the *Last Supper* (1527)[21] colorful figures with shimmering color planes are set into a huge blank space, while in Andrea's latest works large figures are arranged without any environment. The ordering of formal elements into a vivid and seductive scheme is the test of a successful work, very much as in some "formal" painting of the twentieth century.

10. The Sistine Ceiling

Michelangelo interrupted work on his battle painting and on a set of twelve large statues in Florence to go to Rome to plan the tomb of Pope Julius II. From this time on he always worked on very large projects, like this tomb involving forty statues. These excited his large-scale imagination but could never reach completion because he was always tempted to accept new ones. So his life became a series of grand beginnings. Julius II was a similarly large planner, who was also arranging with Bramante to redo Saint Peter's, and soon after with Raphael for his room of frescoes (see p. 163). The tomb was set aside when, perhaps, the pope grew more interested in the building, and Michelangelo with some awkwardness was put instead to painting the ceiling of the Sistine Chapel (1508–12; figs. 211a, b). It was a blow because he had less interest in painting and because ceilings in chapels are usually minor, and

211a, b. MICHELANGELO.
General view of chapel and
diagram of ceiling,
Sistine Chapel, Vatican, Rome.
Ceiling fresco, 1508–12,
length 131′, width 44′

rationally limited in their decoration to single figures, while the walls show narrative scenes (in this case by Perugino and others). Still, it was the most important chapel in the Vatican, and Michelangelo consoled himself by managing to change the project to narrative scenes, an essentially poor idea which he carried out with such assurance that it was imitated for centuries; for him the awkwardness is a device in expressing power. There are nine scenes taken from Genesis (because the wall below already told the stories of Moses and of Christ; see colorplate 21): three of God creating the world, three of Adam and Eve, and three of Noah. There are also, around the edges, reflecting the first project, seven prophets and five sibyls (female prophets of Christ's coming, in pagan traditions; recently painted on Roman ceilings by Filippino Lippi and others).

Michelangelo first painted the last scenes and the adjacent prophets and sibyls. These first parts revert, in their stable masses, to the *Pietà* and to the years before he had learned about the mobility of life from Leonardo. The *Delphic Sibyl* is a sym-

metrical beauty, and the *Deluge*, despite its theme and our tendency to associate it with Michelangelesque violence, is a series of detached well-rounded figure groups. All this suggests Michelangelo's caution in a strange context, but he soon hit his stride. *Ezekiel* (fig. 212) is a mass pushed by a windstorm and responding with sideways intensity; his strength is great, but the difficulty he faces is greater still. Thus we are given tragedy in the Aristotelian sense, the failure of the great, which is the only truly tragic theme (unlike the success of the great and the failure of the small). In the nearby *Creation of Eve* the hulking people are cramped and bowed, and in the masterly double scene of Adam and Eve tempted and expelled (fig. 213) the big-boned but cowed people, with rippling shivering contour and neurotic fear of being touched, quote the admired Jacopo della Quercia (see fig. 65). The *Cumaean Sibyl,* in the paradox of her immense muscles, immense age, and painful seeking in her book, symbolizes this dichotomy of physical resources tremendous yet inadequate.

After a short break, Michelangelo, on resuming,

167

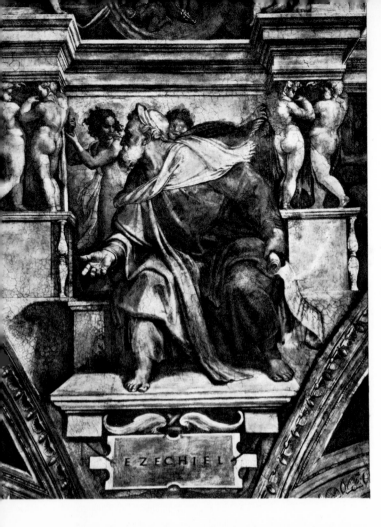

212. MICHELANGELO. *Ezekiel*. 1508–12. Fresco, rectangle containing figure 11′8″ × 12′5″. Ceiling, Sistine Chapel, Vatican, Rome

213. MICHELANGELO. *The Temptation and Expulsion of Adam and Eve*. 1508–12. Fresco, 9′2″ × 18′8″. Ceiling, Sistine Chapel, Vatican, Rome

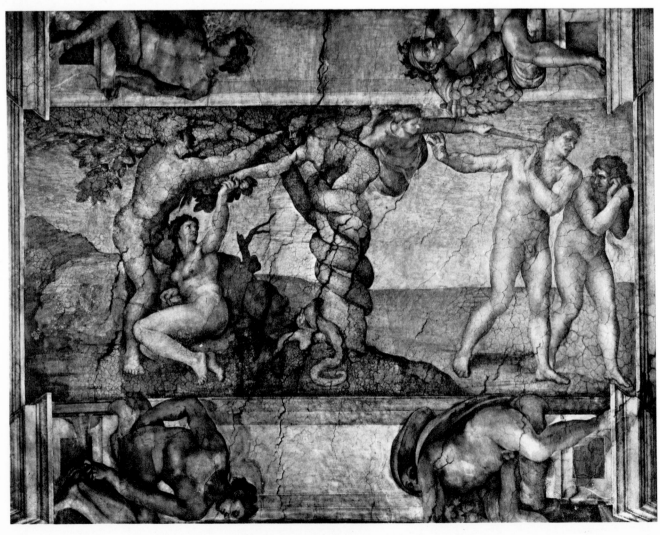

COLORPLATE 25. PIERO DI COSIMO. *The Discovery of Honey.* c.1490. Panel, 31″ × 51″. Art Museum, Worcester

COLORPLATE 26. RAPHAEL. *Parnassus.* 1509–11. Fresco, base line 22′. Stanza della Segnatura, Vatican, Rome

COLORPLATE 27. MICHELANGELO. *Jeremiah*. 1508–12. Fresco, rectangle containing figure 12′9″ × 12′5″. Ceiling, Sistine Chapel, Vatican, Rome

COLORPLATE 28. RAPHAEL. *St. Peter Freed from Prison*. 1512–14. Fresco, base line 21′8″. Stanza d'Eliodoro, Vatican, Rome

went back to the classic calm of the first parts, but it is modified by the richer expressiveness attained in the meantime. This gives us the famous scene of God creating Adam (see fig. 1), the limp athlete in repose, physically perfected but awaiting the life that God on his grand barge of angels will bring. The second half of the ceiling goes through the same evolution as the first, from the stable to the nerve-racked, but like the second stable beginning, the second agitation is more subtle and inward than the first. *Jeremiah's* immense body droops with grief (colorplate 27), evoking the same monumental and tragic contrast between great powers and their insufficiency as in *Ezekiel*, but in less physical terms. The very last figures are the most twisted and complex, including the elegant, difficult *Libyan Sibyl* and *God Separating Light from Darkness*, a torso pushing at the corners of its frame. In this huge collection of people, more easily completed than statues, Michelangelo was evidently modifying himself very fast and excitedly. This happens in works having many parts more often than in a similar quantity or time-span of separate works, because a new idea that came to him too late can be applied immediately to the next related unit. When it was finished Michelangelo had reached his full statement of superhuman strength and loss. He at once applied it to sculpture, returning to the pope's tomb with *Moses* (fig. 214), simply one more prophet as to type, but, as stone requires, less involuted. For the tomb he also carved two attendant *Slaves*,[22] who express struggle but in a late stage, close to defeat, a slackening of a once fierce effort. High Renaissance sweep of motion had conquered unexpected areas.

214. MICHELANGELO. *Moses*.
Marble, height 7'8".
S. Pietro in Vincoli, Rome

11. Raphael's Last Years

After the triumph of the Segnatura, Raphael repeated himself as to his outward conditions, producing large fresco sets with apparent ease, mainly for the popes. Within a few years he headed a large enterprise and became a superintendent who hardly used his hands at all; the projects grew larger and larger, including the supervision of Saint Peter's after Bramante died, and the new office of curator of the antiquities of Rome. Perhaps he would have left painting entirely for architecture if he had lived longer.

But the qualities of the paintings do not repeat. The second room of the Vatican, the Stanza d'Eliodoro (1511–14), concerns themes of the Church

215. RAPHAEL. *The Fire in the Borgo.* 1514–17. Fresco, base line 22′. Stanza dell'Incendio, Vatican, Rome

overcoming its enemies, showing action rather than groups of portraits. It is full of onlookers in modern costume (like Ghirlandaio's frescoes) who are on a different plane of existence, more particularized and more passive, from the protagonist; but with Raphael's usual easiness of solution we take in the distinction without stopping to find it odd that two sorts of lives are being led. The *Miracle of Bolsena,* a vision of the wafer of the Mass bleeding, proving that it is Christ's body, transmits the sensuous action through fresh color, showing that Raphael had been looking at some Venetians at work, and diverging from our standard views of Raphael as well as from the Florentine tradition of form. In *Saint Peter Freed from Prison* (colorplate 28) a violent light shines at us from behind the bars, silhouetting them, and having a variant in the sensuous moonlit armor of the guards at the sides. This luminous and textural painting absorbs the figures of Peter and the angel in the cell; these are new versions of the Raphael figure made of rhythmic curves, his permanent graphic and graceful formula, but heavier and ampler than before.

The focus from the back of the painting toward us recurs from now on, for violent expansiveness. In the *Expulsion of Heliodorus* a tiny praying figure at the far end of the funnel triggers the action, and its results are at the front, in big flung wrestling figures. The tiny far cause and large near effect, with the rushing funnel between, are varied in the next set of frescoes, in the Stanza dell'Incendio (1514–17); in the *Fire in the Borgo* (fig. 215), in the distant center the tiny pope at a window prays and stops the fire that has panicked the foreground crowd. The drama is stretched on extremes of space and scale, a new paradoxical version of the interaction of drama and geometry evoked by the Florentine tradition. The rest of the frescoes in this room are by assistants.

The heavier curving rhythms appear in famous later Madonnas, such as the *Madonna of the Chair,*[23] with its total interlocking of curves packed together in embrace, and in the fresco of *Galatea* (fig. 216), a solid well-fleshed rendering of a Leonardo twining motion. This fresco was painted for the papal banker Agostino Chigi, Raphael's most important patron

after the popes (see p. 177). Later, on Raphael's design, his assistants painted the ceiling of an open porch in Chigi's house, suggesting an arbor overhead and the sky seen through it, as in Mantegna, except that the openings are also frames for mythological scenes of Venus, Cupid, and Psyche (finished 1519). It is a new style for the classical love stories that had pleased Botticelli's patrons.

In the late years the one set of big paintings by Raphael's hand (because they were made as working sketches) are the cartoons for tapestries to be hung in the Sistine Chapel (1515–16). The first, *Saint Peter's Miraculous Catch of Fishes,* is an open-air lightscape like *Saint Peter Freed from Prison;* others are as restrained in their vertical classicism as the contemporary *Sistine Madonna,*[24] who only

216. RAPHAEL. *Galatea.* 1513.
Fresco, 9′8″ × 7′4″.
Villa Farnesina, Rome

217. RAPHAEL. *St. Paul Preaching in Athens.* 1515–16. Watercolor on paper, 11′3″ × 14′6″.
Victoria and Albert Museum, London

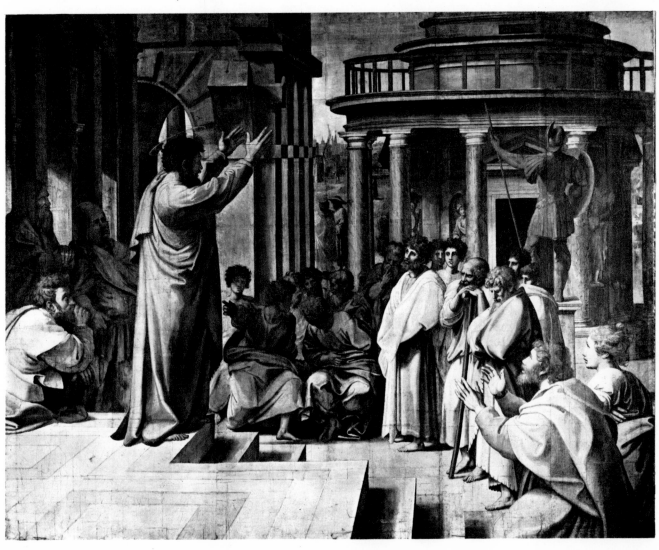

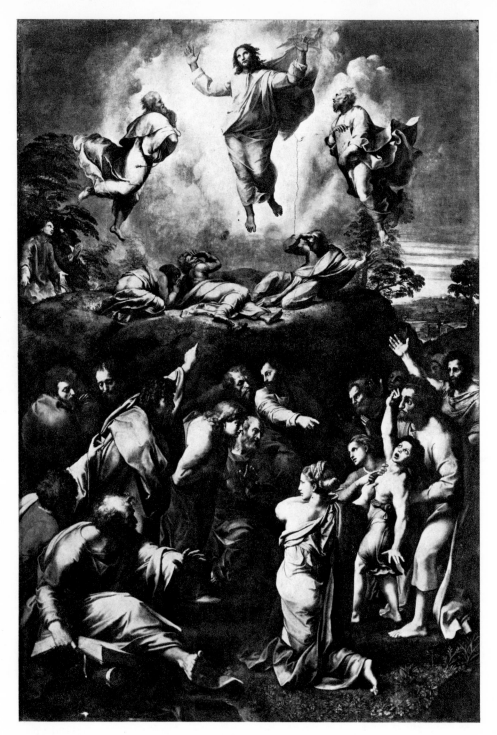

218. RAPHAEL (lower portion
completed by GIULIO ROMANO).
The Transfiguration. 1517.
Panel, 13′4″ × 9′2″.
Pinacoteca Vaticana, Rome

sways slightly because she is indeed a live creature, as all figures are perceived to be after Leonardo had worked. Those were the two poles of Raphael's mood when he began this series, but as he proceeded it changed to a view of crowd action that moves beyond simple energy, to reject balance and resolution. In *Saint Paul Preaching in Athens* (fig. 217) the left and right sides of the crowd and its space are competingly square and round, far and near, tight and loose. Such exploration of open-ended unclassic rhythm is fullest in Raphael's strange last painting, the *Transfiguration* (1517–20; fig. 218). Like the *Fire in the Borgo* it balances a figure of spiritual power, high, small, far off, and weightless, with some very material people, heavy, low, and nearby. But the two parts are now wholly separate, and we can only connect them in our own minds as reciprocals and as events adjacent in time. Thus Raphael does not keep to worn harmonious grooves, like his later imitators who have hurt his reputation. His experiments in form and dramatic vehicles were probably more stimulating to most younger artists than the absolutisms of the alternative great sources, Leonardo and Michelangelo.

12. Architecture in Rome

Under Pope Julius II and his successor Leo X (r.1513–21), Rome had a boom, in secular building particularly. But it began naturally with the Vatican and Bramante himself. The palace had been a casual conglomeration of towers and apartments, unaffected by Alberti's hopes of order. The most obvious first step was Bramante's high screen on the city side (from 1504), consisting of a three-story porch, or loggia, each a long arcade. (It was later turned into one side of a courtyard, the Cortile di San Damaso.) It reflects Albertian emphasis on using the thickness of walls visually and practically, and, indeed, began with a plan to remodel the small two-story loggia that Alberti had designed in front of Saint Peter's, until then the most modern design in the area. But Bramante's grandest scheme was to tie the Vatican buildings to a small villa on a nearby hill by constructing two parallel corridors and arcades, three stories high at the palace end and one story at the villa end, making the whole into one huge building and giving the Vatican the scale it has today (fig. 219). The area between the two corridors, the Belvedere courtyard, was to be arranged with three stepped terraces for gardens and an outdoor theater;

220. DONATO BRAMANTE. Palazzo Caprini, Rome (destroyed; engraving by Lafréry, 1549).

219. DONATO BRAMANTE. Belvedere Courtyard, Vatican, Rome (Drawn by an observer, c.1560. Pen and ink. Gabinetto dei Disegni, Uffizi, Florence)

as one looks upward from the palace end there are two big niches in plain walls, Bramante's trademark, to mark the intermediate and end walls (from 1505). Bramante built a two-story house for himself on an original design (later owned by Raphael; fig. 220): the lower story, of rough cement blocks, contains shops; the upper is the dwelling, with a lively in-and-out rhythm of recessed windows between lightweight half columns. The whole façade alludes to the force of gravity and to the contrasting social purposes and status involved, and so neatly that it became a standard imitated everywhere, from Louis XIV's Louvre to nineteenth-century government offices. The more ornate and formal upper floor became tagged in Italian as the "noble story."

Bramante's only rival was Baldassare Peruzzi (1481–1536), a painter who built the banker Agostino Chigi's house (1509–11; called the "Farnesina" after a later owner). Set in a garden at the edge of town, its open porch on one side replaces the inner court usual in town mansions (fig. 221). Beside the porch two side wings project forward, perhaps reflecting a tradition of castle towers, but the elegant surface is very urbane, leaving a square area for

221. BALDASSARE PERUZZI.
Garden façade,
Villa Farnesina, Rome.
1509–11. 58′ × 121′

223. ANTONIO DA SANGALLO THE YOUNGER.
Façade, Mint (presently Banco di S. Spirito),
Rome, 1523–24. 50′ × 33′

222. RAPHAEL. Chigi Chapel,
S. Maria del Popolo, Rome. 1515.
Height 48′9″, 21′4″ square

224. ANTONIO DA SANGALLO
THE YOUNGER.
Projected plan,
St. Peter's, Vatican,
Rome. 818' × 557'

each window between interwoven thin pilasters and cornices. The wall handling is little altered from one already standard in Rome, derived from the devices preferred by Francesco di Giorgio, Peruzzi's teacher, to suggest the third dimension. Inside the house Peruzzi painted classical friezes, a ceiling representing Chigi's horoscope, and, most startlingly, a wall of columns between naturalistic landscapes as they might be seen in the neighborhood of the house. This illusionistic effect may also have been used elsewhere, since very few earlier domestic frescoes have survived. Peruzzi's one other remarkable painting, the *Presentation of the Virgin* in a church fresco cycle,[25] adopts the architectural expressiveness of Raphael's recent *Saint Paul*

Preaching in Athens. His architecture altogether, painted or built, uses a sharp geometry to explore intellectual possibilities; twenty-five years later he designed one other great building (see fig. 268).

Raphael learned architecture from his friend Bramante, and before succeeding him at Saint Peter's had designed Sant'Eligio degli Orefici (1509) which, in its remodeled state, follows Bramante in having an interior of expanding curved space, but differs in its clean, thin walls as unarticulated as the inside of an egg. That Raphael thought of these as painters' walls is suggested by his next interior, the very original burial chapel for Agostino Chigi (fig. 222), a square with sliced-off corners rising to a dome, for which he designed mosaics that seem to be windows to the sky like Melozzo da Forlì's (see p. 125). Most typical is the unfinished Villa Madama, a series of three communicating semicircular rooms, quoting ancient Roman spaces and perfect for holding receptions. On the thin curved side walls, marked by taut pilasters, are big niches that have small niches in them daintily embracing us; the flat side opens onto a garden, and the whole context is a suggestive parallel to Chigi's porch where he was painting the ceiling at this time. Villa Madama, a lightened variation on Bramante with spatial imagination, workable structure, and social mood all in tune, is more personally Raphael's than his work on Saint Peter's, which languished. There Bramante's plan for a centralized church was changed to the more conventional long one, and at the ends of the short arms, perhaps for balance, semi-

225. ANTONIO DA SANGALLO THE YOUNGER. Façade, Palazzo Farnese, Rome. 1534–46. 95' × 195'

circular colonnades were added, but none of this was carried out.

When Raphael died Saint Peter's was taken over by Antonio da Sangallo the Younger (1485–1546), nephew of the two Sangallos encountered before, and the only architect of this age who came from a stonemason background. Most of his life he built forts and remodeled wings of buildings, and he left a vast file of sensible structural drawings. The first rare suggestion of his personality is in the Rome Mint (1523–24; fig. 223). It somewhat inappropriately uses Bramante's "noble story" pattern, but above the rough base the upper area is not on Bramante's scheme but the more traditional interweave of pilasters and moldings. Sangallo picks up style where he finds it, but then is firm in handling the vocabulary as well as the slightly concave façade, suggested by the site, which pulls the forms together. His entire shapes are more adept than his phrasing. His model for the resumed work on Saint Peter's (1539) is more effective in its proposal to reconcile the equal-armed with the conventional long plan by attaching an almost separate extra unit to an equal-armed structure (fig. 224), than in its notorious exterior, which adds forests of columns to the smaller earlier sets without allowing for the enlarged scale. Sangallo's masterpiece, Palazzo Farnese (1535–46, rebuilding a smaller house; fig. 225), works by simply discarding most of the style vocabulary. Its front omits all vertical accents, leaving only the corner frames, the horizontal moldings marking each of the three stories, and the heavy window frames. The result, a horizontal mass with a window rhythm that could continue indefinitely, is almost like one of his forts. The mild corner framing is the main change from an early Renaissance house like Palazzo Strozzi (see fig. 165). Michelangelo, who inherited Sangallo's tasks, hated and tore down what Sangallo had done at Saint Peter's but respected Palazzo Farnese. He altered parts still to be built, but in the existing structure revised only one window, to shift the rhythm from an almost regular beat to a strongly accented center.

13. Giorgione

In 1500 the seventy-year-old Giovanni Bellini still dominated painting in Venice. Most young painters imitated him, and his brother Gentile and Carpaccio were ineffective as rivals. Giorgione (docs. 1506–d.1510) worked a revolution while adhering to the concern for spatial continuity that was now a Venetian fixture, and specifically to Bellini's version of it built on color sensibility. Yet even in his first mature works, *The Tempest* (colorplate 29) and the Castelfranco altarpiece (fig. 226), he cannot follow Bellini's easygoing willingness to let the traditional big iconic image, the formal Madonna or portrait, occupy the foreground. To him this evidently seemed inconsistent with the optical effect of the visual field, and the assumption of equality throughout it; hence his paintings look like the backgrounds in Bellini's. With further modesty, the spatial thrust keeps to an intimate area. But this involves a fundamental change from all fifteenth-century painting, because it substitutes unity for the older dualism of figure and world, mass and void, that had been dominant in various ways from Masaccio to Raphael. There is now only the field of space, in which the figure is as incidental as a tree or building. Giorgione's results were probably triggered by seeing the logical tonal unity called for by Leonardo (who visited Venice in 1500). Yet Leonardo had retained the figure as an element separate from the space, and only his shadowiness made for unity; Giorgione's eye and palette are Bellinian. This unity became the special character of sixteenth-century Venetian painting based on light and brush stroke, as compared with fifteenth-century Florentine painting based on perspective and figure modeling.

In Giorgione the new dependency of the people on their environment affects them dramatically; they become passive and isolated. In the Castelfranco

226. GIORGIONE. *Enthroned Madonna with St. Liberalis and St. Francis*. Panel, 6'7" × 5'. Cathedral, Castelfranco

227. GIORGIONE. *The Three Philosophers*. Canvas, 48" × 56". Kunsthistorisches Museum, Vienna

altarpiece the Virgin sits very high (a design borrowed from Cossa) so that each figure is remote from the rest, caught in the air and in its own thoughts. The middle of the space in *The Tempest* is occupied only by air, in its most positive aspect as a storm, and figures relate across space in slow meditation. Giorgione introduced the reclining nude as a classic theme for painting, but his (unlike most later ones) is sleeping and outdoors.[26] His *Three Philosophers* (fig. 227; probably the three Magi tracking the star, a subject in backgrounds of earlier Adorations of the Magi) quietly watch the landscape and the light that duskily penetrates their bodies. Giorgione's closest antecedents are such works as Bellini's *Saint Francis* and Carpaccio's *Saint Augustine* (see fig. 174, colorplate 23), which give equal value to a figure and an empty lit area, and Jacopo Bellini's drawings of spaces inhabited by tiny figures (see fig. 129), used only for testing perspective. Giorgione is further from these than from the Impressionists: Renaissance painting is often described as based on the figure, in contrast to nineteenth-century art, but this half truth gives the later age too much credit for originality.

All this involved a revamping of technique, patronage, and subject matter. Giorgione made no drawings, but revised on the canvas drastically, as X-rays have revealed. He worked mainly for patrons who collected art in their houses, who had a taste for philosophical conversation (as in Bembo's *The Asolans*[27] and Castiglione's *The Courtier*,[28] both written in these years) and for pastoral poetry which rejects society and its problems for an imagined parklike nature, pensive love, and melancholy songs, later seen in Shakespeare's *As You Like It*. This produces Titian's "*Concert Champêtre*" with its lute players and nudes,[29] and Giorgione's *The Tempest*, whose subject has been vigorously debated. X-rays have shown the central storm area unchanged in earlier drafts, but the male figure was preceded on the canvas by a female nude, suggesting that the figures cannot have had a serious role in thematic planning. Consistent with this, a Venetian connoisseur about 1530 described the picture without providing us a title. The resulting hypothesis that there is no subject has been rejected as unique and impossible in the period. Such a claim, however, depends on checking paintings only; similar mood imagery without specific narrative is clearly assumed as natural in the lower-ranking products of this culture, like prints and furniture decoration, and Giorgione's small picture for a domestic wall is perhaps a sophisticated offshoot from these. Or it may be that, as in seventeenth-century landscapes with small foreground groups of people, there is an intended theme "for form's sake," so casual that it was lost to awareness at once.

14. Contemporaries of Giorgione

Giorgione's art had such an impact that there is danger of explaining too much by it. Some "Giorgione-like" imagery of earlier date, like Giovanni Bellini's suggestive *Sacred Allegory* (see colorplate 24), reminds us that such ideas were growing anyway, as usual in innovation. Cima, an older artist, resembles Giorgione in subject matter when, for example, he paints *Endymion* asleep in a meadow,[30] involving the overtones of pastoral landscape and amorous mythology. But beside a Giorgione it has a naïve, 11 A.M. look. The most impressive parallels to Giorgione were painted by the aged Giovanni Bellini, who was still trying out everything he came across. His *Baptism* of 1502[31] modifies his earlier ratio between protagonists and distant landscape focus by pulling the landscape upward into a hard hedge of mountains and dimming into bonelessness the figures thus hedged; this still leaves their duality intact. The San Zaccaria altarpiece (1505; fig. 228) modifies tradition in that the saints, under a dusky dome of gold, no longer look at each other or at us, but all meditate in shadows. The only exception, the angel on the step watching us, is perhaps picked up from Dürer. A more literal bow to Giorgione's Castelfranco altarpiece is the strange *Saint Jerome with Saints Christopher and Augustine* (1513),[32]

where the center saint sits on a hill at the top of the painting and the two below ignore him, though sharing the gentle haze. To be sure, such isolation is also an acceptance of a medieval tradition, in which images are lined up in a row, and some of the saints may have a landscape fragment as an attribute.

In the many portraits that Bellini (like Giorgione) was now painting of thoughtfully gazing aristocrats, the figure remains a solid chunk sandwiched between a front parapet and a pillow of clouds. The same style pervades the *Nude with Mirror*[33] which he painted at eighty-five. In the great *Feast of the Gods* (1514; colorplate 30) painted for the duke of Ferrara, the gods are drinking before

a fence of trees and Priapus steals up to a sleeping nymph, soon to be awakened by a braying ass. In this ribald tale from Ovid[34] the chunky little figures retain their sculptural identity within the kaleidoscopic dance of color; Giovanni Bellini was simply using, and mastering, one more method of picture-making, without himself changing.

Alvise Vivarini's one notable pupil, Jacopo de' Barbari (docs. 1497–1511), was the first Italian artist above the artisan level to practice printmaking in quantity. This came about through his links to Germany; his first print, published by a German merchant in Venice, was an astonishing bird's-eye view of Venice, a woodcut on many sheets that took

229. JACOPO DE' BARBARI. *View of Venice*, portion. 1497–1500.
Woodcut, entire dimensions 50″ × 108″. Metropolitan Museum of Art, New York

230. JACOPO DE' BARBARI. *Still Life*.
Panel, 20 1/4″ × 16 1/2″.
Alte Pinakothek, Munich

three years to produce (1497–1500; fig. 229). It is a completely novel object, made possible by a fusion of northern minute description and Venetian atmospheric sweep. He then went to Germany, worked at the courts of several princes, and, along with small paintings, engraved tall figures in a special sinuous linear style, with drooping heads and thin folds like wilted lilies. This was developed from some late works of his teacher Vivarini, who had been seeking a way, in line with current taste, toward atmospheric and psychological subtlety. Barbari had some influence on German artists such as Dürer and Baldung Grien. He also seems to have produced the first autonomous still-life painting in history (fig. 230), again a blend of northern particularism and the Venetian feeling for luminous textures. On the level of opening up modern themes for painting, though not otherwise, he is comparable to Giorgione. The strangeness of his work from an Italian viewpoint has led to the opinion that he worked under German influence, but the many similar German examples are later.

Bartolommeo Veneto (docs. 1502–1530) was Gentile Bellini's one lively pupil. He naturally remained a somewhat dry portrait specialist, though rich in evoking personalities. Heads of women in fancy costumes gaze out at us; these too have been associated with Germany, but only the costumes seem to justify this. He is most remarkable in recording fine young gentlemen, in brilliant costumes, on a large scale, with a weary melancholy touching their refined luxury (fig. 231). Here this minor artist has documented the Giorgionesque personality for us.

231. BARTOLOMMEO VENETO.
Portrait of a Man.
Panel, 29″ × 20″.
Museum of Fine Arts, Houston.
The Edith A. and Percy S. Straus Collection

15. Giulio Campagnola; Riccio

The great masters who established the High Renaissance were rapidly followed, for the first time in history, by widely circulated reproductions in the form of prints. Leonardo's Milanese drawings, sculpture, and the *Last Supper* were copied by anonymous craftsmen, and Raphael's paintings and drawings were published systematically by his associate Marcantonio Raimondi, who made this his career, and by others. The growth of professional printmaking (as in Barbari), of book publishers, and of the great fame of the painters are all interrelated. Giorgione's graphic echo was a somewhat more independent master. The engravings of the Paduan Giulio Campagnola (1482–1515) include copies of Dürer prints, but his Giorgionesque works are probably not copies, but popularizations of the Giorgione mood. This is presumably related to the absence of Giorgione drawings. Melancholy pastorals and other favored contexts give us the youth contemplating a skull, a nude Venus, an astrologer (fig. 232), all in small corners of broad landscapes which often include a view of Venice. With a retrogression consistent with his role as a popularizer, the handling of space and form is still Bellinian, relating the substantial figures to second themes in the far landscape. But the new art is effectively transmitted by a new technical and visual invention (a recurrent factor in the Giorgione circle), the "dotted manner." This evades line and lets thin shadows wash over the surface, drawing the landscape into subtle continuity with the figures.

Giorgionism is not sculptural, and Venetian sculpture continues to be infertile. The leading figure is Tullio Lombardo (docs. 1476–1532), son of Pietro. He carved archaeological figures in Padua, a suitable place for them, with its learned traditions

232. GIULIO CAMPAGNOLA. *The Astrologer.* 1509.
Engraving, 4″ × 6″. Prints Division,
The New York Public Library

233. ANDREA RICCIO. *Arion.*
Bronze, height 9″. The Louvre, Paris

of writers and of Mantegna. Like some other academic classicists, he comes to life when a portrait forces him not to generalize but to apply his sensitive balance of masses to something specific (Guidarelli tomb, Ravenna[35]).

But in Andrea Riccio (1470–1532) Padua produced one sculptor who has fascinating parallels with Giorgione He began as a goldsmith, but then spent years over a strange example of jeweler's elaboration, the bronze Easter candlestick for Sant' Antonio, Padua (1507–17). It is twelve feet high and freely intertwines hundred of religious, allegorical, and pagan figures on its many levels. They became his repertory, yielding hundreds of bronze figurines (fig. 233), mostly pagan and literary—satyrs, nude shepherds, dragons, and, more startling, crabs, spiders, and many goats. The external parallels to Giorgione are the small scale, the context of patronage—these are aesthetic toys for connoisseurs

—and the exploiting of an unusual technical vehicle. Riccio is the first artist to make a career of the small bronze, preceded by the partial explorations by Pollaiuolo and by Bertoldo and Bellano, Donatello's pupils in Florence and Padua. A more interesting parallel to, not an imitation of, Giorgione is the overtone of pathos, the idyllic regret for classical civilization or the sadness of the satyr caught in the subhuman and begging for alms or love. All this is evoked with poignant gesture, and with modeling that emphasizes extremities like an outstretched finger or pointed chin, and also presents the body as a satisfactory solid base with balanced weights of its parts. Such depth of feeling is the more sobering in what at first seems a virtuoso plaything. The small scale of Riccio's work and its separateness from the standard family tree of sculpture has led to neglect of him in general surveys, but he is Michelangelo's most original contemporary.

16. Palma; Sebastiano del Piombo

Two Venetian painters in Giorgione's age group had claims to share his revolution, but both soon drifted toward other magnets. Jacopo Palma (docs. 1510–d.1528; called Palma Vecchio, Palma the elder, to distinguish him from Palma Giovane, a grandnephew) came from the provincial city of Bergamo, on the border between Venetian and Milanese territory, and always retained links there. The distinct small tradition of painting in that town is finely represented at this time by Giovanni Cariani (docs. 1509–1547); he painted figures in large squarish planes near the front of his space, parallel to us but with sensitive velvet and fleshy textures, so that in portraits especially they maintain a dignified presence. Palma always liked a somewhat old-fashioned tradition in altarpieces, but he offers a drenched Giorgionesque effect in his early portrait traditionally labeled "Ariosto."[36] In it he surrounds a soft, tired face with sumptuous hair, laurel branches, and big red sleeves, vividly combining allusions to luxury and poetry. But in later works he treats the motifs with greater superficiality, and they seem Giorgionesque only in official type. Saints sitting in meadows and plump blond nudes are all backed up by heavy foliage; the men have feelings but the women are only pretty. The forms grow heavier and more insistently material, and the reflection of Titian is equally external. The most impressive later painting is *Jacob Meeting Rachel* (fig. 234), where a Biblical theme legitimizes the pastoral and amorous interests.

Sebastiano del Piombo (docs. 1511–d.1547) emerges as a painter with a set of saints whose tentative movements, downward gaze, and subtly dimmed spaces are decisively Giorgionesque.[37] But he transferred his career quickly to Rome, and painted for Peruzzi's newly built Chigi villa (1511; see p. 175) a series of scenes from Ovid's *Metamorphoses,* the *Fall of Icarus* and others. The bright figures against a still brighter sky have a Venetian breeziness that was certainly interesting to Raphael, but Sebastiano admired Raphael even more, making silhouettes of curving bodies emphasize their dramatically indicative gestures. Ever dependent, Sebastiano attached himself to Michelangelo to render his concepts in painting, which the master did not enjoy doing. The most extraordinary result is a *Pietà* (fig. 235), two stony figures with undetailed brown surfaces in a deep moonlit sky, a tonal sculpture. Later, aside from a few altarpieces, Sebastiano restricted himself to portraits, and in that narrow range created novel breadth of design. He loosened the normal limita-

234. JACOPO PALMA.
Jacob Meeting Rachel.
Canvas, 4′9″ × 8′3″.
Gemäldegalerie, Dresden

235. SEBASTIANO DEL PIOMBO.
Pietà. Panel, 8′10″ × 7′4″.
Museo Civico, Viterbo

tion of portraiture as an iconic, timeless image, and allied it instead to temporal or narrative painting by showing his cardinals and officials chatting with their secretaries, who are painted as smaller portraits at their sides; the central portrait retains its formal patterns, only its outward relationships change. (Mantegna and Jacopo de' Barbari, in single ex-periments, had anticipated this play with the tension between icon and narrative, and Raphael had used the design without the narrative implications.) At about forty-five Sebastian obtained a sinecure and stopped painting almost entirely, having also quar-reled with Michelangelo and lost this last crutch. He apparently could not accept his own talent.

17. Ferrara and Bologna

By 1500 there was a modern artist or two in every town, with some autonomy of regional style. Bologna in the fifteenth century had made do with important visitors like Jacopo della Quercia, or less important ones like Marco Zoppo (1433–1478), who, in his shiny, tortuous figures, was a weaker provincial fol-lower of Mantegna than Tura and Crivelli were in their provinces. Ercole de' Roberti came from Ferrara in the 1480s, and his forceful style had strong influence here as elsewhere. From that back-

ground two young Bolognese painters emerge in the 1490s, their eagerness for modernity enhanced by the crossroads location of the city, between Florence, Milan, and Venice. But the sources they tapped were not the most favorable.

Francesco Francia (docs. 1479–d.1517), who started as a goldsmith, painted an early masterpiece in his *Saint Stephen Martyred*,[38] suggesting a bright sheet of tin crumpling as it is hit by stones, and strongly centered in the saint's eye with its keen glance of pain. His partner Lorenzo Costa (docs. 1483–d.1535) at first copied Tura, but then he formulated a Robertian type of spindly figure against a pale sky which he retained through many shifting versions. These painters' first self-revision was to a Venetian key, consisting mainly of a use of Giovanni Bellini's compositional arrangements for altarpieces, with thrones under pavilions, and a slighter use of his figure types; and it seems to have come less from Bellini himself than from imitators like Bartolommeo Montagna and Francesco Bonsignori. A more serious though still superficial modernism they then adopted was Leonardesque shadow, but again it utilizes the work of Leonardo's literal imitators in Milan, like Giampietrino, and produces a soft snaky form and a devout gaze. Perugino's visit to Bologna, when he was past his prime, stimulated a slight modification toward a more old-fashioned modeling, clean and round. The result of all this, in many Francia Madonnas and Costa heads, is round substantial faces, pleasantly gentle, looking out from a darkened space, another variation on the soft post-primitive art, devoutly plain but easy, that later attracted Victorian admirers. The style is also important because it spread among the two hundred pupils of Francia and Costa, who apparently conducted something closer to a school than a shop. These pupils worked chiefly in Ferrara.

Of them, Ortolano (docs. 1512–1524) painted beautiful, identical, archaistic altarpieces, with brightly lit figures in landscapes, drawn in slightly angular planes. Garofalo (docs. 1501–d.1559) began with a brilliant variation in Ferrara on Mantegna's ceiling (fig. 236; see fig. 134), where a chorus of Costa-like ladies and gentlemen looks down at us. But then, after a visit to Rome, he spent forty years repeating little Holy Families, all with a classical modeling and suavity borrowed from Raphael, that seem a little strange in the strong, even, early Renais-

236. GAROFALO. Ceiling fresco. 1519.
Diameter including painted balcony 10′11″.
Palazzo del Seminario, Ferrara

237. ALTOBELLO MELONE.
Massacre of the Innocents. 1516–17.
Fresco, 5′7″×5′11″. Cathedral, Cremona

opportunity was the big fresco series in Cremona Cathedral, shared (1510–19) with others, including Altobello Melone (docs. 1516–1517), whose style also comes from Costa. Both, with self-assured figure drawing, let their hard, individualized people collide in energetic scenes (fig. 237). Altobello may have taken the lead in this; little other work of his apparently short life is known, but he seems to have had exceptional talents, mixing a broad swashy brush stroke with ideas from Dürer woodcuts to represent tough mercenary soldiers, sharp-nosed merchants in big hats, and equally down-to-earth versions of Christ. The crisp technique, developed earlier to accompany a neat sort of image, now underpins scenes with very little composition at all, tending instead to pour out notes of observed action.

The oddest Costa pupil was Amico Aspertini (docs. 1506–d.1522), whose restless hunt for devices of vitality took him, when he visited Rome, to Pinturicchio's fancy ornaments and to ancient battle sarcophagi whose scrambling crowds he recorded in drawings; appeals to antiquity at this date were often far from academic. He perhaps admired most the frescoes of Filippino Lippi. His own swirl nervously with fantasy figures, swimming and crouching, sometimes with one puffed cheek, often in rags and ribbons, an undigested tumult of small original ideas. After two sets of narrative frescoes in Bologna (1506)[39] and Lucca (fig. 238), he seems to have turned to sculpture. His squirming masterpiece, *Nicodemus with the Dead Christ*,[40] comes from the tradition of Niccolò dell' Arca's tableaux (see fig. 171) but has a High Renaissance command of broader, imposing forms.

238. AMICO ASPERTINI.
Miracle of S. Frediano.
Fresco, 10′4″×9′9″. S. Frediano, Lucca

sance lighting. Both of them are probably affected as well by an older pupil, Boccaccio Boccaccino (docs. 1493–d.1524/25), who went back to his parental town of Cremona and painted many crisply drawn round-eyed Madonnas. His one spectacular

18. Dosso and His Successors

The most brilliant developer of Giorgione's approach was Dosso (docs. 1512–d.1542), a probable native of Ferrara who stayed at home, apart from brief trips, and was the resident court artist. His first major work was a *Bacchanal*,[41] made to accompany Giovanni Bellini's *Feast of the Gods* and much influenced by it, with clean cylindrical figures relaxing in a meadow. But this indirect approach to Giorgione soon gives way to direct attachment. His activity has to be reconstructed from several distinct strands. One is in the records of his lifelong service of the ducal pleasures, which led to paintings of flowers, animals, a panorama of Ferrara, scene painting, and designs for pottery; all were made for

239. Dosso. *Melissa*. Canvas, 69″ × 68″.
Galleria Borghese, Rome

the moment and lost, but they provide a suggestive correction to our usual ideas of Renaissance themes. A hint of these nonliterary, nonhuman images remains in the deep sweeping landscapes between caryatids and an arbor that he painted in a rare visit away,[42] under the influence perhaps of the Farnesina frescoes in Rome. An intermediate tone appears in the small diamond-shaped ceiling paintings for Ferrara,[43] with grinning and violent heads. All this seems quite separate from the formal works, church altarpieces that are more and more Raphaelesque as time goes on, with substantial figures turning in broad movements. A third strand is in small Madonnas, mythologies, and scenes apparently of the moment, painted in swift strokes, a spatter for a tree's foliage and a wisp for a figure's arm. Small figures with ardent movements, in glowing colors, are drowned in nature, in high grass or a clump of bushes.

In a few of his masterpieces Dosso blends all his possibilities; these are mostly works of bizarre, still unexplained subjects, produced no doubt on the basis of the whims of local poets like the great

Ariosto, spinner of tales of love, dragons, and the duke's chivalrous ancestors. Besides the *Allegory of Music*[44] and *Jove Painting Butterflies*,[45] the greatest of these is *Melissa* (fig. 239), a witch seeking inspiration like a Michelangelo sibyl, a grand seated figure wearing a dress as rich as a rug in its depth of tone. She holds a smoldering torch; a big dog and a suit of armor lie beside her; trees close in and shadow her; and far away, soldiers are sitting on the ground. With garden-like nature, colorful glitter, and enticing strange themes, the picture is totally Giorgionesque in its evocation of magic poetry. But the sensual immediacy is stronger in flavor now, perhaps under the influence of court interests.

Dosso's many associates were in general more academic; the repetitive small bright scenes by his brother Battista (d. 1548) and Mazzolino (docs. 1504–1528) are toward the Raphaelesque end of Dosso's range. His truest follower is in a later generation, Niccolò dell' Abbate (1512–1571). In Bologna and later at the French court he painted fresco series for rich houses, with illustrations of Virgil and Ariosto and leisured people in meadows. His series of musicians and card players (fig. 240) charms us by its effect of telling us about social reality, going one more stage than Dosso toward simple reporting, away from Giorgione's poetic heightening of such experience. But actually it is the same record of aristocratic social life seen a hundred years earlier in International Gothic domestic frescoes, as in the Borromeo house in Milan. Only the fashions have changed, and they now follow Giorgionesque pastoral.

240. Niccolò dell' Abbate. *Card Players*.
Fresco, 7′1″ × 16′6″.
Palazzo dell'Università, Bologna

19. Young Titian

Though Titian (docs. 1510–d.1576) was probably a pupil of Giorgione's, he first appears at age twenty rebelling against him with the effectiveness of a young genius and vigorous extremism. Titian's earliest known works, outdoor frescoes painted in a joint commission with Giorgione,[46] are in ruins, but the *Christ with the Woman Taken in Adultery*[47] is probably of the same moment. Physically emphatic people meet in a quick unorganized way, with forward pressures and bumping knees, and oddly rough proportions in head height and spatial depth. He pays automatic homage to his master in the slightly dimmed continuity of very rich translucent color areas, but he also appeals to prestigious masters one degree more removed, such as Mantegna and Dürer, and asserts the immediate, sensuous factuality and warm energy of the body that are always fundamental in him. Soon he modifies the contrast, and a swiftly painted set of frescoes in Padua (1511) shows us people still heavy, thick, and sparkling with life but for the most part standing in passive rows (fig. 241). Titian's use of big proportioned figures, majestic and imposing, is normal in the High Renaissance, but he makes them very alive by infusions of light, evading the tendency of massive forms to become academic and dead. In contrast with Michelangelo (who works with potential power), he would persuade us of the glowing life of quite passive people. In the Padua frescoes only one scene, representing a murder, shows foreshortening in the Mantegna formula of shock (see p. 109).

In a few years Titian's expressive mood moved completely into the Giorgionesque vein, most obviously in the famous *Concert* (fig. 242), where the subject is suitable. The close-up figures evoke the sensuous experience of art as they listen intently and watch each other's reactions. Yet the central motif is muscular, the elastic diagonal pull between the fingers pressing the keys and the neck turned

241. TITIAN.
The Miracle of the Speaking Infant. 1511.
Fresco, 10'6" × 10'4".
Scuola del Santo, Padua

242. TITIAN. *The Concert.* Canvas, 43" × 48".
Pitti Palace, Florence

the opposite way. In the *Three Ages of Man*[48] an empty landscape fills the center, as in Giorgione's *Tempest,* but at the sides the figures again feel with their bodies. Simpler works are single female figures, *Salome*[49] or the *Girl Combing Her Hair,*[50] girls idealized only slightly into objects of aesthetic admiration. The key painting of the group is *Sacred and Profane Love* (colorplate 31), the nudity of the girl yearning for Heaven balanced with the pleasure of rich materials in the earthly girl's robe. They sit to be contemplated, in large symmetry, before a landscape whose distant sunset is more like one of Bellini's than the vaguer mysteries of Giorgione's lights.

Pendulum swings between forceful and quiet styles seem to mark Titian's life, and the huge *Assumption* (1516–18; fig. 243) reverts to the active grandeur of almost a decade earlier. It is set at the end of a long Gothic church, pulling its space into focus. Above the brawny apostles with glistening arms is a slice of deep sky, then the heavy yet soaring Mary surrounded by sailing robes and clouds of angels, then another slice of sky and God the Father. Luminous big colored forms are the elements of a physical life that moves with smooth excitement. Other altarpieces of the following years, using similar sandwiches made of forms and sky and freely borrowing poses from Michelangelo but refusing his psychological implications, alternate with Bacchanals that continue the series begun by Giovanni Bellini for the duke of Ferrara (see colorplate 30). The *Worship of Venus* (1518),[51] a packed sea of tumbling cupids kissing and fighting, and the *Andrians* (1518–19),[52] dancers and drinkers around a river of wine, culminate in *Bacchus and Ariadne* (1523; fig. 244), a procession with satyrs and leopards moving diagonally across a sunny island toward the sky. The surprising altarpiece for the Pesaro family (finished 1526)[53] sets the Madonna and saints along a diagonal line in depth, while columns rise up in front of and behind drifting clouds; but the donors, the real contemporary people, kneel in stiff archaic profile on the front plane.

Toward 1530 textures of cloth and flesh become the chief concerns of a new group of quiet works, including many portraits. A nude in furs and earrings shows us textures that seem more highly charged in the painting than in real life because the focused light enhances the already special limitation to their visual qualities only.[54] Such pictures

243. TITIAN.
The Assumption of the Virgin. 1516–18.
Panel, 22′6″ × 11′10″.
Church of the Frari, Venice

193

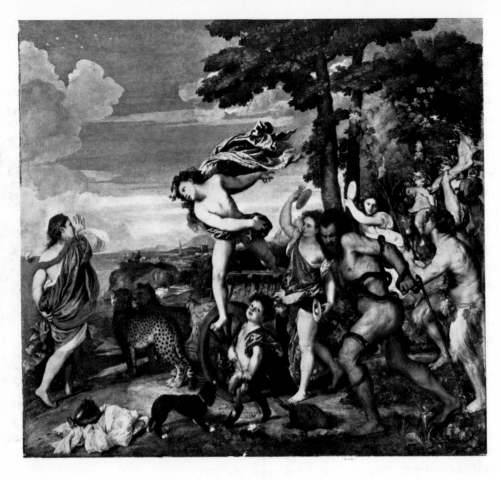

244. TITIAN.
Bacchus and Ariadne. 1523.
Canvas, 69″ × 75″.
National Gallery, London

were enjoyed by Titian's lordly patrons as "the woman in the blue dress" or "the nude" more than as illustrations of namable topics. Meanwhile the artist lived luxuriously, was created a count by the Holy Roman emperor, and enjoyed the most in-teresting and talented society of Venice, while at the same time he showed business acumen in his contracts and assembled a huge crew of assistants. At forty he no longer had any rivals and dominated the procedures of Venetian painting.

20. Lotto, Pordenone

Venetians of Titian's age group who painted in their own distinct styles failed in their careers. The brilliant Lotto (docs. 1503–d.1556) shares a rebellious agitation against the calm classicism of preceding traditions with Titian and other major and minor contemporaries; but unluckily his rebellion was also antimodern, seeking against the grain to conserve a figure-space duality (see p. 138). He had been deeply taught by his old master Alvise Vivarini, and rebels only in the self-conscious layers of his painting. His earliest distinctive work, the portrait of *Bishop Rossi* (1505),[55] masters a gently luminous cubic effect in the Bellini tradition. Its allegorical cover-panel[56] is more unusual, a pastoral landscape making a contrast between disorder, a Riccio-like satyr, and order, a child with compasses.

Such command of current fashion soon yields to Madonnas with saints tossing their heads, and then to altarpieces where sculptural figures twist in distress, in flapping garments and wriggling folds. When such figures appear not in traditional altarpieces but in less formal, more psychological works, we have many sharp, unquiet portraits and scenes like *Susanna and the Elders* (1517),[57] whose neat space, with bright realistic background landscape, contains bodies swung around under pressure built up and not released. In *Christ Taking Leave of His Mother* (1521; fig. 245) the thick forms flop on the

194

ground, and in the *Annunciation*[58] an angel with dislocated bones greets Mary, who, overcome, flutters her hand along the front plane as though it were a window while a realistic cat races between them. Lotto absorbs poses from German prints, which many action-minded Italian painters were using, into his Venetian vehicle of colored throbbing surfaces. And he was modern in his concern with the potential mobility of all his figures. But he resists the modern unity of the visual field, and seeks to keep the figures as distinct from their background as they were in the early Renaissance, with its more stable images. Since Lotto's people are alive and irregular, their duality with the environment must be a discordant one, and their restless probing unbalance seems to evoke their uncomfortable relation to the world. They tautly offer papers, nervously tear up flower petals, or merely stare with a pain the more poignant because of Lotto's mastery of vivid tonal harmonies.

Pordenone (1483–1539) learned to paint fresco cycles in churches in provincial mountain towns north of Venice. A visit to central Italy about 1515 seems to have left him excited about the monumental grandeur of Michelangelo's Sistine Ceiling, and perhaps also the spatial daring of Melozzo da Forlì. The result is an imagery of power that rivals Titian's *Assumption,* painted at the same moment. In the same Cremona Cathedral cycle where Boccaccino and others worked, Pordenone produced a masterpiece in his scenes of Christ's Passion and death (1521; fig. 246), based on the thrust of muscular forms and thick spiraling lines. These occur in wool folds, horses' thick manes, sickles, and turbans, and then in muscles powering swords and ropes which are propelled like whips or lassos, so that we feel how they inexorably hit their victims. The large scale harnesses the space between walls

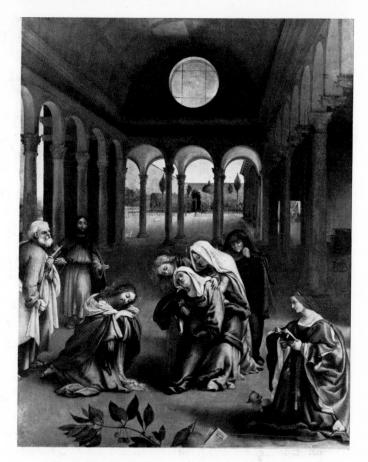

245. LORENZO LOTTO.
Christ Taking Leave of His Mother. 1521.
Canvas, 50″ × 39″.
Staatliche Museen, Berlin-Dahlem

and ceilings, where angels tumble from the side of a dome or a false prophet from the sky. After years as a journeyman in many small-town churches, Pordenone came to Venice when he was almost fifty, proposing to compete with Titian. He benefited from Titian's increasing work for foreign lords and kings and lessening interest in Venetian jobs, but just as Pordenone received his official appointment he died, and his achievements remain little known because of their obscure locations.

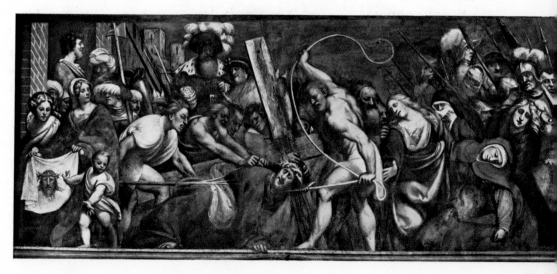

246. PORDENONE.
Christ Led to Calvary.
1521. Fresco, 10′8″ × 24′7″.
Cathedral, Cremona

21. Savoldo, Romanino

247. GIROLAMO SAVOLDO. *St. Mary Magdalene Approaching the Sepulchre.*
Canvas, 34" × 31 1/4".
National Gallery, London

248. GIROLAMO ROMANINO.
The Death of Cleopatra.
Fresco, width at base 8'9".
Castello del Buonconsiglio, Trent

The flourishing town of Brescia, on the road between Venice and Milan, belonged in the fifteenth century to Milan and sent Foppa there, but in the sixteenth to Venice and sent Savoldo there. Girolamo Savoldo (docs. 1508–1548) lived in Venice all his adult life, and the label "Brescian school" for him was at one time the result of local pride, more recently a hasty deduction from the great gulf between him and Titian. If the Venetian school means the style of Titian, then Savoldo has to belong to some other school, but in fact he, like Lotto, was a product of a different Venetian strain. Perhaps trained by Cima, he kept all his life to the old-fashioned sense of the human form as impenetrable and separate. He seems to insist on it, in that nearly all his pictures—most exceptionally—represent one figure and little more, a heroic static mass. Visiting Florence in his youth, he shared the general attraction to northern art, but, again old-fashioned, seems to have liked Van der Goes best. His early *Seated Hermits*[59] show the resultant mountain-like figures, stable and complex in silhouette, deep and rich in color. He was tempted a little later by Giorgione, when Titian was, but found in Giorgione an aid toward quietude; Savoldo's Holy Families and musicians sit in the dusky, subtle air, translating pastoral dreaminess into passive grandeur. His conservatism is shy rather than combative like Lotto's, and it is typical that despite lack of success, he stayed in Venice instead of moving about as Lotto and

COLORPLATE 29. GIORGIONE. *The Tempest*. c.1503–6. Canvas, 30″ × 29″. Accademia, Venice

COLORPLATE 30. GIOVANNI BELLINI. *The Feast of the Gods*. 1514. Canvas, 67″ × 74″.
National Gallery of Art, Washington, D.C. Widener Collection

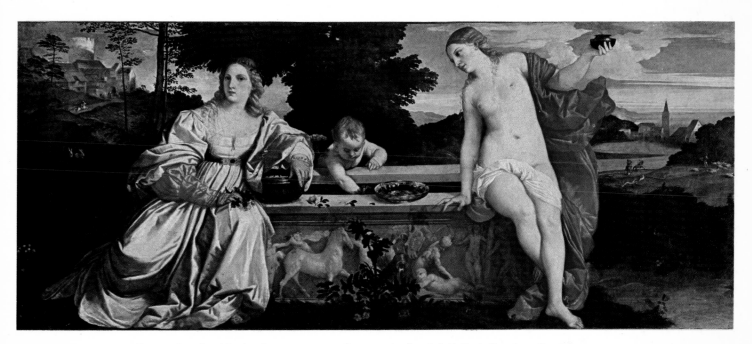

COLORPLATE 31. TITIAN. *Sacred and Profane Love*. c.1512–15. Canvas, 3′11″ × 9′2″. Galleria Borghese, Rome

COLORPLATE 32. GIROLAMO SAVOLDO. *St. Matthew.* c.1532. Canvas, 37″ × 49″.
Metropolitan Museum of Art, New York. Purchase 1912, Marquand Fund

Pordenone did. He also recognized as a problem in his work the inconsistency between figural autonomy and atmospheric realism. His answer was to make the figure more and more luminous and planar, so that although separate from the environment, it is congruent with it. This reaches a paradoxical crisis in his masterpiece, for once full of excitement, the candle-lit *Saint Matthew* (colorplate 32), where the extreme contrasting light and dark mark the separation of the red body and the black space but also create a single optical field. This nocturne, a tour de force, nearly made him famous. But in his last works he returns to probing unity still further, making his figure of *Magdalene* (fig. 247) a silver-gray plane in the dawn.

Romanino (1484/87–docs. 1559) stayed in Brescia, but he is not labeled as of a "Brescian school." His training seems to have been with the Bologna-Ferrara group, especially its Cremona annex, but a visit to Padua at once converted him to Titian's fireworks of big active people in high color. He was also delighted by Venetian technique, and became a master of the sketchy visible brush stroke used for dynamic effects. But his work is never fully Venetian, always a bit leaner and never as comfortable in opulence. He shared his friend Melone's attraction to German woodcuts for the excitement of irregularly interacting bodies and caricatured realism (see fig. 237). Hence his frescoes in Cremona (1519–20), after Melone's but before Pordenone's, are a bumpy drama of soldiers at their devices and plump citizens in shimmering light, with Titian-like live textures of glowing cheeks, velvet, and armor. The sense of events is satirical, and in later frescoes in Brescia his Olympian gods on house ceilings are neither classical nor poetic, but incongruously naked peasants of comic vitality. Technically, his use of keen line as a spice for his basic reliance on the truth of color has an equally striking result (fig. 248). Just as Delacroix is said to draw with color, Romanino paints with line; his brush works like a pen constantly shifting in breadth and thrust. All his resources are blended in his effects. He is an original quirky talent who left no talented successors, though later Caravaggio certainly enjoyed his coloristic roughness.

22. Correggio

Of the many painters to come at this time from middle-size north Italian towns, Correggio (docs. 1514–d.1523) is the greatest. At some later times, especially in the eighteenth century, he was placed on the short list of giants along with Leonardo and Raphael, but today the soft luxuriance of his surfaces and his extraordinary technical ease seem repellent, and he is further from our taste than Raphael is. But a close look will compel recognition of his brilliant inventiveness in design as well as his accomplished execution.

His early work alludes to the sources natural in his city of Parma, the same as in nearby Bologna: Mantegna's late work and Francia's dilution of Leonardo. His *Madonna of Saint Francis* (1514–15)[60] uses the composition of Mantegna's *Madonna of Victory*,[61] with the daring diagonal relationship of figures at a distance, but the paint style comes from Francia. Still it is so much more alive that it looks more like a direct derivation from Leonardo.

Moving soon to Parma (from his small hometown nearby) he got his first unusual commission, ceiling frescoes for the small parlor in which a worldly and intellectual abbess received guests to the convent. The painted arbor through which we see the sky is still Mantegnesque, but the new details are immensely sophisticated. The openings are oval, a softening change, and through them we see pairs of children playing games in constantly changing motifs of fantasy; below are tiny allegories of the course of life, with learned allusions. The children already show how, moving from Leonardo, Correggio developed his own special forms like elaborately shaped clouds, shadowy, downy, and evanescent. This ceiling leads to two church domes. In the first, San Giovanni Evangelista (1520–24; colorplate 33), we look up to see Christ in the middle of the heavens, his arms and legs spread out irregularly as if we were looking from below at a swimmer. At the base of the dome literal clouds and people are inter-

249. CORREGGIO. *Adoration of the Shepherds*
(*Holy Night*). 1530. Panel, 8′5″ × 6′2″.
Gemäldegalerie, Dresden

250. CORREGGIO. *Jupiter and Io.*
Canvas, 64″ × 28″.
Kunsthistorisches Museum, Vienna

woven, the people only slightly more complex in
form. Audacious virtuosity and weightlessness at-
tain grandeur in the second cupola, for Parma
Cathedral (1526–30), where Mary, being received
in Heaven, is one of the figures mingled with the
clouds, and Christ, who receives her, is again seen
from below. The angels push their legs about like
beating wings, making a loosely irregular silhouette
of vibration.

Altarpieces take even more surprising, if simi-
lar, liberties with tradition and the law of gravity.
In an early one[62] the three figures—saint, Madonna,
and saint—are at descending heights from left to
right, in a beautiful texture as of matte porcelain.
In the *Madonna of the Basket*[63] the Child slips
forward diagonally, pushing his feet at us, as the
spine of a diagonal design. In both the famous "Day"
and "Night" altarpieces—the *Madonna with Saint
Jerome* (finished 1528)[64] and the *Adoration of the
Shepherds* (1530; fig. 249)—the light and figures

are placed so that the masses form an isosceles triangle with its base the left side of the painting and its point at the right, containing a tangle of twisted garments and smiling faces. It is striking that virtuosity and luxuriousness are developed as much here as in Correggio's erotic pagan mythologies, where they are so much more easily exploited. As a present for the emperor, the duke of Ferrara ordered both the *Danaë*,[65] who smiles to herself as she sits up on her mattress and holds her legs apart to catch the divine shower of gold, and the *Leda*,[66]

whose swan kisses her with a beak at the end of a twisting neck, which is at the end of a downy body. The most perfect Correggesque erotic image is *Io* (fig. 250), who, true to the Greek myth, embraces the god Jupiter when he comes in the form of a cloud. The cloud contains a face and foggily enfolds her, while she lets her head fall back in boneless but precisely rendered ecstasy. This is the peak and the end of the career of Correggio; he died at forty, having made more than anyone else out of Leonardo's fluid forms of life.

23. Michelangelo: the Medici Years

In 1512 the Medici recaptured Florence from the republic, and in 1513 one of them was elected Pope Leo X. Michelangelo had been shuttling between the republic and the papacy, and so now had one patron. He again put aside the tomb of Pope Julius II, although he probably worked privately about 1520 on the four *Slaves* that to us seem so expressive as rough fragments (fig. 251). Michelangelo's procedure of determining the torso first, leaving the extremities for later, seems to imprison them in the stone blocks and make them more poignant than polished statues. Though this was not the artist's intention, it so moved Rodin in the nineteenth century that he made it a basis for his art, and Michelangelo was conscious of it at least to the extent that he thought of unfinished sculpture as a symbol of unreached ideal goals.

Under the Medici popes, Leo X and Clement VII, both very permissive patrons, Michelangelo came closer than at any other time to completing a big set of sculptures. These were the Medici tombs in San Lorenzo (1520–34), made for two scions of the family who died young. He designed and built the chapel for them (fig. 252; see also fig. 80) and then worked simultaneously on seven statues, including a *Madonna*. Each tomb has a figure of

251. MICHELANGELO. *Slave.*
Marble, height 8′7″.
Accademia, Florence

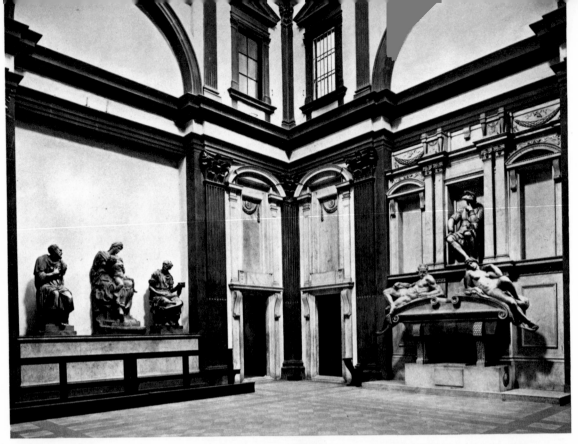

252. MICHELANGELO. Medici Chapel (including *Medici Madonna* and tomb of Lorenzo de' Medici).
Begun 1519. Main area of chapel 34′6″ square. S. Lorenzo, Florence

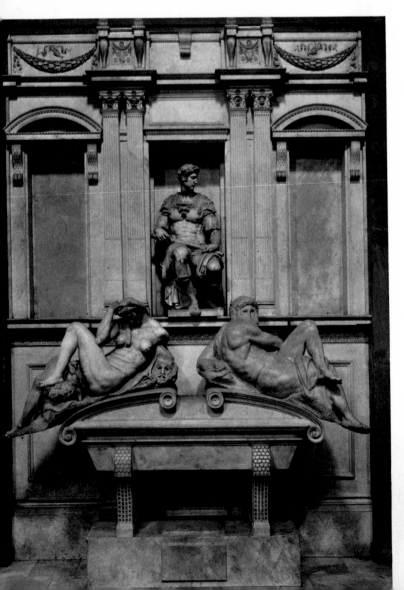

254. MICHELANGELO. *Dawn*, from the tomb of
Lorenzo de' Medici. 1520–34.
Marble, length 6′9″.
Medici Chapel, S. Lorenzo, Florence

253. MICHELANGELO.
Tomb of Giuliano de' Medici, with
Night and *Day*. 1520–34. Marble,
bay 22′9″ × 15′3″.
Medici Chapel, S. Lorenzo, Florence

the deceased and two symbolic figures (fig. 253). Michelangelo seems to have invented an original symbolism and fitted to it the odd and novel curved lids of the tombs on which the figures lie. *Day* and *Night* in one case, *Dawn* (fig. 254) and *Twilight* on the other, evidently allude to the endless round of time which leads to death. But then, Michelangelo said, the death of the duke has blinded day and night, and he carved them so. This tone of courtly flattery is remote from our conventional notion of Michelangelo as an unsocial tragedian, but it is a real factor, just as flattery of Queen Elizabeth I is integral to Shakespeare. The figures seem often in modern comments to be remembered as passionately heroic (like the *Moses;* see fig. 214), more than they candidly are. *Dawn* comes closest, pushing upward along her curved base as is suitable to her role, and in the process suggesting panic strain. But *Twilight* is restfully contemplative, like a maturer version of the Sistine *Adam* (see fig. 1). *Day,*

with enormous bunchy muscles, stares with inarticulate blindness, but *Night,* the most finished figure, is a thin-cheeked, richly ornamented beauty of almost Leonardesque grace. Similar ornament and proportions mark the two dukes, who seem to originate a new type of court portrait. The figures are unrealistic, with emphasis on their official costumes and thus on their status; this formula was one of Michelangelo's influential inventions. The tombs realize in spatial tension all the formal grandeur of their heavy, simplified shapes; motion is understood as required to secure each figure in place.

Two single sculptures of this period show rather thin male nudes standing in a serpentine twist like the *Medici Madonna.* One is the *"David or Apollo,"*[67] the other the *Victory,*[68] standing over its victim like Donatello's *Judith.* The resolution of stability into a spiral, the most extreme form of mobility that remains vertical, was also very influential on young artists.

24. Sculptors in Michelangelo's Orbit

To be a rival for commissions with Michelangelo was unlucky. He was not only eager to start new projects and overwhelming in his designs for them, but difficult in his personal character, always berating everyone, including himself, for failure to meet high standards. Many of his contemporaries were content to be craftsmen or to imitate him. But several strong personalities offered to compete, with drastic results.

Jacopo Sansovino (1486–1570), the brilliant pupil—not son—of Andrea Sansovino (see p. 164), went to Rome with Andrea and looked at ancient sculpture, but more at Raphael. The result on his return to Florence was his *Bacchus* (1512; fig. 255), for a garden, a magnificent criticism of Michelangelo's early work (see fig. 200). Rejecting unbalance and pressure, it lives in ascending and expanding curves, like Raphael's, harmoniously extended into the third dimension. Perhaps a Raphaelesque sculpture was the only possible way to create an alternative to Michelangelo, but the technical ease and assurance of the *Bacchus* recalls

that Sansovino was also the heir of the strong and graceful Florentine carving of the late fifteenth century, as seen in Antonio Rossellino's *Saint Sebastian* (see fig. 116). After losing a job for which he competed with Michelangelo, Sansovino went back to Rome, where his big *Madonna*[69] is more directly classical and more ample in harmonies, like a later Raphael Madonna. When Rome was sacked in 1527, he gave up and fled to a new career in Venice, where he was a tremendous success (see pp. 230–31).

Baccio Bandinelli (1493–1560) was constantly favored by the Medici rulers after 1512, and carved a number of their portraits. His career centered around a huge marble block which was first meant for Michelangelo, then for him, then for Michelangelo again, and finally carved by him into the *Hercules and Cacus* (finished 1534; fig. 256). It was set beside, and meant to complement, Michelangelo's big *David* (see fig. 202). Even though the *David* was thirty years older, the *Hercules* looked old-fashioned: simple-minded, boxy, and inflexible, almost a

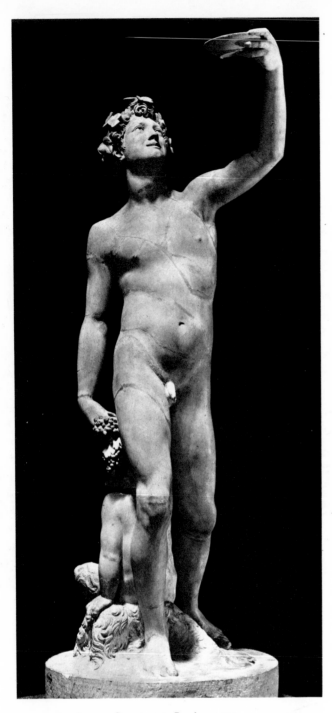

255. JACOPO SANSOVINO. *Bacchus*. 1512.
Marble, height 57″.
Museo Nazionale, Bargello, Florence

set of four planes with lines cut on them. It has a geometric logic of design which constricts it; Bandinelli was a devotee of theory who could never see why his well-planned works were not as well liked as Michelangelo's, and he made it more difficult by always seeking large commissions. His schematic drawings are, if mannered, strong and intense, and he was an effective teacher. Perhaps he can be most happily remembered through an untypical work made on his design, an engraving of his studio at night with his pupils drawing among the lamps (fig. 257). Flatness, linearity, small scale, and personal theme are all favorable.

In a younger generation Guglielmo della Porta (docs. 1534–d.1577) is a fine sculptor who belies the supposition that in Rome in the 1540s there were only Michelangelo and some slavish imitators of him. Della Porta had the typical background of a Lombard stonecutter, as apprentice

256. BACCIO BANDINELLI.
Hercules and Cacus. 1534.
Marble, height 16′4″.
Piazza della Signoria, Florence

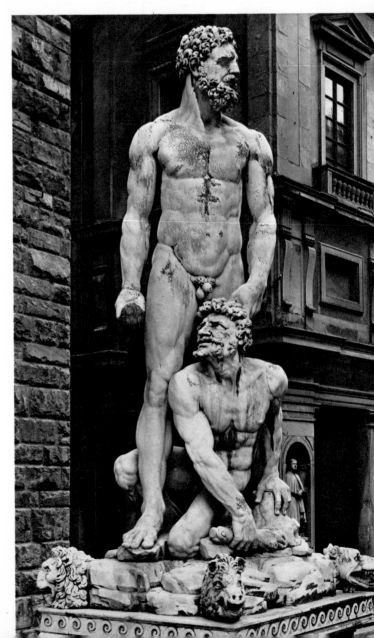

to and then collaborator with an uncle. During these long modest years he polished a zest for portraiture and for ornament. When he came to Rome in 1537, Michelangelo had retired from new sculpture projects of large scale, and encouraged and influenced him. He took to the new styles he found with skilled comprehension, like other traveling carvers from Lombardy before (see p. 131). On Michelangelo's recommendation he was assigned (1549) the tomb of Pope Paul III, and spent the rest of his life on it. He planned a huge freestanding block with eight allegories, reflecting Michelangelo's tombs of Pope Julius and the Medici dukes, and proposed the four seasons as a theme, like the Medici Chapel times of day. But the consultant on allegory rejected this and steered him to Roman coins, and Michelangelo vetoed the scale of the plan because it took too much space in Saint Peter's; finally his nude *Justice* was covered up. As a result

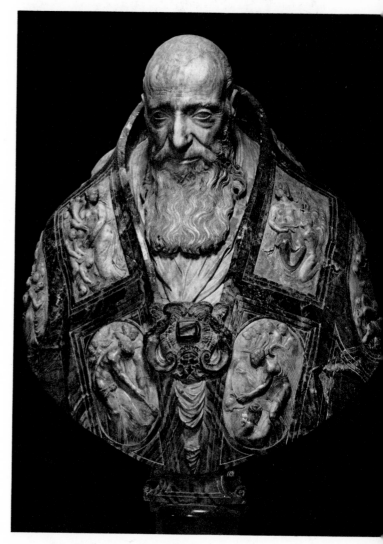

258. GUGLIELMO DELLA PORTA.
Pope Paul III. 1546. Marble, height 30".
Museo Nazionale di Capodimonte, Naples

257. AGOSTINO VENEZIANO (after a drawing by Baccio Bandinelli). *Sculptor's Studio.* 1531.
Engraving, 12" × 11". The Metropolitan Museum of Art, New York. Elisha Whittelsey Fund, 1949

of these calamities he now shows up best in his portraits of Pope Paul III, in Saint Peter's and elsewhere (fig. 258), with a masterly sweep of grand rhetoric. The sharply expressive solid head makes a firm and lively center, and colored marble, used with great aplomb, reveals that he has grasped a new style, Titian's, after Titian visited Rome and portrayed the pope (see fig. 279). He imposes a forceful order on the pulsating and gaudy materials.

25. Pontormo, Rosso

Following Fra Bartolommeo and Andrea del Sarto, the bright young painters in Florence were Andrea's assistants. Pontormo (1494–1557) emerged at twenty as the chief talent. Not surprisingly, he was a superb draftsman, and followed his master's accomplished harmonies, if in a slightly less relaxed way. His *Visitation* (1514–16),[70] and the pastoral-mythological fresco of peasant pagans in the Medici villa at Poggio a Caiano (1520–21; fig. 259), a sunny genre scene, have contour lines a bit sharper than Andrea's and the forms are pulled more tautly together, less like Leonardo. Perhaps this higher tension reflects unsureness, but it is maintained as a positive principle in the Passion frescoes for a convent (1522–24; fig. 260), where Dürer prints are used as a source. The figures, no longer easy and cushioned, become bony and thin; in *Christ before Pilate,* a tall skeletal Christ in white, isolated in the middle, bows his head while the floor strangely shoots up behind him and down to us. Then in the *Entombment* altarpiece (1525–28; colorplate 34) space disappears and the composition is a card house of linear

bodies twisting around each other, with masklike faces and round eyes, in bizarre harmonies of pink and icy blue. In his drawings of the same time line becomes autonomous, as the contours of bodies are shaped into ornamental rhythms. This is Mannerism, in which style is not a pattern for presenting nature, but for presenting its own technical vehicles, including previous styles. The resulting new forms and distortion of nature are personally bold and imply sophisticated culture in the audience. Theories of its rise have included inner stress and emotional reaction to the decline of Italy or of the Catholic Church as powers. But the forms seem to use distortion no more in tragic than in amusing themes, and in the tragic theme of Christ's death simply retain the traditional Renaissance point of view that the work should bring out the dramatic qualities of the assigned subject. (Such an attitude lacks the personal emphasis of modern painting, but would be familiar today for actors or architects.) But a source of Mannerism in inner stress is supported by Pontormo's behavior, which was eccen-

259. JACOPO PONTORMO. *Vertumnus and Pomona.* 1520–21. Fresco, 15′ × 33′. Villa at Poggio a Caiano (near Florence)

260. JACOPO PONTORMO. *Christ before Pilate.*
1524–27. Fresco, 9′10″ × 9′6″.
Certosa del Galluzzo, Florence

impracticable people was translated, when he went to Rome, into superb and influential engravings. He was still more influential after he fled the Sack of Rome and went to the court of Francis I of France, who had had poor luck with his previous invitations to Leonardo and Andrea del Sarto. Rosso stayed ten years at the palace of Fontainebleau, painted mythologies in a long gallery, framed them in stucco moldings of an elaborate decorative logic, and started the Fontainebleau school, which specialized in erotic scenes filled with stylish figures too tall and willowy to be possible.

tric and antisocial, making him finally a recluse concerned with daily meals, a few friends, and his art. It is not likely that he was anxious to state a pessimistic view of public affairs. The main result of his personal quirks was that after his great decade he subsided into court portraiture of a sure-handed artificiality.

Rosso (1495–1540) had an identical early career. His frescoed *Assumption* (1517),[71] in the same set with Pontormo's *Visitation,* is further from Andrea; it uses its command of realism to produce caricatured faces. In his great *Deposition from the Cross* (1521; fig. 261) the controlled line and modeling are so abstract that the too-tall figures are geometric colored planes, often lozenge-shaped, which are assembled into irregular prisms or polygons. Only here, in Rosso as in Pontormo, is the stress tragic in effect. The color planes again mark his *Moses Defending the Daughters of Jethro* (colorplate 35), and often build up the figures, color units of artificial rainbow sequences, in implied but unstated spaces. The elegance of his tall, hot-toned,

261. ROSSO FIORENTINO.
Deposition from the Cross.
Panel, 11′ × 6′6″.
Pinacoteca Comunale, Volterra

209

26. Beccafumi, Parmigianino

Mannerist style in painting emerged in various places at once, but only where several conditions were present. It is the third stage, following first the creation of the High Renaissance as an unprecedented harmonious formulation of nature (by Leonardo, Michelangelo, or Raphael), and a second stage of great or minor masters (Andrea del Sarto, Correggio, Sodoma) who cannot carry naturalism

262. DOMENICO BECCAFUMI.
Birth of the Virgin.
Panel, 7′8″ × 4′9″.
Pinacoteca Nazionale, Siena

any further, and who simply refine the harmonious formulas. Their pupils from the beginning learn these sophisticated patterns by heart, and allusions back to nature can easily fade away. If the pupil is talented, original, or rebellious, powerful stylizations result. The key to this is the existence of the second stage, so that the first Mannerists never had direct contact with the intensive study of natural forms by someone like Raphael, but only with the intensive study of Raphael by a formal stylist like Andrea del Sarto.

It is not known whether Beccafumi (1486–1551) was taught by Fra Bartolommeo or Sodoma, both polished rearrangers of the forms of Leonardo. Since Beccafumi was Sienese and visited Rome in his youth, Sodoma is his traditionally assigned master, with a few compositional ideas adopted from Fra Bartolommeo, but the opposite view is also held. His sinuous figures and the archaeological element in his early works, like Sodoma's in Rome, seem to confirm the tradition. The figures, through Sodoma's sweet and luminous ones, derive from Leonardo's *Leda;* in Beccafumi the S-curves become unrealistic patterns and the light becomes an inner glow shining out as if through a plastic membrane (fig. 262). These ghostly and sugary people occupy an elegantly distorted and patterned space, making large and small figures that seem far from each other collide laterally. He borrows intricate compositions and sets of scenes from the Raphael shop. Despite his pleasure in yellows and pale pinks, he is really a tone painter in the Leonardo tradition; this is the context of his strongest technical creations, the gray painted sketches on paper and the stone inlay scenes for the floor of Siena Cathedral (fig. 263).

Parmigianino (1503–1540) was a brilliant challenger at nineteen, in his native Parma, of the twenty-eight-year-old Correggio. His early female saints in the church where Correggio had painted the dome (see colorplate 33), and his Greek myths in a villa,[72] suggest a rich mobility of thin figures through long sketchy strokes that make up a pasty surface. He begins to play virtuoso games in a round self-portrait (fig. 264), in which he paints his hand

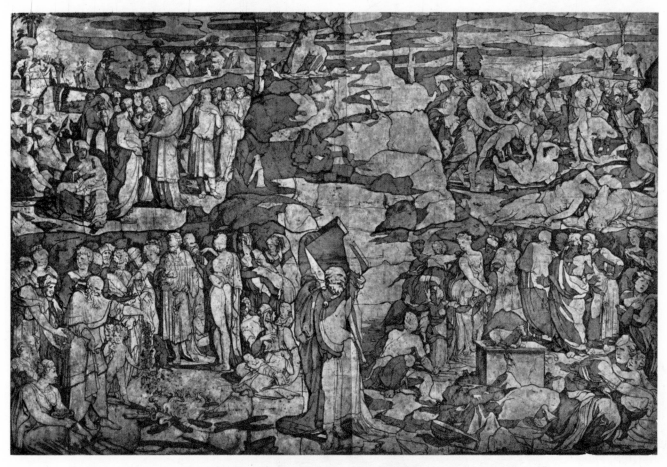

263. DOMENICO BECCAFUMI. *Moses Receiving the Tablets of the Law.* 1531. Inlaid marble, 16′×24′6″.
Cathedral, Siena

264. FRANCESCO PARMIGIANINO.
Self-portrait. 1524.
Panel, diameter 9″.
Kunsthistorisches Museum, Vienna

very large, as it would appear at the front of a mirrored space, not making the conventional readjustment; it is a tour de force of ambiguous truths. He took this with him when he went to Rome to seek his fortune. There he was attracted by the engravings of Rosso's work. The result was a series of Madonnas only a little more shimmeringly colorful than his earlier works, but with line that has its own decorative life. Fingers grow to impossible lengths and folds make parallel twists like rake marks. The faces lose texture and become hard, beautiful masks. He took this style with him when he fled home after the Sack of Rome in 1527, and it produced his best-known work, the *Madonna of the Long Neck* (1534; fig. 265). Her head and feet, tiny in proportion to her body, suggest the close kinship of this artificial beauty with fashion. This is an imagined type that many cultures have associated with chic elegance because it involves novel amusement, sophisticated appreciation, and luxurious elaborateness. In Parma he had an unhappy life, developing a consuming interest in alchemical experiments to the point of going to jail for breach of contract because he never finished his largest commission. But the influence of his elegant formula was enormous through space and time.

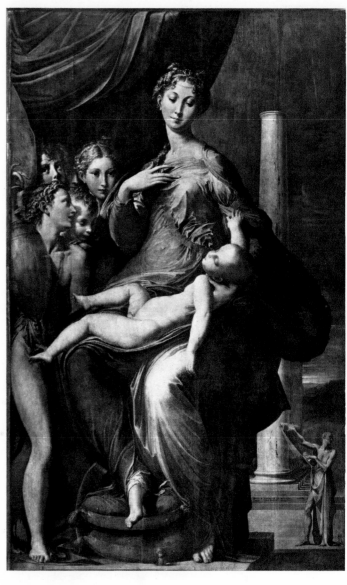

265. FRANCESCO PARMIGIANINO.
Madonna of the Long Neck. Begun 1534.
Panel, 85″ × 52″.
Uffizi Gallery, Florence

27. Mannerism in Architecture

Like Brunelleschi and Bramante, the most brilliant architects of Mannerist buildings came from other arts. Michelangelo began his building activity for the Medici, and his first actual walls were those of the Medici Chapel (1520–21; see fig. 252). The interior surfaces are conceived as frames for the sculpture, following his earlier designs of the Sistine Ceiling and for a façade for the Medici Chapel's church, San Lorenzo. As a sculptor's frame, it is full of active projections and recessions, but, unlike

sculpture, the unit is not the cut of a chisel but the masonry block. Hence this is a sort of relief sculpture of cubes, and Michelangelo's architecture retains this quality for some time. As nonprofessional architecture it is free of standard conventions, and so it unexpectedly ties small capitals to wider pilasters, or leaves large blocks in narrow niches, setting up a Mannerist zest for paradoxical games. It is also, like the one statue finished here, the *Night*, full of small elegant ornamentation. The library built for

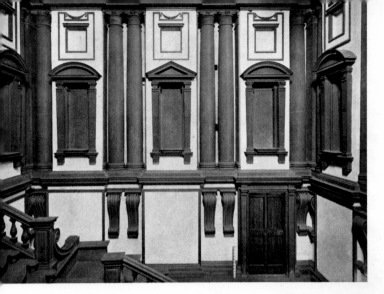

266. MICHELANGELO. Stairhall, Laurentian Library, S. Lorenzo, Florence. Begun 1524. Entire height 48'8"

the Medici (begun 1524; fig. 266) in the same convent of San Lorenzo develops the paradoxes further. The main reading room is again marked by small sharp ornament in ceiling and floor, and the walls have a strong functional rhythm of windows between supporting pilasters. But the entrance lobby with its triple staircase (meant for a lord between attendants, Michelangelo said) develops witty artifice as never before. Columns are recessed in walls instead of being in front of them as usual, and they rest not on the floor but on brackets halfway up; and pilasters widen as they rise. The dynamic units are now not blocks but whole building elements. The disruption of our sense of normal security responds, perhaps, to the fact that this is a staircase in which the human relation to space is unbalanced

and irregularly shifting, in any case. This is perhaps the earliest "grand staircase" in an interior, with balustrades.

Giulio Romano (1499–1546), the foreman of Raphael's enterprises, painted with allusion to classical sculpture and correct, somewhat drier line, producing a cultured variation on Raphael's natural harmoniousness. The finest result is in the lower part of Raphael's *Transfiguration* (see fig. 218). Going to Mantua in 1524 as court artist, he designed everything, including the ducal plates and spoons with realistic leaves and fish in them, a playful fantasy on levels of illusion that recalls Riccio's inkwells. But his major work was to build and fresco the Palazzo del Tè, a country house (fig. 267). Giulio as an architect is two steps from Bramante, using the younger Antonio da Sangallo's neat formulas of intersecting moldings and pilasters, so that we are not surprised when he plays Mannerist games with them. In the courtyard a keystone slips down at regular intervals, as if the building were in decay, but we are also meant to know it is a contrivance. The unresolved pull between order and disorder is developed imaginatively in the frescoes, where deceptively real horses stand before white classical pilasters, but since they are on high pedestals over doors the deception is not carried all the way. In the most spectacular room all four walls are one continuous fresco of gods fighting giants, and gods throw boulders down on the giants and toward us, leaving us shocked but amused and appreciative.

More than twenty years after the Villa Farnesina, Peruzzi (see p. 177), who was occupied mean-

267. GIULIO ROMANO. Courtyard, Palazzo del Tè, Mantua. 1527–34. Height 34'

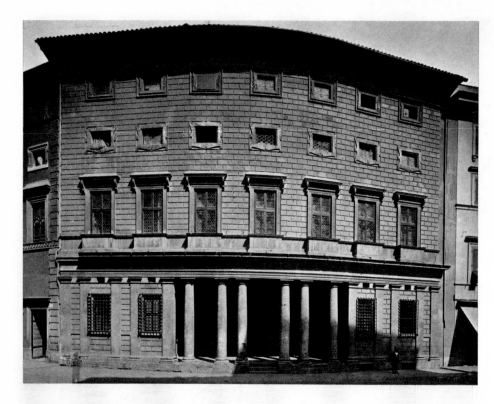

time with routine work in small towns, built his second masterpiece in Rome, Palazzo Massimi (fig. 268). Again the façade is paper-thin and marked by pilasters, but now it violates conventions startlingly, always with the excuse of practical reasons. The unique curving front—still effectively bold today—is justified by the curve in the street, but it did not appear in the first project. The four stories, with their unique rising rhythm of large, large, small, small, trail off in an unbalanced way, but with a reference to the real nature of attic stories. The portico, deeply shadowed in tension with the flat wall, seems to suck us in, and refers to the meaning of front porches. The ingenuity of such transferred suggestion is at its peak in the pairs of pilasters running across the front wall, changing from pilasters to columns right in the middle of a pair, with the excuse of shifting from flat to thick where wall shifts to porch. The two simultaneous rhythms (unchanging pairs; flat changing to round, and back to flat) symbolize the interplay of pure and applied thinking about design. The building remained without successors.

28. Perino del Vaga; Florentine Decorative Sculpture

The Florentine Perino del Vaga (1501–1547) joined Raphael's workshop at a late stage, when older assistants were doing most of the painting. He took part in small units of big decorations, notably in the ceiling of the Vatican loggia,[73] but emerges more clearly later as perhaps the most talented successor to Raphael in painting. He was drawn into the Mannerist orbit of Parmigianino and Rosso, with whom he collaborated on a project for engravings, and one of his fellow pupils, Polidoro da Caravaggio (docs. 1519–d.1543), painted outdoor murals on house fronts—none survives—which seem to have been in the lead of the new decorative style. Here may have originated the approach that we find full-

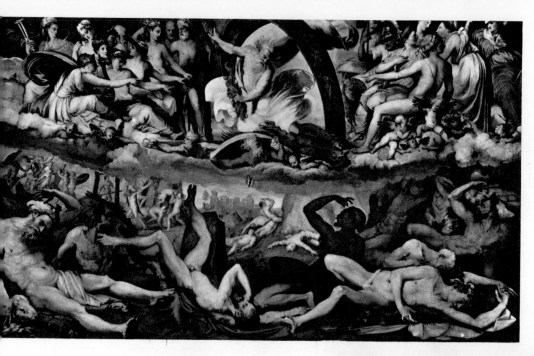

269. PERINO DEL VAGA.
The Fall of the Giants.
Begun 1528.
Fresco, about 21′4″ × 29′6″.
Palazzo Doria, Genoa

270. BENVENUTO CELLINI. *Diana.* 1543–44.
Bronze, 6′9″ × 13′5″. The Louvre, Paris

fledged in Perino after he fled the Sack of Rome and painted in the new palace of Andrea Doria, the new ruler of Genoa (fig. 269). The frescoed scenes are rhythmic patterns of people, gracefully active, filling the frame with an even density and avoiding depth. Each figure is an ornament in itself as well, with curving linear elegance. This very influential style is parallel to Rosso's at Fontainebleau. Ten years later Perino returned to Rome and painted a similar palace interior, the remodeled Castel Sant' Angelo, for Pope Paul III. Conscious of Michelangelo's potent presence, he modified his friezes into sculptural monochromes of larger scale, emphasizing pure formalism even more. He used a large shop, from which most of the leading painters of Rome in the next generation came.

Several talented Florentine sculptors of Perino's age group were decorators in the same mood. They were slower in maturing, and flourished best after 1540, under the aegis of the new ducal court and away from Michelangelo. Niccolò Tribolo (1500–1550), though a pupil of Jacopo Sansovino's, spent years assisting Michelangelo and others on large projects, until he came into his own with a series of complex fountains, a typical display object of the court. His are indeed the first in the line that leads to Bernini's in Rome. His typical figure is a fat, energetic, dancing baby, whose vivid muscularity is a nod to Michelangelo. But it is essentially a descendent of Sansovino's *Bacchus* and early Renaissance Florentine carving in its solid simple forms and harmonious mobility.

The much more famous Benvenuto Cellini (1500–1571) began as a jeweler and goldsmith in Florence. He turned to large sculpture on a trip to Fontainebleau, and his *Diana* for the top of a gate there is a figure of graceful artifice, not surprisingly in the Rosso style, with long graceful legs and tiny feet (fig. 270). Coming home, he secured (1545) his great ducal commission for the *Perseus* (fig. 271), a bronze to be set in the main city square beside the statues by Donatello, Michelangelo, and Bandinelli (the first two of these had been civic symbols, but all now were regarded virtually as a museum of Florentine art). The *Perseus,* though it reveals the goldsmith in its elaborate base and the polished detailing of the main figure, handles its grand scale with authority. It is thus, apart from the special case of Michelangelo, the fullest statement of Mannerist style in sculpture that had been made. Cellini's *Autobiography* does not so much show us his age as his superbly vain view of it; its most significant documentation is of the artist's feeling about his patrons the rulers, whose precious accolades meant everything to him.

A brilliant short-lived pupil of Tribolo's, Pierino da Vinci (docs. 1546–1553), was the only sculptor of this group to specialize in reliefs, which are low, luminous, and subtle. His few statues in the round have a similar surface quality, giving them an unequaled suave grace. Pierino in some ways suggests the average tendency of the group, like Tribolo more fluid in action than the ornamental Cellini, like Cellini more formally patterned than the traditional Tribolo. But the sensitive handling with which he evoked a gently breathing life is a personal observation.

271. BENVENUTO CELLINI.
Perseus. 1545–54.
Bronze, height 18′.
Loggia dei Lanzi, Florence

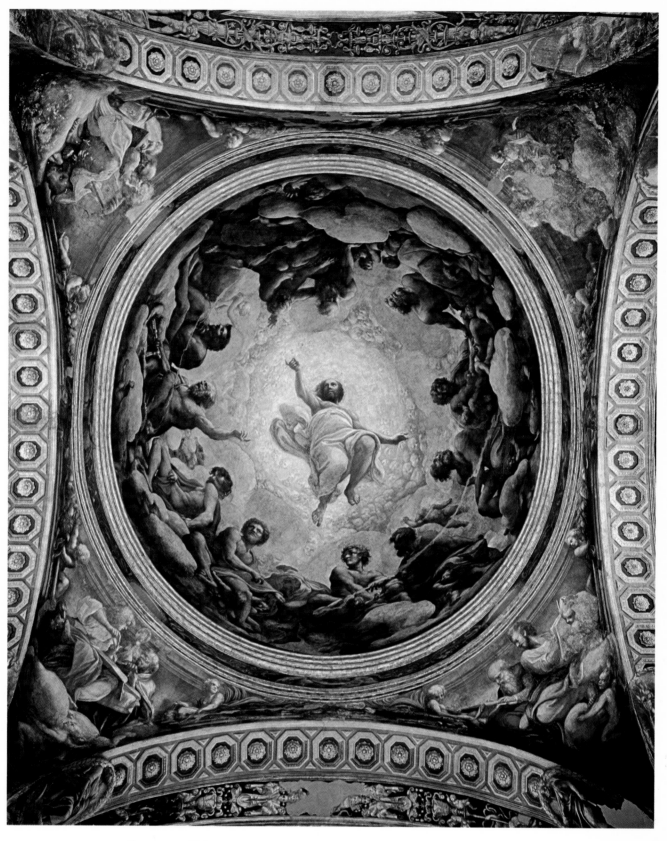

COLORPLATE 33. CORREGGIO. *Vision of St. John the Evangelist*. 1520–24. Dome fresco, axes 31′8″ × 28′5″.
S. Giovanni Evangelista, Parma

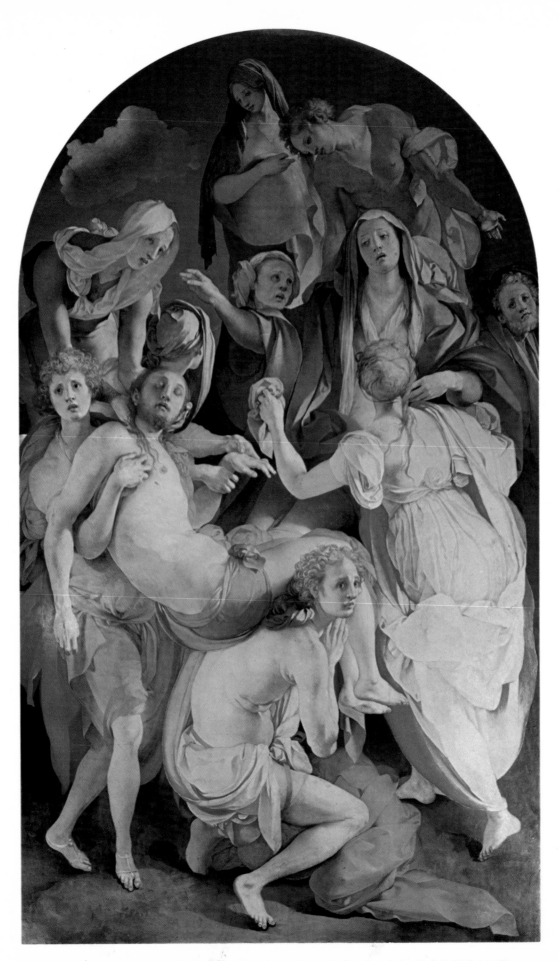

COLORPLATE 34. JACOPO PONTORMO. *Entombment.* 1525–28. Panel, 10′3″ × 6′4″. S. Felicità, Florence

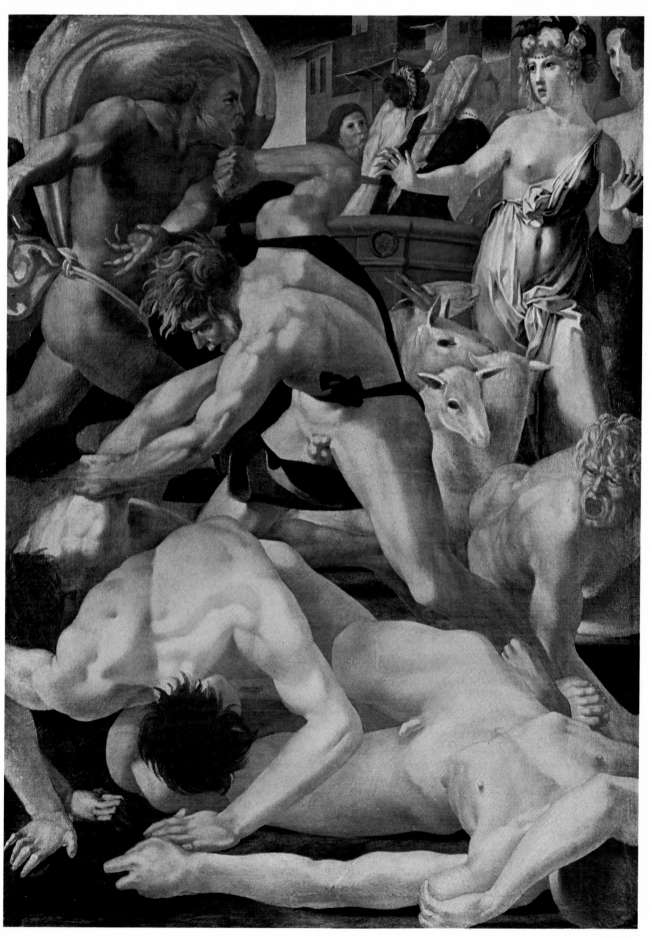

COLORPLATE 35. ROSSO FIORENTINO. *Moses Defending the Daughters of Jethro*. c.1524. Canvas, 63″×46″.
Uffizi Gallery, Florence

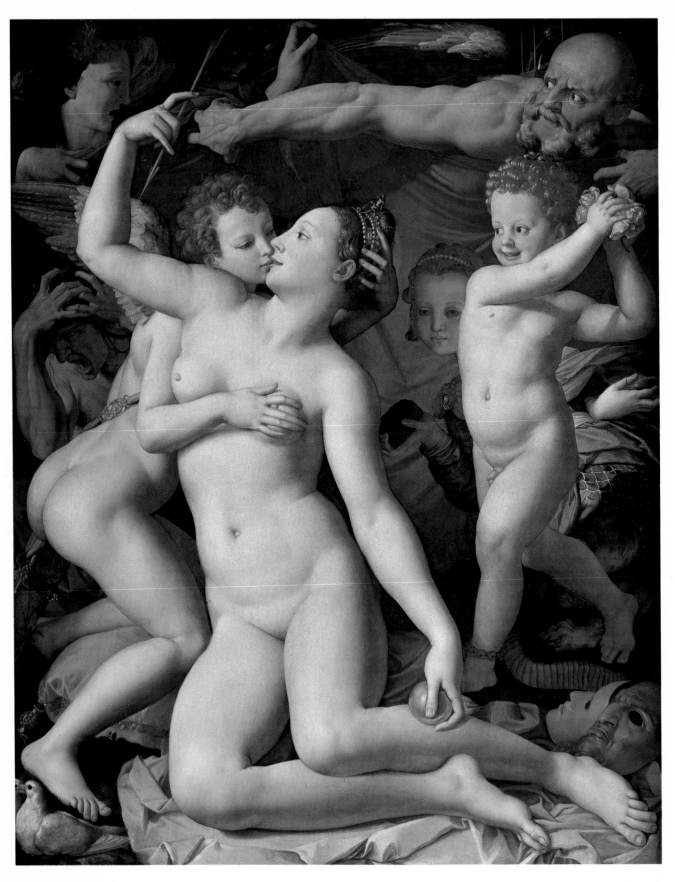

COLORPLATE 36. Agnolo Bronzino. *Venus Disarming Cupid.* c.1524. Panel, 61″ × 57″. National Gallery, London

29. Bronzino and His Contemporaries

In 1530 the last change of government occurred in Florence, when the emperor declared the Medici its dukes. Their transformation from politically influential bankers seems typical of this epoch, which was turning from commercial and committee power to hereditary rule (as with the Habsburg emperors), greater focus on the executive (the Tudors in England), and greater centralization (Spain). When, in an apparent parallel, Florentine painting abandons the rationalistic and humanistic Renaissance traditions, Bronzino is its instrument. As a devoted pupil of Pontormo, he follows the style of his *Deposition* at first (see colorplate 34), and always in religious works. The slick cylindrical figures are even further from reality and gravity; they have lost the effect of pressing toward a goal that was conveyed by Pontormo's throbbing outlines and twisted poses, and are now unmovingly suspended in a cool light. One might conceive of this as a Mannerist way of reacting to the original Mannerists, who may now be regarded as the natural and given; in one sense it is twice as Manneristic, adding chill to the old artificial tension, but in another sense it can be read as a doubling back, negating Pontormo's negation of harmony and arriving somewhere near the passive grandeur of Fra Bartolommeo. The exception to such a view would be in a small group of allegories such as *Venus Disarming Cupid,* whose cold eroticism still has a witty involvement like Parmigianino's and a tight weave of its own (colorplate 36). But Bronzino and his patrons are chiefly interested in portraits, where he is a great inventor. First he paints rich impassive citizens clad in black, in the gray courts of their palaces, precise and complex in line. His later result, in such a masterpiece as the *Duchess Eleonora* (fig. 272), owes much to the portrait sculptures on Michelangelo's Medici tombs. The face is a mask that cannot move, and the three-quarter length emphasizes the opulent costume, so exactly rendered that it could be used as a pattern. Hence the duchess we see is not a woman with a character, as in earlier Renaissance portraits, but an embodiment of royal status, as she would sit at a formal reception. This is the state portrait which

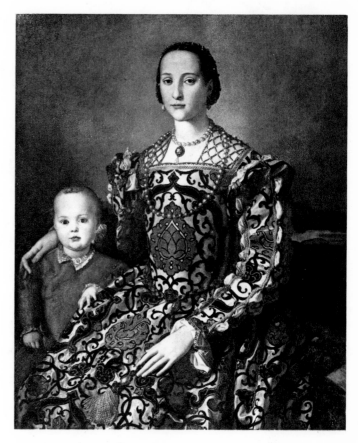

272. AGNOLO BRONZINO.
Eleonora of Toledo and Her Son. 1553–55.
Panel, 45″ × 37″. Uffizi Gallery, Florence

appears all over Europe from this date on, most famously in those of Queen Elizabeth of England. Its antirealism is intentional, the availability of Mannerist artificiality was a lucky aid to it, and in Bronzino it found the master who perfected it as a vehicle.

When the duke turned Florence's old city hall into his family palace, Giorgio Vasari (1511–1574) frescoed the ceilings (from 1555) to record the Medici family glory. Each ceiling has elaborate subdivisions, and the scenes mix careful historical portraits with newly devised allegories. Such organized learnedness is suitable to the artist most famous for having written the lives of his predecessors, the great artists (mainly the Florentines) from Giotto on. Lat-

273. FRANCESCO SALVIATI. *Triumph of Camillus*. Fresco, 13′10″ × 19′4″. Sala dell'Udienza, Palazzo Vecchio, Florence

er he crowned his career by painting the inside of Brunelleschi's Cathedral cupola, greatest monument of the Florentine past. His painting style, wiry and glittering, and favoring translucent reds in careful curves, derives from Rosso's loose and willful Mannerism but is toned down by academic knowledge of Bandinelli and of Giulio Romano's archaeology. His fellow pupil Francesco Salviati (1510–1503) practiced a similar style with a fresher painter's touch, without the overtones of an archivist and entrepreneur so basic to all Vasari did. Living much

in Rome, Salviati, like the other painters there, used the ideas of the later Raphael, making figures move in heavy rhythmic processions, and even establishing spatial breadth. He was an ingenious designer for tapestries, parade floats, and other similar decorative media, and so evolved his mature style, best seen in his wall frescoes in the city hall of Florence (fig. 273). Space has vanished, shiny white and pink surfaces, robes and horse trappings, enclose us, and only an ingrained volume in the modeling recalls Florentine painting.

30. Moretto and Venetian Painters of His Generation

While Mannerism matured and became a formula in central Italy, Titian was still finding new subtleties of the life of the body in light—in Venice the Renaissance had not run down. Painters a generation younger than Titian were unable to try anything else than refined variations on him. Paris Bordone (1500–1571) starts in Titian's *Assumption* style, producing many Holy Families that sit heavily on the grass. Big brilliant people lean diagonally toward each other, their glinting red robes sinking into the downy green. His masterpiece, the *Doge Receiving the Ring*,[74] full of wrinkled velvets and slithering brush strokes, is a typical Venetian record of a traditional civic ceremony, as in Gentile Bellini, stabilizing traditions with pompous pride. Later, attracted by Giulio Romano's work in Mantua, Paris painted Raphaelesque erotic myths, with frizzled blonde girls. They come close to Mannerism, but not until about 1550 when it had reached Venice in other ways. Bonifazio Veronese (1487–1553), more routine than this, for years painted saints to decorate government offices, donated by the citizens elected to those ceremonial posts. His masterpiece, the *Finding of Moses* (fig. 274), presents the princess of

Egypt and her ladies by the riverside as if the event were a luxurious picnic with velvets and dwarfs. As with all Titianesque painting, its richness extends from the choice of objects to the textures and shifting lights, which directly evoke the sensuous gratification of living.

In the market towns in Venice's mainland territories only Moretto (docs. 1516–d.1554) is now comparable to Lotto, Romanino, and other talents in Titian's own generation. Moretto was a pupil of Romanino in Brescia, and his first commission produces saints who are ambling horsemen, gazing out from under their big hats as his teacher's do, or those of his teacher's friend Altobello Melone. But the raw naturalistic thrust has been subdued, and classical niches isolate figures in cool air. As Moretto moves farther from his sources he grows closer to Raphael, whose work he probably only knew through prints. Hence the paintings have a somewhat linear and slow dryness, the price of the classical clarity which he evidently was looking for and could not find nearer home. By 1530, through gradual self-revision, Moretto had reached success in a beautiful and sure, if limited, art, of broadly

274. BONIFAZIO VERONESE. *Finding of Moses.* Canvas, 11′4″ × 5′8″. Brera, Milan

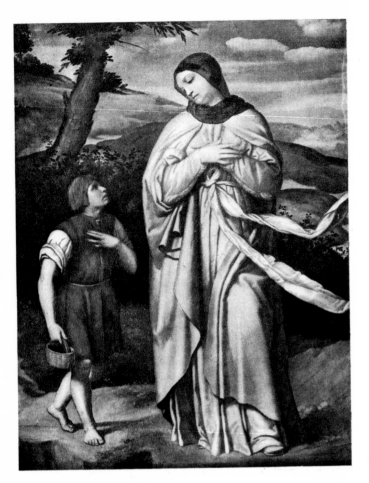

painted standing figures, large and simple, barely moving, dusky or silver in tone (fig. 275). The effect is somewhat like Savoldo's big detached figures (see fig. 247), but apparently Moretto had to use his own route to arrive at this because Savoldo's old-fashioned dualism of figure and space was not acceptable to him. Using Raphael, Moretto amends Savoldo's heavy-limbed humble shepherds into judicial observers with a classicizing majesty, a society without fashion but with good manners, and sets up the only effective non-Titianesque painting of this region at this time. It benefits from belonging, genuinely in this case, to a "Brescian school," since the harmony of gray air and unaggressive figures harks back to Foppa. Moretto was always in danger of slipping back into more literal and complicated Raphaelism, but his purest paintings, idyllic and contemplative, were important to younger painters in challenging Titian directly.

275. Alessandro Moretto.
The Virgin Appearing to a Shepherd Boy.
1533. Canvas, 7′5″ × 5′10″.
Sanctuary, Paitone (near Brescia)

31. Mannerist Painters in North Italy

The stage was set for a Mannerist penetration of north Italy when Giulio Romano painted his archaeological and erotic exercises in the Raphael tradition in the Mantuan duke's Palazzo del Tè. The invasion was complete when Parmigianino came back from Rome.

Primaticcio (1504–1570) started by assisting Giulio in Mantua, making stucco ceiling ornaments. From this obscurity he was lifted by an invitation from Francis I of France to come to Fontainebleau, perhaps recommended by Giulio in place of himself. He stayed forty years, first under Rosso, whose work he must have found very congenial, and then in charge. The remodelings of the palace have destroyed his paintings, quite aside from the loss of his masquerade costumes, and we have only the draw-

ings to explain his huge influence in France. In a minor way, as Bronzino is to Pontormo so Primaticcio is to Rosso; he removes the important factor of tension, turning the artificial forms into frozen ornament, courtly and sophisticated. Series of amusing Greek myths, framed in ovals, are played by tall, beautifully translucent people, formed by crisply undulating contours that progress in clear round drawing like Spencerian script (fig. 276). These formulas are mechanically repeated by later painters at Fontainebleau, but Primaticcio, who made stucco reliefs all his life, found brilliant assistants and successors in some young French sculptors (see pp. 394–97).

Lelio Orsi (docs. 1536–d.1587), a very limited but distinctive artist, began too with a bow to Giulio

276. FRANCESCO PRIMATICCIO, with assistants. Long Gallery, detail of stucco sculpture and paintings. Palace, Fontainebleau. Height of frieze 7′5″, of oval painting 4′

was to Correggio; he explored his black night effects and especially his rippling edges of cloth. In Correggio these shapes are a secondary result of his soft fluttering motion, but Orsi's tiny polished panels make them central, altering Correggio's downiness in a wildly inappropriate way by jelling it into a kind of modeling-clay texture. This curious conceit creates an ambiguity between agitation and frozen fixity that recalls the local popular tradition of realistic sculpture groups, and gives Orsi an unmistakable trademark, like eccentric small talents of other epochs up to Dali.

Andrea Schiavone (docs. 1547–1563) immigrated from the Balkans to Venice and completely learned Titian's technique—the zest with which the brush pulls in the hand, and the way translucent oil-diluted pigments on a white opaque base suggest life in colored light. Like many painters in Venice he was interested in paint and in the reality of observed phenomena, but little in composition and design. So, like Titian, he casually borrowed these elsewhere, chiefly from Parmigianino's etchings. He also produced his own, less technically sure but warmer. Most of all he liked Parmigianino's very tall figures with undulating bodies (fig. 277). He changes their Mannerist, linear module to something like a very wide brush stroke, liquidly and sinuously moving from head to foot. It is boneless but lively and glowing. Schiavone's achievement is minor, apparently because, like Orsi's, his technical expression was in a narrow range, a problem recurrent when, as in Mannerism, a formula of style is important.

Romano. He is the only Mannerist in the Parma area who is not a routine follower of Parmigianino. His solution was to retreat to a less modern source, a pattern by which a minor artist often can retain his character in the orbit of a major one. Orsi's appeal

277. ANDREA SCHIAVONE.
Adoration of the Magi.
Canvas, 6′1″ × 7′4″. Ambrosiana, Milan

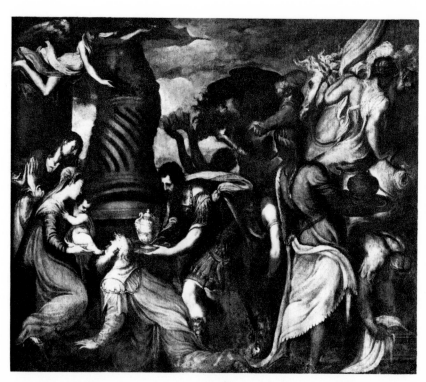

32. Titian's Later Years

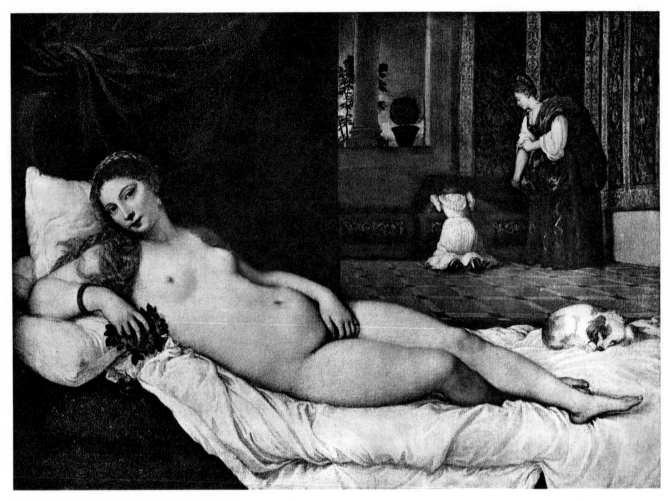

278. TITIAN. *Venus of Urbino*. 1538. Canvas, 7'3" × 8'9". Uffizi Gallery, Florence

While painting more portraits than ever, Titian at fifty was finishing the twenty-five-foot-long *Presentation of the Virgin* for a convent of nuns in Venice (1534–38).[75] The more he became involved with international powers the longer he took to deliver his local commissions, and perhaps they have the more visual richness for that. This one, filling the side wall of a room, shows the girl in profile as she climbs the steps, and makes the whole scene a frieze of gently breathing people and shiny columns in veined marble, that we can never see all at once. The *Venus of Urbino* was called "the nude" by its owner, the duke of Urbino's son (fig. 278). It is a direct vision:

she looks at us with the frank model's gaze that Manet repeated centuries later,[76] and far behind her, near a bit of clear sky, servants roll up their sleeves; one burrows in a chest. The nonformal reality of the courtesan's life is tacked on to a standard immobile icon of the goddess. There is less here of Giorgione than of Giovanni Bellini (see p. 138): the easy acceptance of the solid conventional thematic image, the "second theme" footnoted behind, the unfaltering opticality.

After 1540 another pendulum swing produced a third period of very energetic scenes. In a series of ceiling paintings of Biblical fights,[77] the foreshort-

ening makes Abel's body and Goliath's head seem about to tumble out at us. The huge wrestlers in the sky appear to be inspired by a Michelangelo project for a *Samson* group. But any Mannerist effect of tenseness is excluded by the full resolution of all the movements, and their absorption in the stormy deep sky. Even portraits grow vehement, like *Pope Paul III and His Grandsons* (1546; fig. 279), painted on a trip to Rome, where Titian was lionized. It is an astonishing document, the aged pope bent double, with claw hands, one grandson passive in a corner like a gray eminence, the other bowing sycophantically. But instead of being incredibly satiric, it is simply Titian's almost naïve unrevised celebration of the world as seen through its physical motion. The

majestic group portrait of the Vendramin family kneeling before their prized relic has a similar loose design and sparkling surfaces of ermine, gold, and fire.[78] This culminated when Titian traveled to Augsburg to the one patron who impressed him, Emperor Charles V, the most powerful man on earth. He painted him (1548) on horseback as a victor in battle,[79] Titian's nearest bow to the system of the state portrait. He exploits it as he does other formulas, but the painting lives in the horse's nervous pawing and the rider's watchful control, all absorbed in tremulous landscape.

For one of Pope Paul III's grandsons Titian painted (1545) another nude, *Danaë*,[80] the beauty to whom Zeus, in the myth, flies down magically

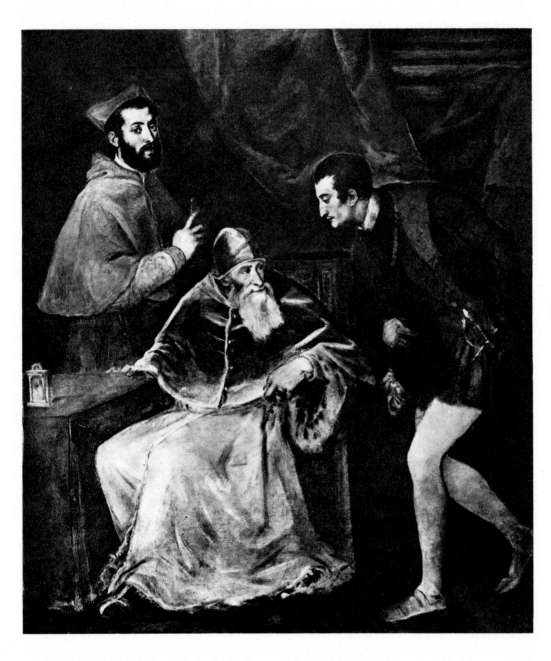

279. TITIAN.
Pope Paul III and His Grandsons. 1546.
Canvas, 6'10" × 5'8".
Museo Nazionale di Capodimonte, Naples

transformed as a shower of gold. For the Habsburgs he later repeated the same composition (fig. 280), replacing the cupid with an old woman who is leaning forward trying to catch the gold in her apron while Danaë watches, unposed, with her knees up. A sensual myth, having as its central motif bits of shining metal flying through air, must surely be the perfect Titian subject. Erotic myth continues in the *Rape of Europa* (1559–62),[81] showing the girl sprawled on the back of the agreeable white animal in one lower corner of the painting, while the rest is full of choppy water and streaky sky, and far back the minute figures of Europa's friends are waving. The paint surface is used to set up the stretch of space and the force of drama, but in a loose, incredibly asymmetrical way that seems to emphasize the

painted liveliness of the surfaces. Paint seems to eat up space again in the *Martyrdom of Saint Lawrence* (fig. 281), done for a friend in Venice with a ten-year delay. The tall canvas relates the yearning saint at the base to God at the top through the lines of tall columns. Since this is a night scene, we actually see little but the fire that burns the saint's body, the divine apparition at the top, and the polished columns between like glowing harp strings.

Having discarded line and form and composition, in the 1560s Titian seems to give up color, leaving a flickering glow of varnish brown. Like Donatello, he is working in an old-age style, not trying to satisfy any demands for finish or elaboration, knowing he can get his own effect with just the right allusion, like an old singer who retains perfect art.

280. TITIAN. *Danaë*. 1554. Canvas, 50″ × 70″. The Prado, Madrid

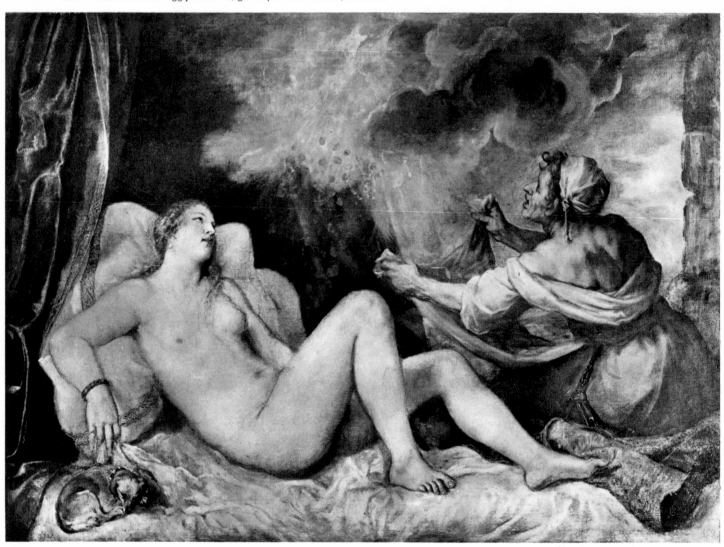

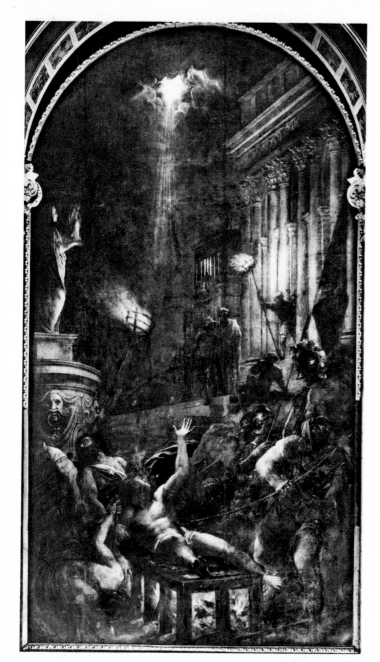

A few brightly lit portraits and mythologies appear, but most of the late works are religious, with very plain elementary compositions. *Christ Crowned with Thorns* (colorplate 37) reuses a design from the violent 'forties but dabs at it with a technique like an Impressionist's in 1870, and with deep human expressiveness. The dull copper glints and pasty swipes convey the relationships of ourselves, the wounded Christ, and those who poke at him. The drama is still of body movement, but, like the style, it has been reduced to a suggestion, while its implied meaning has grown. At ninety Titian was remote from contemporary painting styles, and these last works of his were picked up only by Baroque and nineteenth-century painters after the mass of artists had gradually worked around to this point.

281. TITIAN.
Martyrdom of St. Lawrence. 1555.
Canvas, 14′9″ × 9′2″.
Jesuit Church, Venice

33. Falconetto, Sanmicheli, Jacopo Sansovino

Venetian sculpture and architecture continued to be very secondary, as in the early Renaissance (but not in the Middle Ages). Architecture develops, though, its own strong attitude, which is scenographic, based on lively façades. The death of Mauro Coducci marked a break, and after an interval the first modern architecture is by Gianmaria Falconetto (docs. 1472–1533). He had been a minor painter, trained in perspective tricks by Melozzo da Forli, and had lived in Rome, where he had been entranced by the fussy archaeology of Pinturicchio and others. When at fifty he started to build, he was encouraged by and was perhaps the executant for a remarkable patron, the patrician philosophical writer Alvise Cornaro in Padua. For him he built (1524) a garden house and a concert room, called Odeon, reflecting the new Roman pleasure pavilions like the Villa Madama (see p. 179). The façades are thinly linear and orna-

229

282. MICHELE SANMICHELI.
Façade, Palazzo Bevilacqua, Verona. 1530.
61′ × 122′

283. MICHELE SANMICHELI. Choir screen,
Cathedral, Verona. 1534. Height 19′,
radius 19′

mental, with pilaster strips, and half columns are the only three-dimensional element. An octagonal room with four niches is adorned with thin stuccoes that copy ancient Rome as neatly as any in Regency England. Falconetto also built city gates in Padua with the same light neatness, as of a stage backdrop.

The gates built in Verona by Michele Sanmicheli (1484–1559) are very different.[82] His beginnings as a stonemason in Lombardy were reinforced by working for the younger Antonio da Sangallo in Rome, and a long career as a military engineer. Settling then in Verona, he soon built an impressive group of town houses (fig. 282); like Lombard stone workers before him, he adopted the available style vocabulary with skill and zest. They reflect Sangallo's Mint—"noble story" over rough-hewn ground floor (see figs. 223, 285)—and still more Sangallo's study of ancient ruins. Sanmicheli's whole style, typified by the sharp fluting of his columns, is more literally Roman than that of any other architect of the "Renaissance of Antiquity." But it is not tight and purist; its confident construction, with sweeping and majestic plain forms, shows the mastery of a familiar meter. That classical forms are only a vocabulary is shown by the retention of the traditional Venetian ground plan, with a series of courtyards from front to back. He is more simply scenographic in smaller works like Verona's Cathedral choir screen (fig. 283), a pure grand circle of smoothly polished columns, in several wall tombs whose framing columns underline their firm and satisfying proportions, and in his imposing city gates. They typify his two interests, conspicuous display and military strength.

At the same time Jacopo Sansovino, a refugee from the Sack of Rome, settled in Venice. Earlier he had done monumental sculpture and small architectural jobs; now the proportions were reversed. His later sculptures, when large, tend to repeat, and when small, to function as building accents. He had not planned to stay in Venice, but was courted by citizens who had no one to design the splendid displays they wanted. Soon he was a fixture, one of the Titian circle, and the deviser of much that we regard as typical in Venice. At the foot of the Bell Tower of Saint Mark's he placed a noblemen's reviewing stand for processions (1537–40; on right, fig. 284). It is a wall made of three multicolored marble arches, the piers marked by four bronze statues. The interaction of architecture with sculp-

ture, structure with decoration, may in its unity be called pictorial, since it depends on color action. His Mint (1537–45; fig. 285), around the corner, was meant to be an imposing government building but also a workshop for smiths, so it is visually a different "class" of building, with no sculpture or color but enriched by the light and relief effects of its rough boulder construction throughout, balancing the deep windows. Between the two in location and in type is the Library of Saint Mark's (from 1536; on left, fig. 284), a two-story façade, the lower a pedestrian arcade that matches the Gothic Doges' Palace across from it. Smooth half columns bear the arches and roofs, but all nonbearing sur-

faces are sculptured, even continuing above the roof in pinnacles. Between the deep inner shadows below and the blue sky above, the tapestry-like vibration of the carved façade is a happy backdrop for the promenades of the Venetians. Sansovino also cast two sets of bronze relief panels for points of accent inside Saint Mark's,[83] in which he adopts a Titian-like powerful movement of figures in large airy spaces; but later his sculpture is limited to designing gilded stucco ceilings over the stairway of the Doges' Palace. Like Titian, he works with a continuing High Renaissance approach, evolving naturally onward instead of reacting against it and cutting it off as was done in Tuscany.

284. Jacopo Sansovino.
Loggetta and Library,
Piazza San Marco, Venice.
1537–40.
Width of Loggetta 48′,
of Library 274′8″

285. Jacopo Sansovino.
Façade, Mint,
Venice. 1537–45.
77′ × 88′6″

34. Ammanati, Vignola

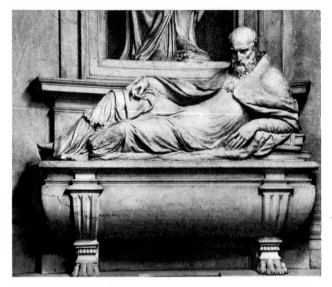

286. BARTOLOMMEO AMMANATI.
Effigy, on tomb of Cardinal del Monte. 1550–54.
Marble, width of base 7′4″.
S. Pietro in Montorio, Rome

Bartolommeo Ammanati's career profile (1511–1592) illustrates the situation now typical. A sculptor-architect in the Sansovino pattern, he was a pupil of Bandinelli in Florence but was more affected by Michelangelo and by the graceful mild Mannerism of the 'forties in Florence. He would always carve standing male nudes with Bandinelli's inflexible squarish forms, but his other figures attain a relaxed poise. For tomb commissions he quickly evolved a suave formula: a meditative reclining figure, softened and unified by drapery that hangs from shoulder to knee, with a satisfying balance of weights. Its pose and broad gentleness of expression are inspired by Michelangelo's *Twilight,* suggesting that the period saw that work in a way surprisingly different from the way we do. The formula appears in Ammanati's first large work, a tomb which Bandinelli jealously prevented from being installed,[84] and again a decade later in his masterpiece, the tomb of Cardinal Antonio del Monte in Rome (1550–54; fig. 286). In the interim he had assisted Sansovino, carving small figures to adorn his buildings, and developed an architectural scheme which also flowers in the Del Monte tomb. It is based on a very

plain slab, richly framed, used as the surface for very fluid sculptural forms. This tranquil Mannerism brilliantly marks the bronzes of the Fountain of Neptune in Florence (1560–75),[85] a ducal commission which he took over from Bandinelli; ironically, its colossal central figure still reflects Bandinelli's anatomical style.

Growing more involved in architecture, he

287. BARTOLOMMEO AMMANATI. Courtyard, Palazzo Pitti, Florence. Begun 1558. Center wall 118′ × 131′

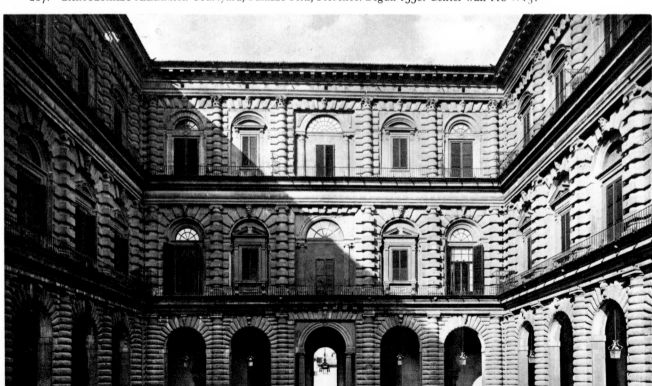

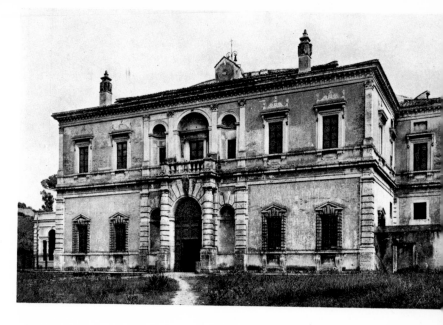

288, 289. VIGNOLA and AMMANATI.
Plan and façade, Villa Giulia,
Rome. 1550–55.
Length of plan 544′;
façade by Vignola 54′6″ × 118′

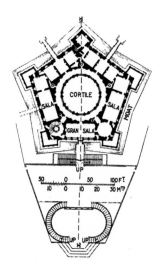

290, 291. GIACOMO VIGNOLA.
Plan and courtyard,
Villa Farnese, Caprarola. Begun 1559.
Maximum width of plan about 260′;
height of courtyard 62′6″,
diameter 105′

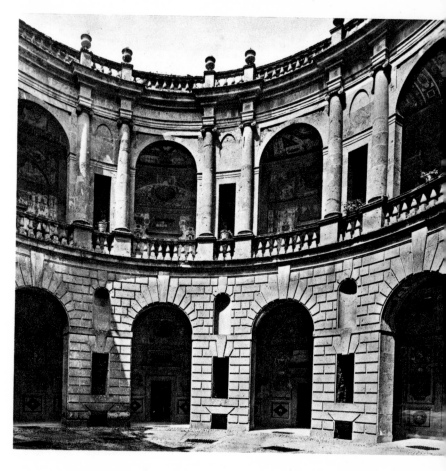

developed a more strenuous and complex expression in it, no doubt stimulated by his collaboration with the more experienced Vignola. As the junior partner in their project for Pope Julius III's villa in Rome (1550–55; fig. 288), Ammanati built a garden, mixing a pool, sculpture, and a deeply shadowed screening niche. In Florence he then built for the duke an addition to the new ducal residence, the Palazzo Pitti (1558–70; fig. 287), wings extending back into a garden. The courtyard between the wings has rough boulder walls ("rustication") on all three sides, recalling Sansovino's Mint, but here disassembled into stripes that reveal normal columns and arches beneath, thus setting up the tension of classical order and raw disorder of Giulio Romano's Mantuan villa (see fig. 267). Ammanati is less witty and brainy than Giulio, but sensuously richer in his heavy, jumpy textures. His Ponte Santa

233

Trinita (1557)[86] is often called the most beautiful of bridges. Since it was a replacement for one washed away in a flood, it naturally was made with as few and as solid piers as possible, and a roadway as high as possible. The result is the wide, shallow, tensile curve of its three arches; the refined ellipse is a Vignola-like idea, but to combine it with a suggestion of engineering necessity is unique and powerful.

Giacomo Vignola (1507–1573), a north Italian who worked mainly in Rome, is rare in being an architect only (the younger Sangallo and Sanmicheli were the only ones in the preceding generation) and surprising as one who had an original stylistic imagination. (It is probably significant that he had had training as a painter.) In his works the technical and the intellectual thus dovetail in a special way. Unlike the older pure architects, he wrote a book,[87] but unlike the older architectural books it was severely practical, and went through two hundred editions. He started as a perspective draftsman—a typical juncture of the technical and intellectual—doing backgrounds for Primaticcio's paintings at Fontainebleau. His own building trademark is a network of fairly thick pilasters articulating the walls, neither flattened pilasters like Peruzzi's nor heavy half columns like Sangallo's, but suggesting structure and its rational comprehension; its source is Michelangelo. He built the first oval churches (Peruzzi had drawn some, using ancient Roman sources), bracketing the favorite concept of the circle as ideal form with the practical needs of church services. He does it by stretching the circle into an oval dome, as at Sant'Andrea in Via Flaminia (fin-

ished 1554). This involves as well another constant expressive quality of Vignola's, the elastic pull of his lines along walls and through spaces. In his first important work, Palazzo Bocchi in Bologna (1545), a heavy rusticated door contrasts with a flat wall surface, making it centripetal; the motifs are the same copies from Giulio Romano, Sangallo, and Peruzzi that Peruzzi's pupil Serlio presented in his architectural handbook,[88] but here they have unity and power. In Rome, at Julius III's villa (figs. 288, 289), the door with deep narrow niches squeezed between extruded rusticated frames is a knot that pulls the wall's pilaster forms to itself. For his great patrons, the Farnese family, he remodeled a fort of Sangallo's into the Villa Caprarola (from 1559; figs. 290, 291). It had been a pentagon, normal in a fort but odd in a villa; he made the pentagonal central court a circle and in front added a double curved staircase, a half oval. These lively softenings of shape allude to the villa quality. He designed his greatest interior for the Jesuit church in Rome, a key commission at the end of his life from Cardinal Farnese (from 1568; fig. 292). The single nave under a vault (stipulated by the patron) reflects Alberti's Sant'Andrea in Mantua (see fig. 105). But it uses these elements for pulling lines and centralization: the nave seems to rush toward the altar without distraction. To call this Mannerist is probably wrong, since, partly through the quick spread of the Jesuit order, it was very influential in the Baroque age and helped to make concentrated weight and powerful motion familiar vehicles of Baroque expression.

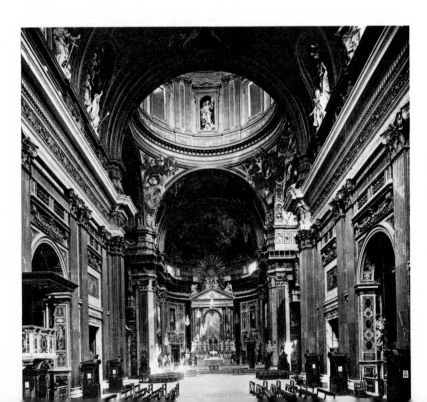

292. GIACOMO VIGNOLA. Interior, Il Gesù, Rome.
Height of nave 95', width 55'

35. Palladio

Andrea Palladio (1508–1580) was much like Vignola in age and other ways. Until he was thirty he was a modest stonecarver in provincial Vicenza, west of Venice, and he did his first major buildings at forty. Like Falconetto, he was trained by a nobleman interested in antiquities. As craftsmanship and intellect mix in Vignola, craftsmanship and archaeology mix in Palladio, along with a Venetian tradition of stage scenery. His first buildings were rural seats for small estate owners, cheaply done in brick and stucco without ornament, emphasizing the Venetian big central entrance and symmetrical windows. In the 1550s, with Palladio's sophistication, they grow into large villas with side wings and columned front porches which allude to Roman temples. These units are tied together three-dimensionally by arithmetical proportions of height, width, and length, for which he used a half-dozen formulas. These villas were year-round dwellings, unlike the fancier and smaller weekend retreats near Rome and Florence. One exceptional weekend house by Palladio is the Villa Rotonda (figs. 293, 294), a domed box on a rise with four identical temple fronts, a jewel-like object to look at (like Bramante's Tempietto, with which it shares its fame as a perfect object; see fig. 189) and to look out from.

Palladio's fame began when he won the job of monumentalizing the Vicenza market hall (model 1546), turning it into a Basilica by wrapping a portico around it. This is a two-story colonnade, rich in rhythm and imitating Sansovino's Library in the pictorial play of light, but not depending on sculpture. He then built town houses in a similar vein; Palazzo Chiericati—tackling a problem like the one in Vignola's oval church (see p. 234)—blends two traditions of houses, the important central entrance and the covered pedestrian walk running in front (fig. 295). The covered walk projects in the center; above, the central block is left hanging over it, but the unbalance is absorbed in the active Venetian luminism of the façade. If the irresolution is intentional, it suggests Mannerism; that label applies better to Palazzo Valmarana (1566; fig. 296), which certainly is playing games with the purposes of its

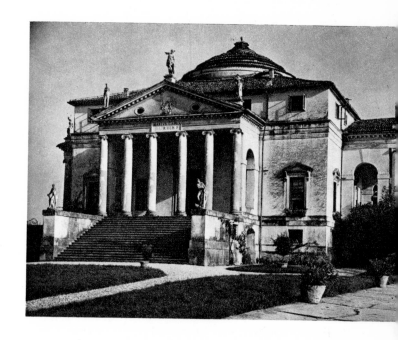

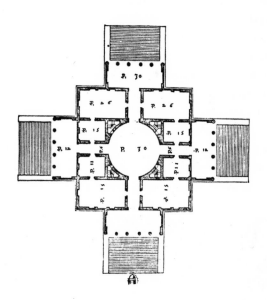

293, 294. ANDREA PALLADIO.
Exterior and plan,
Villa Rotonda, near Vicenza.
Height 75′, main blocks 80′ square
(woodcut plan from Scamozzi, *Idea dell'architettura universale*, Venice, 1615)

235

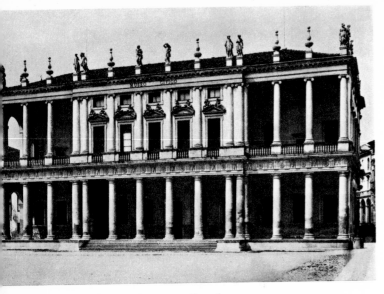

295. ANDREA PALLADIO. Façade,
Palazzo Chiericati, Vicenza. Begun 1551.
58′ × 138′

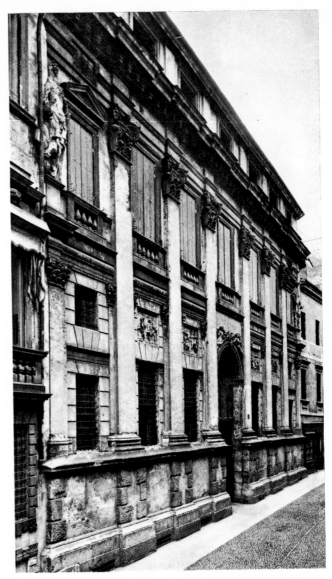

296. ANDREA PALLADIO.
Façade, Palazzo Valmarana,
Vicenza. 1566. 46′ × 79′6″

elements, like Michelangelo's Laurentian Library. The sides are left frayingly open instead of being firmly framed, and windows are framed by walls that may or may not be meant as pilasters. But this is a technician's gentle game with his own materials, not a sharp twist of irony. The later palaces grow ever more pictorial, with imaginative dynamism in their half columns and carvings, and grow in scale beyond the clients' resources, so that they were not finished. Palladio's fame rested on his villas, especially the early ones, which he publicized from his small city in a successful book with woodcut illustrations.[89] The reproductions in this medium conveyed their plain shapes and fine proportions, inviting imitation in distant countries and times by cultivated readers interested in building, such as Thomas Jefferson.

In Palladio's latest years his ambitious mathematical, archaeological, and scenic effects are clearest in churches, to which he turned only at this time. They are mainly in Venice. In his learned and practical way he solved the much-considered problem of how to put a classical front on a church that has a high central nave and lower aisles: the answer is to build two temple fronts, one tall and narrow and the other wide and low, as if behind the first (figs. 297, 298). The scenic effects appear further in the white plain interiors enriched by soft light and spatial sequences, where all paintings and sculpture are hidden in niches. Arcades partially screen naves from crossings and choirs, which are distinct in their visible uses but draw the eye through the screens; the whole has a grand scale and Palladio's unassertive mastery of three-dimensional proportions. Since geometric sensitivity underlies his sensuous surfaces, as in the great Venetian musicians of this time, he can move among building types and from spare to elaborate forms. And thus he is the only match for the great Venetian painters then at work, Tintoretto and Veronese, and a stimulus in surprisingly many ways to architects of later centuries.

236

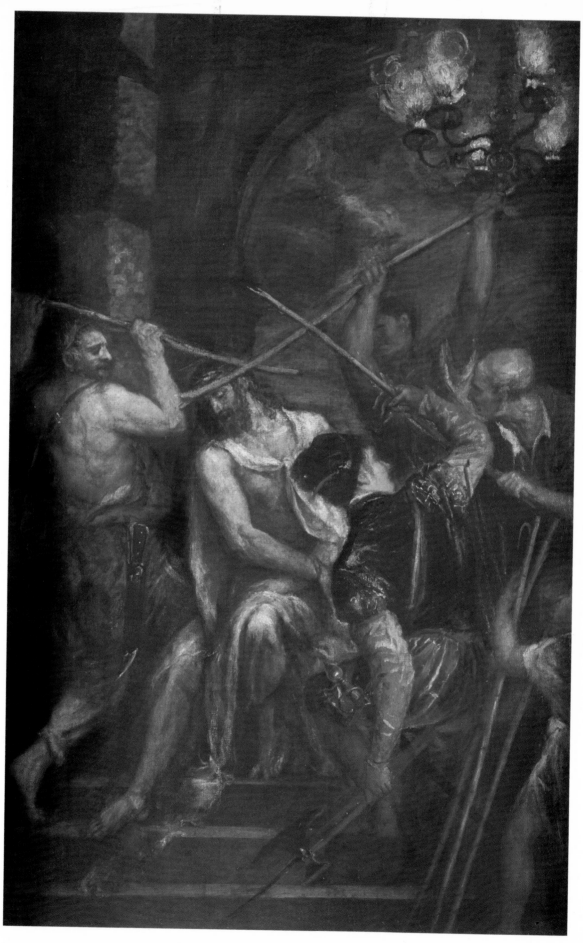

COLORPLATE 37. TITIAN. *Christ Crowned with Thorns*. c.1570. Canvas, 8'6" × 5'11". Alte Pinakothek, Munich

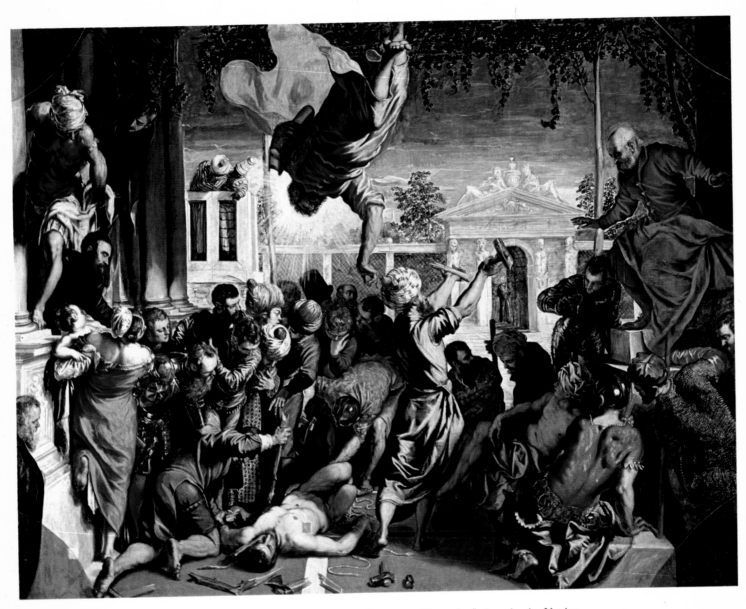

COLORPLATE 38. Jacopo Tintoretto. *Miracle of the Slave*. 1548. Canvas, 13′8″ × 17′11″. Accademia, Venice

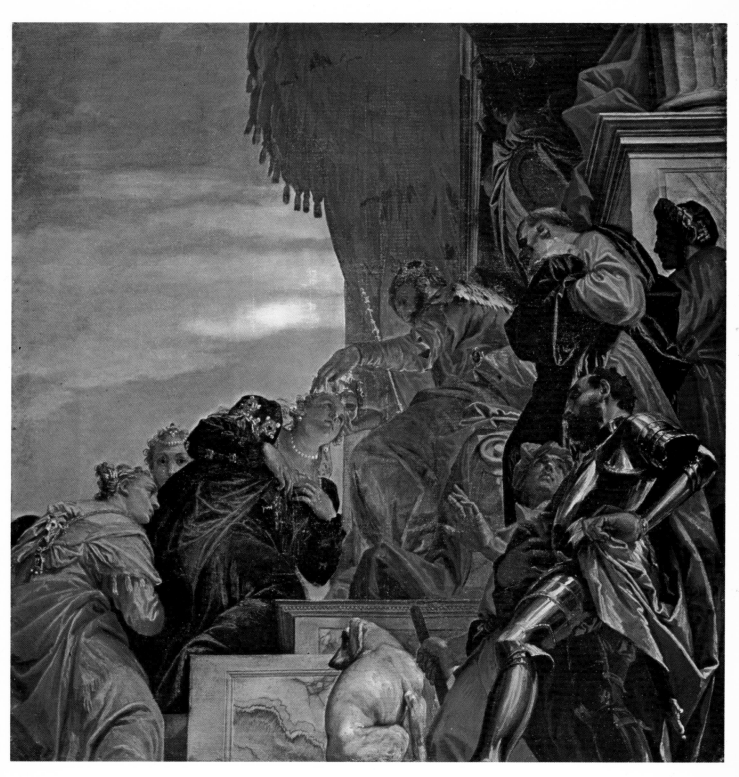

COLORPLATE 39. PAOLO VERONESE. *The Coronation of Esther.* 1555–58. Canvas, 13′1″ × 12′2″.
Ceiling, S. Sebastiano, Venice

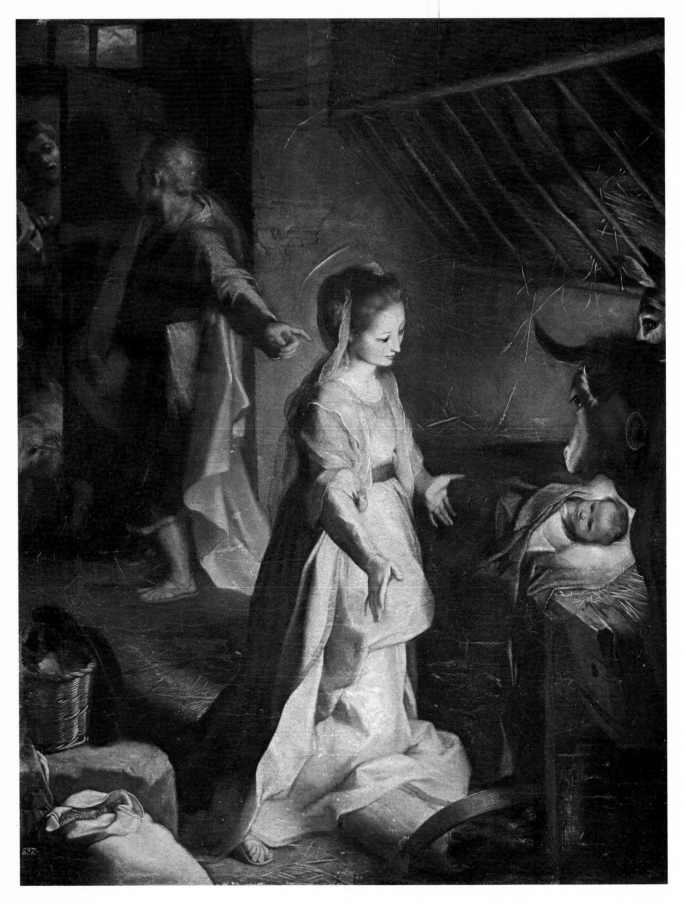

COLORPLATE 40. FEDERIGO BAROCCI. *The Nativity*. c.1580. Canvas, 53″ × 41″. The Prado, Madrid

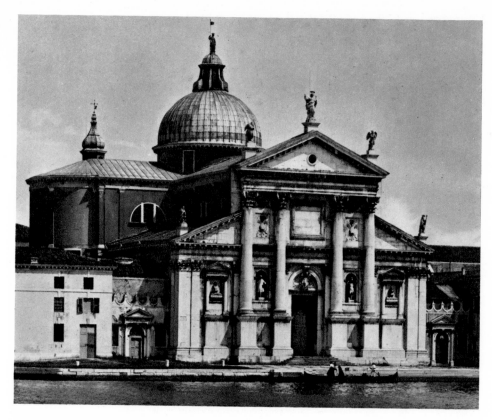

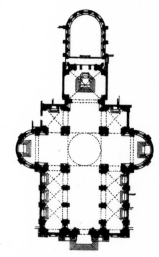

297. ANDREA PALLADIO. Façade,
S. Giorgio Maggiore, Venice.
Begun 1556. 105′ × 88′6″

298. ANDREA PALLADIO. Plan,
S. Giorgio Maggiore, Venice.
Begun 1556. Width 157′, length 272′

36. Tintoretto

Around 1545, when Titian began to work almost entirely for his great international clients, young Venetian painters for the first time in several generations had an opportunity for independent careers. Tintoretto (1518–1594) worked steadily for the local government and confraternities, like Carpaccio before him, but always remained anxious. When famous, he would still take small fees and modify his style to meet competition, even imitating younger artists like Veronese and Palma Giovane. His famous sketchiness, complained of by Titian's connoisseur friends, is surely connected with his desire to do as much as possible.

His first great success (1548) was a scene of the saint freeing a slave, for the Confraternity of Saint Mark (colorplate 38). Sunny and shining in the established Venetian language, it is new in the figures, which are clearly meant to startle by their

virtuosity. They are foreshortened, backwards, on diagonals, and understandably more conservative in solid modeling than Titian's. This to be sure is prepared by Titian's recent experiments and by Tintoretto's awareness of Michelangelo's figure movement; Sansovino had already conjoined those strands in his bronze reliefs (see p. 231). The *Presentation of the Virgin* (fig. 299) is also offered as a sensational challenge to Titian's handling of the theme as a lateral frieze. Tintoretto makes it pure recession into pyramidal depth, the more striking because the chief figure, the little girl, is at the far side at the top of the stairs; then he invents devices to keep her, despite all that, the center of our concern. These effortful paradoxes seem Mannerist, but are resolved in the natural dappling of light and color, in ways parallel to Palladio's Palazzo Chiericati of the same moment (see fig. 295). A mas-

241

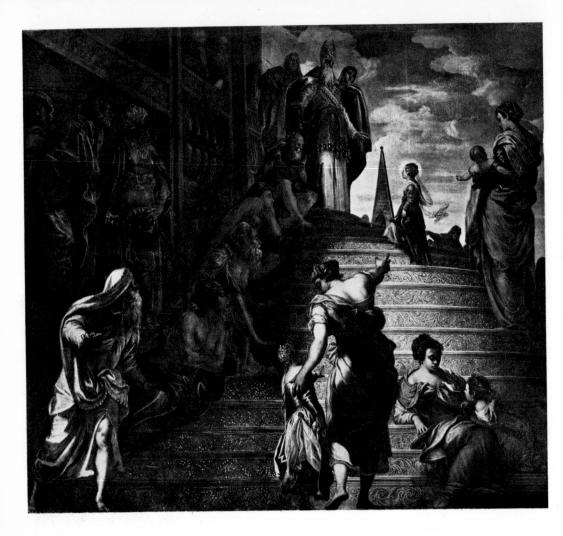

299. JACOPO TINTORETTO.
The Presentation of the Virgin.
Canvas, 14′ × 15′9″.
S. Maria dell'Orto, Venice

terpiece of trickery eased by light is *Susanna and the Elders*,[90] where the elders poke their heads around the two ends of a steeply foreshortened hedge. The hedge is covered with roses, and Susanna's schematic diagonal pose is absorbed in the water reflections. Such a witty nude is rare for Tintoretto, who usually takes a simple and direct approach to his usually simple themes.

The sculptural figure plays a lesser role in Tintoretto's maturity, a phase introduced by the *Healing at the Pool of Bethesda* (1559).[91] The crowd of bodies is packed into a continuous rhythmic group of tied diagonals, marked by pools of color and shadow and reduced emphasis on particular hues. The contrast of the driven crowd and the vertical columns suggests that Tintoretto had looked at the reliefs in Padua by Donatello (see fig. 98), who was being revived by the Florentine Mannerists. The firm construction of linear forces in space, with closely grouped figures, is also conspicuous in the three later *Miracles of Saint Mark* (1562–64);[92] in them an immense empty hall or portico

in diagonal perspective contrasts with diagonally falling forms and ropes pulling against them. The schematism of figure placement that he seems to need lets him push his breathless, fervent athletes in charged thrusts, but he is using the Venetian controls of pervasive air to correct the earlier splintering tendencies. This style dominates the first group of many for the "Scuola" or Confraternity of San Rocco, with which he eventually arranged an annual salary. The huge *Crucifixion* (1565–67) organizes the crowds in triangular clusters, bordered either by silhouettes or light patches. In *Christ before Pilate* (fig. 300) the Pontormo-like Christ, tall, emaciated, and intense, is part of a rhythm of spaced columns. Some of the paintings replace architectural patterns by a stormy sky, now traditional in Venice; the *Crucifixion* at San Cassiano (1568) puts all the diagonal crosses in the right half and storm clouds in the left.

In the 1570s Tintoretto was able to let his rich air dominate and the schematic patterns relax, so that the figure groups can turn in softer curves; in

the big upper room at San Rocco (1577–81) the *Temptation of Christ,* for all its confronting diagonal blocks of figures, drowns them in a world of vegetation and ruins. These sketchy canvases are contemporary with more smoothly finished mythologies for the Doges' Palace (1578), similar in gently revising the diagonal formula. The New Testament series at San Rocco (1583–87) extends this tendency further, especially the *Saint Mary of Egypt* sitting in her striped landscape, and leads to the final triumph, the huge paintings for San Giorgio Maggiore (1592–94; fig. 301), where complete tonal unity brackets the crowd life. Like Andrea del Sarto responding to Leonardo, Tintoretto responds to Titian by constant preoccupation with problems of figure composition, even in drawings. But in Tintoretto, a greater artist than Andrea, the references back to nature and its resources are always strongly maintained.

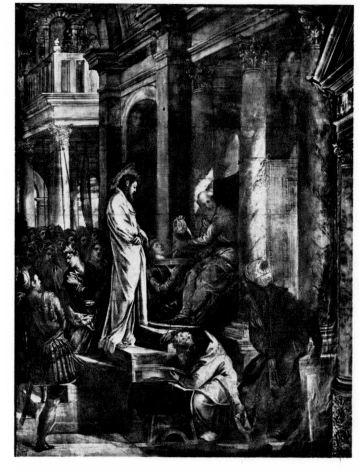

300. JACOPO TINTORETTO.
Christ before Pilate. 1566.
Canvas, 18′ × 13′6″.
Scuola di San Rocco, Venice

301. JACOPO TINTORETTO. *Last Supper.* 1592–94. Canvas, 12′ × 18′8″. S. Giorgio Maggiore, Venice

37. Veronese

Tintoretto and Veronese are the two equally great Venetian painters of their age. Where Tintoretto is excited, Veronese is quiet, so that Tintoretto has received more public attention, but Veronese has probably had more effect on painters: his works in the Louvre have meant much to the hedonistic color tradition in French art, from Boucher to Matisse. This difference is connected with his early life in Verona, a provincial town that had not had recent notable painters like those in Brescia and Bergamo. It had long been a preserve of Mantegna imitators, from the greatest miniaturist of fifteenth-century Italy, Liberale da Verona (docs. 1465–1526), who produced earthy fantasies like a minor Tura, to a group in the early sixteenth century whose ruby-like surfaces are modified by Giorgionesque moodiness (Caroto, Giolfino, Cavazzola). Paolo Veronese (1528–1588) was more impressed by Moretto of Brescia, whose silver light and grand relaxed figures in classic poses remained important to him all his life, helping him in his detachment from

Titian. He also felt a congruence with Sanmicheli, the one major artist of Verona when he was growing up, and painted frescoes in one of Sanmicheli's villas.[93] To be sure, he first emerges like Tintoretto with a virtuoso piece, a *Temptation of Saint Anthony* (1552)[94] with Michelangelesque and foreshortened dynamics. It led, easily, when he moved to Venice, to ceiling paintings for the Doges' Palace, ovals with allegorical figures at striking angles of vision.[95] But the figures do not commit themselves to the allegorical subjects; they are real people, alive in animated color areas with contrasting brilliant sky areas around them, who wait in their satins to go on stage and represent Temperance or Honor in a pageant. Titian's rejection of Florentine conceptual painting for the physical life had been extended by Tintoretto, who no longer cared for stories of loves of the gods but only for dance figurations; and it is taken still further by Veronese, who has scarcely any interest in interpersonal contacts.

His first masterpieces are the ceilings at San Sebastiano (1555–58; colorplate 39), on the theme of Esther. The figures pose against columns, their faces and robes and the buildings all forming thinly painted planes, luminous and squarish, in sensuously magnetic colors of pale key—apple green, chalky blue, canary, and persimmon. The squarish shapes of the white Sanmicheli-like building fronts tend to make the canvases work as two-dimensional designs, as well as quite fantastic perspective arrangements. Veronese frescoed the main rooms of Villa Barbaro at Maser, one of Palladio's most ambitious symmetrical villas. The ceilings have allegories, worked out by the learned owner, of his family's marital happiness and farm prosperity, but these allegories are simply pretty girls along with other equally simple elements of fresh vision (fig. 302), the family servants, children, a hunter, and pet animals leaning over white balconies or walking toward us through trick painted doors. Along with the single, true, serious figures, there are illusions of wide open landscape through fake windows, but these were considered minor art and may well have been painted by an assistant. There follows a series of big

302. PAOLO VERONESE. *Women on a Balcony.* Fresco, width 5′3″. Villa Barbaro, Maser

banquet canvases with Biblical themes, the Marriage at Cana (1562–63), Last Supper, Supper at Emmaus, and still others. The architecture is grand but the space has become elementary, without perspective tricks; marble columns define an area and in it are gold satin robes and far flat skies. Extra figures swarm—pages, dwarfs, and caterers—and Veronese was actually called before the Inquisition for disrespect (1577); his defense was that painters have a tacit license to fill leftover space in church pictures with diversions. He was sentenced to revise his work, but instead simply changed the title from the *Last Supper* to the *Feast in the House of Levi*. The late masterpieces are ceiling canvases in the Doges' Palace (1575–77; fig. 303), still simpler, now omitting not only perspective but almost all architecture. The allegorical girls sit against the sky, a flat patch of lit color, creating a human essence against the thin blue. This concentrated seriousness oddly makes the names of the allegories, Industry, Meekness, etc., more memorable than any that preceded them.

303. PAOLO VERONESE. *Industry.* 1575–77. Canvas, 59″ × 87″. Ceiling, Sala Collegio, Doges' Palace, Venice

38. Bassano, Vittoria

Jacopo Bassano (docs. 1535–d.1592) either ranks with Tintoretto and Veronese and is merely less known because he lived in a little town, or else his limited environment did restrict his development. Jacopo da Ponte remained all his life in Bassano (so that he was known by its name), a place far smaller than Brescia or Bergamo, not even having a bishop. He learned in Venice, as a pupil of Bonifazio Veronese, his brush technique and airy realism of pleasant scenes, but returned home, perhaps so as not to be in competition with Titian. He then painted mainly altarpieces for nearby towns and villages, in many styles, using Pordenone, Parmigianino, and others, a variability which has induced complex theories of his evolution. But he seems, rather than adopting any of these styles as his own, to have represented them as he would have a person, so that a Mannerist figure does not imply refined decoration but is being seen as a visible shape and

coolly recorded. This was partly because, in his isolation, he became acquainted with painting styles in fragmentary ways, often through prints. After his early paintings his figures move little, but pause in detachment like a film still (fig. 304). They are also absorbed into his brushwork, which is fresh, luminous, and brilliant as in all the great Venetians. His surface is bright and fat as a crayon drawing, but shinier and pastier, full of streaks or dabs. It rejects not only Titian's and Tintoretto's brushed energy of the figures, but also Veronese's constructions of beautiful people, and celebrates only the beautiful visible field. Such detachment, related to his remoteness, would today produce pure painting, but in him was expressible through subjects considered secondary, either low-class situations in religious painting (the shepherds in the Nativity, the man helped by the Good Samaritan, the parable of the laborers, beggars at feasts, hermit

245

304. JACOPO BASSANO. *The Adoration of the Shepherds*. Canvas, 41″ × 62″.
Galleria Nazionale, Palazzo Barberini, Rome

saints) or paintings of animals, seasons, and nocturnes. Bassano developed all these many—but related—motifs, which were so successful in a cheap market that his sons mass-produced them. His own later work submerges all the Mannerist styles he had learned into a new personal one in which a fragmented paint surface close to Titian's builds a direct vision of undramatic shepherds and optical nocturnes close to Savoldo. El Greco, a late pupil of Titian who drew on Mannerist prints and lived in isolation, has striking technical parallels with Bassano (see pp. 415–18).

Many decorative sculptors worked on Jacopo Sansovino's big projects, and later emerged on their own. Some are prolific but routine (Danese Cattaneo, Tiziano Minio), but one is remarkable. Alessandro

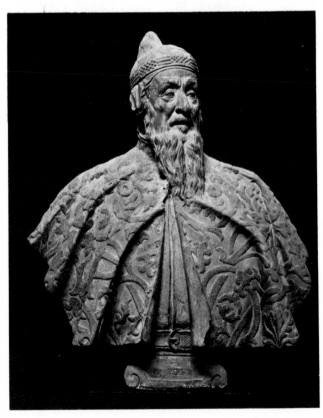

305. ALESSANDRO VITTORIA.
Doge Niccolò da Ponte.
Marble, height 28″.
Seminario Arcivescovile, Venice

246

Vittoria (1525–1608) was led by his training to model figures whose life is in beautifully spiraling rhythms, somewhat like Sansovino's other most talented assistant, Ammanati (see p. 232). But Vittoria's temperament seems to have been vehement and eager, causing him to venerate Michelangelo but to be awkwardly hasty. His colossal stone entrance statues (1550) for Sansovino's Library (see fig. 284) are overpowering but lumpy, his Mannerist tall saints twisting in ecstasy sometimes seem off balance. Effects that call for planning are absent, but Vit-toria is a master of stucco sculpture, which he had learned for Sansovino's ceilings and then applied to unusually large figures in rows, with impetuous angular motion. And he is most impressive in portraiture, a vehicle much in demand but always treated as secondary by Titian and Sansovino. Vittoria's graphic old gentlemen of character (fig. 305), exploiting dashing mobile fragments of robes, are among the few personal variants on Mannerist mobility that were used without change in the Baroque age.

39. Michelangelo's Late Years

In 1534 Michelangelo left Florence for the last time, mainly to avoid the Medici duke, and in the same year Clement VII, the Medici pope, died. Thereafter Michelangelo, staying in Rome, had a series of popes as his only patrons. He was involved with immense projects, some of which seemed to reach fruition with less difficulty than before, and he was regarded as an awesome patriarch and genius. His style has a more open, simplifying self-assurance; the works may be complicated, but the treatment is not so intricate. Pope Paul III was interested in the worldly success of his family, the Farnese, but also in church reform (he called the Council of Trent), and Michelangelo's work reflects both concerns. The latter dominates his paintings: first the huge fresco of the *Last Judgment* (1536–41; fig. 306), which, reviving a medieval arrangement of this theme, fills the end wall of the Sistine Chapel. At the top center Christ judges, and souls slowly rise on one side and slowly fall on the other, all of them hulking bodies without waists, brown on a blue field. Heaviness is sluggish, a changed basis for the frustration of action (fig. 307). In the pope's new Pauline Chapel Michelangelo's two frescoes (1541–50)[96] celebrating Saints Peter and Paul are the only ones he ever painted at eye level; perhaps therefore the figures move back into space, and the air and color modulations are important.

He also had a growing interest in large architectural schemes, and designed a city center on the Capitoline Hill (figs. 308, 309, 310). The two buildings already there were at odd angles; he made one his focal center, with a grand staircase, and matched the second at the side by a third symmetrical with it on the other side. The result is a wedge-shaped axial space, ordered and dynamic. The two side buildings have each a long portico on the lower story and a solid wall above, tied together by colossal pilasters. The effect of a skeleton of heavy beams suggests structural rationalism along with sumptuous ceremony. The change from Michelangelo's previous relief style to a more directly three-dimensional approach is also seen in Saint Peter's, which he took over at Sangallo's death (1546). Getting rid of Sangallo's forest of standard-size columns, he turned to fewer and larger units (figs. 311, 312; see fig. 224). He returned to Bramante's central plan but made it both simpler and livelier; the building becomes a square with four projecting semicircles so large that the corners of the square seem the secondary points. Since the exterior walls are given the same decorative treatment all the way around (not shifting in reference to each wall), there is a mobile effect of constant shifting along an almost wayward path. The building is too big to permit the viewer to grasp the correspondence of each angle to others elsewhere, and Michelangelo uses this difficulty for a new feeling instead of trying to reduce it. Colossal pilasters accent each turn of the wall, their size emphasized by the vertical rows of windows

247

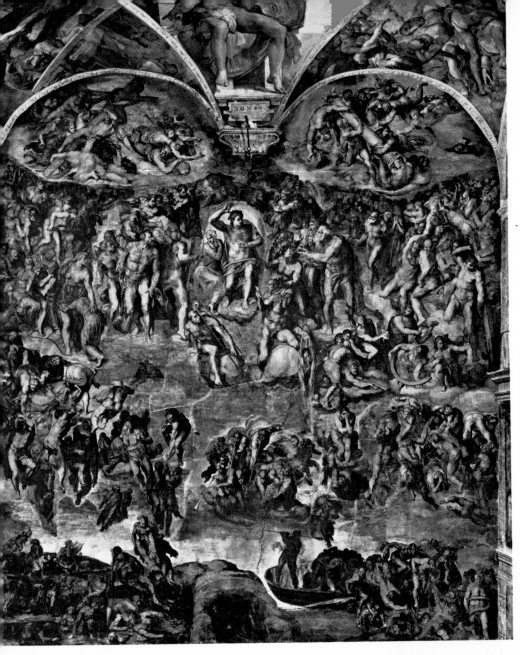

306. MICHELANGELO.
Last Judgment. 1536–41.
Fresco, 48′ × 44′.
Sistine Chapel, Vatican, Rome

307. MICHELANGELO. *Damned Soul*,
detail of *Last Judgment.* 1536–41.
Sistine Chapel, Vatican, Rome

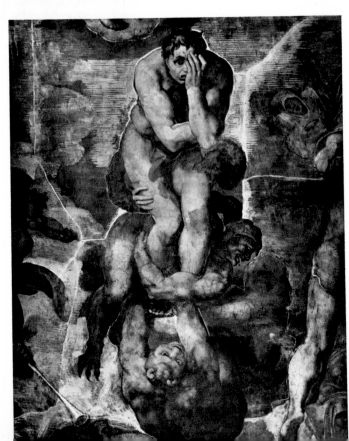

309. MICHELANGELO. Plan,
Capitoline Hill, Rome.
Axis, to door of
Palazzo Senatorio, 249′

308. MICHELANGELO. Project for Capitoline Hill, Rome
(engraving by Dupérac, 1569)

310. MICHELANGELO. Façade, Palazzo dei Conservatori, Capitoline Hill, Rome. Entire dimensions 63′ × 141′

312. MICHELANGELO.
Plan for St. Peter's,
Vatican, Rome. 450' square

311. MICHELANGELO. View of apse, St. Peter's, Vatican, Rome. Begun 1547.
Wall height 144'

squeezed between them. The result is a sense of
live force on a superhuman scale, rising to the dome
that Michelangelo planned but did not build. Inside,
the piers also have more complicated profiles, refer-
ring to the wider, more fluid openings between the
areas.

In his very last years Michelangelo explored a
new building style, even more strongly three-dimen-
sional through its erasure of articulating columns,
leaving smooth massive forms. But these projects
were not executed. Instead we know his late sculp-
ture, done for no patron but himself. A *Pietà*,[97] at
first meant for his own tomb, reverts to an early
Renaissance formula of Christ's body held up to our
gaze by three symmetrical mourners. As the weight
slips down, the mass carries the conviction of tragedy.
Abandoning this as still inadequate to his concept,
he turned when over eighty to a two-figure version,
in which the spindly thin Mary and Christ are iden-
tical except that the Christ slips lower (fig. 313). He
was working on a third revision of this in the week
of his death. Like Titian's last works, these were
notations too unformed to be influential until several
generations had worked around to similar expressive
approaches.

313. MICHELANGELO. *Pietà.* 1552–64.
Marble, height 6'4".
Castello Sforzesco, Milan

250

40. Giambologna

The grand duke's fountains and other objects of display kept many sculptors busy in Florence. Ammanati and Cellini were joined after 1560 by Vincenzo Danti (1530–1576), who resembles Cellini in his polished linear sharpness because both had been trained as goldsmiths. His large bronze group of the *Beheading of John the Baptist* (1571; fig. 314) is most notable for the fashionable Salome, leaning her small head to one side. So does the upper figure of *Honor Conquering Deceit*,[98] an elegantly twined version of Michelangelo's *Victory* which had already been imitated by Ammanati, Cellini, and Pierino da Vinci. All these sculptors had died or lessened their activity by about 1575, when Giambologna emerged as the leading sculptor of the Medici and of Italy.

Giovanni Bologna (1529–1608) was born and trained on the French-Flemish border, and was returning from an ordinary tour of Italy when he was induced to stay in Florence. No doubt what first attracted patrons there was his virtuosity; he bubbled over with facility. It appears in the fantastic naturalism of small works, like the bronze sketch of a turkey walking, which reflect his Flemish taste

(fig. 315). He could also adopt with ease the Mannerist canon of the figure turning artificially, and especially his small bronzes add urbane polish to his sources. Indeed, his eager exploration of available methods, as well as his habit of doing revised versions, make it hard to trace his career. Still more suggestive is the *Bacchus*,[99] his bow in his first big work in Florence to the older Renaissance tradition represented by Sansovino's.

With balanced rhythms and a remarkable fusion of the local Mannerist system and his Flemish naturalism, Giambologna's mature works bring Mannerism back to life in a newly powerful way. Thus his first large work, the Neptune fountain in Bologna (1563–67; made after losing out to Ammanati in competing for the one in Florence),[100] is formal and strict in placement, yet the figure has the air of a big bear waking and growling. His famous *Rape of the Sabine Woman* (1579–83; fig. 316a, b) is a tower of twined figures simpler and truer than the pose would seem to permit, and *Hercules and the Centaur* (from 1594),[101] even more subtly, holds its bursting stress in equipoise in a way that signals the birth of the Baroque rather than late

314. VINCENZO DANTI. *Beheading of John the Baptist* (above South Doors). 1571. Bronze, height 8′. Baptistery, Florence

315. GIAMBOLOGNA. *Turkey*. Bronze, height 24″.
Museo Nazionale, Bargello, Florence

Mannerism. In his fountain statue of the *Apennine* (1570; fig. 317), a mountain god (because streams are born from mountains), he covers the colossal crouching figure with rubble stalactites under which the personified mountain crawls like Caliban; an abstracted fantasy has stimulated elemental life. It is Giambologna who makes it seem normal that generals or rulers put their statues on horseback in city squares; in Florence he started a series that was continued in Paris, with Henri IV, and in Madrid. (Since Donatello's and Verrocchio's, a century before, there had been none, but now they became continuous.) The *Sabine Woman* marks Giambologna as one of those artists who have created an image more famous than themselves, an anonymous item of general culture; still more so is the flying *Mercury*.[102] We see that they have virtuosity and life too, regardless of changing taste, and these, not the classical subjects, are the point. The name *Sabine Woman* was given only after the sculpture had been finished.

316a, b. GIAMBOLOGNA.
Rape of the Sabine Woman.
1579–83. Marble, height 13′5″.
Loggia dei Lanzi, Florence

317. GIAMBOLOGNA. *The Apennine.* 1570. Plastered brick with stone, height about 35′. Villa Demidoff, Pratolino (near Florence)

On a lower level, minor contemporaries of Giambologna invented some images that jump out of the taste of their time. The intentionally sweaty, awkwardly mobile art of Vincenzo de' Rossi (1525–1587), realistic in detail and often vulgar, has kept him underrated in Florentine tradition, though his *Dying Adonis, Theseus Embracing Hippolyta,* and six *Labors of Hercules*[103] are tinglingly original and have an anonymous popularity. Valerio Cioli (1529–1599), despite a Bandinellian rigidity in his habits of design, was able in his youth to rival Giambologna's naturalistic use of Mannerist conceits by carving the duke's fat dwarf sitting nude on a tortoise (fig. 318), and later echoed it in a series of garden statues, of which a woman washing a child's hair is the most effective.[104]

318. VALERIO CIOLI. *The Dwarf Morgante on a Tortoise.* Marble, height 46″. Boboli Gardens, Florence

41. Leone Leoni, Moroni

The date 1530, when the pope crowned Emperor Charles V (who had recently sacked papal Rome) in Bologna, best marks the end of the Italian pattern of independent cities, other than Venice and in part Rome itself. Thereafter for centuries Italy was a set of Austrian or Spanish dependencies. Milan had a viceroy, and the duke of Florence, installed by an imperial gesture, was happy to marry the daughter of Spain's viceroy in Naples. These circumstances shaped the career of Leone Leoni (1510–1592), resident of Milan and portraitist of Charles V. He was first a diecutter of coins and medals in Rome; since like most medals (but not Pisanello's) these were struck rather than cast, Leoni was trained to incise rather than model a head. Only when he was forty and master of the Milan Mint did his strong and ambitious character lead him to large-scale work. After visits to Brussels and Augsburg he drew several Habsburg portraits, and soon after in Milan cast lifesize statues from them (fig. 319). Their authority is in their firm volume, marked on the surface by metallic shine and intricate linear ornament. Along with the smith's training which made it possible for him to produce a figure of the emperor that could be shown either nude or in a suit of armor,[105] he may well have been spurred on by seeing in Flanders work by Conrad Meit (see p. 383), the Habsburg portrait sculptor of the previous generation, which similarly connects plain density and sharp linear definition. The masklike remoteness of Leoni's royal faces, in the state portrait formula, is a startling contrast with his only large works in stone. They are a row of slaves carved on the front of his own house, with dangling heads and legs cut off at the knee (fig. 320). Leoni was a violent person, who had even been a galley slave after a fight in Rome, and these statues articulate his private character remarkably. The splendid house of the successful artist was a growing tradition (from Mantegna to Giulio Romano and Vasari), but such an acute difference between public and private art is new, and foretells the habits of the official artists in the age of absolutism, such as the Carracci and Bernini. Yet it seems natural that in this early tentative case

319. LEONE LEONI. *Mary of Hungary.* Bronze, height 5′5″. The Prado, Madrid

320. LEONE LEONI. Sculptured façade,
Casa degli Omenoni, Milan. Width 54′

321. GIAMBATTISTA MORONI. *The Tailor.*
Canvas, 38″ × 29″. National Gallery, London

the difference results in part from the private art
being executed by others; Leoni designed the slaves,
but perhaps more in the role of patron and owner
than as master of the workshop assistants.

Painting in Milan at this period (until a fore-
taste of the Baroque appears with young artists
about 1575) was a Mannerist routine, alluding to
Parmigianino and to Raphael. But the single sculp-
tor, Leoni, has a suggestive parallel with the single
painter of nearby Bergamo, Giambattista Moroni
(docs. 1547–d.1578). They share the specialty of
portraiture—it is the first instance in an Italian
painter—and the Spanish social context. Though
Bergamo was under Venetian rule, many of Moroni's
sitters wear Spanish clothing or have Spanish or
German mottoes. He inherits from his teacher
Moretto the effect of the subtle gray air on the quiet
substantial figure. Early ones are relatively active,
with jumpy silhouettes, but more and more they

wear black and stand before gray walls, and the
faces, watchfully noted for reality but not psychology,
achieve a monumental stability. Gestures continue
to illustrate a sitter's motto or trade, as in the famous
Tailor (fig. 321), cutting cloth but looking out with
the usual tranquil assurance. (Most of the sitters
are noble, and this portrait must have been a private
favor.) Moroni, like Bassano seemingly contented
as the only talent in his town, has immortalized the
local society, which has the same restrained confi-
dence in its mores that we find in other stable and
complacent provincial centers, such as the one in
Edinburgh immortalized in Raeburn's portraits
two centuries later.

255

42. Alessi and Tibaldi

322. GALEAZZO ALESSI. Interior view toward courtyard, Palazzo Cambiaso, Genoa. Height of courtyard 45′, open area 21′ × 15′

Genoa had less to do with early Renaissance art than any other sizable city in Italy. It had no artists of its own and did not even, like Naples, invite visitors for stays of any length. Its great families constantly fought civil wars, but it did manage oddly to import unique quantities of Flemish paintings, no doubt connected with the unique dominance of its life by the port and shipping, to the exclusion of local manufactures. But when in Charles V's time Genoa became a client state, it brought Perino del Vaga for ten years to paint court decorations. And from 1550 the architect Galeazzo Alessi (1512–1572) set the tone of elegant living. Alessi was a trained builder from Perugia, who typically began by assisting Sangallo with forts, and then skillfully absorbed in Rome the sophisticated style of the painter-architect Peruzzi. He learned it from Peruzzi's works and from the somewhat decorated version in the hand-

book of Serlio, Peruzzi's pupil. In Genoa Alessi could expand from modest labors to rather grand mansions and villas, which play on the forms of the Farnesina and Raphael's Villa Madama, with elegantly proportioned façades of thin pilasters (fig. 322). In his majestic church, Santa Maria Assunta di Carignano (from 1549; fig. 323), he virtually executed Bramante's plan for Saint Peter's, only making the dome taller. For clients in Milan he seems to have added ornament, still more similar to Serlio, encrusting church façades with carvings, and in Palazzo Marino designing a particularly imposing courtyard with a double-columned portico under an elaborate upper-story wall. His originality is not in forms but in the airy grandeur of his space handling. Entrance halls wider than long, courtyards growing out from the palaces into porticoed gardens, the bridge from the front of Santa Maria di Carignano across to another hill and its interior which replaces Bramante's sharp geometry with a luminous broad stability, these are the optical creations of a master more of building than of designing.

Pellegrino Tibaldi (1527–1596) grew up in Bologna in a family of Lombard stonemasons, but was trained as a painter under local imitators of Raphael. He too went to Rome, joined Perino del Vaga's large crew, and became his most independent assistant. His talent in decorative painting flowered when he frescoed a ceiling, back in Bologna, for

323. GALEAZZO ALESSI. Plan, S. Maria Assunta di Carignano, Genoa. 174′6″ × 156′

Cardinal Poggi, with Mannerist figures in violent, tricky positions (fig. 324). They bow remotely to the Sistine Ceiling but belong more in spirit with Giulio Romano's court Mannerism, designed to be shocking and witty; they also have some of the sugary decorative richness of that other Mannerist fresco painter in Rome, Salviati. The figures are audacious and absurd in taking impossible poses, and know it. This is a solution to the problem of Michelangelo's suffocating power: to admit one is imitating him but make it an impersonal game. Tibaldi's wittiness reappears thirty-five years later in his frescoes in the Escorial Library near Madrid,[106] but otherwise he painted almost nothing. Working as an architect in Milan for Archbishop (eventually Saint) Carlo Borromeo, he again plays artfully with powerful motifs, effective because he really is bold as well as clever. Here too he is like Giulio Romano, when he makes a column begin to fall but then carves an angel to catch it. He is most impressive in his Collegio Borromeo (1564; fig. 325) for the University of Pavia, where big niches alternate with windows in up-down and in-out harmony, and rusticated boulders swoop forward to clamp the main door. The plastic exuberance and whimsical vitalism are more genuine successors of Michelangelo's Laurentian Library than any other Mannerist architecture, but rest on the structural stonemason background. Tibaldi's last works develop a cleaner style with spatial stress upward, into a dome, and bold free colonnades in front of a church façade, whose centralizing force predicts the High Baroque.

324. PELLEGRINO TIBALDI. *Giant*. Fresco, entire dimensions 6′11″ × 11′10″. Ceiling, Palazzo Poggi, Bologna

325. PELLEGRINO TIBALDI. Façade, Collegio Borromeo, Pavia. 1564. 83′6″ × 236′

43. Painters in Rome and Florence after 1550

In 1550 Vasari's *Lives* included only one living artist, the seventy-five-year-old Michelangelo. In 1568 the second edition of the *Lives* expanded to include some who were quite young, but this only reinforced its attitude that art had reached a peak with Michelangelo and Raphael and then declined. Certainly the attitude of Mannerism toward past art as a mine of style tended to assume, and to reinforce, the same view, and today we admire the work of many Roman and Florentine painters younger than Raphael, but few younger than Bronzino. The Medici dukes did very well with their sculptors, culminating in Giambologna, who was a European figure though perhaps not a Florentine one. Their architects, similarly busy with festivals and mansions, repeat old ornaments with a professional neatness, decorative and rather gentle, that seems to mark their awareness that they are wearing their tremendous heirlooms in a provincial backwater (Bernardo Buontalenti; Giovan Antonio Dosio). Indeed Florence had lost its political and commercial importance completely and was comparable to an eighteenth-century German duchy employing good musicians. Among painters, Bronzino's chosen heir, Alessandro Allori (1535–1607), is totally routine, but in 1570 he and a group of Vasari's students produced an original decorative work, the study of Duke Francesco I. A series of rectangles and ovals, with figures of graceful artifice in the Parmigianino vein, surprisingly describe the trades and industries of Tuscany (fig. 326). These to be sure are an odd list, ranging from alchemy to coral fishing, but still create freshly, once more, the Mannerist idea of artifice played against observation. The whole project is a minute treasure vault, and hardly any of the young artists ever accomplished anything else; its qualities were evidently brought to life by Vasari, again the entrepreneur of a systematic project, and by the hedonistic duke.

Rome was better off because of its continuing great role as the papal city, and the presence of the aged Michelangelo. Yet the leading work about 1550, Salviati's and Perino del Vaga's wall decorations, still exploiting Raphael's last formulas, must

have been discouraging. Typically, the chief exception to the trend worked a very narrow vein. Daniele da Volterra (docs. 1532–d.1566), a strong individual talent, rebelled by the simple expedient of becoming a virtual copyist of Michelangelo's recent work. His pictures are closer than ever to being sculptural drawings, without color or space around the figures. These are gigantic, usually looming before us alone or in pairs colliding, with rippling muscles and harder texture than Michelangelo's own. This limited range actually avoids any sense of competing with Michelangelo, but by concentrating power in these elementary images creates the most serious painting of the time, in both senses, of nonfrivolous and imposing. His one masterpiece, the many-figured

326. FRANCESCO MORANDINI, IL POPPI.
The Foundry. 1570. Canvas, 45″ × 34″.
Studiolo of Francesco I, Palazzo Vecchio, Florence

327. DANIELE DA VOLTERRA.
Deposition from the Cross. 1541.
Detached fresco, about 13′×8′6″.
S. Trinita dei Monti, Rome

Deposition from the Cross, is early (1541; fig. 327); thereafter timidity reduced him more and more, finally to a few sculptures, of which a head of his master Michelangelo is the most significant (1564–66).[107] Other painters began to use a very odd mannered blend of Daniele and Perino's ornament. This appears in the talented Taddeo Zuccaro (1529–1566), who died young, and the less talented Siciolante da Sermoneta (1521–1580?); both paint hulking monumental groups of figures covered with wriggling folds.

Sculptors' problems are illustrated by the repeated encouragement Michelangelo gave to young sculptors who were not imitating him, and who

indeed were the best. In each case he helped to secure a big commission for a tomb and himself provided an architectural plan for it, but the result, in the 1540s, was that Guglielmo della Porta got bogged down and never did another large work, Ammanati in the 1550s left Rome and turned to architecture more and more, and Leone Leoni in the 1560s was not in Rome anyway. In 1570 Vignola was the one first-rate artist there, and he was one of those rare architects who practiced no other art. Yet at his death in 1573 he bequeathed to Giacomo della Porta the Gesù, the church which may well be called the first Baroque work of art, and so confirmed the fertility of Rome.

44. Cambiaso, Barocci

The belief that (except for Venice) Italian painting was in a bad way in 1575 is a normal, but wrong, extrapolation from Rome and Florence. The same odd phenomenon that saw Palladio, the greatest living architect, content to stay in Vicenza and send out illustrated books allowed small, previously unproductive towns like Bassano, Bergamo, and Urbino, and the sterile great city of Genoa, each to have a painter superior to all those in the established centers. This may have a stylistic cause: the repetitive artificiality of Mannerist imitation puts a premium

328. LUCA CAMBIASO.
The Madonna of the Candle.
Canvas, 57″ × 43″. Palazzo Bianco, Genoa

by contrast on freshness and even provincial naïveté, soon to be illustrated at its peak by Caravaggio's use of his Lombard training in his Baroque revolution. It may also have an economic cause: Italy declined as a patronage center, and the leading artists of Venice, Genoa, Milan, and Urbino all made trips to Germany and Spain anyhow; when that happened, Florence had no advantage over Urbino.

The Genoese Luca Cambiaso (1527–1585) emerged at the same moment as Alessi, by looking at what visitors had done in the city, not so much at Perino del Vaga as at Beccafumi, who had been there more recently. Hence come his ceiling mythologies, with foreshortened figures in a filmy translucent brown. His drawings, in transparent brown wash, have a quick zest of line, and his shorthand methods include cubes for figures (a convention that he did not invent—Dürer had used it). Both paintings and drawings exist in enormous quantity, and stories were told of his painting with both hands. The paintings are very unequal; the altarpieces often reflect local provincial traditions, the mythologies the lubricity of Perino. The strongest are the religious stories containing a tough genre element (fig. 328); in them he, like Romanino earlier, borrows from German prints, which seem to match the plain surface handling.

The much more remarkable Federigo Barocci (1526–1612) also liked luminous color surfaces. He visited Rome while young but returned to his native Urbino, where he avoided company and lived in poor health. The turning point came when in some indirect way he learned of Correggio. The mining habits of the Mannerists had made possible such direct leaps back across generations, but the dead ends of their imitative works seemed to recommend a return to a pre-Mannerist art. This was indeed being tried in Florence by Santi di Tito (1538–1603), but he produced merely an academic rendering of Andrea del Sarto, with neat figures in blank rooms (though he does seem to foretell Guido Reni). Barocci's return to Correggio produces something more, because Correggio had himself been so experimental and because he is used only as a stimulus.

The diagonal forms floating in cloudy textures reappear, but Barocci goes further in what he convinces us is the same direction. Iridescent mother-of-pearl emulsions and chalky pastels blend, with rich shadowy transitions; figures, without plasticity or line, have a sweetness that does not seem cosmetic. Each is a pink or green nucleus spreading outward into a dawn-gray world. These effects carry the motifs of vision and ecstasy of the Counter Reformation and its altarpieces, and, on a milder level, its motif of encompassing, ingratiating love (colorplate 40). This art, so far from our taste, is disconcerting, and, produced in isolation, had small influence and is easy to dismiss. Yet we must recognize a complete fusion of technical brilliance and emotional viewpoint so close in late instances to seventeenth-century artists like Lanfranco and Bernini that they do not foretell but already are Baroque. Here, as in the late evolution of Vittoria and Giambologna, Vignola and Tibaldi, the Renaissance slides off the stage not when it has worn itself out, but when it has constructed a grand overture for its successor.

Supplementary Notes to Part Two

1. Leonardo da Vinci, *Annunciation*, Uffizi Gallery, Florence.

2. Leonardo da Vinci, *Ginevra de' Benci*, National Gallery of Art, Washington, D.C.

3. Leonardo da Vinci, project for colossal equestrian statue of Duke Francesco Sforza of Milan; stages of design shown in drawings, mainly in the Royal Library, Windsor Castle.

4. Filippino Lippi, frescoes of the lives of Sts. Philip and John the Evangelist, Strozzi Chapel, S. Maria Novella, Florence.

5. Filippino Lippi, *Crucifixion*, 1497, Staatliche Museen, Berlin-Dahlem.

6. Piero di Cosimo, *Death of Procris*, National Gallery, London.

7. Piero di Cosimo, *Cleopatra*, Musée Condé, Chantilly.

8. Piero di Cosimo, portraits of Giuliano da Sangallo and of his father Francesco Giamberti, Rijksmuseum, Amsterdam.

9. Andrea Solario, *Virgin with the Green Cushion*, The Louvre, Paris.

10. Sodoma, *St. Sebastian*, Pitti Palace, Florence.

11. Sodoma, *St. Catherine of Siena*, Chapel of St. Catherine, S. Domenico, Siena.

12. Leonardo da Vinci, *Leda and the Swan*: known through several drawings; a copy of one by Raphael; paintings by Milanese imitators.

13. Michelangelo, *Battle of Lapiths and Centaurs*, Casa Buonarroti, Florence.

14. Michelangelo, *Cupid*, formerly in the collection of Isabella d'Este, Mantua (now lost).

15. Raphael, portraits of Angelo Doni and of his wife Maddalena, Pitti Palace, Florence.

16. Andrea Sansovino, altar of the Sacrament, Corbinelli Chapel, S. Spirito, Florence.

17. Andrea Sansovino, tombs of Cardinal Ascanio Sforza and of Cardinal Girolamo Basso della Rovere, S. Maria del Popolo, Rome.

18. Fra Bartolommeo, *Last Judgment*, Museo di San Marco, Florence.

19. Andrea del Sarto, *Birth of the Virgin*, courtyard, SS. Annunziata, Florence.

20. Andrea del Sarto, *Madonna of the Harpies*, Uffizi Gallery, Florence.

21. Andrea del Sarto, *Last Supper*, Convent of S. Salvi, Florence.

22. Michelangelo, *Dying Slave; Rebellious Slave*, The Louvre, Paris.

23. Raphael, *Madonna of the Chair*, Pitti Palace, Florence.

24. Raphael, *Sistine Madonna*, Gemäldegalerie, Dresden.

25. Baldassare Peruzzi, *Presentation of the Virgin*, S. Maria della Pace, Rome.

26. Giorgione, *Sleeping Venus*, Gemäldegalerie, Dresden.

27. Cardinal Pietro Bembo, *The Asolans (Gli Asolani)*, written 1505.

28. Baldassare Castiglione, *The Courtier (Il libro del cortegiano)*, written c.1514, published in Venice, 1528; English translation, 1561.

29. Titian, *Concert Champêtre*, The Louvre, Paris.

30. Giambattista Cima, *Endymion*, Galleria Nazionale, Parma.

31. Giovanni Bellini, *Baptism*, S. Corona, Vicenza.

32. Giovanni Bellini, *St. Jerome with Sts. Christopher and Augustine*, S. Giovanni Crisostomo, Venice.

33. Giovanni Bellini, *Nude with Mirror*, Kunsthistorisches Museum, Vienna.

34. Ovid, *Fasti*, written in late first century B.C.: six books on the days from January to June—myths, legends, rituals, notable events.

35. Tullio Lombardo, tomb of Guidarello Guidarelli, Accademia, Ravenna.

36. Jacopo Palma, *Ariosto*, National Gallery, London.

37. Sebastiano del Piombo, *Sts. Bartholomew, Sebastian, Louis of Toulouse, and Sinibald*, S. Bartolomeo, Venice.

38. Francesco Francia, *St. Stephen*, Galleria Borghese, Rome.

39. Amico Aspertini, frescoes in Oratory of S. Cecilia, S. Giacomo Maggiore, Bologna.

40. Amico Aspertini, *Nicodemus with the Dead Christ*, S. Petronio, Bologna.

41. Dosso, *Bacchanal*, National Gallery, London.

42. Dosso, Camera delle Cariatidi, Villa Imperiale, Pesaro.

43. Dosso, diamond-shaped panels for Castello Estense, Ferrara; now Galleria Estense, Modena.

44. Dosso, *Allegory of Music*, Horne Collection, Florence.

45. Dosso, *Jove Painting Butterflies*, Kunsthistorisches Museum, Vienna.

46. Giorgione and Titian, frescoes painted for the Fondaco dei Tedeschi; some fragments now in the Accademia, Venice.

47. Titian, *Christ with the Woman Taken in Adultery*, Corporation Art Galleries, Glasgow.

48. Titian, *Three Ages of Man*, National Gallery of Scotland (on loan from the Earl of Ellesmere), Edinburgh.

49. Titian, *Salome*, Galleria Doria-Pamphili, Rome.

50. Titian, *Girl Combing Her Hair*, The Louvre, Paris (one of several versions).

51. Titian, *Worship of Venus*, The Prado, Madrid.

52. Titian, *Bacchanal of the Andrians*, The Prado, Madrid.

53. Titian, Pesaro altarpiece, S. Maria dei Frari, Venice.

54. Titian, *Nude in Fur Coat*, Kunsthistorisches Museum, Vienna (also Hermitage, Leningrad).

55. Lorenzo Lotto, *Bishop Bernardo de' Rossi*, Museo Nazionale di Capodimonte, Naples.

56. Lorenzo Lotto, *Allegory* (cover panel to *Portrait of Bishop Rossi*), National Gallery of Art, Washington, D.C. (Samuel H. Kress Collection).

57. Lorenzo Lotto, *Susanna and the Elders*, Contini-Bonacossi Collection, Florence.

58. Lorenzo Lotto, *Annunciation*, S. Maria sopra Mercanti, Recanati.

59. Girolamo Savoldo, *The Hermit Saints Anthony and Paul*, Accademia, Venice.

60. Correggio, *Madonna of St. Francis*, Gemäldegalerie, Dresden.

61. Andrea Mantegna, *Madonna of Victory*, The Louvre, Paris.

62. Correggio, *Rest on the Flight into Egypt, with St. Francis*, Uffizi Gallery, Florence.

63. Correggio, *Madonna of the Basket*, National Gallery, London.

64. Correggio, *Madonna with St. Jerome*, Galleria Nazionale, Parma.

65. Correggio, *Danaë*, Galleria Borghese, Rome.

66. Correggio, *Leda and the Swan*, Staatliche Museen, Berlin-Dahlem.

67. Michelangelo, *"David or Apollo,"* Museo Nazionale, Bargello, Florence.

68. Michelangelo, *Victory*, Palazzo Vecchio, Florence.

69. Jacopo Sansovino, *Madonna*, S. Agostino, Rome.

70. Jacopo Pontormo, *Visitation*, courtyard, SS. Annunziata, Florence.

71. Rosso Fiorentino, *Assumption of the Virgin*, courtyard, SS. Annunziata, Florence.

72. Parmigianino, *Story of Diana and Actaeon*, fresco cycle, Castello Fontanellato (near Parma).

73. Raphael, Loggia of the Vatican: thirteen bays overlooking courtyard of S. Damaso, each bay vaulted in four frescoed zones painted by artists in Raphael's workshop.

74. Paris Bordone, *Doge Receiving the Ring*, Accademia, Venice.

75. Titian, *Presentation of the Virgin*, Accademia, Venice.

76. Edouard Manet, *Olympia*, 1863, Museum of Impressionism, The Louvre, Paris.

77. Titian, *Cain Slaying Abel, The Sacrifice of Isaac,* and *David Slaying Goliath,* ceiling paintings, Sacristy, S. Maria della Salute, Venice.

78. Titian, *Vendramin Family*, National Gallery, London.

79. Titian, *Charles V on Horseback*, The Prado, Madrid.

80. Titian, *Danaë*, Museo Nazionale di Capodimonte, Naples.

81. Titian, *Rape of Europa*, Isabella Stewart Gardner Museum, Boston.

82. Sanmicheli, gates for Verona: Porta S. Giorgio, 1527; Porta Nuova, 1533–40: Porta S. Zeno, 1541; Porta Palio, begun 1546.

83. Jacopo Sansovino, eight bronze reliefs of the life of St. Mark, on tribunes in choir, St. Mark's, Venice: right tribune, 1537; left, 1544.

84. Bartolommeo Ammanati, effigy of Mario Nari from his tomb (in fragments), Museo Nazionale, Bargello, Florence.

85. Bartolommeo Ammanati, Neptune Fountain, Piazza della Signoria, Florence.

86. Bartolommeo Ammanati, Ponte S. Trinita (across Arno River), Florence.

87. Giacomo Vignola, *Regola delli cinque ordini d'architettura* (*Rule of the Five Architectural Orders*), first published 1562.

88. Sebastiano Serlio, *Il primo (-quinto) libro d'architettura* (*The First* [to *Fifth*] *Book of Architecture*), published separately in Venice and Paris, 1537–47.

89. Andrea Palladio, *I quattro libri dell'architettura* (*The Four Books of Architecture*), first published Venice, 1570.

90. Tintoretto, *Susanna and the Elders*, Kunsthistorisches Museum, Vienna.

91. Tintoretto, *Healing at the Pool of Bethesda*, S. Rocco, Venice.

92. Tintoretto, miracles of St. Mark: *Finding of St. Mark's Body*, Brera, Milan; *Removal of St. Mark's Body*, and *The Miraculous Rescue of the Saracen by St. Mark*, Accademia, Venice.

93. Paolo Veronese, frescoes in Sanmicheli's Villa Soranza, Treville di Castelfranco: fragments preserved in sacristy of Cathedral, Castelfranco; Museo Civico, Vicenza; Seminario Patriarcale, Venice.

94. Paolo Veronese, *Temptation of St. Anthony*, Musée des Beaux-Arts, Caen.

95. Paolo Veronese, ceiling paintings in Doges' Palace, Venice: many still *in situ*; others in Accademia, Venice, and The Louvre, Paris.

96. Michelangelo, *Crucifixion of St. Peter; Conversion of St. Paul*, frescoes in Pauline Chapel, Vatican, Rome.

97. Michelangelo, *Pietà*, Cathedral, Florence.

98. Vincenzo Danti, *Honor Conquering Deceit*, Museo Nazionale, Bargello, Florence.

99. Giambologna, *Bacchus*, Borgo S. Jacopo, Florence.

100. Giambologna, Neptune Fountain, Piazza del Nettuno, Bologna.

101. Giambologna, *Hercules and the Centaur*, Loggia dei Lanzi, Florence.

102. Giambologna, *Mercury*, Museo Nazionale, Bargello, Florence.

103. Vincenzo de' Rossi: *Dying Adonis*, Museo Nazionale, Bargello, Florence; *Theseus Embracing Hippolyta*, Boboli Gardens, Florence; six *Labors of Hercules*, Palazzo Vecchio, Florence.

104. Valerio Cioli, *Woman Washing Child's Hair*, Boboli Gardens, Florence.

105. Leone Leoni, *Emperor Charles V*, The Prado, Madrid.

106. Pellegrino Tibaldi, ceiling frescoes of the Liberal Arts, Library of Printed Books, Escorial.

107. Daniele da Volterra, *Portrait of Michelangelo*, Museo Nazionale, Bargello, Florence.

PART THREE # The Renaissance outside Italy

SUPPLEMENTARY NOTES, PAGES 419-420

1. Jean Pucelle

Everywhere north of the Alps, nearly every work of art in the fourteenth century is completely medieval. Architecture is most obviously so; it had dominated the other arts in the Gothic world, and perhaps for that reason was unlikely to seek out change. Special Gothic media like stained glass and ivory carving were equally traditional. A very few outstanding works of sculpture show innovation. The one widespread change occurs in manuscript illustration, in its great center in Paris. Naturally influence from Italy helped this along, but it also involves a great original personality, Jean Pucelle (records c.1323–d.1334).

A large shift was also going on in the conditions of patronage. All the Gothic cathedrals had been begun, and only continuations and annexes were to follow. They had implied roughly equal importance among towns of varying sizes from Chartres to Paris, communities stimulated to great enterprises by their bishops, and they had interlocked

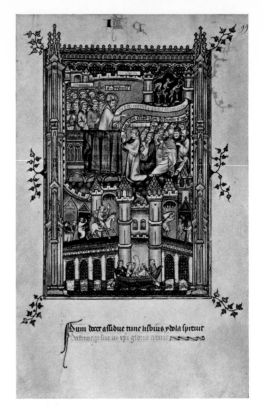

330. MACIOT(?). *St. Denis Preaching,*
illuminated page in the Life
of St. Denis. 1317. Vellum,
illumination 9″ × 5″.
Bibliothèque Nationale, Paris

all the arts in one project. But now Paris was achieving the dominance it has today, the royal family was becoming the main patron, and though religious themes continued preeminent, the works were less often destined for churches. As the cathedral is the typical vehicle of the finest thirteenth-century achievements, in the fourteenth century it is the royal person's prayer book, rich but small like a jewel. Pucelle's masterpiece is a Book of Hours measuring less than three by four inches made for Queen Jeanne d'Evreux (fig. 331). A Book of Hours is a compilation of an individual's prayers for the year; no two books have the same text. Pucelle was also a personality, such that forty years after the book was made, the queen in her will bequeathed "my book by Pucelle." He is only the second outstanding French illuminator known to us by name, preceded by an anonymous sea but followed by more and more frequent allusions to admired artists.

His predecessor a generation before had been Master Honoré from Amiens, whose Breviary for King Philip the Fair (1296; fig. 329) represented real, thick people, in vigorous actions channeled through flowing Gothic rhythms, on flat backgrounds. The

329. MASTER HONORÉ. *Stories of David,*
illuminated page in the Breviary of
Philip the Fair. 1296.
Vellum, page 6 7/8″ × 4 1/2″.
Bibliothèque Nationale, Paris

leading master of Pucelle's youth, Maciot (docs. 1302–1319), may be the artist who illustrated a Life of Saint Denis for King Philip the Tall in 1317 (fig. 330), with lively groupings of Paris street crowds, but still in a flat diagrammed environment. Pucelle's most obvious innovation is to explore depth; he draws dollhouses, rooms with walls all around except in front, with receding beams and light and shadow, and in them, people acting out the scenes (figs. 331, 332). These schemes are taken directly from Duccio, and Pucelle may have been in Italy. But if that were all, he would only count as local talent, the first to import an invention into a province. He is also famous for importing another modern device, the *drôleries* that had recently developed in English illustration. These are the little figures in the margins beside formal scenes— comic, whether real or fantastic, showing anecdotes of games, fights, and lovemaking—sometimes quite unconnected with the official scenes but often parodies of them, such as the fables of apes and foxes that mock human behavior. (Contrary to a cliché, medieval art does not ignore the everyday physical world; it just classifies it in another section of its system.)

Pucelle uses these marginal types and adds a new one, in which the main story is sprawling out from its frame (fig. 332). The margin is then likely to show the tougher or earthier part of the holy event: the margin of the *Resurrection* in the Breviary of Belleville shows the sleeping soldiers; below the *Adoration of the Magi* we see the *Massacre of the Innocents;* below the *Flight into Egypt,* pagan idols falling to the ground. These annexed scenes and Pucelle's depth probing are two symptoms of his personal tendency to break down the Gothic allocation of data in clear slots, and to create allusive links and fluid continuities through which people stretch themselves. Again in his grotesques, the ornamental rectangles that had previously filled paragraph-ends grow into the margins as live creatures. He loves spatial and physical thrusts, as in the intensely geometric and natural anecdote of a figure running up a spiral staircase, or a night scene as atmospherically fresh as Taddeo Gaddi's a little

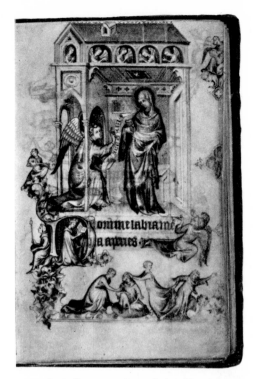

331. JEAN PUCELLE. *Annunciation*, illuminated page in the Hours of Jeanne d'Evreux. 1325–28. Grisaille and color on vellum, page 3 1/2″ × 2 1/2″. The Cloisters, Metropolitan Museum of Art, New York

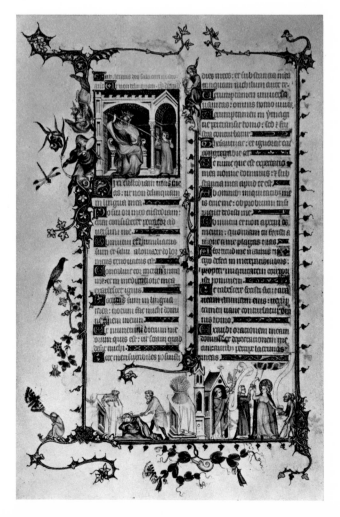

332. JEAN PUCELLE. *Saul and David,* illuminated page in the Belleville Breviary. 1323–26. Vellum, page 9 1/2″ × 6 1/2″. Bibliothèque Nationale, Paris

later (see fig. 28). As he likes color less than ranges of gray, so he is inexhaustible in motifs of action, people wringing hands, beating and dropping things, excitedly finding themselves penetrating the world. The world itself in motion is the theme of his most famous invention, a set of illustrations in the Breviary for a calendar in which, month by month, a landscape of trees grows twigs and then loses its leaves, without human observers except for a peasant in December who comes to cut branches. Pucelle is still a Gothic draftsman of flowing line and a medieval artist whose vehicle is a part of some larger object, in his case a book, and his calendars still emphasize systems for dividing up the cosmos. But he remakes the calendar through his sense of nature and the visible continuum of organic life, just as in his style he uses his Italian sources for new positive purposes.

2. French Painting, 1340–1380

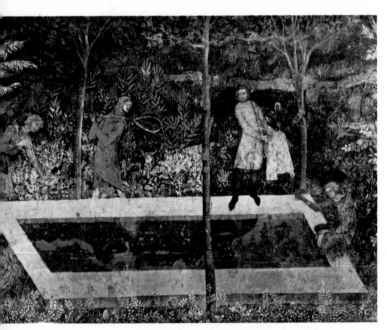

333. *Fishing*. Fresco (portion), height of entire visible area 14′10″, width 14′7″. Chamber of the Deer, Palace of the Popes, Avignon

The only competition for Paris was Avignon, home of the popes for seventy years (1309–78). The palace that was gradually built through their stay is an immense structure that is now the best surviving illustration of the transition from castle to palace. It was also one of the earliest, preceding King Charles V's rebuilding of the Louvre. A casual mixture of thick donjon towers and open courts, it is adorned with frescoes. The most surprising to us are the pleasant scenes of fishing, hunting, and hawking, with figures strolling before a flat green wall of landscape (fig. 333). We are likely to label this as the style of tapestries, which, being helpful in warming the increasingly numerous rooms, seem perhaps to have evolved later in imitation of such murals. Secular frescoes of this kind were probably frequent in castles, being described in chivalrous romances, but secular paintings have a far lower chance of survival than church paintings (just as among buildings we have ruins of castles but surviving churches). These frescoes were painted under the supervision of the papal master painter and priest Matteo Giovanetti (docs. 1336–1368) from Viterbo, near Rome. We can think of him among French artists, since we know his work only after he got to Avignon, and even his obvious dependence on Simone Martini may have been acquired or reinforced there. His palace frescoes recall the style of Simone's other chief pupil, Barna da Siena (see fig. 47). Both alter Simone's twining line to make the people thicker, settled on the ground plumply in rocky landscapes, with loose and jumpy interrelations. Barna is more passionate and Matteo more earthy, but the insistent temperaments of both manage to use their master's more subtle and aristocratic patterns to mark a personal note, even if more blaring and less modulated than his. In Matteo's series of the life of Saint Martial (1344–45)[1] the most startling wall has as its theme all the churches the saint founded. It presents them as a kind of picture inventory, a rougher and more

268

primitive version of Sienese spatial surveys like the Lorenzettis'. This and the hunting landscapes done under Matteo's eye suggest that, even when reduced to an elementary form in this outpost, the Sienese teachings were highly capable of relating imaginatively to new problems.

Paris was more sophisticated and perhaps the largest city in Europe, but no doubt Parisian artists watched Avignon as a clue to Italian methods. This may explain the style of the leading artist at King John II's court, whose varied works have been grouped under the name Maître aux Boquetaux ("Master of the Thickets"). In a late work, illustrating the poems of Guillaume de Machaut (c. 1370),[2] figures in manuscripts for the first time relate to an open landscape with a sense of breadth that reflects monumental painting, and with the same rather loose, tough, bunched effect as Matteo's. But Gothic training makes the artist modify this vision conservatively, constructing tall people out of smooth curves and flattening the panorama of hills. A closer link to Matteo appears in a panel painting that may be this master's, the portrait of King John in profile (c. 1360; fig. 334), often honored as the first French painting, produced with a working symbiosis of Gothic curvilinear formulas and solid cubic modeling. The least heavy of his works, if

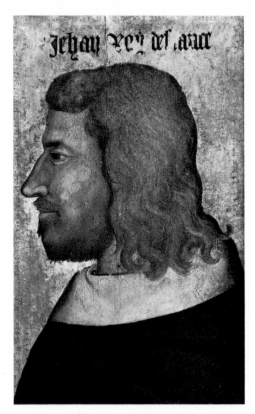

334. *King John II of France*. c.1360. Panel, 22″ × 13″. The Louvre, Paris

335. MAÎTRE AUX
BOQUETAUX(?).
Lot and Abraham,
illuminated page in the
Bible of Jean de Sy.
1355–c.1380. Vellum,
page 16″ × 12″.
Bibliothèque Nationale,
Paris

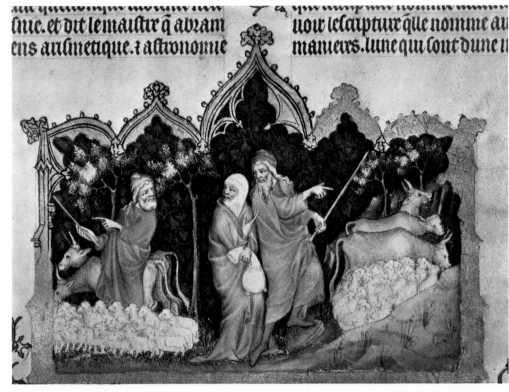

they are really his and not simply the product of a group style, are the small illustrations in the large Bible with the commentaries of Jean de Sy, made for King John (1355–c.1380; fig. 335). Figures and trees are strung alternately along a base line with no other environment, both sinuously forceful and with a tough thrust of gesture.

The tendency to slip back to provincial traditions from Pucelle's difficult refinement of observation seems confirmed by the case of André Beauneveu (docs. 1360–1402). He was a sculptor at first, much favored by King John's son Charles V for his own (1364–66) and other tombs, standard but strong carvings in the High Gothic tradition.[3] Later, when he illustrated books for Charles' brother the duke of Berry (c. 1380–85),[4] he naturally produced sculptor's figures without context or color, enthroned bearded men repeated with few variations in a vigorous Gothic formula of rhythmic gesture and folds. The contemporary chronicler Froissart recorded him as the duke's most esteemed artist, as he had apparently been Charles V's, but both patrons also made use of rather more modern talents.

3. Accomplishments around King Charles V

King Charles V emerges as an active patron, curious about ideas, constantly wanting his portrait painted but letting it be realistic. When he made the Louvre over into a palace, he built a grand spiral staircase with lifesize statues of himself and relatives on its exterior. The subjects and their location make an instructive contrast with the rows of saints carved in the thirteenth century for cathedral doorways. The Louvre figures are lost, but their appearance may be guessed from echoes such as the nine statues in three high rows on the north tower at Amiens Cathedral (1376–80): three saints, three royal persons, and three civil servants. The Chancellor Bureau shows us a sharp inquiring face above his conventionally folded robes, and the whole figure is independent from the building. Also an echo of the Louvre project, it seems, is the most brilliant sculpture surviving from this period, of Charles and his queen, from the Chapel of the Quinze-Vingt in Paris (c. 1370; fig. 336). Some High Gothic sculpture is as open and undetailed in its solidity as this, but the minimizing of pattern in folds and face is new, letting plump queen and fresh-faced king get their dignity from frank human individuality.

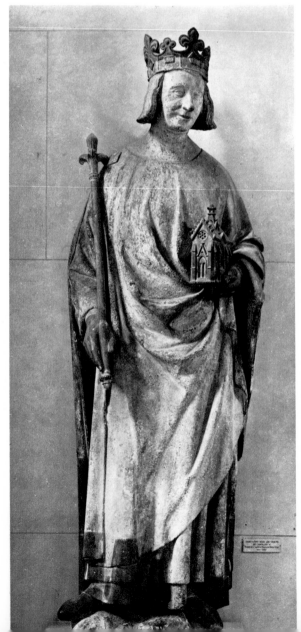

336. *King Charles V.*
Stone, height 6′5″.
The Louvre, Paris

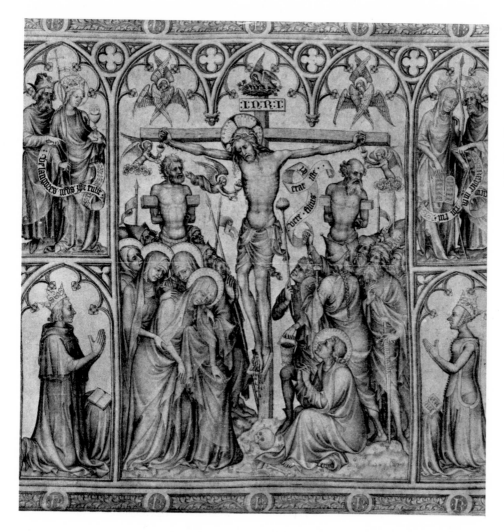

337. *Parement de Narbonne*,
center portion.
Silk, entire dimensions
2'7″×9'5″.
The Louvre, Paris

All the king's architecture, nearly all of the major painting, and a vast amount of the sculpture is lost as a result of the Hundred Years' War, the intermittent struggle with England during which his reign is a relatively mild phase. (His father had been captured in battle and died a knightly prisoner.) One impressive big picture remains, known as the *Parement de Narbonne* (c. 1370; fig. 337). It is a nine-foot-wide white silk cloth for the front of an altar, drawn in black because it was for ritual use during the mourning period of Lent. Gothic tracery frames the scenes, with King Charles and Queen Jeanne kneeling in their own niches. As if cued by the standard decorative frames, the figures are sharply drawn in grand curves, which build strong forms and also communicate the physical pressure of their pain. In the austere denial of space the unknown Master of the *Parement* might seem, like Beauneveu, to be regressing in time, but his focus on physicality is so modern that the spacelessness may be a conscious device of expressive stress.

The *Parement* may have been rare as a large painting when it was made, since we later find its artist illustrating books,[5] and there even probing spatial depth in small scooping ways.

The leading role of book illustration in carrying modernity seems confirmed by one more remarkable portrait of King Charles. It is the frontispiece of a Bible, in which the seated king, dressed in the academic gown of a Master of Arts, receives the book as a gift (fig. 338). The opposite page is filled by a huge inscription recording the date, 1371, and the names of the king, the donor, and the artist, John of Bruges, whom we know as Jean Bondol (docs. 1368–1381). He is the first of a long line of Flemish painters who dominated French royal patronage. This, his only certain painting, is far more original than Beauneveu's and more forward-looking than the *Parement* in its soft glowing forms, modeled without line, in a space firmly established by a squarish platform. The king, in this casual, unstructured freedom to move, seems to push his

chair forward to see the book better. The assumptions about modeling here are related to recent painting in Florence, such as Maso's (see colorplate 4). This accidentally surviving page shows the origin of a widespread phase of Renaissance style, discarding linear convention for a human realism eased by soft light and grace. Yet Bondol's only other surviving work is the design of a set of tapestries for the king's military-minded brother, the duke of Anjou, on the complex theme of the Book of Revelation (c. 1375).[6] These are the oldest existing tapestries (other than small fragments), but as works of Bondol they are odd since they are copied from a thirteenth-century book that he needed to work out the old-fashioned themes. Thus the Paris court had ambiguous values, and the king's other brothers, the dukes of Berry and Burgundy, were far more stimulating patrons.

338. JEAN BONDOL. Frontispiece, Bible of Jean de Vaudetar. 1371. Vellum, illumination 8 3/4″×6″. Rijksmuseum Meermanno-Westreenianum, The Hague

4. Claus Sluter

Philip the Bold, duke of Burgundy, received an appanage from his father King John II almost equal to his oldest brother's royal inheritance. He lived partly in his provincial capital of Dijon, partly in Paris, but in 1384 he inherited Flanders, the richest and most urban part of the Netherlands, from his father-in-law. Since part of Flanders was outside the borders of France, he became even more independent; the Flemish merchants were concerned about managing their town governments, so it was convenient to both sides for Philip to collect Flemish taxes but use the money to adorn his feudal court in Dijon. Like his brothers, he also considered that the best artists were Flemish, so we find town-bred artists working at the royal and ducal courts. Among

these is the greatest sculptor of the century and one of the most original in any century, Claus Sluter from Haarlem (docs. from 1380–d.1405), the first of the great realists of the Netherlands.

A monumental realism had emerged at times in High Gothic sculpture, as in the transept portals of Chartres, but always in the context of figures framed and set in a big encyclopedic system that tended to cool down their individual differences. Organization overruled realism entirely in most fourteenth-century sculpture in France, Germany, or England, and it offers smooth stamped-out curvilinear formulas for faces and robes. Even the rare realistic face seems to be treated as a type. Hence Sluter's powerful reference to particular ex-

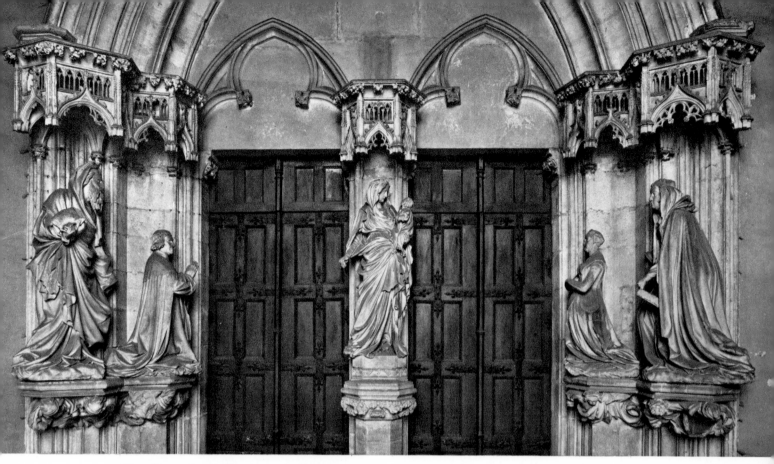

339. Claus Sluter. Portal, Chartreuse de Champmol, Dijon. 1393. Stone, height of kneeling figures 8'9"

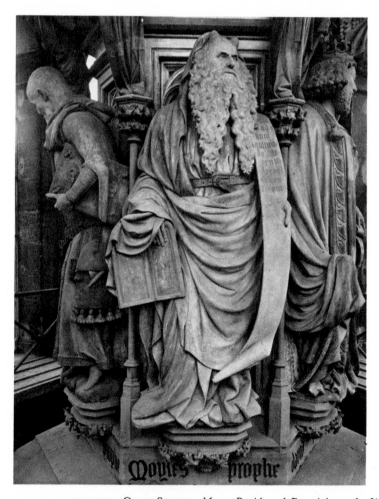

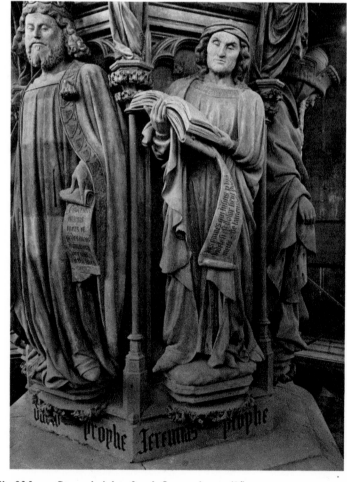

340, 341. CLAUS SLUTER. *Moses, David,* and *Jeremiah,* on the Well of Moses. Stone, height of each figure about 5'8".
Chartreuse de Champmol, Dijon

perience, supported by imposing weightiness, has as another expressive factor its loosened relation to its environment. The process recalls Italian thirteenth-century painting but is now more violent, since naturalism at this later date has a more explosive birth. Sluter came to Dijon from Brussels, the year after the duke inherited Flanders, to work as an assistant, but he took over in 1389 when his master died. In 1393 he carved the doorway sculpture of the new Carthusian monastery (fig. 339) where Philip was planning his dynastic tombs. At either side duke and duchess kneel, each presented by a patron saint, and are received by the Virgin, set against the central door post. This is basically a classic Gothic door-sculpture arrangement, even underlined by very heavy ornamental brackets above and below the figures; but those kneeling thereby leave a gap above themselves which is all the more conspicuous, like a musical rest. The look directed by the people across the door openings involves real space and stretches the self-sufficient internal rhythm of the system near to the breaking point. Robes are thicker and heavier than usual, almost sloshing around the feet, and are soft and pliable so that an imposing materialism gives the figures reality and significance, yet these qualities are infiltrated into a standard Gothic linear rhythm of folds. The ducal faces reflect the realism in King Charles V and Queen Jeanne at the Quinze-Vingt (see fig. 336), by Sluter's clearest predecessor. Otherwise his sources are a problem, eased by this earliest work which shows new principles but only a small change in the visual qualities of the sculptured figure. He next built (1395–1404) inside this monastery a huge Crucifixion group over a fountain. The base survives in place, under the name of the Well of Moses, with six prophets (c.1400–1403; figs. 340, 341). These are set in front of panels, but irregularly; the tension between a firm static frame and the naturalistic mobile figure is basic to Sluter. It appears within each figure too, the fantastic naturalism being constantly underlined by ornamental patterns. Zachariah's soft old flesh mixes with a frizzled beard, Jeremiah's bony and fleshy face is framed by an ornamental neckband, David's is set in a crown and formal curls; these mixtures were more marked when the figures were painted and Jeremiah had his eyeglasses!

Powerful particularism in contrast with patterned background reappears in Sluter's last, unfinished work, the duke's tomb (carving begun 1404). A frieze of small mourners all around the sarcophagus was traditional; he modifies them to small separate statues in an arcade, again loosening the scheme (fig. 342). These become the famous *pleurants,* weepers, showing endless variety of incidental evocations of grief, natural yet cubically simplified and therefore impressive, most of all when the typical soft robes hide even their faces.

Sluter's shift of emphasis from organization to particularity is a Renaissance innovation and has its chief impact on the Flemish painting most famous through Jan van Eyck. In Burgundy it merely resulted in copies for fifty years, partly as a result of a later duke's discouraging removal to Flanders. Broadly it affected all European sculpture, not least the *Zuccone* of Donatello (see fig. 93).

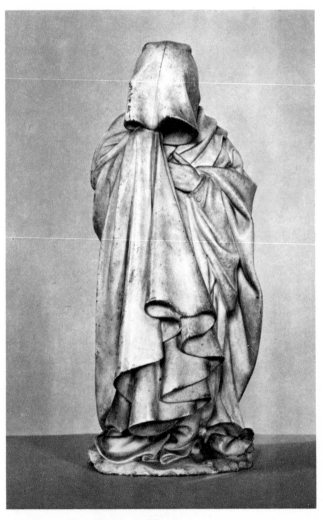

342. CLAUS SLUTER. *Mourner,*
from the tomb of Duke Philip of
Burgundy. 1404. Alabaster, height 18″.
Musée des Beaux-Arts, Dijon

274

5. Broederlam and Bellechose

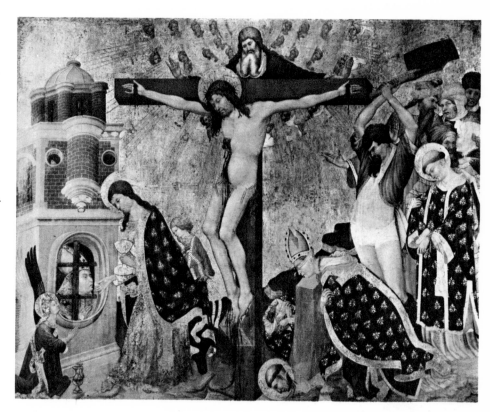

343. HENRI BELLECHOSE.
*Crucifixion, with Communion
and Martyrdom of St. Denis.*
1416. Panel, 5'3" × 6'10".
The Louvre, Paris

When the duke of Burgundy wanted a Flemish altarpiece, he sent the panels to Ypres and let Melchior Broederlam (docs. 1381–1409) paint them there. The result was this artist's only surviving work, since later religious wars destroyed what he did at home. A Flemish sculptor, Jacques de Baerze, produced the central gilded wood relief of the altarpiece and two hinged wings that fold over it, and Broederlam's part was the outer surface of the wings (colorplate 41). They are oddly shaped, and on each he had to crowd two scenes, one indoors and one outdoors. He does not fight against the frame, like Sluter, but tends to ignore the trickiness of its forms, even while using every bit of available surface. Where Sluter built on real mass, Broederlam hunts real spaces, constructing one complicated building in a corner view next to another seen straight on, and making our eyes climb a mountain where people, a wayside shrine, and a castle cling. The people, in big curving robes, develop in this vehement environment a pushy vigor of action. It is most obvious in the fat Joseph, a famous figure drinking as he walks in front of the donkey, an earthy matter-of-fact peasant whom Bruegel will later see in the same way. Broederlam's vivid low comedy is only one phase of the three-dimensional mobility of all the people. Not only do the people push energetically through the spaces, but so does the light, blending in depth from tone to tone, lubricating the flow of force so that the beautiful opalescent glows move over the surface. Sluter and Broederlam share a revolutionary concern for vibrating physical activity of people, with a base of spatial environment, which is not Burgundian but Flemish. Its origins are seen slightly in the Maître aux Boquetaux, but primarily in Pucelle and the Sienese painters (see pp. 267–68). These had, however, suggested more fully the sense of restless human energy, and not as much the highly tuned manipulation of spaces that now supports it. Broederlam's elaborate and articulate working of space makes Pucelle's look primitive, but he has modified

the pressure of physical motion relatively little.

One other large altarpiece survives that the Burgundian court commissioned from a Flemish painter. Jean Malouel was court painter in Dijon until his death in 1415 (earlier he had apparently worked in Paris, and several small votive images of the dead Christ seem to reflect his presence there). When he died his position in Dijon was taken over by another Fleming, Henri Bellechose from Brabant (docs. 1416–1440), who fulfilled Jean's commitment to paint the altarpiece for the Carthusian monastery, representing Saint Denis (1416, fig. 343). Its figures have a physical impact of almost brutish massiveness, but also a soft surface continuity between figures and robes as in the Flemish Bondol (see fig. 338). Both qualities will reappear, and this altarpiece, old-fashioned in presenting several incidents on one gold panel, exemplifies average trends from which extraordinary individuals like Broederlam stand out.

6. The Duke of Berry and the Limbourg Brothers

344. GUY DE DAMMARTIN. Great Hall,
Château of the Duke of Berry,
Poitiers. 1330. Width 56′

The duke of Berry was less oriented to politics and war than the other brothers, King Charles V and the dukes of Anjou and Burgundy. Beyond his responsibilities as a feudal ruler, he was happy to live a life of luxury and patronage. He traveled among the many rich castles he built, taking along his tapestries, jewel cases, and illustrated manuscripts, of which a hundred survive out of three hundred in his inventory. Only one castle remains, at Poitiers (fig. 344). There we see his grand dining hall with three fireplaces at one end surmounted by a carved balustrade, and statues of the royal family more elegant and less individual than Charles V's. The room is as rebuilt in 1388 after the English had destroyed it. The duke's master mason, Guy de Dammartin, emerges from a typical family of builders—his brother had done the duke of Burgundy's Carthusian monastery at Dijon. The duke's tomb (begun 1405)[7] presents his marble recumbent statue by Jean de Cambrai (d. 1438); its characterizing realism betrays admiration for Sluter, but the form is an incised cube rather than a cushiony mass. The duke's first sculptor was André Beauneveu, who came after Charles V died, but Beauneveu's only surviving work for the duke is painted, the figures of prophets illustrating a psalter in the sculptural way already noticed. Another of Charles V's artists, the Master of the *Parement de Narbonne,* painted for the duke a Book of Hours which is full of ex-

345. THE LIMBOURG BROTHERS. *January*,
illuminated page in the *Très Riches Heures*
of the Duke of Berry. 1416.
Vellum, illumination 9″×6″. Musée Condé,
Chantilly

346. THE LIMBOURG BROTHERS. *October*,
illuminated page in the *Très Riches Heures*
of the Duke of Berry. 1416.
Vellum, illumination 8″×5″. Musée Condé,
Chantilly

pressive looping rhythms of line like the *Parement*, but freer in color and depth. But his favorite painter seems to have been another Fleming, Jacquemart de Hesdin (docs. 1384–1410). The identity of his work is controversial, since he was evidently a manager who worked in collaborative teams. If his hand can be isolated in one of the duke's Books of Hours, now in Brussels,[8] he has a less personal style than the Gothic Master of the *Parement* and a less modern one than Broederlam. It offers processional but lively groups before spatial backdrops, with the typical Flemish soft organic surface, shifting little from the schemes of the Maître aux Boquetaux but less linear and more jointy in detail.

After Jacquemart died the duke engaged Pol de Limbourg (docs. 1402–d.1416) and his two brothers, who produced the most famous manuscript illustrations of this age, the *Très Riches Heures of the Duke of Berry* (1415–16). When we know Broederlam, the Boucicaut Master (see p. 279), and other contemporary explorers of landscape and peasants, the *Très Riches Heures* seems less surprising. On the other hand its realism also conceals tracings from older art, like the pack of hunting dogs copied from Giovannino de' Grassi's notebook of animal motifs (see p. 102). Yet of course it still remains an extraordinary document of life and work of art, especially the famous calendar which, like others, records typical activities of each month (colorplate 42; figs. 345, 346). People enact their lives in front of castles which render accurately the duke of Berry's various homes; there is a somewhat two-stage effect of front and back as in Jacquemart, but also an atmospheric blend as in Broederlam, and more than his in cast shadows and clouds. In one month the duke feasts, in another ladies stroll and pick flowers, and the sense of luxury is heightened by the artificial rhythm of very thin curving line, a Late Gothic device like Lorenzo Monaco's in the same years (see fig. 59). In other months the duke's peasants plow or sit by a fire while snow covers the fields, and the realism is as specific as in Broe-

derlam's Joseph (see colorplate 41), all the more graphic through the contrast with the huge castles. The sense of seeing everyday life among various classes is inescapable, and the ladies strolling are as true as the peasants working; a contemporary report describes the morning routine of the lady of a manor who walked with her attendants, sat on the grass and prayed from Books of Hours, and returned picking flowers. The contrast of classes was conscious and sharp, as in the contemporary poetry of Chaucer. But (despite our temptation to see it so) this does not imply social protest, and of course not in the duke's luxurious book. What we have is a medieval habit of classifying all the world in slots, and a modern visual realism. The result is social reporting.

7. The Boucicaut Hours and the Rohan Hours: Some Conclusions

King Charles VI, who became insane and under whom the second phase of the Hundred Years' War was lost at Agincourt, symbolizes the loss of central power. His father Charles V's artists did not come to him but to his uncles, the dukes. His gold and jewels, recorded in long inventories, were melted and dispersed. One bauble survives, a New Year's gift to him in 1404 from Queen Isabel, a fantastic jeweled gold-and-enamel ornament (later pawned) in which the king kneels before the Virgin while his horse and groom wait below (fig. 347). It seems typical of this court art that the horse is more prominent than the Virgin, giving the object its familiar name, "the little golden steed." It is a mixture of anecdotal realism and radiant glow.

Generals are the most interesting Paris patrons; in the royal burial church of Saint Denis the one remarkable tomb at this time is of the swashbuckling Bertrand du Guesclin (fig. 348). It was carved in 1397 by Thomas Privé and Robert Loisel, the latter a French pupil of a Flemish sculptor of Charles V, Jean de Liège, but shows a quick appreciation of Sluter in its rich surface and irregular ugly detail. Another rare survivor is the tomb of the count and countess of Mortain (1412?),[9] whose hard mass has a fascinatingly gauzy surface.

The marshal Boucicaut, military governor of many cities, ordered the finest Paris painting of the reign, a Book of Hours as marvelous as the duke of Berry's *Très Riches Heures,* though less famous (finished c.1415; fig. 349). It is extreme in modernity and in backwardness. The unknown Boucicaut Master loves the Gothic and feudal, displaying the

347. *The Virgin with King Charles VI Kneeling.* 1403. Enameled gold with jewels, height 24". Parish Church, Altötting

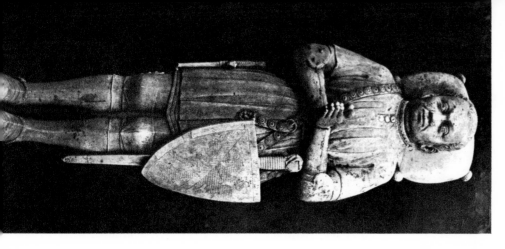

marshal's coat of arms everywhere and using a line rhythm as thinly graceful as any in the *Très Riches Heures*. But he explores space and light subtly, with gradually shifting gleams that avoid the front-back discontinuities of the *Très Riches Heures* calendar pages. In the famous *Visitation* the Virgin's train and her book are held by pages, while the light runs back to an atmospheric panorama more visually modern than anything before in north or south Europe; medieval and modern intersect when sun rays are shown by gold lines. Interior spaces are as sensuously alive as landscape; developing from Broederlam, partial side views in deep rooms let us see glittering little objects, no longer fabulous jewels but ordinary objects picked out by real light, and therefore pleasurable. The artist, who has left many other, simpler works, may have been Jacques Coene (docs. 1398–1403), another Flemish visitor.

A little later (1415 or 1425) a very different anonymous artist illustrated another Book of Hours for the ducal Anjou family; it is called the Rohan Hours, from a later owner. Its space is not at all modern, but its figures are, and the effect is like the popular drama of the time. In the scene of the shepherds informed of Christ's birth, a very fat shepherd with a big bagpipe and his thin wife are lower-class character types who fill the page as anecdotes of the shepherds fill extra scenes in English miracle plays. The physical exaggeration changes in the Passion scenes, with distortions of horror that culminate in the famous scene of man's death (fig. 350). There is a dried, shrunken corpse as seen on some tombs of the time, with an oversize God looming above; this is the tone of the play *Everyman*. The expressive violence that insists and simplifies makes the message loud and clear today, to a remote audience, but in its own time marked provincial extremism. This is the last token of even partly medieval art, for by now the Renaissance has re-observed all the themes and left only a trace of the old patterns.

Because there are so unusually few regional differences in European art of about 1375–1425, it is commonly called "International Gothic." This is often defined by its use of ornamental line, tending to be abstracted from nature, fashionably elegant and with aristocratic references; but this

349. BOUCICAUT MASTER. *The Visitation*, illuminated page in the Hours of Marshal Boucicaut. Vellum, page 11″ × 8″. Musée Jacquemart-André, Paris

279

excludes too much, and is too much like the definition of earlier Gothic. A better definition combines this linearity with nonlinear naturalism that shows people and things in ways that emphasize their social status. Some International Gothic is almost all line, like Lorenzo Monaco, or the Wilton Diptych (fig. 351), a provincial English panel of King Richard II kneeling before the Madonna, feudal homage paid to a court filled with long-winged angels. In such works only the flowers are realistic, and are selected because as natural objects they are already consistent with Gothic ornament; the same applies in other paintings to greyhounds, armor, embroidered dresses, and pointed towers. Other International Gothic artists are entirely nonlinear, like Gentile da Fabriano and Sluter, who agree in the soft surfaces of their forms; only some edges of robes have Gothic traces. Usually the style mixes both in various suggestive ways, as in the *Très Riches Heures* and the Rohan Hours. Some of the most brilliant works fully synthesize both, naturalism being ornamentally linear and vice versa: Pisanello and the Boucicaut Hours show this. Transitional artists are coping in their technical vehicle with the shift from feudal to capitalist social psychology, and from Gothic line to Renaissance modeling.

350. *The Judgment of Mankind*, illuminated page in the Rohan Hours. Vellum, 10″ × 7″. Bibliothèque Nationale, Paris

351. The Wilton Diptych. Panel, each 19″ × 12″. National Gallery, London

COLORPLATE 41. MELCHIOR BROEDERLAM. *Annunciation and Visitation; Presentation and Flight into Egypt,*
wings of an altarpiece. 1394–99. Panel, each 66″ × 49″. Musée des Beaux-Arts, Dijon

COLORPLATE 42. THE LIMBOURG BROTHERS. *April*, illuminated page in the *Très Riches Heures* of the Duke of Berry. 1416.
Vellum, illumination 8″ × 5″. Musée Condé, Chantilly

COLORPLATE 43. MASTER THEODORIC. *St. Matthew.* C. 1360–65. Panel, 45″×37″. National Gallery, Prague

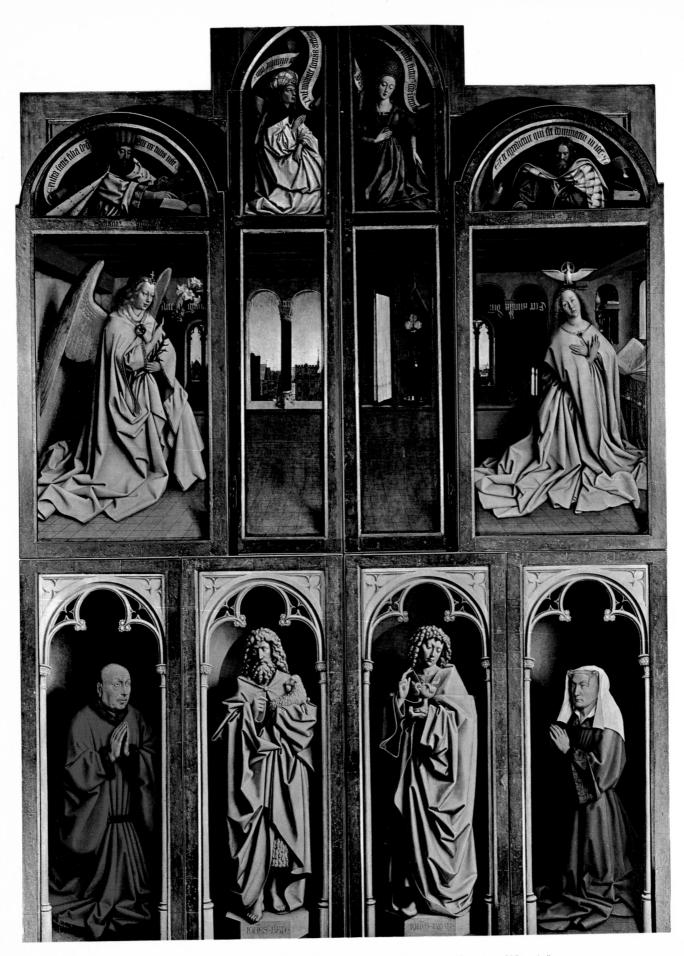

COLORPLATE 44. HUBERT and JAN VAN EYCK. Ghent Altarpiece (closed). 1426–32. Panel, 11′6″ × 7′7″.
Cathedral of St. Bavo, Ghent

8. Prague and Its Following

The most intense influence from the court art of Paris was on the court art of Prague, sometimes too facilely called the most distant point that makes this art international. Charles IV (1316–1378), the king of Bohemia, became Holy Roman Emperor and concentrated great resources on his ancestral capital. He had been educated in France and married King John II's sister, so it was natural that he brought an architect from Flanders to supervise Prague Cathedral. But the succeeding architect was Peter Parler (1330–1399) from south Germany, the head of a large staff whose small-scale church sculptures, groups of stocky busy figures, can be seen in many cities. Between 1374 and 1385 he carved in the triforium gallery of this cathedral a series of portrait busts (fig. 352)—the emperor, princes, and other notables, and himself—apparently a kind of credit list for the building. It is not surprising that the portraits seem naturalistic, and yet their smiles, as in archaic Greek sculpture, seem to be devices for liveliness, and some of the heads are probably standard types of realism. But the latest do seem to be directly personal, as much so as the figure of Charles V in Paris (see fig. 336). This is clearest in the head of Wenzel von Radecz, who took over as administrator of the cathedral in 1380 and had to be added to the set.

Everywhere in the fourteenth century that the new ways of the Sienese and of Pucelle did not reach, there survives an old-fashioned painting and sculpture almost mechanical in its effect, flat with tensionless thick curves, much like the nineteenth-century Gothic revival known to everyone today from playing cards. It is easily applied to English brass tombs (so well known in rubbings), Spanish altarpieces, conservative French book illustration, and quantities of ivories (fig. 353), church and secular textiles, and stained glass. A close variant appears everywhere in tomb sculpture, even that by a leading Flemish sculptor in 1367 (Jean de

352. PETER PARLER.
Wenzel von Radecz. 1380–85.
Stone, width about 19".
Cathedral, Prague

353. Triptych of St. Sulpice du Tarn.
Ivory, 13 × 11". Musée de Cluny, Paris

354. CONRAD VON EINBECK. *Self-portrait*.
Sandstone, height 20". St. Maurice, Halle

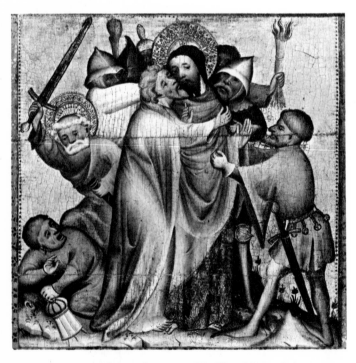

355. MASTER BERTRAM. *The Kiss of Judas*, from
Passion Altarpiece. Panel, 20" square.
Niedersächsische Landesgalerie, Hanover

Liège's tomb of Queen Philippa of England, West-minster Abbey). Grand paintings in this style are typical in Prague until the emperor's court painter Master Theodoric (docs. 1359–1381) painted in 1367 a series of panels with heads of saints, soft and translucent in flesh tones and startling in their irregular bulkiness (colorplate 43). Where he came from is unknown; he applies paint in the Bondol manner and even more like provincial Flemish panel painters, but the massive breadth of these glowing people is different. Theodoric may have got the idea when the emperor brought paintings by Tommaso da Modena back from Italy (see fig. 50). Thus his nonschematic modern painting gains a new if somewhat awkward lumbering grandeur, lubricated by its opalescent color. His only talented successor in Prague (which soon ceased to be a center) was the anonymous Master of the Třeboň (formerly Wittingau) Altarpiece,[10] who thins the proportions down again and emphasizes the glowing surface light, thus producing a haunted cluster of figures that suggest a mannered reworking of Bondol.

The only worthy continuation of the Prague group nearby is the work of the extraordinary sculptor and architect, for thirty-five years, of a church in Halle, Conrad von Einbeck (docs. 1382–1416). The grimness of his realistic figures of the mourners of Christ, fiercely violent, and of his self-portrait (fig. 354), seems to anticipate the expressionistic vein in much later German art, all the more so for being embedded in rigid traditional symmetries and conventional fold patterns. The explanation may be found in the fact that Conrad carved them in his old age, using the conventions of his Gothic youth along with more recent attitudes.

Theodoric's truest heir is Master Bertram (docs. 1367–1415) working in Hamburg, one of the ports of the Hanseatic League. He fills his narrative panels with densely painted thick-limbed woody figures in active motion and collision, even though there is no space and the figures tend not to be behind the front plane (fig. 355). Bondol's tradition seems to become increasingly restricted from the exploitation of light and space, though retaining the modern excitement about the physical thickness and energy of the figures which will be basic in the next century of German painters. Master Bertram in turn formed Conrad von Soest, who (in 1404 or 1414) signed the most notable German painting

356. CONRAD VON SOEST. *Crucifixion*, center panel of Niederwildungen Altarpiece. Height 6'7".
Stadtkirche, Niederwildungen

of the following generation (fig. 356). He worked in Dortmund near the Dutch border, and thus naturally modified his training by a renewed look at the prestigious Flemish masters. He was evidently most attracted by the Master of the *Parement de Narbonne*'s crowd action (see fig. 337), composed with a sharper grace than the local works, and so he evolves intricate actions of weighted motion in broad swirling rhythms. As this tradition is passed

on, it has become rid of Gothic conventions of mechanical pattern in the mere process of sloughing off richness of resource; its fertility is widespread and long-lived though it is always provincial and limited. Conrad Laib of Salzburg (docs. 1448–1457), the leading Austrian painter of his time, was in his youth perhaps the last exponent of the Prague formula, until he turned to Conrad Witz' more up-to-date ideas.

9. Jan van Eyck: the Ghent Altarpiece

Certainly the mainstream of modern art was in Flanders. The third duke of Burgundy, Philip the Good, was less concerned than his predecessors with French and feudal questions and more with close administrative control of his Flemish properties. Thus in his time the Flemish painters shifted to working at home, and the Flemish Renaissance school of painting really begins. Observers looking back later always tended to make it begin with a great person, Jan van Eyck (docs. 1422–d.1441), who worked both for the duke and for burghers (only the latter works survive). This rise of the school from nothing was a simple idea that rediscovery of the great earlier artists has corrected. Looking now at Jan's work, we see that the *Très Riches Heures* (the first of his antecedents to be

357. HUBERT and JAN VAN EYCK. Ghent Altarpiece (open). 1426–32. Panel, 11′6″ × 15′2″. Cathedral of St. Bavo, Ghent

agreed to) taught him the pleasure of specific real detail; that Sluter, perhaps more significantly, showed him that a naturalistic figure can be a dignified monument; and that the Boucicaut Master showed him reality as a sensitive continuum of light. Human action in the world, as in Broederlam, and the modern portrait, as in the Charles V statues, are also important. All are aspects of the artists' transformation of naturalism into an art that celebrates nature.

No doubt the idea of Jan van Eyck as "the beginning" also was reinforced by the fact that his very first work is the largest produced by any Flemish painter in his century (though it has contemporary rivals in north Germany), This altarpiece in many parts, about eleven by fifteen feet over-all, was made for the chapel of a rich citizen (later mayor) of Ghent in the Cathedral (fig. 357). The lower part deals elaborately but rather elementarily with Christ's sacrifice: in the center, generally labeled the *Adoration of the Lamb*, the Holy Lamb on the altar behind the fountain of life is approached from all sides by clusters of saints in categories. The upper part refers to divine rule and judgment; Christ with a triple crown is flanked by his usual assistants in the Last Judgment, Mary and John, and by angels. At the far edges are Adam and Eve, alluding evidently to man's sin which Christ's sacrifice redeems; Adam and Eve appear similarly at the far edges of the frescoes by Masaccio at the same date (see p. 74). All these images can be covered by folding the sides over the central fixed panels, whereupon we see images of the witnesses of God's action, prophets and saints, the *Annunciation*, and, finally, the kneeling portraits of Mayor Vyd and his wife (colorplate 44). The painting all shows the most authoritative mastery of realism. Since Jan van Eyck certainly intended this, we may ask why he commands our respect when we reject realism as a criterion in art. The image of Christ, smooth-fleshed and luminous, is decked with heavy jewels, insistently massive and shiny; the angels with stiff robes sewn with pearls make odd faces as they sing; below, the meadow shifts our focus to a total field of vision (as when we shift it from Sluter to the Boucicaut Master) where grass, far buildings, and people glisten and tremble slightly. Similar atmospheric continuity appears in the large figures of Adam and Eve and the donors, whose bodies and niches are invaded by a slight duskiness.

This synthesis of mass and light may be absolutely new, and has the human effect that the massive figures are humbly aware that their environment, the world, limits their capacities (as a Gothic figure was limited by its environment, a carved or painted frame). What emerges is that Van Eyck does not simply copy reality (like the academic realists of later centuries for whom we have no respect) but that his intense look proposes the fascination, the dignity, and the brilliance of physical reality by absorbing it in gentle light, or polishing it with emphatic festive light, by following detail seriously, by stabilizing the forms, thus by honoring it. This is a basic Renaissance approach, which Jan van Eyck's immense skill completely articulates.

This altarpiece is surrounded by controversies which luckily affect only secondary questions. Its size and the odd variety of the pieces may mean that it was assembled from smaller previous projects. Its inscription tells us that Hubert van Eyck (who died in 1426) began it, and that his brother Jan finished it in 1432. Which parts did Hubert paint? Some observers say none, that the inscription is a forgery (a less likely occurrence than the growth of such speculation around any famous person associated with few facts, as in the case of Shakespeare). Indeed, we know no other work by Hubert with certainty. Many different parts of the altarpiece have been considered his. One of the more plausible ideas is that he painted the Sluter-like hulking figures, more formal and less atmospheric. If so, the *Annunciation* would mark the point where he stopped, after doing the figures; Jan would then have painted the room with its shadows, shelf, and still life, and the view through the window, which would explain why the figures and the room in this scene seem to be inconsistent.

10. Jan van Eyck: the Other Works

Some twenty other works by Jan van Eyck survive. (This is another factor illustrating his new status as a modern artist-personality; in the generations before him it is exceptional to find an artist with half a dozen.) All these belong to the last ten years of his life, and most are small, hardly bigger than the book illustrations of his predecessors.

The *Madonna in the Church* (fig. 358) presents Jan's new utter realism of light on solid surfaces and his specialized notations of textures. Mary stands bigger than a person could be because she symbolizes the Church. All this shows Jan's position at the frontier between medieval and modern ways of attributing meaning to what we see. A modern viewer could not accept the physically impossible scale, based on symbolic meanings; a medieval image, showing symbolic sizes, would not be realistic in any respect and so would not be subject to Jan's difficulties. Jan wishes to satisfy both needs. A spectacular case is the portrait of Giovanni Arnolfini and his wife (1434; fig. 359). It is the only double portrait, and the only full-length portrait, of its epoch; these oddities cease to be puzzles when we learn that this is not simply a portrait, but represents a specific moment (which portraits in principle do not): the marriage of the couple. This fact resolves the strangeness of a portrait in a bedroom and the one candle in a chandelier, lit in the daytime, both symbols of marriage; the shoes and the dog of fidelity are among the ones that survive even now. All the symbols have to be given a persuasive role as realistic objects, possible to see in a room; this the Middle Ages would not have required of them. This demand for physical truth can—at its extreme, in the age of Impressionism—exclude symbolism, but not yet. We can almost inspect the picture as full of ordinary objects, on a nonsymbolic level, but there are always a few like the lit candle and the gestures of the hands that can't quite be fitted in with such an approach. When Jan makes symbols fit in this way, we might suppose that he is a realist by temperament, forced by patrons to paint symbols. But a better reading is that the realism of the symbolic objects is an extra tribute to their high value, charging them with more strength. It is part of Jan's presentation of the world as won-

358. JAN VAN EYCK. *The Madonna in a Church.* Panel, 12 1/4″ × 5 1/2″. Staatliche Museen, Berlin-Dahlem

derful and dignified; we are meant to admire the things, not (as with later realists) the artist's skill in copying them.

Natural reality as something splendid and holy appears in another way in the Virgin painted for Philip the Good's great minister Chancellor Rolin (fig. 360). Along with shining jewels and the microscopic and telescopic landscape, the donor is not only in the same scale as the Virgin (as earlier with Sluter; see fig. 339) but in the same space, and without a saint to perform an introduction. The *Virgin of Canon van der Paele* (1434–36; fig. 361) is more

traditional in this respect, but equally extraordinary in its minute, exact drawing of reality, from wrinkles to armor-hinges, which never looks fussy because it is always light-filled and thereby unified and glorified. Besides the significant portraits in these works, eight of Jan's surviving paintings are simple portrait heads, including his wife's (1439; fig. 362). This large proportion of all his works contrasts with his contemporaries in Florence, Masaccio and others, who painted no portraits other than donors in religious works (see fig. 86), leaving portraiture to minor, more conservative artists. The contrast is a

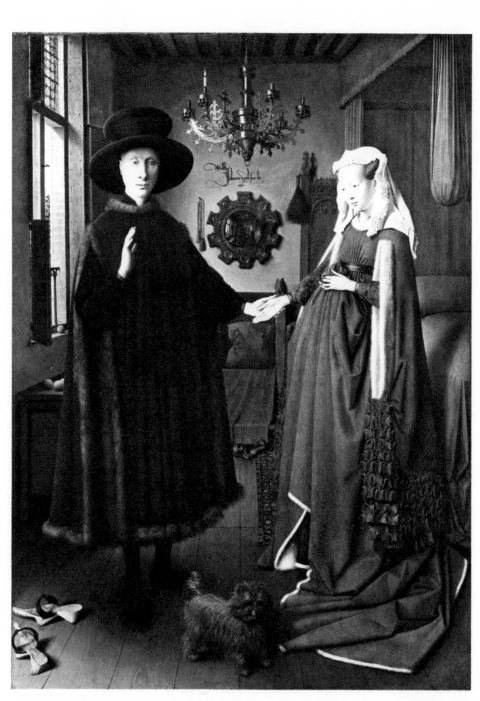

359. JAN VAN EYCK.
Giovanni Arnolfini and His Wife.
1434. Panel, 32″×23″.
National Gallery, London

360. JAN VAN EYCK.
The Virgin and Chancellor Rolin.
Panel, 26" × 24".
The Louvre, Paris

361. JAN VAN EYCK.
Virgin of Canon van der Paele. 1434–36.
Panel, 48" × 62".
Groeninge Museum, Bruges

token of a differing view of reality. In Jan the specific detail is real, and many details collect to make a world. In Florence the field of vision is real, which perspective and other tools then neatly subdivide down to the detail. The same difference emerges in the pleasure in texture in the north, in formal composition in the south, and in many other corollaries.

Still Jan's last works move toward more breadth and simplicity than before, with fewer and larger figures dominating an area. He is thus the master not only of the object but of its bonding into an optical continuum of the world.

362. JAN VAN EYCK.
Portrait of His Wife. 1439.
Panel, 13″ × 10″.
Groeninge Museum, Bruges

11. The Master of Flémalle

After the death in 1416 of Pol de Limbourg, the last of the older generation, there is a ten-year gap before the sudden appearance of Jan van Eyck's mature statements. In that decade another painter emerged, older than Jan yet already a worker on panels for city merchants, not on books for dukes in castles. He thus may have the better claim to be called the originator of Flemish Renaissance painting, but he was soon eclipsed, and only rediscovered by twentieth-century historians. They first assembled a group of paintings that appeared to be the work of one artist, whom they labeled the Master of Flémalle. Later they identified the artist (with high probability but not certainty) as Robert Campin, who appears in many documents (from 1406– d.1444). Campin was the leading painter in the city of Tournai with many apprentices; an officeholder during a citizens' revolt against the aristocracy, but later helped out of trouble by the local countess.

He is concerned with the same things as Jan, and celebrates physical man and objects as participants in the holy mysteries. He evidently developed the oil medium, with which Jan was later credited, as a key ingredient (it had long been used in minor ways) for translucent or polished effects. Deep shadows is rooms and cool bright surfaces reinforce spaces and volumes. Still, compared with Jan, the Master is less sure of himself, the objects he paints (nearly all in altarpieces; he made few portraits) have a rougher and more impetuous form. His early *Betrothal of the Virgin* (fig. 363) shows, somewhat like Broederlam, two buildings placed irregularly side by side, one round and one square. The nearer one is packed with people crowding and bumping. Space and mass are in active explosion, they cannot be accepted and employed for some further aim as they are by Jan; at this earlier moment, how to manage them is the topic of the experiment.

293

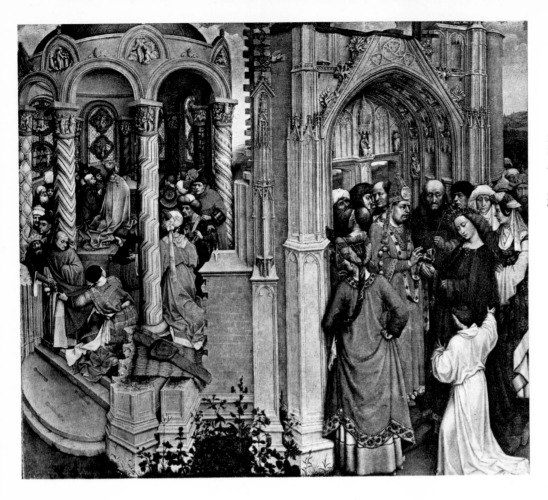

363. MASTER OF
FLÉMALLE.
*Betrothal of the
Virgin.* Panel,
30 1/4" × 34 1/2".
The Prado, Madrid

363. MASTER OF
FLÉMALLE.
*Betrothal of the
Virgin.* Panel,
30 1/4" × 34 1/2".
The Prado, Madrid

364. MASTER OF
FLÉMALLE.
*Virgin of the Fire
Screen.* Panel,
24 3/4" × 19 1/4".
National Gallery,
London

A Madonna in a room is a huge white-robed figure sitting scarcely above the floor (fig. 364). A firescreen behind her is neatly placed to serve as a halo—an ordinary object doing duty as a symbol, as in Jan, but in a glaringly noticeable, even heavy-handed way. The far end of the space is accented by window shutters that project forward in a zigzag. The heavy planks with studs and hinges are typical Flémalle objects, roughly articulated, spatially expansive, not dexterous.

Thick people near the floor and big jostling furniture again fill his most famous work, the Merode altarpiece of the *Annunciation* (fig. 365). The floor in perspective tends to rise too much, as if seen from above, and we are often shown broad tops of objects, which curiously flatten the paintings for eyes ready to focus in that way. A *Descent from the Cross,* perhaps his largest painting, is preserved only in a fragment with a wicked thief and two spectators (fig. 366); the whole was almost the size of the Ghent altarpiece. The writhing muscular figure outlined on the gold has an expressive force that Jan never sought; it recalls Sluter and is to be thought of in relation to Campin's close links with sculptors in Tournai. For he designed statues and painted

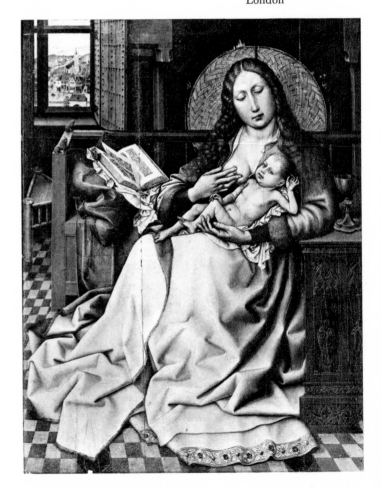

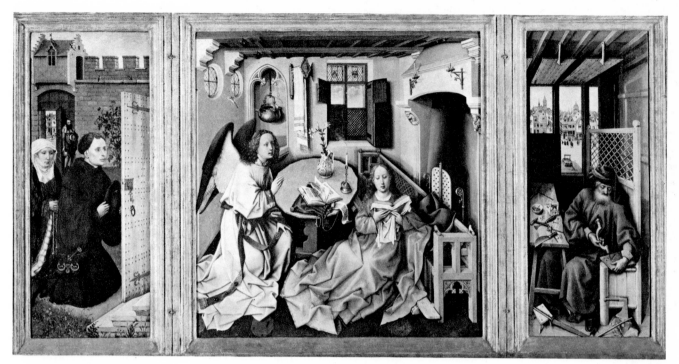

365. MASTER OF FLÉMALLE.
Merode Altarpiece of the *Annunciation*.
Center panel 25″ square, each wing 25″ × 10″.
The Cloisters, Metropolitan Museum
of Art, New York

366. MASTER OF FLÉMALLE.
Descent from the Cross, surviving
fragment. Panel, 52″ × 32″.
Städel Institut, Frankfurt

finished ones, and originated the device of statue-
like monochrome paintings on the backs of altar-
piece wings. One two-figure group, an *Annunciation*
carved in 1428 by one Jean Delemer and painted
by Campin, is preserved in bad condition.[11] It resem-
bles the Master's dramatic thrusts of masses into
space and suggests that painting and sculpture in-
teracted in early Flemish art, but too little sculpture
is known to say more.

The gold background, the tilt, and the straw
halo are old-fashioned elements that mix but do not
blend with the Master's eager modernity. After
about 1430 new ideas had passed him and he starts
to imitate Jan and then Rogier van der Weyden, so
that it is not surprising that he was forgotten later.
Yet outside Flanders he was more imitated by young
artists than Jan was, perhaps because this less com-
plete modernity was more accessible.

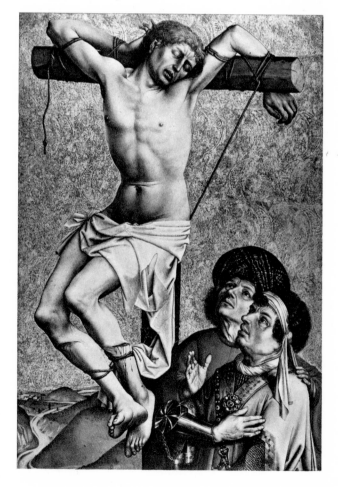

12. The Flémalle Style in Germany and Elsewhere

Towns all over Germany in the early fifteenth century were producing altarpieces with slight regional variations. Most are old-fashioned and anonymous; the few modern ones tend to be those by named artists—a typical correlation at the beginning of the Renaissance. Far up the Rhine near Switzerland, Lucas Moser "from Weil" signed an altarpiece in 1432 in the village of Tiefenbronn.[11a] Its space has as modern a system as the Master of Flémalle's, and heavy irregularly linked buildings filled with people who press each other at close quarters. But excitement about physical volume is mixed with elements more archaic than in the Master's work; there is light but no air, and faces and objects become simple bright planes with graphic force, which do the jostling themselves, making asymmetrical powerful gestures. The result is a cool, clean, strong, fiercely energetic image, oddly supported by the complex altarpiece carpentry that cuts up the space as arbitrarily as in a stained glass window. On the frame of this, his only surviving work, Moser added a statement to his signature: "Cry, art, cry, and complain deeply, no one cares for you any more." The word "art" must have the sense of expert skill in the craft of painting, but Moser's distress must have been based really on having no one to share his new standards imported from Flanders.

But from the town of Rottweil, not far away, a more urbane artist with these standards, Conrad Witz (docs. 1434–1444), came in 1434 to settle in Basel, in what has now become Switzerland, where the General Council of the Church was meeting. His huge altarpiece there is of suitable theological elaboration, showing the correlation of the Old and New Testaments in the twelve parts that survive (fig. 367). Space is not much explored; figures standing against gold backgrounds are thick and solid, hard and very shiny in texture, and often with intricate turning or leaning poses or brought suddenly to life by vivid and even comic expressions, almost like Broederlam's Joseph (see colorplate 41). But when there is space it is Flémallian, tilted up at a wide

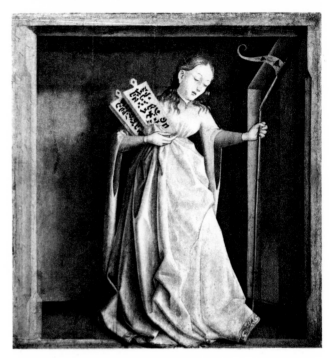

367. CONRAD WITZ. *The Synagogue*, from Altar of Salvation. Canvas on panel, 34″ × 32″. Kunstmuseum, Basel

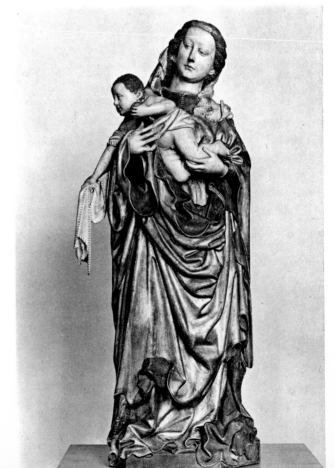

368. JACOB KASCHAUER. *Madonna and Child*. 1443. Painted wood, height 69″. Bavarian National Museum, Munich

angle for people to sit on in crumpled spreading robes. The only obvious likeness is to those works of the Master of Flémalle with few figures, like the London *Madonna* (see fig. 364). In 1444 Witz painted for the bishop of Geneva (a participant in the council) an altarpiece of Saint Peter, which no doubt reflects the bishop's political position on the papacy. Besides energetic stocky pressing people, with burnished costumes, it also presents an extraordinary lake landscape in the scene of the *Miraculous Draft of Fishes* (colorplate 45). Its smooth glassy breadth is a provincial modification of wide water landscapes by the Master, in turn inspired by

such pioneering images as the Boucicaut *Visitation* (see fig. 349). The figures similarly modify the Master's figures, away from relatively complicated flexibility toward the elemental and plain. Using his predecessor's sense of weight, depth, and force of character, Witz is impelled to use his own feeling for big clear units in painting a landscape space of unprecedented sweep, and figures with a special power of simple gesture.

It is not surprising that the Master also attracted German sculptors looking for modernity. The Viennese Jacob Kaschauer (who was also a painter) is known from one set of painted statues made in 1443

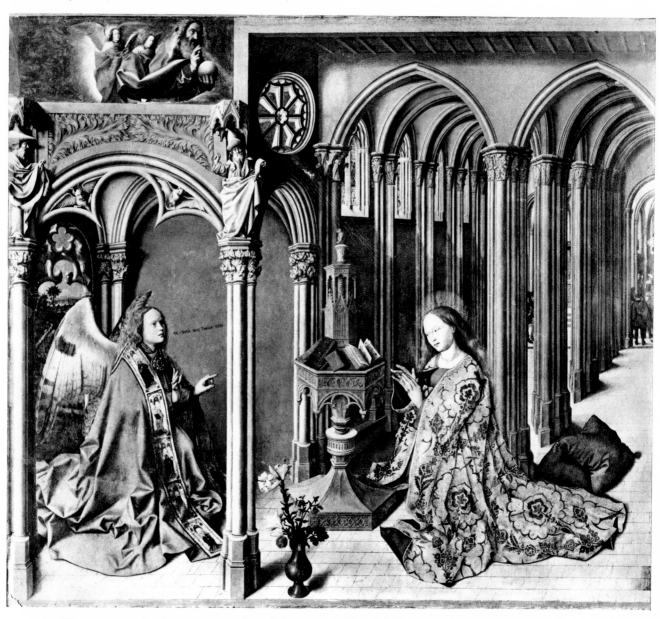

369. MASTER OF THE AIX ANNUNCIATION. *Annunciation*. 1443–45. Panel, 61″ × 69″. Church of the Magdalene, Aix-en-Provence

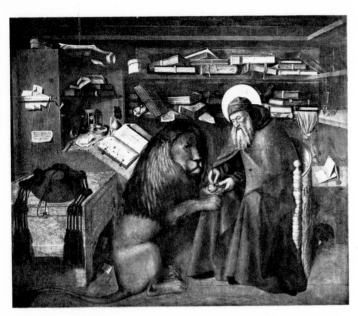

370. COLANTONIO. *St. Jerome in His Study.*
Panel, 50″ × 60″.
Museo Nazionale di Capodimonte, Naples

for the main altar of the Cathedral of Freising in Bavaria (fig. 368). The revolt against graceful line and soft surface is even more conspicuous than in painting; the Madonna moves heavily and irregularly, with angular, blocky, centrifugal thrusts of line. The rocking motion focuses on the Child, who in sudden informal realism crawls horizontally like a puppy in his Mother's arms. The artist, thus barely saved from oblivion, is a basic ancestor of the realism of the next two generations of German sculptors.

Witz' own school in the Upper Rhine included the Master E. S. (fl. 1466–67), the first clear personality in the history of engraving, who kept these formulas vigorously alive until his death around 1470. The school's masterpiece is the anonymous *Saints Anthony and Paul* (1445);[12] two saints in crumpled costumes sit and gaze at each other quietly across the space of a shadowed meadow, with a

vibrant cityscape far behind. The painter, more sophisticated than Witz himself, may have had direct links with the Master of Flémalle. So also may the anonymous artist of the astonishing *Annunciation* for a church in Aix-en-Provence (1443–45; fig. 369). All these regions are politically connected; Witz' patron the bishop of Geneva had earlier been bishop of Avignon, the next town to Aix, and still earlier chancellor to the duke of Burgundy. The figures of the *Annunciation* again kneel on the floor in wide crumpled robes. Close to the foreground, they contrast abruptly with an immense perspective flight of depth. But now the skin has an Eyckian (or Flémallian, of the last phase) textural realism of flesh, and wrinkles in cheeks and fingers. Some have thought the artist was a Flemish wanderer, and not the first distinct French painter since the Master of the Rohan Hours twenty-five years before. But the cubic wooden form of the head of God, like one of Witz', and the disjunctive composition of space doing everything except contain the figures, while they in turn press downward statically, indicate still another talent in the provinces. He is restating the Flémalle idea of physical truth with his own emphatic simplifications.

Since René of Anjou, the remarkable ruler of Provence (and thus of Aix), invaded Naples, it is not strange that the same form of modern vocabulary is used by the chief Neapolitan master around 1440, Colantonio. His *Saint Jerome* (fig. 370), swamped among tumbling books and other vigorous still life, is another wide-limbed figure in wide-angled space, but with suaver Italian modeling. The tradition still shows traces in Naples when the great Antonello da Messina arrives twenty years later. But its effectiveness is best suggested when a Florentine master, Fra Filippo Lippi, uses it in 1437. His *Madonna*[13] in a wide-angled room, with a copy of the Flémalle hinged shutters, is proof that he had looked intently at some example of this art.

13. Master Francke; Stefan Lochner

371. MASTER FRANCKE. *St. Barbara Betrayed*, from Legend of St. Barbara Altarpiece. Panel, 36″ × 21″. National Museum, Helsinki

In north Germany the strongest personality of the Master of Flémalle's generation learned, like him, from the great Flemish book illustrators. Master Francke superseded Master Bertram as the artist of the Hamburg merchants, and has left two big altarpieces of many parts (doc. 1424, the order for the later altarpiece), all with the look of pages illumi-

nated by the Boucicaut Master or Pol de Limbourg. The likeness is less surprising since their illuminated pages already had the quality of little independent paintings. Master Francke's earlier and more unusual altarpiece, the legend of Saint Barbara (fig. 371), is blond in tone and thick with figures who turn through space, gracefully linear in their gestures but also full of graphic character. All this, and the spatial scoop behind the front plane that sets up an adequate platform stage, speaks for the Flemish tradition traceable to Bondol in 1371. In the best-known scene, *Saint Barbara Betrayed,* she is concealed in bushes while her richly dressed pursuers pause to ask two shepherds where she has gone. When they betray her, a miracle transforms their sheep into grasshoppers, some twenty painted one by one on the ground. The effective drama, the precision of the anecdote, has made the image famous. Its contrast of brocaded lords and small ugly shepherds is much like the separate areas in the calendar of the *Très Riches Heures,* and its forms that grow small in the foreground are much like the small foreground trees in the Boucicaut Master's *Visitation* (see fig. 349), not disturbing because they help to show everything plainly. But unlike the Boucicaut Master, Master Francke eliminates effects of light, which in his provincial view must have seemed a distraction from his storytelling; thus he is a mix of old convention and fresh observation like the Boucicaut Master, but in him the conventions are more powerful.

Of course the simple, purely ornamental factor in International Gothic has a constant effect on German panel painting, too. A neat example is the little *Garden of Paradise* (c. 1420 or later; fig. 372) by an unknown artist who was perhaps of the Upper Rhine, near Switzerland, but perhaps of the Middle Rhine, near Cologne; the uncertainty reflects the standardized quality of the International Gothic, especially toward the end. A wall with Flémalle-like wide perspective encloses ladies loosely grouped in the garden, the Virgin and Child, saints and an angel, and charming birds and flowers, all the elements of "tapestry-like" artificial grace and none of the tough elements.

372. MASTER OF THE FRANKFURT GARDEN OF PARADISE.
Garden of Paradise. Panel, 10″ × 12″.
Städel Institut, Frankfurt

This mood prepares the way for Stefan Lochner (docs. 1442–d.1451), born on the Upper Rhine but later the leading artist in Cologne. His concern seems to be to preserve the International Gothic scheme of things when it has become archaic, the more so as he goes on. His early work tries for a skillful Eyckian reality with perspective systems, skin textures of hands, and brass dishes on the shelf. But as he matures, his *Adoration of the Magi* is rigidly symmetrical on a gold background (fig. 373), and in a Madonna image he paints brocades and the flowers of an arbor on a gold-leaf base,[14] so that their space is presupposed and then denied. Since the saints' sweet blank faces continue to be painted with the textural materialism of Jan van Eyck, the result is the phenomenon of "easily accepted late primitivism" so favored by Victorian observers in Fra Angelico and other artists. In a late work, figures stand before an altar,[15] which alone asserts space for their wriggling robes, the rest being a motionless vacuum. The total effect of the bright soft surfaces is a skilled sentimentality; this remains a basic component in the vast fifteenth-century production of German church paintings, along with the energetic toughness of another more modern vehicle.

373. STEFAN LOCHNER. *Adoration of the Magi*, center panel of triptych. 7′10″ × 8′7″.
Cathedral, Cologne

14. Rogier van der Weyden

The Master of Flémalle's greatest successor was naturally in the Master's own town of Tournai. Among the great painters of history, Rogier van der Weyden is one of the few (along with Giotto and Michelangelo) who completely dominated artists in a wide region for more than a generation. We know him well enough through his work but little through his life: he was born in Tournai (1399 or 1400) but lived chiefly in Brussels, where he was official city painter; he made a trip to Italy in 1450, and died in 1464. None of his works is dated, and we can guess their sequence only from hints. He was officially apprenticed to Campin from 1427 to 1432, but his age at the time suggests that he was really an assistant; his earliest work is already very independent. It is basic to it that Rogier takes the con-

374. ROGIER VAN DER WEYDEN.
St. Luke Painting the Virgin.
Panel, 54″×44″.
Museum of Fine Arts, Boston.
Gift of Mr and Mrs.
Henry Lee Higginson

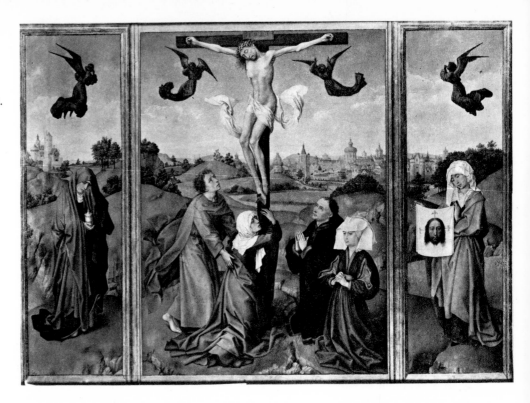

375. ROGIER VAN DER WEYDEN.
Crucifixion Altarpiece.
Panel, 40″ × 54″.
Kunsthistorisches Museum,
Vienna

quest of realism for granted; his art is not excitedly involved with it like the Master's and Jan van Eyck's. As Castagno, in Florence, does not demonstrate perspective any more, Rogier does not demonstrate volumes or textures or light.

The early *Annunciation*[16] uses Flémallian motifs, like the long bench and still-life objects, but the room is comparatively very empty. Rogier's concentration is on human reality, impressively so in his early masterpiece, the *Deposition from the Cross* (colorplate 46). The figures are set on an abstract background as if they were sculpture in a shallow shrine, with emphatically silhouetted gestures; their interrelationships, a woven net of arms and torsos, make a drama of tensions. We see that abstract space is reinforced by abstract design when we become aware that the farthest figures to left and right are symmetrical, each a zigzag profile pressing forward with bent knees. Likewise Christ's body, hinged in three parts at hips and knees with one arm trailing, has a shadow or repetition in the fainting body of Mary. The thin boniness of all the people makes these patterns more obvious; the physiognomic type is also a device suggesting tension, as the forms seem pulled and stretched. Sometimes it suggests a reversion to the over-tall elegant people of International Gothic, as in the duke of Berry's garden (see colorplate 42), but these people have a different implication from all the earlier ones except perhaps the Rohan Hours (see fig. 350). Rogier's

mastery of all Jan van Eyck's modern material realism, and his use of it to further a new expressiveness, is illustrated in the bony fingers of Mary Magdalene when their pressure on each other uses realism for poignancy, and again in the one figure who is fat, in a brocade robe, painted as an Eyckian type very possibly because he is the rich man who provided Christ's tomb. Bony people may also pose in zigzag rhythms when tragic stress is not involved, as in *Saint Luke Painting the Virgin* (fig. 374), a theme updated in that the artist-saint draws from the model, implying realism; earlier images of Luke as artist show him holding a completed icon. The space and landscape here are closely copied from Jan van Eyck's *Rolin Madonna* (see fig. 360), but with tall, thin proportions and a less filled landscape. The shallow stage with a window on a deep space beyond the terrace allows Rogier to cultivate the values both of medieval concentration on meaning and of modern natural truth.

The *Crucifixion* triptych (fig. 375), a fencelike system of taut bodies and flung robes, is set against a huge open landscape, perhaps the first that continues through three panels of a triptych, and it even sweeps the donors into the event. The landscape runs back to a sharp horizon and a huge sky which silhouettes the dark cross and the angels. The result is a wide-embracing blend of familiar natural context and dramatic stress, fascinating to young artists and to a society interested equally in religion and

nature, and inclined to think of both as parts of a single whole. Traditional schemes and fresh locations for them relate sharply again in the *Last Judgment,* ordered by Van Eyck's old patron Chancellor Rolin for the chapel of his newly endowed hospital in Burgundy.[17] A celestial court above, in Rogier's hard glassy color, presides hieratically but also atmospherically above a strip of earth where panicked souls scramble and run, insect-like versions of Rogier's thin-jointed people with Eyckian skin textures. But the airy breadth of these works reduces the high-pitched stress of the earlier ones and is perhaps less in revolt against Jan.

The Italian trip in 1450 seems to have made overt mathematical designs more attractive, leading to a more reposed balance of figure relations. The triptych of the life of Saint John the Baptist (fig. 376) is a virtual paradigm of Rogier's gamut of resources. The *Birth,* a domestic event, is in an Eyckian room full of warm light and dishes; the *Baptism,* a ceremonial, is centralized, and the anointed Christ suggests International Gothic daintiness and rank; the *Death,* a melodrama, uses space to pull arms and legs from their sockets and bring home the physical character of pain. The new interests dominate the Braque triptych,[18] a row of half-length figures (an Italian idea new to Flanders) against a cool series of skies, as well as the Bladelin altarpiece for the duke of Burgundy's financial secretary,[19] where the stringy people grow gentler and more sensitive; and the Columba altarpiece (fig. 377), an *Adoration of the Magi* done for Cologne, a city where this was a favorite subject, echoing the static symmetry of Lochner's version (see fig. 373). It is typical of Rogier that he could absorb into his unchanging figure style of angular skeletal types a cushioned amiability that would have seemed its opposite. His unity is that these figures articulate human feelings—of almost any emotional timbre. It was his dramatic range that made him the favorite mine for artists all over northern Europe during the next fifty years.

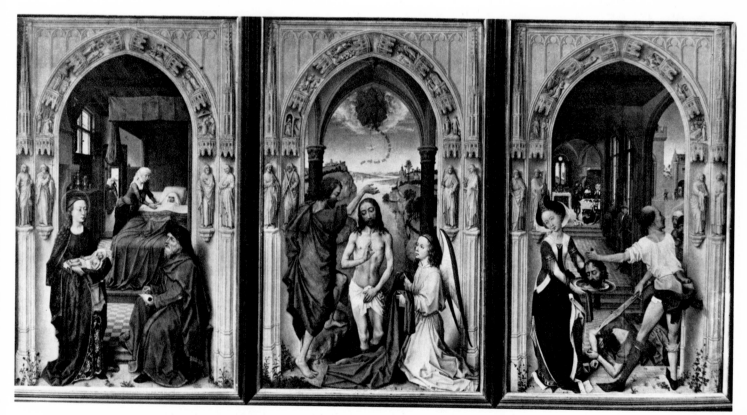

376. ROGIER VAN DER WEYDEN. St. John Altarpiece. Triptych, each panel 30" × 19". Staatliche Museen, Berlin-Dahlem

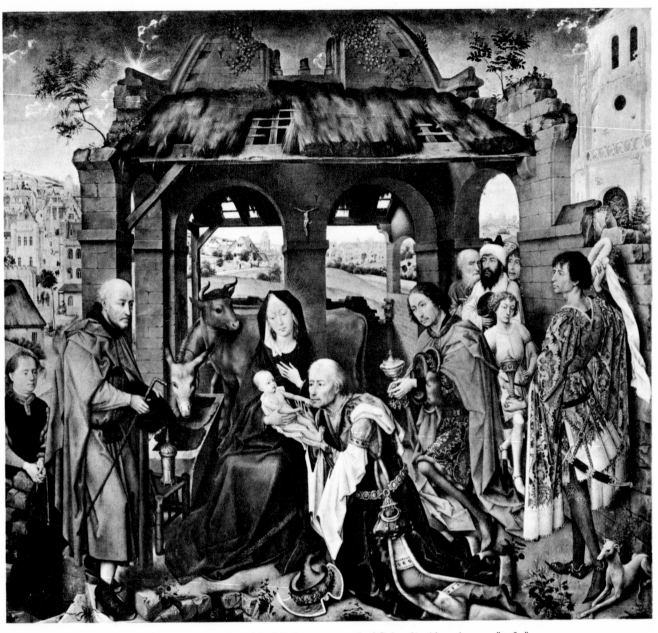

377. ROGIER VAN DER WEYDEN. *Adoration of the Magi*, center panel of Columba Altarpiece. 54″ × 60″. Alte Pinakothek, Munich

15. Rogier's Contemporaries

Lesser figures begin soon to use the methods of the pioneers, which become the standard vocabulary of Flemish realism. The earliest is Jacques Daret (docs. 1418–1468); he had a long career and was head of the guild in Tournai, but only one early group of his works is known (1434–35).[20] They imitate the Master of Flémalle directly; since Daret is a recorded assistant of Campin, this helps to prove that Campin was the Master of Flémalle. That is their main interest to specialists; beyond that, these rather flabby echoes of the Master's later, Eyckian works serve to show an idiom in use by an imitator which a few years before had belonged to two or three bold individuals.

Petrus Christus (docs. from 1444–d.1472/73) worked with Jan van Eyck and finished some pictures incomplete at Jan's death. His distinction from Jan is a limited one, but it is of a kind often evolved by followers: he simplifies the images, wiping the subtle surface detail down to smooth round shapes. His sense of clear order takes a positive form in his accurate perspective, since Jan's had always been an approximation. He is most individual in portraits, which vivify persons not only in features and lighting but in environment, in a corner of a room or behind a ledge on which a single fly is painted. This specificity of place is richest in his panel of *Saint Eligius,* patron saint of goldsmiths, who is shown in his shop selling a ring to a bridal couple (fig. 378). The tools and stock on the shelf record the same particular reality that Jan had given to dishes in a cupboard; but the larger scale lets this painting work as a unique portrayal of daily life of the period, anticipating what becomes very common in sixteenth-century Flemish painting.

Albert van Ouwater (no exact records; active c. 1450–1475) is the first Renaissance painter of the north Netherlands, detached from the great towns

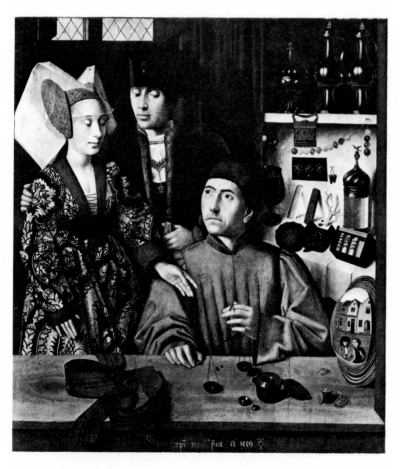

378. PETRUS CHRISTUS.
St. Eligius in His Shop. 1449.
Panel, 39″ × 33″.
Courtesy of the Robert Lehman Collection, New York

of the time which are all in modern Belgium (Bruges, Brussels, Ghent, Tournai, Louvain). Almost nothing but rather traditional book illustration precedes him here, and not even that in his town of Haarlem. There the patrons were not burghers but monasteries, and to this difference his one surviving work, the *Raising of Lazarus*, no doubt owes its unrelieved solemnity as well as its complex symbolism (fig. 379). It also reflects awareness of Petrus Christus, i.e., of a very recent aspect of painting in the southern cities. In the firmly constructed space of the temple, solid, plain figures make their serious intricate gestures, apostles on one side and doubting Jews on the other, while still more peer in through a grille behind. The control of composition and diffuse light make credible the tradition that Ouwater was also a master of landscape, and his authoritative work was also a natural source for younger artists in this northern Dutch area, starting with Geertgen tot Sint Jans (see p. 315).

379. ALBERT VAN OUWATER.
The Raising of Lazarus.
Panel, 48″ × 36″.
Staatliche Museen, Berlin-Dahlem

16. Dirk Bouts

Major talents as well now emerge, to work within the established revolution and to evolve subtle variations upon it. The first, Dirk Bouts, is one of the least-known artists of the highest level in the early Renaissance, partly because his work is still largely in Louvain, a little-visited city, and partly because of its own understated tone, even hiding its originality.

Bouts (docs. from 1447–d.1475) came from Haarlem, and shares something of Ouwater's mood, but lived in Louvain all his mature life and was chief painter to the city. At first he follows Rogier's approach to the figure, giving it all the emphasis

380. DIRK BOUTS. *Martyrdom of St. Erasmus,*
center panel of triptych. 32 1/8″ × 31 3/4″.
St. Pierre, Louvain

306

and articulating it by angular movement. But sharp tense angles are held to slight tentative movements, so that the figures become stabilized and silent, reserved and self-contained, resting hard on the ground. The bodies acquire a quality of being there like mountains, unarguable facts rather than vehicles of passion. In this way Bouts starts out with a negative compromise between Rogier and Jan van Eyck, omitting what in each master conflicted with the other. While, like Jan, he excludes the nervous stress with which Rogier would endow his people, he reduces, like Rogier, the rich detail of their environing world. Expressions are distant, and when melancholy, are so in the manner of faces grown set after they have long discounted any feeling. This shows up most extraordinarily when the themes are violent, such as the *Martyrdom of Saint Erasmus* (fig. 380). While the saint's entrails are being wound up on a windlass (following the typical medieval horror fantasy) spectators contemplate this with

382. DIRK BOUTS. *John the Baptist as Herald of Christ.* Panel, 20″ × 15″. Wittelsbacher Ausgleichsfonds, Munich

remote rigidity, merely turning necks and arms with a stiffness that seems as mechanical as the martyrdom. Painting examples of justice for Louvain's law court (a theme Rogier had painted in Brussels, in a lost work[21]), Bouts' two panels show a condemned man beheaded and then the appeal to the emperor by his widow, who in a trial by fire proves her husband's innocence and the guilt of the emperor's wife (fig. 381). Gangling courtiers watch all this with intelligent impassivity, and the reality of each person and thing is overwhelmingly credible.

Such a grasp of realism is easier for us in a *Last Supper* (1464–68),[22] arranged unusually around a squarish table so that the figures are farther from each other. As a result the space is without pressures, and a ritual effect like Ouwater's can emerge, highly

381. DIRK BOUTS. *The Appeal of the Countess.* Panel, 10′7 1/2″ × 5′11 1/2″. Musées Royaux des Beaux-Arts, Brussels

383. Dirk Bouts the Younger(?).
St. Christopher, right wing of Pearl of
Brabant Altarpiece (*Adoration of the Magi*
triptych). Panel, 25″ × 11″. Alte Pinakothek,
Munich

suitable to this altarpiece whose four side panels also refer separately to the sacrament of communion (colorplate 47). This approach also strengthens the environmental imagery, light, interior structure, and, most remarkably, landscape. In three of the sacramental scenes, where Abraham greets Melchizedek, an angel feeds Elijah, and the Israelites gather manna, the rich-robed stiff-jointed people, irregularly distant from each other, are steeped in a lovely deep-clouded area of immense meadows. In *John the Baptist as Herald of Christ* (fig. 382) the religious purpose helps the landscape invention. John with the kneeling donor on one side of a river points out Christ on the other; John and donor gaze across the expanse, the river gleams, and Christ never sees them. The truth about the openness of the world is stimulated in an original way, and yields such a concentrated portrayal that it becomes psychologically pressing. In the *Way to Paradise* panels[23] isolated sinners are caught in rocks, while angels lead saved souls away from us toward the fountain of life in the middle distance.

Bouts' approach dominated a narrow group of younger artists, sometimes identified with his two sons. One of them made these forms still drier, reducing the heads to devotional icons; the other's altarpieces have such dewy fresh landscapes that one became more famous than any of Bouts' originals: the so-called *Pearl of Brabant*. Its invention of Saint Christopher wading through a deep stream at sunset (fig. 383) helped to stimulate the emergence of entirely uninhabited landscapes shortly after 1500.

17. Joos van Gent; Hugo van der Goes

Generally in this epoch the distinguished painters all belong to different towns—Jan van Eyck to Bruges, Campin to Tournai, Rogier to Brussels, Bouts to Louvain; what they stimulate is not further explorations, as happened when local schools grew in Florence or Ferrara, but a fixed tradition, as in the Middle Ages. The partial exception is Ghent,

which housed two remarkable artists almost simultaneously for very short careers, after which both left under unusual circumstances.

Joos van Gent (docs. 1460–d.1479) arrived from Antwerp, lived in Ghent from 1464 to about 1468 and matured his art there, but soon went off to Italy, and in 1473 became a court painter to

COLORPLATE 45. CONRAD WITZ. *The Miraculous Draft of Fishes*, center panel of altarpiece. 1444. 52″ × 60″.
Musée d'Art et d'Histoire, Geneva

COLORPLATE 46. ROGIER VAN DER WEYDEN. *Deposition from the Cross.* c.1440. Panel, 7′3″ × 8′7″. The Prado, Madrid

COLORPLATE 47. DIRK BOUTS. *The Gathering of the Manna*, side panel of Communion Altarpiece. 1464–68. 35″ × 28″. St. Pierre, Louvain

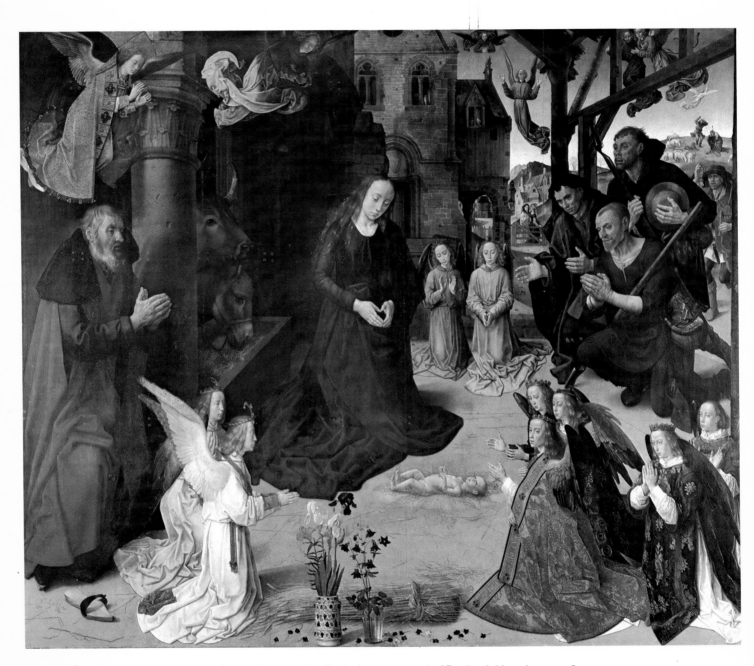

COLORPLATE 48. HUGO VAN DER GOES. *Adoration of the Shepherds*, center panel of Portinari Altarpiece. c.1480.
8′4″×9′11″. Uffizi Gallery, Florence

Duke Frederick in Urbino. Already in 1472 in Urbino he arranged to paint the *Communion of the Apostles* for a pious lay society devoted to the meaning of the Mass (fig. 384). Though this is his greatest work, it is little altered from what he had done before, and makes us realize that Joos had been drawing toward Italian ways already. Of course, his figures are Rogierian, wiry and forceful in a plain world, but he seems to be the only Fleming of his time who never painted on a small scale. Not only the pictures but the people in them are big, and move in broad sweeping rhythms in a world of geometric balances. As Jan van Eyck had done in Ghent in the *Adoration of the Lamb* (see fig. 357), Joos probes depth, but unlike anyone before, he moves his figures into depth gradually. The landscape in his early *Crucifixion*[24] is intensely bright, with an Eyckian glitter in the costumes, and Joos seems to have made exotic and piquant people a regular vehicle. But he usually isolates them sharply in a deep gray atmosphere. Thus Joos, like Bouts, is able to work his own variant on the now accepted tradition.

Hugo van der Goes (docs. from 1467–d.1482) becomes noticeable about the time of Joos' departure from Ghent. He was a great success there, decorated the town for festivals, and painted elaborate works. Some, with the most surprising motifs, are lost, such as a Nativity by night and Jacob and Rachel meeting in a vast meadow.[25] At the peak of his success he

384. JOOS VAN GENT. *The Communion of the Apostles.* 1472–74. Panel, 9'5" × 10'6". Galleria Nazionale delle Marche, Ducal Palace, Urbino

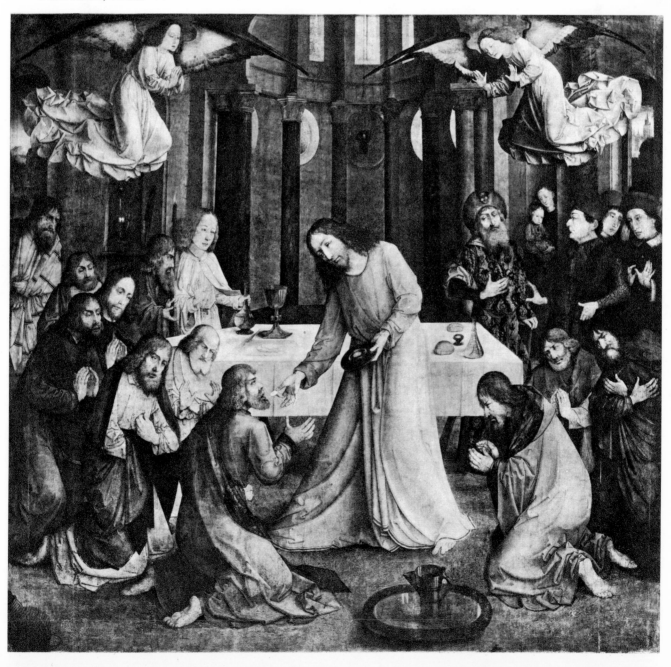

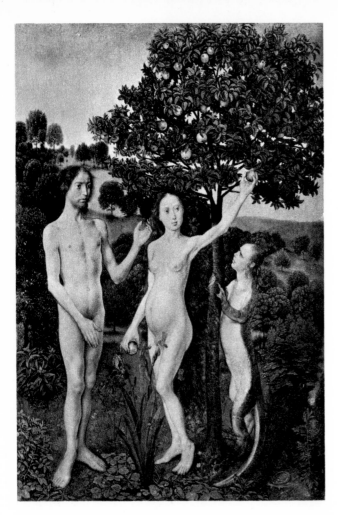

385. HUGO VAN DER GOES.
The Temptation of Adam and Eve.
Panel, 13″ × 9″.
Kunsthistorisches Museum, Vienna

retired to a cloister, but not fully; his superior, impressed by his fame, arranged for important visitors and for his work. The implication that Hugo was torn about what he should do seems confirmed by his next accusing himself of being a damned sinner and trying to "do himself an injury." After a period in this condition he subsided into humility but soon died. Today it is impossible to resist seeing this mental stress in his sixteen or so surviving works.

The early *Temptation of Adam and Eve* (fig. 385) is an astonishing token not of Rogierian but of Eyckian realism. The two figures have a concentrated surface reality that makes them not nude but naked. An *Adoration of the Magi*[26] works with a similar intensity on Italian methods; the perspective and broad modeling result in Hugo's calmest work. Through such imitations he arrives at his own style

386. HUGO VAN DER GOES.
Death of the Virgin.
Panel, 58″ × 48″.
Groeninge Museum, Bruges

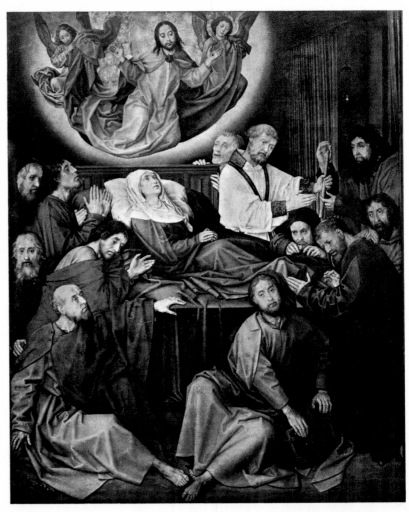

in the famous Portinari altarpiece (colorplate 48), painted to the order of a Florentine banker living in Bruges and shipped in 1483 to Italy, where it had an enormous impact on artists. It is more pressingly Rogierian than anything previous in its thin, tense figures, flying, clutching, or staring, and at the same time more pressingly Eyckian in the glare of reality in things, from flowerpots to brocades, giving the super-reality of a flood-lit sharp-focus photograph and more. All this is on a big scale, so that the tension between line and surface, plane and depth, has a shrill force. There is little unity; indeed, figures tend to be of oddly different sizes, each group

concentrating on realizing itself, but all share the pressure to reality. In his last works, such as the *Adoration of the Shepherds*[27] and the *Death of the Virgin* (fig. 386), Hugo pulls the figures together in grand high-pitched choruses, but he pushes realism so far, with a cutting line, that it turns into a personal style. The color grows thin too, and the resulting sculptural effect of the groups of people tends to discard their reference to space, which is treated as a minor inconsistency. Everything Hugo does is extreme, but he steadily changes from having many external interests to a single narrow statement which he has mastered absolutely.

18. Geertgen tot Sint Jans; Memling

By 1480, when every Flemish town had its own repeatable modern type of painting, the strongest young personality was in a remote province. Geertgen tot Sint Jans (no exact records), literally Jerry at Saint John's, is so called because he was a lay brother at the Hospital of Saint John in Haarlem; he worked there and for other local churches. Presumably learning from Ouwater, he develops his style further; his figures, plotted with elaborate vivacity in a wide space, are an unforgettable type of smooth simplification, a shiny column with an egglike head. But he had also traveled to great cities and was an urbane person; Van der Goes' compositions and perhaps Joos van Gent's spatial constructions seem to have impressed him. His imagery is original in the handling of its religious themes, as Ouwater's had been. A surviving panel from his huge destroyed altarpiece for Saint John's shows the finding of the saint's relics (fig. 387), and hence the community of Hospitalers logically (not in space or time, but in association of ideas) watch from a little farther back, the first group portrait of members of an organization in Dutch art. It is typical that a space relation between parts of the painting stimulates the form taken by this novelty. It does so again in the superficially very different *Nativity* at night (fig. 388), perhaps inspired by Van der Goes; light from the Holy Child glows into the black world, violently striking cylindrical forms partially eaten away by shadow.

Geertgen's few nonspatial works are the ones with unusual and complicated symbolism, which he makes visually simple by his talent for exposition. These include the *Christ Carrying the Cross*,[28] Christ streaming with blood from many tiny wounds, and the *Madonna of the Rosary*,[29] a tiny petal-like image made of an astonishing number of minute objects. Geertgen is often compared to the seventeenth-century Georges de la Tour, another provincial genius whose complexity of religious culture is resolved in abstracted simplified shapes and lighting.

But a more typical artist of the generation 1480–1500 is Hans Memling (docs. from 1465–d.1494), who reflected Rogier's figure style more faithfully than any of the painters so far mentioned. In this fidelity he is like a number of minor artists, but he managed to be a sort of supreme average, a major presenter of the standard. Born in Germany, Memling may have been working in Rogier's shop when Rogier was painting his symmetrical *Adoration of the Magi* for Cologne at the end of his life (see fig. 377). Memling retains the symmetry in his many altarpieces for Bruges (fig. 389). He also traces Rogier's figures so that they lose elasticity and become soft, well washed and dressed for feasts, smiling ingratiatingly in parklike landscapes. The painting is technically splendid, polished and balanced, placid and neat. Like Lochner and Fra Angelico, Memling appealed to the Victorian re-

315

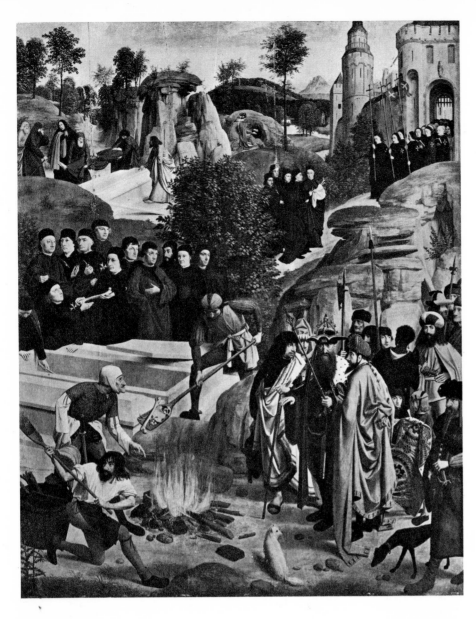

discoverers of the early Renaissance as a "sweet primitive," clean and simple and thus uncorrupted, but sugared and easy to like. Besides his casket for the relics of Saint Ursula (1489),[30] covered all around with bright little scenes from her legend like manuscript pages, with a sunny rendering of Eyckian detail, Memling's most distinctive works are his portraits (fig. 390). Handsome classical features, unlike those of his truthful predecessors, are placed before open landscapes, an original system that was much liked and added light to the faces. But though Memling was very successful, he was not remembered long or much imitated after his death.

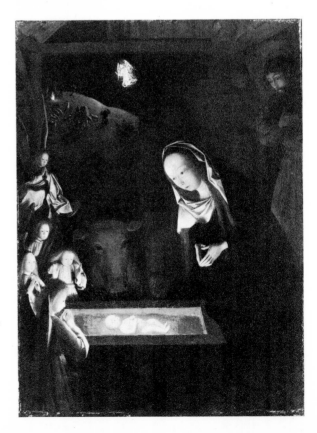

388. GEERTGEN TOT SINT JANS.
Nativity. Panel, 13" × 10".
National Gallery, London

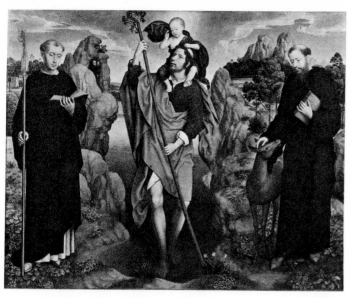

389. HANS MEMLING.
St. Christopher Altarpiece, center panel of
triptych. 1484. 48″ × 60″.
Groeninge Museum, Bruges

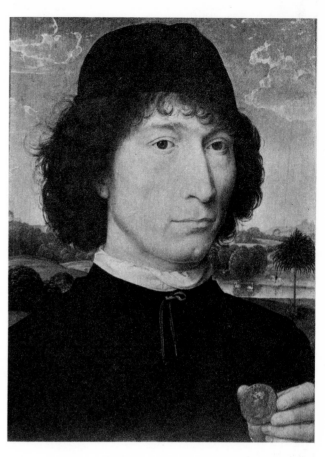

390. HANS MEMLING. *Man with a Coin.*
Vellum on panel, 11″ × 9″.
Musée Royal des Beaux-Arts, Antwerp

19. Jean Fouquet

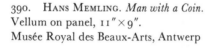

The collapse of France, symbolized by the defeat at
Agincourt (1415), began to be reversed only by a
later generation symbolized by Joan of Arc (military
career 1429–31). It re-emerges with a changed char-
acter when the young King Charles VII, in his mod-
est capital at Bourges, replaces his feudal lords with
a civil service of commoners, following the example
of the dukes of Burgundy. The merchant and finan-
cier Jacques Coeur, drawn into government as a
second career, is the most important of these. As his
activity illustrates the creation of a pattern that now
seems ordinary, his house in Bourges (fig. 391) is a
pioneer among city mansions. Like the duke of
Berry's earlier castle at Poitiers (see fig. 344), in
masonry and style it is a Gothic stone structure
being used for dwelling purposes, so that carved
ornament runs over flat ceilings and frames thin
curtain walls in the style that traditional architects

used to call "Tudor Gothic." It even echoes Poitiers
in its portrait sculptures above eye level, but differs
in having more but smaller rooms, urban luxury,
and sophisticated division of functions counterbal-
anced by limited ground area. These developments
were gradual, but the surviving similar houses ear-
lier than this are rural, hence looser in plan, and
much less ambitious in size. (The best example of
these seems to be the house of William Grevel, at
his death in 1401 the richest wool merchant in Eng-
land, at Chipping Campden, then an important
market.)

The talented painter of this court, Jean Fou-
quet (docs. 1462–1477), is also within a traditional
vehicle, being almost the last major painter in Eu-
rope to specialize in book illustration, but his style
is Eyckian and particularly like Petrus Christus.
His earliest work, a fiercely realistic panel portrait of

317

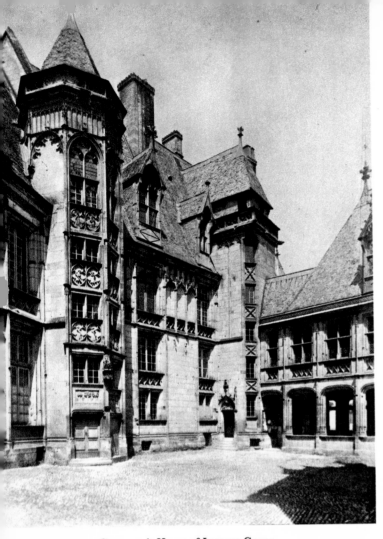

391. Courtyard, House of Jacques Coeur, Bourges. 1443–51. Height of main façade (at left) 39′4″

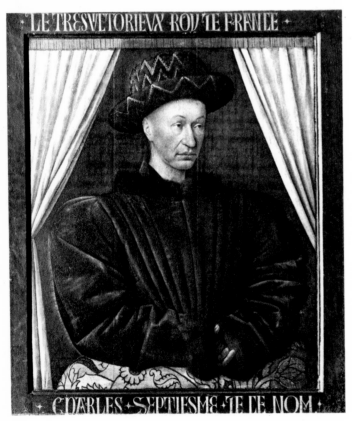

Charles VII (fig. 392), wide-mouthed and flabby-skinned, closely reflects Christus' recent portraits in smoothing down Eyckian reality to an undetailed cylinder, and goes further by eliminating Christus' spatial anecdotes in favor of a framing curtain. The same style, massive and with graphic facial individuation, recurs in the *Madonna* that has often been called a portrait of the king's mistress, Agnes Sorel (fig. 393), and in a big *Pietà* for a church,[31] whose columnar forms at irregular angles and in strong light are a rich variation on a treatment of the theme by Christus.[32] But the later portrait of Jouvenel des Ursins,[33] the royal treasurer, shown as a substantial jowly bourgeois, reflects Van Eyck directly in its small intimacies of texture. This has a preparatory drawing (final and complete, like Jan van Eyck's of Cardinal Albergati[34]), a showpiece in two colors of chalk,[35] perhaps the starting point for a French tradition of portrait drawings in the sixteenth century.

Fouquet's manuscript painting is in this wholly Eyckian vein. The crowd scenes that fill the Book of Hours of Étienne Chevalier, another royal treasurer, and Fouquet's other manuscripts (colorplate 49) derive from the saints crossing the grass in the Ghent altarpiece; vast numbers are unified in a dancing, glinting light on robes and grass, so that we can visually manage the multitude and accept its movements. But Fouquet introduces a surprising modification, probably the result of an Italian trip about 1445; he had then learned perspective and apparently decided, as Dürer did later, that it was the solution to all kinds of problems. Fouquet's buildings are much like some painted by Fra Angelico, who worked in Rome at about the time Fouquet was there. But the clusters of people are measured in perspective too, so that they seem to be undergoing a military drill, and the geometric abstraction of their regiments oddly penetrates the easy naturalness of their Eyckian color. In even more earnest research, Fouquet represents perspective diminution from center to sides (as well as the usual sort from front to back), and therefore shows straight horizontal lines as curves; this system comes from Van Eyck's and Christus' convex mirrors, the

392. JEAN FOUQUET.
King Charles VII.
Panel, 34″ × 28″.
The Louvre, Paris

only type then manufactured, which show a similar curved world (as in Christus' *Saint Eligius*; see fig. 378). A Flemish studio trick is his tool to impose Florentine order on the cosmos. In devoting himself to these curiosities, Fouquet is the victim of his provincial isolation, which allowed him to exaggerate out of proportion what he had learned. Yet despite himself he is an artist of beautiful images in both the massive portraits and the crowd scenes where, anticipating Memling's Saint Ursula casket (see p. 316), he revives Van Eyck's microscopic vibrancy with casual mastery.

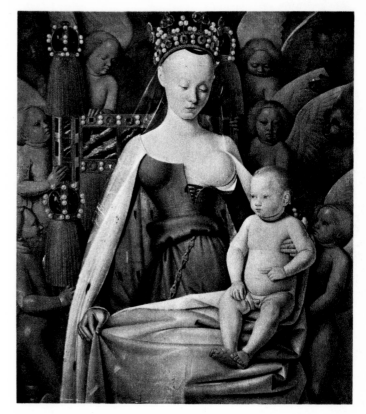

393. JEAN FOUQUET.
The Madonna of Etienne Chevalier,
right panel of Melun Diptych.
36″ × 32″.
Musée Royal des Beaux-Arts, Antwerp

20. Avignon and King René

One of the strangest but most effective of fifteenth-century patrons was René (1409–1480), grandson of that duke of Anjou who was one of King Charles V's brothers. René was fated, as a sort of caricature of late feudalism, to accumulate domains by dynastic accidents: duchies from his older brother, his great-uncle, and his father-in-law, and the kingdom of Naples willed by a cousin, all because none of them had sons. He lost them all in wars with other claimants; but he was remembered in folk literature as "the good King René of Anjou," and so, despite his weakness, was evidently not a failure as a ruler. He wrote romances, was an amateur painter, and a patron of painters by the score. His constant travels match strikingly the spread of the Flémalle style. As a young prisoner of war of the duke of Burgundy in Dijon, he is said to have studied painting avidly, and this must have been Flemish; he attended the Council of Basel in 1434 and may well have met Conrad Witz; from there he went to Naples for four

years (where legend makes him the teacher of Colantonio; see p. 298), and after he lost that, to his duchy of Provence, just before the *Annunciation* of Aix-en-Provence was painted (see fig. 369).

Painting in Provence in René's later quieter years develops more emphatically the approach that Fouquet's larger paintings showed in a mild form, provincial geometric simplification applied to Flemish realism; it attains a hard plainness like sawn planks, which has a great impact on twentieth-century eyes. The leading painter, Enguerrand Quarton (docs. 1447–1461), coming from northern France, in 1454 painted near Avignon a huge altarpiece of the Trinity crowning the Virgin (fig. 394). Its mixing of sizes is archaic, weighty divine figures above, small souls in Heaven, and tiny ones in Hell below. The surfaces are a richer mix, the large figures built up of prismatic stiff robes, the small ones skittering among enamel-smooth hills and seas. This same collection of approaches marks the

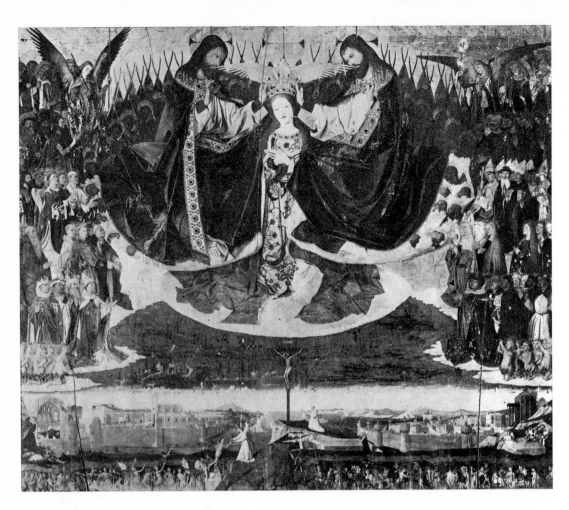

394. ENGUERRAND QUARTON.
Coronation of the Virgin.
1454. Panel, 6′ × 7′5″.
Musée de l'Hospice,
Villeneuve-les-Avignon

395. ENGUERRAND QUARTON(?). *Pietà.* Panel, 5′4″ × 7′4″. The Louvre, Paris

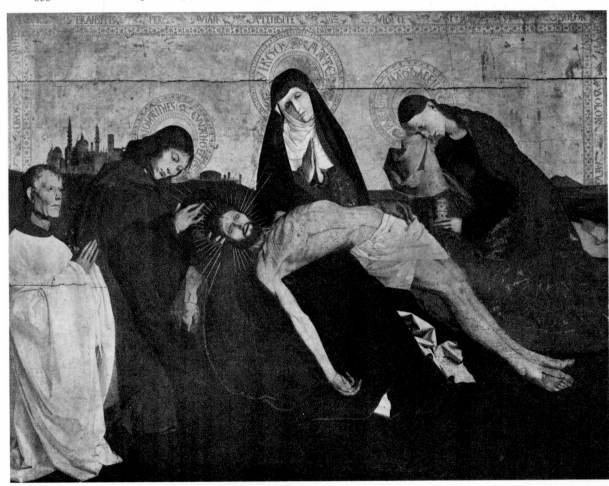

famous *Pietà* of Avignon (fig. 395), which may be by Quarton and certainly shares his aesthetic. Its greater, even shocking, power comes from its tragic theme, which, here as elsewhere, affects both the artist and our response. We are likely to notice first the angular design that makes Mary's face a cubist disjointed scheme, and only later the Flemish sophistication in the taut rib cage and the donor's work-worn face and staring eyes. The cubist component is actually less dominant here than in the closely connected altarpiece from Boulbon.[36] Its theme, the symbols of the Passion, lends itself to a pattern of geometric jigsaw-puzzle fragments strewn on a flat surface, each one glaringly real.

Nicolas Froment (docs. 1461–1479) is a lesser native Provençal master. The Flemish motif of a standing group in brocades gets a provincial translation in his *Raising of Lazarus*,[37] full of jerky movements and nutcracker grimaces. Froment's masterpiece is the *Virgin in the Burning Bush* (1475–76; fig. 396), a huge altarpiece that has two layers of meaning (Moses sees the bush that burns but is unconsumed; Mary bears Christ but remains a Virgin). The work includes very frank portraits of King René, who ordered it, and his skinny queen. The whole is much suaver in drawing than his earlier work, to the point of being a persuasive duplicate of a Bouts.

A more elegant simplification of Flemish painting, like Fouquet's, was practiced at René's other court, in Anjou, near the French king's. Its masterpiece is the anonymous set of illustrations in the manuscript of *Coeur d'Amour Épris (Heart Captured by Love)*, a romance written by René himself in 1457. It tells of courtly love and virtue through personified qualities, like Love, Jealousy, and Sloth, in a tone of intellectual nostalgia for tales of chivalry best known to us in Edmund Spenser's *Faerie Queene* written for the English court a century later. The illustrations thus quite naturally reflect the International Gothic at its subtlest, the styles of the Boucicaut Master and the Limbourg

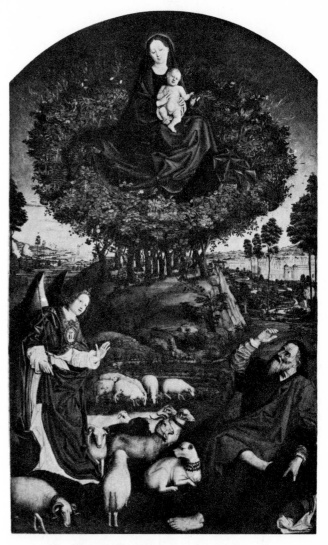

396. NICOLAS FROMENT.
The Virgin in the Burning Bush, center panel of triptych. 1475–76. Height 13′5″.
Cathedral of St. Sauveur, Aix-en-Provence

397. *Heart and Desire at the Fountain*,
illuminated page from *Coeur d'Amour Épris*.
Vellum, page 11″ × 8″.
National Library, Vienna

brothers, mixing ornamental grace with vivid hints of fresh landscape (fig. 397). A few scenes push this interest to an astonishing point of originality, a sunrise with figures meditating on pale grass, and a candlelit bedroom, creating sensitive moods with utter authority; only Bouts' deep landscapes are comparable at the time. In general the *Coeur* Master belongs to the group, from Petrus Christus on, who simplify Flemish figure imagery with a structure of sharp gestures.

21. The Growing Role of Sculpture: Hans Multscher

For generations after the Dutchman Sluter had done his work in France, French sculptors repeated his naturalistic power and his tricks of soft, thick texture, with individual brilliance at times but with no vocabulary change. The authority of his approach was sufficient so that after fifty years a Spanish immigrant, Juan de la Huerta (docs. 1437–1462), retained it while working as the leading master in Dijon. The most impressive single echo is the lifesize *Entombment of Christ* with six mourners, which the otherwise unknown Jean Michel and Georges de la Sonnette carved for a hospital chapel in Tonnerre (1451–54; fig. 398). It is like a theater tableau, with Sluter's massive seriousness but plainer in form. The Italian Niccolò dell' Arca probably derives from this phase of the Sluter tradition.

The experience of Holland and Germany was far more varied. The most important base being exploited is ultimately André Beauneveu's work around 1370; it modified the standard Late Gothic mechanical curves by toughening and simplifying the forms a little, so that the curving movement of the whole patterned body has dramatic expressiveness, like a gesture. In quantity the period is conspicuous for the increase of independent statues unrelated to architecture. They include the many Pietà groups of the dead Christ on Mary's knees, and votive Madonnas. The latter, with their traditional linear decorations based on graceful bending folds, were called the "beautiful Madonnas" in Germany, and rarely emerge from the type. Adventurousness seems a little more marked in occasional works of architectural sculpture. Johannes Junge, a talented carver in Lübeck (docs. 1406–1428), adds to the sweet face and swirling drapery of his *Virgin*, produced for a church location, a sharp leaning of the whole body to the right, giving her a positive identity (fig. 399). Master Hartmann in Ulm (docs.

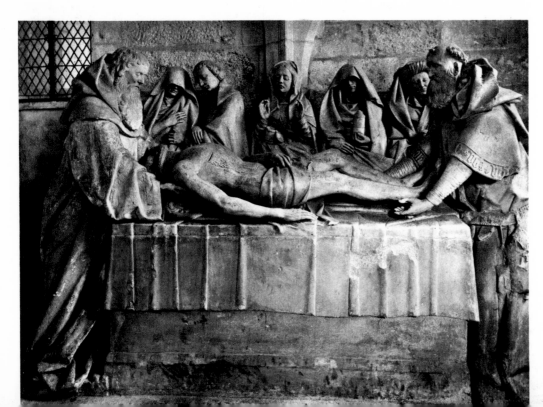

398. JEAN MICHEL and GEORGES DE LA SONNETTE *Entombment of Christ*. 1451–54. Stone, 4′3″ × 11′10″. Cathedral, Tonnerre

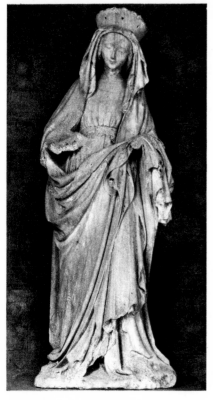

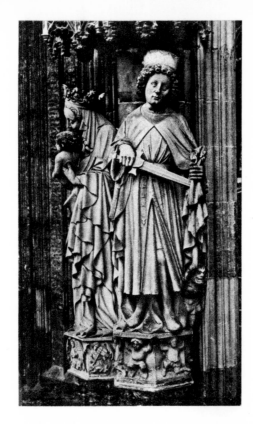

399. JOHANNES JUNGE. *Virgin.*
Stone, height 41″.
St. Annen-Museum, Lübeck

401. *Madonna.* 1430.
Wood, height 67″.
St. Sebald, Nuremberg

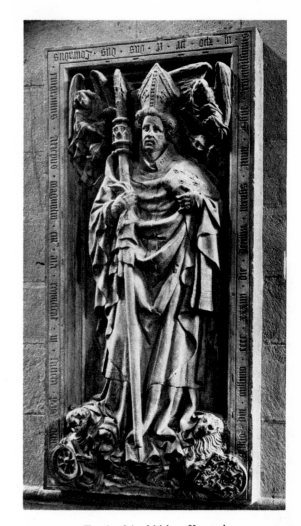

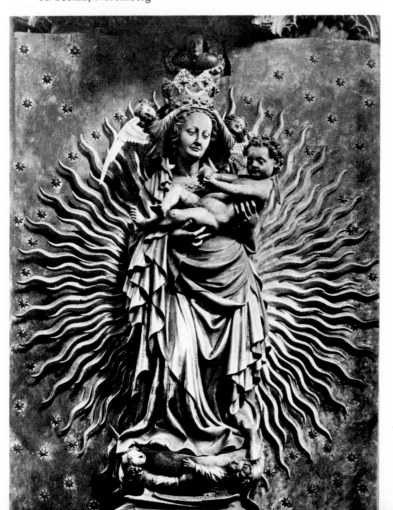

402. Tomb of Archbishop Konrad
von Daun. Stone, 8′10″ × 4′5″.
Cathedral, Mainz

1417–1430) sets beside a conventional Madonna a *Saint Martin* who is a materially solid burgher (fig. 400). As he turns to cut off part of his cloak, illustrating his legend, he does not show ornamental folds but a personal seriousness exactly parallel to the Master of Flémalle. Indeed, Hartmann's work is as early as Flémalle's own collaboration with a sculptor with similar results (see p. 295). Spatial boldness, instead, marks the carved figures of the Strasbourg Cathedral tower. They sit on the parapet and look up, gauging the height to the top as we do; they are not so much detached from the architecture as in counterpoint with it. But the actual carving is fairly conventional. An accommodation between old Gothic habits and Flemish materialism seems to have been worked out in such Madonnas as that at Saint Sebald in Nuremberg (1430; fig. 401), whose plump matronly face presides over an irregular

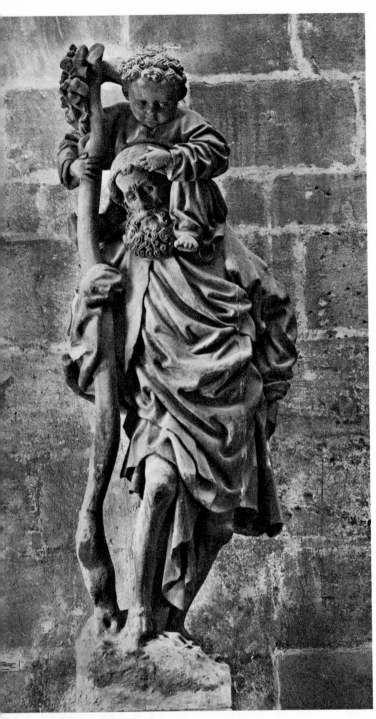

403. *St. Christopher.* 1442.
Stone, height 11'6".
St. Sebald, Nuremberg

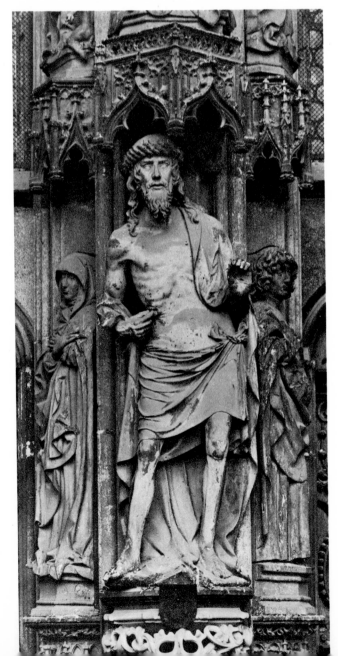

404. HANS MULTSCHER.
Christ as the Man of Sorrows.
1429. Sandstone, height 5'6".
Cathedral, Ulm

cascade of flowing folds. Less accommodating, the masterpiece indeed of these scattered experiments, is the tomb of Archbishop Daun of Mainz (d.1434; fig. 402), where rich but jumpy folds in the robe refer to the twisted wrinkles in the face and the deep shadow patches all over the relief surface, producing an expressive stress parallel to the first works of Rogier van der Weyden. Similar power emerges from a *Saint Christopher* in Nuremberg (1442; fig. 403), holding a serpentine vertical stick that insists on its contrast with the heavy body angled at the waist, its active pull further marked by the stretching of the soft, Sluter-like robe. The whole form states a dynamic splintering of tragic weight.

All these single works in Germany are related to a leading personality, Hans Multscher in Ulm (docs. 1427–d.1467). In his youth he was a vigorous painter of crowd scenes in squarish Flémallian spaces, where the blocky people thrust energetically against each other, less abstract than most of the painters in the Flémalle vein. In sculpture his full power appears in his standing suffering Christ (fig. 404), free from Gothic formulations, leaning out to us with an intense gaze. The possibilities of human expressiveness and environmental space are being grasped simultaneously, both extending a single gesture in which the figure points to his wound. Multscher's later works withdraw into more passive dignity, where saints with smooth broad faces and tired expressions stand in robes spreading outward in thick folds. On a small scale he seems to parallel Rogier van der Weyden's evolution.

22. Nicolaus Gerhaert and Other Sculptors

From about 1460, sculptors who have original personal styles are more concentrated in Germany than anywhere else. They work in the context of the spreading influence of Rogier van der Weyden, wiping out the last traces of the language of curvilinear robes among carvers.

Bernt Notke (docs. 1467–d.1509) late in life traveled from his home in Lübeck near the Baltic Sea to Stockholm, where his eight-foot-long masterpiece, *Saint George and the Dragon* (1488; fig. 405), ordered to commemorate a military victory by Swedes over Danes, functions in its church like an altar. (The nearby statue of the rescued princess is the work of an assistant.) Man and horse are Rogierian in their thin, fierce pressure, but are overwhelmed with decoration in the armor and the dragon, whose scales are made of real deer antlers, and so seem to revert to the International Gothic trick of being realistic whenever nature chances to be elegant. The whole follows a tradition seen in a bronze *Saint George* of 1373 in Prague.[38] All this is

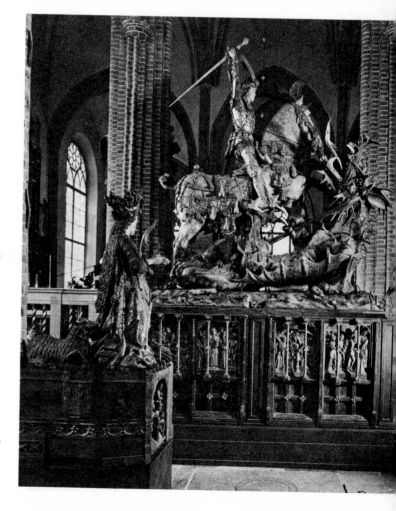

405. BERNT NOTKE.
St. George and the Dragon. 1488.
Painted wood, height
from pedestal 10′, width 8′.
Storkyrka, Stockholm

406. NICOLAUS GERHAERT. *Self-portrait.*
Red sandstone, height 17 3/8".
Musée de la Ville, Strasbourg

407. NICOLAUS GERHAERT.
Tomb of Emperor Frederick III. Begun 1469.
Marble, 9'10" × 5'5".
Cathedral, Vienna

provincial exaggeration and lag, clashing with the extraordinary mastery of space, in which the huge active form pierced by holes dominates its environment dynamically.

A more urbane variant on Rogier is Nicolaus Gerhaert (docs. 1462–d.1473), whose few but brilliant works make him the chief founder of German Renaissance sculpture. He apparently came from Leyden in Holland, but did most of his work in Strasbourg (then a German-speaking city of the Empire). He uses sharp bending line, but in a new way, not incised into a surface but tracing the outermost projection of a volume, like the contour of a mountain range. To this taut twisting line of his main figures there respond ornamental areas swarming near the frames and suggesting a harmonious relation of the live and the decorative. And the irregular volumes of the figures send out centrifugal probes into the space, which also has a positive role in his sculpture. His first known work (1462) is a

tomb slab,[39] typically much higher in relief than previous ones, already mature in the clots of intricate volume peaked by line. His colossal *Crucifix* (1467)[40] relates two disjunctive naturalistic textures, flesh and wood bark, capped by a crown of thorns that expands with the woven decorative richness of a fan vault. Still more striking are the busts for Strasbourg town hall (1464; fig. 406), figures placed to look out from windows but now without their frames. This illusionistic idea is found earlier in the house of Jacques Coeur, and reverts eventually

to such fourteenth-century statues as Emperor Charles IV and his empress at Mühlhausen,[41] stone busts bowing from a stone parapet. Gerhaert's people twist like screwdrivers, and first attract us because their physical vibration of life supports a life of feeling that pops out at us with a smile; they may gaze at us wide-eyed and have a casual, almost Eyckian domestic truthfulness that belies their technical intensity. In 1469 Gerhaert was called to Vienna by Emperor Frederick III and began his red marble tomb (fig. 407), with a brittle brocaded robe framed in equally tremulous coats of arms; this was not finished when Nicolaus died.

His influence turns up soon everywhere, often in inventive wood sculpture such as the apostles at Wiener Neustadt;[42] their heads, wittily characterized, rest on robes that thrust with a grand expressive motion from shoulder to toe. Much later in Vienna Anton Pilgram (docs. 1495–1515), the most brilliant sculptor there in his time, retained Gerhaert's pattern in a portrait peering out of a window, thin-nosed and sharply twisted (fig. 408); in Strasbourg it is echoed earlier in the painted wood busts from the Hospital of Saint Marx,[43] taut sunken-cheeked faces with sharp looks. Most of all, in Ulm in south Germany, a workshop headed by Jörg Syrlin (1424–1491) carves heads for choir stalls (1469–74; fig. 409) that geometrize Gerhaert. The vibrant mobile heads have faceted planes, like diamonds, but of uneven sizes, enhancing their keen dramatic life, which works in space as Gerhaert's did.

Erasmus Grasser of Munich (docs. 1480–1526), a more independent personality, first appears on the scene with his masterpiece, the ten half-size morris dancers carved for the municipal dance hall (fig. 410). They are burlesques, resembling Gerhaert in their flamboyant motion and their expressions that seek contact with us, but simplified to raw caricatures, with plain elementary forms, and tending to convey their graphic motion largely through silhouette. His later work, despite vigorous folklorish simplicity, is visually commonplace, never rivaling these unique secular figures.

The Netherlands at the beginning of the Renaissance exported two great and influential sculptors, Sluter and Gerhaert. One might hence be inclined to guess that the sculpture done in the Netherlands was also notable, but it is largely destroyed and what survives is a literal echo of Flemish

408. ANTON PILGRAM. *Portrait.*
Stone, 25″ × 21″.
Cathedral, Vienna

409. JÖRG SYRLIN. *Tiburtine Sibyl.* 1469–74.
Wood, height 20″. Cathedral, Ulm

painting, so perhaps there was a correlation between Sluter's and Gerhaert's talent and their emigration. Jean Delemer, after collaborating with Campin, did so again with Rogier and with a bronze founder on a lost royal tomb, and is perhaps echoed in one that survives for Princess Isabel of Bourbon (1476).[44] She lies in a tautly folded robe, and small dynamic figures of her ancestors stood around the sides of her sarcophagus, all purely Rogierian in style. There was a virtual industry of small wood figures in that style for altarpieces and choir stalls, loose-limbed hardwood people in pulsating groups, spatially actuated in interlocking filigree webs with small intervals. The most definite personality is Adrien von Wesel (docs. 1447–1499) of Utrecht, whose controlled suavity of curving forms slows down Rogierian nervousness a little.

410. ERASMUS GRASSER.
Morris Dancer. 1480.
Wood, height 30″.
Altes Rathaus, Munich

23. German Painting and Prints in the Wake of Rogier

German fifteenth-century painting is largely concentrated in the Rhine valley, commonly subdivided into the Upper Rhine, near its Swiss source, from Austria through Basel to Strasbourg; and the Middle Rhine, near Cologne. After Witz and Lochner around 1440, the younger generations show a surprising provincial retreat, imitating Flemish narratives of saints with all of the hard brightness of the originals but making them flatter and without air. Possibly this is because the assumptions they made were still medieval (certainly most of the artists are anonymous), and it had been easy to absorb a courtly Gothic language as Lochner had and a still rather stylized modern one as Witz had, but not the human and material realism of Rogier. Of course it is Rogier who is now mainly imitated, directly or indirectly, but his forms are modified with a primitive vigor hardly different from contemporary painting in Spain.

In and near Salzburg the leading painter, Rueland Frueauf the Elder (docs. 1470–d.1507), continued to practice a stylized version of Conrad Witz' style at this extraordinarily late date, constructing his hard enamel figures in imposing pyramids. Near the North Sea Hinrik Funhof of Hamburg (docs. 1475–d.1484), and Hermen Rode of Lübeck (docs. 1485–1504), make even stiffer a Boutsian style of tall detached people in sweeping flat landscapes. The outstanding master in Cologne, the anonymous Master of the Life of Mary, is closer than they are to his source in Bouts, airier and less rigid (fig. 411). Bouts is also reflected in Ulm, near the Upper Rhine, in the last painter to maintain this tradition on a level of competence, Bartholomeus Zeitblom (docs. 1482–1518), whose people, like Bouts', are tall, gentle, spaciously placed, and violent in behavior.

The two artists who rise above this pattern are

411. MASTER OF THE LIFE OF MARY. *The Visitation*, panel of an altarpiece. 1463. 33″ × 43″. Alte Pinakothek, Munich

especially close to Flanders, and both are engravers. Engraving and woodcut are creations of fifteenth-century Germany, obvious parallels to the invention of printing there. Our awareness of them suffers from the separateness generally used in portraying the history of prints, emphasizing techniques and collecting; it should be seen as a variant aspect of the history of painted images. Within the technical context, on the other hand, it is all too common to bracket woodcut and engraving together, although their status is as different as linoleums and Persian rugs. Both, to be sure, stamp a pattern of ink lines on a piece of paper. Woodcuts are an offshoot of similar stamping of woodblocks on textiles, to make an inexpensive imitation of embroidered cloth; in the fifteenth century woodcut always remained a popular art, used for holy pictures and illustrations of moral books. Engraving derives from decorative incision on armor and other metal, and first gets pressed off on paper (perhaps to make a record of a design) about 1430. It quickly becomes a vehicle for individual artists, the first being the master who signed some of his three hundred engravings E.S. (datable 1446–67). They are in the standard Flémalle tradition.

The painter Martin Schongauer (docs. 1453–d.1491) signed a hundred engravings. Like his pictures, they are completely in the Rogierian manner; Schongauer and Memling are the two artists who followed Rogier most faithfully and most elegantly. To Rogierian people, thin-boned in crumpled robes, Schongauer applies his crisp engraver's line, and adds his clean perspective diagrams of broad spaces, which seem to be part of his technician's temperament, happy to show how it works (fig. 412). The forms are tight but vibrating, the metallic line glistens like the white paper. One of their purposes, as in Mantegna's and Pollaiuolo's engravings, was to provide models to artists, for the themes of altarpieces and also for areas of ornament.

412. MARTIN SCHONGAUER.
Nativity. Engraving, 10″ × 7″

413. HAUSBUCH MASTER.
Beggars Fighting.
Drypoint, 2 7/8″ × 2 5/8″.
National Gallery of Art,
Washington, D.C.

414. HAUSBUCH MASTER.
Solomon Worshiping an Idol.
Drypoint, diameter 6″.
Rijksmuseum, Amsterdam

A much more personal art is seen in the ninety drypoints of the Hausbuch Master, a painter near Strasbourg. Drypoints are engravings in which the excess metal dust from the incisions, called "burr," is not wiped off, leaving on the paper a soft effect of graduated shadow rather than a sharp edge. The burr wears away in pressing the plate on the paper, so only a few copies can be made. Indeed, sixty of these ninety survive only in one copy, and nearly all of those in one place,[45] presumably a collection made in the artist's time. All this suggests something not only delicate and experimental, but private, an effect still more enhanced by the smallness of the prints, mostly three to four inches high (fig. 413). Some represent standard saints, but they also range startlingly into typical daily life, genre—peasants fighting, children turning somersaults, two men pausing to chat as they meet on the road, and in a larger print a dog scratching—all twisting actions of flexible bodies which match in this respect the main quality in the Master's rather commonplace paintings. But they further suggest,

330

415. HAUSBUCH MASTER. *The Planet Venus*,
sheet in Hausbuch. Pen drawing, 9″ × 6″.
Graf von Waldburg-Wolfegg, Schloss Wolfegg

beyond common experience, a sharp irony about mankind, its absurdity and foibles, which is still more emphatic in *Samson and Delilah*, the strong man tricked, *Solomon Worshiping on Idol* (fig. 414), the wise man foolish (these are his rare choices from the Old Testament), an old woman making love to a young man (and vice versa), and the famous *Young Man and Death*. This gently mocking satire grows systematic in his drawings with a wide pen, resembling the burr effect, in a notebook called the *Hausbuch* (fig. 415). They show how the planets influence human action, which may be evil or foolish but is observed with refined detachment. The prints, pictorially gentle and psychologically imaginative, are too impractical to have been intended as models, and were perhaps the personal sideline of the merely competent painter. They indicate that art without a definite narrative subject was possible in the period, and it appears occasionally elsewhere (Schongauer's scuffling boys); when recurring, it is perhaps connected with this unusual nonpublic purpose. Even the Master's anonymity today may be the natural result of his behavior rather than of accident, as is usual.

24. The Wood Sculptors

A typical vehicle of fifteenth-century northern art is the big wooden altarpiece, an open-fronted box containing many carved figures. It is transitional between medieval sculpture that is part of a building, and modern ones that stand alone. It comes like much else from the Netherlands, an early example being the Dijon altarpiece whose wings Broederlam painted (see colorplate 41). After about 1470 German sculpture enters on years of splendor, evolving from Gerhaert's lithe, witty spatial inventions and the somewhat graver presence of Multscher's figures in their spreading irregular robes. Of this sculpture such altarpieces are the major vehicle. A standard but imposing early instance is the Crucifixion altarpiece in Nördlingen

(sometimes thought to be by Simon Lainberger, docs. 1478–1495),[46] with its technically splendid carving, similar to the Wiener Neustadt apostles made under Gerhaert's shadow, but less sharply cut.

The great master of this art is Michael Pacher (docs. 1467–d.1498), whose major work is the altarpiece of the parish church at St. Wolfgang, near Salzburg (1471–81; colorplate 50). Its single figures are in the Multscher tradition, serious and broad but intricate, with fleshy naturalistic faces that seem more modeled than carved. But the exploitation of space is an extension from Gerhaert and was also affected by Italian painting, not far to the south. In fact, Pacher painted the wings for his altarpiece with ingenious applications of Mante-

The city of Ulm, not far from the Upper Rhine, was important in sculpture, having been the home of Multscher and of Gerhaert's talented admirer Jörg Syrlin. The masterpiece of Gregor Erhart (docs. 1494–1520) is the Blaubeuren altarpiece (1493–94),[47] with a grandiose row of saints swaying in gentle volume, but concentrating their mass into insistent, expressive gestures. The sculpture of Gregor's father Michael Erhart is of uncertain identification, and it may be that Gregor is only a reflection of him.

The one notable master in Würzburg, Tilmann Riemenschneider (docs. 1483–d.1531), carves with a craft perfection so refined that his figures suggest cut jewels; they pay homage to Syrlin's prismatic planes in the tilted, dainty precision of their realistic, even jowly faces (fig. 416). It is typical that he tried out many materials, even alabaster, and that his wood figures, in contrast to earlier practice, were meant to be seen unpainted, and so apparently to give up some of their human illusion, asserting instead the mannered end of a tradition. Certainly a comparison between them and those of his great contemporary Veit Stoss in Nuremberg (see p. 335) is between the polished elegance of an old culture and the

gna's perspective tricks, extending them to bizarre logical conclusions with provincial literalness. His sculpture absorbs spatial ideas more effectively. The altarpiece blends into the building; the figures and tendril-like ornament in the deep box frames are conditioned by shadow, which in turn is modified by the painting and gilding of the statues. Thus Pacher's work is architectural, sculptural, and pictorial, but in essence theatrical, a ritual tableau. It is the greatest instance of the use of statues in dramatic groups, common at this time in France and Italy too.

417. NIKOLAUS HAGENAUER. *St. Anthony with Sts. Augustine and Jerome,* center of Isenheim Altarpiece (third view). Painted wood, 9′10″ × 10′9″. Unterlinden Museum, Colmar (see colorplate 51)

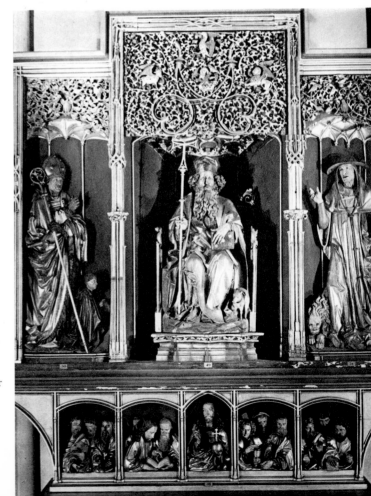

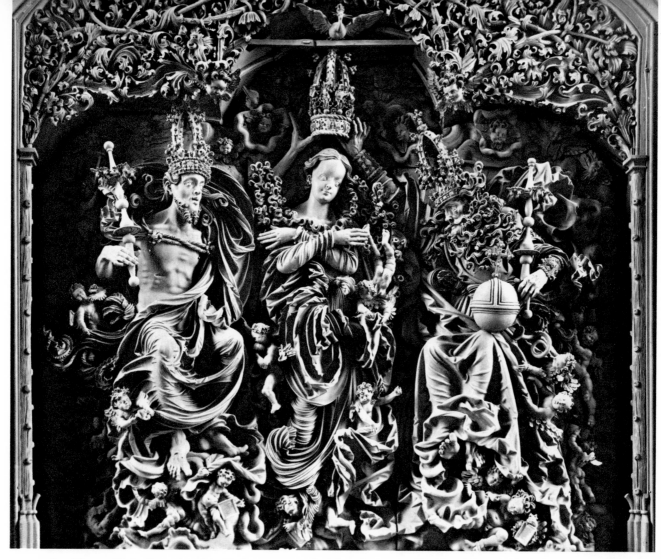

418. MASTER H. L. *Coronation of the Virgin*, center panel of altarpiece. 1523. Wood, 13'9" × 11'11". Cathedral, Breisach

uncouth life of the future. But the power of Riemenschneider's absolute precision is a magnet to some artists even in later generations.

Nikolaus Hagenauer (docs. 1493–1526) carved the altarpiece in Isenheim (fig. 417) whose wings Grünewald was to paint later (see colorplates 51, 52; fig. 434). In it, just as in Pacher's altarpiece, a jungle growth of abstracted vegetable ornament clashes with shockingly realistic faces. But in Hagenauer's there is no light gleam to make a transition, only a certain stiffness in the figures that abstracts them somewhat, too, so that the strongest over-all effect is of a huge flat symmetrical ornament. Still later (1523; fig. 418) in nearby Breisach, the Master

H. L. could fill a carved altarpiece with robes that corkscrew around arms and legs in parallel patterns such that they absorb the bodies into their formula, like the Book of Kells; the whole becomes a mannered fantasy remote from human life, real only in the explosive caperings of line. The Master H. L. is only the most conspicuous of many carvers in remote areas. East of Vienna Andreas Morgenstern produced (1516–25) an equally elaborate and enormous altarpiece.[48] Their art reminds us of the emergence in the same locales of such folk-art expressions as Passion plays and embroidered costumes, produced with an intensity of detailed care, dedicated formalizations of earlier urban styles.

333

25. Nuremberg and Its Sculptors

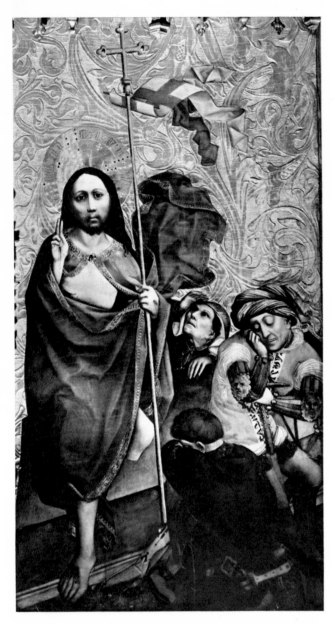

419. *Resurrection*, right side of center panel of Tucher Altarpiece. 69 1/2″ × 43″. Church of Our Lady, Nuremberg

Most German art in the fifteenth century appears in cities on its western or southern edges near the Danube or Rhine, which either had a medieval tradition like Strasbourg and Cologne or were new commercial towns like Ulm. But Ulm's strong succession of sculptors, from Master Hartmann to Multscher, Syrlin, and Gregor Erhart, is shortly surpassed by Nuremberg's, which had hardly any past (its well-known "medieval center" is of the fifteenth and sixteenth centuries). A center of trade routes from Italy and the Netherlands, and a metal manufacturing city which did much to develop the clock, Nuremberg is in east central Germany, far from the traditional leading centers, except Prague.

Its painting was dominated by the usual local imitators of Rogier van der Weyden, the sophisticated Hans Pleydenwurff (docs. 1457–d.1472) and the cruder, prolific Michael Wolgemut (1434–1519). But there is a surprising secondary tradition, led by the unusual Master of the Tucher Altarpiece (fig. 419), whose patrons were the most prominent family. His figures are clumsy and inarticulate, but he strains to make them muscular and solid, with crowd pressures that show an admiration for the Master of Flémalle which parallels Hans Multscher's, that is, for sculpture-oriented painting. This rougher vein persists in a small way later in Bamberg and Würzburg, two lesser towns of the region, and in the bumpy wooden people painted by Jan Polack (docs. 1482–d.1519) in what was then the minor city of Munich. In Bamberg we are shown narratives of blood and torture, with figures attacking each other crudely, but with rich implications for sculpture.[49] And the earlier sculptures in Nuremberg (see figs. 401, 403), the informally plump *Madonna* at Saint Sebald and the twisting, burdened *Saint Christopher* of 1442, had implied the most distinctive style of any German city, roughly vigorous, with irregular strong shapes and physical impact.

This then becomes the style of a great master, Veit Stoss (docs. 1477–d.1533). He left Nuremberg to practice it, reflecting the dominance of the other tradition, and went to Cracow in Poland. For the German church there he produced his first master-

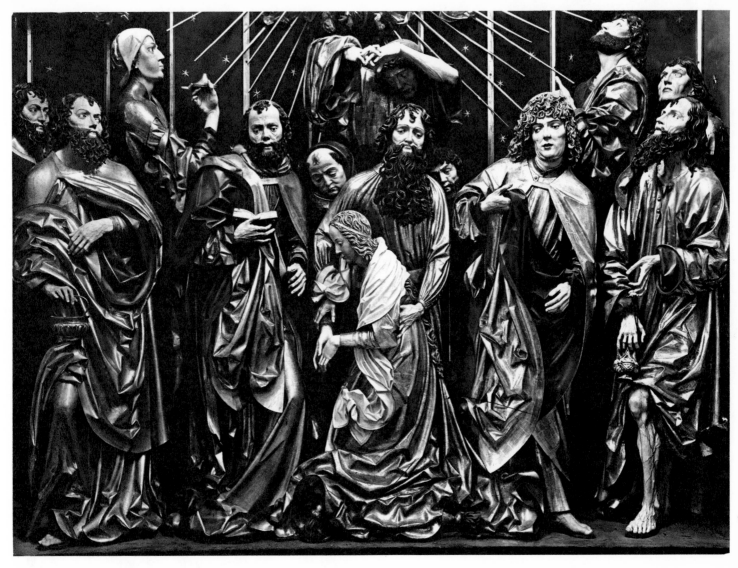

420. VEIT STOSS. *Death of the Virgin*, center panel of altarpiece (lower portion). 1477–89. Painted wood, about 13′4″ × 18′. St. Mary, Cracow

piece (1477–89; fig. 420), the hugest of all the wooden altarpieces, forty feet by thirty-five. It is not the usual series of enthroned saints but an asymmetrical event, the death of the Virgin; she is surrounded by the apostles, big lumbering men trying to help. In general this matches the trend of the moment—Gerhaert's spatial incisiveness slowed down by the dignity of Multscher—but it is overwhelmingly more powerful in weight and life than all other candidates. Only Pacher competes, and Stoss, like him, paints large areas, giving the faces a waxy, molded naturalism. (But he uses little ornament and no gilding.) The small side panels with figures and landscape are in very low relief, as if pressed flat, so that the color in them creates an odd conflict of sculptural and pictorial energies. The idea that

Stoss might be called not a polychrome sculptor but a three-dimensional painter seems confirmed by his engravings, rough echoes of Schongauer.

He continued to have a difficult life after returning to Nuremberg; he was convicted of forging a financial document and branded on both cheeks. Pardoned by the emperor, he carved two more masterpieces at the end of his life. The *Annunciation* (1517–18; fig. 421) consists of two statues inside an immense wreath, the whole suspended in the air from the vault of Saint Lorenz; it might be regarded as a variation on a wooden altarpiece (like Bernt Notke's *Saint George*; see fig. 405). It too is ambiguous between the carved and the flat, since the openwork wreath offers an essentially two-dimensional effect. His altarpiece of the Virgin (1520–23)[50] is

421. VEIT STOSS.
Annunciation. 1517–18.
Painted wood, 12′2″ × 10′6″.
St. Lorenz, Nuremberg

still asymmetrical but quieter, even classical in its simple cylindrical shapes, under the influence of younger talents like Peter Vischer and Dürer.

Only Nuremberg at this time produced sculptors in media other than wood. Adam Krafft, a stoneworker (docs. 1490–d.1509), began by copying a painting, and later shows a very belated derivation from the routine types of the Parler workshop, once the dominant producer of stone figures in the region and without a successor in the interim (see p. 285). But as a craftsman, in the new city self-consciously led by skilled shopowners (such as the shoemaker-

423. ADAM KRAFFT. *The Weighmaster*, relief over the door of the Municipal Weighing House, Nuremberg. 1497. Stone, width 5′11″

422. ADAM KRAFFT. *Self-portrait*, from Sacramental Shrine. 1493–96.
Sandstone, height 35″.
St. Lorenz, Nuremberg

COLORPLATE 49. JEAN FOUQUET. *The Fall of Jericho*, illuminated page in Josephus' *Antiquités Judaïques*. c.1470. Vellum, 17″ × 12″. Bibliothèque Nationale, Paris

COLORPLATE 50. MICHAEL PACHER. High Altar, with *Coronation of the Virgin*. 1471–81.
Painted and gilded wood, 12′9″ × 10′9″. Church, St. Wolfgang

COLORPLATE 51. MATTHIAS GRÜNEWALD. *Crucifixion*,
center panel of Isenheim Altarpiece
(first view). 1515. 9′10″ × 10′9″.
Unterlinden Museum, Colmar

COLORPLATE 52. MATTHIAS GRÜNEWALD. *Resurrection,*
right wing of Isenheim Altarpiece (second view).
1515. Panel, 9′10″ × 5′4″.
Unterlinden Museum, Colmar

424. PETER VISCHER.
Man Breaking a Stick of Wood. 1490.
Bronze, height 14″. National Museum, Munich

425. PETER VISCHER.
St. Thaddeus, from the
tomb of St. Sebald.
1508–19. Bronze,
height about 36″.
St. Sebald, Nuremberg

426. PETER VISCHER.
King Arthur, from the
tomb of Emperor
Maximilian. 1513.
Bronze, lifesize.
Hofkirche, Innsbruck

poet Hans Sachs), Krafft can suddenly evoke the early capitalist tone of his environment. His sacramental shrine in Saint Lorenz (1493–96) is a pure Flamboyant Gothic pinnacle filled with Parler-like figures, but the base is carried on the shoulders of stumpy figures who are the artist and his helpers (fig. 422), skilled laborers in their aprons though still, to be sure, types like Parler's portraits. The carving over the door of the municipal weighing house (1497; fig. 423) is a graphic scene of a weighmaster physically establishing a just price for some goods and a buyer accepting it, an implicit definition of what is postulated by Renaissance cities and art from Giotto on.

While exploiting nearby tin and copper mines, Nuremberg also produced the first great bronze sculptor of the northern Renaissance. (There were earlier individual works.) Peter Vischer the Elder (docs. 1487–d.1529), seeking to secure the big commission for the shrine at the tomb of Saint Sebald, presented as a test piece a small figure of a man on one knee (1490; fig. 424). This is genre as vivid as

his friend Krafft's self-portrait, and like it implies supporting something on a shoulder, but of a different style. It translates bodily naturalism into a compositional rhythm, going from prose reality to the intense order of rhyme, which means that it is not Flemish but Italian. And just then the independent small bronze was developing in Padua, near Venice, where Nuremberg merchants were always to be found (see p. 186). When, after a career on smaller tombs, Vischer did begin the Saint Sebald shrine (1507), he surrounded it with saints who stand with the simplest dignity (fig. 425). They are clear vertical cylinders, with regular horizontal folds, supporting faces that are classical in their openness; this approach is a masterly reworking from such stimuli as Pietro Lombardo (see p. 131). In Germany it was revolutionary, and its capacity to yield anthology pieces is illustrated by two big bronzes of Emperor Maximilian's ancestors, including King Arthur (1513; fig. 426), that Vischer contributed to the emperor's Innsbruck mausoleum, perhaps using a design of Dürer's—two in a procession of royal forebears that are the overgrown descendents of Sluter's mourners.

26. Dürer

427. ALBRECHT DÜRER. *The Four Horsemen*,
from the Apocalypse series. 1498.
Woodcut, 15″ × 11″

Albrecht Dürer of Nuremberg (1471–1528), though apprenticed to Michael Wolgemut, hardly relates at all to older German painting. He is a product of its printmaking and of the special Nuremberg achievements in sculpture. Wolgemut's most remarkable act was to be the first painter to design woodcuts, upgrading them from their cheap tradition. His apprentice quickly learned the skill, and earned a living as an illustrator for publishers when he made his first trip away, at twenty-one, to the Rhine cities. His designs, cut in the woodblock by other craftsmen, have the traditional flat stiffness. But the trip also confronted him with the far more sophisticated metal prints by the Hausbuch Master, which he echoed in his own first engravings, and by Schongauer, whom he adopted as a model for impeccable technique and the Rogierian vocabulary of figure action. The result is his first masterpiece, the Apocalypse series (1498; fig. 427), one of the world's unforgettable sequences of images. It consists of fifteen woodcuts, full-page illustrations of a book he published himself in Nuremberg. Like no woodcuts before, they are executed with engraving-like suppleness and complexity. Such grandeur

428. ALBRECHT DÜRER. *View of Trent.*
Watercolor, 6″×9″.
Kunsthalle, Bremen

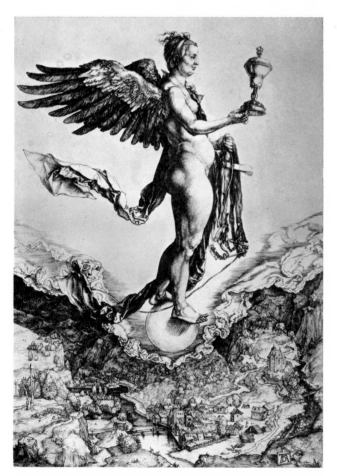

429. ALBRECHT DÜRER. *Nemesis.*
Engraving, 13″×9″.
Metropolitan Museum of Art, New York.
Fletcher Fund, 1919

and active power in Rogierian figures had appeared before only in Veit Stoss. The theme is Saint John's vision of the end of the world, a matter of popular anxiety near the magic date 1500, as works by Signorelli and Botticelli also attest (see figs. 150, 156). The old problem of portraying the supernatural in a realistic style demands that we react to the vision as beyond nature, but still be convinced of every object. Dürer emphasizes the flatness of the black-and-white pages with vertical compositions, but makes the details rich. This Eyckian principle of "imaginary gardens with real toads in them" is exemplified when the famous *Four Horsemen* stretch through unreal space so keenly that we run with them, or in *Saint John Eating His Book,* where Dürer exploits literally the words in the text that the angel's legs were "like columns."

The only available means Dürer had not yet used and enlarged was the Italian clear order visible in Peter Vischer. In 1495 he visited Venice, and on the trip sketched the Alps in watercolor (fig. 428). This is part of his pleasure in recording everything —costumes, flowers, fish—but it also results in the earliest pure pictorial landscapes, optical unities rather than topographic records. (But, as sketches, they are meant to appear in public only as backgrounds.) After the visit his paintings and engravings develop his lifelong device of explicitly playing Italian and northern methods of rendering against each other in one image. This is the first of the ways in which Dürer adds to his simple visual fertility the visible effects of planning and theorizing. Among his female nudes (a favorite Venetian theme) the most remarkable is the engraved *Nemesis* (fig. 429), the allegory of retribution, shown standing in absolute profile, thus geometric and classical, in a sky above an incredibly detailed Eyckian panoramic landscape: the world as experience, under a psychological law. The *Vision of Saint Eustace* (fig. 430), the largest engraving he ever made, offers the same doubleness in a profile of a classical horse (which is Christian order) in a jungle landscape of cliff and forest (which is pagan disorder). Its paradigm is *Adam and Eve* (1504), a study of anatomical proportion like Pollaiuolo's engraving of battling men, with a backdrop of foliage like his but far more detailed and sharp. In the prolific years 1504–12 Dürer produced several sequences in woodcut and engraving of the lives of Christ and Mary, constantly inventive in dramatic motifs and steadily

343

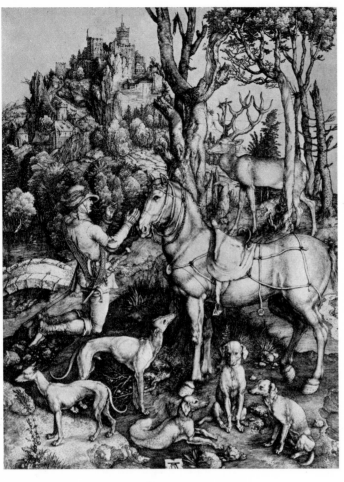

430. ALBRECHT DÜRER.
The Vision of St. Eustace.
Engraving, 14″ × 10″.
Metropolitan Museum of Art, New York.
Fletcher Fund, 1919

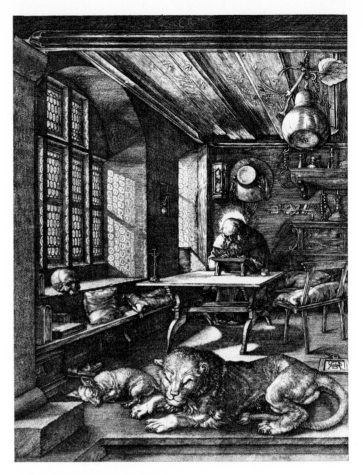

431. ALBRECHT DÜRER.
St. Jerome in His Study. 1514.
Engraving, 10″ × 7″

more subtle in working light into the linear medium. White areas no longer contrast with black borders, the surface becomes instead a continuous net of lines of varying density, and thus moves from an early Renaissance to a High Renaissance pictorial style, without diminishing crisp precision. These are also the years of his most ambitious paintings, an altarpiece[51] on a second trip to Venice in 1506 (where the artists treated him as the greatest of printmakers but did not accept his painting), and a lost *Assumption of the Virgin* (1509)[52] for a citizen of Frankfurt, known best today because many needle-fine preparatory drawings for it in-

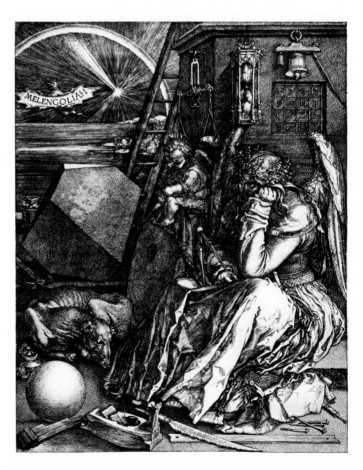

432. ALBRECHT DÜRER.
Melencolia I. 1514.
Engraving, 9″ × 6 1/2″

cluded one for the hands of a kneeling apostle. This has now become sentimentally isolated and famous as "Dürer's *Praying Hands,*" as if it had no context.

Three famous engravings of 1513–14 mark the peak of Dürer's technical mastery and his fertile collision of local styles. In *Knight, Death, and Devil* the knight, in clear profile and thus clear in his ideal aims, ignores the shadowy monsters in the forest about him. They are fantastic amalgams of texturally real details, with action more lifelike than the knight's, but the focuses of light and design are able to make his abstract figure more solid and convincing than the empirical ones. The imagery of a hero's internal self-confidence parallels

the recently published *Handbook of a Christian Knight* by Erasmus of Rotterdam,[53] who called for personal rational virtue as a response to the world's corruption. The other two engravings also have life styles as their themes. *Saint Jerome in His Study* (fig. 431) reports the balance and contentment of the life of the mind through the thinker in his Eyckian room, extraordinarily warm with sunlit plaster and worn wood, insistently exact in perspective. To this the complement is *Melencolia I* (fig. 432), a title alluding to the medieval and Renaissance medical concept which assigned everyone to one of four temperaments: the melancholic was connected with cold and dry bodies and minds,

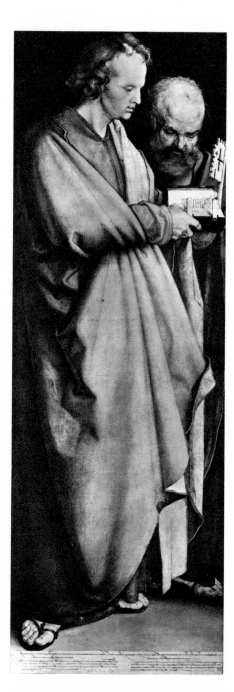
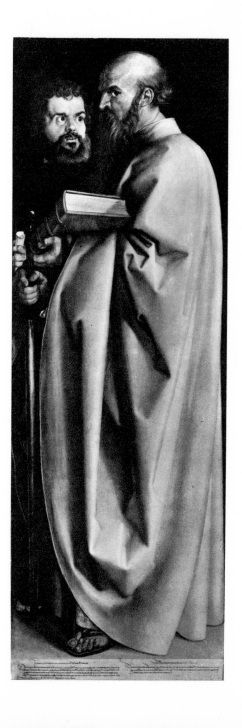

433. ALBRECHT DÜRER.
Four Apostles. 1526.
Two panels, each 85″ × 30″.
Alte Pinakothek,
Munich

with depression and insanity, with work involving geometry and construction (whose tools we are shown), and sometimes with artists. The allegorical figure carrying these references is as awkwardly heavy and incapable as some of Michelangelo's, and was perhaps suggested by his *Jeremiah* (see colorplate 27). Melencolia lives in a definite but disturbing world, the converse of Saint Jerome's. Dürer was now working also on his books on human proportion and perspective which, when successfully published in 1525 and 1528,[54] modified the strict rules of his youthful Italian experience to approximations and options.

In 1515 the famous artist was engaged full time by Emperor Maximilian, who wanted elaborate monuments to himself. Like the huge bronze tomb on which Vischer was at work, they have a natural emphasis on the Habsburg genealogy. Dürer was to make books of woodcuts for him, a form of glorification perhaps natural in the literary and typographical context of German humanism, but none of the projects was finished when the emperor died in 1519. Dürer's last years glorify instead the ideas of Martin Luther and, with his genius for making intellectual attitudes visible, they produce the first great Protestant art. Like some other great artists' late work, Dürer's turns to elementary statements, so simple and declarative that at first they seem disappointingly like ordinary generalizations. A drawing of boats on a beach,[55] a souvenir of a

trip to Flanders, has an architectonic simplicity less like Ruysdael than Van Gogh. Figures cease to exert pressure, and stand as large bare forms, not in academic perfection like Fra Bartolommeo's but with the minimal pure dignity that makes no claims, not even that one. It is not puritanical, as has been said, but evangelical. It is illustrated by a woodcut *Last Supper* (1523) which omits the sacrificial food to illustrate Luther's view that church sacrifices do not literally repeat Christ's sacrifice, and most famously by the *Four Apostles* (1526; fig. 433). Dürer gave these paintings to his native city, with an inscription about avoiding false prophets. They stand with the clear-eyed absolute presence of Masaccio, powerful because they exist. Yet in general Dürer is the only great artist whose prints are far more important than his other works. His being German made this both possible, because of the printmaking tradition there, and necessary, because a German artist could only become famous enough to be called great if his work circulated elsewhere. Dürer's work was mainly produced not for patrons, but offered to the public by him as publisher; it was thus that he chose his own subjects, which turn out to be conspicuously an intellectual's notations on the qualities of an intellectual's life. This is more typical of modern art than of the Renaissance, but the style in which he communicates it is deeply imbedded in familiar traditions, forcibly reoriented by his skill and power.

27. Grünewald

Following the constellation of sculptors one generation before, the years 1470–80 saw the births of the greatest group of painters in German history: Dürer, Cranach, Altdorfer, Grünewald. All had roots in the area around Nuremberg (Franconia), though some worked elsewhere. Matthias Grünewald (docs. 1503–d.1528) is known through about ten surviving paintings, of which just one, the Isenheim altarpiece (1515; colorplates 51, 52; fig. 434), is world famous—indeed, only part of it is. With a few other Renaissance artists, like the Master of the Avignon *Pietà,* Pontormo, and Rosso, Grüne-

wald is today the beneficiary of our awed response to an art that approached tragic violence through distortion. We err, it should be repeated, if we respond to the distortion as if it were the artist's personal statement of tragedy. Renaissance artists' stylistic languages represent the tragic, the happy, and the comic too, with modulations of detail to articulate each as called for. Such a commitment to themes assigned by clients is still familiar to us today in actors, architects, and others. In cases when the artist's language was a rather unrealistic one, and when it was being used for a painting on a

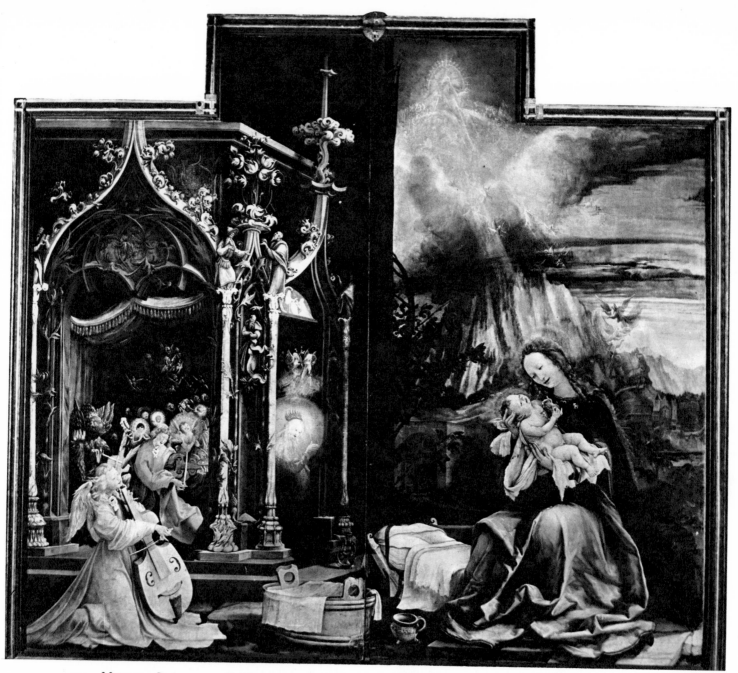

434. MATTHIAS GRÜNEWALD. *Nativity*, center panel of Isenheim Altarpiece (second view). 1515. 9′10″ × 10′9″. Unterlinden Museum, Colmar

tragic theme, we react with suddenly greater warmth because it seems to match our own idea of painting, which calls for a tragic theme (if there is any human theme) and an unrealistic style, and has its stimulus in private feeling. We readily take the Renaissance work to have a like personal stimulus, and we tend to look less at the artist's nontragic work in the same style. We should not consider the Renaissance artist insincere for accepting all his clients' themes, and giving them a full expression, but rather note our own inconsistency in denying to painters the behavior we take for granted in actors. The change

to personalism in modern painters is somewhat like the change in an actor who becomes a star and acts chiefly himself.

Grünewald was brought up in Würzburg, not far from Nuremberg, and the area where works like an anonymous Rothenburg altarpiece of 1494[56] belong to the tendency to a crude and vehement art (see p. 334) that precedes Veit Stoss. In his *Mocking of Christ*[57] he retains its brutality of thick bodies colliding in little or no space, but paints thick soft High Renaissance people instead of hard angular ones. Their fatty, succulent forms with a texture

347

like plastic emulsion, swollen cheeks, and pudgy fingers, fluttering in thin, vibrating clothes, will become his trademark. It is a painter's reworking of the basic emphasis of Stoss and of Dürer's Apocalypse series; Grünewald replaces incisive drawing with strange, dazzling light, unharmonious yet soft. In the Isenheim altarpiece raspberry reds press against milky blues, the face of a fainting figure is plastery, in the *Resurrection* a miraculous light of chicken-broth tone dissolves the body.

The Isenheim altarpiece was painted for a hospital chapel run by the monastic order of Saint Anthony Abbot, a hermit. It is so splendid that it not only shows the painted backs of the hinged wings (on weekdays), and the open center and the fronts of these wings (on Sundays), but is opened further (on great holidays) to show the innermost surface, painted wings and Nikolaus Hagenauer's carvings (see fig. 417). The weekday image is a *Crucifixion* (colorplate 51), painted with a more than Flemish medical realism of color; the dying Christ has a green skin covered with sores, he claws with his fingers, plaster-faced Mary faints, all against a black sky. But on Sundays in the *Nativity* a plump, smiling Mary holds a preciously smiling fat Child

(fig. 434), and Grünewald's succulent world takes the form of a jungle-thick rose garden beside a chapel, whose Gothic tracery resembles climbing roses. This is equally typical of Grünewald's fantasy, as is the *Resurrection* next to it (colorplate 52). In the innermost wings Saint Anthony appears, once tossed about in his temptation, attacked by fatty slugs and other forms of sensual nastiness, and once calmly meditating, along with Saint Paul the Hermit, in a fir forest of thickly silhouetted drooping branches.

The artist's smaller paintings are variants of either this *Crucifixion* or this *Madonna*. Though only paintings and drawings survive, he was also a professional hydraulic engineer, which seems to suggest his concrete concern with materials, such as pigments. Though apparently an intense Protestant, he, like Dürer, worked for the cardinal of Mainz, Luther's foremost antagonist; he lived obscurely in the Mainz diocese, in two small towns halfway between Würzburg and the Rhine. Grünewald is an up-to-date explorer of expressive human bodies, differing from the many others in experimental sensibility of light and color, and matched in his time perhaps only by Correggio.

28. Cranach and Altdorfer

Lucas Cranach the Elder (1472–1553) was born about sixty miles north of Nuremberg, but was in Austria by the time he painted his first surviving work at thirty; it is impressively innovative (fig. 435). The *Crucifixion* is given a quarter turn, and we see Christ in profile and one thief partly from the back. This idea was perhaps developed from the odd-angle perspective of Mantegna, introduced into Austria by Pacher and at the time still being practiced there by his school. But Cranach removes the linear tightness that had been used to support the logical persuasiveness of such compositions, and substitutes a High Renaissance concern for light, pasty color, and landscape, so that we seem accidental arrivals on the scene. The shock effect is increased by the subject, since the Crucifixion has a ritual tradition of fixity to an unusual degree. (Similar

color and landscape, without the spatial twists, were being explored at the time by minor painters in this area, Hans Fries in Switzerland [docs. 1480–1518] and Rueland Frueauf the Younger in Austria [docs. 1498–1545].) Cranach's early masterpiece, the portrait of the Viennese professor Cuspinian (fig. 436), again plunges a traditional scheme into light and landscape. The sitter turns to look up, a natural response to being surrounded by wooded hills; this sensuous base in nature for life and events soon becomes stabilized among the artists grouped today in the Danube school.

Cranach's early style lived on for some time in his rough, emphatic woodcuts, but his painting changed abruptly in 1505 when he went to far-off Wittenberg in northeast Germany, accepting the elector of Saxony's invitation to be court artist. He

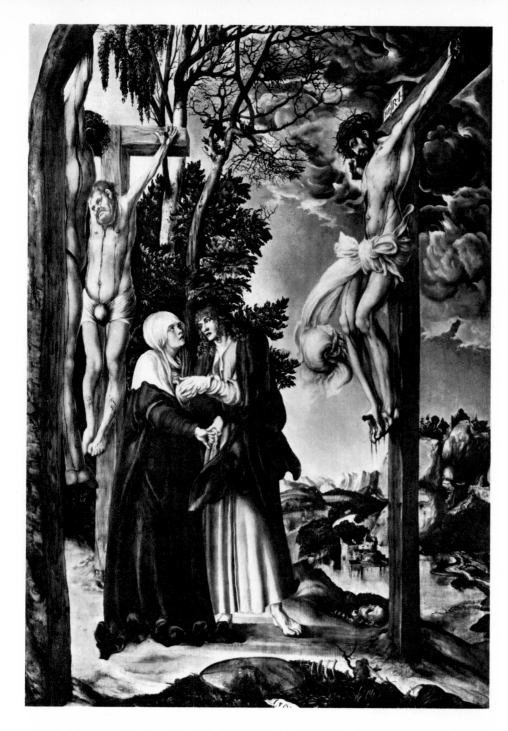

435. LUCAS CRANACH.
The Crucifixion. 1503.
Panel, 54″ × 43″.
Alte Pinakothek, Munich

lived and prospered there for many years, even being mayor. The elector's great protégé was Martin Luther, and Cranach was Luther's friend from the start, one of the three witnesses at his wedding. The Reformation cut off demand for altarpieces, which had been the mainstay of German artists; Luther did not oppose church paintings, only their veneration, but Protestant churches largely excluded them. In rare cases new religious images appear, such as "Suffer the little children to come unto me" painted several times by Cranach, supporting the Protestant emphasis on man's relation to God without a mediating clergy. In general Cranach was the first artist to practice in a society interested only in secular art. The result bears an astonishing likeness to the poverty of commissioned art in the nineteenth century (that is, excluding artists' spontaneous work or display pieces for exhibitions). It becomes reduced to specialties, notably portraits, which Cranach's shop produced in vast numbers, including many of Luther and the electors, the latter works mass-produced to the point of having printed captions. The other specialty is erotic, including titillating anecdotes (Lot and His Daughters, Hercules and Omphale), but chiefly nudes adorned only with necklaces, big hats, or transparent veils (fig. 437)—apparently here, as later, the escape hatch for tight ethical codes—and labeled as

warnings of what to avoid. These too are mass-produced in a hard, mechanical style and a simplified formula, with a sinuous silhouette and stylish elongation that seem to derive from Parmigianino.

Albrecht Altdorfer (docs. 1505–d.1538) is the artist of Regensburg, on the Upper Danube, sixty miles south of Nuremberg. His starting point is Cranach's early sensuous landscape. Tiny paintings, and drawings quickly scratched on colored paper (a technique invented shortly before by a local printmaker), emphasize the vital influence of environment on human acts. Lovers seated in a field, a family of satyrs, Saint Nicholas calming a storm, and Saint George slaying the dragon (fig. 438)—a minute figure in a forest, the whole surface dominated by shimmering foliage—all these people are absorbed into the inviting, beautiful landscape. Their moods, dreamy or alert, reflect the tone of nature, so that they are basically similar to Giorgione's people in the *Tempest* (see colorplate 29). Altdorfer's *Nativity*[58] shows a ruined brick house

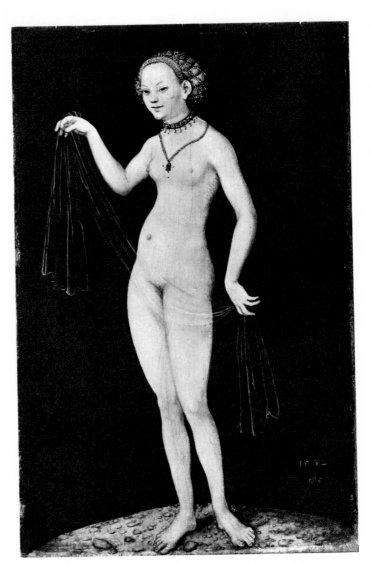

437. LUCAS CRANACH. *Venus.* 1532.
Panel, 15″ × 10″.
Städel Institut, Frankfurt

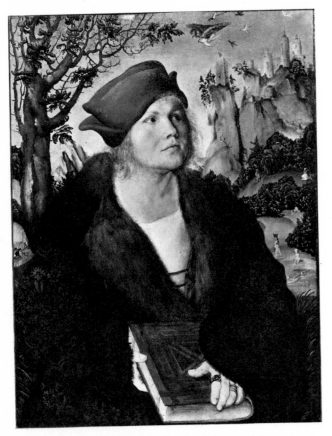

436. LUCAS CRANACH. *Dr. Cuspinian.*
Panel, 23″ × 18″.
Oskar Reinhart Collection, Winterthur

in elaborate perspective, made to vibrate luminously by the fine white lines of the mortar, and the Holy Family crouching in a shadowy corner. This is a fatalistic art, not in the depressive sense but in an organic and even elegant tone: strength is not in individual purpose but in the lushness of inevitable movement through the seasons. Later this art grows more architectural, as in the famous woodcut of the *Holy Family by the Fountain* (fig. 439), a design of a huge construction with the people squashed at the side. Altdorfer was in fact the city architect of Regensburg (as well as a long-time city councilman). About 1520 he suddenly produced a series of pure landscape etchings, with Alpine panoramas

350

and fir trees as in his other works, but in the more loosely scrawled line natural in this technique. These seem to be the first pure landscapes in Western art that are autonomous objects and meant to be public; as Altdorfer's few other etchings are equally special cases, he was clearly aware of being experimental here. (Etchings had been made from about 1510, but these are the first in which the style is based on the technique; the earlier ones were imitations of engravings.)

438. ALBRECHT ALTDORFER.
St. George in a Wood. 1510.
Parchment on panel, 11″×9″.
Alte Pinakothek, Munich

His altarpieces of later years are more conventional, the large figures being mannered in their heavy loud color and wriggling outlines like clay figurines; but it is still evocative when Christ, in the *Resurrection,* [59] is swept up from a deep landscape into an orange and blue sky. In his one large secular painting Altdorfer produced his late masterpiece (1529; colorplate 53), the *Battle of Alexander*

and Darius, part of a set of ancient heroes ordered by the duke of Bavaria from many artists. There is no fighting, but hundreds of men move in streams which are diagramed for us by the direction of thrust of their hundreds of glinting spears, like a river under the wild sky. From a starting point near Giorgione, Altdorfer ends by anticipating the human herds of Bruegel.

Hans Leinberger (docs. 1513–1530), the finest sculptor in this generation of great painters, also belongs to the Danube area and style. Working in small towns, he produces Madonna images having mannered artificial life, based on sharp ropy rhythms and nervous two-dimensional silhouettes, less like other sculpture than like an Altdorfer drawing. Far from being provincial, Leinberger experimented with the new fashionable medium of the small bronze. These delicate nonsculptural effects are analogous to those of his only rival in his generation, Hans Backoffen (d. 1519), a tomb sculp-

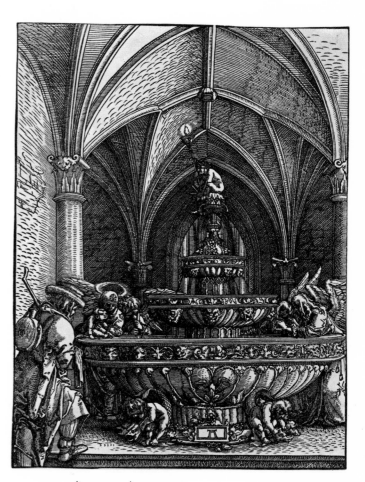

439. ALBRECHT ALTDORFER.
The Holy Family by the Fountain.
Woodcut, 9″×7″

351

tor in Mainz, and symptomize the abrupt decline of sculpture. This extreme of daintiness, based on immense skill, seems to have a final fling in Benedikt Dreyer (docs. 1507–1555), a fantastic artist in Lübeck on the Baltic coast (fig. 440). He has an affinity with the earlier Lübeck master Bernt Notke (see fig. 405), and there was an intermediate tradition of Lübeck carvers, but his stimulus in style is from the south. He treats wood like wax, pulling and twisting it and leaving perverse hollows so that his figures are both decorative inventions and carriers of soulful pressure, again like a phase of Parmigianino. All this makes a provocative analogy with the contemporary mannered country sculpture of the Master H. L. and others; they are two parallel lines and do not meet.

440. BENEDIKT DREYER. *St. Michael.*
Wood, height about 60″.
St. Mary, Lübeck

29. Dürer Pupils and Other Painters

By 1520 regional distinctions in German art were almost obsolete, and the main forces were the drawing style of Dürer's woodcuts (fewer engravings were being done), the Danube landscape mood, and the prestige of Italy. There was no second group of great individuals like the painters born about 1470–80; the one great painter, Holbein, and the most distinctive sculptor, Conrad Meit, are both exceptions who prove the rule by emigrating. A seal was set on this sudden decline in 1530 when radical Protestant groups burned church paintings in various cities. "German sixteenth-century painting" means work of the first third of the century; the

sheer quantitative drop after that date seems unique in the history of art.

The most brilliant of Dürer's early pupils was Hans Suess von Kulmbach (docs. 1501–d.1522). He was faithful to Dürer in his strong woodcut line but perhaps was more naturally a painter, and affected by the warm glow of Venetian color. These qualities make him the most impressive designer of stained-glass windows in the Renaissance. His most interesting difference from Dürer is that his figures, with their cubic breadth and tremolo of outline, are able to fuse the Italian and northern craft traditions which in Dürer had always remain-

ed separate. That is presumably because Dürer
had had to struggle with the Italian ideas, and Hans
could absorb them as an apprentice.

Hans Baldung Grien (docs. 1507–d.1545) of
Strasbourg was certainly the most original of the
Dürer pupils. Along with rather conventional
church paintings, and woodcuts hard to distinguish
from Dürer's own, he produced strange small paint-
ings intense in color, woodcuts often in color too,
and finished drawings of scenes, all with themes of
haunted stress: Death seizing a woman who tears
off her clothes (fig. 441), a witches' sabbath with
bony crones in an Altdorfer fir forest (1510),[60] the
famous woodcut of the stableboy stretched on the
floor, apparently knocked unconscious by a be-
witched horse (1544; fig. 442), and among religious

442. HANS BALDUNG GRIEN.
The Bewitched Stableboy. 1544.
Woodcut, 14″×8″

441. HANS BALDUNG GRIEN.
Death Seizing a Woman.
Panel, 12″×7″.
Kunstmuseum, Basel

images the limp corpse of Christ hauled up to
Heaven by a crew of little angels (1519).[61] The
figure drawing is Dürer's, but the mood projects a
fatalism opposite to Altdorfer's, of men not part of
the flow of nature but the victims of unnatural
powers. This imagery of battered fear truly shows
the temperament often less properly ascribed to
Grünewald, and its small private scale reveals the
important impact upon Baldung of his greatest
predecessor in the Strasbourg region, the Hausbuch
Master (see p. 330), with an amplified pressure
that has lost the Master's civilized irony. The pri-
vacy also allowed Baldung, alone among German
painters, to remain creative after the burning of
church pictures.

A less-known Rhineland painter of violent

443. JERG RATGEB.
The Flagellation,
from Herrenberger Altarpiece.
1519. Panel, 8′10″ × 4′11″.
Staatsgalerie, Stuttgart

imagination is Jerg Ratgeb (docs. 1508–d. 1526). His tall Gothic altarpiece panels are old-fashioned, but his formations of architectural space and active people are acutely dramatic in a modern way. To behead the female martyr the executioner pulls her hair up;[62] the balconies of Pilate's palace, up endless stories, are filled with faces peering at Christ's scourging, as in a Piranesi prison (1519;

fig. 443); when the Christ Child is circumcised, He screams.[63] This is less up-to-date than Baldung only because the fantasy belongs to storytelling rather than introspection.

Virtual copyists of Altdorfer are a series of artists who draw and etch the same Alps and fir trees, and thus disseminate the pure landscape widely. Wolf Huber (docs. 1515–d. 1553), who in his

444. Urs Graf.
Soldiers on the Road. 1516.
Pen, 12 1/2″ × 9 1/2″.
Kupferstichkabinett, Basel

445. Hans Burgkmair.
The Weisskunig Visits an Artist,
illustration in *Der Weisskunig,*
by Emperor Maximilian. Woodcut, 9″ × 8″

paintings repeats Altdorfer's clayey modeling and fluid translucency, provided drawings for the multi-faceted craftsman Augustin Hirschvogel (1503–1553) to turn into prints, and Hans Sebald Lautensack (b. 1524–docs. 1561) worked the same vein. At a date when most German painting was repetitious their sketches seem fresh, especially to our landscape-oriented eyes.

Somewhat less literal analogies to Altdorfer recur among Swiss artists. They surround us with ornamentally rich nature when they paint Orpheus playing to the animals on a luminous fir-covered hillside (1519, by Hans Leu; docs. 1510–d.1531),[64] the dead Pyramus mourned by Thisbe,[65] and Saint John beheaded in front of a rainbow (both by Nicolas Manuel Deutsch; docs. 1509–d.1530);[66] or they use quick curly pen lines to draw soldiers in slashed sleeves and pants (fig. 444), with a bitter caricaturing vehemence that reflects the Swiss trade of mercenary soldiering at the time (Urs Graf; docs. 1503–d. 1527/28). Indeed there is also a flavor of Baldung in such a drawing as Graf's young pregnant woman smiling as she walks past a hanged man.[67]

When these Swiss painters move away from Altdorfer by stabilizing their people with symmetrical ornament, they recall the painting being done in the only city that was now emerging as a new regional center, Augsburg. It was Emperor Maximilian's favorite residence, and its leading artist, Hans Burgkmair (1473–1531), was the most Italianate in his generation. He likes broad simple spaces and large undetailed figures, but his bent is more obvious in superficial copying of Italian decorative flourishes on costumes, buildings, and door frames (fig. 445). This Italianism of his has perhaps inflated his importance in modern histories, as it gave him more success than Dürer in the ceremonial woodcuts of the emperor's triumphs and ancestry.[68] The same sort of Italianate tight decoration and majestic figures dominates Augsburg sculpture, too (see p. 382). These fashions were much assisted by the emergence of engravings, not woodcuts this time, by the Beham brothers (Hans Sebald, 1500–1550; Barthel, 1502–1540) and Georg Pencz (docs. 1523–d.1550), pupils of Dürer's late years whom print collectors call the "little masters" because of the tiny scale of their works. They provide patterns of decoration and Raphaelesque profile Madonnas with equal smoothness.

30. Holbein

Hans Holbein the Elder had been a leading painter in Augsburg (docs. 1493–d.1524), skilled in the accepted patterns of Rogier and especially Schongauer. His son Hans the Younger (1497/98–1543) learned his father's craft, but was more attracted to the modernisms of Burgkmair. So when the young man went to try his fortune in nearby Basel (then still within the Empire), his first portraits, at age twenty, show broadly formed heads surrounded by thick architectural ornaments that carefully repeat Italian classical conventions. Yet already the zest of motion in the friezes and the juicy fleshiness in the faces allow us to forget Burgkmair's decorative thoroughness. Holbein, who experimented all his life with interesting styles he came across, now also saw Baldung's work (in nearby Freiburg) and followed him in trying out night scenes. Yet he filled them out with weightier figures and made the black air enforce unity of design, not anxiety and paradox.

But the most important Italian influence was probably a trip to Milan, where the work of Leonardo and his local successors, especially Andrea Solario, excited him to something quite new. Holbein thus becomes the great master of the generation after Dürer's, by presenting (as Hans von Kulmbach had done tentatively) a single High Renaissance statement in which Italian and northern dialects are synthesized; he is not playing one against the other, as Dürer was still doing, but makes each one an ingredient plainly calling for the other. The first masterpiece thereafter is the *Dead Christ* predella (1521; fig. 446). The rigid tension of death is the theme; it is seen naturalistically, as in Grüne-

wald's *Crucifixion* (see colorplate 51), but also is a balancing allusion to the shape of the rectangle. In the profile portrait of Erasmus (1523; fig. 447), face and hands describe the personality conspicuously, in character and appearance, but are also the units of a compositional pattern, firm, simple, and flat. This participation of real detail in a measured design gives Holbein's portraits their effect of being the last epigrammatic word about the people, telling because it is truly observed and neatly boxed, and even ironically making them seem detached and objective.

Holbein had gone to Basel to work as an illustrator for the great publishing industry there, as the scholar Erasmus had been attracted from Rotterdam. In five or six years he drew about thirteen hundred printer's designs for translation into tiny woodcuts. The most famous, and the only ones not prepared to go with a text, are the fifty Dance of Death scenes (1523–26; fig. 448). Derived from a folk tradition and related to mystery plays, they show Death as a skeleton coming to fifty people who are labeled by social class; with infinite invention of motif, Death replaces the king's cupbearer at his feast, tumbles the carter's load of barrels on the ground, and, most unforgettably, whips the farmer's horses to finish plowing this one furrow. The poignancy is keener because of the graphic simplification of the images, so that each tiny picture again has the unanswerableness of a four-line epitaph in strict meter, the concentration on essential points underlined by the tight order. While drawing these, not with slowly revised perfection but with a daily fertility, he was also painting fres-

446. HANS HOLBEIN. *Dead Christ*. 1521. Panel, 12″ × 74″. Kunstmuseum, Basel

COLORPLATE 53. ALBRECHT ALTDORFER. *The Battle of Alexander and Darius.* 1529. Panel, 52″ × 47″. Alte Pinakothek, Munich

COLORPLATE 54. HANS HOLBEIN. *The Artist's Family.* 1528–29. Paper, 30″ × 25″. Kunstmuseum, Basel

COLORPLATE 55. JEROME BOSCH. *The Hay Wain*, center panel of triptych. c.1490–1500. 55″ × 39″. Palace, Escorial

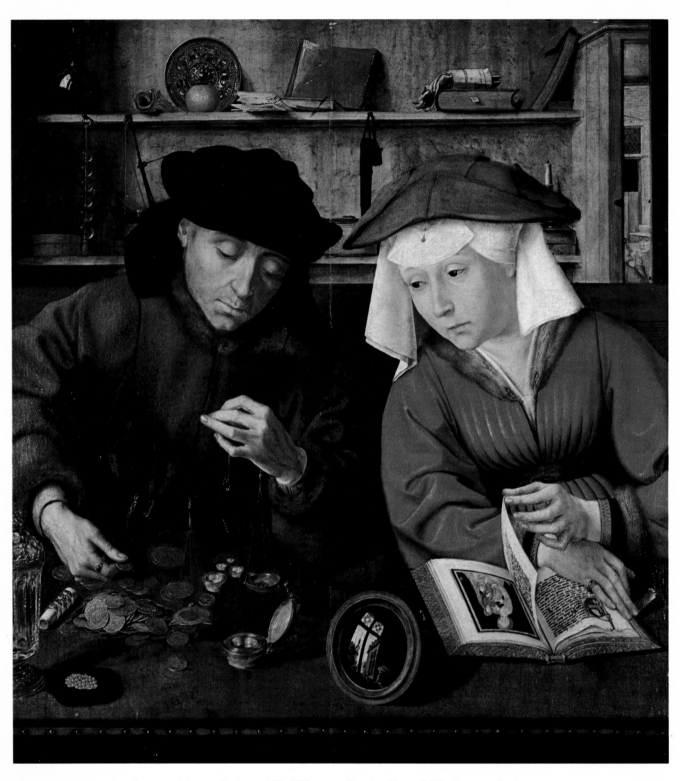

COLORPLATE 56. QUENTIN MASSYS. *Banker and His Wife*. 1514. Panel, 28″ × 27″. The Louvre, Paris

447. HANS HOLBEIN. *Erasmus of Rotterdam*. 1523.
Panel, 17″ × 13″. The Louvre, Paris

448. HANS HOLBEIN. *Death and the Farmer*,
from the Dance of Death series. 1523–26.
Woodcut, 2 1/2″ × 2″.
Metropolitan Museum of Art, New York.
Rogers Fund, 1919

coes for the outside and inside walls of houses, now all destroyed (fig. 449). These developed out of Burgkmair decoration into very complicated perspective systems related to Bramante. His portraits develop sculptural volume as well as a sense of character defined, and extend into group designs like the *Madonna* of the Meyer family, painted for Mayor Meyer's private chapel (commissioned 1526),[69] and the portrait of his own wife and children (1528/29; colorplate 54). The clinging figures constitute pyramids which are surprising versions of Leonardo's *Virgin with Saint Anne* (see fig. 195), but with fewer and fewer lines to evoke their portrait intensity and with volume as of a single monumental figure.

Visiting England as a member of the Basel intelligentsia in 1526–28, Holbein was favored by Sir Thomas More (whose *Utopia* had been published in Basel), and through him by the archbishop of Canterbury, the royal astronomer Kratzer, and others, and painted their portraits. In 1529 radical Basel Protestants burned church paintings, and Holbein went into exile along with Erasmus and Mayor Meyer, moderates who advocated religious

449. HANS HOLBEIN. Drawing for façade of
the Dance House, Basel.
Ink and wash, 23″ × 14″.
Kunstmuseum, Basel

361

450. HANS HOLBEIN. *Anne of Cleves.* 1539.
Parchment, 26″ × 19″. The Louvre, Paris

toleration. Heading back to London, Holbein in Flanders was evidently struck by the work of Jan van Eyck; the result is seen in two great portraits of 1532 and 1533; *Georg Gisze*,[70] a German merchant in London, who sits in a corner surrounded by countless glass, wood, and otherwise textured objects, and the full-length double portrait of the French ambassador and a visiting bishop, called *The Ambassadors*,[71] a curious High Renaissance remodeling of Jan's Arnolfini couple. The musical instruments, globes, and so on, between the two men, are in virtuoso perspective, and most fantastically so a skull on the floor whose acute distortion the viewer must correct by looking in a mirror placed in a particular position. But these experiments soon give way to a steady increase in simplicity. Portraits are now his only subject for paintings, as with most artists in Protestant England for the next two centuries. He also did designs for pageants, embroideries, and jewels, and when Thomas Cromwell, the royal jeweler, became the chief minister, Holbein became the royal artist of Henry VIII. Of the king and his wives he produced images that are the counterpart of Bronzino's state portraits at the same time in Florence, typically frontal and three-quarter length with fixed faces and emphasis on costume, making the person a vessel of status (fig. 450). Luckily for Holbein (as for Bronzino), this pattern coincided with personal interests, as we see best in the poised late drawings where a few acute lines create a mass, in contrast to the sensuously chalky ones done earlier.

31. The Last and Remotest Extensions of Early Renaissance Flemish Painting

By 1450 the acceptance of Rogier's idiom was becoming very widespread. It was maintained in Flanders and France with little dissent until 1500, and the amendments that it evolved in the interim were often precisely in the direction of the routine and easy. The interesting exceptions occur in marginal circumstances. Memling, the immigrant accepted in Bruges as the leading painter for twenty years (see p. 315), made a principle out of drawing the fangs of the expressive Rogierian language, leaving it gentle and almost immobile. A more positive conservatism seems suggested by his successor as the local leader, Gerard David (docs. 1484–d.1523). Accomplished in the tradition and amiable in mood, he first offers people who stand quietly and without sharp edges in a well-lit and softly shaded world of blue-green air. Besides Rogier, Jan van Eyck is being imitated in the microscopic surfaces and exact textures of velvet and skin. But literalism decreases and generalization grows in his *Baptism of Christ*

451. GERARD DAVID.
Baptism of Christ,
center panel of triptych.
52″ × 37″.
Groeninge Museum, Bruges

(fig. 451), conspicuous for its symmetry and deep openness, analogous to Perugino's work in Italy. These emphases almost produce a new kind of image in the late *Crucifixion*,[72] whose figures seem heroic in front of a faint sky. Perhaps David's hardest test was his early pair of scenes for a hall of justice (1498),[73] on a theme like Bouts'. An unjust judge is first condemned and then duly skinned, and each event is watched by quiet spectators in a softly blended light with a detachment that makes Bouts' seem involved.

Such graceful acceptance of a well-nurtured style of working had spread out from Bruges some time earlier. In nearby Valenciennes on the French border a miniature painter called Simon Marmion, from Amiens (docs. 1449–d.1489), painted a small altarpiece (finished 1459)[74] which adopts the most stable, Eyckian aspect of Rogier's range, exemplified in his *Birth of Saint John*. He tells the story of the local Saint Bertin through solid groups of people, sharply lit and bound firmly in architectonic frames. Marmion's emphatic and linear portraits are his most individual work, as they are in Memling, but Marmion's particular way of toning down

452. MASTER OF MOULINS.
Nativity with Cardinal Rolin.
Panel, 22″ × 28″.
Musée Rolin, Autun

ders. His Madonnas (fig. 452) again are a rounded, almost classically bland version of a source that now is Hugo van der Goes. Beautifully outlined, not too sweet, the mothers gaze at standardized infants while donors kneel in their official furs and stare heavily. Again, the Master's portraits are keener and suggest the idiosyncrasies of great court persons.

To judge from the few surviving remnants of their works, distinguished French sculptors were

454. MICHEL COLOMBE. Tomb of Duke François of Brittany and Marguerite of Foix. 1502–7.
Marble, 5′3″ × 11′10″ × 5′4″.
Cathedral, Nantes

Rogier, by blander mood and broader shapes, might be considered French, on the analogy of Fouquet. The idea perhaps gains support again from the work of the Master of Moulins, the most notable French painter about 1480–1500 and perhaps still active later on. He worked in eastern French provinces for the dukes of Bourbon (this no longer involved an independent feudal duchy, but an aristocracy dependent on King Louis XI), but is widely thought to be identifiable with Jean Hay (doc. 1494), who was probably an immigrant from Flan-

using a similar vocabulary. The *Entombment* at Solesmes (1496; fig. 453), similar in type to the earlier one in Tonnerre (see fig. 398), again tamps down Flemish realism to large plain surfaces, and builds to a pyramidal cubism of great force in its famous figure of the Magdalene sitting on the ground; the whole group is distractingly framed in Italianate ornament. We know one sculptor of this time, Michel Colombe (docs. 1473–1512), from his late tomb of the duke of Brittany (1502–7; fig. 454). Italian specialists carved panels of ornament, and a painter called Jean Perréal (docs. 1485–1529) provided the over-all design. Although a theory that Perréal was the Master of Moulins has now been dropped, there is a connection between them. Colombe's carving is somewhat more detailed than we saw at Solesmes, both in realism and ornament,

453. *Entombment.* 1496.
Stone, width 17′9″.
Abbey, Solesmes

and accumulates symbolic objects with an amiable, solid truthfulness that is perhaps the worthiest tribute of a sculptor to Jan van Eyck's ideas.

Real individuality in this context reappears in Flanders in the curious form of manuscript illustration. This was obviously an old-fashioned art after the invention of printing around 1450, and became very traditional; but it flourished as an extreme luxury, somewhat like the hand-tooled racing automobile with us, and the absence of any normal function opened up an opportunity for wild originality. This was seized by the Master of Mary of Burgundy, who may have been Alexander Bening of Ghent (docs. 1469–1519). Mary, daughter of the last duke of Burgundy, married Emperor Maximilian and thus transferred her Flemish wealth to the Habsburgs of Austria. Her Book of Hours (fig. 455) exploits two habits in earlier Flemish art, the love of materialistic detail and the elaborateness of the frames in earlier manuscripts. The painter now makes the frames bigger than the scenes inside and treats them to dazzling still lifes of flowers, jewels, or even skulls, three-dimensional enough to suggest the surrealist illusion that they have been dropped on the book; one frame is occupied by a lady inspecting her jewel boxes. Less flamboyant but still more inventive are the minute scenes within the frames; logically, they appear far back in space, rich in aerial perspective. Not only do we have dimmed air and experiments with moody nocturnes, but the notion of distance from us is again logically extended to the treatment of the themes, such as the crowd in front of Christ that almost prevents us watching him being nailed to the cross, or the series of calendar landscapes, virtually without figures, that note the changes in light throughout the year (a modern variation on Pucelle). Thus the strict and reactionary context of book illustration leads by paradox to the freest experiment, and yet the ordinariness of the figure drawing reminds us that this is a minor offshoot from the great inventors of Flemish style.

Mary of Burgundy's Habsburg son married a daughter of Ferdinand and Isabella of Spain, and an apparent pupil of Mary's illuminator went to Spain as Isabella's court painter; he was known

455. MASTER OF MARY OF BURGUNDY.
Madonna and Saints Framed by a Window Scene,
illuminated page from a Book of Hours.
Vellum, 9″ × 6″.
National Library, Vienna

456. JUAN DE FLANDES.
Magdalene at the Feet of Jesus,
from an altarpiece. Panel, 8″ × 6″.
Royal Palace, Madrid

there as Juan de Flandes (docs. 1496–1508). He has left an extraordinary masterpiece, an altarpiece for Isabella's oratory, of fifty small scenes of the lives of Christ and Mary (fig. 456). Each enamel-like panel encloses bright, polished little figures, like faceted jewels, in a neatly plotted perspective that suggests he might have been in Italy on his way to Spain. Again the drawing forms are traditionally Rogierian, but the light, both in color and space, has a unique assertion of precious intensity. Clearly Isabella preferred northern painters to the Spanish altar-craftsmen, who were more countrified even than the Germans in their distant medievalizing echoes of Flanders. Another of Isabella's court painters was Michael Zittoz (or Sithium; 1469–1525), a wanderer from Reval on the Baltic and a pupil of Memling's; later he turned up at the English and Danish courts too. His portraits were especially approved by Isabella's daughter, the Catherine of Aragon who was queen of England, and by other royal patrons; in the vivid surviving head of Don Diego Guevara (fig. 457), we can see why. It modifies Memling's portrait pattern toward looser and irregular shapes, happily intertwined with rich variety of costume texture.

In Bruges itself Gerard David has a livelier but more obscure younger contemporary in Jan Provost (docs. 1491–d.1529), an immigrant from Valenciennes, where he had married Marmion's widow. Before the identities of Juan de Flandes and Michael Zittoz were made firm by modern inquiries, some of their works were considered his, and he does suggest an average of this whole context. His figures and many of his small-scale objects are mobile and fresh, with a festive and impulsive air surprising in the domain of Memling and David, and possibly connected with his awareness of Antwerp, a less stagnant environment than Bruges. But it is only contrast that makes them conspicuous, since they are grouped archaically, in a monotonously routine pattern only the more noticeable because of the bright details.

More typical of the last years of Bruges, no

457. MICHAEL ZITTOZ. *Don Diego Guevara.*
Panel, 12″×9″.
National Gallery of Art, Washington, D.C.
Andrew Mellon Collection

doubt, is the prolific painter who was probably Adrien Isenbrant (docs. 1510–d.1551). He was faithful to his teacher David, and as he copies David and others the shadowy, soft tonality of this tradition is ever more accentuated. However tragic the themes of Christ's Passion and death, the figures are as remote from stress, being born only from other art, as the repetitious Isenbrant is remote from the ideas of his time, a survivor. His sensitivity to tone and texture is absolutely skilled, but it is a holding action in a vacuum.

32. Bosch

Just when the all-purpose Flemish language of Jan van Eyck and Rogier was wearing away, a genius in a small town developed a different art out of still older materials. Bosch, like El Greco later, worked in a locality where no important artists had lived earlier; thus observers who have not the great patience to hunt out the very minor currents making up the traditions of these masters have understandably, if unfortunately, regarded them as unique eccentrics, and built rather fanciful theories to explain what they did. (The romantic modern habit

of calling Bosch "Hieronymus," the Latin for Jerome, is a token of this somewhat skewed and uninformed attitude; if it is preferred, Jan van Eyck ought to be called "Johannes.") The importance of Bosch's background is suggested by the fact that he (docs. 1486–d.1516) had a father, two uncles, and a grandfather who were all artists in the same small Dutch town of 's Hertogenbosch, near the Flemish and German borders, from which, so far as any records report, he never traveled. Yet he became famous enough to receive an order from the Habsburg ruler,

458. JEROME BOSCH. *The Temptation of St. Anthony,* center panel of triptych. 52″×47″. Museu Nacional de Arte Antiga, Lisbon

Mary of Burgundy's son; the combination of extreme localism and major contacts seems parallel to the mix of the old-fashioned and the innovative in his art.

His way of painting people, especially nudes, soft, boneless, and glowing, is closest to the late fourteenth-century Flemish style first seen in Bondol and last, perhaps, in Conrad von Soest, who was working just across the German border in the time of Bosch's grandfather; it is still a factor in Lochner, who was so influential in the time of Bosch's father. Lochner uses another medieval tradition that becomes Bosch's most famous motif, the fantastic evil creatures such as devils with heads on their bellies; others of Bosch's creatures, with heads and feet but no bodies, descended from medieval manuscript borders and gargoyles, and Bosch seems to have retained all of these as a natural inheritance. But he learned to be an expert in the modern Flemish realities of textures of things within a Boutsian airy space, so that the old stylized fantasies seem guaranteed real. The new result is the hallucination effect that makes him fascinate us, like dreams where we positively see what we cannot accept. It is a different phase of the tension between supernatural values and visible facts that Jan attacked in *Arnolfini and His Wife* (see fig. 359); Bosch paints as if the Eyckian style had grown up without a matching growth of new bourgeois themes. And his sophistication greatly enlarges the repertory of monsters, all combined from real details, especially the crawling and the slimy, made doubly disturbing by being monstrous. To these, with his textural assurance, he gives a filmy transparent surface, all within the atmospheric panorama.

We may readily connect the hallucinations with our cultural view of the subconscious. But Bosch, a rich citizen and active member of a pious laymen's lodge, can be better linked to a religious trend typical of the less cosmopolitan cities of his time and known to have been active in 's Hertogenbosch. A forerunner of the Protestant Reformation, it emphasized an emotional approach to God, a relatively slight importance for the Church, a puritanical emphasis on hard work, and special hatred of the most physical sins, gluttony and lechery. It is indeed a constant syndrome of the Western tradition, though for various reasons not of its art. In this age it produced some of its greatest effects, Thomas à Kempis' book *The Imitation of Christ*

459. JEROME BOSCH. *Christ Bearing the Cross.* Panel, 30″ × 33″.
Museum of Fine Arts, Ghent

(the communities of Thomas' admirers were strongest in small Dutch towns), the career of Savonarola, and some aspects of Erasmus. If Bosch is to be seen as a twentieth-century type, he is less the psychoanalyst than the revival preacher.

The paintings, all undated, are usually considered in three groups. The earliest, in small scale, show daily life under ethical judgment. The seven deadly sins[75] are jeered through caricatures of the glutton at table and the vain girl before a mirror, with an inscription, "Beware, the Lord sees" (the most authentic words of Bosch). As a systematic set they maintain the tradition of calendar pictures, as a berating of society they belong to the same trend as the secular moral literature of the *Ship of Fools* by Brant (1494) or the *Praise of Folly* by Erasmus (1509). In a nonreligious picture of people cheated by a carnival huckster,[76] Bosch can be compared to the Hausbuch Master; both were concerned with human silliness, but one is angry and one gently rueful.

The large triptychs, the second group, are again sermons to the sinner's conscience, with a flavor of fatalism about the world's instincts. The Hay Wain (colorplate 55) proceeds from original sin in Eden on the left, to humanity indulging it-

self in the center, to Hell's torments on the right, all in Bosch's glowing light, with wayward inventions of plant and animal life. The same theme reappears in the *Garden of Earthly Delights*,[77] but more systematically, making a tapestry-like inventory of hopping beasts and spiky bushes. A simpler variant, the *Temptation of Saint Anthony* (fig. 458), surrounds the shrinking hermit with the immense variety of his nightmares, and introduces one of Bosch's important compositional forms, the focus on the soft weak good figure at the center, pressed and crushed by tough evil all around it. This is the motif of Bosch's last works, in which regretful fatalism seems to replace preaching, such as the repeated *Christ Bearing the Cross* (fig. 459), a close-up probably influenced by motifs of Leonardo.

33. Antwerp and the High Renaissance

As the kings of Spain were replacing the dukes of Burgundy as rulers in Flanders, making it a constituent part of a widely scattered state, the burgher towns of Bruges and Ghent were giving way to Antwerp, still a great world port today. High Renaissance art began in Antwerp when one forceful artist, Quentin Massys (1465/66–1530), came from Louvain and for the first time in memory began to paint in a way not dependent on Van Eyck and Rogier. His instinct for the figure is not taut or thin, the materials of objects do not greatly interest him; he wants to present people of imposing grandeur and monumental sweep (fig. 460). It is like the change from Verrocchio to be seen in Leonardo, the change from Perugino seen in Raphael, the change from Schongauer seen in Dürer. Massys is older than both Raphael and Dürer, and although he copied Leonardo and found him a comfort, he is distinct. But the bigger and louder scale is not evoked at every level; Massys paints, as he must have learned to do, with a minute precision, and his flesh imitates the real thing. In the main, though, sharp focus survives not in things but in acts, so that a banker and his wife confer in the shop and a reference to Petrus Christus arises (colorplate 56; see fig. 378). Portraits are important, and Massys typically worked effectively on double portraits, as of Erasmus and another scholar at the ends of a table.[78] Parallel to Leonardo in the way congested groups of heavy people turn to each other, Massys also copies his monstrously jowled grotesques and takes them seriously as persons, recording the minutiae of their strange heavy heads.

Evidently Massys, even without full capacities of articulation, wanted to be modern, and so he also behaved like an artist-figure rather than a craftsman, taking no role in the local guild but building a grand house that was a tourist attraction. His aims were perhaps only understood by Peter Paul Rubens, the great Antwerp artist a century later, both as to his way of living and as to painting the massive energies of real Flemish flesh. In his own time Massys was given fame but oddly limited imitation. A High Renaissance mood, though, did permeate the city, usually in more literal Italian imitations than Massys', and continually implying a puzzled disturbance about how to proceed.

Jan Gossaert (docs. 1503–1532), called Mabuse from his native town, journeyed to Italy as a young man in the train of a Burgundian prince and made drawings of ancient sculpture. It was clearly an exoticism to him and dominated his whole life. In painting he is fascinated by nudes, anatomically extremely articulate, the males extremely muscular and the females extremely cushiony, both bulky. They are surrounded by extremely intricate architectural frames, and both frames and figures are polished and sharp-edged (colorplate 57). The classical nude thus becomes not an idealization of humanity, but a precious curiosity displayed with virtuosity in a jewel box. The double distance— man seen as statuary, from a foreign land—is related to the artificial eroticism of bodies entwined with the precise laboriousness of a blueprint. These paintings were made for a series of royal patrons of the Burgundian family, and the feeling of a cultivated

460. QUENTIN MASSYS. *Deposition from the Cross*, center panel of triptych. 8′6″ × 8′11″.
Musée Royal des Beaux-Arts, Antwerp

collector of dead exactitudes anticipates the grand-ducal court of Florence. Gossaert's small Madonnas specialize in infant Christs with Herculean muscles, and his rare altarpieces in ornamental tracery, like that of some other Antwerp painters.

When Joos van Cleve (docs. 1511–d.1540/1) settled in Antwerp, he absorbed the High Renaissance more calmly, and more superficially. For his many Madonnas he develops an efficient and smooth formula, with a plumply soft and bland figure more like Dürer and Raphael than like Rogier, as if the new ways had already become routine. A very successful portraitist, he went in 1530 for some years to

the court of Francis I of France (the same year Rosso arrived there). The sitters smile mildly, luxurious and centralized (fig. 461), in a flavorless alternative to Holbein, and, like him, reflect the portrait type established by Leonardo's followers in Milan.

At the French court Joos found a provincial carbon copy of himself already established, Jean Clouet (docs. 1516–d.1540), who had immigrated from Flanders—which city is not sure—and settled down to be court painter, naming his son François. His routine art has been given attention because of his accidental status as the leading painter of his time in France; a more human spark appears only

461. JOOS VAN CLEVE. *King Francis I.*
Panel, 28″ × 23″.
John G. Johnson Collection, Philadelphia

in his albums of portrait drawings, technically imitative of Leonardo and maintaining the Fouquet tradition. These two visitors, Joos and Jean Clouet, are the last in the succession of Flemish painters for French kings that had begun with Bondol; Francis I's invitations to Rosso, Primaticcio, and others soon transformed the visual environment in France.

The most surprising Antwerp artist of these years, perhaps a token of the sense of international modernity, is Joachim Patinir (docs. 1515–d.1524). He was the first painter anywhere to make his career as a landscape specialist, which he did both alone and in collaboration on panels having figures by Massys and Joos van Cleve, a very early example of this kind of division into specialties. In all his landscapes wide miles of geography are filled with the same rocks, forests, villages, and lakes (fig. 462). The objects are often on our eye level, but we look down on the total panorama. The picturesque ob-

462. JOACHIM PATINIR. *The Flight into Egypt.*
Panel, 7″ × 8″.
Musée Royal des Beaux-Arts, Antwerp

463. ANTWERP MANNERIST ARTIST.
The Beheading of John the Baptist.
Panel, 19″ × 14″.
Staatliche Museen, Berlin-Dahlem

jects are real, but the assemblage cannot be; yet the clear atmospheric intervals permit an uncrowded, agreeable sequence of contemplation. This might be thought of not as landscape but as an atmospheric still life, a very Flemish set of interesting objects. Indeed it would be strange if these primitives of professional landscape were not in essence something else. Patinir learned his blue air from Gerard David, but Bosch, his greatest contemporary, freed him to see the wide world as provocative small notations in an equal series.

A group style was practiced in Antwerp by the mainly anonymous "Antwerp Mannerists" of this same generation. They are even more agitated by exotic interests than Gossaert (who probably was one of them briefly in his youth). The best known, Jan de Beer (docs. 1490–1520), is less acutely mannered than others, but they all paint traditional panels with scenes of the lives of saints as if they were costume jewelry (fig. 463). Besides emphasizing carved banisters, sword scabbards, embroidery, and candlesticks, they twist their thin people in a snaky

464. BERNARD VAN ORLEY. *Job's Afflictions*, center panel of triptych. 1521. 69″ × 72″.
Musées Royaux d'Art et d'Histoire, Brussels

movement that seems to want to substitute games for dramas. They are best as makers of surfaces, with tiny brilliant ornamental designs that are meaningless but authentically inventive.

Their mood is related to that of Bernard van Orley, the leading painter in Brussels (docs. 1515–d.1542). His thick small-scale ornament of the surface takes two contradictory forms, a static pattern on buildings and a genuinely Rogierian nervous action in figures. He was dominated by his awareness of Raphael, whose tapestry designs were shipped to Brussels to be woven (see p. 175). His masterpiece, the triptych of *Job's Afflictions* (1521; fig. 464), shows Job's dying sons and daughters flung forward out of the space of a massive cubic palace, a congested variation on Raphael's *Death of Ananias*. By keeping many ideas in control, Van Orley makes this one of the most impressive assertions of the Flemish High Renaissance, but he had no more successors in his city than his contemporaries in Bruges had in theirs.

34. Haarlem and Leyden

It is wrong to contrast Flanders and Holland in this period (they were not split until the next century), but they do contain regional schools, and just after 1500 the northern one in Holland was the most promising. It neither ran conservatively into the ground, like Bruges, nor was it like Antwerp, swamped by the attraction of Italy. The painters managed to build a modern language on the base of older suggestions, and were especially lucky in being able to tap Geertgen tot Sint Jans and Bosch.

After Geertgen's early death the leading painter in Haarlem was Jan Joest (docs. 1505–d.1519), who came from the German border town of Calcar. He is another literal-minded user of Rogier's spindly jointed figures in precisely adjusted actions, with more smoothness than some others, and oddly accented by the vehement caricatured heads of the wicked that suddenly dart out at us. He differs from a host of regional masters in German towns only in his competence, but his wide influence may suggest the strategic position of Haarlem. Joos van Cleve may have learned from him before moving on to Antwerp, and so did Bartel Bruyn (1493–1555), who settled down as the leading painter of Cologne and produced stolid enamel-hard portraits of generations of its citizens.

The long career of Jan Mostaert (docs. 1500–d. 1556) brings to Haarlem a somewhat more distinctive flavor, now stemming from Geertgen, the local old master. His figures indeed have their provincial and conservative cast, hard, wooden, and angular, tight in contour, and unshadowed. Yet he rejects the Rogierian formula in favor of a shorter and thicker physique, and above all he piles on deep complexities of color, especially in costume, so that merely by the saturation of adjacent elementary color areas the people grow malleable and easily alive, moving in rich crowds. Without borrowing from Italy he has found a modern resource for High Renaissance airiness and mobility. It is a narrow vein, but this rich precision made him a favored portraitist, even at the Habsburg court. And there, presumably, he was able to stretch to a surprising novelty, an imagined landscape of the New World (now a Habsburg territory; fig. 465), with hills, huts, and naked Indians fighting, a graphic variation on Patinir and a curious parallel to Piero di Cosimo's Flemish-tinged fantasies of primitive life.

In nearby Leyden Cornelis Engelbrechts first asserts a distinct school (1468–1533). His costumes again are a purposeful device. Elaborate and modish from hats to shoes, they are as decorative as those of the Antwerp Mannerists but not so artificial, and reinforce the wearers' actions, bonelessly twisting with acrobatic rhythms in crowded dramatic tableaux. Thus color areas, along with inevitable linear neatness, can validate modern fluid motion (fig. 466). And Engelbrechts paints only narratives, no portraits or Madonnas. His most constant theme is the Crucifixion, with choric groups swirling around

465. JAN MOSTAERT.
New World Landscape.
Panel, 34″ × 60″.
Frans Hals Museum,
Haarlem

the central post, and side panels repeating Geertgen's blood-spattered Christ. Jan Cornelis of Amsterdam (docs. 1506–1533), the first painter in that as yet minor city, shows the effectiveness of this Leyden style by his provincial copy of it. He is a craftsman who translates Engelbrechts into more old-fashioned orderly patterns, and his color areas into glittering points, until carried away by the different ideas of his own pupil Jan van Scorel.

But a parallel to Engelbrechts is the still more vivid Leyden master Jan de Cock (docs. 1503–1526). He went to Antwerp and was so successful that he became head of the guild, but we have to recon-struct his work from slight indications. He too paints action in sharply marked color fields, but instead of costume, the units are fantasy landscapes. They are filled with hermit saints, Anthony tempted or Christopher crossing the river, and never repeat, but each time invent a wayward jungle of twisting trees in which the saints' robes whip and flounce. Lakes and fires behind them form pasty color areas and complete the wildly decorative dream worlds. All this, including the landscape color, draws heavily on Bosch, but is less ambitious, visual without moral overtones. The artist apparently named his son Jerome after Bosch; Jerome Cock became an Antwerp publisher who issued prints after Bosch, providing the link from Bosch to Bruegel that is otherwise hard to trace.

466. CORNELIS ENGELBRECHTS.
The Lamentation,
center panel of triptych. 5′11″ × 4′1″.
Stedelijk Museum "De Lakenhal," Leyden

35. Lucas van Leyden

The one great Netherlandish artist in this generation was Lucas van Leyden (1494–1533), a pupil of Engelbrechts. He seems to have been a child prodigy, since he produced important works in 1508; his birthdate in 1494 has been doubted, but seems to be right, and other factors seem consistent. His father was an artist, which often favors early development; his first works are engravings, where the exceptionally high importance of technical factors is susceptible to early mastery (as in children's musical and mechanical talents) as well as to learning from great models at long distance. He also seems to have been unhealthy and small, and adolescent self-preoccupation may also be behind the very original themes, repeatedly concerned with people who are victims of a greedy world, which pour out in his early work. Background, skill, and message are remarkably similar to those of the youth of Picasso.

The first great prints record people hurt beyond hope: Hagar is told she must leave her home, Adam and Eve are bizarrely seen not when expelled or as workers, but as tattered refugees on the road from Eden (1510). The very first print (1508) conceals the source of hurt from its victim; its exceedingly odd theme is the sleeping Mohammed falsely charged with a murder. When the sleeping Samson's hair is cut off, in another print, ugly soldiers creep up on him from all directions like a chorus entering a stage. The relation of world and victim grows more intense when the hero-victim is a tiny background figure, hurt by large observers in the foreground; in *Susanna and the Elders,* Susanna is just visible in the faint lines of aerial perspective, while the piglike old men looking at her become identified with us, the lookers-on or voyeurs, from in front of the engraving. Saint Paul in his conversion falls blinded from his horse in the airy distance; we see him again in the foreground staggering wretchedly among his soldiers, like King Lear. The greatest print of this kind is *Christ Shown to the People* (1510; fig. 467), a small pathetic Bosch hero, stared at by a tumultuous foreground crowd who again are us, a composition soon famous in Italy and frankly copied in a great Rembrandt etching. The subject most often repeated is the part of the Passion in which Christ is mocked and beaten. These more ordinary themes allow us to pay attention to the drawing style, which is a technically taut version of the Rogierian tradition, showing hard bony unideal people in action; he concentrates it to insist on ugliness and uncomfortable proportions. A minor work, a small Madonna sitting on a bank, gleamingly brilliant in line, presents a tired and dull-witted woman; others dissect beggars and pilgrims and a silly peasant having

467. LUCAS VAN LEYDEN.
Christ Shown to the People. 1510.
Engraving, 11″ × 18″.
Metropolitan Museum
of Art, New York.
Harris Brisbane Dick Fund,
1927

468. LUCAS VAN LEYDEN
David and Saul. 1508.
Engraving, 10" × 7".
Metropolitan Museum of Art, New York.
Rogers Fund 1918

469. LUCAS VAN LEYDEN. *The Milkmaid.* 1510.
Engraving, 4 1/2" × 6".
Metropolitan Museum of Art, New York.
Gift of Felix M. Warburg
and his family, 1941

his purse stolen while his tooth is pulled (1523). In Lucas' world people cannot come together: David plays to Saul (1508; fig. 468), keeping his distance, while Saul is the first great image of insanity in art. Saint George, having killed the dragon, has trouble coping with the hysteria of the princess, whom he gingerly touches. Saint Anthony and his temptress (1509) are two tight verticals. In this vein the masterpiece is *The Milkmaid* (1510; fig. 469), a scene of daily life always noted as a century ahead of the type developed in Adriaen Brouwer's peasant paintings. At the far left a gangling farmhand stares at the girl at the far right, and she coquettishly ignores him; they are held apart by the horizontal lines of the two bony cows who fill up the middle and represent the world in which this faulted human relation is occurring. Lucas reports not so much monumental tragedy as a muddled despair of things going wrong. Even a miracle by Christ, the *Raising of Lazarus,* with its open-jawed crowd and its animal-like main actors, seems to mark less a triumph of goodness than an incomprehensible violation of reasonable expectations. While the analogous depression in Baldung Grien's prints is privately haunted, Lucas' becomes a social judgment.

The traditionalism of Lucas' drawing style aided the speed with which he presented his fertile ideas. The prints were famous at once, but were imitated only for their piquancy, not their charge. The few early paintings are less skillful but similar in mood and originality of motif, such as the chessplayers with gawking kibitzers.[79] Later the paintings gain command, and the prints grow less original. Lucas shifted his technical allegiance to engravings after Raphael. The satire grows milder, with its one late triumph in the scene of Mary Magdalene, before her conversion, strolling through a meadow crowded with lovers, a world of mass instincts. Lucas tolerates their foibles with amusement, as he does in the painted crowds of the *Last Judgment* (1526–27; colorplate 58) and *Moses Striking the Rock;*[80] he is mellower and throws away hard impact. He becomes a great painter, exploiting the Leyden color tradition but eliminating its tight detail: thinly painted saturated planes, gently modeled, create figures alive in shafts of light. Even single portraits analyze character in the set of mouth and wrinkles, with penetration but withholding a formula of judgment. Yet these works seem to be tentative moves in a direction unsettled when Lucas died at thirty-nine.

COLORPLATE 57. JAN GOSSAERT. *Danaë*. 1527. Panel, 45″ × 37″. Alte Pinakothek, Munich

COLORPLATE 58. LUCAS VAN LEYDEN. *The Last Judgment*, center panel of triptych. 1526–27.
9′3″ × 6′1″. Stedelijk Museum "De Lakenhal," Leyden

COLORPLATE 59. PIETER BRUEGEL. *Hunters in the Snow*. 1565. Panel, 46″×64″. Kunsthistorisches Museum, Vienna

COLORPLATE 60. EL GRECO. *View of Toledo*. c.1600–14. Canvas, 48″ × 43″.
Metropolitan Museum of Art, New York. Bequest of Mrs. H. O. Havemeyer, 1929. The H. O. Havemeyer Collection

36. The Beginning of Italianate Architecture and Sculpture

All buildings of northern Europe in the fourteenth and fifteenth centuries, and many later ones, are Gothic in structural technique and therefore in style. On the other hand, the emphasis in the types of building changed. Hardly any cathedrals and not so many large churches were begun, but more civic buildings, and rising living standards brought a change from the elemental castle with a few all-purpose rooms to complex mansions and palaces. They needed fewer high vaults and more flat ceilings and rectangular windows because they had several stories, hence spaces with balanced proportions and human scale. This is a slow and obscure growth. The new kind of relatively low wide rooms might evolve inside a traditional castle tower, as a stack of stories, but we can't tell about their visual qualities, particularly their surface handling, since secular building has a much higher rate of remodeling, not to mention destruction. Their appearance may be reflected in new treatments of church interiors, when horizontals and verticals are strongly equalized on the walls of a broad hall-like space (choir of Gloucester Cathedral, begun 1329). The surprising idea that a church is borrowing secular motifs seems confirmed when other churches, built as low cubes, are crowned with battlements borrowed unfunctionally from castles (Edington, 1352, built by the powerful Bishop Edington of Winchester). Only in the fifteenth century do we begin to see elegant dwellings that are in no way castles, such as Jacques Coeur's (see fig. 391); when wooden they seem most noticeably like the Gloucester choir forms (Ockwells, about 1460).

After 1500 their small decorative elements, window frames and moldings, may be Italian. When King Charles VIII of France inherited a peaceful, centralized, no longer feudal state in 1483, he turned to invasions, and from Italy brought back fashion and some craftsmen. The first visible result is in the château of Gaillon, begun in 1501 for his counselor, the cardinal of Amboise. It picks its motifs from north Italy, such as those of the Certosa of Pavia or Pietro Lombardo's work, easier to absorb since they were themselves surface elements, not integral to the structural viewpoint as the Tuscan originals were. Short neat pilasters, filled with curlicues, lively grotesque animals, and mythological fancies, are drawn on Gothic masonry. The same procedure will emerge soon in Spain, where it gives a name to a whole epoch of style, *plateresco* (silversmith-like), and also in Germany and the Low Countries. In one true sense these buildings are Gothic in essentials (the approach to masonry construction) and the ornament is Renaissance; yet from another viewpoint they are Renaissance in essentials (the organizing of space and social character) and the ornament is Gothic, a tracery evoking profuse plant growth rather than asserting rectangular order. These

470. Staircase, Château of Blois. Begun 1515. Height 49', width 26'

paradoxes characterize an art that is not fully expressive of its makers but a suspenseful and uncertain transition, dominated by art forms prepackaged elsewhere, and on both counts possible to define as mannered.

After the first tentative probes this becomes the settled vocabulary of local craftsmen trained by Italian visitors. The first spectacular products are the châteaux of the Loire, originally royal hunting lodges. The most famous part of Blois (begun 1515; fig. 470), the spiral stair in the courtyard, is an intimate enough blend of Gothic masonry and Italian decorative panels to be labeled French Renaissance. Round stair towers are a Gothic tradition, but this one is widened and given an easier gradient; the balustrades articulate these changes outside, producing a novel pattern of tension between stocky vertical and near-horizontal in a unit

which at the same time is the exclamatory focus of the building. Still more emphatically, a similar staircase at the four-hundred-room château of Chambord (begun 1519; figs. 471, 472) is moved to the center of a square building, an Italianate novelty in itself.

Sculpture of course felt the same stimuli. The chief resulting work is the cardinal of Amboise's tomb (begun 1515, later modified to accommodate another cardinal of the same family).[81] Its focal figure is in the recent French tradition of Flemish textural realism in a milder translation with broader forms, and allegorical virtues like Michel Colombe's stand behind in a row. But they are set in heavy ornamental panels, which impose cubic measurements on the statues and add to their seriousness.

Italian fashions came to German sculpture through the Fugger family of Augsburg, the richest in Europe, bankers to the emperor. Their family chapel (1509–18) is packed with carvings on which many artists are known to have worked, and which show a range of styles from tightly decorated Italianate panels to wooden choir-stall figures in the older tradition. It is much debated whether the artist in

471. DOMENICO DA CORTONA(?).
Staircase, Château of Chambord.
Begun 1519.
Visible part of shaft, height 40′8″,
diameter 35′9″

472. Plan, Château of Chambord.
Begun 1519. Main block 140′ square

charge was a craftsman from Ulm, Adolf Daucher (docs. 1491–1523), because he was the eldest, or one of the younger participants, Sebastian Loscher (1482/83–1551), because he was the architect. The question may not even be a genuine one, and in any case we do not know either of them from a body of other works. The large central image of the suffering Christ, either by Daucher or his son Hans (1486–1538), is, in a close comparison with what went before in Germany, very modern, boldly freestanding and with a soft rhythm of thin swinging cloths, though in Italy such an achievement would not seem remarkable. In a broader sense, though, it is still fundamentally in a continuity with Multscher in Ulm almost a century before (see fig. 404), in pose, mood, and intended impact. And of course the reliefs in the chapel exploit the rich accepted tradition of Italianate German prints, made for such copying; Dürer, Cranach, and the Augsburg printmaker Burgkmair are faithfully reproduced. Their success is also indicated by Holbein's far more original Dance House in Basel (see fig. 449). But the outcome most visible today is a vast production of tiny precise plaques, medals, and other low-relief sculpture, with satyrs and fine Roman lettering.

The energies of German sculptors are divided between the "overripe Gothic" altars of Leinberger, the Master H. L., and others, this classicism in miniature, and a very few monuments also copied from Italy. The great Nuremberg sculpture after the era of Veit Stoss is the Apollo Fountain (1532; fig. 473), apparently the one ambitious sculpture by Peter Flötner (docs. 1522–d.1546), a dominant figure in ornamental designing; it is copied from an Italian engraving of about 1500. The Bavarian Loy Hering (docs. 1499–1554) carved one major cult image of a seated bishop saint (1514),[82] imposingly plain though rather flat, but he then fell back on repeating the miniature reliefs. The favored themes are Dürer's *Adam and Eve* and the Judgment of Paris; the nude is viewed as half classical idealism and half daring titillation.

Out of this context comes one real personality, Conrad Meit (docs. 1511–1544). After an obscure youth in the Rhine area he is found working under Cranach at the Protestant court in Wittenberg. He revises the standing nude formula of Cranach's paintings in statuettes of alabaster, bronze, and wood; they are compactly built and densely heavy, the specific material being thus charged with in-

473. PETER FLÖTNER.
Apollo Fountain. 1532.
Bronze, height (without base) 30″.
City Hall, Nuremberg

controvertible reality (fig. 474). Not surprisingly, he left Wittenberg and soon became court artist in Malines to the regent Margaret, the Habsburg who ruled Flanders on behalf of the emperor. For her Meit made statuettes, court toys like the small bronzes of Italy but serious in tone, and then equally solid portrait busts that to us may recall the plain factuality of Roman ones (fig. 475). She then ordered family tombs which were set up in her deceased husband's family domain at Brou near Geneva (1526–31).[83] These are an odd mixture of funerary traditions, using the French *memento mori* device of representing the deceased twice, once on the bier richly dressed as if asleep, and once underneath as a desiccated corpse. Meit wraps all this in a florid

475. CONRAD MEIT. *Portraits of a Couple.*
Boxwood, heights 5″ and 4″.
British Museum, London

476. CONRAD KREBS. East wall, Courtyard,
Schloss Hartenfels, Torgau. 1532.
Length 179′, height of projecting bay 89′,
width at ground level 20′4″

474. CONRAD MEIT. *Lucretia.*
Boxwood, height 10 1/2″.
Kunsthistorisches Museum, Vienna

Gothic shrine; peering through, we see Meit's firmly monumental people, dignified by the same allusion to the unyielding stone, which is emphasized by polishing. After the regent died Meit remained in Flanders, but his last years are again obscure.

The first German Renaissance building is also near Wittenberg, the castle at Torgau, the main seat of the Saxon court, ordered by a new duke in 1532 (fig. 476). Its walls focus at the center in a round staircase tower, which has a symmetrical base of two staircases at its left and right. This suggests Blois (see fig. 470), but without the panels of ornament. The builder, Conrad Krebs (1492–1540), was a skilled Gothic mason; he may have got his ideas from Peter Flötner, who designed in a Nuremberg town house (1534) the first German room with the same Italianate pilasters already used in France. These and some lesser related structures precede the full appearance of German Renaissance architecture by twenty years.

37. The Scorel Generation

A less well-known generation separates the careers of Massys, Mabuse, and Lucas van Leyden, who have a certain public fame, from the emergence of Bruegel about 1550. In Antwerp, the new cosmopolitan city that had asserted itself so distinctively with Massys, the spark indeed died rapidly. Massys' two rather untalented sons had successful careers there. The most typical personality of these decades is Pieter Coecke van Aelst (1502–1550); no certain paintings by him survive and those that may be his are fairly poor. But he was brilliant in organizing activities: a print publisher and an architect, he designed tapestries and stained glass, translated Serlio's handbook on architecture, and took charge of a royal procession in 1549 and wrote a book describing it, much like Vasari. And his one visual legacy is a set of woodcuts resulting from a trip to Constantinople, full of interesting reporting of costumes and topography. Antwerp was certainly busy in the arts.

The trend to specialize in painting certain themes (as seen in Patinir) is the context of Massys' two most distinctive imitators. Both make clear that Massys was most usable at the least Italianate end of his range, by imitating his more Flemish habits of minute drawing and realism of particulars and his more personal notation of daily life and caricature. Marinus van Roymerswaele (docs. 1505–1567) was trained in Antwerp, but then retreated to his native rural area and there spent his life repeating a few themes, all of them based on half-length figures in little rooms painted in hot colors. Apart from the repentant Saint Jerome in his study,[84] these curiously concentrate on financiers, merchants, tax collectors, or gold weighers, surrounded by an older Flemish clutter of precisely drawn objects and sharp-edged papers on which we can read bills and receipts (fig. 477; see colorplate 56). The people wear archaic costumes and are twisted, physically and psychologically, in cutting caricature. The painter seems smolderingly obsessed with the style of life that the classic Flemish painters had assumed as their base.

Jan Sanders van Hemessen (docs. 1519–1557) has a softer and more modern touch but the same archaic costumes, colors, and spaces, and similar themes. Often with a loose attachment to a Biblical text, he insists on social corruption, the man robbed in the parlor of the bawdy house (fig. 478), Saint Matthew among the tax collectors, Christ driving out the moneychangers. His congested groups of ghastly smiling people make him the truest precursor of the modern Belgian painter James Ensor. (Ensor's work is often traced back to Bosch, but by analysts who know only the few Renaissance painters adopted by today's tastemakers.) These two are the only good painters of Antwerp in their time, and they are a real part of Bruegel's base.

Holland's vein is not so thin. One might say that in Massys' time the Antwerp artists had to assimilate both the High Renaissance and Italian methods, and fell under the weight, but the Leyden artists only had to assimilate the High Renaissance.

477. MARINUS VAN ROYMERSWAELE.
The Moneychanger and His Wife.
1539. Panel, 33″ × 38″.
The Prado, Madrid

478. JAN SANDERS VAN HEMESSEN.
Loose Company. Panel, 33″ × 45″.
Staatliche Kunsthalle, Karlsruhe

It was then easy for the next generation, with Jan van Scorel (1495–1562), to assimilate Italy. As a pupil of Jacob van Amsterdam, he manages crowd scenes, in his first works, with modern depth of color and rich ornament, giving them sparkling variety, and his later works, in Lucas van Leyden's vein, still prefer the crowd to the hero. His travels had taken him to Jerusalem as a pilgrim, and his travel sketches also became a permanent base of his imagery. While returning he stopped in Rome to work for the Dutch pope Adrian VI (whom the Italian artists considered to be uninterested in art). After all this his first big work on his return, an altarpiece of *Christ's Entry into Jerusalem,* not

479. JAN VAN SCOREL. *Entry of Christ into Jerusalem,* center panel of Lochorst Triptych. 1527. 31″ × 58″.
Centraal Museum, Utrecht

surprisingly involves a crowd scene, a city map, and, most fascinating, a version of Michelangelo's *Deluge* on the Sistine Ceiling so thoroughly translated into Dutch that it does not seem an intrusion (fig. 479). The foreground climbing figures become silhouettes in front of a far-off vista, creating the formula of a landscape with decorative foreground people whose primary function is to emphasize the receding space, a constant of seventeenth-century classicistic landscape.

Scorel is most memorable in portraits and perhaps he first exemplifies the complete separation of style for portraits and for other works, hinted by Massys and later common (e.g., in Tintoretto). Scorel's portraits, inspired by Lucas and comparable at their best to Holbein's, use translucent simple cubes for the heads and graphic hands. He painted members of a club of pilgrims to Jerusalem in long rows (1525–28),[85] like Geertgen, foretelling the group portraits typical of seventeenth-century Holland, but he is finest when most personal, as in

480. JAN VAN SCOREL.
Agatha van Schoonhoven. 1529.
Panel, 15″ × 10″.
Galleria Doria-Pamphili, Rome

481. MARTIN VAN HEEMSKERCK. *St. Luke Painting the Virgin*. 1532. Panel, 66″×91″. Frans Hals Museum, Haarlem

portraits of his lifelong mistress (1529; fig. 480), and of a smiling twelve-year-old boy.[86] Both pin their liveliness to a fixed moment by devices of transparent surfaces of paper or cloth.

A rival Dutch portraitist, Jan Vermeyen (1500–1559), is less known today, though he was much favored by Emperor Charles V. Typical of the times is the record he made and then used in tapestries of a trip to Tunis with the emperor. His velvety costumes and rigidly frontal faces of court dignitaries are again early instances of the state portrait. A more versatile Dutch rival of Scorel is Martin van Heemskerck (1498–1574). He is best remembered for his four years in Rome (1532–36); the sketchbook he made there includes accurate renderings of the half-finished Saint Peter's,[87] the

best record of its construction. Such drawings are a typical expression of this artist and others, entranced by the dignity of Italy but still wanting to pin down the facts about it. Before leaving his home in Haarlem, he presented to his fellow guild members his most individual painting, *Saint Luke Painting the Virgin* (1532; fig. 481). It is aggressively expert in perspective and in sculptural modeling, but the comic touch of the saint peering at his drawing through his spectacles saves it from bombast and becomes symbolic of the artist's instinctively close perception of his high-toned subject. He is a splendid portraitist, enhancing his very real people with the deeply glowing color now traditional in Holland and with rich contexts of gesticulation as well as of still life.

38. The Hegemony of Antwerp

In the new generation at work from the 1540s, Antwerp nearly monopolized painting in the Low Countries. The artists were generally pupils of Pieter Coecke and sometimes of Lambert Lombard, who is even less known for his own paintings today. Lombard (1506–1566) drew pupils to his school in Liège, where he transmitted knowledge of the ancient sculpture he had copied on a trip to Italy. He sought remains of Roman sculpture north of the Alps and corresponded with Vasari about the origins of Italian painting; though his own work is almost primitively stiff, these teachings were prized.

Frans Floris (1516–1570) became Antwerp's leading painter about 1550, soon after returning from Rome. There he had studied Michelangelo's *Last Judgment,* and his own grand-style work is dominated by nudes in complex poses, often foreshortened, which make a network of limbs without spatial context (fig. 482). The particular figures are not original; only the arrangements are claimed as inventions, as if they were poems using ordinary

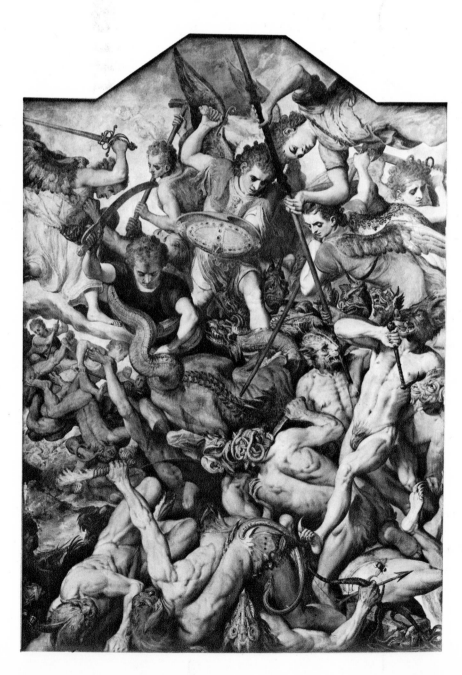

482. FRANS FLORIS.
The Fall of the Rebel Angels.
1554. Panel, 10′1″ × 7′3″.
Musée Royal des Beaux-Arts, Antwerp

483. ANTONIS MOR. *Queen Mary Tudor*. 1554.
Panel, 43″ × 33″. The Prado, Madrid

As these heads suggest, portraits naturally flourished in Antwerp. Willem Key (docs. 1542–d. 1568), who also produced smoothly constructed Biblical compositions, was the master of an exceptionally low-keyed portraiture, sensitive to individual mood with delicate shadows, an effect like some of his contemporaries in Venice. But the great Antwerp portraitist is Antonis Mor (1519–1575). His move to Antwerp from Utrecht, in Holland, where he had been Scorel's pupil, symbolizes Antwerp's capacity to wipe out artistic autonomy elsewhere. He at once became the favorite of the Habsburg court group and was sent about to Madrid and other capitals, painting the royal families, who were more interconnected with each other than with the inhabitants of any of their nations. His *Queen Mary Tudor* (fig. 483; wife of the Habsburg Philip II of Spain) took him to London, and it remains the classic version of her appearance. Indeed Mor's portraits do all that is needed to make them seem ideal frontispieces to biographies of their important sitters. Suave, secure, and in control, they are large, usually knee-length, and always turn a bit to the side; they suppress active gesture and environmental interest in favor of calm and as a result are clamped into rigid patterns, yet are distinctly soft, rich, and graphically individual in expression. He and his slightly older contemporary Bronzino mark the classic moment of the state portrait. In its early phase (Holbein, Vermeyen) its imposing formality had emphasized the importance of the person who was a ruler; now the ruler is a different species of person, restricted by patterns of etiquette that mark his status above casual mortals. A later evolution among Mor's countless followers (even more numerous than Floris') destroys the individual and substitutes a pure mask, but that has not happened to Mor's cool well-bred people, all each other's cousins and the lords of all around them.

The fine balance in Mor between individuality and good breeding may reflect the fusion of his Antwerp residence and his Dutch training (he never ceased to admire Scorel). The same fusion is more obvious in Pieter Aertsen (1508–1575), an Amsterdamer who spent his twenty most active years in Antwerp, but eventually went back to Holland. He is proportionately more a direct observer and less a learned designer than Mor. But he rose as it were to the challenge of Antwerp by the intellectual invention of a new category of ob-

words. Our taste for personal brushwork makes such art seem academic in the worst sense, but the age of Floris considered composing, as an intellectual phase of painting, to be the most attractive area of concentration. His men show idealized muscles and his women sinuous limbs, but both also have an unerasable Flemish reality of skin surface. If this saves them from being copies, it sets up an unwanted tension between the grand and the ordinary. Yet Floris' authoritative sweep in composing is on a quite different level from Coecke and Lombard and his style is found echoing all over Europe for the next fifty years, a period easy to misinterpret if this building-block is not known. Being very busy, he only sketched compositions and painted separate head studies, for use by his assistants. The heads have a globular substance and creamy freshness that make them, more intimately than anything else in Floris, a synthesis of Roman and Flemish aims.

servation; as the first career still-life painter in history, he was even more influential than Mor or Floris, outliving their narrow social relevance. But he is a portraitist, a painter of portraits of meat, vegetables, cheese, the imagery of a passionate shopper at a market (fig. 484). He makes these solid objects monuments, heavy and a little simplified, full of substance not only physical but philosophical; they are as much more grandly dominant over the occasional earlier still life as Mor's portraits are more grandiose than Van Eyck's. Conversely, he is a weak composer, installing little figures in his backgrounds to give his works legitimate themes in a manner that recalls Jan van Hemessen's Biblical backgrounds. The only people who really command respect are cooks and farmers; they are given their admiring due of statuesque stability, like the food they produce. Aertsen's work and world foretell the great Baroque still-life school of Antwerp by approving of these materials and backing them up with orchestral glorification, abolishing the superciliousness that pervades all other sixteenth-century imagery of peasant life.

Herri met de Bles (no firm documents) reminds us that Antwerp also retained the landscape specialty established by Patinir (perhaps his uncle). Suitable to this less impulsive, more learned age, Herri's landscape is impeccable in perspective, both linear and aerial. It continues to be a stage for episodes, with Biblical or otherwise traditional crowds, painted with microscopic correctness as in miniatures or as in the Van Eyck revival. This cosmopolitan command of all sorts of imagery has as perhaps its only virtue for us that it made available feeding materials for the great Antwerp artists still to come, and it was indeed utilized by Bruegel and Rubens.

484. PIETER AERTSEN. *The Butcher's Stall.* 1551. Panel, 48"×66". University Art Collection, Uppsala

39. Palaces and Other Buildings in Spain

A large fraction of the most famous names among the palaces of Europe—Fontainebleau, Hampton Court, the Louvre, the Escorial—belongs to the mid-sixteenth century, a natural effect of the growth of absolutism and of unified national states. Spain had been most dramatically transformed from a congeries of local kingdoms. A great increase in universities, hospitals, and administrative centers is also manifested there in the new buildings of the *plateresco* style. Their blocky façades have ornament drawn on them, rather more fluid and active translations from the Italian sources than their French and German counterparts, catching small shadows like latticework as if the masons were still recalling the Arabic traditions of older Spanish builders. Sometimes the formulas are borrowed not from north Italy but from Andrea Sansovino's work at the end of the fifteenth century in Florence.

The early masterpiece is the town hall of Seville (1527), by Diego de Riano (docs. 1523–d.1534), an all-window front marked by narrow pilasters of the usual Italian patterns; it is curious to find inside its vestibule a Gothic fan vault carved in the same expressive tone. A short generation later, here as elsewhere, the borrowed vocabulary has been ac-

486. PEDRO MACHUCA. Courtyard, Royal Palace, Granada. 1546. Height 42′, diameter 100′

climatized into the local idiom, producing what is called the "second *plateresco*." Its most brilliant product, the University of Alcalà (1541–53; fig. 485), by Rodrigo Gil (docs. 1525–d.1577), is plainer, with narrow bands of elegant ornament on its smooth façade like ribbons around a package. Ornament grows thicker and more exclamatory around the door, where short scallops spawn fantasies on classical themes.

Since the king, Emperor Charles V, rarely came to Spain, it is not surprising that his royal palace at Granada (model 1539) is in a completely

485. RODRIGO GIL. Façade, University, Alcalá. 1541–53. Dimensions of two main stories, 54′ × 132′

487. DIEGO DE SILOE.
Plan, Cathedral, Granada. 1528.
Length 190′

488. JUAN BAUTISTA DE TOLEDO
and JUAN DE HERRERA.
Plan, Escorial. 1136–80.
679′ × 528′

489. JUAN DE HERRERA. Court of the Kings
and façade of Church, Escorial.
Width of courtyard 125′, depth to steps 170′;
height of façade 131′

foreign idiom. It was commissioned from Pedro Machuca (docs. 1520–d.1550), a painter who had lived in Italy for years. He proves a master of the great scale and the very pure modern Italian forms that were certainly what his patron was seeking. He follows Giulio Romano closely in designing an intensified Mannerist version of Bramante's basic two-story aristocratic mansion, and perhaps goes a bit further, like Sanmicheli, in its more archaeological and engineered precision. The interior court, designed later (1546; fig. 486), is still more up-to-date, with detailing like Sangallo's latest Roman work. But it is the most special element of the building; as a huge circle, it realizes the Italian architectural theories of perfect form, like Bramante's plan for the San Pietro in Montorio courtyard (see fig. 190). Apparently only an emperor could execute it on the proper scale, far from Italy, and even this palace is unfinished. Almost as Italian is the Cathedral of Granada (model 1528; a cathedral was needed because the city had only recently been conquered from the Arabs). Its designer, the sculptor Diego de Siloe (docs. 1520–d.1563), had also long lived in Italy. Its five aisles and semicircular apse (fig. 487) give it a normal Gothic outline, but the choir inside is not Gothic with radial chapels, but almost a complete circle. This is probably Siloe's revision of a Gothic system intended but barely begun before he started work. It is a Renaissance geometer's idea of the Holy Sepulchre in Jerusalem, and on a much smaller scale had been built by Michelozzo at the Santissima Annunziata in Florence (see fig. 119).

Philip II, heir only to the Spanish half of his father Charles V's Habsburg lands, brought the royal scale to its peak. He was the first to give Spain

a capital, Madrid, and near it he built his private center of rule, the Escorial (fig. 488). In a sense it is a swollen and belated castle, or a square fort with immense bare walls. But Philip also wanted it to be a monastery with a church at the center, matching his own devoutness and leadership of the Catholic Counter Reformation. Juan Bautista de Toledo (docs. 1559–d.1567) built the fort (cornerstone 1563), but his pupil Juan de Herrera (docs. 1548–d. 1597) built the church inside (1574–80; fig. 489). It is a gray, bare, immensely heavy imitation of Alessi's Santa Maria di Carignano (see fig. 323), and thus of Bramante's plan for Saint Peter's. The king lived in some small rooms with a window looking down at the altar and at the tombs of his family, near his Titians but probably nearer his Bosches.

40. Palaces and Their Sculptors in France

Francis I, the great French rival of Charles V, had built grandly in his châteaux on the Loire, but he was at his grandest at Fontainebleau, his suburban palace near Paris. Its builders simplified and neutralized current Italian fashions, and the interiors by Italian visitors, Rosso and Primaticcio, were the most original and influential elements (see pp. 209–224). Their paintings set a standard for mannered eroticism, with nudes twisting their small heads and feet in involuted poses, and their decorative stucco framing designs likewise set a standard for architects, especially the tricky "strapwork," cutout patterns that ambiguously seem to hold the pictures but curl forward like leather. These two motifs, widely diffused in fine engravings, identified the Fontainebleau style. At the same time the Italian architect Sebastiano Serlio (1475–1554) came to France in 1541 and was a consultant at Fontainebleau. But his importance was through his illustrated handbooks for builders (a series begun in 1537), which spread a simplified Mannerism to fashionable mansions all over Europe. Its base of Italian principles of order with an amusing frosting of mannered decoration had great appeal.

Francis' son Henry II and his queen Catherine de' Medici rebuilt the Louvre, and luckily

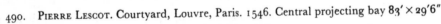

490. PIERRE LESCOT. Courtyard, Louvre, Paris. 1546. Central projecting bay 83′ × 29′6″

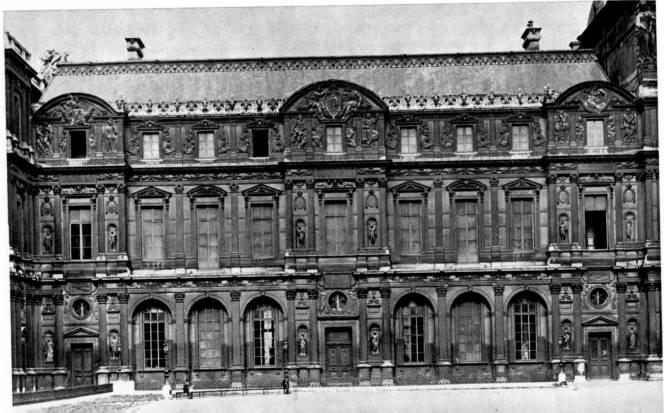

491. JEAN GOUJON.
Nymph, from Fountain of the
Innocents. 1547–49.
Marble, 7′9″ × 2′6″.
The Louvre, Paris

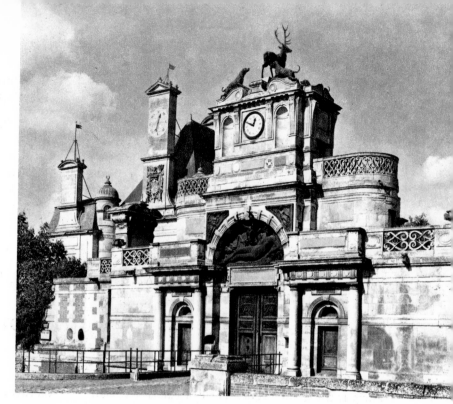

492. PHILIBERT DE L'ORME.
Gate, Château of Anet.
Height to highest cornice 37′

found in Pierre Lescot (docs. 1541–d.1578) the first Renaissance architect in northern Europe with a personality of his own. His courtyard (from 1546; fig. 490) is engraver's architecture, sharp lined and classically neat. But the austere rectangular ornament controls rather than hides the majestic proportions and the refined adjustments of its slight projections and recessions. Here begins French classicism, the slightly dry but heroically grand exposition of clear logic, that in the seventeenth century dominates intellectual Europe.

Lescot had as collaborator a marvelously talented sculptor, Jean Goujon (docs. 1540–1562), who seems to have worked out his own style by using the available engravings of Fontainebleau nudes, but stating a mood of grave classicism. All his work is subordinated to architecture, most spectacularly

in the caryatids (1550), women replacing columns, that support a gallery in a music room of the Louvre. His greatest work, panels for the walls of Lescot's Fountain of the Innocents (1547–49; fig. 491), is carved in such low relief that it lives by incised outline. But Goujon's line is not agitated as it is in other artists such as Botticelli. It curves with slow suavity, human and never surrendering to abstract rhythm, yet still alluding to the nature of chiseled stone. The nymphs breathe with a gentle life, yet manage to fill just suitably their tall assigned rectangles.

The greater architect Philibert de l'Orme (docs. 1533–d.1570) contemplated materials in the same serious, rather systematic way, but, having spent time in Italy, he approached them not through engraving but through construction, on which he wrote useful treatises.[88] The one major surviving work partly by him is Anet, the château of Henry II's mistress Diane de Poitiers (fig. 492). Its gate and doorway get emphasis and even grandeur from three-dimensional block relationships, plain cubes alternating with voids, the borders being articulated by columns and moldings. The chapel at Anet is a pure cylinder, as we are reminded by the intricate curves drawn on the floor. The weight and insistent impact of such forms theoretically imply dynamism, which is realized by De l'Orme's most

395

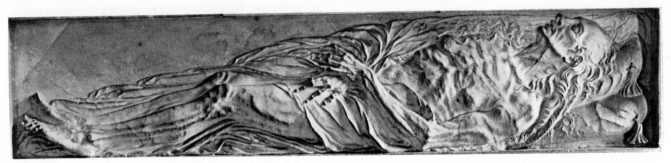

493. GERMAIN PILON. *Corpse*, relief on tomb of Valentine Balbiani. 1572. Marble, 13″ × 64″. The Louvre, Paris

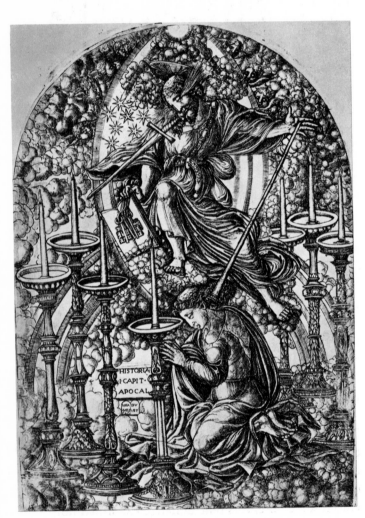

494. JEAN DUVET. *The Seven Candlesticks*,
from the Apocalypse series. 1546–55.
Engraving, 12″ × 8″.
Metropolitan Museum of Art, New York.
Harris Brisbane Dick Fund, 1925

495. LIGIER RICHIER. *Effigy*,
tomb of Count René de Châlons (d. 1544).
Stone, height 69″. St. Pierre, Bar-le-Duc

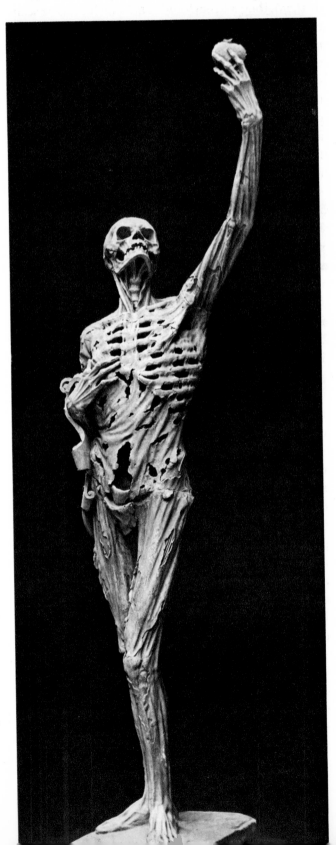

notable follower, Bullant (docs. 1540–d. 1578), who breaks the rules of classicism, but in a rather learned way, with colossal units and vertical pressures. It is hard to know whether a similar development in England is copying Bullant or responding similarly to the better-known De l'Orme.

Erotic court painting after Fontainebleau takes rather stodgy and provincial forms in nudes by the portraitist François Clouet (docs. 1540–d. 1572) and by Quentin Massys' son Jan (docs. 1531–d. 1575), long a French resident. The ladies are seen either lying down, in inflexible copies from Leonardo, or oddly sitting in baths. Richer related effects mark Germain Pilon (1535–1590), the finest sculptor of his time in northern Europe. For the tomb of Henry II's heart, [89] buried separately by old ritual, Primaticcio made the general design and Pilon carved three Graces holding the urn, facing outward in a triangle. They surrender Primaticcio's wittiness for a gentle mobility, a mildly sweeping flow of organic naturalism. To amend Primaticcio's tone Goujon's was evoked, but then Pilon amended Goujon to be more sculptural. The capacity of this series of artists to develop from limited local stimuli is extraordinary. Pilon's later more independent work includes the bronze kneeling tomb figure of Chancellor Birague (d.1583),[90] in which the typical meditative seriousness exploits the soft cloak to set up a single massive shape, imposing but natural like a mound and downy in surface, and thus sure of a very human dignity. Other tomb figures, including the naked corpses traditional in France (fig. 493), tighten their mastery of the body's flowing masses to mark a stress of feeling.

Here Pilon's court art seems related to a very different contemporary French art, practiced in small towns of eastern France by a surprising series of dissimilar artists. Its religious vehemence, sometimes taking archaic forms, reflects the wars of religion that drowned France in the second half of the century. Its first major monuments, crudely violent, are the Apocalypse engravings (1546–55; fig. 494) of Jean Duvet (1485–1561), which rework Dürer into tough, elaborate rigidity, and the tomb of a count by the Lorraine sculptor Ligier Richier (docs. 1530–1566). The count's will had ordered that his body be shown as it would look three years after he died (which was in 1544), so the sculptor shows him with scraps of flesh clinging as he lifts an arm that holds his heart (fig. 495).

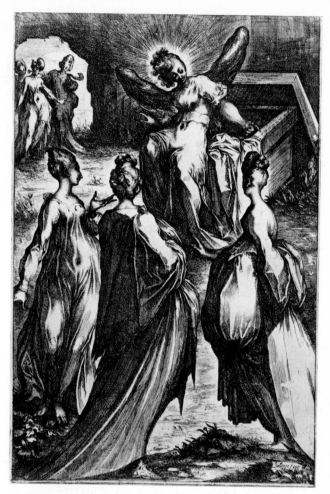

496. JACQUES BELLANGE.
The Three Marys at the Tomb. Etching, 13″ × 8″.
Metropolitan Museum of Art, New York.
Harris Brisbane Dick Fund, 1930

Later, in a greater artist, this mordant religiosity strangely uses the vehicle of Fontainebleau Mannerism, showing smiling sinuous ladies with tiny heads. The artist is Jacques Bellange (docs. 1600–1617), who was a painter and pageant designer for the dukes of Lorraine but is now only known through drawings and large-scale etchings (fig. 496). They are provincial in their pious extremism and in their stylistic language, which makes Bellange the last Mannerist. But they are urbane in their technical splendor, an astonishing ability to let needle line produce fluffy surfaces, which has convinced some observers that Bellange examined not only Fontainebleau but Barocci's art. Here, much more than with Pontormo, it is clear that snakily distorted people and perverse spatial measurements are intended to let formal whimsies assert emotional fervor. Still later, in a Baroque generation, Lorraine produces other odd brilliant artists involved with printmaking and religious vehemence (Jacques Callot, Georges de la Tour).

41. Architecture in the Low Countries, Germany, and England

497. CORNELIS FLORIS. Façade,
City Hall, Antwerp. 1561–65.
Height to ridgepole 80′, width 223′

498. WILHELM VERNUCKEN. Porch,
Town Hall, Cologne. 1569 (restored 1866–81).
Two main stories, including steps and
cornice, 37′6″ × 53′

About 1520 Renaissance fronts were applied to a few of the narrow houses in Bruges by simply coating the posts between their neat square windows with fluted half columns. The steep gables offered a difficulty, but were given Albertian scrolls as a new silhouette. The steeper ones required several scrolls, one diagonally above the other; when treated dashingly, this originally awkward patching became the trademark of Dutch architecture for three centuries. Ornament also preoccupied the first personality in Dutch Renaissance architecture, Frans Floris' brother Cornelis (1514–1575). After the usual Italian trip he returned to Antwerp, became the head of his guild, and published engravings through Jerome Cock's shop (see p. 374) that popularized Fontainebleau strapwork. His major work is Antwerp's town hall (1561–65; fig. 497), where the basic type follows a long line of Late Gothic town halls in Flanders, with high belfries and gorgeous carvings. This Floris modifies toward heavy clarity and thus to dignity: four stories high, and wide like earlier ones, the building underlines its width with horizontal moldings beneath heavy colonnades and windows, but at the center is placed what seems to be a grand tower; it is actually a false-front gable. The centralization and the calming balance of vertical and horizontal is new and makes this the ancestor of a city-hall type long standard in the Netherlands and Germany.

German buildings modified imports from several sources and gradually worked up several distinct traditions. In eastern Germany the pioneer example of borrowing from France, at Torgau (see fig. 476), led to the capable town halls of Leipzig (1556) and Altenburg (1562), the latter by a builder who had worked at Torgau; in both town halls smooth octagonal towers are set over smooth squares. The dukes in Bavaria and the Habsburgs in Prague imported Italian artists, entirely unoriginal in home terms, whose works in this Gothic context have a startling effect of clear freshness. The balance of space in their measured porches and walls is especially noticeable. A rare native response to this is the town hall porch at Cologne (1569; fig. 498) by the sculptor Wilhelm Vernucken (docs. 1559–

499. GABRIEL VON AKEN
and ERHARD ALTDORFER.
Courtyard façade, Wismar Castle. 1553.
Height 57′

d.1609). Its echo of Palladio's Basilica and its dependence on membering rather than ornament for its Renaissance effect overcome the fact that the upper-story arches are pointed. The castle at Wismar is a more modest adoption of Italian patterns (from 1553; fig. 499). Its courtyard façade is basically

the century-old one of Alberti's Palazzo Rucellai, studied through his followers in Ferrara. The wall is squared off by wide moldings and flat pilasters, with a window in each square; the fact that pilasters and moldings are in red terracotta adds a refreshing note. These restrained effects contrast with the street façade of the same building, Flemish in the ornamental Floris vein, where herms replace the pilasters. Indeed there is as much of this sort of designing, with vibrating ornament that speaks of Late Gothic feeling through Floris' or Serlio's idioms, as there is of the measured simple kind. The most spectacular ornament is at the Ottheinrichsbau, now a ruined palace, built in Heidelberg by the ruler Otto Heinrich (fig. 500). Carved under the supervision of the Flemish sculptor Alexander Colin (1527/29–1612), from 1558, its crawling surface is still in the spirit of the Certosa of Pavia, with windows framed as complexly as a series of Serlio fireplaces.

This ornamental fashion is echoed in many city halls and houses, while the simplicity of Wismar develops most suggestively in the castle of Horst, begun in brick (1559) by the Dutch architect Arndt Johannsen and finished by Vernucken. Built on water, Horst is a huge square in plan with four corner towers. The walls are measured off only by the white stone window frames, while the courtyard adds colonnades and rich voluted gables with linear

500. Courtyard façade, Ottheinrichsbau, Heidelberg. 1556–59. 55′ × 203′

501. ROBERT SMYTHSON. Façade, Longleat. 1568. Width 242′

patterns, all severely two-dimensional to be sure, producing a restrained finesse that suggests Dutch seventeenth-century building. The contrast of plain exterior and rich interior is typical of fortresses changing to mansions, such as the one in Stuttgart (1553)[91] with large round corner towers and in the courtyard three stories of loggias, each with ornamental Renaissance columns. What is unusual at Horst is that the outside, though windowed like a mansion, inherits enough of the plainness of castles to exclude all ornament; as a result it is by exception not given a Gothic or a Renaissance label, but suggests the future direction of the country house.

The first impressive results of the transition between castle and mansion are in England. Unlike all other countries, England gave itself to the Reformation before it let the Renaissance take root, which is why it has virtually no Renaissance painting or sculpture; its Renaissance architecture is brilliantly unlike any other. To be sure, a wandering Florentine sculptor, Pietro Torrigiani, had modeled the tomb of King Henry VII (from 1512)[92] with old-fashioned skill, but his figures compromised with local tradition and his ornament had no influence. Hampton Court,[93] which Henry VIII expropriated after he beheaded its builder, Cardinal Wolsey, in 1530, is a medieval mansion still in the tradition of the duke of Berry's at Poitiers, though now the Gothic vaults and the fortifications and even the coats of arms, in this post-chivalric culture, become ornament. Henry himself then built Nonesuch (1538)[94] to rival Fontainebleau, and on the interior walls copied its strapwork and herms, but the outside walls of colored tiles suggest that it was a fabulous pleasure dome. It was torn down in the

following century, and we also know little of slightly later buildings such as Somerset House, which seem to have copied Philibert de l'Orme and Bullant.

The mansions of the 1570s and later, on the contrary, inaugurate the country-house tradition that continued to a peak in the eighteenth century. Their owners, Queen Elizabeth's courtiers, themselves often coordinated the masons' work. Burghley House and others reflect French buildings and Serlio's books, but the finest are the most original architecture then being produced. Longleat (begun 1568; fig. 501) and Hardwick Hall (begun 1590; fig. 502) both seem to be designs of Robert Smythson (1535–1614), and if so, he must rank as one of the great architects of his century. Some observers credit the designs to the owners of the houses, but that is less plausible. The rectangular façades, long, symmetrical, and low, are filled with clusters of wide windows accompanied by no nearby

502. ROBERT SMYTHSON. Façade, Hardwick Hall, Derbyshire. 1590. Width 202′

ornament, only a slight trace at the roof line. As at Horst, they glass the plain castle wall to arrive at a non-Gothic, non-Renaissance effect. But here there is more; the absence of the big corner towers, the walls being articulated instead by very slight projections of parts of the façade, produces a flat screen, a glittering two-dimensional backdrop for the owners' vast green lands. This effect of inviting display and lightness is perfectly to the point, since the houses were constructed to receive visits from the queen. The sense of fanciful pageant mixed with the unornamented construction is much like some phases of Elizabethan drama, such as the holiday mixture of Cockneys and mythological people in Shakespeare's *Midsummer Night's Dream*. The owners were all newly rich beneficiaries of the expropriation of monasteries, clever men without ancestry, and no doubt viewed their property not in traditional ways but as a delightful outcome of briskly practical exertions.

42. The Portrait Phenomenon

In twentieth-century culture the context of portrait painting is so remote from the painting we call art that we not only omit portrait painters like Annigoni from our surveys, but do not notice the exclusion. Portraits and the Renaissance were born together, but it is only about 1525 in northern Europe that we see slight indications of a difference in the style with which portraits and other works are approached, either in the same artist's work or through the emergence of the portrait specialist. Both situations have been mentioned in scanning the artists involved and in considering the beginning of theme specialties among Antwerp artists (see pp. 391–92). Several reasons for the shift at that date are possible. One is the new Italian fashion; this had little effect on portraits, since they had always played a lesser role in Italy than in the North, and hence portraits continue in isolation to use traditional northern modes of drawing. Another, paradoxically, is antirealistic, the use of portrait images by the new absolutist dynasties of the Habsburgs, Medici, Tudors, and others, making the portrait an ideological sign, like a Madonna, and thus a vehicle of formulas. Still another is Protestantism, which in various places left portraiture as almost the only theme for painting, notably in England.

At the beginning of the period a role is played by a minor artist, Bernhard Strigel (1460/61–1528), who late in life in the imperial city of Augsburg revamped his style on the example of Burgkmair, and had success with vivacious paintings of families

503. BERNHARD STRIGEL.
The Emperor Maximilian and His Family. 1515.
Panel, 28″ × 23″.
Kunsthistorisches Museum, Vienna

504. BARTEL BRUYN.
Johann von Reidt, Mayor of Cologne. 1525.
Panel, 24″ × 18″.
Staatliche Museen, Berlin-Dahlem

Bruges in his time; he makes plain patterns and enamel surfaces support the serious faces of businessmen, although he paints altarpieces in the mode of Antwerp Mannerism. Bruyn and Pourbus, like Clouet, had sons who painted portraits, and Pourbus' grandson was the court portraitist of an Italian duke in 1610.

The culmination came with Bronzino and Antonis Mor, who made a code of imagery match a code of manners. They certainly used the occasional experiments of greater precursors who had expressed this situation, such as Raphael's *Joanna of Aragon*[95] and Michelangelo's Medici dukes (see fig. 253). Mor's patrons, the Habsburgs, were evidently the largest consumers of such portraits, and from the time of Strigel seem often to have brought forth inventive schemes from minor artists. The full-length portrait, seen earlier as a very limited German tradition, now becomes official through their favorite portraitist in Austria, the otherwise obscure Jacob Seisenegger (1505–1567). The potentials were immediately picked up by Titian, that inveterate user of handy compositions, and became the norm for Velázquez and even later artists. At the same time the opposite social end of the range of portraiture leads, in Amsterdam—a rising mercantile center far from courts—to the codifying of the group portrait of members of a lodge (after isolated experiments, also in Holland, by Geertgen

with children climbing about, the Holy one or contemporary ones. This coincided with Emperor Maximilian's delight in celebrating in all media the Habsburg kinship, and the result was the most famous image of its members at this period (fig. 503). It unpretentiously notes the unfortunate family nose and chin, and seems in its homely charm more bourgeois than lordly.

Joos van Cleve in Antwerp and the French court, Jean Clouet at the French court, and Jan Vermeyen with the Flemish Habsburgs, all at work by 1530, have clearly standardized the portrait composition and given it a coolness remote from the observer, as it is from the artists' other works. Vermeyen and Holbein were perhaps the first to paint royalty more abstractly than other people, yet in portraits of townsmen too at this time rigidity attacks traditional true reporting. Thus Bartel Bruyn records the citizens of Cologne as sharply individual but immobilized (fig. 504). He is paralleled by Pieter Pourbus (docs. 1538–d.1584), the only painter in

505. DIRCK BARENDS.
Members of a Gun Club. 1562.
Panel, 56″ × 72″.
Rijksmuseum, Amsterdam

402

506. NICOLAUS NEUFCHATEL.
Johannes Neudorfer and His Son. 1561.
Canvas, 40″ × 36″.
Alte Pinakothek, Munich

and Scorel). Dirck Barends (1534–1592) lines up rather awkward rows of thoroughly drawn heads of men, like a visual membership list (1562; fig. 505). After this formula becomes contaminated with a genre formula much later, it will be worked on by Frans Hals and Rembrandt.

Mor's formula was the favorite one. In his own time his discreet designs, all-over velvet texture, and incisive identifications have almost equally accomplished users in Nicolas Neufchatel (docs. 1539–1567), an Antwerp painter who went to Nuremberg and became an entrancing recorder of intimate groups among the old families (1561; fig. 506), and Hans Muelich (1516–1573), the favorite artist of the dukes of Bavaria in Munich, whose slightly drier patterns and shinier costumes suggest that when he visited Rome he learned something from Salviati's version of the formula.

Not only do such artists have uniform and minor but definite ambitions, but each is in most cases the only painter of any sort in his town. Indeed some of their continuing fame is due to the fact that such a question as "Who were the outstanding German painters in the generations after Dürer's

507. TOBIAS STIMMER.
Jacob Schwytzer and His Wife. 1564.
Panel, each 73″ × 31″. Kunstmuseum, Basel

403

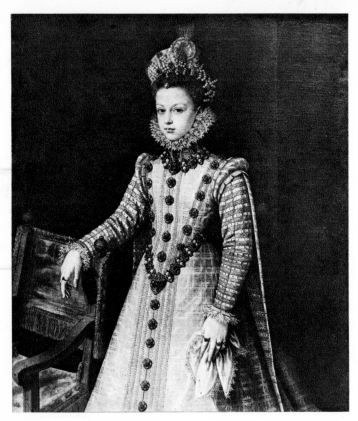

508. ALONSO SANCHEZ COELLO.
The Infanta Isabella, Daughter of Philip II.
1579. Canvas, 45 5/8" × 40 1/8".
The Prado, Madrid

graphic notation of character that still remembers Holbein (1564; fig. 507). A suavity like Mor's invades Italy and around 1550 sets the direction of the career of Moroni in Bergamo, the Italian town near Switzerland, where Moroni is the only painter and the first Italian portrait specialist (see p. 255). But court portraits are the chief type; the frozen formula of the face as mask and the elaborate costume now become so puppet-like and far from nature that they look medieval. François Clouet uses the style of Salviati in his portrait of a botanist,[96] but later paints the king as a costume mannequin in silhouette;[97] and Mor's heir in Spain, Alonzo Sanchez Coello (docs. 1557–d.1588), transforms his princes and princesses into hangers for starched ruffs and rigid farthingales (fig. 508). The most familiar images of Queen Elizabeth of England are of this type. It affects Italy in Bologna, another town of few artists, in the portraits by Passerotti (1529–1592), more like Clouet than like anything Italian; and in Rome in the tin-mold cardinals by Scipione Pulzone (docs. 1567–d.1598). Although Pulzone's effect of social abstraction has rightly been described as removing the sitters from time, it should be kept distinct from the less extreme phase of Bronzino and Mor.

The freshest and most surprising variant on the full-length portrait is tiny rather than grand, and in England. Following some visiting Flemish court portraitists, Nicholas Hilliard (1547/48–1618/19) became the first and greatest specialist in the miniature portrait (fig. 509). The handbook he wrote on his technique[98] also mentions the impor-

death?" has to be answered somewhat apologetically by citing Muelich or Neufchatel, as for Spain it would call up Sanchez Coello or in England Nicholas Hilliard. Protestantism is certainly a cause in Nuremberg of this monopoly by one artist, as it was in Cranach's Wittenberg and later in England and Basel. It determined the striking career of Ludger tom Ring the Younger (1496–1547), a Protestant who left his brother to paint Antwerp-type Catholic altarpieces in their native town and moved to the Protestant town of Münster to be a portrait specialist. When such a monopoly happens in a very Catholic context, as with Muelich in Bavaria or Sanchez Coello in Madrid (see below), it seems that the modish kings in those courts liked to import Italian artists for many tasks but found it natural to fall back on the one local talent to record their faces.

In the late sixteenth century these lonely specialists, now strongly tending to the full-length formula, occupy a very large proportion of the stage. They are quite sharply split between courtly and bourgeois. In Basel Tobias Stimmer (1539–1584) can paint a husband and wife full length with a

509. NICHOLAS HILLIARD.
A Youth Leaning on a Tree.
Card, 5 1/2" × 3".
Victoria and Albert Museum,
London

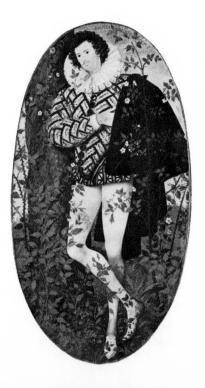

tance of the flicker of eyes and the shadow on a cheek to suggest emotions in a face. The portraits show this in young men who, recalling the pastoral suggestions of Giorgione's patricians in Venice, lean on a tree or gaze into space. These are the young lords who patronized playwrights and exchanged sonnets—another expression of feeling in tiny frame (and both were exchanged as love tokens). This portrait art, like the English country houses, is supported by courtiers and expresses their lightweight hedonism, but it is not a court art. Neufchatel in Nuremberg is the most suggestive source of its small-scale sensitivity, but Hilliard's variant is airier and more lyrical.

43. Bruegel

Pieter Bruegel (docs. 1551–1569), the greatest artist of his time in all northern Europe, is traditionally labeled as the successor of Bosch. They share, besides modern fame extracting them from their context, piquancy of satire on the human condition. But Bruegel's specific reflection of Bosch occurs consistently only in engravings from his drawings, published by Jerome Cock and at one time Bruegel's only widely familiar work. His paintings exploit Bosch slightly, and make much more use of the patterns current in Antwerp just before his own time: Patinir's sweep of landscape with bumpy incidents, Hemessen's sermons on social ills in Biblical contexts, and especially Aertsen's monumentalization of lower-class people. More fundamentally than these local sources, used almost as a technical method, Bruegel uses and glorifies the rich antiheroic

tradition of printmaking in the Hausbuch Master, Altdorfer, Baldung Grien, and Lucas van Leyden, in which the individual Renaissance man loses his dignity, is satirized as amusingly silly, shown as the victim of evil forces or blind fate, and reduced to an antlike mass. His closest precursor in space, time, and greatness, Lucas van Leyden, had completely prophesied one phase of Bruegel in his *Conversion of Paul*, with its major event an unnoticed small detail in the human crowd. And as these earlier artists seem parallel to the *Praise of Folly* by Erasmus, unread today but still a great name, Bruegel's reworking of them may be compared to Rabelais; both treat life as a comedy, absurd and vulgar and hence zestful, endlessly detailed and all part of a great stream.

On his youthful trip to Italy—the standard

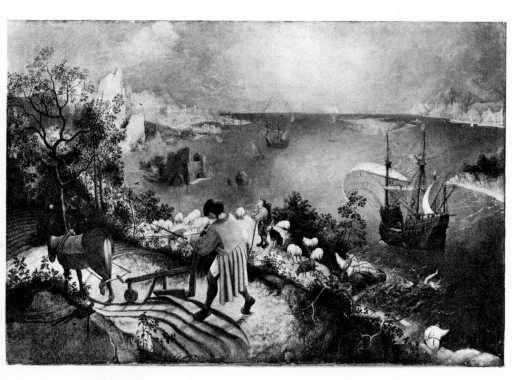

510. PIETER BRUEGEL.
The Fall of Icarus.
Panel, transferred to
canvas, 29″ × 44″.
Musées Royaux des Beaux-Arts,
Brussels

405

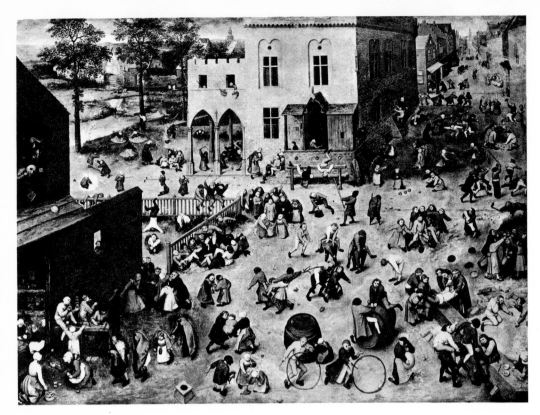

511. PIETER BRUEGEL.
Children's Games. 1560.
Panel, 46″ × 63″.
Kunsthistorisches Museum,
Vienna

move—Bruegel painted landscapes, not as conventional as most. Figures inserted in the corners supplied titles (*Christ Appearing to the Apostles at the Sea of Tiberias,* 1553[99]), and this scheme soon evolved into the *Fall of Icarus* (fig. 510). W. H. Auden has admirably observed the point of the picture, that the ordinary workaday life of plowing, herding, and sailing outweighs the extraordinary event of Icarus' fall from the sky. Icarus' ambitiousness had made him fly impractically high, so that he fell and drowned, but the second and most fitting punishment is that his fall is not noticed. Bruegel always attacks individual pride as egoism, but its opposite is not the virtue of humility, it is the automatic continuum of nature's life. The hero here is thus the plowman with his plodding horse, already showing Bruegel's elemental cylindrical modeling. But no other theme of Bruegel's comes from classical mythology, which may have seemed too high class.

His great paintings of 1559–69 show almost annual revisions in figure composition, constantly seeking greater and greater unity out of infinite details. The first works, the *Battle Between Carnival and Lent* (1559[100]), and *Children's Games* (1560; fig. 511), make a rather flat all-over pattern out of very many tiny equal units of trembling importance, the subjects being approached like an inventory. In the first, actors in a pageant in a village square present a combat, assisted by the fat and the thin, the worldly

and the pious. In the second, the endless games—hoop rolling, hair pulling, going around the mulberry bush—underline through hard precision their meaningless and fated repetition. Likewise *Flemish Proverbs*[101] lets tiny figures act out sayings such as "Don't butt your head against a wall" or "Blocking up the well after the calf is drowned," some eighty in all, and the figures seem to repeat the same action over and over as proverbs do, failing in their aim of preventing man's tendency to do silly things.

This accumulative imagery is then revised by being given a slightly larger-scale central focus, while yet retaining the suggestions of mechanistic behavior. In the *Triumph of Death*[102] the skeleton on the horse, out of Dürer, holds the center, while he leads a Holbein-like dance of skeletons seizing a cardinal, a mother and baby, lovers, and so on, and skeletal armies march through the open world. In the Apocalypse scene of the *War in Heaven* (1562)[103] between angels and the dragon devil, the traditionally posed Saint Michael coordinates the fantasy of swarming doomed creatures; and *Dulle Griet* (1562)[104] illustrates a folk tale about "Mad Meg," a greedy giant scavenger followed by tumults of grasping women. Only these latter two paintings copy Bosch's images of fires and squelchy monsters, and in this period of self-revision Bruegel was leaning on many models, as noted. In the same year he further reinforces unity of aim, while still being

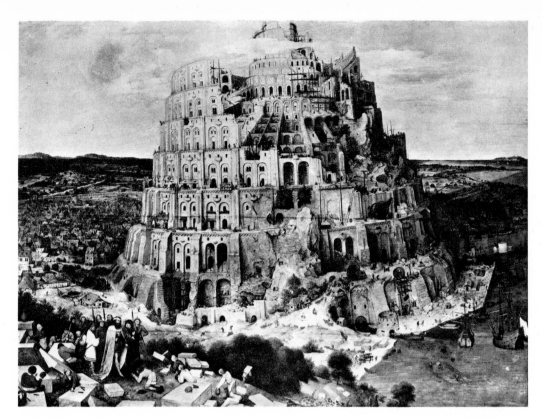

512. PIETER BRUEGEL.
The Tower of Babel. 1563.
Panel, 45" × 61".
Kunsthistorisches Museum,
Vienna

antiheroic and still borrowing, this time from Lucas van Leyden and from Altdorfer, in the *Suicide of King Saul*.[105] Here the mass of men, the mindless herd of the spear-carrying army, is funneled along a single path across the center, while the king (whose insanity had also struck the attention of Lucas) falls on his spear in a front corner, unknown to them. As the lances in a line do there, endlessly spiraling pillars make the *Tower of Babel* (1563; fig. 512) a tight structure. This meaningless object has the message of human ambition to match God, soon punished by the birth of confused babbling languages.

In 1563 Bruegel, who had lived in Antwerp, moved from there and from his publisher, and thereafter concentrated, in Brussels, on painting only. At once his work grows thin, subtle, and airy in color, and suggestively expansive in space. In *Christ Carrying the Cross* (1564)[106] the mourning group of the three Marys, in larger scale in the corner, again contrasts with the thousands of other people, including the unnoticed Christ at the center (an idea used long before by the Master of Mary of Burgundy), but all are absorbed atmospherically into the deep sandy landscape and evoke the sense of an excursion into the country. Bruegel now pursues this kind of unity more and more, along with larger scale. The latter is emphatic in the *Adoration of the Magi* (1564),[107] the first work made out of big figures, caricatured peasants suggesting that they are Bottom

the Weaver and his friends botching a church play. Unity of air is most relied on in the famous *Hunters in the Snow* (colorplate 59), *Corn Harvesters*,[108] and *Return of the Herd* (all 1565),[109] which to us can easily look like pure landscape views but are actually calendar illustrations—January, August, and November—i.e., an old-fashioned demonstration of the automatism of nature's cycle. The figures in many cases are made more typifying by being seen from the back as they perform their jobs, and we focus the more on frozen ponds, ripe wheat fields, and the forest, lyrically celebrated by Bruegel's new thin color. The most powerful unity of air is in two snow scenes. The *Adoration of the Magi* (1567)[110] occurs during a snowfall, blurring our focus, with a long train of attendants as in the International Gothic tradition of this theme, and the *Numbering at Bethlehem* (1566)[111] catches the barely visible Joseph and Mary getting in line to be counted in the census and pay their taxes, a drastic new metaphor of the nonindividual life.

From 1566 on, compositions with large figures are favored more and more. The *Peasant Wedding Dance*,[112] a crowd of bulky jingly hicks responding to a stimulus, is remodeled in the *Peasant Wedding Feast* (fig. 513). Its diagonal feast table, with big servants working in front of it, borrows Tintoretto's *Last Supper* composition with similar intent (see fig. 301; Bruegel had traveled in Italy with Marten

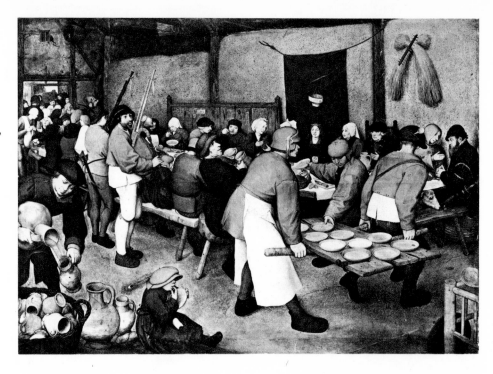

513. PIETER BRUEGEL.
Peasant Wedding Feast.
Panel, 45" × 64".
Kunsthistorisches Museum,
Vienna

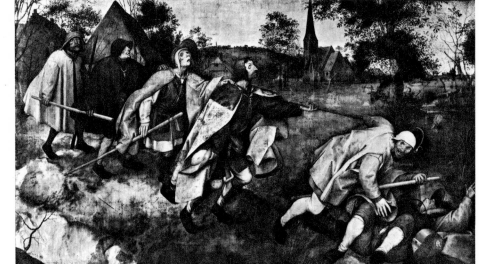

514. PIETER BRUEGEL.
*The Blind Leading the
Blind.* 1568.
Canvas, 34" × 61".
Museo Nazionale
di Capodimonte,
Naples

de Vos, an admirer of Tintoretto). The crude comedy is more imaginative in *Cloud Cuckoo Land* (1567),[113] where fat men lie and wait for sweets to fall in their mouths, and the complementary *Crippled Lepers* (1568),[114] who beg on a day when it is permitted. At last, in 1568, Bruegel could make his unchanging point in a way that seems a denial of it, by representing a single monumental figure. The *Peasant and the Bird's Nest*[115] illustrates the proverb: "He that knows where the bird's nest is, knows; he that steals it, has it." Our hero walks along in the fresh weather and gives us hints of his knowledge, but he does not see or know the small thief. Humanity compressed into one person is most

powerful in Bruegel's only immobile creature, *The Misanthrope* (1568),[116] the man who hates everything, hiding austerely in his black coat, while a small figure robs him and confirms his judgment if not his procedures. Monumental mobility is totally realized in the *Blind Leading the Blind* (1568; fig. 514), where one parable does the work that required a hundred proverbs when Bruegel began. As each ugly and pathetic creature repeats his predecessor, we know that this will continue to the end. The world will not mitigate its force; Bruegel tells us this louder than ever, but also with a pity and sensitivity that have grown steadily while he, very much an individual, reviewed and remade himself.

44. The Move from Antwerp to Haarlem

Antwerp maintained its status as the distribution center for style in the next generation after the Floris brothers, under the similar hegemony of the painter Marten de Vos (1532–1603). He spent his standard visit to Italy as a youth mainly in Venice, and he modified his teacher Frans Floris' Michelangelism by imitating Tintoretto, whose procedures could so easily be translated into formulas. Yet despite this infusion of sensuousness into the anatomical compositions of Antwerp, the formula grew more and more desiccated. The key role of prints and especially print publishers is significant. The greatest of them, Jerome Cock, employed a number of engravers at his shop, the Four Winds; they worked from drawings by painters, and he sent out quantities of illustrated books, popular religious prints, maps, and travel scenes. The most obvious recurrent type in their work is the Mannerist female nude that echoes Tintoretto and Fontainebleau; they also retain Floris' flat interlocked figure dramas, and are technically splendid in smooth line and luminous surface. Model books also provided vast circulation for Cornelis Floris' ornamental patterns.

The individual Antwerp artists are less interesting than various reflections of their export trade.

The Floris ornament stimulated a whole school of goldsmiths and jewelers in Nuremberg, still a town of metal crafts. Wenzel Jamnitzer (1508–1585) and other makers of goblets and treasure chests were citizens of the merchant town but, like the portraitists with whom they share German art of this epoch, worked for the little luxurious courts that were to dominate German life for the next two centuries.

The young artists who traveled to Italy from the north often got commissions for an altarpiece or two there, and after 1550 some became permanent residents. They could supply the specialized subjects demanding particular realism—landscape, genre—that Italian artists found insignificant but Italian patrons increasingly amusing. Ludwig Toeput (docs. 1584–1603) painted landscapes as part of large palace schemes of decoration near Venice, and was renamed Pozzoserrato. Jan van der Straet (1523–1605), as Stradanus, took care of tapestries and hunting scenes for the Medici court at Florence (fig. 515), where of course the sculptor Giambologna was the great model for such immigrants. Denis Calvaert (1540–1619), with standard Floris-type altarpieces, dominated painting in Bologna along

515. JAN VAN DER STRAET (Giovanni Stradano). *The Hunt.* Tapestry, 13′ × 16′9″. Camera d'Ercole, Palazzo Vecchio, Florence

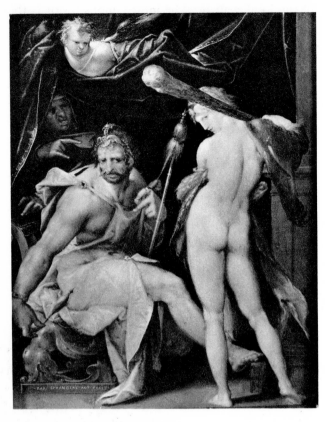

516. BARTOLOMEUS SPRANGER.
Hercules and Omphale.
Copper, 9 1/2" × 7 1/2".
Kunsthistorisches Museum, Vienna

astronomers Tycho Brahe and Kepler) and the most artificial, toylike court art even of Mannerist courts. His favorite painters were Arcimboldo (d.1593), a Milanese painter of trick pictures—human heads discoverable in arrangements of fruit or flowers, and the like—and Spranger, who lived in exalted grandeur in Prague for the rest of his life. From studying Parmigianino and Giambologna he had evolved the perfectly Mannerist female nude, like an engraving in its precise, complex outline and its shiny, brittle texture, and with extraordinary involuted poses, titillating smiles, and erotic subjects (fig. 516). More than Primaticcio's art at Fontainebleau, it is the criterion of this hothouse breed of amusing artifice. It at once had a whole school of imitators at the court of Munich, and a more interesting one at Haarlem. There at the end of the century a Dutch variation on the Antwerp formula suggests, once again, a more colorful and airy revision of an official Flemish style.

Hendrick Goltzius (1558–1617) learned en-

with the Italian portraitist Passerotti. Calvaert and the younger landscapist Paul Brill are basic to the formation of the first great Baroque painters, the Carracci, who moved from Bologna to Rome, and indeed late in the century the mood and situation among artists in Antwerp and Rome are very similar. The Italian Federigo Zuccaro is like Marten de Vos in being a leader of an artists' community, a promulgator of high-class theory, a reworker of several High Renaissance formulas of figure drawing, and a very limited talent.

The most interesting Antwerp emigrant was Bartolomeus Spranger (1546–1611), who went to Italy at nineteen and never returned home. During ten Italian years, mainly in Rome and Parma, he helped complete an interrupted fresco project which made him familiar with the work of Parmigianino. Obviously bright, he was recommended by Giambologna to the Habsburgs as a court painter, first in Vienna and then in Prague. There the eccentric Emperor Rudolf II amused himself with alchemy (which by accident led him to support the great

517. HENDRIK GOLTZIUS.
The Standard Bearer. 1587.
Engraving, 12" × 8". Metropolitan Museum of Art, New York. Gift of Robert Hartshorne, 1918

graving in Haarlem on Antwerp methods, and became the particular master of the swelling line, a long curve that imperceptibly widens and then narrows, and thus is beautifully adapted to the sharp drawing of the human body in movement. It was his luck to see drawings by Spranger at the right moment, which he at once reproduced in engravings His own originals are even surer and more sweeping, toning down the elegant artifice with some infusion of the local realism. The most famous result is the *Standard Bearer* (1587; fig. 517), a smiling soldier carrying a huge pennant, a gleamingly flamboyant image out of real life with a sufficiently stylish composition. Thus Goltzius and Spranger demonstrated that in 1600 the Mannerist tradition and the Antwerp tradition were as alive as ever, perhaps more so than a little earlier, and hence worthy of the revolt of the young Baroque artists.

45. Painting and Sculpture in Spain before El Greco

A courtly or International Gothic painting had worked its way out of medieval traditions in Spain after 1440 and followed Franco-Flemish patterns, just as it did in many other places. Of the many similar Spanish altarpieces the most attractive is *Saint George and the Dragon* (fig. 518), probably by Bernardo Martorell (docs. 1433–1453). It illustrates a quality long persistent in the painting of Spain, Germany, and the back hill provinces of Italy. Copying the International Gothic or a later style, in the way a fine local cabinetmaker might copy a pattern from a center of fashion, it wipes away the overtones of wit and feeling, and emphasizes the flat panel and the bright color areas, the expert gold tooling and contour drawing, always on the edge of falling back out of Renaissance imagery into the craftsmanship of medieval church furniture. Such a relationship to Flemish Renaissance painting is seen in the finest Iberian achievement of the century, the altarpiece of Saint Vincent by Nuno Gonçalves (docs. 1450–1471), in Lisbon (fig. 519). Discarding space, it presents its rows of figures in steely texture, their faces inflexibly ironed flat. Painters at this time were lucky to have Dirk Bouts' art available as their model; his repressed, angular people, incapable of a liberating gesture, lend themselves to this dehumanized draining, Nuno's portraits here of Prince Henry the Navigator and others (reminding us that this is Portugal's moment in world history) acquire a serious weightiness even more abstracted from the Flemish models than Fouquet's portraits are. A Spanish parallel is Jaime Huguet (docs. 1448–1487), a painter of simple,

518. BERNARDO MARTORELL.
St. George and the Dragon.
Panel, 56″ × 38″. Art Institute, Chicago.
The Charles Deering Collection.
Gift of Mr. and Mrs. R.E. Danielson and
Mrs. Chauncey McCormick

519. NUNO GONÇALVES.
St. Vincent Venerated by the Royal Family.
Panel, 82" × 51".
Museu Nacional de Arte Antiga, Lisbon

Pacher's (see p. 331). Still later the French immigrant Juan de Borgoña (docs. 1495–1553) designs open Renaissance space platforms for his altarpieces, whose closest analogy is with his contemporary Marco Palmezzano, a provincial follower of Melozzo da Forlì.

The continuing likeness between these painters of Spain and Italian ones of very secondary significance from remote areas, outside the scope of a general overview, prompts the small space given here to Spanish art, contrary to our instinctive tendency to give it more weight as we turn to a different section of the world. Our spontaneous admiration of these Spanish primitives for hard stylization, and the belief that this had a sophisticated aesthetic purpose (as with American colonial portraits), can continue only in ignorance of the urbane Flemish models which they were constantly emulating. There is also a problematic element when, in the name of the widest aesthetic freedom, we admire an art so committed to a standard set of formulas.

Spanish painters learned of Flanders by travel, or through the arrival in Spain of paintings by Rogier van der Weyden and other masters. In the case of sculptors, minor Flemish, German, and French craftsmen came to Spain to work, and Spanish

strongly passive people in separate situations, setting a Bouts type against a gold patterned ground. The widely traveled Bartolomé Bermejo (docs. 1474–1498), in a younger generation, seems to begin by translating Memling into polished cubes, but then, affected perhaps by the importance of movement through space and shadow in the later Bouts and Gerard David, his late *Pietà* (fig. 520) and *Christ's Descent into Limbo*[117] are the most emphatic dramas yet seen in Spanish painting, with complex reaching gestures that introduce a startling "Baroque" pathos into the rectangular figures. But the standard technique of simple bright color areas continues to work for Pedro Berruguete (docs. 1483–d.1503), who seems to have assisted Joos van Gent in Italy, returned home to paint spaceless and depthless copies from him, and later to have evolved a kind of abstracted pattern of perspective lines strangely like

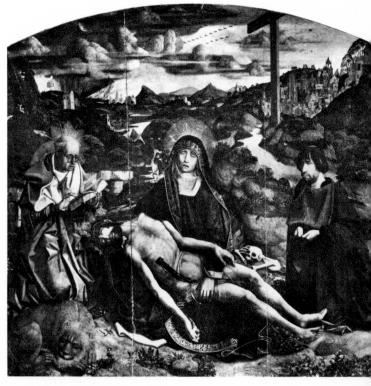

520. BARTOLOMÉ BERMEJO. *Pietà.*
Panel, 74" × 69".
Cathedral, Barcelona

Renaissance sculpture had a stronger growth. It flourished quantitatively in enormous altarpieces, built onto the choir walls of churches, consisting of dozens of little panels richly ornamented like Moorish and *plateresco* buildings. They were still being built well into the sixteenth century. The most original sculpture was on tombs, whose portrait effigies simply adapt Flemish realism with great geometric strength. The most remarkable single tomb, carved in 1489 by Sebastián de Almonacid (docs. 1494–1527) for the constable De Luna and his wife,[118] is a reduction of the French type by Michel Colombe, with four large kneeling monks set pyramidally at the corners in contrast with flourishing Gothic decoration. A greater personality, Gil de Siloe (docs. 1486–1499), began in 1489 to carve the royal tombs at Burgos, and used the most impressive of models, Nicolaus Gerhaert's imperial tomb at Vienna. Again he simplifies and shifts to craft patterns, emphasizing a surface studded with carved jewels as an openwork outer layer, while holes of shadow further enrich the texture visually.

As the sculptors draw closer to their models in space and reduced time lag, the talented Bartolomé Ordóñez (docs. 1517–d.1520) in his Barcelona choir stalls (fig. 521) produced the first adequate translation into sculpture, anywhere, of Raphael's late style. (The reliefs can be directly compared with the work of Lorenzetto, Raphael's executant in sculpture, and are much stronger and more sweeping.) Ordóñez can manipulate crowds that twine through depth with dramatic evocation and rhythm. He spent most of his time in Naples and at the Carrara marble quarries, and his later work in Spain indicates a gradual loss of tension into a routinely nervous Raphaelesque line.

After that the appearance of a truly original artist with continuously self-assured style, Alonso Berruguete (docs. 1504–d.1561), is not surprising. In his youth, when in Florence, he is known to have made a wax copy of the *Laocoön,* and this experience of the soft invertebrate medium and of the most melodramatic monument of classical prestige may have been decisive. Having settled in the royal town of Valladolid, he carved (1527–32) the altar of San Benito,[119] including a series of saints recalling his sophisticated German contemporary Benedikt Dreyer, but with none of his Gothic trace elements, and lacking little of anticipating the Rococo. The thin figures assert their anguish by straining their muscles through three dimensions, indeed suggesting pulled wax. The figures of the Toledo Cathedral choir reliefs, boxed in their frames on blank backgrounds, blow thinly to one side like sails. A full-round group is even more spectacular, when the figures of the *Transfiguration* seem tossed upward from a base of stormy ocean waves (fig. 522). All of

521. Bartolomé Ordóñez.
Entombment of Christ. 1518.
Wood, width inside frame 13″.
Cathedral, Barcelona

these surprising, dislocated, and elastic images are authentically sculptural, and at the same time their wild religious tension and their sticky textures make them genuine foretastes of El Greco. That Berruguete was not isolated is suggested by a kind of folk version of his style, in the wooden *Calvary*[120] by Juan de Valmaseda (docs. 1516–1548). These emaciated grief-stricken figures with simplified parallel folds in their robes suggest in theory a Late Gothic tradition, but do not resemble anything Gothic in particular.

The French immigrant Juan de Juni (docs.

1536–d.1577), a talent of equal authority if less bizarre individuality, tells us that Berruguete was not an isolated sport as to quality either. Juan's generally Michelangelesque background has close links to Michelangelo's assistant Montorsoli, who worked in Spanish-owned Sicily. He first worked in terracotta, and retains his clay-modeling effect in grander works, with painterly gradations of flowing surface and wriggling folds in stormy undulations. The grand manner in which the fleshy figures behave involves tearful melodrama in its heavy curling pressures, and his most expressive work is a *Mater Dolorosa* (fig. 523). She suggests that there is a common factor in Juni, Berruguete, the mystic Saint Theresa of Avila, the soldier-saint Ignatius Loyola, and King Philip II's fortress-monastery of the Escorial, all strong phenomena in the sixteenth-century Spain whose unique emphasis on Catholicism played so large a role in Europe.

Painting at this time was again less rich. Pedro Machuca, before he became Emperor Charles V's architect, painted a Madonna[121] in Italy that was a more than provincial rendering of Raphael, with a High Renaissance softness and a religious firmness not equaled in his later work, nor by any other Spanish "Romanist" painters. Of these the most conspicuous was Pedro de Campaña (1503–1580),

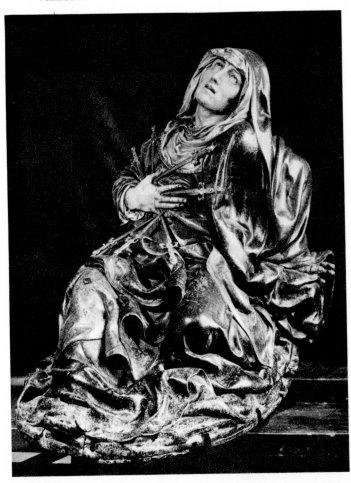

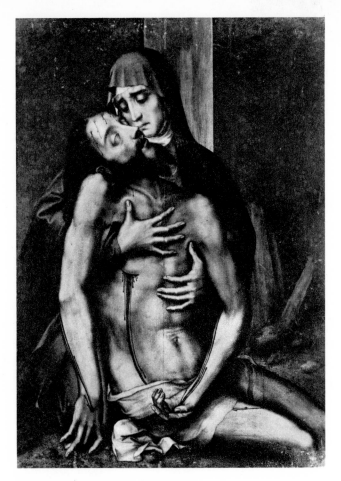

524. LUIS DE MORALES. *Pietà*.
Panel, 49″ × 37″.
Accademia de S. Fernando, Madrid

an immigrant from Flanders via north Italy, who offered Spain a metallic, tight version of the Mannerist anatomies, an abstracted copy of Floris and Salviati. But a remote and minor town near the Portuguese border, Badajoz, sheltered the one extraordinary Spanish painter of this century, Luis de Morales (docs. 1546–d.1586). He rapidly evolved a single kind of image, a face of Mary or of the dead Christ, with sallow skin and cheeks shadowed in almost ghastly refinement of soft transitional tones (fig. 524); he repeated this sickly pious type over and over in related compositions, most effective when most geometric and most passively contemplative, as in Christ gazing at the cross. His style gained for him the religious accolade of "the divine Morales" from some and made him distasteful to others, in a revulsion much like that felt toward the style of Sodoma, with whom he shares a debt to Leonardo. Yet even though he seems "typically Spanish" in his single-minded piousness, no one around him created so distinctive a statement. And his spindly figures and otherworldly expressions make him, too, a part of the background of El Greco.

46. El Greco

Domenikos Theotokopoulos (1541–1614) was born and grew up in Crete, an island owned as a colony by Venice but Byzantine in culture and Greek Orthodox in religion. He may, however, have belonged to a Roman Catholic minority linked to the governing power, and at twenty-five, when he was already a painter, he went to Venice. There he worked under Titian (1567–70) but it was not Titian's style, at this date colorlessly thin and brown, that he imitated, but Jacopo Bassano's. Bassano was then evolving his own richest style, which leans on Parmigianino's long-limbed people who do not even pretend to be real, and yet is still Venetian in its high coloristic charge. It finds enjoyment in gleaming, rather pasty surfaces, high-keyed pinks and

greens of clothing emerging from shadowy spaces, dancing action, and candlelight, all in the Venetian terms of airy breathing motion and beauty. El Greco used all these technical resources, if not their expressive implications, throughout his career. The glowing color may well have reinforced what he had learned of Byzantine icon types in Crete, but the mobility is opposed to them; in adopting that, El Greco renounced his native background for high modern culture.

Soon he tried out Rome, and the surviving token of his modest success there is a brilliant, completely Bassanesque portrait of an older artist,[122] with a flickering smile and a landscape behind him. He was also remembered for his remark that, if

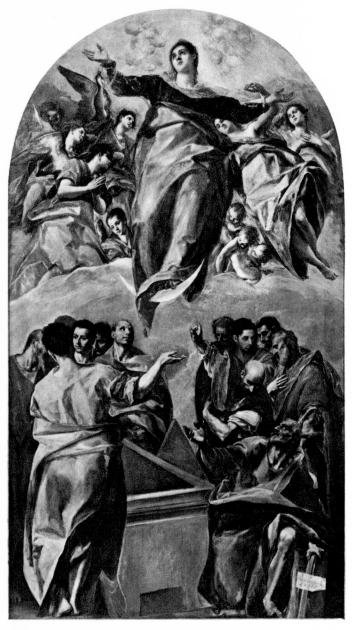

525. EL GRECO.
Assumption of the Virgin. 1577.
Canvas, 13′2″ × 7′6″. Art Institute, Chicago.
Gift of Nancy Atwood Sprague in memory of
Robert Arnold Sprague

He made his statement in a series of rich altarpieces, the *Assumption of the Virgin* (1577; fig. 525) and the *Stripping of Christ* (1577–79)[123] among others. They are like Bassano in color rhythm, and the figures are not more elongated than his, but the texture has changed. Pastiness is enhanced, so that it seems to suggest neither form nor light on a form, but only paint. The capricious shapes also suggest sketchily modeled clay figures. The paintlike surface was probably stimulated by Titian's last works, though the specific texture is different, not a field of vibration but wide oily streaks; clay figures were used as models by Tintoretto and by El Greco, but only Greco allows them to transmit the clayey effect to the painting. The preference for forms over representation, leading to airless constructions, was equally marked in the Fontainebleau Mannerists, but in them it is in the context of a court ornament far less interesting to us than Greco's sketchy color art. The definition of El Greco's originality may be the effect of airless manipulation within the Venetian vocabulary of airy life.

We easily overstate the religious and emotional extremism of El Greco. He is often supposed to have been rescued from neglect by German expressionists in the early twentieth century, who quite often made elongated figures a vehicle of anguish. But he had actually been admired several generations before by Eugène Delacroix, who made pasty color a spark for motion, and by J. F. Millet, a builder of clayey form. Conversely, emaciated or dematerialized figures of hysteria are more central to Berruguete and Morales, who even so have remained unrediscovered, than to El Greco. It may be that the vibrant power of his Venetian color has a larger part in our reaction and in Greco's art, and the soulful overtones a slighter one, than has sometimes been thought. He is certainly a moderate compared to the Spanish mystics of his century, Saints Theresa and John of the Cross, and has little relation to their written imagery of very live flesh transmuted into identity with God, at either pole of the process. Feelings do become violent in his paintings, as in Pontormo's, when the theme demands them—again we are being proffered a sensitive concern with the exposition of assigned themes. But we can only find emotional excitation in neutral themes—portraits, Madonnas, or heads of saints, El Greco's most frequent images—if we supply an expressionist flavor of our own; without that, we record coloristic

Michelangelo's *Last Judgment* were destroyed, he could redo it just as well and with more moral decency, an indication that he shared the strong piety of the Counter Reformation. It is not surprising that he next tried Spain, the place where foreign artists were most honored as well as the center of Catholic energies. He settled in Toledo, the residence of the chief archbishop, and never left, soon achieving local success and the nickname El Greco ("the" in Spanish; "Greek" in Italian).

416

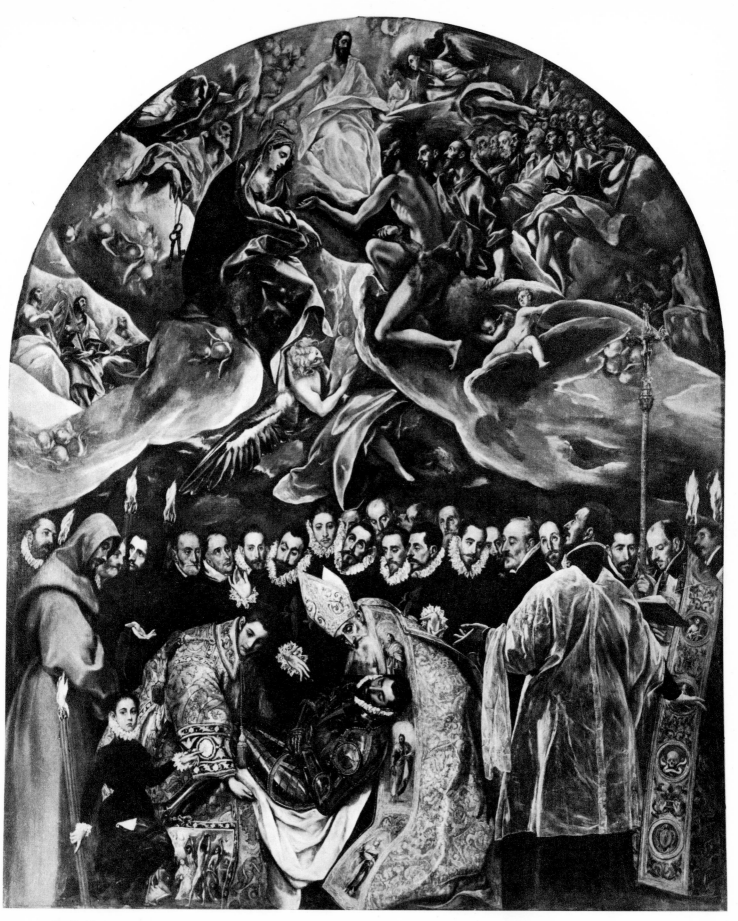

526. EL GRECO. *The Burial of the Count of Orgaz.* 1586–88. Canvas, 16′ × 11′10″. Santo Tomé, Toledo

brilliance steeped in Bassano's Mannerist figure types.

In altarpieces depthlessness is traditional, as much in Titian as in Pontormo. El Greco makes it assist the action of his color, meandering over the bumpy relief surface. This is most striking in the *Burial of the Count of Orgaz* (1586–88; fig. 526) which, with proper ritual formality, records a local medieval miracle (saints came down from heaven to help bury the pious count, who had left a bequest to the church). If we link him strongly to Venetian and other Italian traditions, El Greco's remarkable landscapes also no longer seem extraneous to his central concerns. City views are in the tradition of Dürer and Heemskerck, except that El Greco is making records of the city he lived in, not the mementos of a traveler to Italy as those artists' views mostly are; but then El Greco was a foreigner in Toledo. Visually his landscapes depend on the Giorgionesque landscape tradition of toned atmospheric flow of color, modified to capricious shapes and shimmers. Indeed the more famous of his two views of Toledo (colorplate 60) is the truest successor of Giorgione's *Tempest*. He gave the second the form of a map[124]—building on the other Venetian tradition of Jacopo de' Barbari (see fig. 229)—and a long inscription explaining that some landmarks had to be altered in size, location, and lighting. It is the nearest we have to a statement from the artist about his method of work.

El Greco was a great local success in church images, and repeated his saints and compositions over and over again. He clearly attached himself to the Church establishment, just as in his comment on Michelangelo in Rome and his choice of the cathedral town of Toledo. In this he is unlike Saint John of the Cross, whose puritanical reformism took him to prison. El Greco's later works build on the stylistic habits of the earlier ones, and the figures now are indeed more elongated than in any other Mannerist artist, while the textures become softer and more gently brushed. This seems to apply only to the few works that he painted personally in his late years, especially those with new themes. A masterpiece among these, and a rare case of an unrepeated theme, shows Saint John, in the Apocalypse, watching the Opening of the Fifth Seal (1608–14; fig. 527), with its glowing unreal light and dancing unreal angel. Ever further from nature, like other isolated geniuses, El Greco now is insisting on Mannerism at a time when the first modern masters of the Baroque had worked and died. Yet this final assertion of an obsolete style is not a fading but an expert's reaffirmation that it is working as well as ever, so that he can express pleasure in celebrating it.

527. EL GRECO. *St. John's Vision of the Mysteries of the Apocalypse.* Canvas, 7'3" × 6'4". Metropolitan Museum of Art, New York. Rogers Fund, 1956

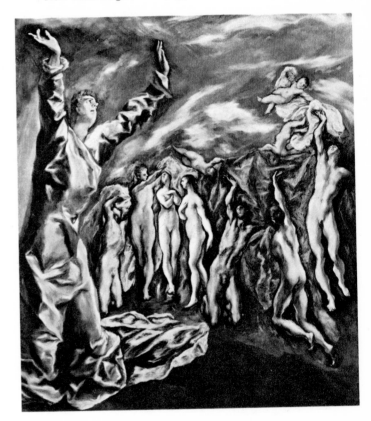

Supplementary Notes to Part Three

1. Matteo Giovanetti, frescoes of the life of St. Martial, Chapel of St. Martial, Palace of the Popes, Avignon.

2. Maître aux Boquetaux, two illuminations in *Works of Guillaume de Machaut*, Bibliothèque Nationale, Paris.

3. André Beauneveu, tombs in Abbey Church, St. Denis: King Philip VI; King Jean le Bon; Queen Jeanne de Bourgogne; King Charles V.

4. André Beauneveu, Psalter of the Duke of Berry, Bibliothèque Nationale, Paris.

5. Master of the *Parement,* supervisor of book illustrations, *Très Belles Heures de Notre Dame,* Bibliothèque Nationale, Paris.

6. Jean Bondol, design for tapestries of Book of Revelation, Musée des Tapisseries, Angers.

7. Jean de Cambrai, tomb of Duke John of Berry, crypt of Cathedral, Bourges (from the Sainte Chapelle).

8. Jacquemart de Hesdin, *Les Très Belles Heures* of the Duke of Berry (also known as *Les Très Belles Heures* of Brussels), Bibliothèque Royale, Brussels.

9. Tomb of the count and countess of Mortain, The Louvre, Paris.

10. Master of the Třeboň (Wittingau) Altarpiece, panels of altarpiece (now dismembered), National Gallery, Prague.

11. Jean Delemer and Robert Campin, *Annunciation,* St. Marie Madeleine, Tournai.

12. Master of 1445, *Sts. Anthony and Paul,* Kunstmuseum, Basel.

13. Fra Filippo Lippi, *Madonna and Child* (formerly *Tarquinia Madonna*), Galleria Nazionale, Palazzo Barberini, Rome.

14. Stefan Lochner, *Madonna in the Rose Bower,* Wallraf-Richartz Museum, Cologne.

15. Stefan Lochner, *Presentation in the Temple,* Hessisches Landesmuseum, Darmstadt.

16. Rogier van der Weyden, *Annunciation,* The Louvre, Paris.

17. Rogier van der Weyden, *Last Judgment* triptych, Musée de l'Hotel-Dieu, Beaune.

18. Rogier van der Weyden, Braque triptych, The Louvre, Paris.

19. Rogier van der Weyden, Bladelin altarpiece, Staatliche Museen, Berlin-Dahlem.

20. Jacques Daret, *Nativity,* Thyssen-Bornemisza Collection, Lugano; *Adoration of the Magi* and *Visitation,* Staatliche Museen, Berlin-Dahlem; *Presentation in the Temple,* Petit Palais, Paris.

21. Rogier van der Weyden, four panels of legends of Trajan and Herkinbald, formerly Town Hall, Brussels (destroyed by fire, 1695); free copy preserved in tapestry, Historical Museum, Berne.

22. Dirk Bouts, *Last Supper,* side panel of Communion altarpiece (see colorplate 47).

23. Dirk Bouts, altarpiece with *Way to Paradise* panels: center panel, *Last Judgment,* now lost; wings, *Hell* and *Paradise,* Musée des Beaux-Arts, Lille (*Hell* on loan from The Louvre, Paris).

24. Joos van Gent, *Crucifixion,* Cathedral of St. Bavo, Ghent.

25. Hugo van der Goes, *Jacob and Rachel,* lost painting known from drawing in Library of Christ Church, Oxford.

26. Hugo van der Goes, *Adoration of the Magi* (surviving portion of Monforte altarpiece), Staatliche Museen, Berlin-Dahlem.

27. Hugo van der Goes, *Adoration of the Shepherds,* Staatliche Museen, Berlin-Dahlem.

28. Geertgen tot Sint Jans, *Christ Carrying the Cross,* Archiepiscopal Museum, Utrecht.

29. Geertgen tot Sint Jans, *Madonna of the Rosary,* Boymans-van Beuningen Museum, Rotterdam.

30. Hans Memling, Shrine of St. Ursula, Hospital of St. John, Bruges.

31. Jean Fouquet, *Pietà,* Church, Nouans.

32. Petrus Christus, *Pietà,* Musées Royaux des Beaux-Arts, Brussels.

33. Jean Fouquet, *Jouvenel des Ursins,* The Louvre, Paris.

34. Jan van Eyck, *Cardinal Nicholas Albergati,* silverpoint drawing, Kupferstichkabinett, Dresden.

35. Jean Fouquet, *Jouvenel des Ursins,* drawing, Kupferstichkabinett, Berlin-Dahlem.

36. School of Avignon, Boulbon altarpiece, The Louvre, Paris.

37. Nicolas Froment, *Raising of Lazarus,* Uffizi Gallery, Florence.

38. Martin and Georg von Klausenburg, *St. George,* on the Hradčany (beside the Cathedral), Prague.

39. Nicolaus Gerhaert, tomb slab for Archbishop Jacob von Sierck, Bischöfliches Museum, Trier.

40. Nicolaus Gerhaert, *Crucifix*, Old Cemetery, Baden-Baden.

41. Statues of Charles IV and his empress, Marienkirche, Mühlhausen.

42. *Apostles*, nave of Cathedral, Wiener Neustadt.

43. Busts from the hospital of St. Marx, Strasbourg (now in Musée de l'Oeuvre, Notre-Dame).

44. Tomb of Princess Isabel of Bourbon, originally in abbey of St. Michel, Antwerp: bronze effigy now in Antwerp Cathedral; ten bronze portrait statuettes in Rijksmuseum, Amsterdam.

45. Hausbuch Master, 60 drypoints, Rijksmuseum, Amsterdam.

46. Simon Lainberger(?), *Crucifixion*, St. George, Nördlingen.

47. Gregor Erhart, Blaubeuren altarpiece, Benedictine Monastery, Blaubeuren.

48. Andreas Morgenstern, altarpiece for the convent at Zwettl, center panel now in church of Adamsthal, Czechoslovakia.

49. This type of painting was produced by the dominant local family of painters, the Katzheimers, and is also notably illustrated by the anonymous Hersbruck altarpiece.

50. Veit Stoss, altarpiece of the Virgin (made for a Carmelite monastery, Nuremberg), Cathedral, Bamberg.

51. Albrecht Dürer, *Feast of the Rose Garlands*, National Gallery, Prague.

52. Albrecht Dürer, *Assumption of the Virgin* (Heller altarpiece), formerly in Dominican Church, Frankfurt (destroyed by fire, 1729).

53. Erasmus of Rotterdam, *Enchiridion militis christiani* (*Manual of the Christian Knight*), 1503.

54. Dürer's writings on perspective and human proportion: *Underweisung der Messung mit dem Zirckel und Richtscheyt* (*Course in the Art of Measurement with Compass and Ruler*), 1525; *Vier Bücher von Menschlicher Proportion* (*Four Books on Human Proportion*), 1528

55. Albrecht Dürer, *The Harbor at Antwerp*, Albertina, Vienna.

56. Passion altarpiece, Museum, Rothenburg.

57. Matthias Grünewald, *Mocking of Christ*, Alte Pinakothek, Munich.

58. Albrecht Altdorfer, *Nativity*, Staatliche Museen, Berlin-Dahlem.

59. Albrecht Altdorfer, *Resurrection*, from the *Passion of Christ*, altarpiece of St. Florian, Monastery of St. Florian (near Linz).

60. Hans Baldung Grien, *Witches' Sabbath*, chiaroscuro woodcut.

61. Hans Baldung Grien, *Christ with Angels*, woodcut.

62. Jerg Ratgeb, St. Barbara altarpiece, Schwaigern.

63. Jerg Ratgeb, *Circumcision*, inner wing of Herrenberger altarpiece (see fig. 443).

64. Hans Leu, *Orpheus Playing to the Animals*, Kunstmuseum, Basel.

65. Nicolas Manuel Deutsch, *Pyramus Mourned by Thisbe*, Kunstmuseum, Basel.

66. Nicolas Manuel Deutsch, *The Beheading of St. John*, Kunstmuseum, Basel.

67. Urs Graf, *Pregnant Woman and Hanged Man*, Kunstmuseum, Basel.

68. *Triumphal Arch of Maximilian*, woodcut, 11′×9′ (in 192 blocks), designed by Dürer, executed by many artists. *Triumphal Procession of Maximilian*, woodcut, length over 177′ (in numerous blocks), executed by many artists, among whom Burgkmair was important.

69. Hans Holbein, *Madonna with the Meyer Family*, Hessisches Landesmuseum, Darmstadt.

70. Hans Holbein, *Georg Gisze*, Staatliche Museen, Berlin-Dahlem.

71. Hans Holbein, *The Ambassadors*, National Gallery, London.

72. Gerard David, *Crucifixion*, Galleria di Palazzo Bianco, Genoa.

73. Gerard David, *Judgment of Cambyses: Seizure of the Judge, Flaying of Sisamnes*, Groeninge Museum, Bruges.

74. Simon Marmion, altarpiece of St. Bertin, Staatliche Museen, Berlin-Dahlem.

75. Jerome Bosch, *The Seven Deadly Sins*, The Prado, Madrid.

76. Jerome Bosch, *The Conjurer*, Musée Municipal Saint-Germain-en-Laye.

77. Jerome Bosch, *The Garden of Earthly Delights*, The Prado, Madrid.

78. Quentin Massys, *Erasmus*, Galleria Nazionale, Palazzo Barberini, Rome; *Petrus Aegidius*, Earl of Radnor, Longford Castle.

79. Lucas van Leyden, *The Chess Game*, Staatliche Museen, Berlin-Dahlem.

80. Lucas van Leyden, *Moses Striking the Rock*, Museum of Fine Arts, Boston.

81. Tomb of the cardinals of Amboise, Cathedral, Rouen.

82. Loy Hering, *St. Willibald*, Cathedral, Eichstatt.

83. Conrad Meit, family tombs in St. Nicolas de Tolentin, Brou: Margaret of Austria; her husband, Philibert of Savoy; his mother, Margaret of Bourbon.

84. Marinus van Roymerswaele, *St. Jerome in His Study*, The Prado, Madrid.

85. Jan van Scorel, *Pilgrims to Jerusalem*, Frans Hals Museum, Haarlem; three similar sets in Centraal Museum, Utrecht.

86. Jan van Scorel, *The Schoolboy*, Boymans-van Beuningen Museum, Rotterdam.

87. Martin van Heemskerck, Sketchbook, Kupferstich-kabinett, Berlin-Dahlem.

88. Philibert de l'Orme, *Le premier tome de l'architecture*, Paris, 1567.

89. Primaticcio and Germain Pilon, tomb of Henry II's heart, The Louvre, Paris.

90. Germain Pilon, *Chancellor René de Birague*, The Louvre, Paris.

91. Alberlin Tretsch, Old Palace, Stuttgart.

92. Pietro Torrigiani, tomb of Henry VII, Chapel of Henry VII, Westminster Abbey, London.

93. Hampton Court Palace, Middlesex (near London); Henry VIII added the chapel and great hall to the cardinal's residence. Major additions in seventeenth century by Sir Christopher Wren.

94. Nonesuch, Surrey (demolished c.1670).

95. Raphael, *Joanna of Aragon*, The Louvre, Paris.

96. François Clouet, *Portrait of the Botanist Pierre Quthe*, The Louvre, Paris.

97. François Clouet, *Francis I*, The Louvre, Paris.

98. Nicholas Hilliard, *The Art of Limning*, written c.1600 (not published until 1912).

99. Pieter Bruegel, *Christ Appearing to the Apostles at the Sea of Tiberias*, private collection, New York.

100. Pieter Bruegel, *Battle between Carnival and Lent*, Kunsthistorisches Museum, Vienna.

101. Pieter Bruegel, *Flemish Proverbs*, Staatliche Museen, Berlin-Dahlem.

102. Pieter Bruegel, *Triumph of Death*, The Prado, Madrid.

103. Pieter Bruegel, *War in Heaven (Fall of the Rebel Angels)*, Musées Royaux des Beaux-Arts, Brussels.

104. Pieter Bruegel, *Dulle Griet*, Musée Mayer van den Bergh, Antwerp.

105. Pieter Bruegel, *Suicide of King Saul*, Kunsthistorisches Museum, Vienna.

106. Pieter Bruegel, *Christ Carrying the Cross*, Kunsthistorisches Museum, Vienna.

107. Pieter Bruegel, *Adoration of the Magi*, National Gallery, London.

108. Pieter Bruegel, *Corn Harvesters*, Metropolitan Museum of Art, New York.

109. Pieter Bruegel, *Return of the Herd*, Kunsthistorisches Museum, Vienna.

110. Pieter Bruegel, *Adoration of the Magi*, Oskar Reinhart Collection, Winterthur.

111. Pieter Bruegel, *The Numbering at Bethlehem*, Musées Royaux des Beaux-Arts, Brussels.

112. Pieter Bruegel, *Peasant Wedding Dance*, Institute of Arts, Detroit.

113. Pieter Bruegel, *Cloud Cuckoo Land*, Alte Pinakothek, Munich.

114. Pieter Bruegel, *Crippled Lepers*, The Louvre, Paris.

115. Pieter Bruegel, *Peasant and the Bird's Nest*, Kunsthistorisches Museum, Vienna.

116. Pieter Bruegel, *The Misanthrope*, Museo Nazionale di Capodimonte, Naples.

117. Bartolomé Bermejo, *Christ's Descent into Limbo*, Diocesan Museum, Barcelona.

118. Sebastián de Almonacid, tombs of Alvaro de Luna and his wife Juana Pimentel, Santiago Chapel, Cathedral, Toledo.

119. Alonso Berruguete, Altar of S. Benito, Museo Nacional de Escultura, Valladolid.

120. Juan de Valmaseda, *Calvary* (Crucifixion group), high altar, Cathedral, Palencia.

121. Pedro Machuca, *Madonna*, The Prado, Madrid.

122. El Greco, *Giulio Clovio*, Museo Nazionale di Capodimonte, Naples.

123. El Greco, *Stripping of Christ*, Sacristy, Cathedral, Toledo.

124. El Greco, *View of Toledo*, Museo del Greco, Toledo.

Bibliography

GUIDE TO FURTHER READINGS

This list has only one function: to give the average reader more sources of information on the subjects of this book. It is therefore limited to writings in English, and of these it omits many: very rare books; those that have no greater detail than this book has; those that seem to make no original points not found elsewhere; and those whose information has become obsolete so that they offer less help than hindrance. It no doubt excludes other writings too, inadvertently, and is by no means a full survey of all those that meet its criteria.

Its exclusions also vary somewhat from section to section. A list of all helpful writings on Michelangelo, for example, would be so long that it would merely confuse, and this one is cut down to what seem to be the most probably beneficial. But in the cases of many minor artists virtually any of the sparse writings in English is likely to be welcome to a concerned reader. Thus the standards may possibly be lower in these lists, but I have continued to omit writings on very small or abstruse points.

The arrangement corresponds to the divisions of the book. There is first a General List; there are three lists for the three main parts of the book, and a list for each of the short sections. Every entry appears in the narrowest, most specific place where it fits, for ease in looking it up. The same one may appear in two or three of the section-lists, but beyond that point it will be cited instead in one of the main lists if its subject belongs (wholly, or almost wholly) to either the early Renaissance in Italy, or the High Renaissance in Italy, or the Renaissance outside Italy. Writings of still broader application are in the General List. In the small section-lists are also cited appropriate useful chapters in the more general books. Such references back to more general books are given selectively, however, in a way that seems to be functional though it may look inconsistent. (The same variation is found in citing encyclopedia articles, and the like.) Thus, when a book on sixteenth-century sculpture says much on Michelangelo and less on Bandinelli, it will not be cited under Michelangelo but will be cited under Bandinelli, about whom there are so few available sources.

General List: Surveys of the Age as a Whole and Studies of Wide Scope

1 Anderson, W. J., and Stratton, Arthur, *Architecture of the Renaissance in Italy*, 5th ed., New York, 1927

2 Berenson, Bernard, *The Drawings of the Florentine Painters*, 3 vols., 2nd ed., Chicago, 1938

3 ———, *Italian Painters of the Renaissance*, London, 1963 (also paperback)

4 ———, *Italian Pictures of the Renaissance: Venetian School*, 2 vols., London, 1957; *Florentine School*, 2 vols., London, 1963; *Central Italian and North Italian Schools*, 3 vols., London, 1968 (also paperback)

5 Bergström, Ingvard, *Revival of Antique Illusionistic Wall Painting in Renaissance Art*, Göteborg, 1957

6 Blunt, Anthony, *Artistic Theory in Italy 1450–1600*, Oxford, 1940 (also paperback)

7 Bode, Wilhelm von, *Florentine Sculptors of the Renaissance*, 2nd ed., London, 1928

8 ———, *Italian Bronze Statuettes of the Renaissance*, 3 vols., London, 1908–12

9 Burckhardt, Jakob, *The Civilization of the Renaissance in Italy*, London, 1965 (originally 1860) (also paperback)

10 Chastel, André, *The Age of Humanism: Europe 1480–1530*, New York, 1964

11 ———, *The Crisis of the Renaissance, 1520–1600*, Geneva, 1968

12 ———, *The Myth of the Renaissance, 1420–1520*, Geneva, 1969

13 ———, *The Studios and Styles of the Renaissance; Italy 1460–1500*, London, 1966

14 Clark, Kenneth, *Landscape into Art*, London, 1949 (also paperback)

15 ——, *The Nude*, London, 1956 (also paperback)

16 Crowe, J. A., and Cavalcaselle, G. B., *A History of Painting in Italy*, 2nd ed., ed. L. Douglas, 6 vols., London, 1903–1914 (originally 1864)

17 ——, *A History of Painting in North Italy*, 2nd ed., ed. T. Borenius, 3 vols., New York, 1912 (originally 1871)

18 DeWald, Ernest, *Italian Painting 1200–1600*, New York, 1961

19 Frey, Dagobert, *Architecture of the Renaissance from Brunelleschi to Michelangelo*, The Hague, 1925

20 Gilbert, Creighton, "On Subject and not-Subject in Italian Renaissance Pictures," *Art Bulletin*, Vol. 34, 1952, 202–216

21 —— (ed.), *Renaissance Art* (in Contemporary Essays Series), New York, 1970

22 Goldwater, Robert, and Treves, Marco, *Artists on Art*, New York, 1945 (also paperback)

23 Gombrich, Ernst H., *Norm and Form: Studies in the Art of the Renaissance*, London, 1966 (also paperback)

24 Hill, George F., *A Corpus of Italian Medals of the Renaissance before Cellini*, 2 vols., London, 1930

25 Holt, Elizabeth, *Literary Sources of Art History*, Princeton, 1947 (also paperback, entitled *A Documentary History of Art*, 2 vols.)

26 Keutner, Herbert, *Sculpture, Renaissance to Rococo*, London, 1969

27 Lowry, Bates, *Renaissance Architecture*, New York, 1962 (also paperback)

28 MacLagen, Eric, *Italian Sculpture of the Renaissance*, Cambridge, Mass., 1935

29 Morelli, Giovanni, *Italian Painters: Critical Studies of Their Works*, London, 1892–93

30 Murray, Peter, *The Architecture of the Italian Renaissance*, New York, 1963 (also paperback)

31 ——, *An Index of Attributions Made in Tuscan Sources before Vasari*, Florence, 1959

32 Panofsky, Erwin, *Idea*, Columbia, S.C., 1968 (originally 1924)

33 ——, *Meaning in the Visual Arts*, New York, 1957 (paperback)

34 ——, *Renaissance and Renascences in Western Art*, 2 vols., Stockholm, 1961 (1 vol. ed. 1965; also paperback)

35 ——, *Studies in Iconology: Humanistic Themes in the Art of the Renaissance*, Oxford, 1939 (also paperback)

36 ——, *Tomb Sculpture*, New York, 1964 (also paperback)

37 Pevsner, Nikolaus, *An Outline of European Architecture*, 6th ed., Baltimore, 1960 (also paperback)

38 Pope-Hennessy, John, *The Portrait in the Renaissance*, New York, 1966

39 Saxl, Fritz, *A Heritage of Images: a Selection of Lectures*, Harmondsworth, 1970 (also paperback)

40 Seznec, Jean, *The Survival of the Pagan Gods*, 3rd ed., New York, 1961 (also paperback)

41 Stegmann, Carl, and Geymüller, Heinrich von, *Architecture of the Renaissance in Tuscany*, 2 vols., New York, 1924 (originally 1885–1908)

42 Sterling, Charles, *Still Life Painting*, New York, 1959

43 Tietze, Hans, and Tietze-Conrat, Erica, *The Drawings of the Venetian Painters in the 15th and 16th Centuries*, New York, 1944

44 Valentiner, Wilhelm, *Studies in Italian Renaissance Sculpture*, London, 1950

45 Vasari, Giorgio, *Lives of the Most Eminent Painters, Sculptors, and Architects*, trans. G. De Vere, 10 vols., London, 1912–15 (originally 1568)

46 ——, *On Technique*, ed. G. B. Brown, New York, 1960 (paperback)

47 Venturi, Lionello, *Italian Painting*, 3 vols., New York, 1950–51

48 Watrous, James, *The Craft of Old Master Drawings*, Madison, Wis., 1957

Part One. The Early Renaissance in Italy: Surveys of the Age as a Whole and Studies of Wide Scope

1 Antal, Frederick, *Florentine Painting and Its Social Background*, London, 1948

2 Berenson, Bernard, *Essays in the Study of Sienese Painting*, New York, 1918

3 ——, *Venetian Painting in America: the Fifteenth Century*, New York, 1916

4 Bologna, Ferdinando, *Early Florentine Painting: Romanesque and Early Medieval*, Princeton, 1964

5 Borenius, Tancred, *Florentine Frescoes*, London, 1930

6 ——, *Four Early Italian Engravers*, London, 1913

7 Borsook, Eve, *The Mural Painters of Tuscany from Cimabue to Andrea del Sarto*, London, 1960

8 Carli, Enzo, *Italian Primitives*, New York, 1965

9 ——, *Sienese Painting*, Greenwich, Conn., 1956

10 Cecchi, Emilio, *The Sienese Painters of the Trecento*, London, 1931

11 Garrison, Edward B., *Italian Romanesque Panel Painting: An Illustrated Index*, Florence, 1949

12 Hind, Arthur M., *Early Italian Engraving*, 7 vols., London, 1938–48

13 Ivins, William, *On the Rationalization of Sight*, New York, 1938

14 Kaftal, George, *Iconography of the Saints in Tuscan Painting*, Florence, 1952

15 ——, *Iconography of the Saints in Central and South Italian Painting*, Florence, 1965

16 Lipman, Jean H., "The Florentine Profile Portrait in the Quattrocento," *Art Bulletin*, Vol. 18, 1936, 54–102

17 Magnuson, Torgil, *Studies in Roman Quattrocento Architecture*, Stockholm, 1958

18 Meiss, Millard, "Italian Primitives at Konopiste," *Art Bulletin*, Vol. 28, 1946, 1–16

19 ——, *Painting in Florence and Siena after the Black Death*, Princeton, 1951 (also paperback)

20 Offner, Richard, *A Critical and Historical Corpus of Florentine Painting*, Section III, 8 vols.; Section IV, 5 vols., New York, 1930–67

21 ——, *Italian Primitives at Yale University*, New Haven, 1927

22 ———, *Studies in Florentine Painting, the Fourteenth Century*, New York, 1927
23 Pope-Hennessy, John, *Italian Gothic Sculpture*, London, 1955
24 ———, *Italian Renaissance Sculpture*, London, 1958
25 Seymour, Charles, *Sculpture in Italy 1400 to 1500*, Baltimore, 1966
26 Sirén, Osvald, *Giotto and Some of His Followers*, 2 vols., London, 1917
27 Toesca, Pietro, *Florentine Painting of the Trecento*, New York, 1929
28 Van Marle, Raimond, *The Development of the Italian Schools of Painting*, 19 vols., The Hague, 1923–38
29 Vavalà, Evelyn Sandberg, *Sienese Studies: the Development of the School of Painting of Siena*, Florence, 1953
30 ———, *Studies in the Florentine Churches*, Florence, 1959
31 ———, *Uffizi Studies: the Development of the Florentine School of Painting*, Florence, 1948
32 Weigelt, Curt, *Sienese Painting of the Trecento*, New York, 1930
33 White, John, *Art and Architecture in Italy 1250 to 1400*, Baltimore, 1966
34 ———, *The Birth and Rebirth of Pictorial Space*, London, 1957

1. INTRODUCTION

1 Coomaraswamy, Ananda K., and Carey, A. Graham, *Patron and Artist: Pre-Renaissance and Modern*, Norton, Mass., 1936
See also General List, 9 Burckhardt, 21 Gilbert, 34 Panofsky

2. THE LIBERATION OF THE PAINTING

See General List, 18 DeWald; Part I List, 8 Carli, 11 Garrison, 21 Offner, 28 Van Marle, 33 White

3. NICOLA PISANO

1 Crichton, George H. and Elsie R., *Nicola Pisano and the Revival of Sculpture in Italy*, Cambridge, England, 1938
2 Weinberger, Martin, "Nicola Pisano and the Tradition of Tuscan Pulpits," *Gazette des Beaux-Arts*, Vol. 55, 1960, 129–146

4. GIOVANNI PISANO AND ARNOLFO

1 Ayrton, Michael, *Giovanni Pisano*, London, 1969
2 Weinberger, Martin, "The First Façade of the Cathedral of Florence," *Journal of the Warburg and Courtauld Institutes*, Vol. 4, 1940–41, 67–79
See also Part I List, 23 Pope-Hennessy, 33 White

5. CIMABUE, CAVALLINI, AND OTHER PAINTERS

1 Battisti, Eugenio, *Cimabue*, trans. R. and G. Enggass, University Park, Pa., 1966
2 Coor-Achenbach, Gertrude, "A Visual Basis for the Documents Relating to Coppo di Marcovaldo and His Son Salerno," *Art Bulletin*, Vol. 28, 1946, 233–247
3 Lothrop, Samuel K., "Pietro Cavallini," *Memoirs of the American Academy in Rome*, Vol. 2, 1918, 77–98
4 Meiss, Millard, *Giotto and Assisi*, New York, 1960
5 Nicholson, Alfred, *Cimabue*, Princeton, 1932
6 Stubblebine, James, *Guido da Siena*, Princeton, 1964
7 Toesca, Pietro, *Pietro Cavallini*, New York, 1960
8 White, John, "Cavallini and the Lost Frescoes of San Paolo,"
Journal of the Warburg and Courtauld Institutes, Vol. 19, 1956, 84–95
See also General List, 18 DeWald; Part I List, 33 White.

6. GIOTTO

1 Battisti, Eugenio, *Giotto*, Cleveland, 1966
2 Fisher, M. Roy, "Assisi, Padua, and the Boy in the Tree," *Art Bulletin*, Vol. 38, 1956, 47–52
3 Gilbert, Creighton, "The Sequence of Execution in the Arena Chapel," *Essays in Honor of Walter Friedlaender*, Locust Valley, N.Y., 1965, 80–86
4 Gnudi, Cesare, "Giotto," *Encyclopedia of World Art*, Vol. 6, 1962, 339–355
5 Offner, Richard, "Giotto, non-Giotto," *Burlington Magazine*, Vol. 74, 1939, 259–268; Vol. 75, 1939, 96–113
6 Perkins, F. Mason, *Giotto*, London, 1902
7 Stubblebine, James (ed.), *Giotto: the Arena Chapel Frescoes*, New York, 1969
8 Suida, Wilhelm, "A Giotto Masterpiece," *Burlington Magazine*, Vol. 59, 1931, 118–193
9 Tintori, Leonetto, and Borsook, Eve, *Giotto: The Peruzzi Chapel*, New York, 1965

7. GIOTTO'S PUPILS

1 Gardner, Julian, "The Decoration of the Baroncelli Chapel in S. Croce," *Zeitschrift für Kunstgeschichte*, Vol. 34, 1971, 89–114
2 Offner, Richard, *Bernardo Daddi* (*Corpus*, Section III, Vol. 3; Part I List, 20)
3 ———, "Four Panels, a Fresco and a Problem," *Burlington Magazine*, Vol. 54, 1929, 224–245
See also General List, 18 DeWald; Part I List, 7 Borsook, 22 Offner, 26 Sirén, 28 Van Marle, 33 White

8. DUCCIO

1 Valentiner, Wilhelm, "Notes on Duccio's Space Conception," *Art Quarterly*, Vol. 21, 1958, 351–381
See also General List, 18 DeWald; Part I List, 9 Carli, 10 Cecchi, 28 Van Marle, 29 Vavalà, 32 Weigelt, 33 White

9. SCULPTORS OF THE EARLY FOURTEENTH CENTURY

1 Morisani, Ottavio, "Tino di Camaino," *Encyclopedia of World Art*, Vol. 14, 1967, 109–112
2 Valentiner, Wilhelm, "Observations on Sienese and Pisan Trecento Sculpture," *Art Bulletin*, Vol. 9, 1926–27, 177–220
3 ———, *Tino di Camaino*, Paris, 1935
4 ———, "Tino di Camaino in Florence," *Art Quarterly*, Vol. 17, 1954, 116–133
5 White, John, "The Reliefs on the Façade of the Duomo at Orvieto," *Journal of the Warburg and Courtauld Institutes*, Vol. 22, 1959, 254–302
See also Part I List, 23 Pope-Hennessy, 33 White

10. SIMONE MARTINI

1 Coletti, Luigi, "The Early Works of Simone Martini," *Art Quarterly*, Vol. 12, 1949, 290–308
2 Paccagnini, Giovanni, "Martini," *Encyclopedia of World Art*, Vol. 9, 1964, 502–508
See also Section 8 List above, books cited from the General List and Part I List

11. THE LORENZETTI BROTHERS

1 DeWald, Ernest, *Pietro Lorenzetti*, Cambridge, Mass., 1930
2 Rubinstein, Nicholas, "Political Ideas in Sienese Art: the Frescoes by Ambrogio Lorenzetti and Taddeo di Bartolo in the Palazzo Pubblico," *Journal of the Warburg and Courtauld Institutes*, Vol. 21, 1958, 179–207
3 Rowley, George, *Ambrogio Lorenzetti*, 2 vols., Princeton, 1958
See also Section 8 List above, books cited from the General List and Part I List

12. ORCAGNA AND HIS CONTEMPORARIES

See Part I List, 19 Meiss, 20 Offner, 21 Offner, 28 Van Marle

13. BARNA AND TRAINI

1 Faison, S. Lane, "Barna and Bartolo di Fredi," *Art Bulletin*, Vol. 14, 1932, 285–315
2 Meiss, Millard, "The Problem of Francesco Traini," *Art Bulletin*, Vol. 15, 1933, 97–173

14. THE FOURTEENTH CENTURY OUTSIDE TUSCANY

1 Arslan, Edoardo, "Tommaso da Modena," *Encyclopedia of World Art*, Vol. 14, 1967, 157–159
2 ———, "Vitale da Bologna," *Encyclopedia of World Art*, Vol. 14, 1967, 802–805
See also Part I List, 23 Pope-Hennessy, 28 Van Marle

15. THE COMPETITION FOR THE DOORS OF THE FLORENCE BAPTISTERY

1 Goldscheider, Ludwig, *Ghiberti*, London, 1949
2 Krautheimer, Richard, and Krautheimer-Hess, Trude, *Lorenzo Ghiberti*, 2nd ed., 2 vols., Princeton, 1970
3 Manetti, Antonio, *The Life of Brunelleschi*, trans. C. Enggass, ed. H. Saalman, University Park, Pa., 1970
See also Part I List, 25 Seymour

16. LATE GOTHIC PAINTERS IN FLORENCE

1 Arslan, Edoardo, "Gentile da Fabriano," *Encyclopedia of World Art*, Vol. 6, 1962, 108–111
2 Baldini, Umberto, "Masolino," *Encyclopedia of World Art*, Vol. 9, 1964, 574–578
3 Eisenberg, Marvin, "A Crucifixion and a Man of Sorrows by Lorenzo Monaco," *Art Quarterly*, Vol. 27, 1955, 45–49
4 Gronau, H. D., "The Earliest Works of Lorenzo Monaco," *Burlington Magazine*, Vol. 92, 1950, 183–188, 213–222
5 Levi D'Ancona, Mirella, "Some New Attributions to Lorenzo Monaco," *Art Bulletin*, Vol. 40, 1958, 175–191
6 Pudelko, George, "The Stylistic Development of Lorenzo Monaco," *Burlington Magazine*, Vol. 73, 1938, 237–248; Vol. 74, 1939, 76–81

17. JACOPO DELLA QUERCIA

1 Hanson, Anne C., *Jacopo della Quercia's Fonte Gaia*, Oxford, 1965
See also Part I List, 24 Pope-Hennessy, 25 Seymour

18. NANNI DI BANCO AND THE YOUNG DONATELLO

1 Goldscheider, Ludwig, *Donatello*, New York, 1941
2 Grassi, Luigi, *All the Sculpture of Donatello*, 2 vols., New York, 1964
3 Janson, H. W., *The Sculpture of Donatello*, 2 vols., Princeton, 1957
4 Pope-Hennessy, John, *Donatello's Relief of the Ascension*, London, 1949
See also Part I List, 24 Pope-Hennessy, 25 Seymour

19. THE LATER BRUNELLESCHI AND ARCHITECTURAL TRADITION; THE LATER GHIBERTI

1 Argan, Giulio C., "The Architecture of Brunelleschi and the Origins of Perspective Theory in the Fifteenth Century," *Journal of the Warburg and Courtauld Institutes*, Vol. 9, 1946, 96–121
2 Prager, Frank, and Scaglia, Gustina, *Brunelleschi: Studies of His Technology and Inventions*, Cambridge, Mass., 1970
3 Wittkower, Rudolf, "Brunelleschi and Proportion in Perspective," *Journal of the Warburg and Courtauld Institutes*, Vol. 16, 1953, 275–291
See also Part I List, 33 White (architectural tradition), 34 White

20. MASACCIO

1 Alberti, Leon Battista, *On Painting*, trans. J. Spencer, New Haven, 1956 (also paperback)
2 Berti, Luciano, *Masaccio*, University Park, Pa., 1967
3 Clark, Kenneth, "An Early Quattrocento Triptych from Santa Maria Maggiore," *Burlington Magazine*, Vol. 93, 1951, 339–347
4 Hendy, Philip, *Masaccio: Frescoes in Florence*, Greenwich, Conn., 1956
5 Janson, H. W., "Ground Plan and Elevation in Masaccio's Trinity Fresco," *Essays in the History of Art Presented to Rudolf Wittkower*, London, 1967, 83–88
6 Procacci, Ugo, *All the Paintings of Masaccio*, New York, 1962
7 Schlegel, Ursula, "Observations on Masaccio's Trinity Fresco in Santa Maria Novella," *Art Bulletin*, Vol. 45, 1963, 19–33

21. FRA ANGELICO, UCCELLO

1 Argan, Giulio C., *Fra Angelico*, Cleveland, 1955
2 Carli, Enzo, *All the Paintings of Paolo Uccello*, New York, 1963
3 Pope-Hennessy, John, *The Complete Work of Paolo Uccello*, London, 1969
4 ———, *Fra Angelico*, New York, 1952
5 Pudelko, George, "The Early Works of Paolo Uccello," *Art Bulletin*, Vol. 16, 1934, 231–259

22. DOMENICO VENEZIANO, FRA FILIPPO LIPPI

1 Berenson, Bernard, "Fra Angelico, Fra Filippo, and Their Chronology," in his *Homeless Paintings of the Renaissance*, Bloomington, Ind., 1970, 119–234
2 Strutt, Edward C., *Fra Filippo Lippi*, London, 1901
3 Wohl, Helmut, "Domenico Veneziano Studies: the Sant' Egidio and Parenti Documents," *Burlington Magazine*, Vol. 113, 1971, 635–641

23. THE LATER DONATELLO: LUCA DELLA ROBBIA

1 Cruttwell, Maud, *Luca and Andrea della Robbia*, London, 1902
2 Marquand, Alan, *Luca della Robbia*, Princeton, 1914

3 Seymour, Charles, "The Young Luca della Robbia," *Allen Memorial Art Museum Bulletin*, Oberlin, Vol. 20, 1963, 92–119
See also Section 18 List above (Donatello)

24. ALBERTI

1 Alberti, Leon Battista, *Ten Books on Architecture*, trans. James Leoni, London, 1955 (originally 1485)
2 Wittkower, Rudolf, *Architectural Principles in the Age of Humanism*, 3rd ed., London, 1962 (also paperback)

25. CASTAGNO, POLLAIUOLO

1 Cruttwell, Maud, *Antonio Pollaiuolo*, London, 1907
2 Hartt, Frederick, "The Earliest Works of Andrea del Castagno," *Art Bulletin*, Vol. 41, 1959, 159–183, 225–237
3 Horne, Herbert P., "Andrea del Castagno," *Burlington Magazine*, Vol. 7, 1905, 222–231

26. TRENDS IN FLORENTINE PAINTING AT MID-CENTURY

1 Bourges, Fernand, "Medici Chapel," *Life*, Dec. 24, 1945, 43–52
2 Gilbert, Creighton, "The Archbishop on the Painters of Florence," *Art Bulletin*, Vol. 41, 1959, 75–87
3 Gombrich, Ernst H., "The Early Medici as Patrons of Art" (General List, 23)
4 Kennedy, Ruth W., *Alesso Baldovinetti*, New Haven, 1938

27. TRENDS IN FLORENTINE SCULPTURE AT MID-CENTURY

1 Hartt, Frederick, Corti, Gino, and Kennedy, Clarence, *The Chapel of the Cardinal of Portugal at San Miniato in Florence*, Philadelphia, 1964
2 Kennedy, Clarence, *The Tabernacle of the Sacrament by Desiderio*, Northampton, Mass., 1929
3 Markham, Anne, "Desiderio da Settignano and the Workshop of Bernardo Rossellino," *Art Bulletin*, Vol. 45, 1963, 35–45
4 Valentiner, Wilhelm, "Mino da Fiesole" (General List, 44)
See also Part I List, 24 Pope-Hennessy, 25 Seymour

28. MICHELOZZO AND FLORENTINE ARCHITECTURE

1 Saalman, Howard, "The Palazzo Comunale in Montepulciano: an Unknown Work by Michelozzo," *Zeitschrift für Kunstgeschichte*, Vol. 28, 1965, 1–46
2 ——, "Tommaso Spinelli, Michelozzo, Manetti and Rossellino," *Journal of the Society of Architectural Historians*, Vol. 25, 1966, 151–164
See also General List, 27 Lowry, 41 Stegmann and Geymüller

29. SIENESE PAINTING IN THE EARLY FIFTEENTH CENTURY

1 Berenson, Bernard, *A Sienese Painter of the Franciscan Legend*, London, 1909
2 Pope-Hennessy, John, *Giovanni di Paolo*, London, 1937
3 ——, *Sassetta*, London, 1939
4 ——, *Sienese Quattrocento Painting*, Oxford, 1947

30. PIERO DELLA FRANCESCA

1 Bianconi, Piero, *All the Paintings of Piero della Francesca*, New York, 1962

2 Clark, Kenneth, *Piero della Francesca*, London, 1951
3 Gilbert, Creighton, *Change in Piero della Francesca*, Locust Valley, N.Y., 1968
4 ——, "Piero della Francesca's *Flagellation:* the Figures in the Foreground," *Art Bulletin*, Vol. 53, 1971, 41–51
5 Hendy, Philip, *Piero della Francesca and the Early Renaissance*, New York, 1968
6 Longhi, Roberto, *Piero della Francesca*, London, 1930
7 Wittkower, Rudolf, and Carter, B. A. R., "The Perspective of Piero della Francesca's 'Flagellation'," *Journal of the Warburg and Courtauld Institutes*, Vol. 16, 1953, 292–302

31. PISANELLO AND JACOPO BELLINI

1 Hill, George F., *Drawings by Pisanello*, Paris, 1929
2 ——, *Pisanello*, London, 1905
3 Roethlisberger, Marcel, "Notes on the Drawing Books of Jacopo Bellini," *Burlington Magazine*, Vol. 98, 1956, 358–364
4 Sindona, Enio, *Pisanello*, New York, 1961
See also General List, 43 Tietze and Tietze-Conrat; Part I List, 28 Van Marle

32. MANTEGNA

1 Cipriani, Renata, *All the Paintings of Mantegna*, 2 vols., New York, 1964
2 Cruttwell, Maud, *Andrea Mantegna*, London, 1901
3 Fiocco, Giuseppe, *Paintings by Mantegna*, New York, 1963
4 Gilbert, Creighton, "The Mantegna Exhibition," *Burlington Magazine*, Vol. 104, 1962, 5–9
5 Kristeller, Paul, *Andrea Mantegna*, trans. S. A. Strong, London, 1901
6 Martindale, Andrew, *The Complete Paintings of Mantegna*, New York, 1967
7 Tietze-Conrat, Erica, *Mantegna: Paintings, Drawings, Engravings*, New York, 1955

33. FERRARA

1 D'Ancona, Paolo, *The Schifanoia Months at Ferrara*, Milan, 1954
2 Gardner, Ernest A., *The Painters of the School of Ferrara*, New York, 1911
3 Nicolson, Ben, *The Painters of Ferrara*, London, 1950
4 Ruhmer, Eberhard, *Cossa*, London, 1959
5 ——, *Tura*, London, 1958

34. POLLAIUOLO, VERROCCHIO

1 Cruttwell, Maud, *Verrocchio*, 2nd ed., London, 1911
2 Ettlinger, L. D., "Pollaiuolo's Tomb of Pope Sixtus IV," *Journal of the Warburg and Courtauld Institutes*, Vol. 16, 1953, 239–271
3 Kennedy, Clarence, and Wilder, Elizabeth, *The Unfinished Monument by Andrea del Verrocchio to the Cardinal Niccolo Forteguerri at Pistoia*, Northampton, Mass., 1932
4 Passavant, Günter, *Verrocchio*, London, 1969
See also Section 25 List above, 1 Cruttwell; Part I List, 25 Seymour

35. ANTONELLO DA MESSINA; FRANCESCO LAURANA

1 Berenson, Bernard, "Antonello da Messina," *Art News Annual*, Vol. 25, 1956, 24–26

2 Bottari, Stefano, *Antonello da Messina*, trans. G. Scaglia, Greenwich, Conn., 1955
3 Valentiner, Wilhelm, "Laurana's Portrait Busts of Women," *Art Quarterly*, Vol. 5, 1942, 273–298
4 Vigni, Giorgio, *All the Paintings of Antonello da Messina*, New York, 1963
See also Part I List, 24 Pope-Hennessy, 25 Seymour

36. BOTTICELLI AND GHIRLANDAIO

1 Argan, Giulio, *Botticelli*, New York, 1957
2 Ettlinger, L. D., *The Sistine Chapel before Michelangelo*, Oxford, 1965
3 Fahy, Everett, "The Earliest Works of Fra Bartolommeo," *Art Bulletin*, Vol. 51, 1969, 142–154
4 Gombrich, Ernst H., "Botticelli's Mythologies," *Journal of the Warburg and Courtauld Institutes*, Vol. 8, 1945, 7–60
5 Horne, Herbert P., *Alessandro Filipepi, Commonly Called Sandro Botticelli*, London, 1908
6 Marchini, Giuseppe, "The Frescoes in the Choir of Santa Maria Novella," *Burlington Magazine*, Vol. 95, 1953, 320–331
7 ———, "Ghirlandaio," *Encyclopedia of World Art*, Vol. 6, 1962, 320–325
8 Salvini, Roberto, *All the Paintings of Botticelli*, 4 vols., New York, 1965
9 Venturi, Lionello, *Botticelli*, New York, 1937
See also Part I List, 24 Pope-Hennessy (Benedetto da Maiano)

37. PERUGINO AND PINTURICCHIO

1. Hutton, Edward, *Perugino*, New York, 1907
2 Ricci, Corrado, *Pintoricchio*, Philadelphia, 1902
3 Santi, Francesco, "Perugino," *Encyclopedia of World Art*, Vol. 11, 1966, 265–271
4 Williamson, George C., *Pietro Vanucci, Called Perugino*, London, 1900

38. SIGNORELLI; MELOZZO DA FORLÌ

1 Cruttwell, Maud, *Luca Signorelli*, 3rd ed., London, 1907
2 Martindale, Andrew, "Luca Signorelli and the Drawings Connected with the Orvieto Frescoes," *Burlington Magazine*, Vol. 103, 1961, 216–220

3 Shell, Curtis, "Melozzo da Forlì," *Encyclopedia of World Art*, Vol. 9, 1964, 728–729

39. ARCHITECTURE IN CENTRAL ITALY, 1465–1500

1 Maltese, Corrado, "Laurana," *Encyclopedia of World Art*, Vol. 9, 1964, 167–171
2 Marchini, Giuseppe, "Sangallo," *Encyclopedia of World Art*, Vol. 12, 1966, 682–686
3 Rotondi, Pasquale, *The Ducal Palace of Urbino*, New York, 1969
4 Weller, Allen S., *Francesco di Giorgio*, Chicago, 1943
See also General List, 27 Lowry; Part I List, 17 Magnuson

40. PAINTERS IN NORTH ITALY, 1450–1500

1 Ffoulkes, Constance, and Majocchi, Rodolfo, *Vincenzo Foppa of Brescia*, London, 1909
2 Gilbert, Creighton, "The Development of Gentile Bellini's Portraiture," *Arte Veneta*, Vol. 15, 1961, 33–38
3 Hartt, Frederick, "Carpaccio's *Meditation on the Passion*," *Art Bulletin*, Vol. 22, 1940, 220–228
4 Leuts, Jan, *Carpaccio*, London, 1962
5 Ludwig, Gustav, and Molmenti, Pompeo, *The Life and Works of Vittore Carpaccio*, London, 1907
6 Pignatti, Teresio, *Carpaccio*, New York, 1958
7 Rushforth, Gordon M., *Crivelli*, London, 1910
See also General List, 17 Crowe and Cavalcaselle

41. SCULPTORS AND ARCHITECTS IN NORTH ITALY, 1465–1500

1 Beck, James, "Niccolò dell' Arca: A Reexamination," *Art Bulletin*, Vol. 47, 1965, 335–344
See also Part I List, 24 Pope-Hennessy, 25 Seymour

42. GIOVANNI BELLINI TO 1500

1 Borenius, Tancred, *The Painters of Vicenza 1480–1550*, London, 1909
2 Hendy, Philip, *Giovanni Bellini*, New York, 1945
3 Robertson, Giles, *Giovanni Bellini*, Oxford, 1969

Part Two. The High Renaissance in Italy: Surveys of the Age as a Whole and Studies of Wide Scope

1 Alazard, Jean, *The Florentine Portrait*, New York, 1968 (also paperback)
2 Briganti, Giuliano, *Italian Mannerism*, Leipzig, 1962
3 Freedberg, Sydney J., *Painting in Italy 1500 to 1600*, Baltimore, 1971
4 ———, *Painting of the High Renaissance in Rome and Florence*, 2 vols., Cambridge, Mass., 1961
5 Friedlaender, Walter F., *Mannerism and Anti-Mannerism in Italian Painting*, New York, 1957 (also paperback)
6 Haupt, Albrecht, *Renaissance Palaces of Northern Italy and Tuscany*, London, 1930
7 Klein, Robert, and Zerner, Henri, *Italian Art, 1500–1600* (in series Sources and Documents in the History of Art), Englewood Cliffs, N.J., 1966 (also paperback)

8 Lee, Rensselaer, *Ut Pictura Poesis*, New York, 1967 (also paperback)
9 Letarouilly, Paul Marie, *Edifices de Rome Moderne*, 6 vols., London, 1929–30 (English text) (originally 1868–74)
10 Lotz, Wolfgang, "Architecture in the Later Sixteenth Century," *College Art Journal*, Vol. 17, 1958, 129–139
11 Murray, Linda, *The High Renaissance*, New York, 1967 (also paperback)
12 Pevsner, Nikolaus, *Academies of Art, Past and Present*, Cambridge, England, 1940
13 ———, "The Architecture of Mannerism," *The Mint*, 1946, 116–138
14 Pope-Hennessy, John, *Italian High Renaissance and Baroque Sculpture*, 3 vols., London, 1963

15 Ricci, Corrado, *Architecture and Decorative Sculpture of the High and Late Renaissance in Italy*, New York, 1923

16 Shearman, John, *Mannerism*, Harmondsworth, 1967

17 Smyth, Craig H., *Mannerism and Maniera*, Locust Valley, N.Y., 1961

18 Turner, Almon, *The Vision of Landscape in Renaissance Italy*, Princeton, 1966

19 Wölfflin, Heinrich, *The Art of the Italian Renaissance*, London, 1913 (also paperback)

20 ———, *Classic Art*, London, 1952 (originally 1899) (also paperback)

21 ———, *Principles of Art History*, London, 1932 (originally 1915) (also paperback)

1. LEONARDO TO 1500

1 Brachert, Thomas, "A Musical Canon of Proportion in Leonardo da Vinci's *Last Supper*," *Art Bulletin*, Vol. 53, 1971, 461–466

2 Clark, Kenneth, *A Catalogue of the Drawings of Leonardo da Vinci at Windsor Castle*, 2nd ed., New York, 1968

3 ———, *Leonardo da Vinci*, 2nd ed., Cambridge, Mass., 1952

4 Goldscheider, Ludwig, *Leonardo da Vinci*, London, 1959

5 Heydenreich, Ludwig, *Leonardo da Vinci*, 2 vols., New York, 1954

6 MacMahon, A. Philip, and Heydenreich, Ludwig (eds.), *Leonardo da Vinci: Treatise on Painting*, 2 vols., Princeton, 1956

7 O'Malley, Charles, and Saunders, John, *Leonardo da Vinci on the Human Body*, New York, 1952

8 Pirenne, M. H., "The Scientific Basis of Leonardo da Vinci's Theory of Perspective," *British Journal for the Philosophy of Science*, Vol. 3, 1952, 169–185

9 Popham, Arthur E., *The Drawings of Leonardo da Vinci*, New York, 1945 (also paperback)

10 Richter, Jean P. (ed.), *The Literary Works of Leonardo da Vinci*, 2nd ed., 2 vols., Oxford, 1939

11 Sirén, Osvald, *Leonardo da Vinci*, New Haven, 1916

12 Thiis, Jens, *Leonardo da Vinci: the Florentine Years*, London, 1913

2. FILIPPINO LIPPI AND PIERO DI COSIMO

1 Fahy, Everett, "Some Later Works of Piero di Cosimo," *Gazette des Beaux-Arts*, Vol. 65, 1965, 201–212

2 Douglas, R. Langton, *Piero di Cosimo*, Chicago, 1946

3 Friedman, David, "The Burial Chapel of Filippo Strozzi in S. Maria Novella in Florence," *L'Arte*, Vol. 9, 1970, 108–131

4 Mathews, Thomas F., "Piero di Cosimo's *Discovery of Honey*," *Art Bulletin*, Vol. 45, 1963, 357–360

5 Neilson, Katherine B., *Filippino Lippi*, Cambridge, Mass., 1938

6 Panofsky, Erwin, "The Early History of Man in Two Cycles of Paintings by Piero di Cosimo" (General List, 35)

3. PAINTING IN MILAN AFTER LEONARDO

1 Cust, R. H. Hobart, *G. A. Bazzi, Hitherto Usually Styled "Sodoma"*, London, 1906

2 Halsey, Ethel, *Gaudenzio Ferrari*, London, 1908

3 Suida, Wilhelm, "Andrea Solario in the Light of Newly Discovered Documents and Unpublished Works," *Art Quarterly*, Vol. 8, 1945, 16–22

4 Williamson, George, *Bernardino Luini*, London, 1900

See also General List, 17 Crowe and Cavalcaselle

4. BRAMANTE

1 Förster, Otto, "Bramante," *Encyclopedia of World Art*, Vol. 2, 1960, 595–610

See also General List, 17 Crowe and Cavalcaselle (Bramantino), 27 Lowry

5. LEONARDO'S LAST YEARS

1 Heydenreich, Ludwig, "Leonardo da Vinci: Architect of Francis I," *Burlington Magazine*, Vol. 94, 1952, 277–285

2 Loeser, Charles, "Gianfrancesco Rustici," *Burlington Magazine*, Vol. 52, 1928, 260–272

6. YOUNG MICHELANGELO

1 Condivi, Ascanio, *Life of Michelangelo*, trans. C. Holroyd (in Holroyd's *Michelangelo*), London, 1903, 1–79 (originally 1553)

2 Gilbert, Creighton, *Michelangelo*, New York, 1968

3 Goldscheider, Ludwig, *Michelangelo Drawings*, 2nd ed., London, 1966

4 ———, *Michelangelo: Paintings, Sculpture, and Architecture*, 5th ed., New York, 1962

5 Hartt, Frederick, *Michelangelo*, 3 vols., New York, 1965–71

6 Michelangelo, *Complete Poems and Selected Letters*, trans. C. Gilbert, New York, 1963 (also paperback)

7 ———, *Letters*, trans. E. Ramsden, Palo Alto, 1963

8 Symonds, John Addington, *The Life of Michelangelo Buonarroti*, 3rd ed., 2 vols., New York, 1893

9 Tolnay, Charles de, *Michelangelo*, 5 vols., Princeton, 1943–60

10 Weinberger, Martin, *Michelangelo the Sculptor*, 2 vols., New York, 1967

11 Wilde, Johannes, *Michelangelo and His Studio* (in series Italian Drawings in the British Museum), London, 1953

7. YOUNG RAPHAEL

1 Camesasca, Ettore, *All the Frescoes of Raphael*, 2 vols., New York, 1963

2 ———, *All the Paintings of Raphael*, 2 vols., New York, 1963

3 Crowe, J. A., and Cavalcaselle, G. B., *Raphael, His Life and Works*, 2 vols., London, 1882–85

4 Dussler, Luitpold, *Raphael, a Critical Catalogue*, New York, 1971

5 Fischel, Oskar, *Raphael*, 2 vols., London, 1948

6 Gilbert, Creighton, *Paintings by Raphael*, New York, 1956

7 Middeldorf, Ulrich, *Raphael's Drawings*, New York, 1945

8 Müntz, Eugene, *Raphael*, London, 1882

9 Oppé, Adolf, *Raphael*, 2nd ed., London, 1970 (originally 1909)

10 Pouncey, Philip, and Gere, John A., *Raphael and His Circle*, 2 vols. (in series Italian Drawings in the British Museum), London, 1962

11 Wittkower, Rudolf, "Young Raphael," *Bulletin of the Allen Memorial Museum*, Oberlin, Vol. 21, 1963, 150–168

8. ANDREA SANSOVINO; FRA BARTOLOMMEO

1 Huntley, G. Haydn, *Andrea Sansovino*, Cambridge, Mass., 1935

See also Part II List, 4 Freedberg

9. ANDREA DEL SARTO

1 Freedberg, Sydney J., *Andrea del Sarto*, 2 vols., Cambridge, Mass., 1963
2 Shearman, John, *Andrea del Sarto*, Oxford, 1965

10. THE SISTINE CEILING

1 Wind, Edgar, "Maccabean Histories in the Sistine Ceiling," in *Italian Renaissance Studies*, ed. E. Jacob, London, 1960, 312–327
See also Section 6 List above (especially 9 Tolnay, Vol. 2, *The Sistine Ceiling*)

11. RAPHAEL'S LAST YEARS

1 Badt, Kurt, "Raphael's Incendio del Borgo," *Journal of the Warburg and Courtauld Institutes,* Vol. 22, 1959, 35–59
2 D'Ancona, Paolo, *The Farnesina Frescoes at Rome*, Milan, 1955
3 Gombrich, Ernst H., "Raphael's Madonna della Sedia" (General List, 23)
4 Hartt, Frederick, "Raphael and Giulio Romano," *Art Bulletin*, Vol. 26, 1944, 67–94
5 Hirst, Michael, "The Chigi Chapel in S. Maria della Pace," *Journal of the Warburg and Courtauld Institutes*, Vol. 24, 1961, 161–185
6 Oppé, Adolf, "Right and Left in Raphael's Cartoons," *Journal of the Warburg and Courtauld Institutes*, Vol. 7, 1944, 83–94
7 Pope-Hennessy, John, *The Raphael Cartoons*, London, 1950
8 Shearman, John, "The Chigi Chapel in S. Maria del Popolo," *Journal of the Warburg and Courtauld Institutes*, Vol. 24, 1961, 129–160
9 ———, and White, John, "Raphael's Tapestries and Their Cartoons," *Art Bulletin*, Vol. 41, 1958, 193–221, 299–323
See also Section 7 List above

12. ARCHITECTURE IN ROME

1 Ackerman, James S., *The Cortile del Belvedere*, Rome, 1954
2 Greenwood, William E., *The Villa Madama*, New York, 1928
3 Kent, William, *The Life and Works of Baldassare Peruzzi of Siena*, New York, 1925
4 Letarouilly, Paul Marie, *The Vatican and the Basilica of St. Peter, Rome*, New York, 1925
5 Wurm, Heinrich, "Peruzzi," *Encyclopedia of World Art*, Vol. 11, 1966, 271–275
See also General List, 27 Lowry

13. GIORGIONE

1 Baldass, Ludwig von, *Giorgione*, New York, 1965
2 Coletti, Luigi, *All the Paintings of Giorgione*, New York, 1962
3 Cook, Herbert, *Giorgione*, London, 1904
4 Pignatti, Terisio, *Giorgione*, London, 1971
5 Richter, George M., *Giorgio del Castelfranco Called Giorgione*, Chicago, 1937

14. CONTEMPORARIES OF GIORGIONE

1 Gilbert, Creighton, "Bartolommeo Veneto," *McGraw-Hill Dictionary of Art*, New York, 1969, Vol. 1, 254–255
2 Kristeller, Paul, *Jacopo de' Barbari, Engravings and Woodcuts*, New York, 1896

3 Sterling, Charles, *Still Life Painting*, New York, 1959
4 Walker, John, *Bellini and Titian at Ferrara*, London, 1957
5 Wind, Edgar, *Bellini's Feast of the Gods*, Cambridge, Mass., 1948

15. GIULIO CAMPAGNOLA; RICCIO

1 Ciardi Dupre, Maria G., *Small Renaissance Bronzes*, London, 1970
2 Hind, Arthur M., *Early Italian Engraving*, London, 1948 (Vol. 5, 189–206, Campagnola)
3 Mayor, A. Hyatt, "Giulio Campagnola," *Metropolitan Museum of Art Bulletin*, Vol. 32, 1937, 192–196
4 Saxl, Fritz, "Pagan Sacrifice in the Italian Renaissance," *Journal of the Warburg Institute*, Vol. 2, 1938–39, 346–367 (Riccio)
5 Tietze, Hans, and Tietze-Conrat, Erica, "Giulio Campagnola's Engravings," *Print Collectors Quarterly*, Vol. 29, 1942, 179–207
See also General List, 43 Tietze (Campagnola); Part I List, 24 Pope-Hennessy (Riccio)

16. PALMA; SEBASTIANO DEL PIOMBO

1 Dussler, Luitpold, "Sebastiano del Piombo," *Encyclopedia of World Art*, Vol. 12, 1966, 858–862
See also General List, 17 Crowe and Cavalcaselle; Part II List, 3 Freedberg

17. FERRARA AND BOLOGNA

See General List, 17 Crowe and Cavalcaselle; Part II List, 3 Freedberg

18. DOSSO AND HIS SUCCESSORS

1 Gibbons, Felton, *Dosso and Battista Dossi*, Princeton, 1968
See also Part II List, 3 Freedberg

19. YOUNG TITIAN

1 Crowe, J. A., and Cavalcaselle, G. B., *Titian and His Times*, 2 vols., London, 1877
2 Gronau, Georg, *Titian*, trans. A. M. Todd, London, 1904
3 Hadeln, Detlev von, *Titian's Drawings*, London, 1927
4 Morassi, Antonio, *Titian*, Greenwich, Conn., 1964
5 Panofsky, Erwin, *Problems in Titian*, New York, 1969
6 Tietze, Hans, *Titian*, 2nd ed., New York, 1950
7 Valcanover, Francesco, *All the Paintings of Titian*, 4 vols., New York, 1964
8 Wethey, Harold, *The Paintings of Titian*, 2 vols., New York, 1969–71

20. LOTTO, PORDENONE

1 Berenson, Bernard, *Lorenzo Lotto*, rev. ed., London, 1956
2 Bianconi, Piero, *All the Paintings of Lorenzo Lotto*, 2 vols., New York, 1963
See also Part II List, 3 Freedberg

21. SAVOLDO, ROMANINO

1 Gilbert, Creighton, "Milan and Savoldo," *Art Bulletin*, Vol. 27, 1945, 124–138
2 ———, "Portraits by and near Romanino," *Arte Lombarda*, Vol. 4, 1959, 261–267

3 ———, "Savoldo's Drawings Put to Use," *Gazette des Beaux-Arts*, Vol. 41, 1953, 5–26
4 Kossoff, Florence, "Romanino in Brescia," *Burlington Magazine*, Vol. 107, 1965, 514–518
See also Part II List, 3 Freedberg

22. CORREGGIO

1 Gronau, Georg, *Correggio*, New York, 1921
2 Panofsky, Erwin, *The Iconography of Correggio's Camera di San Paolo*, London, 1961
3 Popham, Arthur E., *Correggio's Drawings*, London, 1957
4 Quintavalle, Augusta Ghidiglia, *Correggio: The Frescoes in San Giovanni Evangelista at Parma*, New York, 1964

23. MICHELANGELO: THE MEDICI YEARS

1 Ackerman, James S., *The Architecture of Michelangelo*, 2 vols., New York, 1961–64
2 Gilbert, Creighton, "Texts and Contexts in the Medici Chapel," *Art Quarterly*, Vol. 34, 1970, 391–409
3 Hartt, Frederick, "The Meaning of Michelangelo's Medici Chapel," *Essays in Honor of Georg Swarzenski*, Chicago, 1951, 145–155
4 Wittkower, Rudolf, "Michelangelo's Biblioteca Laurenziana," *Art Bulletin*, Vol. 16, 1934, 123–218
See also Section 6 List above

24. SCULPTORS IN MICHELANGELO'S ORBIT

1 Holderbaum, James, "The Birth Date and a Destroyed Early Work of Baccio Bandinelli," *Essays in the History of Art Presented to Rudolf Wittkower*, London, 1967, 93–97
2 Valentiner, Wilhelm, "Bandinelli: Rival of Michelangelo," *Art Quarterly*, Vol. 18, 1955, 241–262
See also General List, 26 Keutner; Part II List, 14 Pope-Hennessy

25. PONTORMO, ROSSO

1 Carroll, Eugene, "Some Drawings by Rosso Fiorentino," *Burlington Magazine*, Vol. 102, 1961, 446–454
2 Clapp, Frederick M., *Jacopo Carucci da Pontormo, His Life and Work*, New Haven, 1916
3 Panofsky, Dora and Erwin, "The Iconography of the Galerie François I at Fontainebleau," *Gazette des Beaux-Arts*, Vol. 52, 1958, 113–190
4 Rearick, Janet C., *The Drawings of Pontormo*, 2 vols., Cambridge, Mass., 1964
See also Part II List, 3 Freedberg; Part III List, 2 Blunt (Rosso in France)

26. BECCAFUMI, PARMIGIANINO

1 Freedberg, Sydney J., *Parmigianino, His Works in Painting*, Cambridge, Mass., 1950
2 Popham, Arthur E., *The Drawings of Parmigianino*, 3 vols., New Haven, 1971
3 Sanminiatelli, Donato, "The Beginnings of Domenico Beccafumi," *Burlington Magazine*, Vol. 99, 1957, 401–410
4 ———, "The Sketches of Domenico Beccafumi," *Burlington Magazine,* Vol. 97, 1955, 35–40
See also Part II List, 3 Freedberg

27. MANNERISM IN ARCHITECTURE

1 Hartt, Frederick, *Giulio Romano*, 2 vols., New Haven, 1958
2 Murray, Linda, *The Late Renaissance and Mannerism*, London, 1967 (also paperback)
See also General List, 27 Lowry; Part II List, 13 Pevsner; Section 12 List above (Peruzzi); Section 23 List above (Michelangelo)

28. PERINO DEL VAGA; FLORENTINE DECORATIVE SCULPTURE

1 Askew, Pamela, "Perino del Vaga's Decorations for Palazzo Doria, Genoa," *Burlington Magazine*, Vol. 98, 1956, 46–53
2 Cellini, Benvenuto, *Autobiography*, ed. J. Pope-Hennessy, London, 1960 (originally c. 1560) (also paperback)
3 Davidson, Berenice, "Drawings by Perino del Vaga for the Palazzo Doria, Genoa," *Art Bulletin*, Vol. 41, 1959, 315–326
4 Gere, John A., "Two Late Fresco Cycles by Perino del Vaga," *Burlington Magazine*, Vol. 102, 1960, 8–19
5 Hirst, Michael, "Perino del Vaga and His Circle," *Burlington Magazine*, Vol. 108, 1966, 388–405
6 Holderbaum, James, "Notes on Tribolo," *Burlington Magazine*, Vol. 99, 1957; 336–343; 369–372
Wiles, Bertha H., *The Fountains of Florentine Sculptors*, Cambridge, Mass., 1933
See also Part II List, 14 Pope-Hennessy

29. BRONZINO AND HIS CONTEMPORARIES

1 Carden, Robert, *The Life of Giorgio Vasari*, New York, 1911
2 Cheney, Iris, "Francesco Salviati's North Italian Journey," *Art Bulletin*, Vol. 45, 1963, 337–349
3 Hirst, Michael, "Francesco Salviati's *Visitation*," *Burlington Magazine*, Vol. 103, 1961, 236–240
4 ———, "Salviati's Two Apostles in the Oratorio of S. Giovanni Decollato," *Studies in Renaissance and Baroque Art Presented to Anthony Blunt*, London, 1967, 34–36
5 ———, "Three Ceiling Decorations of Francesco Salviati," *Zeitschrift für Kunstgeschichte*, Vol. 26, 1963, 146–165
6 McComb, Arthur, *Angelo Bronzino*, Cambridge, Mass., 1928
7 Smyth, Craig H., *Bronzino as Draughtsman, an Introduction*, Locust Valley, N.Y., 1972
8 ———, "The Earliest Works of Bronzino," *Art Bulletin*, Vol. 31, 1949, 184–210
See also Part II List, 3 Freedberg, 16 Shearman

30. MORETTO AND VENETIAN PAINTERS OF HIS GENERATION

See General List, 4 Berenson; Part II List, 3 Freedberg

31. MANNERIST PAINTERS IN NORTH ITALY

1 Johnson, W. McAllister, "Primaticcio Revisited," *Art Quarterly*, Vol. 29, 1966, 245–268
See also Part II List, 3 Freedberg; Part III List, 2 Blunt (Fontainebleau)

32. TITIAN'S LATER YEARS

See Section 19 List above

33. FALCONETTO, SANMICHELI, JACOPO SANSOVINO

1 Langenskjold, Eric, *Micheli Sanmicheli,* Uppsala, 1938
2 Zevi, Bruno, "Sanmicheli," *Encyclopedia of World Art,* Vol. 12, 1966, 691–700
See also General List, 27 Lowry; Part II List, 10 Lotz

34. AMMANATI, VIGNOLA

1 Coolidge, John, "The Villa Giulia: A Study of Central Italian Architecture in the Mid 16th Century," *Art Bulletin,* Vol. 25, 1943, 177–226
2 Wurm, Heinrich, "Vignola," *Encyclopedia of World Art,* Vol. 14, 1967, 791–799
See also General List, 27 Lowry; Part II List, 10 Lotz

35. PALLADIO

1 Ackerman, James S., *Palladio,* Harmondsworth, 1966 (also paperback)
2 ———, *Palladio's Villas,* Locust Valley, N.Y., 1967
3 Sinding-Larsen, Staale, "Palladio's Redentore," *Art Bulletin,* Vol. 47, 1965, 419–437
4 Wittkower, Rudolf, *Architectural Principles in the Age of Humanism,* 3rd ed., London, 1962 (also paperback)

36. TINTORETTO

1 Newton, Eric, *Tintoretto,* London, 1952
2 Osmaston, Francis, *The Art and Genius of Tintoret,* 2 vols., London, 1915
3 Phillips, Evelyn, *Tintoretto,* London, 1911
4 Tietze, Hans, *Tintoretto,* New York, 1948

37. VERONESE

1 Fehl, Philipp, "Veronese and the Inquisition," *Gazette des Beaux-Arts,* Vol. 58, 1961, 325–354
2 Gould, Cecil, "Observations on the Role of Decoration in the Formation of Veronese's Art," *Essays in the History of Art Presented to Rudolf Wittkower,* London, 1967, 123–127
3 Harcourt-Smith, Simon, *The Family of Darius before Alexander,* London, 1945
4 Osmond, Percy, *Paolo Veronese,* London, 1927
5 Schulz, Juergen, *Venetian Painted Ceilings of the Renaissance,* Berkeley, 1968

38. BASSANO, VITTORIA

1 Rearick, W. Roger, "Jacopo Bassano's Later Genre Paintings," *Burlington Magazine,* Vol. 110, 1968, 241–249

2 ———, "Jacopo Bassano: 1568–69," in *Renaissance Art,* ed. C. Gilbert (General List, 21)
See also Part II List, 14 Pope-Hennessy (Vittoria)

39. MICHELANGELO'S LATE YEARS

1 MacDougall, Elizabeth B., "Michelangelo and the Porta Pia," *Journal of the Society of Architectural Historians,* Vol. 19, 1960, 97–108
2 Millon, Henry A., and Smyth, Craig H., "Michelangelo and St. Peter's, I," *Burlington Magazine,* Vol. 111, 1969, 484–500
See also Part II List, 10 Lotz; Section 6 List above

40. GIAMBOLOGNA

1 Keutner, Herbert, "The Palazzo Pitti Venus and Other Works by Vincenzo Danti," *Burlington Magazine,* Vol. 100, 1958, 427–431
2 Pope-Hennessy, John, *Samson and a Philistine by Giovanni Bologna,* London, 1954
3 Utz, Hildegard, "The *Labors of Hercules* and Other Works by Vincenzo Rossi," *Art Bulletin,* Vol. 53, 1971, 344–366
See also General List, 26 Keutner; Part II List, 14 Pope-Hennessy

41. LEONE LEONI, MORONI

See General List, 3 and 4 Berenson (Moroni), 26 Keutner (Leoni); Part II List, 14 Pope-Hennessy (Leoni)

42. ALESSI AND TIBALDI

See Part II List, 10 Lotz

43. PAINTERS IN ROME AND FLORENCE AFTER 1550

1 Davidson, Berenice, "Some Early Works of Girolamo Siciolante da Sermoneta," *Art Bulletin,* Vol. 48, 1966, 55–64
2 ———, and Hirst, Michael, "Daniele da Volterra and the Orsini Chapel," *Burlington Magazine,* Vol. 109, 1967, 498–509, 553–561
3 Gere, John A., *Drawings of Taddeo Zuccaro,* Chicago, 1969
4 ———, "Girolamo Muziano and Taddeo Zuccaro," *Burlington Magazine,* Vol. 108, 1966, 417–418
5 ———, "Two of Taddeo Zuccaro's Commissions, Completed by Federico Zuccaro," *Burlington Magazine,* Vol. 108, 1966, 288–293, 314–345
See also Part II List, 3 Freedberg, 10 Lotz

44. CAMBIASO, BAROCCI

1 Olsen, Harald, *Federico Barocci,* Copenhagen, 1962
2 Suida Manning, Bertina, "The Nocturnes of Luca Cambiaso," *Art Quarterly,* Vol. 15, 1952, 197–220

Part Three. The Renaissance outside Italy: Surveys of the Age as a Whole and Studies of Wide Scope

1 Benesch, Otto, *The Art of the Renaissance in Northern Europe,* Cambridge, Mass., 1947
2 Blunt, Anthony, *Art and Architecture in France 1500 to 1700,* 2nd ed., Baltimore, 1957
3 Blomfield, Reginald, *History of French Architecture 1494–1661,* London, 1911

4 Châtelet, Albert, and Thuillier, Jacques, *French Painting from Fouquet to Poussin,* Geneva, 1963
5 Coremans, Paul (ed.), *Flanders in the Fifteenth Century: Art and Civilization,* Detroit, 1960
6 Cuttler, Charles D., *Northern Painting from Pucelle to Bruegel,* New York, 1968

7 Delevoy, Robert, *Flemish Painting, II: From Bosch to Rubens,* Geneva, 1958

8 Dupont, Jacques, and Gnudi, Cesare, *Gothic Painting,* Geneva, 1954

9 Friedländer, Max, *Early Netherlandish Painting,* 14 vols., Brussels, 1967—

10 ———, *From Van Eyck to Bruegel,* 2nd ed., London, 1965 (also paperback)

11 ———, *Landscape, Portrait, Still Life,* Oxford, 1949 (also paperback)

12 Hind, Arthur M., *History of Engraving and Etching,* London, 1923 (also paperback)

13 ———, *An Introduction to the History of Woodcut,* 2 vols., Boston, 1935 (also paperback)

14 Hollstein, F. W. H., *Dutch and Flemish Etchings, Engravings, and Woodcuts,* many vols., Amsterdam, 1949—

15 ———, *German Engravings, Etchings, and Woodcuts,* many vols., Amsterdam, 1954—

16 Kubler, George, and Soria, Martin, *Art and Architecture in Spain and Portugal . . . 1500 to 1800,* Baltimore, 1959

17 Lassaigne, Jacques, and Delevoy, Robert, *Flemish Painting, I,* Geneva, 1956

18 Lowry, Bates, "High Renaissance Architecture," *College Art Journal,* Vol. 17, 1958, 115–128

19 Mander, Carel van, *Dutch and Flemish Painters,* trans. Van de Wall, New York, 1936 (originally 1604)

20 Muehsam, Gerd, *French Painters and Paintings from the Fourteenth Century to Post-Impressionism,* New York, 1970

21 Müller, Theodor, *Sculpture in the Netherlands, France, Germany and Spain 1400 to 1500,* Baltimore, 1965

22 Panofsky, Erwin, *Early Netherlandish Painting,* 2 vols., Cambridge, Mass., 1953 (also paperback)

23 Parker, Karl T., *Drawings of the Early German Schools,* London, 1926

24 Porcher, Jean, *French Illumination,* London, 1959

25 Puyvelde, Leo van, *The Flemish Primitives,* Brussels, 1948

26 Ring, Grete, *A Century of French Painting 1400–1500,* London, 1949

27 Stange, Alfred, *German Painting of the XVth–XVIth Centuries,* London, 1950

28 Stechow, Wolfgang, *Northern Renaissance Art, 1400–1600* (in series Sources and Documents in the History of Art), Englewood Cliffs, N.J., 1966 (also paperback)

29 Von der Osten, Gert, and Vey, Horst, *Painting and Sculpture in Germany and the Netherlands 1500 to 1600,* Baltimore, 1969

1. JEAN PUCELLE

1 Deuchler, Florens, "Jean Pucelle, Facts and Fictions," *Metropolitan Museum of Art Bulletin,* Vol. 29, 1971, 253–256 (volume contains related articles by others)

2 Millar, Eric, *The Parisian Miniaturist Honoré,* London, 1959

3 Morand, Kathleen, *Jean Pucelle,* Oxford, 1962

4 Nordenfalk, Carl, "Maître *Honoré* and *Maître* Pucelle," *Apollo,* Vol. 79, 1964, 356–364

5 Porcher, Jean, *Medieval French Miniatures,* New York, 1960

6 Rorimer, James, *The Hours of Jeanne d'Evreux,* New York, 1957

2. FRENCH PAINTING, 1340–1380

1 Porcher, Jean, *Medieval French Miniatures,* New York, 1960
See also Part III List, 6 Cuttler, 8 Dupont and Gnudi, 22 Panofsky

3. ACCOMPLISHMENTS AROUND KING CHARLES V

1 Meiss, Millard, *French Painting in the Time of Jean of Berry;* Part, I, *The Late Fourteenth Century and the Patronage of the Duke,* London, 1967

2 Sherman, Claire R., *The Portraits of Charles V of France,* New York, 1970
See also Part III List, 6 Cuttler, 22 Panofsky, 24 Porcher

4. CLAUS SLUTER

1 Pauwels, Henri, "Sluter," *Encyclopedia of World Art,* Vol. 13, 1967, 113–119

2 Zarnecki, George, "Claus Sluter: Sculptor to Philip the Bold," *Apollo,* Vol. 76, 1962, 271–276
See also Part III List, 21 Muller

5. BROEDERLAM AND BELLECHOSE

See Part III List, 6 Cuttler, 22 Panofsky, 26 Ring

6. THE DUKE OF BERRY AND THE LIMBOURG BROTHERS

1 Aubert, Marcel, "Beauneveu," *Encyclopedia of World Art,* Vol. 2, 1960, 409–411

2 Bober, Harry, "The Zodiacal Miniature of the Très Riches Heures of the Duke of Berry," *Journal of the Warburg and Courtauld Institutes,* Vol. 11, 1948, 1–34

3 Porcher, Jean, "Limbourg," *Encyclopedia of World Art,* Vol. 9, 1964, 251–256
See also Section 3 List above, 1 Meiss; Part III List, 6 Cuttler, 22 Panofsky, 26 Ring

7. THE BOUCICAUT HOURS AND THE ROHAN HOURS: SOME CONCLUSIONS

1 Meiss, Millard, *French Painting in the Time of Jean de Berry,* Part II, *The Boucicaut Master,* London, 1968

2 Porcher, Jean, *The Rohan Book of Hours,* London, 1959

8. PRAGUE AND ITS FOLLOWING

1 Friedl, Antonín, *Magister Theodoricus,* Prague, 1956

2 Matějček, Antonín, and Pešina, Jaroslav, *Czech Gothic Painting, 1350–1450,* Prague, 1950
See also Part III List, 6 Cuttler, 27 Stange

9. JAN VAN EYCK: THE GHENT ALTARPIECE

1 Philip, Lotte Brand, *The Ghent Altarpiece and the Art of Jan van Eyck,* Princeton, 1971
See also Section 10 List below

10. JAN VAN EYCK: THE OTHER WORKS

1 Baldass, Ludwig von, *Jan van Eyck,* London, 1952

2 Conway, William, *The Van Eycks and Their Followers,* London, 1912

3 Denis, Valentin, *All the Paintings of Jan van Eyck,* New York, 1961

4 Meiss, Millard, "Light as Form and Symbol in Some Fifteenth Century Paintings," in *Renaissance Art,* ed. C. Gilbert (General List, 21)

433

5 Panofsky, Erwin, "Jan van Eyck's Arnolfini Portrait," in *Renaissance Art*, ed. C. Gilbert (General List, 21)
6 Weale, William, *Hubert and Jan van Eyck*, London, 1908
See also Part III List, 9 Friedländer, 22 Panofsky

11. THE MASTER OF FLÉMALLE

1 Freeman, Margaret, "The Iconography of the Merode Altarpiece," *Metropolitan Museum of Art Bulletin*, Vol. 16, 1957, 138–140
2 Schapiro, Meyer, "Muscipula Diaboli," in *Renaissance Art*, ed. C. Gilbert (General List, 21)
See also Part III List, 6 Cuttler, 9 Friedländer, 22 Panofsky

12. THE FLÉMALLE STYLE IN GERMANY AND ELSEWHERE

1 Geisberg, Max, "Master E. S.," *Print Collectors Quarterly*, Vol. 9, 1922, 203–235
2 Shestack, Alan (ed.), *Master E. S.*, Philadelphia, 1967
See also Part III List, 6 Cuttler, 21 Müller, 26 Ring, 27 Stange

13. MASTER FRANCKE; STEFAN LOCHNER

1 Förster, Otto, "Lochner," *Encyclopedia of World Art*, Vol. 9, 1964, 315–317
See also Part III List, 6 Cuttler, 27 Stange

14. ROGIER VAN DER WEYDEN

1 Blum, Shirley N., *Early Netherlandish Triptychs*, Berkeley, 1969
2 Feder, Theodore, "A Reexamination through Documents of the First Fifty Years of Roger van der Weyden's Life," *Art Bulletin*, Vol. 48, 1966, 416–431
3 Schulz, Ann M., "The Columba Altarpiece and Roger van der Weyden's Stylistic Development," *Münchner Jahrbuch der bildenden Kunst*, Vol. 22, 1971, 63–116
See also Part III List, 6 Cuttler, 9 Friedländer, 22 Panofsky

15. ROGIER'S CONTEMPORARIES

1 Snyder, James E., "The Early Haarlem School of Painting, I," *Art Bulletin*, Vol. 42, 1960, 39–49
See also Part III List, 6 Cuttler, 9 Friedländer, 22 Panofsky

16. DIRK BOUTS

See Part III List, 6 Cuttler, 9 Friedländer, 22 Panofsky

17. JOOS VAN GENT; HUGO VAN DER GOES

1 Wehle, Harry, "A Painting by Joos van Gent," *Metropolitan Museum of Art Bulletin*, Vol. 2, 1943, 133–139
See also Part III List, 6 Cuttler, 9 Friedländer, 22 Panofsky

18. GEERTGEN TOT SINT JANS; MEMLING

1 McFarlane, K. B., *Hans Memling*, New York, 1972
2 Snyder, James E., "The Early Haarlem School of Painting, II," *Art Bulletin*, Vol. 42, 1960, 113–132
3 Weale, William, *Hans Memlinc*, London, 1901
See also Part III List, 6 Cuttler, 9 Friedländer

19. JEAN FOUQUET

1 Cox, Trenchard, *Jehan Foucquet*, London, 1931
2 Pächt, Otto, "Jean Fouquet: a Study of His Style," *Journal of the Warburg and Courtauld Institutes*, Vol. 4, 1941, 85–102
3 Wescher, Paul, *Jean Fouquet and His Time*, London, 1947
See also Part III List, 26 Ring

20. AVIGNON AND KING RENÉ

1 Harris, Enriqueta, "*Mary in the Burning Bush*: Nicolas Froment's Triptych in Aix en Provence," *Journal of the Warburg Institute*, Vol. 1, 1938, 281–286
See also General List, 25 Holt (Quarton)

21. THE GROWING ROLE OF SCULPTURE: HANS MULTSCHER

See Part III List, 21 Müller

22. NICOLAUS GERHAERT AND OTHER SCULPTORS

1 Frankl, Paul, "The Early Works of Erasmus Grasser," *Art Quarterly*, Vol. 5, 1942, 242–258
See also Part III List, 21 Müller

23. GERMAN PAINTING AND PRINTS IN THE WAKE OF ROGIER

1 Geisberg, Max, "Martin Schongauer," *Print Collectors Quarterly*, Vol. 4, 1914, 103–129
2 Lehrs, Max, *Late Gothic Engravings of Germany and the Netherlands*, ed. A. H. Mayor, New York, 1969 (originally 1908–34)
3 ———, *The Master of the Amsterdam Cabinet*, Berlin, 1893–94
See also Part III List, 12 Wind, 27 Stange

24. THE WOOD SCULPTORS

1 Bier, Justus, "Riemenschneider's *St. Jerome* and His Other Works in Alabaster," *Art Bulletin*, Vol. 31, 1951, 226–234
2 Rasmo, Nicolò, *Michael Pacher*, New York, 1971
3 Weinberger, Martin, "Riemenschneider," *Encyclopedia of World Art*, Vol. 12, 1966, 215–218
See also Part III List, 21 Müller

25. NUREMBERG AND ITS SCULPTORS

1 Weinberger, Martin, "Stoss," *Encyclopedia of World Art*, Vol. 13, 1967, 434–438
2 ———, "Vischer," *Encyclopedia of World Art*, Vol. 14, 1968, 800–802
See also Part III List, 21 Müller, 27 Stange

26. DÜRER

1 Conway, William, *The Art of Albrecht Dürer*, Liverpool, 1910
2 Dodgson, Campbell, *Albrecht Dürer*, London, 1926
3 Dürer, Albrecht, *Diary of His Journey to the Netherlands*, intro. J. Goris and G. Marlier, New York, 1971
4 ———, *The Writings*, trans. W. Conway, ed. A. Werner, New York, 1958
5 Kurth, Willi, *The Complete Woodcuts of Albrecht Dürer*, New York, 1963 (also paperback)

6 Panofsky, Erwin, *The Life and Art of Albrecht Dürer*, 4th ed., Princeton, 1955
7 Schilling, Edmund, *Dürer, Drawings and Watercolors*, New York, 1949
8 Waetzoldt, Wilhelm, *Dürer and His Times*, London, 1950
9 Wölfflin, Heinrich, *The Art of Albrecht Dürer*, New York, 1971 (originally 1905) (also paperback)

27. GRÜNEWALD

1 Burkhard, Arthur, *Matthias Grünewald, Personality and Accomplishment*, Cambridge, Mass., 1936
2 Huysmans, J. K., and Ruhmer, Eberhard, *Grünewald: The Paintings*, New York, 1958
3 Pevsner, Nikolaus, and Meier, Michael, *Grünewald*, London, 1958
4 Schönberger, Guido, *The Drawings of Mathis Gothart Nithart Called Grünewald*, New York, 1948

28. CRANACH AND ALTDORFER

1 Chamot, Mary, "Early Baroque Tendencies in German Sculpture," *Apollo*, Vol. 27, 1938, 316–319
2 Ivins, William, "The Woodcuts of Albrecht Altdorfer," *Print Collectors Quarterly*, Vol. 4, 1914, 31–60
3 Noehles, Gisela and Karl, "Altdorfer," *Encyclopedia of World Art*, Vol. 1, 1959, 221–226
4 Ozarowska Kibish, Christine, "Lukas Cranach's *Christ Blessing the Children*," *Art Bulletin*, Vol. 37, 1955, 196–203
5 Ruhmer, Eberhard, *Cranach*, London, 1963
6 Wehle, Harry, "A *Judgment of Paris* by Cranach," *Metropolitan Museum Studies*, Vol. 2, 1929, 1–12
See also Part III List, 1 Benesch, 6 Cuttler, 29 Von der Osten and Vey

29. DÜRER'S PUPILS AND OTHER PAINTERS

1 Appelbaum, Stanley (ed.), *The Triumph of Maximilian I: 137 Woodcuts by Hans Burgkmair and Others*, New York, 1964 (also paperback)
See also Part III List, 29 Von der Osten and Vey

30. HOLBEIN

1 Clark, James, *The Dance of Death by Hans Holbein*, London, 1947
2 Ganz, Paul, *The Paintings of Hans Holbein the Younger*, London, 1956
3 Gundersheimer, Werner, *The Dance of Death*, New York, 1971 (also paperback)
4 Parker, Karl T., *The Drawings of Hans Holbein . . . at Windsor Castle*, London, 1945
5 Samuel, Edgar R., "Death in the Glass: A New View of Holbein's 'Ambassadors'," *Burlington Magazine*, Vol. 105, 1963, 436–441

31. THE LAST AND REMOTEST EXTENSIONS OF EARLY RENAISSANCE FLEMISH PAINTING

1 Alexander, Jonathan (ed.), *The Master of Mary of Burgundy: a Book of Hours for Engelbert of Nassau*, New York, 1970
2 Châtelet, Albert, "A Plea for the Master of Moulins," *Burlington Magazine*, Vol. 104, 1962, 517–524
3 Eisler, Colin, "The Sittow Assumption," *Art News*, Vol. 64, 1965, 34–37
4 Pächt, Otto, *The Master of Mary of Burgundy*, London, 1948
5 Post, Chandler R., *History of Spanish Painting*, Vol. 12, Part 2, Cambridge, Mass., 1958 (Juan de Flandes)
See also General List, 36 Panofsky (Colombe); Part III List, 1 Benesch (Master Michael), 6 Cuttler (David), 9 Friedländer, 21 Müller (Solesmes), 26 Ring (Marmion)

32. BOSCH

1 Baldass, Ludwig von, *Hieronymus Bosch*, New York, 1960
2 Cuttler, Charles D., "The Lisbon Triptych of St. Anthony by Jerome Bosch," *Art Bulletin*, Vol. 39, 1957, 109–126
3 Philip, Lotte Brand, "The Prado Epiphany by Jerome Bosch," *Art Bulletin*, Vol. 35, 1953, 267–293

33. ANTWERP AND THE HIGH RENAISSANCE

1 Bialostocki, Jan, "New Observations on Joos van Cleef," *Oud Holland*, Vol. 70, 1955, 121–129
2 Friedländer, Max, *Jan Gossaert (Mabuse): The Adoration of the Kings in the National Gallery*, London, n.d.
3 ———, "Quentin Massys as a Painter of Genre Pictures," *Burlington Magazine*, Vol. 89, 1947, 114–119
4 Koch, Robert A., *Joachim Patinir*, Princeton, 1968
See also Part III List, 7 Delevoy, 9 Friedländer

34. HAARLEM AND LEYDEN

See Part III List, 6 Cuttler, 9 Friedländer

35. LUCAS VAN LEYDEN

1 Hollstein, F. W. H., *The Graphic Art of Lucas van Leyden*, Amsterdam, n.d.
See also Part III List, 6 Cuttler, 9 Friedländer

36. THE BEGINNING OF ITALIANATE ARCHITECTURE AND SCULPTURE

1 Evans, Joan, *English Art 1307–1461*, Oxford, 1949
See also Part III List, 2 Blunt, 29 Von der Osten and Vey

37. THE SCOREL GENERATION

See Part III List, 6 Cuttler, 9 Friedländer

38. THE HEGEMONY OF ANTWERP

1 Van de Velde, Carl, "The Labours of Hercules, a lost series of paintings by Frans Floris," *Burlington Magazine*, Vol. 107, 1965, 114–123
See also Part III List, 6 Cuttler, 9 Friedländer

39. PALACES AND OTHER BUILDINGS IN SPAIN

1 Bevan, Bernard, *History of Spanish Architecture*, London, 1938
2 Byne, Arthur and Mildred S., *Spanish Architecture of the Sixteenth Century*, New York, 1917
3 Rosenthal, Earl, *The Cathedral of Granada*, Princeton, 1961
See also Part III List, 16 Kubler and Soria

40. PALACES AND THEIR SCULPTORS IN FRANCE

1 Blunt, Anthony, *Philibert de l'Orme*, London, 1958
2 Miller, Naomi, "The Form and Meaning of the Fontaine des Innocents," *Art Bulletin*, Vol. 50, 1968, 270–277
3 Panofsky, Dora and Erwin, "The Iconography of the Galerie François I at Fontainebleau," *Gazette des Beaux-Arts*, Vol. 52, 1958, 113–190
4 Popham, Arthur E., "Jean Duvet," *Print Collectors Quarterly*, Vol. 8, 1921, 122–150
5 Zerner, Henri, *The School of Fontainebleau, Etchings and Engravings*, New York, 1969
See also General List, 36 Panofsky; Part III List, 2 Blunt

41. ARCHITECTURE IN THE LOW COUNTRIES, GERMANY, AND ENGLAND

1 Saxl, Fritz, and Wittkower, Rudolf, *British Art and the Mediterranean*, Oxford, 1948
2 Summerson, John, *Architecture in Britain 1530 to 1830*, 4th ed., Baltimore, 1963 (also paperback)
3 Whinney, Marcus, *Renaissance Architecture in England*, London, 1952

42. THE PORTRAIT PHENOMENON

1 Auerbach, Erna, *Nicholas Hilliard*, London, 1961
2 Dimier, Louis, *French Painting in the Sixteenth Century*, London, 1904
3 Jenkins, Marianna, *The State Portrait, Its Origin and Evolution*, New York, 1947
4 Judson, Jay R., *Dirck Barendsz*, Amsterdam, 1971
5 Pope-Hennessy, John, *The Portrait in the Renaissance*, New York, 1966
6 Waterhouse, Ellis, *Painting in Britain 1530 to 1790*, 2nd ed., Baltimore, 1947

43. BRUEGEL

1 Grossmann, Fritz, *Bruegel, the Paintings*, 2nd ed., London, 1966

2 Münz, Ludwig, *Pieter Bruegel the Elder, The Drawings*, New York, 1961

44. THE MOVE FROM ANTWERP TO HAARLEM

See Part III List, 1 Benesch, 7 Delevoy, 19 Mander, 29 Von der Osten and Vey

45. PAINTING AND SCULPTURE IN SPAIN BEFORE EL GRECO

1 Baecksbacka, Ingjald, *Luis de Morales*, Helsinki, 1962
2 Gomez-Moreno, Manuel, *The Golden Age of Spanish Sculpture*, London, 1964
3 Harris, Enriqueta, *Spanish Painting*, London, 1938
4 Lassaigne, Jacques, *Spanish Painting*, I, Geneva, 1952
5 Post, Chandler R., *History of Spanish Painting*, 12 vols., Cambridge, Mass., 1930–58
6 Santos, Reynaldo dos, *Nuno Gonçalves*, London, 1955
7 Trapier, Elizabeth, *Luis de Morales and Leonardesque Influences in Spain*, New York, 1953
See also Part III List, 16 Kubler and Soria

46. EL GRECO

1 Dvorak, Max, "Greco and Mannerism," *Magazine of Art*, Vol. 46, 1953, 15–23 (originally 1924)
2 Goldscheider, Ludwig, *El Greco*, 3rd ed., New York, 1954
3 Trapier, Elizabeth, "El Greco in the Farnese Palace, Rome," *Gazette des Beaux-Arts*, Vol. 100, 1958, 73–90
4 ———, *El Greco's Early Years at Toledo, 1576–86*, New York, 1958
5 Waterhouse, Ellis, "El Greco's Italian Period," *Art Studies*, Vol. 8, 1930, 59–88
6 Wethey, Harold, *El Greco and His School*, 2 vols., Princeton, 1962
7 Wittkower, Rudolf, "El Greco's Language of Gestures," *Art News*, Vol. 56, 1957, 44–49

CHRONOLOGICAL CHART OF
RENAISSANCE ARTISTS AND ARCHITECTS

ALTDORFER

MARINUS VAN ROYMERSWAELE

JEAN DUVET

GIORGIONE

ANDREA DEL SARTO

JAN CORNELIS

H. DAUCHER

BECCAFUMI

ASPERTINI

J. SANSOVINO

BONIFAZIO VERONESE

HANS BALDUNG GRIEN

BENEDIKT DREYER

JERG RATGEB

SAVOLDO

CARIANI

PALMA

ISENBRANT

TITIAN

JOOS VAN CLEVE

CONRAD MEIT

SEBASTIANO DEL PIOMBO

ORTOLANO

CONRAD KREBS

DOSSO

LEINBERGER

BARTEL BRUYN

BANDINELLI

LUCAS VAN LEYDEN

CORREGGIO

PONTORMO

PATINIR

ROSSO FIORENTINO

BERNARD VAN ORLEY

JAN VAN SCOREL

J. CLOUET

ALTOBELLO MELONE

MORETTO

ORDOÑEZ

HOLBEIN

SLUTER

JACQUEMART DE HESDIN

BROEDERLAM

CONRAD VON EINBECK

STARNINA

LORENZO MONACO

CONRAD VON SOEST

BRUNELLESCHI

JACOPO DELLA QUERCIA

GHIBERTI

POL DE LIMBOURG

NANNI DI BANCO

JOHANNES JUNGE

MASTER OF FLÉMALLE

DONATELLO

GENTILE DA FABRIANO

BELLECHOSE

MICHELOZZO

MASTER HARTMANN

ANGELICO

UCCELLO

ROGIER VAN DER WEYDEN

LUCA DELLA ROBBIA

MASACCIO

JAN VAN EYCK

PISANELLO

MASOLINO

SASSETTA

GIOVANNI DI PAOLO

MASTER FRANCKE

JACOPO BELLINI

ALBERTI

FILIPPO LIPPI

MULTSCHER

B. ROSSELLINO

JACOB KASCHAUER

TURA

WITZ

DOMENICO VENEZIANO

AGOSTINO DI DUCCIO

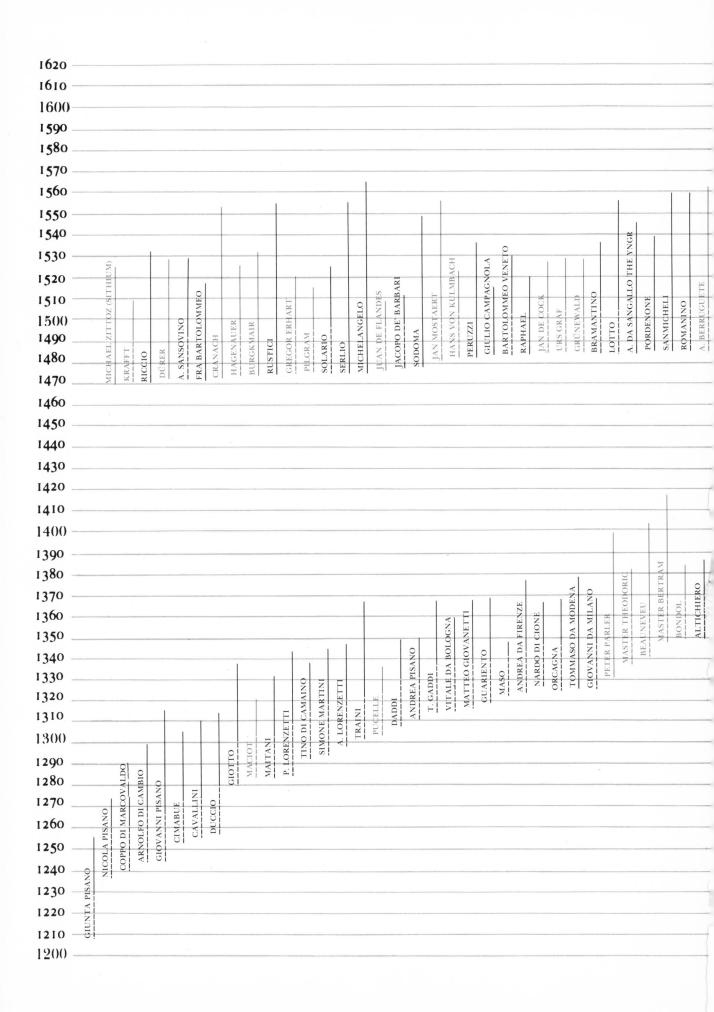

A chronological timeline chart of artists, with date gridlines from 1200 to 1620 (marked in increments of 10) down the right side.

Years (right margin, top to bottom): 1620, 1610, 1600, 1590, 1580, 1570, 1560, 1550, 1540, 1530, 1520, 1510, 1500, 1490, 1480, 1470, 1460, 1450, 1440, 1430, 1420, 1410, 1400, 1390, 1380, 1370, 1360, 1350, 1340, 1330, 1320, 1310, 1300, 1290, 1280, 1270, 1260, 1250, 1240, 1230, 1220, 1210, 1200

Artist names (labels on timeline bars):

- NICOLAS NEUFCHATEL
- ANTONIS MOR
- GOUJON
- F. CLOUET
- LESCOT
- WILLEM KEY
- JAN VAN DER STRAET (STRADANUS)
- VITTORIA
- PIERINO DA VINCI
- LUIS DE MORALES
- BAROCCI
- MORONI
- SCHIAVONE
- CAMBIASO
- TIBALDI
- PAOLO VERONESE
- JUAN DE HERRERA
- VALERIO CIOLI
- GIAMBOLOGNA
- VINCENZO DANTI
- BRUEGEL
- MARTEN DE VOS
- DIRCK BARENDS
- GERMAIN PILON
- ALLORI
- SMYTHSON
- SANCHEZ COELLO
- JUAN BAUTISTA DE TOLEDO
- TOBIAS STIMMER
- WILHELM VERNUCKEN
- EL GRECO
- SPRANGER
- HILLIARD
- GOLTZIUS
- BELLANGE
- PACHER
- FILIPPINO LIPPI
- NOTKE
- MONTAGNA
- GHIRLANDAIO
- MAURO CODUCCI
- MASTER OF MARY OF BURGUNDY
- COSSA
- LEONARDO DA VINCI
- CARPACCIO
- PERUGINO
- FALCONETTO
- MICHIEL COLOMBE
- BERMEJO
- SIGNORELLI
- A. DA SANGALLO THE ELDER
- STOSS
- ERCOLE DE' ROBERTI
- PINTURICCHIO
- GEERTGEN TOT SINT JANS
- GRASSER
- ZEIT BLOM
- PIERO DI COSIMO
- P. BERRUGUETE
- RIEMENSCHNEIDER
- COSTA
- GERARD DAVID
- MASSYS
- G. DE SILOE
- BOSCH
- P. VISCHER
- CORNELIS ENGELBRECHTS

RENAISSANCE ARTISTS AND ARCHITECTS

MARTIN VAN HEEMSKERCK
GIULIO ROMANO
JAN SANDERS VAN HEMESSEN
PEDRO MACHUCA
H.S. BEHAM
TRIBOLO
JAN VERMEYEN
D. DE SILOE
PARIS BORDONE
CELLINI
PERINO DEL VAGA
B. BEHAM
FLÖTNER
PIETER COECKE VAN AELST
DIEGO DE RIANO
PARMIGIANINO
GEORG PENCZ
BRONZINO
PEDRO DE CAMPANA
PRIMATICCIO
SEISENEGGER
RODRIGO GIL
VIGNOLA
PALLADIO
SALVIATI
LIGIER RICHIER
LEONE LEONI
VASARI
AMMANATI
DANIELE DA VOLTERRA
NICCOLÒ DELL' ABBATE
ALESSI
PHILIBERT DE L'ORME
CORNELIS FLORIS
GUGLIELMO DELLA PORTA
J. BASSANO
FRANS FLORIS
JUAN DE JUNI
LELIO ORSI
PIETER POURBUS
TINTORETTO

GOZZOLI
LOCHNER
CASTAGNO
PESELLINO
PETRUS CHRISTUS
J. SYRLIN THE ELDER
BALDOVINETTI
ENGUERRAND QUARTON
BOUTS
A. ROSSELLINO
JAIME HUGUET
MINO DA FIESOLE
NUNO GONÇALVES
MANTEGNA
POLLAIUOLO
BERNARDO MARTORELL
DESIDERIO
SCHONGAUER
VERROCCHIO
FOPPA
ANTONELLO DA MESSINA
MELOZZO DA FORLÌ
F. LAURANA
FRANCESCO DI GIORGIO
GIOVANNI BELLINI
JOOS VAN GENT
FROMENT
GERHAERT
FOUQUET
BENEDETTO DA MAIANO
NICCOLÒ DELL' ARCA
PIETRO LOMBARDO
BRAMANTE
RIZZO
GENTILE BELLINI
BOTTICELLI
G. DA SANGALLO
L. LAURANA
MEMLING
MASTER E. S.
HUGO VAN DER GOES

LEGEND

ITALIAN ARTISTS AND ARCHITECTS

NON-ITALIAN ARTISTS AND ARCHITECTS

———— *documented birth and death dates*

------- *estimated birth date, documented life span*

NOTE: *estimated birth date is arbitrarily set at 20 years
before first documented work date, and
should not be taken as exact*

Index

453

457

LIST OF PHOTOGRAPHIC CREDITS

The author and publisher wish to thank the libraries, museums, and private collectors for permitting the reproduction of paintings, prints, and drawings in their collections. Black-and-white photographs have been supplied by the owners or custodians of the works of art except for the following, whose courtesy is gratefully acknowledged:

A.C.L., Brussels (357, 360–62, 380–81, 388–89, 392, 451, 459–60, 462, 464, 482, 510); Alinari, Anderson, Brogi (1–5, 7, 9–14, 16–19, 21–25, 29–30, 32–39, 41–55, 57–59, 61, 63–72, 74–75, 77–79, 82, 84–90, 92–103, 106, 109–11, 113–14, 116–18, 122–23, 126, 130–34, 138–43, 147–49, 151–53, 156–63, 165–71, 173, 175, 179–81, 185, 189, 193, 197, 200, 202, 205, 207–16, 218, 221–23, 226, 228, 235, 237–39, 241–43, 246, 251–58, 261–63, 265–69, 272–75, 277, 279–82, 284–87, 289, 291–92, 295–97, 299, 301–3, 306–7, 311, 314–18, 320, 322, 326–27, 370, 384, 514); V. Aragozzini, Milan (186); Archives Photographiques, Paris (340–41, 344, 348, 390, 398, 453, 470, 493, 495); Bulloz, Paris (349, 386, 394, 396, 452); Bundesdenkmalamt, Vienna (407–8); Calzolari, Mantua (105); Eugenio Cassin, Florence (225); Cortopassi, Lucca (62); Daspert, Avignon (333); Deutscher Kunstverlag, Munich (421); A. Dingjan, The Hague (466, 481); Dumont-Schauberg, Cologne (426); A. Edelmann FFM, Frankfurt (366, 434); Encyclopedia of World Art (73, 323); Fototeca Unione, Rome (8, 76, 125, 283, 310, 312; Bohm, 300; Fiorentini, 304–5); Gabinetto Fotografico Nazionale, Rome (20, 236, 248, 308, 325); Giraudon, Paris (120, 204, 233, 339, 345–46, 369, 454, 492); Gundermann, Würzburg (416); S. Hallgren, Stockholm (405); Martin Hürlimann, Zurich (271); Institut für Denkmalpflege, Halle (354); A.F. Kersting, London (497); Rollie McKenna, New York (103, 293); Marburg-Art Reference Bureau (356, 372–73, 376, 399, 401, 404, 418–19, 422, 436, 440, 476, 499–500); Mas, Barcelona (319, 363, 456, 477, 483, 485–86, 489, 508, 520–24, 526); National Monuments Record, Crown Copyright, London (501–2); Organization of Government Distributed Art Objects, The Netherlands (465); Fernando Pasta, Milan (178); Eric Pollitzer, New York (220); Ludwig Richter, Mainz (402); Sagep, Genoa (322); Helga Schmidt-Glassner, Stuttgart (352, 409, 471); Service Photographique, Musées Nationaux, Paris (60, 177, 196, 206, 270, 334, 336, 343, 358, 391, 395, 447, 450); Soprintendenza alle Gallerie, Gabinetto Fotografico, Florence (26, 28, 107–8, 115, 192, 260); Walter Steinkopf, Berlin (245, 377, 442, 463, 504); Stickelmann, Bremen (428); Dr. Franz Stoedtner, Düsseldorf (400, 425); Strauss, Altötting (347); Photo Editions "Tel" (276); TWA (144); A. Villani, Bologna (49, 136, 324, 328)